VSTAVO·ADOLFO

EZIA

DALI· &c. &c. &c.

DVCA·DI·SLESVIG·HOLSTEIN·&c.&c.

O·DELLE·BELLE·ARTI·

LIA·E·CONSACRA

Veduta della Porta di detta Citta' ma

erte

sino al 1792.

restando il piu nobile

diversi ripiani

che all'interno di essi

dell'altre Case segnate N.º 2

Casa segnata N.º 27.

THE LAST DAYS OF POMPEII

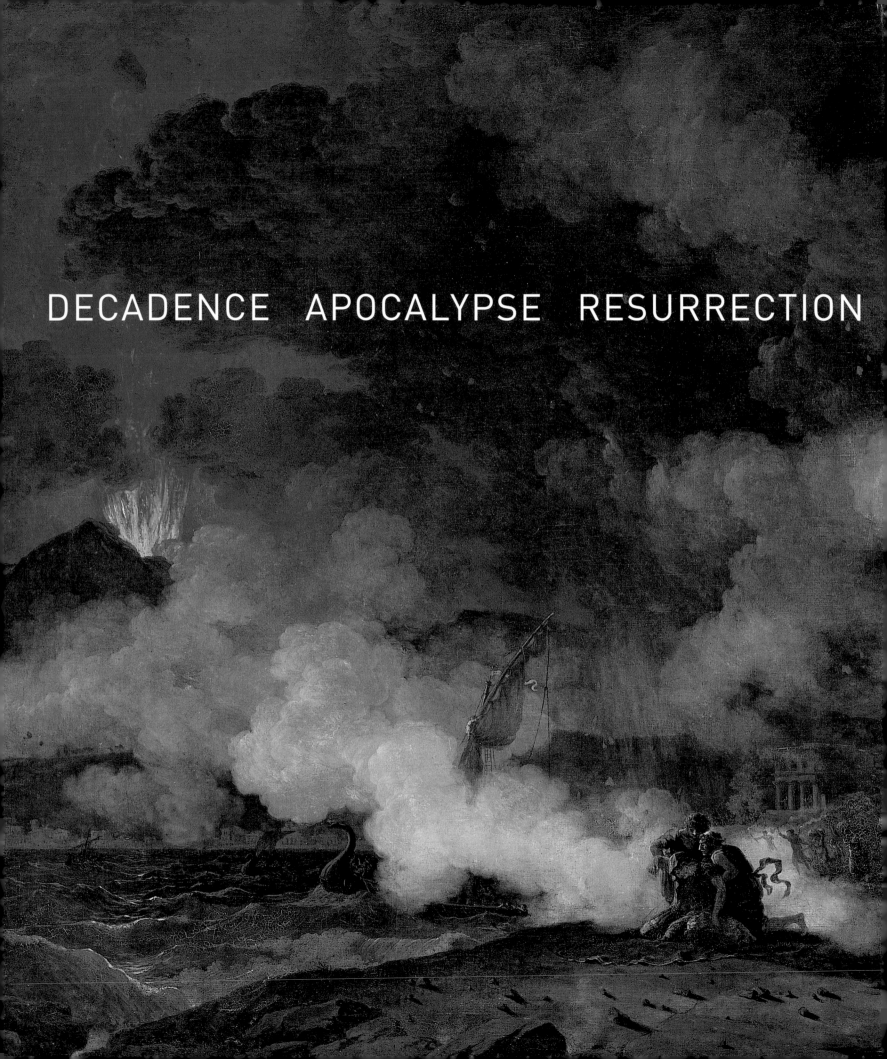

DECADENCE APOCALYPSE RESURRECTION

The
Last Days
of
Pompeii

VICTORIA C. GARDNER COATES

KENNETH LAPATIN

JON L. SEYDL

with contributions by
Mary Beard
Adrian Stähli
William St Clair and Annika Bautz

The J. Paul Getty Museum, Los Angeles | The Cleveland Museum of Art

This publication is issued on the occasion of the exhibition
THE LAST DAYS OF POMPEII: DECADENCE, APOCALYPSE, RESURRECTION
on view at the J. Paul Getty Museum at the Getty Villa in Malibu,
from September 12, 2012, to January 7, 2013; at the Cleveland Museum
of Art from February 24 to May 19, 2013; and at the Musée national
des beaux-arts du Québec from June 13 to November 8, 2013.

This exhibition is co-organized by the J. Paul Getty Museum and the
Cleveland Museum of Art. Not all works appear in every venue;
for complete checklists please consult the websites of the respective
museums.

This exhibition is supported by an indemnity from the Federal
Council on the Arts and the Humanities.

PUBLISHED BY THE J. PAUL GETTY MUSEUM, LOS ANGELES

Getty Publications
1200 Getty Center Drive, Suite 500
Los Angeles, CA 90049–1682
www.getty.edu/publications

Beatrice Hohenegger, *Editor*
Jeffrey Cohen, *Designer*
Elizabeth Kahn, *Production Coordinator*

Printed in Hong Kong

LIBRARY OF CONGRESS CATALOGING-IN-PUBLICATON DATA

The last days of Pompeii : decadence, apocalypse, resurrection /
Victoria C. Gardner Coates, Kenneth Lapatin, Jon L. Seydl ; with
contributions by Mary Beard, Adrian Stähli, William St. Clair
and Annika Bautz.
 pages cm
 This publication is issued on the occasion of the exhibition The Last
Days of Pompeii: Decadence, Apocalypse, Resurrection, on view at the
J. Paul Getty Museum at the Getty Villa in Malibu, from September 12,
2012, to January 7, 2013; at the Cleveland Museum of Art from February
24 to May 19, 2013; and at the Musée national des beaux-arts du Québec
from June 13 to November 8, 2013.
 Includes bibliographical references and index.
 ISBN 978-1-60606-115-2 (hardcover)
1. Pompeii (Extinct city)—In art—Exhibitions. 2. Vesuvius (Italy)—
Eruption, 79—Exhibitions. 3. Disasters in art—Exhibitions. 4. Art and
history—Exhibitions. 5. Art, Modern—Themes, motives—Exhibitions.
I. Gardner Coates, Victoria C. II. Lapatin, Kenneth D. S. III. Seydl, Jon L.,
1969– IV. J. Paul Getty Museum. V. Cleveland Museum of Art. VI. Musée
national des beaux-arts du Québec.
 N8214.5.I8L37 2012
 937'.7256807—dc23
 2012012303

Front jacket: Hector Leroux (French, 1829–1900),
Herculaneum 23 August AD 79, 1881 (detail, plate 32)
Back jacket: Antony Gormley (British, b. 1950), *Untitled*, 2002
(plate 89)
PAGE 1: César (French, 1921–1998), *Seated Nude*, Pompeii, 1954
(plate 35)
PAGE 2: Pierre Henri de Valenciennes (French, 1750–1819),
The Eruption of Vesuvius, 1813 (detail, plate 21)
PAGE 5 (left): Alfred Elmore (British, 1815–1881), *Pompeii, A.D. 79*,
1878 (detail, plate 9)
PAGE 5 (middle): Andy Warhol (American, 1928–1987),
Mount Vesuvius, 1985 (detail, plate 50)
PAGE 5 (right): Alessandro Sanquirico (Italian, 1777–1849), *The Forum
of Pompeii Decorated for a Festival*, ca. 1827–32 (detail, plate 67)
PAGES 6–7: Jakob Philipp Hackert (German, active Italy, 1737–1807),
The Excavations at Pompeii, 1799 (detail, plate 54)
PAGES 8–9: Alessandro Sanquirico (Italian, 1777–1849), *Entrance
to Pompeii from the Nolan Gate*, ca. 1827–32 (detail, plate 66)
PAGE 12: Robert Rauschenberg (American, 1925–2008),
Small Rebus, 1956 (detail, plate 39)
Pages 14–15: Joseph Franque (French, 1774–1833), *Scene during
the Eruption of Vesuvius*, 1827 (detail, plate 25)
PAGES 32–33: B. J. Falk (American, 1853–1925), *No. 1 of Pain's
Spectacle, Coney Island*, 1903 (detail, plate 85)
PAGES 44–45: Giorgio Sommer (Italian, b. Germany, 1834–1914),
Pompeii, House of the Hanging Balcony (no. 1256), 1870s (detail,
plate 82)
PAGES 52–53: Lawrence Alma-Tadema (Dutch and British, 1836–1912),
Glaucus and Nydia, 1867, reworked 1870 (detail, plate 70)
PAGES 60–61: Théodore Chassériau (French, 1819–1856), *Tepidarium:
The Room Where the Women of Pompeii Came to Rest and Dry
Themselves After Bathing*, 1853 (detail, plate 7)
PAGES 70–71: *Sigmund Freud's Cast of Gradiva*, ca. 1910 (detail, plate 14)
PAGES 78–79: Film still from *Gli ultimi giorni di Pompeii*
(directed by Eleuterio Rodolfi, Italy, 1913), (detail, figure 55)
PAGES 88–89: Francesco Netti (Italian, 1832–1894), *Gladiator
Fight during a Meal at Pompeii*, 1880 (detail, plate 10)
PAGES 124–25: John Martin (British, 1789–1854), *The Destruction
of Pompeii and Herculaneum*, ca. 1822–26 (detail, plate 22)
PAGES 180–81: Edouard Alexandre Sain (French, 1830–1910),
Excavations at Pompeii, 1865 (detail, plate 75)

ILLUSTRATION CREDITS

Every effort has been made to contact the owners and photographers
of objects reproduced here whose names do not appear in the captions
or in the illustration credits at the back of this book. Anyone having
further information concerning copyright holders is asked to contact
Getty Publications so this information can be included in future print-
ings.

Authors of the catalogue entries are identified by their initials
AS Alexandra Sofroniew
CK Cory Korkow
JLS Jon L. Seydl
KL Kenneth Lapatin
LZ Lucy Zimmerman
MC Mark Cole
NSH Niki Stellings-Hertzberg
VCGC Victoria C. Gardner Coates

Contents

6 **Foreword**
DAVID FRANKLIN TIMOTHY POTTS

8 **Acknowledgments**

13 **Lenders to the Exhibition**

14 **Decadence, Apocalypse, Resurrection**
JON L. SEYDL

32 **Pompeii on Display**
KENNETH LAPATIN

44 **On the Cutting Edge: Pompeii and New Technology**
VICTORIA C. GARDNER COATES

52 **The Making of the Myths: Edward Bulwer-Lytton's *The Last Days of Pompeii***
WILLIAM ST CLAIR AND ANNIKA BAUTZ

60 **Dirty Little Secrets: Changing Displays of Pompeian "Erotica"**
MARY BEARD

70 **Pompeii on the Couch: The Modern Fantasy of "Gradiva"**
VICTORIA C. GARDNER COATES

78 **Screening Pompeii: The Last Days of Pompeii in Cinema**
ADRIAN STÄHLI

DECADENCE 88

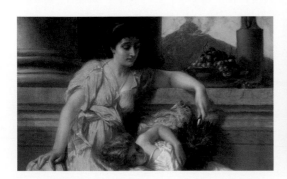

APOCALYPSE 124

RESURRECTION 180

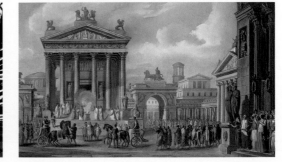

242 **Appendix: Pompeii Exhibitions**

251 **Selected Bibliography**

255 **Illustration Credits**

256 **About the Authors**

257 **Index**

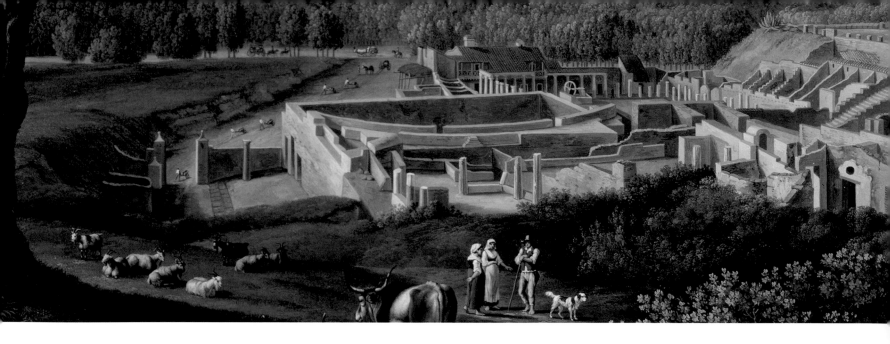

Foreword

DAVID FRANKLIN
Sarah S. and Alexander M. Cutler Director,
The Cleveland Museum of Art

TIMOTHY POTTS
Director, The J. Paul Getty Museum

Pompeii occupies a unique place in our historical consciousness. The spectacular destruction of the city by the eruption of Mount Vesuvius in A.D. 79 has become for us the archetypal apocalypse, the ultimate catastrophe, the first fixed point in our iconology of disaster. Most of history depends on myriad particularities—people and places, beliefs and motives, technologies and institutions—that are safely unrepeatable. Pompeii, on the other hand, is the disaster that makes us shudder still. Despite all that has changed in the past two millennia, this is the event that could happen again and with much the same consequences. Our fascination with Pompeii as an historical event brings with it, just below the surface, an unwelcome relevance to the present. Little wonder, then, that it has given artists, poets, and thinkers so much to dwell upon, and provided a trope in which to see the precariousness of their own condition.

Pompeii is as much the name of an event as a place, the first of many ambiguities that are part of its fascination. It is the most famously dead of all ancient cities, yet the one that comes most vividly alive to us today. It is one of the iconic events of ancient history, yet it is known to us through an eye-witness account every bit as graphic and sensationalist as twenty-first-century cable-TV reportage. "Many besought the aid of the gods," writes Pliny the Younger of those trying to escape, "but still more imagined there were no gods left, and that the universe was plunged into eternal darkness for evermore." The Roman gods are gone, but Pompeii remains the definitional "act of God."

Pliny's letters were rediscovered and published in the 1400s, but it was only with the excavation of Pompeii, Herculaneum, and the other ancient sites around the Bay of Naples in the early 1700s that Pompeii became the main source of inspiration in the growing enthusiasm for classical antiquity. Since that time, these sites have enjoyed tremendous popularity, both among scholars, who found in them an invaluable record of ancient Roman daily life, and among the general public, who have traveled in increasing numbers to the sites themselves. The Vesuvian cities have also been explored at a distance through ever-changing technologies, from engravings and photography to traveling exhibitions, television documentaries, and virtual-reality presentations.

The investigation of these ancient sites has been a powerful engine in the development of archaeology as a scientific discipline, and finds from the Bay of Naples also initiated a taste for Pompeiana across Europe and North America. The phenomenon of Pompeii has been thoroughly examined in books, films, and exhibitions around the world. In the three centuries since their rediscovery, Pompeii and other sites have also engaged and inspired contemporary artists and thinkers of the first rank, from Piranesi and Ingres to Rothko and Warhol. It is this legacy in thought and art that *The Last Days of Pompeii* explores, showing how the destruction wrought by Vesuvius two thousand years ago has provided artists with a historical and artistic motif

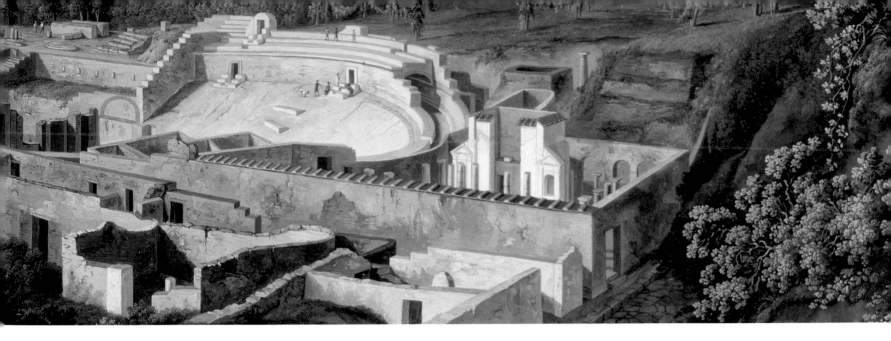

through which to explore a range of contemporary concerns. It presents Pompeii not as a window to the past but as a mirror of an ever-changing present.

The Last Days of Pompeii takes its name from the popular novel by Edward Bulwer-Lytton, first published in 1834. A blockbuster in its own day, the novel was translated into numerous languages and adapted for stage plays and extravagant outdoor performances (including two that took place in Cleveland in 1896 and 1935 and one in Los Angeles in 1905)—and its influence has continued into the present, inspiring everything from comic books to films and television specials. Not the least interesting manifestation of this phenomenon is J. Paul Getty's decision forty years ago to construct a replica of the Villa dei Papiri at Herculaneum—a luxurious Roman residence thought to have been owned by Julius Caesar's father-in-law—to house his growing art collections.

But while Pompeii remains very much with us, the ancient story that we think we know is at the same time one of our own making. The essays in this volume and the exhibition it accompanies explore how the disaster visited upon Pompeii has taken on new meanings in modern times, whether in light of the ravages of the American Civil War, the cataclysm of the great San Francisco earthquake, the obliteration of Hiroshima and Nagasaki, the attacks of September 11, 2001, or the devastation of the 2011 earthquake and tsunami in Japan. As the subtitle of the exhibition makes clear, modern notions of decadence, apocalypse, and resurrection have shaped our ideas about the Pompeian past as much as—and sometimes more than—the actual city that was both destroyed and preserved by Vesuvius.

This exhibition is only the most recent of many collaborative ventures between the J. Paul Getty Museum and the Cleveland Museum of Art, and more are planned for the future, including a major exhibition in 2013 treating the art and culture of ancient Sicily. We are grateful to the co-curators of the exhibition and co-editors of this volume, Victoria C. Gardner Coates, consulting curator at the Cleveland Museum of Art; Kenneth Lapatin of the Getty Museum's Department of Antiquities; and Jon L. Seydl, the Paul J. and Edith Ingalls Vignos, Jr., Curator of European Painting and Sculpture, 1500–1800, at the Cleveland Museum of Art, for their efforts over many years in developing this project and seeing it through to completion. Our appreciation also goes to Line Ouellet, director of the Musée national des beaux-arts du Québec, and her staff for their work in mounting the exhibition there.

Additionally we offer thanks to the distinguished authors of the essays published here, William St Clair (University of London), Annika Bautz (Plymouth University), Mary Beard (Cambridge University), Adrian Stähli (Harvard University), as well as the other contributors to this catalogue. We are especially grateful to our museum colleagues and private collectors in North America and overseas who have responded so positively to the expansive and unorthodox approach to Pompeii's legacy taken in this project by generously lending to the exhibition.

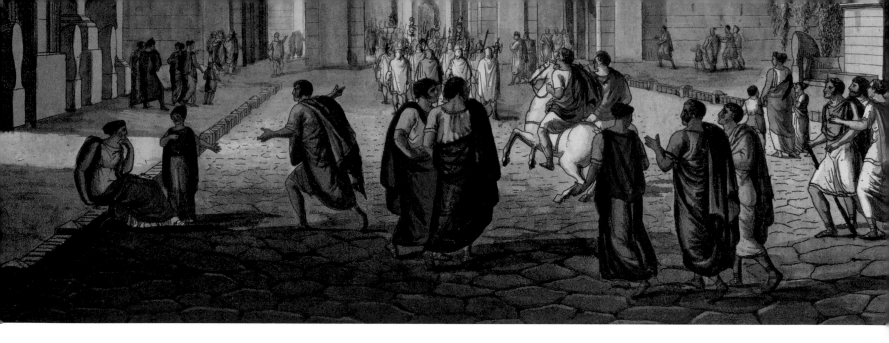

Acknowledgments

The presentation of *The Last Days of Pompeii* in the galleries of three museums and in the following pages would not have been possible without the generous assistance of colleagues and institutions around the world, and it is a pleasure to thank them here.

This project has been long in preparation, but it was a retreat in 2008—supported by the office of the associate director for collections at the J. Paul Getty Museum—that allowed us to shape its conceptual framework. We are enormously grateful to David Bomford for underwriting this critical period of reflection and for his subsequent enthusiasm for the exhibition. Mary Beard, Claire L. Lyons, Margaret Malamud, Nick Yablon, and Katja Zelldjat joined us at the retreat in Los Angeles, contributing many stimulating ideas, and we are deeply indebted to each of them.

The research for this project, which ranges over centuries and many different media, could never have been conducted without the liberal assistance of so many private collectors, curators, scholars, museums, libraries, and archives.

We would also like to express our deepest gratitude to the artists who aided our project, particularly Hernan Bas, Mirosław Bałka, Antony Gormley, Michael Huey, Matts Leiderstam, Allan McCollum, and Jeremy Paul.

We would like to thank private collectors and dealers who generously contributed to the exhibition, Ciléne Andréhn, Keith De Lellis, Hans Kraus, Daniel Malingue, Marisa Newman, Friedrich Petzel, Tony Shafrazi, and Steven Yusi. We also profited from the kind help of Renée Albada Jelgersma, Vera Alemani, Yana Balson, George Homer, Cary Leibowitz, Rose Lord, Bryony McClennan, and Jennifer Parkinson, as well as those who have asked to remain anonymous.

To the staff of institutions that recognized the merit of this project and graciously allowed the objects in their care to travel we would like to express our sincere thanks:

In France, Henri Loyrette, director, and Delphine Burlot, Cécile Giroire, Sylvain Laveissière, Jean-Luc Martinez, and Daniel Roger of the Musée du Louvre generously facilitated research and parted with significant works; likewise Guy Cogéval, direc-

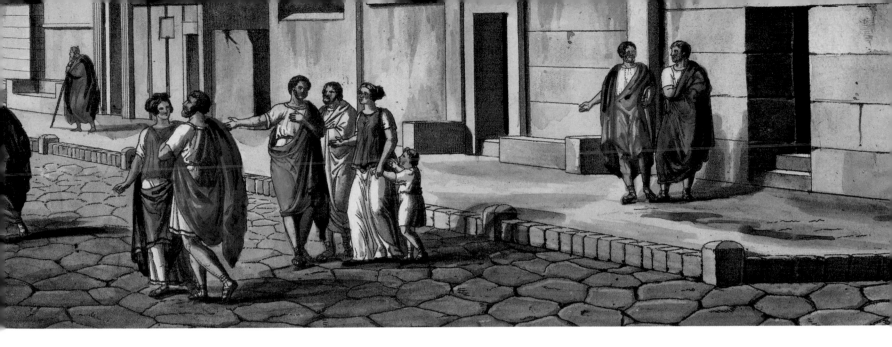

tor, and Catherine Chevilliot, Hélène Flon, Caroline Mathieu, Odile Michele, Edouard Papet, Sylvie Patry, and Anne Pingeot at the Musée d'Orsay. Gilles Chaznal, director, as well as Maryline Assante di Panzillo and Hubert Cavaniol at the Musée du Petit Palais were supportive and encouraging throughout the process. Alfred Pacquement and Brigitte Leal at the Centre Georges Pompidou also agreed to send a work of paramount significance. We are also grateful to Axel Hémery of the Musée des Augustins in Toulouse and Bénédicte Magnin of the Musée des Beaux-Arts Salies of Bagnères-de-Bigorre.

Italian colleagues have been extraordinarily generous and helpful in their support of the exhibition. In Naples we extend our profound thanks to Lorenza Mochi Onori, soprintendente speciale per il patrimonio storico, artistico ed etnoantropologico e per il Polo Museale della città di Napoli; Mariella Utili, director of the Museo Nazionale di Capodimonte; and Teresa Elena Cinquantaquattro, soprintendente ai beni archeologici di Napoli e Pompei; Valeria Sampaolo, director of the Museo Archeologico Nazionale; Luigia Melillo, head of conservation,

and Maria Paola Guidobaldi, director of excavations, at Herculaneum; archaeologists Michele Borgongino, Domenico Esposito, and Grete Stefani; conservator Giuseppe Zolfo; and architects Angela Vinci and Valerio Pappaccio, as well as Mariarosaria Esposito of the historical archive of the Soprintendenza. We are especially thankful to Antonio Paolucci, director, and curators Guido Cornini, Claudia Lega, Maurizio Sannibale, and Giandomenico Spinola, and conservators Massimo Alessi, Flavia Callori, Vittoria Cimino, Guy Devreux, and Fabiana Francescangeli of the Musei Vaticani.

We are also pleased to acknowledge the kind assistance of chief curator Guillermo Solana at the Thyssen Bornemisza Museum in Madrid.

In the United Kingdom, we extend our profound thanks to many individuals: Alastair Laing of the National Trust; Saraid Jones and Sarah Kay at Attingham Park; Peter Cannon-Brookes of the Tabley House Collection; Susan Worrall and Sarah Kilroy at the University of Birmingham; Michael Clarke and Helen Smailes at the National Gallery of Scotland; Jane Duffy,

Reyahn King, and Sandra Penketh at the Liverpool Museums; and Sophie Leighton and Carol Seigel at the Sigmund Freud Museum.

In the United States, we are indebted to many colleagues for their generosity of time, expertise, and loans: Angela Elliot, Katy Rothkopf, and Oliver Shell of the Baltimore Museum of Art; Malcolm Rogers, director, and Marietta Cambareri, Katie DeMarsh, Richard Grossman, Pamela Hatchfield, Frederick Ilchman, Christine Kondoleon, Winona Packer, George T. S. Shackelford, and Gerry Ward of the Museum of Fine Arts, Boston; Arnold Lehman, director, as well as Terry Carbone and Karen Sherry at the Brooklyn Museum; James Cuno and Douglas Druick, former and current directors of the Art Institute of Chicago, as well as Bruce Boucher, Natasha Derrickson, Lisa Dorin, Gloria Groom, Adrienne Jeske, Jane Neet, Mark Pascale, James Rondeau, Nora Tobbe Riccio, and Matthew S. Witkovsky. Jeffrey Deitch, director, Paul Schimmel, chief curator, and Naomi Abe at the Museum of Contemporary Art; Darin Drabing, president and CEO of Forest Lawn Memorial-Parks & Mortuaries, and Joan Adan, curator at the Forest Lawn Museum; Juan Roselione-Valadez, director of the Rubell Family Collection in Miami; Amy Meyers, director, and Abigail Armistead, Adrianna Bates, Gillian Forrester, John Monahan, and Angus Trumble of the Yale Center for British Art in New Haven; in New York, Glenn Lowry, director, as well as Jen Schauer and Ann Temkin of the Museum of Modern Art; Stacy Brinkman and Jessica Ann Wray of the Wertz Art and Architecture Library of Miami University in Oxford, Ohio; Timothy Rub, director, and Carlos Basualdo, John Ittmann, Shelley Langdale, Brooks Rich, Joseph J. Rishel, Michael Taylor, Jennifer A. Thompson, and Jennifer Otte Vanim at the Philadelphia Museum of Art; Mike Dabrishus of the Frick Fine Arts Library at the University of Pittsburgh; Eric C. Shiner, director of the Andy Warhol Museum in Pittsburgh; Mary-Kay Lombino of the Frances Lehman Loeb Art Center of Vassar College in Poughkeepsie, New York; Susan M. Taylor, director, and Betsy Rosasco of the Princeton University Art Museum; at the George Eastman House, Joseph Struble and Rachel Stuhlman; Lial Jones, director, and Scott A. Shields of the Crocker Art Museum in Sacramento; in Washington, D.C., Earl A. Powell III, director, and Véronica Betancourt, Janet Blyberg, Judith Brodie, Harry Cooper, Anne Halpern, Gregory Jecmen, Mary Levkoff, Lisa MacDougall, Katy May, Gregory P. J. Most, Andrew Robison, Josephine Rogers, Sydney Skelton, and Neal Turtell at the National Gallery of Art; Elizabeth Broun, director of the Smithsonian Museum of American Art; Richard Koshalek, director of the Hirshhorn Museum and Sculpture Garden; and Carol Johnson and Patrick C. Shepler at the Library of Congress.

Many colleagues, scholars, and friends kindly offered valuable advice, assistance, and information, and we are greatly in their debt: Aileen Agopian, Helga Aurisch, Anna Austen, David Aylsworth, Joe Baptista, Marina Belozerskaya, Bettina Bergmann, Mary Betlejeski, Thomas Bompard, MaryAnn Bonino, Anne Buckingham, Kevin Burke, Timothy Burns, Elena Calandra, Jim Cassaro, Anne Ricard Cassidy, Pieranna Cavalchini, Kathleen Chabla, Giacomo Chiari, David Christie, Louise Chu, John R. Clarke, Sara Cochran, Robert Cohon, James Crump, Gerard Dessere, Louise Désy, Judith Dolkart, Vincent Droguet, Denyse Durand-Ruel, Eugene Dwyer, Charlotte Eyerman, Lisa Fentress, Lucia Ferruzza, Cindy Fink, Claudio Fogu, Ilene Fort, Maria Fratelli, Patti Gibbons, Larry Giles, Jason Goldman, Alden Gordon, Michael Govan, Suzanne Greenawalt, Vivien Greene, Alison de Lima Greene, Stephanie Grimm, Barbara Grosclose, Michael Hackett, Shelley Hales, James H. Hamilton, Maurizio Harrari, Riccardo Helg, Jennie Hirsh, John Hirx, Rena Hoisington, Thomas Noble Howe, Luciana Jacobelli, Catherine Johnson-Roehr, Sophie Jugie, David Kessler, Joe Ketner, Marina Kiseleva, Ann Kuttner, Russell Lord, Sarah Maisey, Peter Marquand, Carol C. Mattusch, Walt Meyer, Carolyn Miner, Heather Hyde Minor, Jerzy Miolek, Eric M. Moormann, Monique Moulène, Erin Munroe, Martin Myrone, Rui Nakamura, Lawrence W. Nichols, Marden F. Nichols, Rosslyn Njuguna, Fabrizio Pesando, Joanna Paul, Ann Percy, Allen Phillips, Amy Pickard, Gertrud Platz, Nigel Pollard, Maria Possenti, Deana Preston, Kendall S. Rabun, Nancy Ramage, Jacquelene Riley, Laura Rivers, Paul Roberts, Stefano Rocchi, James Rosenzweig, David Saja, Lucy Salt, Hope Saska, Ann Schafer, Ann Sindelar, Camilla Smith, Freyda Spira, Perrin Stein, Cindi Strauss, Antero Tammisto, Virginie Tchakoumi, Annabelle Ténèze, Nancy Thomas, Francesca Tronchin, Bernhard von Waldkirch, Denise Wamaling, Barbara Weinberg, David H. Weinglass, Steve West, Jochen Wierich, Jennifer Wight, Holly Witchey, Del Zog, Mary Zuber, and Joyce Zucker. Finally, we would like to express particular thanks to Daniel Abadie, Francesca Bongioanni, Katherine Woltz, and Eric Zafran for their exceptional commitment to this project.

The staffs of the organizing institutions have enthusiastically supported the exhibition since its inception. Colleagues from the J. Paul Getty Museum and the Getty Research Institute have aided this project considerably under the initial leadership of former museum director Michael Brand and former acting director David Bomford, as well as Thomas Gaetghens, director of the Getty Research Institute. In the museum's department of antiquities, curators Jens Daehner, Claire L. Lyons, David Saunders, Alexandra Sofroniew, and Karol Wight; interns past and present Chelsey Flemming, Laure Marest-Caffey, Rachel Patt, Emma Sachs, Ambra Spinelli, and Niki Stellings-Hertzberg; as well as Peter Evans, Paige-Marie Ketner, Minyoung Park, and Tricia Wilk; in antiquities conservation, David Armaderiz, B.J. Farrar, McKenzie Lowry, Jeffrey Maish, Jerry Podany, Erik Risser, and Eduardo Sánchez; in the department of photography, Karen Hellman, Anne Lyden, Judy Keller, Paul Martineau, Aja Sui, and Alana West; in the department of paintings, Scott

Allan and Scott Schaefer; Yvonne Szafran and Laura Rivers in paintings conservation; Julian Brooks, Edouard Kopp, and Stephanie Schrader in drawings; Antonia Böstrom and Anna-Lise Desmas in sculpture and decorative arts; and in the education department, Shelby Brown, Eric Bruehl, Rainer Mack, and Ann Steinsapir; in the registrars office, Jacqueline Cabrera, Carole Campbell, Cherie Chen, Leigh Grissom, Sally Hibbard, Amy Linker, and Betsy Severance; in collections information and access, Erik Bertelotti, Nina Diamond, Maria Gilbert, Sahar Tchiatchian, and Karen Voss; Laurel Bybee, Robert Checchi, Elie Glyn, Emily Morishita, and Merritt Price in design; Liz Andres, Quincy Houghton, and Robin McCarthy in exhibitions; and Norman Frisch, Lisa Guzzetta, Laurel Kishi, Kelli O'Leary, Guy Wheatley, and Anna Woo in Villa programming.

At the Getty Research Institute invaluable assistance was provided by Peter Bonfitto, David Brafman, Jory Finkel, Irene Lotspeich-Phillips, Louis Marchesano, Karen Meyer-Roux, Marcia Reed, Sara Scotti, Frances Terpak, Stephan Welch, and the amazing team of librarians working in circulation, reference, special collections, and interlibrary loan.

The Cleveland Museum of Art is honored to partner with Baker Hostetler, Presenting Sponsor of Artistic Excellence in Exhibitions. The firm's significant investment enabled the museum to present the Pompeii exhibition in Cleveland. In addition, the museum is grateful for the outstanding leadership and support of Steve Kestner, National Partner of Baker Hostetler and Chairman of the museum's Board of Trustees. Thanks go out to Timothy Rub, director from 2006 to 2009, who initially encouraged the project; Deborah Gribbon, interim director 2009–10, who supported the show during her tenure; and now David Franklin, the Sarah S. and Alexander M. Cutler Director, who led the project through its implementation. Deputy director and chief curator C. Griffith Mann offered leadership throughout the project's development. Heidi Strean, director of exhibitions, shepherded the exhibition along with Emily Mears, while Mary Suzor and Elizabeth Saluk coordinated and facilitated the loan requests and the complex shipping arrangements. We appreciate Jeffrey Strean and Jim Engelmann in architecture and design for their inventive installation in Cleveland; Caroline Goeser, Dale Hilton, and Seema Rao in education and public programs for organizing educational programming; and Betsy Lantz, Louis Adrean, Christine Edmonson, Matthew Gengler, and the staff of Ingalls Library for facilitating research. Other staff deserve mention: August Napoli and his institutional advancement staff; Howard Agriesti and his staff in photographic and imaging services; Marcia Steele, Dean Yoder, and Moyna Stanton in conservation; Mary Thomas and Terra Blue in design; Barry Austin, Arthur Beukemann, Joseph Blaser, Nicholas Gulan, and Tracy Sisson in collections management; Robin Roth and the staff of exhibition production; Elizabeth Bolander and other marketing and communications staff members;

Jane Takac Panza and Amy Sparks in curatorial publications; and Dave Shaw in media productions.

In Cleveland June De Phillips also deserves special mention. Lucy I. Zimmerman was the research assistant on the project, and her work must be singled out, as should that of Paola Morsiani, who expertly guided us, as novice curators in contemporary art, through the particular challenges in dealing with living artists. Many other colleagues assisted us, including Barbara Bradley, Karen Bourquin, Joan Brickley, Mark Cole, John Ewing, Elizabeth Funk, Alicia Husdon Garr, Jane Glaubinger, Tom Hinson, Lisa Kurzner, Betsy Lantz, Heather Lemonedes, Constantine Petridis, William Robinson, Massoud Saidpour, Colleen Snyder, Samantha Springer, Barbara L. Tannenbaum, and Tom Welsh.

Also invaluable was the assistance of the staff at the Musée national des beaux-arts in Québec: Line Ouillet, executive director, Anne Eschapasse, director of exhibitions and scholarly publications, André Sylvain, operations coordinator, Jean-Pierre Labiau, curator of exhibitions, André Gilbert, editor, and Catherine Perron, registrar.

For the elegant design of the catalogue we are grateful to Jeffrey Cohen of Getty Publications. Beatrice Hohenegger managed the project, which was copyedited by Cynthia Newman Edwards and proofread by Catherine Chambers. Pam Moffat collected the images and Elizabeth Burke-Kahn oversaw production. Thanks are also due to contributors to the catalogue, both the authors of the essays and those who researched and wrote entries and helped to compile the appendix: Mary Beard, Annika Bautz, Mark Cole, Cory Korkow, Adrian Stähli, William St Clair, Alexandra Sofroniew, Niki Stellings-Hertzberg, Antero Tammisto, and Lucy I. Zimmerman.

VICTORIA C. GARDNER COATES
KENNETH LAPATIN
JON L. SEYDL

Lenders to the Exhibition

The Art Institute of Chicago
Attingham Park, The Berwick Collection (The National Trust), U.K.
The Baltimore Museum of Art
Peter Blum Gallery, New York
Brooklyn Museum
Cadbury Research Library: Special Collections, University of Birmingham, U.K.
Centre National d'Art et de Culture Georges Pompidou, Paris
The Cleveland Museum of Art
Crocker Art Museum, Sacramento, CA
George Eastman House, Rochester, NY
Forest Lawn Museum, Glendale, CA
Freud Museum, London
Frick Fine Arts Library, University of Pittsburgh
J. Paul Getty Museum, Los Angeles
Getty Research Institute, Los Angeles
Hans P. Kraus, Jr., New York
Hirshhorn Museum and Sculpture Garden, Smithsonian Institution, Washington, DC
Kenneth Lapatin, Santa Monica, CA
Keith de Lellis Gallery, New York
Library of Congress, Washington, DC
The Frances Lehman Loeb Art Center, Vassar College, Poughkeepsie, NY
Mead Art Museum, Amherst, MA
Musée des Augustins, Toulouse, France
Musée des Beaux-Arts Salies, Bagnères-de-Bigorre, France
Musée d'Orsay, Paris
Musée du Louvre, Paris
Museo Archeologico Nazionale di Napoli, Italy
Museo Nazionale di Capodimonte, Naples, Italy
The Museum of Contemporary Art, Los Angeles
Museum of Fine Arts, Boston
The Museum of Modern Art, New York
National Gallery of Art, Washington, DC
National Gallery of Scotland, Edinburgh
National Museums, Liverpool
Newman Popiashvili Gallery, New York
Petit Palais, Musée des Beaux-Arts de la Ville de Paris
Friedrich Petzel Gallery, New York
Philadelphia Museum of Art
Princeton University Art Museum
Rubell Family Collection, Miami
Tony Shafrazi Gallery, New York
Smithsonian American Art Museum, Washington, DC
Soprintendenza speciale per i beni archeologici di Napoli e Pompei
Tabley House Collection, University of Manchester, U.K.
Thyssen-Bornemisza Museum, Madrid
The Vatican Museums
The Andy Warhol Museum, Pittsburgh
Wertz Art and Architecture Library, Miami University, Oxford, OH
Yale Center for British Art, New Haven
Archive of Raymond D. Yusi, Pacific Palisades, CA
American and European private collectors

Since everyone's anguish is our own,

We live ours over again, thin child,

Clutching your mother convulsively

As though, when the noon sky turned black,

You wanted to re-enter her.

To no avail, because the air, turned poison,

Filtered to find you through the closed windows

Of your quiet, thick-walled house,

Once happy with your song, your timid laugh.

Centuries have passed, the ash has petrified

To imprison those delicate limbs forever.

In this way you stay with us, a twisted plaster cast,

Agony without end, terrible witness to how much

Our proud seed matters to the gods.

Nothing is left of your far-removed sister,

The Dutch girl imprisoned by four walls

Who wrote of her youth without tomorrows.

Her silent ash was scattered by the wind,

Her brief life shut in a crumpled notebook.

Nothing remains of the Hiroshima schoolgirl,

A shadow printed on a wall by the light of a thousand suns,

Victim sacrificed on the altar of fear.

Powerful of the earth, masters of new poisons,

Sad secret guardians of final thunder,

The torments heaven sends us are enough.

Before your finger presses down, stop and consider.

— Primo Levi, "The Girl-Child of Pompeii," 1978[1]

JON L. SEYDL

Decadence, Apocalypse, Resurrection

The Italian writer Primo Levi turned to Vesuvius's victims in his 1978 poem to address the Holocaust and the bombing of Hiroshima. Levi's explicitly political elegy implores leaders with the capacity to annihilate at the touch of a button to reflect on the horrors of the past. Yet Anne Frank and the unknown Japanese girl were both victims of war, exterminated by human actions, while Pompeii was a natural disaster. Even though the calamities are in no way parallel, we intuitively understand the metaphor: Pompeii expresses the unspeakable, makes the annihilated visible, and freezes cataclysm.[2] Pompeii—perhaps more intensely than any other event in the Western imagination—speaks to catastrophe laced with memory.

Primo Levi's metaphor gains its strength by referring at once to the swift destruction of an entire city and remembrance of the devastation through the plaster casts of identifiable bodies. Pompeii is the rare universal, requiring no context to understand the narrative. From the time news of Herculaneum's rediscovery began to leak out in the late 1730s, the cities destroyed by the eruption of Mount Vesuvius have maintained a special hold on the modern imagination, outpacing interest in the specific antiquities and archaeology of the sites and inspiring works of art from the eighteenth century to the present day.

Pompeii as Mirror, not Window

> ...the moment we set our foot in Pompeii,
> we are in a world of illusions.
>
> —Thomas Gray, introduction to the novel *The Vestal;
> or, A Tale of Pompeii*, 1830[3]

The events of Pompeii's destruction in A.D. 79 are well known, as is the gradual recovery of the sites from the eighteenth century forward.[4] For this reason, this volume and the accompanying exhibition neither highlight artifacts from antiquity nor present a history of archaeology in the Bay of Naples—as Kenneth Lapatin's essay in this volume underscores, such projects have been plentiful, thorough, and ongoing. Until recently much

scholarship has generally accepted that the sites offer a unique and straightforward window onto the past—a view of antiquity as it really was. Our project takes a different, anti-archaeological perspective, considering instead the role Pompeii has played, and continues to play, in the modern imagination. We examine how artists have deployed Pompeii over time ("Pompeii" is shorthand here for diverse sites in the Bay of Naples, including Herculaneum and Stabiae), repeatedly using it as a shifting metaphor for a wide repertory of ideas—few having to do with antiquity, but largely responding instead to contemporary events. In this imagined Pompeii, a fascination with apocalypse entwines with perpetually changing understandings of the classical past. But, in the paradox at the heart of this project, the sites are regularly treated anachronistically: disaster is inevitable, cataclysm predestined, portents ignored, and punishment deserved. Indeed, today it is impossible to imagine Pompeii without thinking about the disaster and its layers of retroflections.

To examine this phenomenon, the exhibition takes up three broad themes. *Decadence* examines Pompeii as either a locus of gratuitous violence and gluttony or a site characterized by an intensely luxurious, sensual, and sexualized way of being. According to these views, Pompeian decadence can be problematized as troubling, indulgent behavior that caused the disaster.

FIG. 1. Francesco de Mura (Italian, 1696–1782), *Allegory of Spring*, 1759. Oil on canvas, 103 × 130 cm (40½ × 51 in.). Toledo Museum of Art, Purchased with funds from the Libbey Endowment, Gift of Edward Drummond Libbey, 1979.79.

Or, alternatively, it allowed an otherwise impermissible eroticism or other hyperbolic possibilities to emerge (or, most often, an amalgamation of both). *Apocalypse* explores Pompeii as the overriding archetype of disaster in the Western imagination, the event to which all other cataclysms are compared, a site of constant destruction that is simultaneously dead and alive. *Resurrection* delves into the extraordinary acts of revivifying that are associated with Pompeii, especially the enduring drive to repopulate the site, despite (or because of) the poverty of ancient textual accounts and the complexity of the evidence from the excavations.[5] Pompeii uniquely provides opportunities to resurrect and recast the classical past.

This exhibition and book therefore do not take the history of archaeology—with its focus on excavation, classification, and recovering a sense of daily Roman life—as the primary topic.[6] Likewise, the use of Pompeian motifs in the history of style is not our central subject, nor are we particularly interested in the concept of Neoclassicism.[7] Instead, we examine how artists from the time of the initial eighteenth-century discoveries to the present have adapted ideas about the ancient cities, whether consciously or not, to reflect on contemporary concerns. In the modern imagination, the most compelling considerations of Pompeii fall at the point where the empirical and archaeological aspects of history and science meet the imaginative projections of staged fiction. Our aim is to explore the phenomenon we call the Last Days of Pompeii. Although this notion takes its

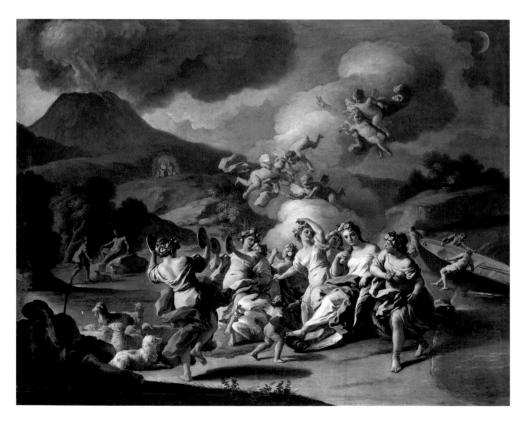

name from the 1834 novel by Edward Bulwer-Lytton, it is for us a broader term that encompasses the three critical frames of decadence, apocalypse, and resurrection—concepts that characterized a particular idea of Pompeii that emerged early in its recovery and remains alive to the present day.

From Antiquarianism to the City of the Dead

As an ancient Roman site with few written accounts surviving from antiquity, Pompeii demanded new pictorial strategies in the eighteenth century. Prior expressions of classicism, such as Francesco de Mura's *Allegory of Spring* (fig. 1), likely commissioned in the late 1750s by the court of Charles III, sponsor of the digs at Pompeii and Herculaneum, came up short. In this allegory drawn from Roman myth, the floating nymphs and elegantly drawn Venus interpret an ode by Horace celebrating the return of spring, while Vesuvius is cast as a generating force. Yet the painting strikes most viewers as flat-footed, reminding us how ill equipped Baroque poetics were to articulate the importance of the excavations (which de Mura avoids depicting) and how quickly a new visual language emerged in tandem with the discoveries.

The rediscovery of Herculaneum and Pompeii came at a complex intersection of absolutist treasure hunting and Enlightenment investigation. While the Bourbon monarchs who sponsored the excavations hoarded the new finds and tightly controlled access, simultaneously, a project of recording, disseminating, and deciphering the sites and their artifacts was launched—through both official and subversive channels. Prints and publications explicated the discoveries with precision, detail, and learned glosses, but perception was considered at least as important as documentation. And so, the view of the Temple of Isis by Francesco Piranesi and Louis Jean Desprez (fig. 2)—crawling with visitors, locals, guides, and servants—emphasizes the importance of visiting, discussing, and decoding the ruins. At the same time, a separate tradition of sublime, emotive volcanic imagery—especially in the paintings of Joseph Wright of Derby and Pierre-Jacques Volaire—remained fixed on the geological observation of volcanic phenomena.[8]

By the 1780s, representations had shifted into something more openly imaginative. Pliny the Younger's letters to Tacitus describe his uncle's death on the shores of Stabiae; as the sole eyewitness description of the eruption, his account became the vital conduit into reenvisioning the events of A.D. 79.[9] The depiction of scenes from Pliny opened an avenue to historical, but necessarily invented, images, ranging from conflagrations depicting Pliny the Elder's death (pls. 19 and 21) to Angelica Kauffman's more cerebral drama of Pliny's family witnessing the eruption from across the Bay of Naples (pl. 20).[10]

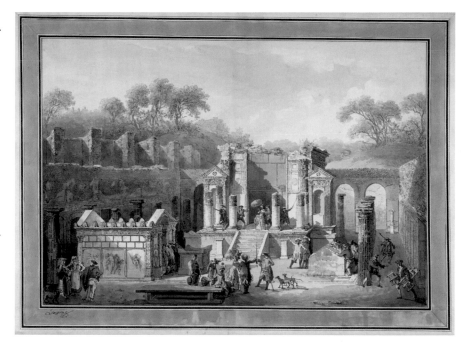

FIG. 2. Francesco Piranesi (Italian, ca. 1756–1810) and Louis Jean Desprez (French, 1743–1804), *The Temple of Isis at Pompeii*, 1788. Etching, hand-colored with watercolor, sheet: 47.7 × 69.6 cm (18¾ × 27⅜ in.). Cleveland Museum of Art, John L. Severance Fund, 2001.19.

This tension between documentation and restaging connects to the crisis in classicism crystallized by the discoveries at Pompeii and Herculaneum. The finds repeatedly overturned firmly held beliefs about the ancient world. Newly uncovered wall paintings undermined earlier conceptions of painting in antiquity, and papyrus scrolls from the Villa dei Papiri challenged notions about the very nature of a classical text, in both the documents' form (charred papyri instead of books) and content (the philosophical materialism of Philodemus instead of classical idealism).[11] Yet the new capacity to understand life in antiquity in unprecedented detail, made possible by the extraordinary finds, also contributed to the renewed ability of ancient subjects and forms to speak to modern life in the late eighteenth century.[12]

A watershed in the move toward projection and revivification came with Francesco Piranesi's three widely distributed volumes of prints, *Antiquités de la Grande Grèce…*, printed in 1804–7.[13] Francesco had traveled to Pompeii with his better-known father, Giambattista, in the 1770s, a visit during which the elder Piranesi made drawings on site that ultimately led to a map of the excavations (fig. 3). First issued in 1785, this print by Francesco derives squarely from a broader eighteenth-century rationalist impulse for precise cartography. After relocating to Paris during the Napoleonic era, Francesco radically reinterpreted his father's sketches to create images for the *Antiquités*.

FIG. 3. Francesco Piranesi (Italian, ca. 1756–1810), *Topographical Map of the Discoveries at Pompeii*, 3rd edn., 1792. Engraving, sheet: 67.7 × 100 cm (26¹¹/₁₆ × 39³/₈ in.); image: 43.2 × 80.7 cm (17 × 31¾ in.). Los Angeles, Getty Research Institute, Special Collections, 90-B21721.

The plans, elevations, and depictions of individual objects continue in Giambattista's characteristically crystalline vein, but the moody views of the ancient city, depicted from an omniscient bird's-eye perspective on heavily worked plates, depart from this approach (fig. 4 and pl. 63). While connected to the late states of the elder Piranesi's *Prisons* series, this dark mode had never been applied so aggressively to archaeology. Although Pompeii in the *Antiquités* was excavated and in ruins, living figures in ancient dress inhabit the prints, a remarkable shift away from reconstruction of the city to resurrection of its former inhabitants. Here Pompeii becomes an imaginative space, with Francesco Piranesi addressing the desire to repopulate the city, while paradoxically still seeing it as a city of the dead.

The impact of these prints has been considerably underestimated, especially since their blend of living and dead, of excavation and re-creation—a tension that never fully disappears—casts a long shadow on later understandings of Pompeii.[14] Indeed, the importance of Piranesi's work is on a similar scale to that of the far better known *Last Days of Pompeii* by Edward Bulwer-Lytton, the 1834 novel often considered the catalyst for the nineteenth-century preoccupation with Pompeii. This Victorian love story, which superimposes archaeological detail over sensational narratives of pagan decadence, a Christian subculture, and volcanic eruption, had a huge impact on Western culture, as Annika Bautz and William St Clair emphasize in their essay in this volume.[15] However, the novel's more conventional historical fictionalization stands in notable counterpoint to Piranesi's reimagining of the present-day ruins as populated by living figures from antiquity.[16]

Tied to the efflorescence of tourism in the post-Napoleonic era and the ever-expanding excavations and increasing number of publications, interest in the destruction and reconstruction of the ancient cities escalated in the wake of Piranesi's volumes.[17] The 1819 edition of the guidebook *Pompeiana*, by William Gell and John Peter Gandy, an inexpensive and widely used volume, initially included illustrations that oscillated between reconstructions and ruins (thus separating out more prosaically what Piranesi had conflated so imaginatively). However, the 1832 expanded and revised version incorporated prints in the Piranesian vein (fig. 5). The success of this guidebook underscored the gradual shift toward privileging the experience of the site itself more than appreciation of individual treasures.[18]

In Gell's wake, a burst of interest, coalescing in London, conjoined visual and literary culture as well as ephemeral spectacle. This interweaving of text and image would characterize many interpretations of Pompeii in this period. Following a June 1821 fireworks display in Vauxhall Gardens that incorporated

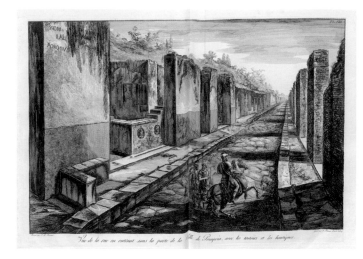

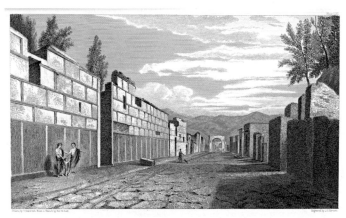

FIG. 4. Francesco Piranesi (Italian, ca. 1756–1810), *View of the Street Passing under the Gate to the City of Pompeii Showing the Sidewalks and Shops*. Etching and engraving, 65 × 99 cm (25⅝ × 39 in.). In *Antiquités de la Grande Grèce, aujourd'hui Royaume de Naples* vol. 1 (Paris, 1804), pl. 8.

FIG. 5. James Harfield Kernott (British, fl. ca. 1828–1849?), after a design by T. Scanden, drawn from a sketch by William Gell (British, 1777–1836), *Pompeii: Street of the Mercuries*. Illustration in William Gell and John P. Gandy, *Pompeiana: The Topography, Edifices, and Ornaments of Pompeii or Pompeii; The Result of Excavations since 1819* vol. 2 (London, 1832), pl. 6. Los Angeles, Getty Research Institute, Special Collections, 85-B17314.

a mock eruption of Mount Vesuvius, Edwin Atherstone published the poem "The Fall of Herculaneum," at the same time as his close friend John Martin began painting *The Destruction of Pompeii and Herculaneum* (pl. 22).[19] These twin epics, rather than offering sustained narratives, overwhelm with torrents of destruction, part of the era's interest in the sublime and in catastrophe, which in its broadest strokes stemmed from the larger dislocations of the French Revolution and the Napoleonic Wars.[20] Nonetheless, in contrast to the poem, the publication and key that accompanied Martin's large-scale painting asserted its archaeological accuracy (many architectural elements were based on sites presented in Gell) and, by including Pliny the

Elder in the foreground, Martin also drew on the "authenticity" of this ancient account.

The importance of the 1820s in crystallizing the Last Days phenomenon has been so overshadowed by the publication of Bulwer-Lytton's novel in 1834 that it is worth recounting the key developments from the previous decade:

JUNE 1821
Fireworks display with Mount Vesuvius in Vauxhall Gardens, London.

1821
English writer Edwin Atherstone publishes the poem "The Fall of Herculaneum."

1822
English painter John Martin displays in London *The Destruction of Pompeii and Herculaneum*.

OCTOBER 1822
Vesuvius erupts.

NOVEMBER 1823
Robert Burford's panorama *The Ruins of Pompeii and the Surrounding Country* debuts in the Strand, London.[21]

1824
French architect François Mazois issues the first of four lavish volumes of engravings of Pompeian art and architecture: *Les ruines de Pompéi* (pl. 61.1).

NOVEMBER 1825
The opera *L'ultimo giorno di Pompei* opens in Naples, with music by Giovanni Pacini, libretto by Andrea Leone Tottola, and staging by Antonio Niccolini; presented for five consecutive seasons in Naples. Performances subsequently take place in Milan (see pls. 65–68) and Vienna, 1827; Rome, 1828; Paris, 1830; and Venice, 1830–31. The production establishes a key Pompeian trope: lovers who escape the eruption at the end. Niccolini's staging gives explicit directions not to use exact replicas of the sites, but reviewers nevertheless praise the production for its fidelity to the ruins.[22]

1826
French painter Joseph Franque displays *Scene during the Eruption of Vesuvius* (pl. 25) in Naples, subsequently shown at the 1827 Salon in Paris.

1827
Excavation director Carlo Bonucci publishes a key guidebook, *Pompei descritta...*, translated into French the following year.[23]

1828
French writer Delphine Gay de Girardin publishes the poem "Le dernier jour de Pompéi" (written in 1827).[24]

1828
British poet Felicia Hemans publishes "The Image in Lava," based on an impression of a woman and her child found outside the Herculaneum Gate at Pompeii.[25]

1830
A Boston writer, "Thomas Gray," publishes *The Vestal; or, A Tale of Pompeii*, the first novel explicitly based on the excavation's architecture and human remains, which introduces Christian elements to the Pompeian narrative.[26]

1832
William Gell reissues his guidebook to show the excavations' progress from 1819.

1832
The Scottish novelist Walter Scott visits Pompeii, guided by William Gell, and declares it "The City of the Dead!"[27]

1832
The Philadelphia poet Sumner Lincoln Fairfield publishes "The Last Night of Pompeii."

1833
Karl Bryullov displays his massive painting, *The Last Day of Pompeii* (pl. 26), in Rome, then in Milan and Paris, where he wins the Gold Medal in the 1834 Salon. Anatole Demidov subsequently ships the painting to Russia, where Nicolai Gogol and Pushkin write enthusiastic responses.[28]

AUGUST 1834
Vesuvius erupts again.

SEPTEMBER 1834
Edward Bulwer-Lytton publishes *The Last Days of Pompeii*.

FIG. 6. John Sartain (American, 1808–1897), after a painting by Emanuel Gottlieb Leutze (German, active in the United States, 1816–1868), *The Blind Girl of Pompeii*. Illustration in *Graham's Lady's and Gentleman's Magazine* for February 1841.

FIG. 7. John Vanderlyn (American, 1776–1852), *Flight from Pompeii*, prior to 1815. Oil on wood, 61.6 × 76.2 cm (24½ × 30 in.). Kingston, N.Y., Senate House State Historic Park, SH.1981.157.

This sequence of events should not be understood as a teleological chain of influence as much as a cascading cultural shift in which accounts of Pompeii move from a focus on mass destruction to more particularized stories that culminate in the cataclysm.[29] Although the texts, performances, and images of the 1820s and 1830s might be loaded with details from the excavations, the narratives, rather than depending heavily on the authenticity of Pliny's account, are invented. Moreover, the chaos that dominates Atherton and Martin gives way to more intimate stories, and even Bryullov's epic machine breaks down into a set of separate, contained narratives, with individuals and small groups responding in different ways to the calamity (pl. 26.1).

These accounts of Pompeii had particular currency in the United States at this moment. Evangelical Christianity, an increasingly important element of American culture, cast Romans as the pagan oppressors of early Christians, rather than as a political model for the republic. Simultaneously, the broader interest in catastrophe resonated among the surging millenarian movements and their apocalyptic cosmologies. Moreover, ideas about democracy were undergoing a critical shift, with Americans increasingly supplanting Rome with Greece as a classical model for governance.[30]

Bulwer-Lytton's novel appeared in the United States on the heels of its publication in England and immediately inspired stage performances, starting with an 1835 adaptation by Louisa Medina.[31] The first documented American visual representation of the *Last Days of Pompeii* (fig. 6) illustrated the serial publication of the novel in 1841. Rather than developing a new iconography rooted in Pompeian archaeology and Bulwer's narrative, Emmanuel Gottlieb Leutze chose a more conventional approach, depicting the blind slave Nydia as a demure young woman in a vaguely classicizing setting.[32]

Another American artist's response to the Last Days phenomenon probably predates Leutze's work by some time. John Vanderlyn prepared an ambitious oil sketch (evidently never pursued as a full-scale composition) focusing on the eruption (fig. 7). While historically dated to the 1840s, recent technical research indicates a much earlier date, perhaps as early as 1806. Vanderlyn's correspondence reveals a keen interest in Pompeii. While he may not have succeeded in actually visiting the ruins, his active participation in Parisian antiquarian circles placed him at the center of current thinking about the sites, given the significant French archeological projects undertaken during the Napoleonic era. The painting itself, however, amalgamates Renaissance and Baroque motifs far more than anything ancient and lacks Vesuvius in the background. For Vanderlyn, Pompeii was less about recognizable topography and classical sources than about physical and emotional chaos, and his sketch draws on the first plate of Piranesi's *Grande Grèce* volumes (pl. 62), which were surely available to Vanderlyn in Paris.[33]

Decadence

… There's a moral laxity around. Herpes and AIDS have come as the great plagues to teach us all a lesson. It was fine to have sexual freedom, but it was abused. Apparently the original AIDS sufferers were having 500 or 600 contacts a year, and they are now inflicting it on heterosexuals. That's bloody scary. A good reason for celibacy. It's like the Roman Empire. Wasn't everybody running around just covered in syphilis? And then it was destroyed by the volcano.

— Joan Collins interviewed for *Playboy*, 1984[34]

To convey the intensity of her moral judgment in the early years of the AIDS epidemic, Joan Collins resorted to Pompeii. Her analysis—while inaccurate and insensitive—came from a (mis)understanding of the buried cities with a long history: Pompeii was not purely a natural disaster; its citizens colluded in their own destruction. Beyond the extravagance of the cataclysm itself—increasingly made visible as the excavations expanded throughout the nineteenth and twentieth centuries—the cities in the shadow of Vesuvius were seen as sites of excess that portended, deserved, and caused the disaster, their stories merging with the biblical accounts of Sodom and Gomorrah.[35]

Joseph Franque depicted a woman and her two daughters bombarded by ash and heat (pl. 25), based on an 1812 excavation where jewelry was discovered among human remains.[36] This evidence allowed the painter to spin a narrative suggesting the materialistic selfishness of the victims: the pursuit of valuables slowed their escape and contributed to their deaths. But for figures intended to represent ancient victims, the women are remarkably un-classical. Franque rejected the conventions of the classical body for those of actual humans: fleshy, destabilized, prone, destroyed. While a broader critique of the poise and elegance of classicism is surely at work here (Franque's painting appeared at the same Salon as Eugène Delacroix's *Death of Sardanapalus*), the women's supposed lack of virtue permitted Franque to present them in a charged, eroticized way. Their paganism provided a pretext for their nudity and their lack of decorum, with Franque explicitly separating his notion of actual ancient bodies from the idealized artifice of conventional classical style.

This impulse to eroticize Pompeii intensified in the early 1820s, as Mary Beard observes in her essay in this volume, but it had begun much earlier. In 1763 Joseph-Marie Vien—one of the first artists to gain access to images of wall paintings—transformed the *Cupid Seller* fresco from Stabiae (pl. 1)—an amorous, but hardly erotic image (especially compared to other antiquities emerging from the excavations; see, for example, figs. 40 and 41)—into a far more explicit image (pl. 3). Vien thus imbedded a coarser sexuality associated with other finds (the bolder glances, the cupid's rude gesture) into the original ancient fresco. And as the nineteenth century unfolded, even the experience of the site itself was eroticized, as in Luigi Bazzani's *Visit to Pompeii* (fig. 8), where two unaccompanied young women gingerly step inside an empty room in the House of the Ancient Hunt (VII.4.48)[37] and see a naked male painted on the wall—a public encounter with nudity titillating for the women and the audience alike.

Pompeii also allowed the projection of current political and social problems onto antiquity, and the notion of the selfish, materialistic, decadent pagan gradually took hold. As the essay by Bautz and St Clair emphasizes, Bulwer-Lytton's novel courses with critiques of slavery, aristocratic luxury, and compromised masculinity, which readers understood in light of contemporary Christian moralizing and classical liberalism. The *Last Days of Pompeii* also proved exceptionally capable of articulating a range of new concerns. Thus, the critique of aristocracy was sharpened in the novel's first American stage adaptation in 1835, in which New York playwright Louisa Medina addressed her particular audience of artisans in lower Manhattan by reworking Bulwer-Lytton's narrative to emphasize the villainy perpetrated by large industrialists on skilled workers.[38]

Americans on both sides of the slavery debate aggressively marshaled antiquity to support their arguments, but the *Last Days* narrative, with the plight of the blind slave Nydia at the

FIG. 8. Luigi Bazzani (Italian, 1836–1927), *A Visit to Pompeii*, 1880s. Oil on canvas, 47.8 × 66 cm (18⅞ × 26 in.). Private collection (sold Sotheby's, New York, October 24 1989, lot 90).

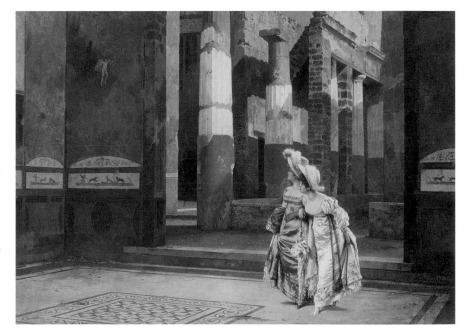

plot's center, was especially well suited to address that question at mid-century.[39] While images of Nydia herself did not generally confront the issue directly (see fig. 6, pls. 69 and 70) other works did, such as James Hamilton's 1864 *Last Days of Pompeii* (pl. 29).[40] The painting alludes to the climax in Bulwer-Lytton, where a statue crashing to the ground kills the villain Arbaces. Hamilton's urban conflagration, painted at the end of the Civil War, presents the event from a distance, emphasizing the cataclysm over the specific story. By not depicting the dark-skinned Egyptian Arbaces, Hamilton skirted the issue of race, but the scene implies that Arbaces's death and the destruction of Pompeii were retribution for a slave-holding society. Likewise European artists used Pompeian decadence to construct pungent critiques, such as *An Exedra*, Lawrence Alma-Tadema's deeply sympathetic depiction of the plight of slaves (pl. 8). Despairing and exhausted, the slave at left slumps over, excluded from the patrician gathering, in contrast to the elderly man nearest him, sated and oblivious to the slave's presence.

This notion of Pompeii as a site of indulgence persisted well into the twentieth century, as Mark Rothko's Seagram murals demonstrate (pls. 40–49). The artist's 1959 visit to Pompeii and his broader interest in Roman wall paintings have been well documented, although the relevance of Pompeii to Rothko's oppositional stance to the commission remains less well under-

stood. Situated atop Mies van der Rohe's Seagram Building, the Four Seasons restaurant catered to the late 1950s New York elite. Rothko's paintings were meant to crown the chic décor, but the artist found the restaurant's excess deeply troubling, calling it "a place where the richest bastards in New York will come to feed and show off." Rothko strenuously objected to the use of his work as decoration and considered his murals to be a harsh critique of American capitalist decadence in the shadow of the Cold War. Seeking "to ruin the appetite of every son of a bitch who ever eats in that room," he turned to Pompeii for a model, drawing on the perceived decadence of the red frescoes in the Villa of the Mysteries, with their implicit narrative of excess, indulgence, and collapse.[41]

Yet decadence can be understood not only as cause for moral disapprobation but also as a celebration of erotic possibilities. Thus Pompeii opened up ways for some artists to explore forbidden or restricted pleasures. Bettina Bergmann has, for example, convincingly connected the intense interest in the Villa of the Mysteries by several generations of women artists and writers to a long tradition of feminist theories about the villa as a uniquely female space devoted to women's sexuality.[42] Representations of the ancient cities also permitted the retrojection of gay culture into antiquity and by doing so constructing a visible history of sexual identity. For American author Samuel Steward in 1961, the ruins themselves held vital historical evidence:

> Go to the ruins of Pompeii, dear reformer. Find your
> way to the house of the Vetti brothers. Pay the guard
> a few lira and ask him to show you the small, shuttered
> painting in the vestibule [see fig. 41]. It is of a stalwart
> young man, exposed, standing next to a pair of scales,
> and resting part of himself on one of the balances, whilst
> in the other—outweighed—stands a pot of gold....
> can anyone in America, by city ordinance or state law,
> undo a world tradition that is centuries old?[43]

This perception of the ancient sites as a subversive sexual environment had emerged long before Stewart. In the hands of Lancelot-Théodore Turpin de Crissé (fig. 9), for example, one of the most familiar monuments, the Tomb of Mamia (later the setting for Lawrence Alma-Tadema's *Exedra* [pl. 8] and a photograph by Guglielmo Plüschow [pl. 13]) becomes the site of a sexualized encounter between men. In the painting a shepherd solicits a man seated within the monument (a tourist?), the transaction's visibility underscored by the woman dragging a child away from the couple.

Photographers Plüschow and Wilhelm von Gloeden (pls. 11–13) both cast the Bay of Naples as a homoerotic Arcadia, populated by young men and boys. This fantasy of contemporary youths, some in antique dress, within a land of ruins, recalls the paradoxical blend of ancient and modern in Piranesi's prints,

FIG. 9. Lancelot-Théodore Turpin de Crissé (French, 1782–1859), *View of Pompeii and the Tomb of Princess Mamia*, 1822. Oil on canvas, 54.5 × 70.5 cm (21 × 27 in.). London, Collection of Emmanuel Moatti.

limbo'"[44]—the young men likewise resist clear categories—are they in love or are they the Hardy Boys on a Neapolitan adventure? Bas has expressed his interest in "coding" (applying a variety of strategies for masking and revealing same-sex desire) and in examining the roots of this idea in nineteenth-century dandyism. His *Vesuvius* thus differs from the erotic fantasy of von Gloeden's youths across the bay from the mountain or the explicit activism of Andy Warhol's volcanoes (pls. 50–53) or David Cannon Dashiell's 1993 *Queer Mysteries*. Bas's youths respond to the eruption threat less with calculated cool than with lassitude. Are they threatened by violence? Avoiding bullying? Resisting making the implicit explicit? Seeking to stay between past and present, hovering in the improbable space prior to adulthood? They offer no clear answer to these questions, yet remain comfortable within that ambiguity, intensified by the presence of the erupting volcano.

Apocalypse

> Outside on the sidewalk, the scene looked like Pompeii after the eruption of Mount Vesuvius. Inches of ash on the ground. Smoke and dust clouding the air.
>
> — *Wall Street Journal,* September 12, 2001[45]

FIG. 10. Alvin Langdon Coburn (British and American, 1882–1966), *Vesuvius*, 1905. Multiple gum platinum print, 39.7 × 31.9 cm (15⅝ × 12½ in.). Rochester, N.Y., George Eastman House, 1967:0161:0018.

By the twentieth century, Pompeii had become the key point of comparison for other disasters—from the 1906 San Francisco earthquake and the bombings of Hiroshima and Nagasaki[46] through to more recent cataclysms such as 9/11, Hurricane Katrina, and the Fukushima Daiichi nuclear disaster.[47]

Pompeii and Herculaneum have often been portrayed mid-eruption, frozen in a moment of perpetual destruction. This way of seeing the cities stems from an interest in images of natural disaster that emerged in the mid-1700s. The devastation following the 1755 Lisbon earthquake and tsunami placed a modern cataclysm at the center of Enlightenment discourse, sparking wide-reaching discussions on topics ranging from the role of Providence and the benevolence of God to seismic engineering and disaster recovery.[48]

By 1800, disaster imagery had become inextricably intertwined with geological debates disputing the formative roles of volcanic action versus massive flooding in the creation of the earth. In turn, each theory connected to contemporary ideas about the sublime—an overwhelming intensity of emotion triggered by vastness and the unfamiliar that surpassed beauty, encompassing feelings of fear and awe.[49] As a result, some artists—such as Jacob More (pl. 19)—began to envision Pompeii's catastrophe as a spectacular event that underscored the smallness of humanity. During the Enlightenment, these

but in a languorous, pastoral mode free of moody anxiety. Both photographers focused on the young men's bodies, rather than the archaeological settings, and so rejected the dominant nineteenth-century modes of visualizing Pompeii photographically, as forged by Giorgio Sommer and his followers (pls. 81–83) or the Symbolist imagery of Alvin Langdon Coburn (fig. 10). These landscape photographers generally presented the sites as depopulated, making architecture or topography the subject of the photographs. Von Gloeden looked instead to the language of history painting, even at times adapting compositions from Alma-Tadema to articulate and ennoble same-sex desire.

The dandyism of these German photographers comes back, turned inside out, for contemporary artist Hernan Bas. In contrast to their explicitly sexual imagery, Bas densely layers his works, like the paint itself, in a knowing ambiguity. In *Vesuvius* (pl. 18) two boys languidly push a rowboat off shore while the volcano erupts behind them; the classical architecture jars with their rumpled T-shirts—are we in the past or the present? With a particular kind of early twenty-first-century masculinity— "a new style of boy that lives in the androgynous room of 'fag

geological debates had de-emphasized questions about the world's creation. By the 1820s, however, the discourse on disaster, especially in light of the Great Awakening and other early-nineteenth-century millenarian religious movements, more explicitly addressed the Creation and the Apocalypse.[50] This Christianized interpretation provides a useful frame for understanding works by John Martin and Sebastian Pether (pls. 22 and 23).

Another mode had emerged in the late 1700s that would increasingly affect Pompeian imagery. Disasters, rather than being fixed to a specific historical event, were presented in a more generalized way.[51] At the same time, the cataclysms were played out on the frame of the individual body and the family unit, hence making them more personal. This empathetic, non-historical imagery—closely connected to the sublime—gained ground in the nineteenth century, as artists presented the eruption's effect less on large groups and more on single figures or families, as exemplified by Franque and Giovanni Maria Benzoni (pls. 25 and 28).

As the nineteenth century progressed, a kaleidoscope of models for depicting apocalypse unfolded. Thus, starting in the 1830s, for many artists Vesuvius no longer served as an active agent; in their works only a smoking reminder of its threat remains at best. This imagery is one of stillness, a silence established through the erasure of human presence. Up to this point, archaeological imagery had presented humans and animals among the ruins, both for scale and to situate Pompeii within a tradition of pastoral landscape. Now ruins appeared in their present state, but instead of an Arcadia, traces of the apoca-

lypse are everywhere evident—in the severity of line, intensity of light, and absence of figures. In a moment that saw a serious escalation in tourist traffic (a train line to Pompeii opened in 1840, with improved roads soon to follow), Christian Købke's sun-drenched view of one of Pompeii's busiest sites (pl. 71)—a place increasingly impossible to see uninhabited—draws attention to its vanished occupants through their marked absence. Købke created his painting with a camera obscura, but instead of using technology to capture an accurate likeness—as early photographers at Pompeii had done (fig. 11)—he did the reverse. Rather than portraying the actual experience of the sites, whether under excavation, visited by tourists, or mediated by guides, Købke excluded humanity to underscore civilization's destruction.

In mid-nineteenth-century America, Pompeian visions of mass apocalypse came to serve "as a metaphor for the vast socioeconomic forces unleashed by modern industrial capitalism itself."[52] While for some social classes Pompeii ably continued to address earlier concerns (e.g., liberalism, enslavement, and providentialism) via novels, plays, and works of art, massive commercial enterprises now emerged that turned away from Pompeian narratives focused on individuals to huge events that concentrated on the overall spectacle. Chief among these were James Pain's depersonalized *Last Days of Pompeii* pyrodramas, large-scale outdoor performances (in Cleveland, the staging was reported to handle crowds of up to 10,000),[53] which criss-crossed the country from the 1880s to the first decade of the next century (see fig. 54, pls. 85 and 86). These events, also discussed in Adrian Stähli's essay in this volume, were filled with interludes of dancing, gladiator battles, and music, and they culminated in a massive pyrotechnic display that nightly destroyed Pompeii.[54]

The psychoanalytic approach to Pompeii (discussed in Victoria Coates's essay in this volume), forged by Sigmund Freud in 1907 and deepened with the 1909 discovery of the Villa of the Mysteries, moved the primary frame away from apocalypse to the recovery of memory. The advent of film also returned the focus to more personalized narratives (see Stähli's essay in this volume). However, in Fascist Italy, where antiquity played such an important role in Italian cultural and political identity, Pompeii occupied an awkward position. On the one hand, Mussolini, who visited the site in 1940, enthusiastically supported the excavations, which increased tremendously under the oversight of superintendent Amadeo Maiuri.[55] Yet, Pompeii was in historical reality a relatively minor seaside town largely dedicated to serving villas and a culture of *otium* (leisure). Moreover, Pompeii was linked in the modern imagination with sensuality and death. Neither concept sat comfortably with Fascist uses of classicism, so Pompeii never found a central role in Fascist myth and aesthetics. Only a handful of startlingly expressive works by the sculptor Arturo Martini (pl. 33), who

explored the body casts, really address Pompeian imagery in a meaningful way. Yet these carvings questioned Fascist aesthetics and so remained at the margins.[56]

In the wake of World War II, apocalyptic Pompeii returned with a vengeance. On the most concrete level, the spectacular and widely publicized eruption of Vesuvius in 1944 reinserted the ruined cities into the world's imagination. At the end of the war Europe was reduced to rubble; the excavations of Pompeii were themselves considerably damaged by Allied bombing in 1943, which obliterated the Pompeian Museum and numerous body casts (pls. 34 and 34.1–.4).[57] Coming to terms with the horrors of the Holocaust, wartime atrocities, and the destruction of Hiroshima and Nagasaki, many saw European civilization itself as fundamentally in ruins.[58] Finally, the rapidly advancing Cold War, the concomitant fears of nuclear annihilation, and the dominance of an existentialist mindset created an atmosphere open to renewed attention to Pompeii. The casts in particular emerged as a stimulus for artists to address the embattled body and the traumatized postwar psyche.

European and American artists divided in their responses, and artists in Europe reacted first. Visits to the Bay of Naples deeply affected Germaine Richier, César, and Marino Marini. Participants in a postwar turn to figuration, these artists used their experience of Pompeii as one element in their diverse reflections on breaking apart the body. The casts helped these artists explore fragility and loss and provided an avenue away from the formal, mathematical terms then dominating much modernist discourse. Moreover, the anticlassicism of the casts helped lead away from the Fascist ideal of the perfect, classicized body, while still finding a source in the antique. The traumatized bodies at Pompeii stirred them to dematerialize their own figures, without recourse to formalism, abstraction, or historicism.

The French sculptor Richier visited Pompeii in 1935, but the site's impact settled in slowly, only fully developing after the war (pl. 36).[59] Her weighty, organic hybrid forms, often based on human models, seem trapped in their own embodiment. Their surfaces, punctured and interrupted—often open to hollow interiors—and their coarse cladding, formed in part by pressing organic matter into molds, emphasize their nature as cast objects. This paradoxical quality of solid form and empty vessel connects Richier's work to the body casts from Pompeii.[60]

Unlike Richier, whose hybrids look to Surrealism, César more directly addressed contemporary concerns. A 1949 visit to Pompeii profoundly affected him. Struck by their voids, which he called "négatif du mort," César saw the casts as sculptures of negative space rather than shapes of the dead.[61] Thus, his *Seated Nude, Pompeii* (pl. 35), an assemblage of scrap metal, must be understood as a living void. Particularly in the context of the early 1950s, the sculpture's dematerialized flesh—seemingly seared off the body—evoked a victim of a nuclear blast. César's

work appears to be the wreckage of war, in both its materials and its tormented form.

Initially inspired by Etruscan and Renaissance sources, Marino Marini explored the theme of horse and rider over several decades. In the late 1940s, Marini increasingly began to destabilize and strain his figures: the horses buckle; the riders tumble. He extinguished his earlier use of historical references and left the bronze raw and unchased (pl. 37). Marini explicitly connected these works, "symbols of the anguish I feel when I survey contemporary events," to his anxiety about the imminent annihilation of civilization.[62] Pompeii was crucial to his thinking; he described the figures appearing "as if they had both been suddenly overcome by a tempest of ash and lava like the one beneath which were found the petrified victims of the last days of Pompeii. The horseman and the horse…have become strange fossils, symbols…of a world which…is destined to vanish forever."[63]

Several decades later, in part as a fund-raiser following the 1980 Irpinia earthquake, the Neapolitan gallery director Lucio Amelio commissioned Andy Warhol to create a series depicting Vesuvius (fig. 12, pls. 50–53).[64] These works are impersonal—they carry no signs of humanity within the frame—but they are also remarkably embodied and sexualized by the unmistakably phallic eruption. Amelio's well-documented interests in disaster

FIG. 12. Andy Warhol (American, 1928–1987), *Vesuvius #365*, 1985. Screenprint, 79.9 × 99.7 cm (37⁷/₁₆ × 39¼ in.). The Andy Warhol Museum, Pittsburgh, Founding Collection, Contribution The Andy Warhol Foundation for the Visual Arts, Inc., 1998.1.3868.

and gay culture (he possessed a major repository of von Gloe-den photographs) connect in this series.[65] Playing at once on the metaphors of apocalypse and decadence, the prints allude to the new catastrophe of AIDS, which was otherwise absent from public discourse in Italy until the late 1980s but was of unmis-takable concern at the time of the commission for both artist and patron.

Resurrection

> The sight of those breasts, so perfect in contour, so pure in outline, filled Octavian with emotion. It seemed to him that they exactly fitted the hollow imprints in the Museum of Naples, which had cast him into such an ardent reverie, and a voice called out from within his heart that that was the woman who had been stifled by the ashes of Vesuvius in the villa of Arria Diomedes.
>
> —Théophile Gautier, *Arria Marcella*, 1852 [66]

Despite archaeologists' dogged attempts to reconstruct antiq-uity accurately from its remains, the projection onto them of an imagined reality, an approach that still vexes many scholars today, fundamentally outpaced scientific recovery of the sites. The impulse to resurrect antiquity in no way began with Pompeii and Herculaneum, but the finds' completeness, coupled with how little was known about the identity of the cities' inhabitants, allowed for an unprecedented kind of reconstruction. Unlike Rome, Pompeii had no well-known history and needed to be repopulated by imagining its inhabitants, as Francesco Piranesi did in the *Grande Grèce* volumes with his anonymous ancients (see fig. 2, pls. 62 and 63). The discovery of human remains (pls. 61 and 61.1) opened up narratives, but these stories took on a life of their own and subsequently informed the ruins. Thus, the archaeologist William Gell, after reading Bulwer-Lytton (who based many of his novel's characters on excavated bones), found that the fictional characters had become the point of reference for (and ultimately gave their names to) specific buildings. Pom-peii's fiction had imbricated itself with the city's archaeological reality. This overlay of fiction contributed to the relative lack of success of historical reenactments at Pompeii, such as the gladi-ator battles staged in the amphitheater in the 1880s (pls. 84 and 84.1)—play-acting had trouble coexisting with the actual victims littering the site. Far more effective have been the many elabo-rate re-creations in spaces—theaters, outdoor spaces, or movie screens—far away from Pompeii.

As Victoria Coates observes in her essay here on psycho-analysis, Pompeii fully emerges as a site for the resurrection of memory at the beginning of the 1900s. The repopulation of the ruins with bodies known from casts has a long literary his-tory, extending back to Felicia Hemans's 1828 poem "An Image in Lava" and Théophile Gautier's 1852 novel *Arria Marcella* and continuing through Valerii Briusov's 1901 poem "A Pompeian Woman" and Wilhelm Jensen's 1906 novel *Gradiva*. In *Arria Marcella* and *Gradiva* the protagonists, while in the excava-tions, fall in love with women who appear in visions or dreams. The artist Paul Alfred de Curzon stages a similar scene (pl. 73), where figures in ancient dress roam the excavations—discon-nected from one another in a dreamlike state but very much alive—while Vesuvius erupts in the background, about to redestroy the city. Freud's influential reading of *Gradiva*, which had considerable sway in Surrealist circles (pls. 15 and 16), com-pared the excavation of Pompeii to the recovery of repressed memory and saw the story as allegorizing the uncovering of lost childhood desire.

In the 1990s Jacques Derrida rejected Freud's notion of the repression of memory, noting the impossibility of Freud's desire to seek a living presence among the ruins. For Derrida, Freud conveniently forgot that Pompeii stays a ruin, no matter what is uncovered; its inhabitants remain both dead and alive, rather than fully recovered.[67] In a similar vein, several contem-porary artists have used Vesuvius and Pompeii to explore the problematics of resurrection. For her series *The Russian Ending*, Tacita Dean collected postcards from flea markets depicting disasters and re-presented these found objects as the endings of films. Drawing on an earlier European practice in which films for the American market received cheerful endings, while those for Russian markets received sad ones, Dean covered an image of Vesuvius with scrawled director's instructions for a nonexis-tent film (pl. 90). For Dean, photography is incapable of telling a single truth. Her depiction of the volcano combines the imagery of disaster, the melancholic consideration of time passing, and the cacophony of multiple narratives, accentuating the failure of a Pompeian image to reconstruct an earlier reality.

Michael Huey also uses found images in his work to reflect on cataclysm, absence, and re-presentation. But rather than despairing of the inability of photography to carry meaning, he prefers "to force new meanings upon these images, and, at the same time, encourage them, individually, toward new relationships with one another."[68] For *Pompeii* (pl. 91), Huey rephotographed a reproduction of a colorized Giorgio Sommer photograph of a reconstruction drawing of a wall painting—simultaneously calling attention to the dense layers involved in creating the work (including, importantly, the burial and exca-vation of the original wall painting), while muddling their indi-vidual contributions, including his own. The very unreliability of images casts them as "repositories for present-day storytell-ing and myth, for conjecture and happenstance."[69]

Bodies

…And at Pompeii

The little dog lay curled and did not rise
But slept the deeper as the ashes rose
And found the people incomplete, and froze
The random hands, the loose unready eyes
Of men expecting yet another sun
To do the shapely thing they had not done…

—Richard Wilbur, from "Year's End," December 1948[70]

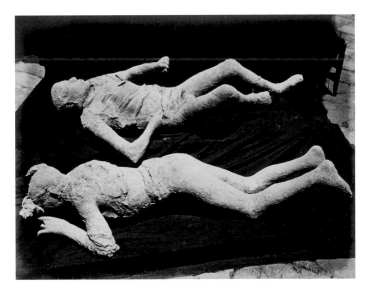

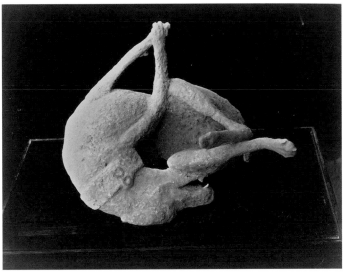

FIG. 13. Giorgio Sommer (Italian, b. Germany, 1834–1914), *Two Body Casts, Pompeii*, after 1875. Albumen silver print, 19.7 × 24.8 cm (7¾ × 9¾ in.). Los Angeles, J. Paul Getty Museum, 84.XP.726.54.

FIG. 14. Giorgio Sommer (Italian, b. Germany, 1834–1914), *Pompeii, Cast (no. 1287)*, ca. 1874. Albumen silver print, 19.5 × 25.2 cm (7¹¹⁄₁₆ × 9¹⁵⁄₁₆ in.). Los Angeles, J. Paul Getty Museum, 84.XP.677.31.

The verse above reminds us, along with the poem by Primo Levi which began this essay, that the Vesuvian sites' hold on our collective memory stems from their destruction and preservation, while a particular form of remembrance takes place through the Pompeian body casts. The skeletal remains found in the early excavations captured visitors' imaginations and inspired artists and writers, but the casts—first made in 1863 under the director of excavations, Giuseppe Fiorelli—fundamentally changed perceptions of Pompeii.[71]

The casts, which Victoria Coates also addresses in her essay on technology in this volume, used plaster to fill the void left in the ash when the bodies of the victims disintegrated. The casts thus bring the dead back to life, but they live perpetually at the moment of death. As voids which take the place of a living body, these casts had a huge impact on the dismantling of the classical body in the nineteenth century. Thus this exhibition considers the casts in sculptural terms, and not simply as artifacts, relics, or dramatic props. Profoundly anticlassical, the casts constituted a revolt against the conventional language of ancient sculpture. These bodies are contorted, not self-possessed; they are prone, not upright; they are plaster, not marble or bronze; they are clothed (and even worse, they wear the wrong clothes—women wearing pants!); they are pregnant or thought to be slaves (with all that identity implied in the post-slavery era). They hover between sculpture and artifact; they were excavated, yet also created out of nothing—new objects made from empty space.

Only sixteen casts were made in the decades after 1863, but photography made them omnipresent—they appear in nearly every album purchased in Naples in this era (figs. 13, 14, and 30) and were popular subjects for stereographs and book illustrations. The main practitioners were commercial photographers catering to tourists, Giorgio Sommer chief among them.[72] Their works are plentiful and have structured how we now see Pompeii, including the casts.

Photographers resisted presenting the casts as archaeological objects tied to their findspot, and the prints are usu-

ally undated and captioned with the same short title, *Impronte umane* (body casts). In the Sommer photograph with the two humans, the casts lie on a sheet, as if being prepared for burial—only a glimpse of pavement hints at a location (see fig. 13). How the photographers collaborated with Fiorelli remains unclear, though Fiorelli certainly sought out dramatic locations for the casts, divorcing them from the excavations and restaging the disaster for visitors. The photographers in turn rarely presented the bodies with living humans in the frame, nor did they generally give a sense of where the casts were

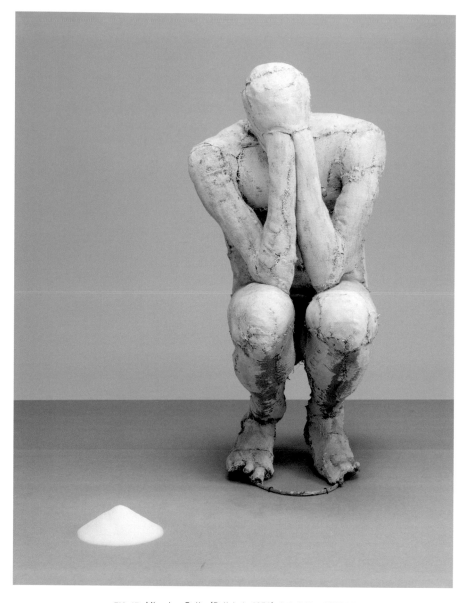

FIG. 15. Mirosław Bałka (Polish, b. 1958), *Salt Seller*, 1988. Wood, jute, salt, and steel, 106.7 × 55.9 × 35.6 cm (42 × 22 × 14 in.). The Art Institute of Chicago, Gift of Donna and Howard Stone in honor of Neal Benezra, 2000.99.

displayed (photographs of the bodies in the Pompeian Museum, formerly near the entrance to the site, being the key exception).[73] Inverting Piranesi's population of Pompeii with living figures, the casts now repopulate Pompeii, but with the dead. The city thus relives the moment of its death in perpetuity, both re-experiencing the eruption and constantly waiting for it.

Body casts have been a significant element in postwar and contemporary art, but their use should not universally be associated with Pompeii. For example, the casts of George Segal—white plaster (or bronze, painted white to look like plaster)—have often been connected to Pompeii, but the artist strongly resisted any relationship between his work and the ancient bodies. Despite superficial similarities, his sculptures—even the 1984 Holocaust monument in San Francisco's Golden Gate Park, which incorporates a number of fallen figures—does not depend on the para-

dox of living and dead implicit in the Pompeian casts. For other artists the question is more open, and we hope this exhibition will spark further research, especially into the work of Eastern European artists more consumed with matters of history and memory. Alina Szaposznikow, a Polish artist who incorporated ideas about Pompeii into her work throughout her career, may well have threaded associations with the body casts into her pivotal 1955 cement and iron sculpture *Exhumed* (Wrocław, National Museum), a sculpture which also deals with the memory of World War II, socialist notions of the monument, and her personal experience with concentration camps. Another Polish artist, Mirosław Bałka, reflecting on this figural tradition, based his early work on the proportions of his own body. *Salt Seller* (fig. 15) recalls the well-known Pompeian cast of the crouching man (pl. 78), while referring explicitly to the destruction of Lot's wife. These ideas in turn connect to matters of collective historical memory and guilt, and Bałka himself associates the work with Marcel Duchamp and the ready-made.[74]

The best-known cast is that of a dog (see fig. 14). This object has had a tremendous afterlife, and two important artists have incorporated it in their work in ways that reflect on its nature as a cast. In the 1956 combine *Small Rebus*, Robert Rauschenberg included a reproduction of a Sommer photograph of the cast (pl. 39). The meaning or the lack of meaning of the elements in these collages has been hotly debated, and most interpretations have centered on the leveling effect of including so many individual images, which largely overrides their independent signifying function. It is, however, helpful to push further on what Rosalind Krauss has called the "space of memory" created by the combines.[75] Without proposing an iconographic program, the use of the dog must be considered in the postwar context, where Thomas Crow's suggestion of an "allegorical" reading offers a helpful avenue into the work.[76] Pompeii, and by extension the dead dog, were quite active in the postwar American imagination (pl. 38). Rauschenberg's Pompeian image can be linked in turn not only to Crow's narrative of rise and fall but even more precisely to anxieties about nuclear war, something very much on Rauschenberg's mind, and something that the dog—and the annihilation of domesticity it represents—addresses directly.[77]

Allan McCollum's 1991 installation *The Dog from Pompei* (pl. 88) focuses intensely on the idea of reproduction, seriality, and lost originals. The artist has often used casts in his work, and other installations have centered on quotidian objects with no specific referent, such as jars or machine parts. In this case he worked with a well-known referent, the cast of a lost body from Pompeii. McCollum went to Naples, made a mold from a second-generation cast and made new casts from his own mold, which were intended to replicate as closely as possible the second-generation cast. He then repeated the process over and over, calling attention to the fact that he was working only

with reproductions. The casts were displayed in groups, their very number unsettling the viewer and diminishing any aura of originality through the repetition. By using an original that is itself a representation of something missing, McCollum comments on representation itself, adopting a stance in which representation, here repeated over and over, substitutes for that which is absent, or as McCollum himself puts it: "they always seem to represent something else, they're never the thing itself. So to the degree to which we're enmeshed in relationships with our own copies in the world, we are constantly in a state of banishment from the imaginary 'source' of things—from the more 'authentic' things that these copies seem to replace. Moreover, the mournful pose of the dog is meant explicitly to have an emotional impact, but then diffuse it by underlining our distance from the original, unknowable dog."[78]

Notes

I would like to thank Victoria G. Gardner Coates, Judith Dolkart, Beatrice Hohenegger, Kenneth Lapatin, Daniel R. McLean, and Lucy I. Zimmerman. Mary Beard, Paul Schimmel, Katherine Woltz, and Joyce Zucker generously shared research and ideas.

1 "La bambina di Pompei," originally published in *Ad ora incerta* (Milan, 1984); *Collected Poems: Primo Levi*, trans. Ruth Feldman and Brian Swann (London, 1992), 34.

2 For Levi's writings in light of Pompeii and the Holocaust, see Joanna Paul, "Pompeii, the Holocaust, and the Second World War," in Hales and Paul 2011, 341–44.

3 [Thomas Gray], *The Vestal; or, A Tale of Pompeii* (Boston, 1830), vi. The author is not listed on the title page, and the identity of the Boston author has never been confirmed.

4 The literature on the art and archaeology of the buried cities, as well as the history of excavations, is vast. For some recent accounts, see Alison E. Cooley, *Pompeii* (London, 2003); Mattusch 2005; Daehner 2007; Judith Harris, *Pompeii Awakened: A Story of Rediscovery* (London, 2007); Mary Beard, *The Fires of Vesuvius: Pompeii Lost and Found* (Cambridge, Mass., 2008); and Wallace-Hadrill 2011; as well as Glen Warren Bowersock, "The Rediscovery of Herculaneum and Pompeii," in *From Gibbon to Auden: Essays on the Classical Tradition* (Oxford, 2009), 66–76.

5 For ancient references to Pompeii, see Cooley and Cooley 2004. Not much was known about Pompeii, Herculaneum, and other cities before their excavation. There are few references to Pompeii in extant ancient texts and specific people who could be reinserted into the site were not identified, except in Pliny and a few other sources, such as Strabo.

6 For this history, see Parslow 1995. For an important, if Francocentric, account of "romantic archaeology," see Blix 2008.

7 For this contested terrain, see Faroult, Leribault, and Scherf 2011. For Pompeii in the decorative arts, see Enrico Colle, "The Evolution of Pompeian Tastes in Europe," in Cassanelli et al. 2002, 26–39.

8 For the politics of archaeology, see Gordon 2007 and Delphine Burlot, "The *Disegni intagliati*: A Forgotten Book Illustrating the First Discoveries at Herculaneum," *Journal of the History of Collections* 23, no. 1 (2011): 15–28. On Desprez, Piranesi, and Pompeii, see John Pinto, "Speaking Ruins": Piranesi and Desprez at Pompeii," in Mattusch 2012. For imagery of Vesuvius in this period, see Murphy 1978; *Alla scoperta del Vesuvio*, exh. cat. (Herculaneum and Naples, 2006); and James Hamilton, *VOLCANO: The Volcano in Western Art* (Compton Verney, U.K., 2010). For Wright of Derby and Volaire, see Benedict Nicolson, *Joseph Wright of Derby: Painter of Light* (London, 1968), 1:75–85, 254–55; and Émile-Beck Saiello, *Pierre-Jacques Volaire 1729–1799: Dit le Chevalier Volaire* (Paris, 2010).

9 Pliny the Younger, *Letters and Panegyrics*, vol. 1, trans. Betty Radice (Cambridge, Mass., 1969), VI.16; and Benedicte Gilman, ed. and trans., *Ashen Sky: The Letters of Pliny the Younger on the Eruption of Vesuvius*, illustrated by Barry Moser (Los Angeles, 2007), 21–27. The letters had been well known since the Renaissance but moved into the spotlight after the discoveries. Some Plinian imagery appeared at mid-century (see pl. 56), but most works incorporating such scenes appeared several decades later.

10 Coates 2011.

11 For wall paintings, see Agnès Rouveret, *Histoire et imaginaire de la peinture ancienne: Ve siècle av. J.-C.–1er siècle ap. J.-C.* (Rome, 1989), 5–6. For papyri, see James I. Porter, "Hearing Voices: The Herculaneum Papyri and Classical Scholarship," in Coates and Seydl 2007, 95–113; and, more broadly, David Sider, *The Library of the Villa dei Papiri at Herculaneum* (Los Angeles, 2005).

12 Hugh Honour, *Neo-classicism* (Harmondsworth, U.K., 1968); Robert Rosenblum, *Transformations in Late Eighteenth-Century Art* (Princeton, N.J., 1967; repr., 1974); and Faroult, Leribault, and Scherf 2011.

13 The literature on Francesco Piranesi and the *Antiquités de la Grande Grèce* volumes remains thin. See Lizzani 1952 and Pucci 1979.

14 Beard 2012.

15 For other recent reconsiderations of the novel, see the essays by Stephen Harrison, "Bulwer-Lytton's *The Last Days of Pompeii*: Re-creating the City," and Meilee D. Bridges, "Objects of Affection: Necromantic Pathos in Bulwer-Lytton's City of the Dead," in Hales and Paul 2011, 75–89 and 90–104.

16 Although Bulwer's omniscient narrator at times acknowledges the reader as a nineteenth-century British person, his characters remain firmly ancient figures in a reconstructed antiquity.

17 The excavations also shifted emphasis in the later eighteenth century from Herculaneum to Pompeii, which was much easier to excavate; see Wallace-Hadrill 2011, 56–57. During the Napoleonic era, Napoleon's sister and brother-in-law, Caroline and Joachim Murat, also escalated the pace of excavation considerably during their rule of Naples from 1806 to 1815; see S. Adamo Muscettola, "Problemi di tutela a Pompei nell'Ottocento: Il fallimento del progetto di esproprio murattiano," in *Pompei: Scienza e società*, ed. P. G. Guzzo (Naples, 2001), 29–49.

18 Gell and Gandy 1817–19 and Gell 1832. For the history of publications on the buried cities, see Claire L. Lyons and Marcia Reed, "The Visible and the Visual: Pompeii and Herculaneum in the Getty Research Institute Collections," in Coates and Seydl 2007, 133–56. For the transformation away from treasure hunting to the "historicizing gaze," see Blix 2008, 8–27.

19 Atherstone 1821 and Myrone 2011, 109–11.

20 Curtis Dahl, "Bulwer-Lytton and the School of Catastrophe," *Philological Quarterly* 32, no. 4 (October 1953): 428–42; and Stähli 2011.

21 Thomas Leverton Donaldson and J. Burford, *Description of a View of the Ruins of the City of Pompeii, and Surrounding Country, now Exhibiting in the Panorama, Strand, Painted from Drawings Taken on the Spot by Mr Burford* (London, 1824); and Thomas Leverton Donaldson and J. Burford, *Description of a Second View of Pompeii, and Surrounding Country, Representing the Tragic Theatre, Covered Theatre, Temple of Isis, Small Forum* (London, 1824).

22 Jacobelli 2009.

23 Carlo Bonucci, *Pompei descritta… terza edizione, con nuove osservazioni ed aggiunte* (Naples, 1827).

24 "Le dernier jour de Pompéi," in *Oeuvres complètes de Madame Emile de Girardin, née Delphine Gay,* vol. 1 (Paris, 1861), 119–25.

25 Felicia Hernan, "The Image in Lava," in *Records of Woman: With Other Poems,* 2nd edn. (Edinburgh and London, 1828), 310–13. For a recent analysis, see Isobel Armstrong, "Natural and National Monuments—Felicia Hemans's 'The Image in Lava': A Note," in *Felicia Hemans: Reimagining Poetry in the Nineteenth Century,* ed. Nanora Sweet and Julie Melnyk (Houndmills, U.K., and New York, 2001), 212–30.

26 The novel is not illustrated.

27 Lockhart, 1838, 7:376.

28 Nicolai Gogol, "The Last Day of Pompei (Bryullov's Picture)," in *Arabesques,* trans. Alexander Tulloch (Ann Arbor, Mich., 1982), 203–10; for Pushkin, see Solomon Volkov, *St. Petersburg: A Cultural History,* trans. Antonina W. Bouis (New York, 1995), 62.

29 Nicholas Daly reaches a similar conclusion in "The Volcanic Disaster Narrative: From Pleasure Garden to Canvas, Page, and Stage," *Victorian Studies* 53, no. 2 (Winter 2011): 263.

30 E. R. Sandeen, *The Roots of Fundamentalism* (Chicago, 1970), 42–58; E. S. Gaustad, *The Rise of Adventism* (New York, 1974); Paul A. Manoguerra, "'Like going to Greece': American Painters and Paestum," in *Classic Ground: Mid-nineteenth-century American Painting and the Italian Encounter,* ed. Paul A. Manoguerra (Athens, Ga., 2004), 89–104; and Malamud 2009, 122–27. For early-nineteenth-century American literature and art on the subject of catastrophe, see Curtis Dahl, "The School of Catastrophe," *American Quarterly* 11 (1959): 380–90.

31 Louisa Medina (Hamblin), *The Last Days of Pompeii: A Dramatic Spectacle* (1835; repr., New York, 1856).

32 Barbara S. Groseclose, *Emanuel Leutze, 1816–1868: Freedom Is the Only King* (Washington, D.C., 1975), 72. Correspondence with Barbara S. Groseclose (e-mails of October 20 and November 16, 2009), Jochen Wierich (e-mails of November 23, 2009, and January 6 and 10, 2010), William St Clair (e-mail of July 2, 2011), and Annika Bautz (e-mail of July 2, 2011). The caption on the print connects it to a now-lost painting, *Nydia,* owned by Leutze's Philadelphia patron Joseph Sill, but the circumstances of the image's creation remain unclear. For Sill and Leutze, see "Joseph Sill, Selected Diaries, 1832–1854," Archives of American Art (microfilm rolls P29–P30), although the diaries do not mention a *Nydia.* If the work was painted in Germany, where Leutze lived from 1840 to 1850, he could have read the 1835 or 1837 German translations of Bulwer-Lytton's novel (e-mails from St Clair and Bautz, July 2, 2011). The print's most ancient element is a loose adaptation of a reclining figure on a vase, which Leutze no doubt knew from available representations of the Portland Vase and the Vatican Ariadne.

33 Correspondence with Katherine Woltz (e-mails of August 16, August 22, September 29, 2010, and August 29, 2011) and Joyce Zucker (e-mails of August 19 and August 25, 2010). Woltz and Zucker have shared research materials for their forthcoming catalogue raisonné on the artist. Woltz has posited the earlier date and notes that the title may

well be incorrect and the subject may in fact be the Destruction of Carthage (the title *Flight from Pompeii* first appears in an 1875 inventory).

34 "Playboy Interview: Joan Collins," *Playboy* 31, no. 4 (April 1984), 66.

35 The second-century author Tertullian first made the connection of the buried cities to Sodom and Gomorrah. The inscription SODOMA GOMORAH was found in a Pompeian house (IX.1.25) excavated in 1858, which intensified the connection and resulted in increased use of the metaphor—as, for example, in Marcel Proust's *À la recherche du temps perdu.* See John J. Dobbins and Peter Foss, eds., *The World of Pompeii* (London, 2008), 38, note 3, and Francesca Spiegel, "In Search of Lost Time and Pompeii," in Hales and Paul 2011, 232–45.

36 Rosenthal 1979.

37 These numbers reflect a system of tripartite numbering that divides the site into *regiones* (neighborhoods), *insulae* (blocks), and individual *casae* (houses) and which is used instead of (or sometimes as an adjunct to) the various commonly used names (such as House of the Ancient Faun). The system was developed by Giuseppe Fiorelli, who became director of excavations in 1863.

38 Medina 1835 (note 31) and Yablon 2007.

39 Malamud 2009, 70–97.

40 Hunnings 2011.

41 Fischer 1970.

42 Bergmann 2007. David Cannon Dashiell's important 1993 reworking of the Villa of the Mysteries recasts the fresco in explicitly queer terms; see Alison Mairi Syme, "David Cannon Dashiell's Queer Mysteries," *Art Journal* 63, no. 4 (Winter 2004): 80–95.

43 "The Bull Market in America," *Der Kreis* 29 (June 1961): 19–24; quoted in Justin Spring, *Secret Historian: The Life and Times of Samuel Steward, Professor, Tattoo Artist, and Sexual Renegade* (New York, 2010), Kindle edition, location 5294, chapter 16, paragraph 9.

44 *Hernan's Merit and the Nouveau Sissies,* exh. cat., Frederick Snitzer Gallery, Miami, 2001; and Dominic Mohon, "Towards a New Sensuality: Hernan Bas' Deliberate Decadence," in Coetzee 2007, 45–51.

45 John Bussey, "The Eye of the Storm: One Journey through Desperation and Chaos," *Wall Street Journal,* September 12, 2001, A1.

46 For an example of a contemporary quotation about the atomic bombing of Japan, see Michikiko Hachiya, M.D., *Hiroshima Diary: The Journal of a Japanese Physician, August 6–September 30, 1945* (Chapel Hill and London, 1995): "Concrete buildings near the center of the city, still afire on the inside, made eerie silhouettes against the night sky. These glowing ruins and the blazing funeral pyres set me to wondering if Pompeii had not looked like this during its last days. But I think that there were not so many dead in Pompeii as there were in Hiroshima." For the Windscale Fire, a "nuclear Pompeii," see Geminus, "It Seems to Me," *New Scientist* (October 30, 1958). The Pompeian metaphor for cataclysm was also well used in the 1800s, including for the American Civil War.

47 For 9/11, see Charles R. Pellegrino, *Ghosts of Vesuvius: A New Look at the Last Days of Pompeii, How Towers Fall, and Other Strange Connections* (New York, 2004); for Hurricane Katrina, see "After an Incomparable Disaster, Reaching for Comparisons," *Associated Press* (August 31, 2005); and Susann S. Lusnia, "Pompeii on the Mississippi: The View from New Orleans," *Traumatology* (December 2008); for the Fukushima disaster, see Walter Mayr, "The Pompeii of the Pacific," *Der Spiegel Online* (April 12, 2011): http://www.spiegel.de/international/world/0,1518,756328,00.html (last accessed February 24, 2012). The entire contents of a traveling Pompeii exhibition were in Sendai at the

time of the disaster, and the archaeological objects, lent by the Museo Archeologico Nazionale, Naples, and the soprintendenza archeologica di Pompei, were stranded there on account of radiation exposure. The exhibition later reopened with the body casts removed.

48 The 1755 earthquake took place too early for comparisons to be made to the Bay of Naples disaster, since the breadth of the ancient event would not be truly understood until the excavations had proceeded further and information had been more widely distributed. For the reception of the earthquake, see Theodore E. D. Braun, *The Lisbon Earthquake of 1755: Representations and Reactions* (Oxford, 2005); for images of the event, see Jan Kozák and Vladimír Čermák, *The Illustrated History of Natural Disasters* (Dordrecht and London, 2010). The best-known images of the Lisbon earthquake, prints by Jacques-Philippe Le Bas, concentrate on the destruction, using the Italian *vedute* tradition to connect the contemporary disaster to the language of ancient ruins. For the works of Le Bas, see Rena M. Hoisington, "Beautiful Disaster: The Lisbon Earthquake Prints of Jacques-Philippe Le Bas," paper delivered at the annual meeting of the American Society for Eighteenth-Century Studies, Montreal, 2006.

49 Martin J. S. Rudwick, *Georges Cuvier, Fossil Bones, and Geological Catastrophes. New Translations and Interpretations of the Primary Texts* (Chicago, 1997), 1–12; Nicolaas A. Rupke, *The Great Chain of History: William Buckland and the English School of Geology (1814–1849)* (Oxford and New York, 1983), esp. 81–88; Dennis R. Dean, *James Hutton and the History of Geology* (Ithaca, N.Y., 1992), 1–83; and Daly 2011, 259–60.

50 See note 30.

51 The earthquakes of Jean-Pierre Saint-Ours and the deluges of Girodet and Clodion are among the most significant works in this vein; see Anne de Herdt, "'Le Tremblement de terre' de Jean-Pierre Saint-Ours dans sa version romantique," *Genava* n.s. 37 (1990): 189–96; Mylène Koller, *Zur Genfer Historienmalerei von Jean-Pierre-Saint-Ours (1752–1809)* (Bern, 1995), 95–125; Sylvain Bellenger, ed., *Girodet, 1767–1824* (Paris, 2006), 282–97; and Anne L. Poulet, "Clodion's Sculpture of the *Déluge*," *Journal of the Museum of Fine Arts, Boston* 3 (1991): 51–76. For nineteenth-century disaster imagery, see Albert Boime, *Art in an Age of Bonapartism, 1800–1815* (Chicago, 1990), 89–91; and Stähli 2011.

52 Yablon 2007, 194.

53 "Last Days of Pompeii," *Cleveland Plain Dealer*, July 29, 1892, 8.

54 Yablon 2007, 189–205. Like the pyrodramas, other forms of entertainment surfaced at mid-nineteenth century that sought to reach a mass audience and played down narrative and political interpretations of the Last Days, such as the peephole cabinets, designed for working-class audiences, that opened in 1877 at the Pompeian Museum in Philadelphia's Fairmount Park, which were based on an 1870 set from the Pompeiorama in Naples; see Seydl 2011.

55 Baldassare Conticello, "Scienza, cultura e cronaca a Pompei nella prima metà del nostro secolo," in Redi 1994, 15–26; and Gazda 2007. The Maiuri literature is extensive, although most authors (e.g., A. Cotugno and A. Lucignano, *Il fondo bibliografico di Amedeo Maiuri: Libri, carteggi e cimeli di un grande archeologo* [Naples, 2009]) have avoided questioning his role during the Fascist era. Margharita Sarfatti, a pivotal figure in the arts under Mussolini, wrote enthusiastically about the excavations ("Pompei risorta," *Dedalo* 23–24 [April 1924]: 663–89) but did not encourage artists to work directly from Pompeian motifs. Nor are Gio Ponti's Pompeii-inspired villas pivotal in the history of Fascist architecture; see Gio Ponti, "Una villa alla Pompeiana," *Domus* (July 1934): 16–19. For Fascism and antiquity in film, see Stähli 2008.

56 Braun 2010. Also see Campiglio 2008.

57 García y García 2006.

58 For one introduction to the art of postwar Europe, see Sarah Wilson, "Paris Post War: In Search of the Absolute," in Morris 1993, 25–52.

59 Pierre Restany, "Germaine Richier: Le grand art de la statuaire," *L'Œil* 279 (October 1978): 58; and Barbero 2006, esp. 14–18.

60 For Germaine Richier, see Sylvester 1955. See also Peter Selz, *New Images of Man* (New York, 1959), 129–31; and the biography of Richier by Francis Morris in Morris 1993, 161–62.

61 Cabanne 1971, 87.

62 *Marino Marini: Miracolo; Sculptures, Works on Paper, Photographs*, ed. Cristina Inês Steingräber in collaboration with Sibylle Luig (Ostfildern, Germany, 2006), 61, 65.

63 Interview with Marino Marini, in *Dialogues on Art* by Edouard Roditi (New York, 1960), 45–46.

64 Naples 1985.

65 This interest culminated in the exhibition *TERRAE MOTUS*, partly drawn from Amelio's own collection and intended to explore artists' responses to mass destruction.

66 Gautier 1901, 352.

67 Jacques Derrida, *Archive Fever: A Freudian Impression* (Chicago, 1998), 83–102.

68 Huey 2009, 35.

69 Ward 2010.

70 Richard Wilbur, "Year's End," from *Collected Poems 1943–2004* (New York, 2004); first published in *The New Yorker*, January 1, 1949, 26.

71 Dwyer 2010, 1–31. For the skeletal remains, see Lazer 2009 and Stefani 2010.

72 Weinberg 1981, Miraglia and Pohlmann 1992, and Desrochers 2003.

73 For photographs of the casts, see Dwyer 2010, 96–98; and Victoria Coates's essay in this volume. Images that combine living and cast bodies (see fig. 29) are quite rare in nineteenth- and early-twentieth-century albums and publications.

74 For Szapocznikow, Elena Filipovic and Joanna Mytkowska, *Alina Szapocznikow: Sculpture Undone, 1955–72* (New York and Brussels, 2011). For Bałka, see Andrzej Przywara, "House of Last Things," *Terskel/Threshold* 8, no. 18 (January 1997): 33–49. For Segal, see Marco Livingstone, *George Segal: Retrospective: Sculptures, Paintings, Drawings* (Montreal, 1997). Mirosław Bałka (e-mail of June 14, 2011). Among other artists, the Polish sculptor Magdalena Abakanowicz and the Hungarian performance artist Tibor Hajas in particular deserve further investigation into their works' connection to Pompeii and the body casts. Also see Appendix to this volume for other contemporary artists specifically dealing with Pompeii.

75 Rosalind Krauss, "Rauschenberg and the Materialized Image," in Joseph 2002, 51.

76 Crow 2005, 252–54.

77 Oral history interview with Robert Rauschenberg, December 21, 1965, Archives of American Art, Smithsonian Institution, section on nuclear war as subject of concern circa 1960. Conversation with Paul Schimmel, July 28, 2011; Schimmel disagrees with me about the importance of the dog as a signifier of death or fall, since the postcards stem from Rauschenberg's travels in Italy and refer to this positive moment in his life.

78 Allan McCollum interviewed by Thomas Lawson http://www.allanmccollum.net/allanmcnyc/Lawson_AMc_Interview.html (last accessed February 24, 2012); originally published in *Allan McCollum* (Los Angeles, 1996).

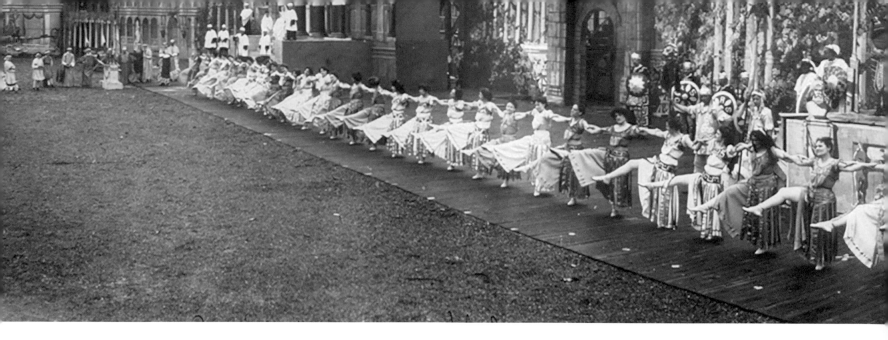

KENNETH LAPATIN

Pompeii on Display

The rediscovery and excavation of ancient sites buried by the eruption of Mount Vesuvius in A.D. 79 have been well studied. The evolving displays of the finds, first in Portici and then in Naples, too, have been the subject of significant scholarly investigations, as has their influence on eighteenth- and nineteenth-century European culture.[1] The nature and impact of temporary exhibitions of material recovered from Pompeii and nearby settlements, however, have yet to receive comparable attention, although more and more blockbuster shows have traveled the globe in recent years.[2] Since 2000 alone, exhibitions focusing on Pompeii and other Vesuvian cities have been held in more than one hundred cities throughout Europe, North America, and Asia—multiple times in many of them. The exhibition accompanying this catalogue travels to Cleveland and Québec after opening in Malibu, while another, more traditional archaeological exhibition *Pompeii and Herculaneum: Living and Dying in the Roman Empire* is on display at the British Museum. Future exhibitions are planned, and there is no doubt that this phenomenon will continue. Compiling a full list of exhibitions, their titles, locations, and dates is a difficult task, but an attempt is made in the Appendix at the end of this volume.[3]

The motivations for such exhibitions have shifted over the years, as have their foci and contents. Recent exhibitions, nonetheless, feature many of the same objects, some of which seem to be constantly on the road. Meanwhile, a single exhibition may differ considerably in appearance from one venue to another. Its objects may change from one museum to the next, and even its title can vary. Likewise, exhibitions with similar titles sometimes present very different works. Whatever the organizational complications, contemporary circumstances, as much as the desire to better understand the past, have always been of great consequence in shaping the form and content of exhibitions.

The earliest displays, of course, were far more modest than today's widespread international loan shows, which have attracted millions of visitors, but the impulse to export artifacts from the excavations seems to have been powerful from the outset. In 1711, even before the opening of the official excavations sponsored by the Bourbon rulers of Naples, the statues

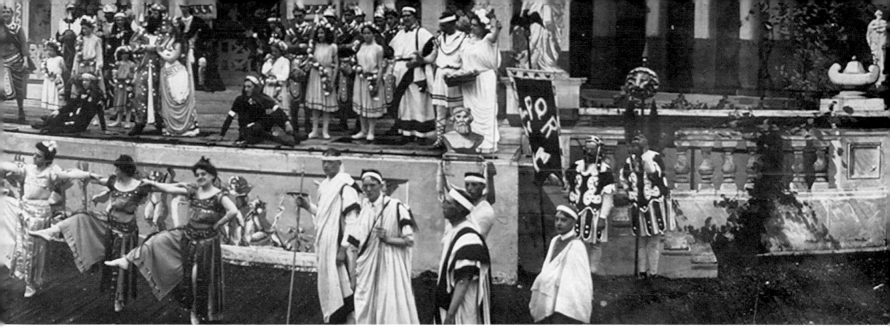

that have come to be known as the Herculaneum Women were sent by their discoverer, Emmanuel-Maurice de Lorraine (also known as the prince d'Elboeuf), to Vienna as a gift to his distant cousin Prince Eugene of Savoy. D'Elboeuf removed the three marbles from the Theater at Herculaneum, had them restored in Rome, and surreptitiously exported. The statues were eventually installed in the Marble Gallery in Eugene's Lower Belvedere Garden Palace before they were sold to Frederick Augustus II, elector of Saxony and king of Poland, in 1736 and sent to Dresden. Whether they were ever exhibited outdoors in the gardens alongside exotic plants and animals possessed by the Viennese prince, as depicted in engravings by Salomon Kleiner published in 1734 (fig. 16), is unclear. Nonetheless, it has been suggested that "the curiosity they generated may have been less archaeo-

FIG. 16. Salomon Kleiner (German, 1703–1761). The Small Herculaneum Woman and other exotica in the lower Belvedere Garden in Vienna. Etching and engraving, 29 × 40 cm (11⅜ × 15¾ in.). In *Représentation des animaux de la ménagerie de S.A.S. Monseigneur le prince Eugène François de Savoye et de Piémont* (Augsburg, 1734), Pl. 3. Los Angeles, Getty Research Institute, Special Collections, 88-B2647.

THE POMPEIAN COURT, AT THE CRYSTAL PALACE.—(SEE PAGE 62.)

FIG. 17. The Pompeian Court at the Crystal Palace, Sydenham. Illustration in *The Illustrated London News*, January 20, 1855, p. 64. Los Angeles, Getty Research Institute, Special Collections, 84-S968.

logical or antiquarian than colonial," serving more the political needs of the present than as windows onto the classical past.[4]

When official excavations at Herculaneum began in 1738, access to both the site and the finds was closely guarded, motivated both by the need to preclude further illicit exports and the desire to insure absolute domestic control of the antiquarian patrimony of the Bourbon kings.[5] In 1749 and again in 1755, however, representatives of the monarchy in Rome highlighted Herculanean discoveries during the *Chinea*, the annual festival that ostensibly commemorated the kings' fealty to the pope, but in actuality ostentatiously celebrated their wealth and power (pls. 55 and 57). Designed as backdrops and launching pads for pyrotechnical displays, the elaborate ephemeral edifices erected in Rome were arguably the first temporary exhibitions of Herculanean finds. However, they offered viewers reconstructions and copies of buildings, statues, and other items recovered from the site, rather than ancient works themselves. This practice would be standard for more than a century to follow.

Replicas of Pompeian material—of both moveable finds and architecture—were widely promulgated in the nineteenth century. King Ludwig I of Bavaria, Queen Victoria and Prince Albert of Great Britain, and Prince Napoléon-Joseph-Charles-Paul Bonaparte of France each constructed more permanent versions of Pompeian buildings designed by professional archi-

tects and touted as accurate representations of ancient structures. These were, in fact, pastiches that combined features of various ancient buildings and included modern conveniences. Other monarchs, like Pope Pius IX, received gifts of excavated material (pl. 74); after his visit to the site German Kaiser Wilhelm II was also sent a dozen half-size copies of body casts.[6]

The grandest display of the nineteenth century, and the one most seen by the general public, was the Pompeian Court erected within the Crystal Palace at Sydenham, which opened in 1854 (fig. 17). The Crystal Palace was intended as "a comprehensive, visual encyclopedia of the world" that also "showcased different aspects of British industry and manufacture."[7] One of several art-historical and architectural installations that employed casts and other replicas to present a march through time, the Pompeian Court was originally intended as a tearoom or refreshment station. This plan was abandoned early on, and the court became one of the exposition's most popular attractions. It was designed by the architect and art historian Matthew Digby Wyatt, who made his first sketches for the building at Pompeii itself. The finished decorations were produced by a team of thirty painters—twenty Italian, ten English—under the direction and management of Giuseppe Abbate, the official draftsman of the excavations at Pompeii. Abbate brought tracings and cartoons of the original frescoes from Naples to London for the occasion (according to one guidebook "he came to this

country almost with the authority of one risen from the dead").[8]

The principal model for the court seems to have been the House of the Tragic Poet, which was familiar to the English public through the evocative descriptions in Edward Bulwer-Lytton's novel *The Last Days of Pompeii*. George Scharf, author of the official description of the court, however, cites eighteen different Pompeian houses as sources for its paintings, as well as tombs and temples from Pompeii and additional buildings from Herculaneum and Stabiae. At the Crystal Palace, visitors could not only see but could also circulate through an atrium, with an *impluvium* (shallow pool) and *compluvium* (opening in the roof to let in air, light, and water), and various other rooms, as well as a peristyle with a *lararium* (household shrine) and perspectival and garden frescoes. Other features included electrotyped bronze statues, mosaic pools with live fish, a bath ("that chamber so essential to the luxurious Romans"),[9] a library with shelves of papyrus book scrolls, and a *thalamusa* (the private bedchamber of the master and mistress). As with other recreations (including the virtual-reality replicas of today), the Pompeian Court was touted not only for its accuracy and extent but also for being more true to the original than the original itself in its ruined state. Scharf boasted that "every part has its prototype at Pompeii" and that the paintings were

> here exhibited on a larger scale and in a much more extensive series than ever before attempted in England; affording, in fact, the sole method by which such decorations can be fully understood … the visitor to Pompeii is but too frequently disappointed at the crumbling condition of the disentombed city … [visitors] look for excellencies that do not exist, and a harmony incompatible with the actual condition of the remains; and, discontented at finding things in opposition to their own conceptions, they depart with imperfect and even prejudiced ideas of what they really have beheld.

But at Sydenham, in contrast, "We behold at a glance the result of the experience of many years [of study], and the combined exertions of our most distinguished architects, and may safely assert that no more agreeable method than that afforded by this reconstruction could be devised for making the public acquainted with the details of a Pompeian house."[10]

According to *Routledge's Guide* to the exhibition, "The idea of reproducing an accurate representation of a Pompeian house is among the happiest and most successful of the measures adopted to make the Crystal Palace the means of blending instruction with recreation."[11] Seeing Pompeii in London was thus presented as more edifying—and more enjoyable—than seeing Pompeii at Pompeii.

Though well received by the general public—the *Illustrated London News* called it the "the most attractive, as well as the most interesting, of the various Courts in the Crystal Palace"[12]—the Pompeian Court was less pleasing to critics, several of whom disparaged the garish colors of its decorations and the ostentatious displays of ancient Pompeian life. In fact, as Shelley Hales has observed, Pompeii itself occupied a peculiar place in the ideology of the Victorians, who sought to distance themselves and their empire from the excess and corruption of Rome.[13] Ancient Pompeii, widely cited as an example of decadence and its just punishment, thus presented a challenge to the organizers of an exposition that sought to provide a positive historical model for domestic living. One solution to the problem was to acknowledge the city's reputation. Pompeii was introduced to visitors as the "fashionable resort of a hedonistic class,"[14] and various guidebooks to Sydenham quoted Bulwer-Lytton and other authors' descriptions of ancient excess. Indeed, some years after the construction of the court, designer and Aesthetic theorist Christopher Dresser linked Pompeii's art directly to its divine punishment. Addressing the Society of Arts, he declared "Pompeian art was false, and Pompeii was destroyed."[15]

The Second London International Exhibition of Industry and Art held in 1862 was another matter altogether. It was more of a world's fair, designed to showcase the various products of diverse countries and, especially, to surpass the rival World Exhibition that had been held in Paris in 1855. Approximately 29,000 exhibitors from thirty-six countries displayed their wares at the 1862 exposition, which was attended by some 6.1 million visitors. The Italian section was relatively small, but national pride was at stake. Metals, minerals, chemicals, pharmaceuticals, foodstuffs, and wine were all exhibited. The fine-arts section featured several drawings, paintings, books, and models of Pompeian material, some exhibited by the artists and architects who created them, others presented as official loans from the National Archaeological Museum in Naples.[16] These consisted of replicas of various frescoes and floor mosaics by Abbate and other artists, some in gilt frames, as well as cork models of the House of the Tragic Poet, the Theater of Herculaneum, the Temple of Neptune, and an ancient tomb at Paestum.[17]

Other international exhibitions on more restricted themes also borrowed and displayed models, replicas, and photographs of Pompeian antiquities from the Naples museum to illustrate such topics as ancient fishing (Berlin, 1880, and Rome, 1911), architecture (Turin, 1890), toys (Florence, 1911), and games and gymnastics (Venice, 1917). Letters to the museum from the Ministry of Public Instruction, which sponsored these events, indicate that those requesting loans were often indifferent as to whether they received originals or reproductions in the form of watercolors, casts, and photographs. As a rule, originals were not sent, for as Giuseppe Fiorelli, who headed the excavations at Pompeii, wrote to an official at the Museum of Physics and Natural History in Florence on March 27, 1888, "regulations prohibit the transport of the monuments themselves."[18]

A notable exception was the *Esposizione nazionale d'igiene* (National Hygiene Exposition) of 1900. Held in Naples itself, the exposition was a grand affair with numerous temporary buildings constructed in the Villa Comunale. Contemporary reports describe the Pompeian Pavilion, designed by Salvatore Cozzi, chief engineer of the excavations at Pompeii, as the best of these edifices (fig. 18). Another pastiche of ancient architecture, the pavilion consisted of a portico with four Corinthian columns supporting an entablature with painted festoons and griffins, appositely modeled on those of Pompeii's Temple of Apollo, the god of healing.[19] Inside, a fountain stood within a central Ionic peristyle colonnade. To the left, architectural models were displayed in a room open to the sky. To the right were two rooms: one containing an ancient bath recently excavated at Boscoreale; the other exhibiting ancient cooking implements, surgical instruments, and other "objects pertaining to the hygiene of the Pompeians." The pavilion opened late, on June 10, some two months after the exposition itself, due to construction delays owing to inaction and bad weather—both meticulously recorded in Cozzi's frustrated letters and other correspondence between officials at the Naples museum, the ministry in Rome, and the exposition's organizers. These letters also mention plans for the separate mounting of replicas of ancient frescoes, so that they might be reused after the event. Preliminary notes describe possible topics that might be addressed in the pavilion—such as *palestrae* (gymnasia), public and private latrines, and brothels—not all of which were pursued. Perhaps most valuable for

a history of temporary exhibitions is the surviving copy of an insurance policy that inventories the loans that were transported from the Naples museum to the completed pavilion. These included not only cork models but also, it seems for the first time, actual antiquities: terracotta amphorae and tiles; two lead water tanks; lead, bronze, and iron baths, pipes, and valves; bronze tables, chairs, basins, pans, and other vessels; a set of surgical instruments; and more.[20]

Despite being largely forgotten today, the importance of the National Hygiene Exposition at the time is clear from its high profile. The prince of Naples and heir to the Italian throne, Victor Emmanuel, was its patron, and his parents, King Umberto I and Queen Margherita of Savoy, accompanied him at the opening ceremonies alongside the queen's father, the duke of Genoa, and numerous other dignitaries. Timed to coincide with the meeting of 1,200 delegates of the International Convention Against Tuberculosis, one of the goals of the exposition was to showcase the transformation of Naples, which had in the previous centuries been notoriously insalubrious. As early as 1772, under Ferdinand IV, draconian laws had been promulgated in the hope of stemming the spread of tuberculosis, the causes of which were then not well understood; and these measures were largely successful. According to Dr. J. F. Jenkins, in a paper read on July 17, 1894, and subsequently published in the *Journal of the American Medical Association*,

> there has been only one locality, which I am able to cite to you, where any effort has been made to control the spread of tuberculosis, viz: the city of Naples... "Smell Naples and die" is a proverbial remark long in use, uttered in every European tongue, in order to point out the unsani-

FIG. 18. The Pompeian Pavilion at the *Esposizione nazionale d'igiene*, Naples 1900. Illustration in *La Domenica del Corriere*, July 1, 1900, p. 3.

tary condition of that city, yet, restrictive laws relative to pulmonary tuberculosis reduced the death rate from this disease, which had heretofore been high, to a very low mortality.[21]

Ten years before Jenkins's encomium, however, Naples had suffered a massive outbreak of cholera. Estimates of the number of victims range from seven to fourteen thousand dead. This epidemic occasioned a major *risanamento* (cleansing) campaign under the liberal government of newly unified Italy, which consisted of clearing slums and significantly improving the water supply and drainage systems, as tainted food, overcrowding, and the all-too-frequent confluence of sewage and drinking water contributed greatly to the propagation of the disease.[22] Thus, by 1900, according to one account of the exposition published in *Journal of the American Medical Association*, "Naples now boasts of the finest water-supply in the world since the waters of the Serino have been piped into the city, and the transformation of most of the famous Naples slums into handsome boulevards during the last ten years is an interesting feature to be seen in connection with the exposition." It is no coincidence that this sentence immediately follows a description of the ancient domestic "heating, lighting and water-supply arrangements" in the Pompeian Pavilion.[23] Guido Bacelli, the minister of Public Instruction and himself an illustrious surgeon, also looked to the ancient Roman past for models of health, declaring in his address at the opening of the exposition on May 9:

> *Salus populi suprema lex*, the word of the fathers is that of their descendants to-day. Rome of old was great not alone in arms and laws, but in social medicine besides. This legacy of public and private hygiene, this reverence for the professors of the healing art, so well summed up in the saying of Cicero: "In nothing do men resemble the gods more than in giving health to men," belong to the most precious patrimony of the Italian people. To-day, when Italy is seeking to unite her new to her ancient greatness, it is well to see arising again, refined and improved by modern science, the old cult of public hygiene. Hygiene is civilization.[24]

Following World War I, Mussolini's Fascist government invested considerably in excavations at Pompeii and Herculaneum. In November and December of 1926, large-scale copies of the frescoes of the Villa of the Mysteries (excavated in 1909) painted by Maria Barosso, head of archaeological drafting for the excavations of the Roman Forum, were temporarily displayed at the Villa Umberto I (the Villa Borghese) in Rome before being sent to the University of Michigan, which had commissioned them. They were highly praised as "a great Fascist triumph in the field of art."[25] A decade later, numerous replicas of

other Pompeian artifacts were exhibited in the *Mostra augustea della Romanità* at the Palazzo delle Esposizione in Rome; they were subsequently transferred to the Museum of Roman Civilization at the Esposizione Universale di Roma (EUR), Mussolini's architectural showpiece constructed south of Rome, where they can still be seen today.[26]

Widespread destruction at Pompeii, occasioned by Allied bombing in World War II (see pls. 34.1–.3), and the time and money necessary for recovery and reconstruction drastically curtailed international loan exhibitions (see fig. p. 242). In 1951 the Fine Arts Museum of Osaka hosted an exhibition consisting of some two hundred photographs, maps, models, and various realia, including paintings, mosaics, vessels, and instruments. Sixteen years later, a major show, simply titled *Pompei: no Iseki* (An Exhibition of Pompeian Art), returned to Japan. Sponsored by the Japanese Ministries of Foreign Affairs and National Education, it featured 255 objects, including marble statues, reliefs, and urns; frescoes and mosaics; bronze statuettes, vessels, and utensils; and coins, glass, and ceramics in Tokyo, Osaka, and Fukuoka. How and why Japan became the site of the first postwar Pompeian loan exhibitions remains something of a mystery, but the success of the second Japanese tour directly inspired *Pompeji: Leben und Kunst in den Vesuvstädten* (Pompeii: Life and Art in the Vesuvian Cities), which six years later drew crowds in Germany, the Netherlands, Switzerland, and Portugal, after having opened in Paris. In Essen, the run of the exhibition at the Villa Hügel—the suburban villa of the Krupp family— was extended, and the catalogue went through four printings. Archaeologist Bernard Andreae's introduction to the Essen catalogue makes it clear that the exhibition was conceived in light of the Japanese show. Is it mere coincidence that Essen, a major German industrial center intensively bombed in World War II, and Japan, the first and only country to suffer the effects of atomic explosions, were sites of the two first postwar exhibitions focusing on Pompeii? Their catalogues, however, make no reference to the recent war, focusing instead on the beauty and historical value of the artifacts displayed and their ability to convey across the centuries something of daily life in classical antiquity. It would be several years before the destruction of Hiroshima and Nagasaki was explicitly compared to that of the Vesuvian cities.[27]

Other exhibitions followed. *Pompeii A.D. 79*, which opened in London in late 1976, subsequently traveled to Denmark and then toured the United States—appearing in Boston, Chicago, Dallas, and New York City before moving on to Australia and Mexico (with a different title, *El Arte de Pompeya*)—was the first transatlantic Pompeian blockbuster and was timed to mark the 1900th anniversary of the eruption of Vesuvius.[28] Initially sponsored by Imperial Tobacco Limited and the *Daily Telegraph*, it was presented at the Royal Academy under the patronage

of Queen Elizabeth II and Giovanni Leone, the president of Italy. Its scholarly catalogue remains an important academic resource; in its preface, Hugh Casson, president of the Royal Academy, touted the show as "the most ambitious and comprehensive exhibition of [Pompeian] treasures...ever to have been shown outside Italy."[29] Among the 325 ancient artifacts were, for the first time, plaster casts of the bodies of victims, which have since become de rigueur in any Pompeian exhibition. However, the casts in this show were not original mid-nineteenth-century objects but rather twentieth-century copies—of the famous dog and a young woman—that had been purchased and lent by Imperial Tobacco.[30]

The 1980s saw some thematically focused exhibitions that addressed artifacts fashioned from specific materials (e.g., wood, gold, and stucco), the inspiration later artists drew from antiquity, and other historiographic themes, but the blockbuster returned in the 1990s with *Rediscovering Pompeii*, cosponsored by IBM-Italia and Fiat Engineering. This exhibition traveled widely, opening at the now-defunct IBM Gallery of Science and Art in New York before moving on to Houston, Malmö, London, Amsterdam, Stuttgart, Hamburg, Rome, Basel, and Sydney. At a time when personal computers were becoming more common, this exhibition was designed to highlight and explain "the usefulness of the most modern computer technologies in many areas of cataloguing works of art and archaeological research," according to Ferdinando Facchiano, Italy's minister of Cultural and Environmental Affairs in the preface to the multilingual exhibition catalogue.[31] Or, as Malcolm Browne wrote more prosaically in a *New York Times* exhibition review: "New computer technology can tease new archaeological insights from old rubble." The show featured some two hundred objects, including detached frescoes; statues in bronze and marble; jewelry; mosaics; a host of vessels, tools, pipes, and valves; and other items, as well as body casts of Vesuvius's victims, which, in New York, were placed at the entrance for maximum impact. While emphasizing ancient daily life, the IBM exhibition predictably stressed the role of computers in mapping the city, restoring frescoes, and enhancing the reading of burned papyri, and great claims were made for potential scientific advances.[32] Browne, however, was less impressed with the technology: the "interactive" computer terminals "sprinkled" throughout the exhibition, "showing the reconstructions at various stages and illustrating the techniques involved...offer a great deal of interesting information, but they are the least effective part of the exhibition."[33]

The allure of actual finds from the Vesuvian sites and their perceived ability to convey directly the experiences of the ancients themselves is, without doubt, responsible for the seemingly unrelenting popularity of Pompeii exhibitions beginning in the 1990s. The technology of daily life was featured in *Homo Faber: Natura, scienza e tecnica nell'antica Pompei / Pom-*

peii: Life in a Roman Town (Naples, Los Angeles, Munich, Paris, Tokyo, and four other Japanese cities 1998–2002), and this focus on the quotidian realities of life in the Roman empire has been maintained by most shows up to the present. Still, some curators have sought to emphasize other aspects of the sites and their finds to attract audiences: exhibitions in the late 1990s and 2000s examined specific houses (for example, those of the Golden Bracelet, of Meander, of Ariadne, of Marcus Lucretius Fronto, and the Villa of the Mysteries) or regions of the city; artworks in specific media (paintings, glass, and silver); and gardens, foodstuffs, wine, perfumes, and other forms of luxury and decadence. While most exhibitions have mingled finds from various Vesuvian cities, Herculaneum and Stabiae came into their own with four different shows that toured the United States and Europe between 2005 and 2009. Aspects of Pompeii's modern reception, meanwhile, were the focus of exhibitions in the United States, France, Spain, and Poland between 2001 and 2010 that also examined the development of specific local connections to the ancient sites.

A few exhibitions have explored distinctively new ground. *Vivre en Europe romaine* (Living in Roman Europe), held at the archaeological site of Bliesbruck-Reinheim on the Franco-German border in 2007, compared early stages of the development of European identity in small towns in different parts of the Roman empire, as well as diverse aspects of the Romanization of populations and the various roles played by people at different levels of society. The exhibition intermixed objects excavated at Bliesbruck-Reinheim and loans from the Vesuvian cities, along with site photographs and, of course, casts of victims. Its themes resonated deeply not only at a site on the border of two large European powers, but throughout the European Union, which continues to strive to develop a shared culture and values as well as a united economy.

While the majority of Pompeian exhibitions have taken place in Western Europe and North America, they have also been extremely popular in Japan and, more recently, have toured other countries in Asia and the South Pacific. *Pompeii: chwe ho we nar* (Pompeii: Living Beneath Vesuvius), on view for six months in 1997–98 in Seoul, Pusan, and Incheon, Korea, was a smaller version of its Italian predecessor, *Abitare sotto il Vesuvio*, with 151 of the 625 objects that had been originally exhibited earlier in the Palazzo dei Diamanti in Ferrara. Its stated goals were to celebrate the 113th anniversary of Italian-Korean diplomacy and to build friendship and increase economic cooperation between the two countries. While prefatory statements from politicians and sponsors are characteristic of modern exhibition catalogues, the Korean publication opened with expressions of welcome, congratulations, and thanks from no fewer than five Korean officials and sponsors, each accompanied by his photograph.

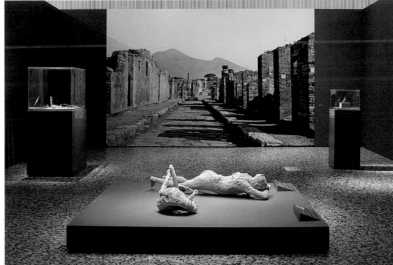

Such declarations have become increasingly common. The exhibition *Pompeya bajo Pompeya* (Pompeii beneath Pompeii), held in Alicante and Valencia in 2007, not only featured introductory statements from the Valencian mayor and city council presidents from both venues, it also extolled the ancient links between Valencia and Pompeii. Corporate sponsorship, a key factor in mounting the major exhibitions of the 1970s, has also become more prevalent. The Valencian exhibition had ten sponsors, each with their logos on the title page of the catalogue. The same year *Ocio y Placer en Pompeya* (Leisure and Pleasure in Pompeii) in Murcia had six sponsors; *Tales from an Eruption* ranged from four in Beijing to twelve in Birmingham, Alabama; *Die letzten Stunden von Herculaneum* (The Last Hours of Herculaneum) in Germany had sixteen; and *Otium Ludens: Stabiae—at the Heart of the Roman Empire* at the State Hermitage Museum in St. Petersburg had forty-one, including banks, insurance companies, car dealers, jewelers, and especially hotels. Pompeii, quite clearly, sells, and one of the stated aims of the Russo-Italian venture was to attract tourists to Campania.[34]

Pompeii and the Roman Villa: Art and Culture around the Bay of Naples (2008–10), organized by the National Gallery of Art in Washington, D.C., and sponsored by Bank of America, represented a return to limited, select, high-level government and corporate sponsorship. Italy's prime minister Silvio Berlusconi and First Lady Laura Bush attended the show soon after its opening (fig. 19). The exhibition, which traveled to Los Angeles and, in abbreviated form, to Mexico City, broke away from the standard emphasis on daily life in the ancient world, focusing instead on the refined, luxurious lifestyles of ancient elites. This topic was explored more sensationally in *Luxus und Dekadenz: Römisches Leben am Golf von Neapel* (Luxury and Decadence: Roman Life on the Bay of Naples), which toured Germany and the Netherlands at approximately the same time (2007–9), per-

FIG. 19. Former Italian prime minister Silvio Berlusconi (left) and former First Lady Laura Bush (right) accompanied by gallery director Earl A. Powell III and exhibition curator Carol Mattusch (center) view a digital replica of the Alexander Mosaic from the House of the Faun in the exhibition *Pompeii and the Roman Villa: Art and Culture around the Bay of Naples*, at the National Gallery of Art in Washington, D.C., October 13, 2008.

FIG. 20. *Pompeii: Tales from an Eruption* as installed at the Museum of Fine Arts, Houston, February 24–June 15, 2008. Photo mural of the Via Scuole and Mount Vesuvius by Jennifer F. Stephens.

haps reflecting the economic boom (or bubble) of the beginning of the twenty-first century.

The display of Vesuvius's victims, eschewed in *Pompeii and the Roman Villa*, has continued to increase in popularity in recent years. In *Storie da un'eruzione / Pompeii: Tales of an Eruption* (2003) body casts were featured prominently on the main staircase of the National Archaeological Museum in Naples, and when an abbreviated version of that show, which eventually traveled to thirteen cities in seven countries, appeared in Houston, they were placed in galleries lined with full-scale photo murals of Pompeii and Herculaneum, as if corpses had littered the streets in antiquity (fig. 20).

The final gallery of the significantly smaller *A Day in Pompeii* exhibition that toured the United States between 2007 and 2009 was dedicated to more than twenty body casts, which the audio-guide script, after describing the eruption of Vesuvius and quoting from Pliny's letters, introduced as follows: "About two thousand Pompeiians did not survive this disaster. Now you will meet some of these victims." Casts were the sole focus of *I calchi* (The Casts) at the Antiquarium in Boscoreale, near Pompeii, in 2010–11, and the promoters of *Pompeii the Exhibit: Life and Death in the Shadow of Vesuvius* at Discovery Times Square in New York City in 2011, a reconfigured version of *A Day in Pompeii*, boasted "the largest collection of body casts ever on dis-

FIG. 21. *Pompeii: The Exhibit* and *Harry Potter: The Exhibition* at Discovery Times Square in New York City, March 4–September 5, 2011.

FIG. 22. Advertising for *A Day in Pompeii* on a luggage carousel at Wellington International Airport, New Zealand, 2010.

play, including a dramatic skeleton collection."[35] This exhibition, which ran concurrently with *Harry Potter: The Exhibition* (fig. 21), also featured modern replicas of artifacts, newly fashioned body casts, a reconstructed bedroom from a Pompeian brothel, and six separate video presentations, including a computer re-creation of the phases of the city's destruction, complete with exploding buildings and external special effects such as flashing lights and gusts of air meant to simulate the final pyroclastic flow that swept over the doomed city. Touted as "A brand-new, immersive movie experience depicting a time-lapsed representation starting from the moment of Vesuvius' massive explosion," this virtual reality presentation was actually previously developed in Melbourne, Australia, for yet another version of *A Day in Pompeii*. The Australian exhibition traveled across the continent to Perth and was also presented in the VISA Platinum Gallery of the Te Papa Museum in New Zealand, where it was cleverly advertised by images of lava flowing relentlessly around the baggage carousels at Wellington's international airport (fig. 22).[36] Pompeii seems to have progressed from the City of the Dead to the City of the Living to the City of Disaster.

Modern technology, which permeates so many aspects of our lives, continues to be employed to attract twenty-first-century viewers to the Vesuvian sites themselves. The Museum of Virtual Archaeology (Museo Archeologico Virtuale–MAV), located just two hundred meters from the entrance to the archaeological site of Herculaneum, boasts more than seventy multimedia installations consisting of "the most innovative audiovisual technologies, including computers, lasers, virtual reality, scanners, holograms and 3D screens [that] allow visitors to see and interact with pots of water, burning clouds, magic lanterns, architectural spaces, sounds and voices" (fig. 23). These are all intended to "bring back the life and splendour of the main archaeological areas of Pompeii, Herculaneum, Baia, Stabia and Capri. Through scene reconstructions, visual interfaces and holograms, [visitors] are led into a virtual dimension, experiencing the archaeological heritage interactively by exploiting the new opportunities offered by multimedia technologies." Aimed, in part, at school groups, the MAV markets itself as "a place for learning and understanding, where the real and the imaginary meet to give life to new ways of learning and of entertainment"[37]—words not so far distant from those of George Scharf describing the Pompeian Court at Sydenham 150 years ago or Johann Wolfgang von Goethe, who visited Pompeii itself on March 11, 1787, and two days later famously wrote: "On Sunday we went to Pompeii—there has been much calamity in the world, but little that has brought posterity so much pleasure."[38]

High-tech presentations have also been installed within the archaeological site at Pompeii. There, as part of an initiative called PompeiViva, a virtual reconstruction led by "a very special guide," Julius Polybius himself, in the form of a "hologram" projected on nebulized water, has been installed in the eponymous house (fig. 24). This "multisensorial" multimedia show is the culmination of an hour-long, expert-led tour of the house, which, following "much in-depth research" in collaboration with the University of Tokyo, has been outfitted with "several copies of objects found buried under the layer of volcanic ash [which] have been placed in the most important rooms of the house" including "faithfully reproduced...beds and cupboards, curtains, ornaments, [and] valuable objects." The tour also includes recorded sounds of construction in the street outside the house; pots and pans and a crackling fire in the kitchen; wind, rain, and water drops in the *impluvium*; and various birds from the garden, before culminating with the tragedy of the eruption. "At a moment of particularly intense concentration and atmospheric sounds, Polybius, his features based on the casts, appears to the visitors in full-length back-projection." He describes the house and tells his story: "Our only thought was to find shelter. I shouted: 'Run, bring with you anything you want to save! Let's barricade ourselves in the end room, beyond the peristyle!' This is the room...this is where we met our fate!" Of the twelve other victims discovered in the house by excavators in the early nineteenth century only a second projection materializes, a pregnant woman, "the final atmospheric apparition of the visit."[39]

More moving—literally—and with less pretense toward educational value or historical accuracy, is the "Escape from Pompeii" shoot-the-chutes water ride that opened in Busch Gardens amusement park in Colonial Williamsburg, Virginia, in 1995 (fig. 25). The ride is set not in antiquity but in a notional present, where excavations have been suspended due to ongoing seismic activity. Visitors queue alongside an abandoned excavation base camp, complete with makeshift tables and broken statues (of the garden variety), before embarking on small boats that are raised some eighty feet, past various "warnings," before entering a darkened "archaeological site" just as a new eruption spews flames, shakes the walls and ceilings of ancient

TOP LEFT
FIG. 23. The House of the Faun at Pompeii imaged at the Museum of Virtual Archaeology, Herculaneum.

BOTTOM LEFT
FIG. 24. A "hologram" of Julius Polybius (back-projected on nebulized water) greets modern visitors to his house at Pompeii.

RIGHT
FIG. 25. "Escape from Pompeii" water ride at Busch Gardens, Colonial Williamsburg, Virginia.

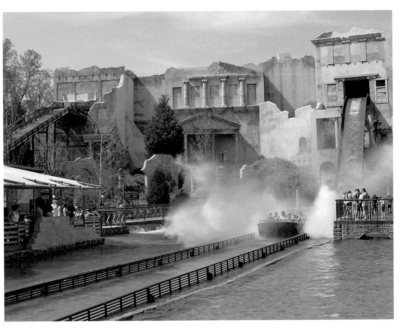

Roman houses, and topples statues. In the nick of time, visitors make their escape, plummeting to safety with a tremendous splash that returns them to the *faux* dig site.[40]

Here, entertainment far surpasses education, but even the best of museum exhibitions have long been designed to amuse as well as enlighten. The political goals of Italian and host governments, the economic needs of sponsors and both lending and borrowing museums, likewise, have always played significant roles in the display of Pompeian artifacts—and Pompeian fantasies. And, given the voracious appetite of the public, they will certainly continue to do so.

Notes

For assistance in the preparation of this essay, I am grateful to Mary Beard, Joanne Berry, David Brafman, Andrew Clark, Jens Daehner, James Harper, Thomas Noble Howe, Kim Hyung-eun, Valentin Kockel, Claire L. Lyons, Louis Marchesano, Ia Mcilwaine, Carol Mattusch, Luigia Melillo, John Moore, Valerio Papaccio, Marcia Reed, Karen Meyer Roux, David Saunders, Niki Stellings-Hertzberg, Antero Tammisto, James Tice, Angela Vinci, and the librarians at the Getty Research Institute. Marina Belozerskaya, Victoria Gardner Coates, and Jon Seydl have sharpened my thinking through their careful reading, comments, and suggestions. Christian Groeben and Massimiliano Meja of the Stazione Zoologica Anton Dohrn di Napoli and C. Troiano and G. Valsuani of the Biblioteca Universitaria di Genova provided valuable bibliographic assistance. I am particularly indebted to Mariarosaria Esposito of the Archivio Storico of the Soprintendenza Speciale per i Beni Archeologici di Napoli e Pompei for her enthusiasm, kindness, and efficiency.

1 On the early exploration of Vesuvian sites and presentation of the finds, see, for example, Parslow 1995; Moormann 2003; Mattusch 2005, esp. 33–123, 339–61; Coates and Seydl 2007; Milanese 2009; and Hales and Paul 2011.

2 See, however, the brief survey of exhibitions in Kockel 1985, esp. 498–501.

3 Among the more popular recent exhibitions were *Pompeii and the Roman Villa: Art and Culture around the Bay of Naples*, which had some 400,000 visitors in Washington, D.C., in 2009, and *Otium Ludens: Stabiae—at the Heart of the Roman Empire*, with 500,000 in St. Petersburg in late 2007 and early 2008. Attendance at *A Day in Pompeii* at the Melbourne Museum in 2009 was over 332,000, "the highest attendance for any Australian museum exhibition at that time," surpassing *Picasso* in 2006 and *Dutch Masters* in 2005. Compare this number with the 290,016 who visited the National Archaeological Museum in Naples in 2008, which, according to the Touring Club Italiano, was down 18.8 percent from 357,032 in 2007. In the same years Pompeii itself was Italy's top tourist attraction, hosting 2,253,655 and 2,571,725 visitors, respectively. Herculaneum, meanwhile, received 264,036 and 301,786 visitors. See Touring Club Italiano, *Dossier Musei 2009*, p. 4, table 1: http://static.touring.it/store/document/21_file.pdf (last accessed March 20, 2012).

4 Daehner 2007; Jens Daehner, "The Herculaneum Women in Eighteenth-Century Europe," in Mattusch 2012; Kordelia Knoll, "From Herculaneum to Dresden: The Modern History," in Daehner 2007, 19–36, fig. 2.3 (for the statues as eventually displayed inside Eugene's palace); and Moritz Woelk, "From the Menagerie to the Plaster Gallery," in Daehner 2007, 141–55.

5 Gordon 2007, esp. 38–40.

6 Ludwig built the Pompeijanum at Aschaffenburg, designed by Friedrich von Gärtner, to offer an up-to-date visual representation of the state of knowledge about ancient art and culture to be studied and experienced by art lovers in Germany in 1843. The Garden Pavilion at Buckingham Palace was built in 1846 by Wilhelm Heinrich Ludwig Grüner for Prince Albert, who hoped to spur a revival of fresco painting in England. A decade later the Maison Pompéienne in Paris was designed by Alfred Nicolas Normand, apparently for Prince Bonaparte's mistress, the actress Rachel Félix, who was famous for reviving the classicizing tragedies of Racine and Corneille. Only the Pompeijanum, bombed in World War II, but subsequently painstakingly restored in several phases, survives; it now houses Roman artifacts from the Bavarian state antiquities collection in Munich. The Garden Pavilion was destroyed in 1928/29, and the Maison Pompéienne was briefly converted into a museum before being demolished in 1891; its still fashionable site, 18 Avenue Montaigne, is now occupied by Giorgio Armani. See Werner Helmberger and Raimund Wünsche, *Das Pompejaum in Aschaffenburg: Amtlicher Führer* (Munich, 1995); Werner Helmberger et al., *Der Wiederaufbau des Pompejanums in Aschaffenburg: Instandsetzung und Restaurierung von 1900 bis 2002* (Munich, 2003); Ludwig Gruner, *Decorations of the Garden-Pavilion in the Grounds of Buckingham Palace: Engraved under the Superintendence of L. Gruner; With an Introduction by Mrs. Jameson* (London, 1846); Marie-Claude Dejean de La Batie, "La maison Pompéienne du Prince Napoléon," *Gazette des Beaux-Arts* 97 (April 1976): 127–34; and Hales 2006. For another Pompeian-style residence, built in 1889 by the Boston hardware magnate Franklin Webster Smith in Saratoga Springs, N.Y., which was filled with replicas of ancient mosaics, frescoes, statuary, and furniture and opened to the public as an educational tourist attraction, see Joanne Berry, "Reconstructing the History of the Pompeia, Saratoga Springs": www.bloggingpompeii.blogspot.com/2009/08/reconstructing-history-of-pompeia.html (last accessed March 12, 2012). Prior to these, between 1788 and 1794, Leopold III Frederick Franz, ruler of the principality of Anhalt-Dessau in northern Germany, having previously met William Hamilton in Naples, constructed in the garden of his estate at Wörlitz a model Vesuvius on the shore of an artificial lake that was meant to recall the Bay of Naples. Fireworks were set off from the crater of the diminutive volcano, the sides of which were fitted with panels of red-tinted glass over which water would flow, simulating the effect of streams of lava. The prince also constructed a replica of Hamilton's villa at Posillipo, complete with a collection of Pompeian-style paintings and other artifacts. See Kulturstiftung Dessau-Wörlitz, *Der Vulkan im Wörlitzer Park* (Berlin, 2005). For Pompeian-style homes in America see Nichols forthcoming; for the Kaiser, see Dwyer 2010, 105–6.

7 Hales 2006, 99; George Scharf, *The Pompeian Court in the Crystal Palace* (London, 1854); Edward MacDermott, *Routledge's Guide to the Crystal Palace and Park at Sydenham* (London, 1845), 127–37; Samuel Phillips, *Guide to the Crystal Palace and Park* (London, 1854), 1:98–102; and Jan Piggot, *Palace of the People* (London, 2004), esp. 98–102.

8 MacDermott (note 7), 130.

9 Phillips (note 7), 102.

10 Scharf (note 7), 65, 72–73.

11 MacDermott (note 7), 127.12 "The Pompeian Court at the Crystal Palace," *Illustrated London News*, January 20, 1855, 62.

13 Hales 2006. See also Nichols forthcoming.

14 Piggot (note 7), 100.

15 Phillips (note 7), 101–2; and Christopher Dresser, "Ornamentation Considered as High Art," *Journal of the Society of Art* 19, 951 (February 10, 1871): 220. Dresser's remarks led William H. Goss to ask, "When Pompeii was so suddenly overwhelmed with the lava and ashes of Vesuvius, was it because of her errors in ornamental art?": William H. Goss, "Truth in Ornamental Art," *Journal of the Society of Art* 19, 953 (February 24, 1871): 277. See also Hales 2006, esp. 109–16; and Virginia Zimmerman, *Excavating Victorians* (Albany, N.Y., 2008), 105–26, esp. 124–26 (the author makes interesting observations despite several errors of fact).

16 *Official Catalogue of the Fine Art Department, International Exhibition 1862* (London, 1862), 251–56, nos. 2141–2531, esp. nos. 2173, 2182–90, 2207–12, 2227, 2263–6; and *A Plain Guide to the International Exhibition: The Wonders of the Exhibition Shewing* [sic] *How They May be Seen at One Visit* (London, 1862).

17 Extensive correspondence in the museum's historical archives indicates that the models by Abbate, Giovanni Castelli, Francesco La Vega, and Felice Padiglione all returned to Naples in 1863 badly damaged and in need of extensive repair, which the Ministry of Public Instruction in Rome, the sponsor of the loans, was reluctant fully to underwrite. Naples, Museo Archeologico Nazionale, Archivio Storico, file XXI D2.3.

18 Naples, Museo Archeologico Nazionale, Archivio Storico, files XI D2, 15 (Berlin: fishing); I C2, 12 (Rome: fishing); I C2, 3 (Turin: architecture); I C2, 16 (Florence: toys; Venice: games and gymnastics).

19 *Guida di Napoli e della Esposizione d'igiene* (Naples, 1900), 82–83.

20 "L'Esposizione d'Igiene a Napoli," *La Domenica del Corriere*, July 1, 1900, 3; *Guida* (note 19), 82–83; and Naples, Museo Archeologico Nazionale, Archivio Storico, file XXI D2, 17.

21 J. F. Jenkins, "Should Cases of Tubercular Consumption Be Reported to Local Boards of Health?" *Journal of the American Medical Association* 23 (1894): 388.

22 Frank M. Snowden, *Naples in the Time of Cholera, 1884–1911* (Cambridge, 1994). Such efforts, in fact, had begun shortly after the unification of Italy in 1860 but had stalled, despite Garibaldi's attempts to link the moral and physical health of the state; see Terry Kirk, *The Architecture of Modern Italy I: The Challenge of Tradition, 1750–1900* (New York, 2005), 196–99.

23 *Journal of the American Medical Association* 34 (1900): 1312.

24 *Journal of Genetic Psychology* 7 (1900): 567.

25 Elizabeth De Grummond, "Maria Barosso, Francis Kelsey, and the Modern Representation of an Ancient Masterpiece," in Gazda 2000, esp. 133–34; and Gazda 2007, esp. 216–19.

26 Anna Maria Liberati, "The Pompeian Collection of the Museo della civiltà Romana," in Annamaria Ciarallo and Ernesto de Carolis, *Pompeii. Life in a Roman Town* (Milan, 1999), 17–18.

27 See, for example, Hosoe 2007. For analysis of the 1973 exhibition and its changes from venue to venue, see Kockel 1985, 499.

28 The *Treasures of Tutankhamun* opened in Washington, D.C., on November 17, 1976, having previously been exhibited in London in 1972 and three cities in the Soviet Union in 1973–75. It then traveled to Chicago, New Orleans, Los Angeles, Seattle, New York, San Francisco, Toronto, and five cities in West Germany.

29 Ward-Perkins and Claridge 1976, 8.

30 For the casts, see Ward-Perkins and Claridge 1976, cats. 21–22; and Ward-Perkins and Claridge 1978, 121, cats. 15–16.

31 Conticello et al. 1990, [vii].

32 Compare more recent advertising that featured the use of the Apple iPad at Pompeii, "the longest active archaeological excavation in the world as a twenty-first century replacement for pen and paper" according to *Macworld* magazine: http://www.macworld.com/article/154717/2010/10/ipad_archeology_pompeii.html (last accessed April 20, 2012).

33 Malcolm W. Browne, "Filling in Pompeii Gaps by Computer," *New York Times*, July 13, 1990: http://www.nytimes.com/1990/07/13/arts/filling-in-pompeii-gaps-by-computer.html (last accessed March 12, 2012). Is it merely a coincidence that the American tour of *Pompeii AD 79* was cosponsored by Xerox Corporation?

34 Although the St. Petersburg exhibition focused on Stabiae, not Pompeii, Antonio Bassolino, president of the Region Council of Campania, invokes the better-known site in the first sentence of his preface to the catalogue *Otium Ludens* (p. 7): "for the first time the art of ancient Pompeii is on display in Russia." See also the preface of Marco di Lello, councilor for Tourism and Cultural Heritage of the Campania Region (p. 9), who also explicitly mentions Pompeii, as does Ferdinando Spagnuolo, managing director of the Restoring Ancient Stabiae Foundation (p. 11).

35 http://www.discoverytsx.com/pompeii (last accessed March 20, 2012). For a more thorough examination of the body casts, see J. M. Deem, *Bodies from the Ash: Life and Death in Ancient Pompeii* (Boston, 2005); Dwyer 2007 and 2010; and Stefani 2010.

36 See http://mastercom.over-blog.com/article-visa-pompeii-ambient-media-lava-airport-conveyor-belt-46855771.html (last accessed March 20, 2012).

37 http://www.museomav.it/doc/brochureENG.pdf (last accessed March 20, 2012).

38 Johann Wolfgang von Goethe, *Italian Journey*, ed. T. P. Saine and J. L. Sammons, trans. R. R. Heitner (New York, 1989), 167.

39 Description and quotes from the brochure *Everyone to Iulius' House / Tutti a Casa di Giulio*, Commissario delegato per l'emergenza dell'area Archeologica di Napoli e Pompei and the Soprintendenza Speciale per i Beni Archeologici di Napoli e Pompei (2010/11) and the website: http://www.pompeiviva.it/pv/en/domus_giulio_polibio_event.htm (last accessed March 20, 2012). See also http://bloggingpompeii.blogspot.com/2010/05/houses-of-julius-polybius-and-chaste.html (last accessed March 20, 2012), for the following description by visitors to the house in May 2010: "The House of Julius Polybius had the guide explaining and answering questions, until we came to a room where Julius Polybius, in person, welcomed us to his house. At least the hologram did. This was delivered by a finely spoken male voice, in perfect English, but went on too long and lost the interest of the group, especially the children. Worse was to come. In another room the daughter of Julius Polybius arose from the dead and proceeded to tell us about what had happened to her, at great length and in Italian. She took a lot longer to die than would have been the case in 79 AD. Despite these shortcomings, the House is another excellent choice for opening to the public."

40 http://www.buschgardens.com/bgw/explore/Rides.aspx?id=494; "Travel Advisory" 1995: http://www.nytimes.com/1995/05/07/travel/travel-advisory-escape-from-pompeii-at-busch-gardens.html?src=pm; and for a complete video http://www.youtube.com/watch?v=EiqQ2UtGePs (all last accessed March 20, 2012).

VICTORIA C. GARDNER COATES

On the Cutting Edge

POMPEII AND NEW TECHNOLOGY

While Pompeii, Herculaneum, and the surrounding sites have been enthusiastically embraced as conduits to the past, the means used to achieve this passage have been, from the time of the eighteenth-century recovery, resolutely modern. Through generations of developing technology, previously unavailable methods have been employed to gain access to antiquity. This process may seem self-evident, but while new technologies have obviously contributed to our ability to accumulate information about ancient Rome, a little-noted byproduct is how these techniques have also served to transform the sites into a form more palatable to contemporary audiences. Most dramatically, two nineteenth-century advances helped wrench Pompeii and its inhabitants into the modern world: photography, which became the most popular medium for disseminating information about the sites and their contents, and the process of plaster casting the bodies of the ancient victims of Vesuvius. A century and a half later we are experiencing a similar seismic shift as digital technology plays an increasingly dominant role in the way we both view and study the sites.

From the time of the early official excavations, there was a strong impulse to make the Bay of Naples sites into modern digs that would be free of the centuries of accumulated strata, intervention, and destruction that had so muddied locations such as Rome itself. Even the Bourbon excavations of the mid-eighteenth century—widely reviled then as now for their demolition of much of the sites' surviving urban fabric, particularly that of Herculaneum—relied on what was then the height of military engineering to remove the heavy sludge of Vesuvius.

The earliest excavators exploited developing mining technology to tunnel into the rocklike pyroclastic flow that had solidified around Herculaneum. Even given the unfortunate damage inflicted on the sites in the process, the fact remains that it was done in the most up-to-date manner by the Swiss military engineer Karl Jakob Weber (1712–1764).[1] Weber's expertise in modern surveying and his methodical approach to the sites differed markedly from the efforts of his predecessors, who in the heady first days of discovery treated the sites as treasure

mines for individual antiquities, with little if any attention paid to their surrounding context.

Early publications of the finds were, likewise, monuments to the most recent developments in illustrated printing.[2] The official Bourbon publication, *Delle antichità di Ercolano* (hereafter the *Antichità*), was executed over four decades, starting in 1752, under the direction of Ottavio Baiardi. The project was pursued with ostentatious secrecy—it was known by all to be in process and was eagerly anticipated, but the product was kept under tight wraps until each volume was completed. Even after publication the volumes were only accessible to an exclusive audience, as they were not for sale and only available as gifts from the Neapolitan king. The archaeological content of the volumes was sharply criticized, but the illustrations were nonetheless a marvel—large, high-quality plates with accompanying interpretations of the objects. This combination of text and image, so commonplace today, was unusual at the time and would have enhanced the impression that the scholarly presentation of the Bay of Naples sites was inherently modern (fig. 26).

Despite this innovation, the *Antichità* was doomed to descend into anachronism in the very course of its publication. Because it took so long—years if not decades—to produce a single volume, technology marched on, leaving the grand project to founder. Numerous unauthorized publications (both illustrated and unillustrated) appeared that spread information about the sites around the globe.[3] Francesco Piranesi's *Antiquités de la Grande Grèce, aujourd'hui royaume de Naples* (see pls. 62–64 and fig. 4), the first volume of which is dedicated largely to antiquities from Pompeii, appeared in 1804 and included grand, oversized prints. Almost two decades earlier Piranesi had published a topographical overview of Pompeii (see fig. 3), a development enabled by advanced cartography, that indicates the growing interest in the broader context of the site in addition to in the individual objects recovered from it.

As the nineteenth century progressed, however, a new technological development occurred that would radically change how the wider public learned about Pompeii and Herculaneum. The extraordinarily rich results of the fortuitous

Scala uniur palm Rom.
Et unus palm Neapolit.

Nic. Vanni Rom. Reg.l delin. Portic. P. Campana sculp.

FIG. 26. Pietro Campana (Italian, b. 1727) after a design by Nicolò Vanni (Italian, active ca. 1760). Plate 11 in *Delle antichità di Ercolano* vol. 2 (Naples, 1760), p. 71. Los Angeles, Getty Research Institute, Special Collections, 84-B21058.

ships and trains brought steady streams of visitors to the Bay of Naples, and enterprising photographers were there to greet them. Particularly after the emergence of the collodion, or wet-plate, process in 1850, photographers could create many prints from a single negative, greatly expanding their ability to meet the new demand. This enormously successful imagery gave the impression that now those who could not travel to the sites could see them as they really were, and provided tourists an authentic record of their visit.

While there were a number of successful photographic firms that produced Pompeian imagery in the nineteenth century, notably that of Michele Amodio, who is discussed below, the preeminent photographer of Pompeii was the German Giorgio Sommer (1834–1914), who emigrated to Italy in 1857 and established a studio in Naples.[5] Sommer's arrival coincided with the fundamental political shift known as the Risorgimento, which eventually resulted in the united state of modern Italy, a new political context that gave fresh meaning to his ancient subjects. His wide-ranging work covered current events and genre scenes, but archaeology was his main stock in trade, and the popularity of this imagery led him to focus on Pompeii. Sommer's photographs, which emphasize recording the ruins and selected finds from the excavations, were so broadly distributed that they have become the ubiquitous images that have shaped how we visualize the sites to this day. Indeed, given the ongoing erosion and decay that has taken place over the past 150 years, Sommer's photographs now stand as a more complete record of the sites as they once were, lending them an additional authority as archaeological documents (figs. 27–28, pls. 81–83).

These circumstances have largely distracted scholars from Sommer's distinctive and artful approach to his most popular subject.[6] His stark, geometric compositions convey a sanitized vision of the ruins, which appear manicured and well organized, thus feeding the impression that these images prioritize science over art. The *Courtyard of the Stabian Baths* (fig. 27), for example, provides a precious record of the fragile stucco and fresco exterior of the structure, but the image is also organized to create a geometric pattern of architecture and shadow. At times the photographs verge on abstraction; only the presence of a few small, contemporary figures bring them back to life (fig. 28). Drama is injected by the faint and distant but smoking presence of Vesuvius, which Sommer includes whenever possible to invoke the narrative of the disaster (upon occasions when the volcano did not cooperate, the smoke was painted in by hand). While Sommer certainly functioned as a chronicler of the sites, it seems disingenuous to ignore the insertion of his artistic viewpoint into this set of images. This modern impression is more the product of the perception of photography as a mechanical rather than creative process—and of the idea that this new technology had

coincidence between the development of modern archaeology and modern photography are so well known as to be taken for granted today.[4] This new way of making images through a machine rather than through a manual process promised to replace artifice with science. The result was a visual record that seemed uniquely suited to what was perceived as the increasingly objective approach to archaeology that was occurring, to some extent synergistically, at the same time. Photographers became an integral part of excavation teams as they provided images of sites before, during, and after digs took place, for the first time recording the process of discovery, which can be by its nature destructive.

Photography also became a major component in the souvenir trade. As more people of lesser means were able to travel to places that had previously been the purview of the wealthy and well-connected, photographers found a ready market for images that could be sold in sets tailored to the customer. Steam-

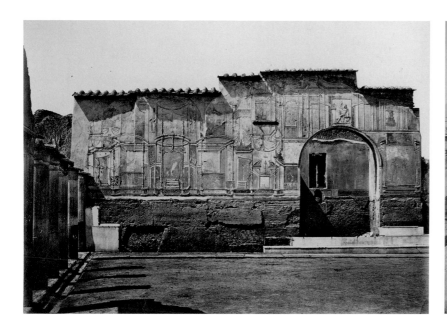
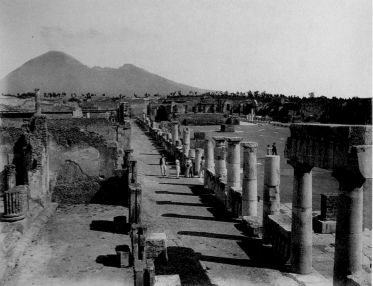

catapulted the documentation of the sites into the modern era.

Six years after Sommer established his studio, a new subject—also the product of a distinctively modern technology—entered the Pompeian lexicon and threatened to eclipse even the volcano in popularity. In the first half of the nineteenth century, as interest in the human victims of the eruption of Vesuvius grew apace with the mania for recovering ancient artifacts, the cavities left in the volcanic ash by decayed bodies received increased attention. Instead of simply plowing through these voids to get to more treasures, excavators began to attempt to preserve them by making casts of the impressions. Available technology, however, was not up to the task until the pioneering archaeologist and director of the excavations Giuseppe Fiorelli (1823–1896) developed a new method that had its first success in early February 1863, when the full body of an adult male victim was cast.[7]

Fiorelli's discovery caused an immediate media sensation. Through this new process, apparently unmitigated by the intervening imagination of a reconstructive artist, the victims of Pompeii became physically present again for the modern viewer. Like the photographs that captured fleeting views, the plaster casts made what should be temporal—a dead body—permanent through the intervention of new technology. The casts, like the photographs, are profoundly nineteenth-century objects that should be understood not simply as simulacra of the denizens of antiquity but as the creations of their own time. While the casts have an obvious and undeniable connection to the ancient bodies, they were produced for an audience that was preconditioned to accept a new cast as a plausible substitute for a classical original. Early episodes of collecting plaster casts of classical statues in the sixteenth century had blossomed into a fad in the eighteenth century, when the practice was rou-

tinely employed to assemble fictive collections of objects that were inaccessible to the collector for reasons of geography or expense. The Pompeii casts should be considered in this context—not as ersatz antiquities, or rather ersatz ancients, but as the companions of widely popular objects whose audience had already enthusiastically suspended the understanding of them as derivative reproductions and was ready to embrace them as authentic stand-ins for their originals.

Without this larger taste for plaster casts, it is debatable if the Pompeian body casts would have even been attempted, let alone emerged as the defining discoveries at the sites. Despite the unprecedented treasure of actual antiquities recovered around the Bay of Naples, no single element has contributed more to the myth of these sites as the re-birthplace of antiquity than these plaster casts. Since their first appearance they have been objects of fascination. Love them or hate them, few have been able to look away, let alone question their relationship to their ancient prototypes. As facsimiles they have taken on an aura of transparent mediation—like photographs, they function as supposedly neutral transmissions of the vanished ancient bodies of Pompeii.

While the casts are an extraordinary record of human (and animal) suffering, their relatively recent manufacture provides

a comfortable aesthetic barrier between the viewer and actual death. Existing, as all casts do, in that liminal space between art and artifact, these objects are especially baffling because of their problematic relationship with the fine arts. Other body casts, notably death masks, are cast directly from contact with the original form, which gives them their hyperrealistic quality. But these objects were cast from voids rather than solids. Their points of origin are ultimately ephemeral and elusive—and so despite the chorus of praise for their verisimilitude, we really have no way to gauge how accurate they are as reproductions.

Fiorelli left a vague record of the arduous process of trial and error that eventually culminated in his successful casts. This opacity was probably purposeful as his attempts may have involved the loss of any number of body cavities. Fiorelli faced formidable technical challenges. He only had one shot at each cast because the creation of his object would mean the de facto destruction of the original—or what we would consider the closest thing to the original—the impression in the *fango* (mud) created by its physical contact with the body. While the casts included some trace elements of the vanished cadavers in the form of bones, cloth, and jewelry picked up from the mud, these elements were largely invisible to viewers. In terms of their appearance, the casts were even further removed from the original bodies than the impressions that were destroyed in their creation would have been.

Breathless commentators from the 1860s to the present day have praised the casts as perfect facsimiles of the victims, but this is to some extent wishful thinking. The casts are for the most part fragmentary and white. Both of these qualities make them resemble antique statuary in its surviving state more than actual human beings—or more than unaltered ancient art for that matter.[8] As such, the casts are less artifacts of classical antiquity than they are art objects produced for their own time.

The combination of the plaster-cast technique and photography produced a powerful new type of Pompeian imagery.

Unlike the classical treasures that were well suited to the kind of elegant reproduction typical of projects such as the *Antichità,* the casts were less satisfactory subjects for drawings or prints.[9] They did, however, make for sensational photographs (see figs. 13, 14, 29, and 30). The staged images of these objects, multiplied and dispersed to a wide audience, again enhanced the impression of direct, visceral contact with antiquity. Contemporary accounts suggested that the photographs of the casts could collapse time itself and bring the ancient disaster almost into the present—at least to yesterday, if not today.[10]

Both Amodio and Sommer photographed Fiorelli's early casts shortly after they were unveiled to the public in 1863, and a comparison between their treatment of the subject is instructive.[11] The casts were stored in the so-called Casa dei Cadaveri di Gesso (House of the Plaster Bodies), but they had to be photographed outside in brighter light. The photographers, therefore, had some discretion in manipulating their setting and so their context for the viewer.

As was generally his practice, Sommer focused closely on his subject (fig. 29). The casts stretch across the horizontal image, supported by their metal display table. The ancients are not alone, however—just behind them stand two contemporary figures for whom the prone casts serve as ancestors. The living contemplate the dead with a calm resignation, as Sommer creates a perpetual juxtaposition between past and present, an encounter that was not, as Jon Seydl points out in this volume, often repeated. The stereograph is an early example of the fusion of drawings and photography that first occurred around 1850. Two images taken from a slightly different viewpoint (as if seen from two eyes) were inserted into a frame and viewed

FIG. 29. Giorgio Sommer (Italian, b. Germany, 1834–1914) and Edmondo Behles (German, active Italy 1841–1892). *Human Body Casts Found February 5, 1863,* ca. 1866–74. Stereograph, 7.2 × 13.9 cm (2¹³⁄₁₆ × 5½ in.). Los Angeles, J. Paul Getty Museum, 84.XD.1625.61.

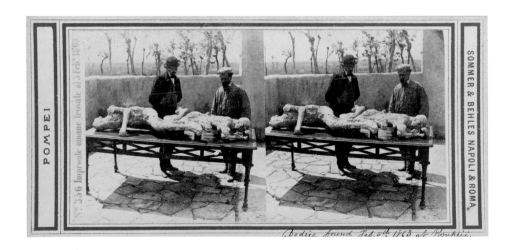

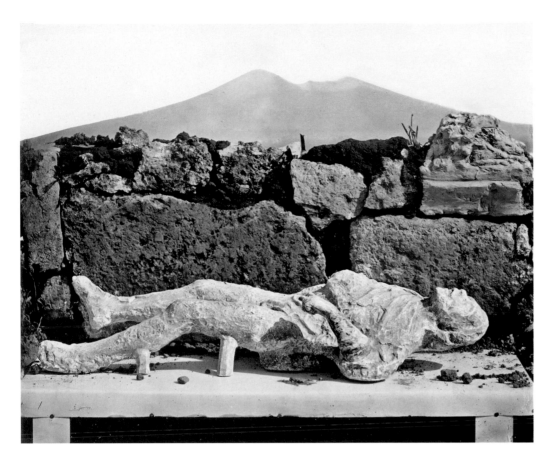

FIG. 30. Michele Amodio (Italian, active ca. 1850–ca. 1880), *Pompeii, Human Cast from the Excavations, 1863*, ca. 1873. Albumen silver print, 20.3 × 25.4 cm (8 × 10 in.). Los Angeles, Getty Research Institute, Special Collections, 91.R.2.

through a special lens to give the impression of seeing them in three dimensions. Stereoscopes were widely popular during this period and would have enhanced the impression that the viewer was gazing directly at the object in question.[12]

Amodio took a typically more scenographic approach to the subject, posing the body in an expansive landscape with Vesuvius centered over the supine cast (fig. 30). Far from a purely scientific attempt to record the appearance of the cast, the photographer has reunited the volcano and its victim in a perpetual re-enactment of the ancient disaster, to which all the viewers of the photograph play witness. The fact is, however, that not only two millennia but also two layers of new technology separate the modern viewer from the imagined moment of death in A.D. 79. Even while we enjoy the melancholy contrast between the living and the dead in Sommer's image, or shiver at the implied threat of Amodio's photograph, we do so at a safe remove, made all the more comfortable by the intervention of the modern technology that sets us apart from the vulnerable ancients who were at the mercy of Vesuvius.

The fusion of new technologies, represented by the Sommer and Amodio photographs of the plaster casts, transformed the way information about the sites was disseminated and understood. The photographers' work was widely reproduced and then imitated as new generations of casts emerged from the mud in the 1870s and beyond. In a new turn, photography itself was then transformed, notably with the introduction of color, which was dramatically exploited in reproductions of the Villa of the Mysteries frescoes after their recovery in 1909 (see fig. 50).[13] While some might lament the loss of the seemingly more pure black-and-white palette that corresponds to the contemporary classicizing ideal, the ability to produce color images mechanically added substantially to the impression of photography's realism. Previously, hand tinting had been used to elevate photographs to the realm of art; now color was evidence of the image's scientific veracity.

Today we face another paradigmatic shift in the depiction of antiquity, and once again we appear to be embracing it as purely documentary science with little or no second-guessing. Late-twentieth- and early-twenty-first-century Pompeian archaeology and reconstruction have become resolutely digital, moving the sites into the computer age and giving us the impression that we are finally able to "see" antiquity properly as

FIG. 31. Pompeii Quadriporticus Project, University of Massachusetts–Amherst.

no one has since A.D. 79. We can zoom over, under, and around the sites from multiple vantage points, peering through walls and around corners, and we can do this from any point on the globe with an Internet connection.[14] Virtual Pompeians in the form of holograms roam the reconstructed streets, providing animate versions of the plaster casts (see fig. 24).[15] While some of the archaeological constructs are static, the most popular are fully virtual, in that they attempt to transport the viewer into a complete, interactive sensory experience.[16]

This technology seems to resolve the now age-old problem with the sites, which are tantalizingly imagined as time tunnels but are instead frustratingly encountered as fragmentary, shifting ruins as Kenneth Lapatin discusses elsewhere in this volume. Through the process of digital reconstruction they become whole, providing an impression of coherence. Even better, this newly complete picture can be preserved, safe from the destructive ravages of time.[17] Damages ranging from additional eruptions or earthquakes to military activity to environmental erosion can be stopped and reversed in the virtual world, making it seem more authentic in some ways than the actual sites. Given our broader contemporary familiarity with digital reconstructions, we take their visual language for granted and accept them at face value as a transparent, scientific means by which we can now access antiquity.

The myriad digital reconstructions of Pompeii and Herculaneum multiply exponentially from year to year. The first-generation reconstructions from the mid-1990s, notably "Virtual Pompeii," developed by Carnegie Mellon University, now look simple and flat by today's standards.[18] From the scholarly Pompeii Quadriporticus Project (fig. 31) to the sensational reconstruction of the eruption that appeared in the video accompanying the 2010 exhibition *Pompeii the Exhibit: Life and Death in the Shadow of Vesuvius*, these developing reconstruc-

tions are instructive and engaging new ways to envision the lost world of antiquity.[19] Google Maps™ now allows virtual tourists to explore the site at will from anywhere on the globe.[20] But just as the nineteenth-century photographs and plaster casts deserve serious consideration as objects produced by and for their own time, we might productively attempt to assess how we are manipulating our cutting-edge technology to reconstruct the sites in our own image.[21] After all, these images do not generate themselves—they are the products of the human beings who manipulate the machines. Yet, unlike the images by Sommer and Amodio, they tend to be presented anonymously, making it difficult to discern the viewpoint and priorities of the creator and ever more tempting to see them as the product of dispassionate science.

In the digital age technology can be freely shared online so that it travels instantly around the globe to all interested parties, a dramatic reversal of the deliberately guarded and elitist approach of the *Antichità di Ercolano* 250 years ago. At the time of this writing, in fact, the volumes of the *Antichità* are in the process of being scanned and put on a free-access website, creating a research tool three steps removed from the original antiquities and a polar opposite of the initial edition in terms of accessibility.[22] Now the books themselves are precious in their own right and to be protectively stored as artifacts, while the digital version can be used by any interested party. With the increasingly precarious physical state of the ruins themselves, how long will it be until the most prudent course is to visit them in their virtual incarnation only? And how long, in turn, until those virtual reconstructions acquire their own patina and become increasingly understood as artful objects that reflect their own time as much as they do the antiquity that inspired them?

In the context of the present volume and exhibition, it may be useful to reflect that the methods that have seemed to bring Pompeii into the modern era most successfully—to create that

elusive conduit to antiquity the sites were supposed to represent—have been modern. Unimaginable to the ancients themselves and distinctively appealing to the societies that produced them, these technologies have indeed served to advance our archaeological knowledge of the sites. But by the same token they have also served to transform the excavations to suit our conceptions of what they should be.

Notes

Many thanks to Mary Beard, Eugene Dwyer, Shelley Hales, Kenneth Lapatin, Eckart Marchand, Joanna Paul, and Jon Seydl, all of whom contributed greatly to this essay.

1 For an overview of Weber's work at the Bay of Naples sites, see Parslow 1995.

2 The very earliest publication, which survives in only three copies, was discarded as not being sufficiently advanced. Delphine Burlot, "The *Disegni intagliati*: A Forgotten Book Illustrating the First Discoveries of Herculaneum," *Journal of the History of Collections*, 23 (2011): 15–28.

3 See Gordon 2007.

4 For an overview, see Lyons et al. 2005, esp. 22–28 and 49–59.

5 For background on Sommer see Weinberg 1981 and Desrochers 2003.

6 Lyons et al. 2005, 18.

7 Fiorelli's process appears to have been based in contemporary advances in forensic science. For the history of the casting, see Dwyer 2010, esp. 32–71.

8 It is noteworthy in this context that the 1984 resin cast of the Girl from Oplontis has not been repeated. Referred to as "somewhat gruesome" even in scholarly circles, this cast allows the viewer to see the bits of bone and jewelry contained within. See "Pompeii: Stories from an Eruption," http://archive.fieldmuseum.org/pompeii/popUps/resin_cast_of_young_girl.html (last accessed March 5, 2012). For the process, see Amedeo Cicchitti, *Il primo calco transparente: Diario di uno scavo* (L'Aquila, 1993).

9 Prints or drawings after the casts are surprisingly rare in the voluminous corpus of graphic material related to the excavations. The most widely disseminated graphic works were actually made after the Amodio and Sommer photographs rather than after the casts themselves (see, for example, Johannes Overbeck, *Pompeji* [1868], which is illustrated with prints after of Sommer's photographs). More recently, however, Estelle Lazer elected to do her own drawings after the casts, declaring it too difficult to get clear photographs of them because of the dirty cases in which they reside; see Lazer 2009.

10 As John Werge observed in 1868, "Appealing, as [photography] does, to the vanity and affections of the people, it is at once a recorder of the changes of fashion, a registrar of marriages, births, and deaths, and a truthful illustrator of the times in which we live; but that it should be brought to bear upon the past, and make the inhabitants of the world in the nineteenth century familiar with the forms, fashions, manners, life, and death of the people of the first century of the Christian Era, is something to be marveled at, and at first seems an impossibility. Yet such is the fact; and photography has been made the cheap and easy means of informing the present generation of the manner in which the ancients behaved, suffered, and died in the midst of one of the most appalling catastrophes that ever overtook the inhabitants of any part of the world, ancient or modern, as vividly and undeniably as if the calamity had occurred but yesterday . . . while looking at the pictures, it is very difficult to divest the mind of the idea that they are not the works of some ancient photographer who plied his lens and camera immediately after the eruption had ceased": John Werge, "Photography and the Immured Pompeiians," *The Evolution of Photography* (London, 1890), 304; quoted in Dwyer 2010, 97–98.

11 For discussion of these early photographs, see Dwyer 2010, 69–71.

12 While a descendent of the stereoscope survives as the Viewmaster, stereoscopes disappeared in the 1930s as motion pictures replaced them. For the early history of the stereoscope, see David Brewster, *The Stereoscope: Its History, Theory and Construction with Its Application to the Fine and Useful Arts, and to Education* (London, 1856).

13 Bergmann 2007, 244–49.

14 See, for example, Procedural, Inc.'s 3-D reconstruction of Pompeii generated through City Engine: http://www.youtube.com/watch?v=iDsSrMkW1uc&NR=1 (last accessed March 5, 2012).

15 The 2007 Virtual Pompeii Crowd Simulation attempts to reconstruct crowd behavior in the urban fabric of the city: http://www.youtube.com/watch?v=blpHk6SoriA&NR=1 (last accessed March 5, 2012).

16 For background on this phenomenon, see *Archaeology and the Information Age*, ed. Sebastian Rahtz and Paul Reilly (Routledge, 1992) and *New Techniques for Old Times: Computer Applications and Quantitative Methods in Archaeology*, ed. Juan A. Barcelo, Computer Applications and Quantitative Methods in Archaeology 98 (British Archaeological Reports, 2010).

17 At Herculaneum, for example, a new museum, the Museo Archeologico Virtuale (MAV), was created so visitors could view reconstructions rather than enter the actual site (see fig. 23). While at the time of this writing the future of the MAV is in some doubt, a record of it is available here: http://www.museomav.it/ (last accessed April 16, 2012).

18 For Virtual Pompeii, see http://artscool.cfa.cmu.edu/~hemef/pompeii/project.html (last accessed April 16, 2012).

19 For the Pompeii Quadriporticus Project, see http://www.umass.edu/classics/PQP.htm; the exhibition video is available at http://www.discoverytsx.com/pompeii (both sites last accessed March 5, 2012).

20 http://maps.google.com/maps?f=q&source=s_q&hl=en&geocode=&q=pompeii,+italy+ruins&sll=40.716428,14.537315&sspn=0.061672,0.132351&ie=UTF8&hq=pompeii,+italy+ruins&hnear=&ll=40.748902,14.484834&spn=0,359.991728&t=h&z=17&layer=c&cbll=40.748902,14.484834&panoid=1e-bu_kis-dL1BnVGZhDdw&cbp=12,209.48,,0,7.63 (last accessed March 5, 2012).

21 For example, in the project "McLuhan incontra Pompei: Scrivere al tempo dei social network; Dai graffiti pompeiani alla realtà aumentata" (October–December 2011), Pompeii has been proposed as the origin point of "digital culture," based on the perceived affinity between the ancient graffiti discovered at the site and contemporary social media. See "Pompei capitale della cultura digitale: Nei graffiti pompeiani le prime tracce dei social network, laboratori da ottobre a dicembre, c'è anche de Kerckhove," *Corriere del Mezzogiorno*, October 28, 2011.

22 http://digi.ub.uni-heidelberg.de/diglit/ercolano1757ga (last accessed March 5, 2012).

WILLIAM ST CLAIR AND ANNIKA BAUTZ

The Making of the Myths

EDWARD BULWER-LYTTON'S *THE LAST DAYS OF POMPEII* (1834)

E dward Bulwer-Lytton's immensely influential novel *The Last Days of Pompeii* begins with a scene of wealthy Romans sauntering through the streets of Pompeii, where they encounter Nydia, a blind slave girl selling flowers.[1] A casual meeting between her and the rich Greek Glaucus introduces the story line. Nydia, who soon loves Glaucus across the insuperable social divide, is purchased by him and presented as a gift to his betrothed, the beautiful and virtuous Greek heiress Ione, who is the ward of Arbaces, an Egyptian priest of the religion of Isis. A plot by Arbaces to gain her (and her money) is thwarted by Nydia, but when Ione's brother discovers this, Arbaces murders him and sets up Glaucus to take the blame. However, when Glaucus is made to fight a lion in the gladiatorial arena, the ferocious beast turns away, much to the disappointment of the baying crowds. Suddenly Vesuvius erupts, and the city is torn by earthquakes. Arbaces is killed by a falling statue of the emperor Augustus. In the darkness and confusion of the last day only the blind Nydia can find her way through the ash-filled, rubble-strewn streets, and she leads Glaucus and Ione to the port. On the voyage to Athens, however, Nydia throws herself into the sea, suicide being allowed by ancient ethics. Her heroic sacrifice earns her a marble shrine but also relieves the narrator of having to invent a later life. Her death makes way for the socially matched, newly converted Christian couple to live together happily ever after.

Bulwer-Lytton's descriptions of Pompeian life before the eruption emphasize the brutality, corruption, luxury, and immorality of the Roman elite. Slaves are treated casually and cruelly (topical allusions are made to early-nineteenth-century debates about the "property rights" of slave owners), while the effeminate and pampered lords go from banquet to banquet, and from one trivial entertainment to another.[2] The Roman men spend much time in unmanly washing—some bathing as often as seven times a day, and fall into an "enervated and speechless lassitude…dreading the fatigue of conversation."[3] The women are vain (fig. 32). Occasional passages hint at unspeakable orgies (fig. 33).

The novel skillfully employs linguistic and framing devices that allow the narrator to move the story, and its lessons,

through time. The characters speak in an invented archaic diction ("howbeit," "didst thou," "Nazarene") that disguises that they are English men and women of 1834, starting a tradition that still flourishes in sword-and-sandal film epics. Assertions of racial continuity ("a strong family likeness to their classic fore-fathers"[4]) enable the people of Pompeii to be explicitly presented as just like people known to readers. Occasionally the narrator points directly to the correlation, warning that the British had better look out. The London boxing ring is alluded to as a modern example of effeminacy as well as brutality, as dangerous to masculinity as the fashionable vapor baths: "male prostitutes who sell their strength as women their beauty; beasts in act, but baser than beasts in motive, for the last, at least do not mangle themselves for money."[5]

The novel capitalized on what was already familiar. Almost all initial readers, for example, would have recognized Arbaces as much the same character as the Arbaces of Byron's play *Sardanapalus* (1821), and some may have seen engravings of Eugène Delacroix's apocalyptic painting *The Death of Sardana-*

palus (1827) inspired by it. Many readers could be confidently expected to know the huge *The Destruction of Pompeii and Herculaneum* by John Martin (see pl. 22), which had been exhibited at the Royal Academy in London in 1822 and more widely circulated as a mezzotint. The *Last Days*, although a work of literature that at first did not include illustrations, both drew on and helped to disseminate the artistic conventions of the apocalyptic sublime.

The story includes a visit to a witch in a cave, picking up themes from a play, *The Witch of the Volcano*, which had recently enjoyed a long run in London, providing an occasion for tried old favorites, such as a switch of love potions.[6] Gladiators, too, were already established on the stage.[7] The *Last Days* also reinforced wider contemporary themes. When Glaucus and Ione are in Athens, they see how hollow Roman civilization is compared with that of the Greeks. Like Victorian travelers to Athens and visitors to the Elgin Room at the British Museum, they "behold the hand of Pheidias and the soul of Pericles."[8]

The *Last Days* was admiringly dedicated to Sir William Gell,

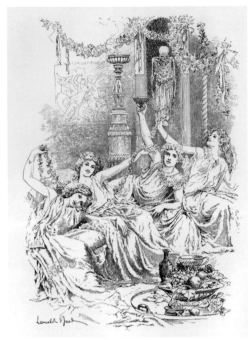

FIG. 32. Franck Kirchbach (German, 1859–1912), *Dressing Room of a Pompeian Beauty.* Illustration in *The Last Days of Pompeii* (London and New York: Routledge, ca. 1900).

FIG. 33. Lancelot Speed (British, 1860–1931), *The Banquet of Arbaces.* Illustration in *The Last Days of Pompeii* (London: Nisbet, ca. 1900).

the greatest contemporary expert on Pompeii, whose grand and lavishly illustrated *Pompeiana* was the source of much of the scholarly apparatus in Bulwer-Lytton's footnotes.[9] In the novel's final words, which reprise the preface, the narrator maintains that, since he wrote the work on the spot, he can claim archaeological accuracy.

The preface also acknowledged the author's debt to Walter Scott and to the immensely popular Waverley novels, and to the theory of historical romance practiced by both Scott and Bulwer-Lytton. Putting fictional characters into real historical situations, they argued, offered a more truthful view of the past than either fiction or history. Bulwer-Lytton also claimed to be filling a gap—the paucity of romances that had survived from the ancient world.

The *Last Days* put individuals into the ruins and thereby reanimated them. A modern visitor to Athens could imagine that he was walking where Pericles had walked. In Rome, too, the ruins were populated by memories of the famous dead. Before the *Last Days*, Pompeii had been mainly art and archaeology with only Pliny providing some human interest. Bulwer-Lytton drew on stock themes, volcanic and operatic spectacle, and apocalyptic paintings of anonymous crowds.[10] What was new was his presentation of an array of individual characters in a romance that unfolds in time, and it was his skill as a novelist

in the style of Scott that was to capture the public's attention and admiration.

The *Last Days* also met another need. Ruins were, according to ancient wisdom, standing reminders of the transitoriness of human pretensions. Ruins instantiated a philosophy of history that had been made famous across Europe by the manifesto of the French philosophic historian and travel writer Count Volney, *The Ruins*, first published in 1788: "I will dwell in solitude amidst the ruins of cities: I will inquire of the monuments of antiquity what was the wisdom of former ages."[11] Pompeii, however, did not molder under wispy briars or creeping ivy like other ancient ruins in the vicinity. On the contrary, it looked fresh. The standard travel guide before the *Last Days* spoke of visitors to Pompeii feeling like intruders, expecting to meet the master of the house in which they were trespassing.[12] The general impression was of silence, solitude, and repose.[13] Pompeii was, in Walter Scott's phrase, a "City of the Dead."[14]

In one large respect, however, for all its learned scholarly apparatus, the *Last Days* was unfair to the archaeological record. Although no unequivocal evidence that there were Christians in Pompeii had been found by 1834, nor indeed has been found subsequently, the *Last Days* has a strong Christian thread (fig. 34). Glaucus's father, readers are told, had played host to Paul when he gave his famous speech on the Areopagus in Athens, recorded by the author of the Acts of the Apostles. However, in a serious misremembering of what his father had told him about what Paul had said, Glaucus attributes his rescue to "the hand of the unknown God!"[15] In another read-across the *Last Days* cautioned against copying the early Christians.

Glaucus is tolerant: "I shudder not at the creed of others."[16] His "lukewarmness" he claims as a virtue. The Christianity of Glaucus is that of a nineteenth-century Anglican.

In the end, however, the *Last Days* is less about nineteenth-century English bourgeois Christianity than it is about providentialism, a more ancient, enduring, and resilient idea. The destruction of Pompeii, according to the *Last Days*, was the result of divine Providence. Pompeii was added to the list of cities, including Sodom, Gomorrah, Babylon, Tyre, and Nineveh that the Judaeo-Christian god had righteously punished. The Pompeians had it coming (fig. 35).

When Bulwer-Lytton drafted the *Last Days*, he was already a famous and financially successful author who understood the political economy of the cultural production of his day. The *Last Days* can help us to retrieve Victorian attitudes to Pompeii. However, without an understanding of the governing structures that enabled the novel to be brought into being in the material form that it was, we risk prolonging the romantic fallacy of the author as "creator," or of treating the printed literary text as an emanation of the zeitgeist.

For a new work of fiction to be published in the British market of 1834, the almost unshakeable convention required the book initially to be published in three volumes. The commercial circulating libraries that were the main initial customers could then have each of the volumes lent out to different subscribers in succession to be read serially over a number of weeks within families. The printed text of the *Last Days* is of a length that could have comfortably fit into one volume, and even that was the result of an artificial lengthening insisted upon by the publisher.[17]

It is also notable that Bulwer-Lytton's name did not appear anywhere in the book. The novel was presented as "By the Author of 'Pelham,' 'Eugene Aram,' 'England and the English' &c. &c. In Three Volumes." By this device, potential buyers and readers were alerted to what to expect. *Pelham*, the novel on which Bulwer-Lytton had made his name, was an exploration of the emerging construct: the "English gentleman" with a classical education. The *Last Days* presented itself as a book written by a real gentleman for real gentlemen and their ladies, guaranteed before it was even ordered to contain nothing to bring a blush to an Ionian cheek (fig. 36).

As Bulwer-Lytton and his publisher knew, the commercial success of any newly published novel depended upon orders from the circulating libraries. The more information that is excavated from the archives of Victorian authors and publishers,

FIG. 34. Frederick Coffey Yohn (American, 1875–1933), *Conversion and Blessing of Apaecides*. Illustration in *The Last Days of Pompeii* (New York: Scribner, 1926), opposite p. 176.

FIG. 35. Joseph Michael Gleeson (American, 1861–after 1902), *"Behold!" He Shouted with a Voice of Thunder.* Illustration in *The Last Days of Pompeii, Vignette edition with one hundred new illustrations by Joseph M. Gleeson* (New York: Frederick A. Stokes Company, 1891).

FRONTISPIECE. *See page 86.*

FIG. 36. Hablot Knight Browne (British, 1815–1882), *The Last Days of Pompeii.* Frontispiece in *The Last Days of Pompeii* (London: Chapman and Hall, 1850).

the more determinative the role of the buyers of the circulating libraries turns out to have been. If they decided not to take a risk on it for whatever reason, a novel had no future. And the libraries' judgment was much influenced by what they thought might be the reactions of a self-selecting group who used their social position or ecclesiastical office to patrol the textual limits of what was suitable for an English Ione. In practice complaints were few, but the whole production system of fiction writing, agents, authors, internal editors, publishers, designers, and others was aimed at forestalling potential objections from these "imagined interventionists."[18]

The *Last Days* was not free of risk. Many users of circulating libraries might have seen references in it to their own lives, and Bulwer-Lytton may have exaggerated and ironized the excesses of the ancient Romans in order to forestall that reaction. Indeed, a providentialist might be inclined to say that the last-minute

printing delays were part of a grand scheme to promote the book and its Christian message. On August 27, 1834, after a few years of rumblings, Vesuvius erupted again. This event was reported in the British press, giving the book the immediate topicality of which publishers dream.

The book went on the market in late September 1834. On October 13, Bulwer-Lytton's friend and fellow novelist Lady Blessington was able to tell him:

> it is in everybody's hands. Hookham [owner of the fashionable circulating library in London] told me that he "knows of no work that has been so much called for" (I quote his words) and the other circulating libraries give the same report. The classical scholars have pronounced their opinion that the book is too scholarly to be popular with the common herd of readers—but the common herd, determined not to deserve this opinion, declare themselves its passionate admirers, so that it is read and praised by all classes alike.[19]

The use of "common herd" by the doyenne of the "silver fork" school needs to be contextualized. The retail price of the *Last Days*, thirty-one shillings and six pence before binding, was equivalent to about three weeks of wages for a clerical worker, and compared with the size of the reading nation, the numbers of copies produced was tiny. During its first sixteen years the total number sold in Britain did not exceed six or seven thousand. The production history of the *Last Days* in Britain can be summarized in the chart on the opposite page, drawn from incomplete archives.

Although incomplete, the record matches the general pattern of Victorian fiction—namely a small, very expensive initial edition aimed at, and self-censored for, the richest one or two percent of society, followed by a move down the demand curve during the period of copyright as each tranche of the market is taken and readerships widen down the socioeconomic scale, to be followed by a flood of extremely cheap, sixpenny paper-covered editions (as well as a continuation of more expensive editions) the moment the text came out of copyright. These patterns can be directly related to the technical-economic governing structures, limitations, and opportunities of that age, including especially stereotype printing and intellectual property. In terms of literary history seen as a parade of authors and first publications, the *Last Days* is a work of 1834. In terms of reputation, readership, and influence, its glory days are the late-Victorian and pre-1914 generation.

Most reviews were highly favorable. However, a remark in the *Morning Post* that the *Last Days* had exaggerated the scale of some of the buildings appears to have stung Bulwer-Lytton personally, perhaps because it undermined his claim to be the successor to Scott, who was always scrupulous in his historical detail.[26] In an "Advertisement to the Second Edition," included

Production History of the *Last Days* in Britain

DATE	EDITION	PRICE (*in shillings*)	PRODUCTION (*in thousands*)
1834	3 vols.	31.5	1[a]
1839	1 vol.	5	5[b]
1850	Chapman and Hall, 1 vol.	3.5	not available
1853	—	Bulwer accepts £20,000 from Routledge for the right to publish nineteen of his novels for ten years in the Railway Library series at prices of 2 shillings and lower, an arrangement that was renewed.[c] Routledge reworked the plates, i.e., the manufacturing plant, over many decades.	
1853–83	—	2 or less	500[d] equivalent to annual sales of 25
1873–79	Different editions	Various prices	37
1879	First paperback	0.5	60[e]
1880	**Title goes out of copyright; many competing editions at different prices of which Routledge alone:**		
1885–97	—	3.5	9
1885–97	—	2	11
1885–97	—	0.5	46
ca. 1900	Penny Novels, abridged	0.05	200–300?[f]

a Our estimate is taken from the discussion by Gettman (see note 17) of the evidence of the Bentley Archives at the University of Illinois and compared with other archives, including other contracts made by Bulwer-Lytton that are in the British Library. Shortly after the book was first published in the United States, a story circulated that 10,000 copies had been sold in London on the first day of publication ("Fictitious Writing," *Atkinson's Casket* [April 1837], p. 186) and that story has entered the secondary literature; see Meilee D. Bridges, "Objects of Affection: Necromantic Pathos in Bulwer-Lytton's City of the Dead," in Hales and Paul 2011, pp. 90–104. However, the claim is not only disproved by the archival record but is at variance with what is known about fiction publication at the time.

b Bentley Records, British Library, add 46,674 (December 1838: first impression 4,042, October 1839; reprinted 1,000).

c Frank Arthur Mumby, *The House of Routledge 1834–1934* (London, 1936), including a transcript of the contract, p. 57.

d Routledge archives, microfilm reel 4, p. 381. We have not yet been able fully to understand the complex entry but Routledge estimated for fifty editions, or rather impressions, of 10,000 each. Only a few copies have survived.

e Routledge archives, microfilm reel 5, p. 711.

f Estimate taken from the discussion on Penny Poets and Penny Novels in Sir Frederick Whyte's *Life of W. T. Stead* (London, 1925), 2:228–31.

in the 1839 edition but never reprinted, Bulwer-Lytton claimed poetic license but also expressed an expectation that he would be vindicated by future excavations. For all his learned footnotes Bulwer had been convicted of being unfair both to his model Scott and to the archaeology. The *Last Days* mythologized a provincial town into a great city comparable with Rome itself.

The *Last Days* made its way into the guides to the best books intended for readers and librarians that flourished in late Victorian times, including Sir John Lubbock's famous and much reprinted *Hundred Best Books* (1896) where it joined the Bible, Homer, Aeschylus, Plato, Shakespeare, Goethe's *Faust*, the Koran, the Mahabharata, and other books of literature, history, exploration, and science in his attempt at a world canon. In Germany, too, the book was sold as one of the masterpieces of world literature.[21]

The progressivist literary paternalism that the *Last Days* embodied, and that enabled it to be regarded as one of the classics of world literature, was, however, defeated by modernism and the experience of World War I. Soon the *Last Days* was being presented as a book for young people. In the postwar years it became common to sneer at the book and the Victorian attitudes it represented, although many households had copies on the shelves which continued to be read. Bulwer-Lytton's reputation follows almost exactly the trajectory of the rise and fall of Scott and of the respect given to his works as moral teachers.[22]

Immediately on its publication in 1834, the *Last Days* changed the way many people looked at Pompeii. As Isaac Disraeli, who had recently been there, wrote to Bulwer-Lytton: "you have done more than all the erudite delvers have done."[23] Or as another friend wrote: "Will it not gratify you to know that people begin to ask for Ione's house, and that there are disputes about which was Julia's room in Diomed's villa? Pompeii was truly a city of the dead; there were no fancied spirits hovering o'er its remains, but now you have made poetical its very air, you have created a new feeling in its visitors."[24]

William Gell had been wary of the successful young novelist, but when his copy arrived in Naples he was delighted: "I own I consider the Tragic Poets house since I read the novel, as that of Glaucus & have peopled the other places with Bulwers inhabitants in my own mind."[25] The archaeologist had not quite surrendered science to myth, but he had made an accommodation with a sorcerer casting magic spells. And the names stuck.[26]

The absence of international copyright in 1834 meant that publishers outside Britain could legally reprint, translate, or adapt as they chose. It was from one of these "piracies" that John Auldjo quickly arranged a translation into Italian, from which an even cheaper version, sold in parts, was produced in Naples. By 1836 the *Last Days* was being read in Italian in Pompeii (fig. 37).[27]

The colonizing myths and fictions soon established themselves as permanent settlers on the site. Throughout the nine-

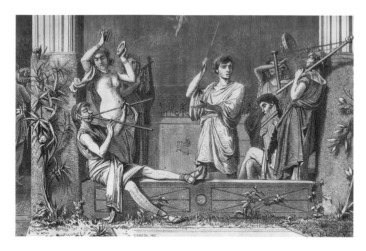

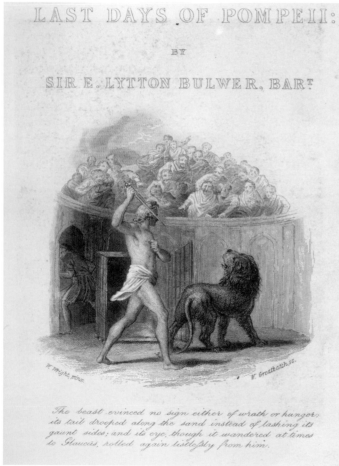

teenth century and later, local guides, showing visitors round the remains of the amphitheater, told elaborate stories of the lions that refused to fight the "Nazarenes" and of Pompeii being destroyed as God's punishment for its wickedness. Since pre–*Last Days* travelers make no reference to these stories, it seems certain the myths were imported from the novel, then locally naturalized, and then re-exported.

As far as the United States was concerned, American publishers in 1834 were also free of legal copyright restrictions.[28] However, Harper Brothers of New York bought an advance set of proofs and thus was able to print the book almost as soon as it was published in London.[29] By exploiting the recently perfected technology of stereotype plates, the firm was able to keep a title in print as long as there was demand at the reduced marginal cost and therefore price.

The adoption of stereotyping enabled publishers across the English-speaking world to share manufacturing plants. And soon they were doing so for illustrations as well as texts. The *Last Days* was one of the first novels to benefit from this transformation of publishing into a globalized business, with some American editions being identical with the English apart from their title pages.[30] The huge success of the *Last Days* was due not just to the novel's innate appeal but also to a precise conjuncture of technical-economic factors.

By the turn of the nineteenth century art historians and archaeologists were becoming impatient at the extent to which the myths of the *Last Days* were overwhelming the site. For example, the authors of *Pompeii, Painted by Alberto Pisa, Described by W. M. Pisa* (1910), in their discussion of the archaeological remains of the kitchens in the House of Pansa, remark despondently: "One wonders whence Bulwer-Lytton conjured up the gorgeous feasts that strew the pages of *The Last Days of Pompeii*."[31]

The "they had it coming" theme, which rode on an archaeology that was almost as mythical, continued to exercise its power, as was made explicit by an American bishop who visited with his family in 1895:

> this ruined city which was overwhelmed by the wrath
> of God in a single night: its polluted streets and houses,
> which even now indicate depths of depravity that
> have seldom been witnessed in the history of the world,
> ruined and utterly destroyed as habitations for the
> living. Surely the moralist will be excused for drawing
> his lesson from the destruction of this comparatively
> modern Sodom and Gomorrah.[32]

This tradition, as it stood around 1900, slipped easily into the new technologies of radio, film, television, and other media, where it has continued to thrive, renewed every few years for a new generation. And the conventions and clichés that Hollywood has adopted from the *Last Days* are those that were for-

malized in 1834. Movies about Pompeii still include the archaic speech, the brutality, the beasts, the banquets, the baths, the lace-up sandals, the burlesques (fig. 38), the insertion of imaginary Christians, the misrepresentation of the scale of the city, and the portentous attempts to awe young people and adults into Anglo-American middle-class conformity.

For the modern visitor to Pompeii, Nydia no longer sells her flowers, Arbaces no longer spins his dark oriental spells, nor does Ione smile sweetly. But for the tens of millions elsewhere who are dependent on contemporary popular cultural production, only the names have changed. Even today it is necessary for any factual presentation of discoveries at Pompeii to begin by disowning the myths of the movies.[33] In the continuing competition between scientific archaeology and moralizing myths, *The Last Days of Pompeii* has not been defeated.[34]

Notes

We should like to record our thanks to the following libraries, galleries, and particular individuals for their help: British Library, Victoria and Albert Museum, East London Theatre Archive, University College London, London Library, Library of the Institute of Classical Studies London, Warburg Institute, and a private collection. We would also like to thank Mary Beard, Matthew Furber, Peter Hinds, Kenneth Lapatin, and other colleagues at the J. Paul Getty Museum.

1 Among recent studies the cultural background of Bulwer-Lytton's *Last Days* and on the afterlife of the novel are Simon Goldhill, *Victorian Culture and Classical Antiquity: Art, Opera, Fiction, and the Proclamation of Modernity* (Princeton, N.J., 2011), Daly 2011, Hales and Paul 2011, Stähli 2011, and Beard in Mattusch 2012.

2 The Slavery Abolition Act of 1833 had voted financial compensation to British slave owners for the loss of their "property."

3 *The Last Days of Pompeii*, I, 7 (since there is no standard edition of the novel, references here are to books and chapters).

4 Ibid., preface to the 1850 edition.

5 Ibid., II, 3.

6 Such a scene is depicted on playbills dated December 26, 1831, and January 2, 1832, for the Pavilion Theatre in London. Victoria and Albert Museum, Theatre Collection.

7 See, for example, a playbill for *The Siege of Troy or the Giant Horse of Sinon*, 1833. Victoria and Albert Museum, Theatre Collection.

8 *The Last Days of Pompeii*, Chapter the Last. On Bulwer's representation of Greek vs. Roman culture, see Goldhill (note 1).

9 The first edition of Gell's *Pompeiana* was published in London in 1817. Revised editions appeared in 1821, 1824, 1827, 1832, 1835, 1837, 1852, 1853, and 1875.

10 On the many sources Bulwer-Lytton could have drawn on for his story, see Daly 2011. For an analysis of Karl Bryullov's painting *The Last Day of Pompeii* (pl. 26), which was especially inspirational for Bulwer-Lytton, see Stähli 2011.

11 Quoted on the title page from a passage in chapter 4.

12 Rev. John Chedwode Eustace, *A Classical Tour through Italy An. MDCCCII*, 4th edn. (Livorno, 1817).

13 Ibid., chap. 3, p. 69. The English poet Samuel Rogers also reported his sense of being an intruder; see *Italy, a Poem* (London, 1835), 195.

14 Walter Scott had famously called Pompeii "the City of the Dead" when he visited shortly before his death in 1832. See Gell's account of Scott's visit in Lockhart 1838, 7:345–57.

15 *The Last Days of Pompeii*, Chapter the Last.

16 Ibid., Chapter the Last.

17 Royal Gettman, *A Victorian Publisher* (Cambridge, 1960), 235.

18 For the imagined interventionists, see William St Clair, "Following up *The Reading Nation*," vol. 6, *Cambridge History of the Book in Britain 1830–1914*, ed. David McKitterick (Cambridge, 2009), 704–34.

19 Earl of Lytton, *The Life of Edward Bulwer, first Lord Lytton* (London, 1913), 1:443.

20 *Morning Post* [London], November 13, 1834.

21 See also A. A. Acland, *A Guide to the Choice of Books for Students and General Readers* (London, 1891) and E. R. Sargant and Wishaw Bernhard, *A Guide Book to Books* (London, 1891).

22 Annika Bautz, *The Reception of Jane Austen and Walter Scott* (London, 2007).

23 Letter of November 14, 1834, quoted in *Life of Edward Bulwer* (note 19), 1:443.

24 *Life of Edward Bulwer* (note 19), 1:445.

25 E. Clay, ed., *Sir William Gell in Italy* (London, 1976), 154.

26 The "disburied house of the Athenian Glaucus" is illustrated opposite p. 19 in the 1891 edition of the *Last Days*, published by Stokes and Grosset. H. V. Morton, *A Traveller in Southern Italy* (Methuen, 1969), 292, notes that the local Italian guidebook referred to the *Last Days*.

27 *Life of Edward Bulwer* (note 19), 1:445.

28 The *Last Days* was translated into numerous languages in the nineteenth century; see Laurentino García y García, *Nova Bibliotheca Pompeiana: 250 anni di bibliografia archeologica* (Rome, 1999).

29 Catherine Seville, "Edward Bulwer-Lytton Dreams of Copyright," in *Victorian Literature and Finance*, ed. F. O'Gorman (Oxford, 2007), 63. Although no receipt has been found for the *Last Days*, a document in the Bentley Records notes the receipt of £50 for [proof] sheets for America, for *Paul Clifford* [another successful Bulwer-Lytton title], no date, early 1830s (British Library, microfilm of Bentley Records 1829–1898, first reel).

30 The Routledge archives has examples of editions manufactured in England to be sold in the United States.

31 *Pompeii, Painted by Alberto Pisa, Described by W. M. Pisa* (London, 1910), 47. Others seem to have had no problem with the novel's influence; see N. Scotti, *Three Hours in Pompeii: A Real and Practical Guidebook Compiled in Harmony with the Description Given by Bulwer Lytton in His Work Entitled The Last Days of Pompeii* (Naples, 1907). Available at http://www.archive.org/streamthreehoursinpompooscotiala/threehoursinpompooscotiala_djvu.txt (last accessed March 8, 2012).

32 Rev. Francis E. D. D. Clark and Harriet E. Clark, *Our Journey around the World* (Hartford, Conn., 1895), 572.

33 See, for example, *Life and Death in a Roman Town*, presenter Mary Beard, director and writer Paul Elston, BBC, 2010.

34 A longer version of this article, which discusses the interplay of the novel with visual representations and performances, is published in *Victorian Literature and Culture* 40.2 (Autumn 2012).

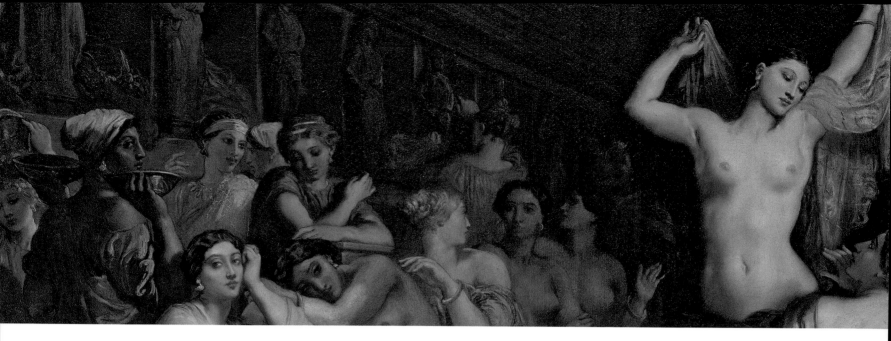

MARY BEARD

Dirty Little Secrets

CHANGING DISPLAYS OF POMPEIAN "EROTICA"

n 1838 "A Traveller"—a respectable Englishman concerned to preserve his anonymity—published his *Notes on Naples*. More than three hundred pages long, this book was in part a memoir of a recent journey to Italy ("a portion…of a continental journal kept to divert the languor of sickness, and the lassitude of idleness"); in part a guidebook for the benefit of future tourists, including descriptions of archaeological sites and museums; as well as a handy appendix on the "Idiosyncrasies of Neapolitans" (listing most of the northern European clichés about the south, from "sloth" to "sensibility").[1]

Unsurprisingly, he devoted a whole chapter to Pompeii, which—he insisted—rather exceeded his expectations. True, before his visit, his interest in the place had been fading ("Alack, our interest palls now toward the old Campanian city" for "stale to us now are…the domestic privacies of Greece and Rome, and the art, and science, and manners of old days"). But as soon as he trod those ancient Roman streets, he experienced the excitement of discovery, almost as if he were the very first person to have uncovered it. "Walk Pompeii," he enthused, "and on you

comes the spirit of the spot as though it were your excavating spade first struck in disentombing its first shaft, as though to you its tale were now first told, and myriads had not trodden its dust before you."[2]

A later chapter is devoted to what is now the National Archaeological Museum in Naples but was then called Il Museo Borbonico (after the Bourbon kings of South Italy). There were some highlights here for our "Traveller": he loved the bronze statue of the dancing faun from the House of the Faun at Pompeii (which he rated almost "the most wonderful statue in the world") (pl. 77.1) and stood in awe of the busts of the famous Greek worthies from the Villa dei Papiri at Herculaneum (copies of which today stand in the atrium and gardens of the Getty Villa in Malibu, Calif.). But there were some uncomfortable curiosities too. He was particularly puzzled by the fact that all the nude statues of Venus had been put together in a single room, picked as "plums out of the pudding and huddled…away out of sight into a dark room by themselves" (fig. 39). Seeing them as a group was a very different experience from seeing the

figures individually, partly because they were all in much the same pose, "the same timorous head and frightened fingers" covering their private parts. As the visitor entered, he felt as if he had interrupted the rehearsal for the performance of some carefully synchronized mimes. And, of course, the visitor was always a "he." Women were strictly excluded from the room, "only allowed to see inside … through the furtive medium of the keyhole." The incongruous result of this arrangement, the "Traveller" observed, was that "those of the gentler gender" were freely allowed to look at "nudities masculine" (for there had been no attempt to segregate the naked male statues); they were prevented only from viewing "nudities feminine," a form with which they were, of course, perfectly well acquainted. Perhaps, as I suspect, the real point was to stop them observing *men* in the act of observing "nudities feminine." But if so, that point was lost on the "Traveller."[3]

Ever since the rediscovery of antiquity in the Renaissance, sex has been one of the most controversial areas of our engagement with the classical world. From pederasty to phallic display,

the different sexual norms of the ancient Greeks and Romans have been vehemently abominated, treated with disdain, secretly admired, or heroically blazoned in various campaigns for sexual liberation. Nowhere have the problems been clearer than at Pompeii and Herculaneum, where from the earliest excavations some of the most startling finds included ingenious or lurid images of copulation and nudes aplenty, not to mention the ubiquitous Roman phallus. What was the modern world to make of a culture in which Pan penetrating a goat (fig. 40) was thought a suitable subject for high-class sculpture and in which male genitalia could proudly hang over a bread oven or decorate an ordinary household lamp? Was this a sign of the prudishness of the modern world or of the depravity of the ancient? And what were the implications for the display and study of this material? How should these "immoral" and potentially dangerous images be policed? Who should, or should not, be allowed to look at them, in what context, and for what purpose? Some of the complexities of those questions (and, more to the point, of their answers) are clearly visible in our "Traveller's" account

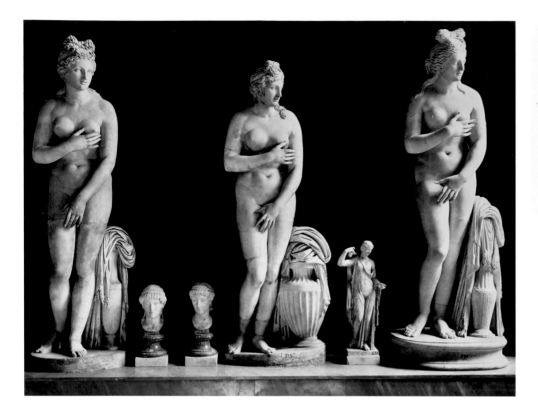

FIG. 39. Giacomo Brogi Photographic Studio, *Venus Room, National Museum, Naples,* ca. 1878–86. Gelatin silver print, 21 × 27 cm (8¼ × 10⅝ in.). Naples, Museo Archeologico Nazionale.

FIG. 40. A. Delvaux, *Pan and Goat.* Illustration in César Famin, *Musée royal de Naples: Peintures, bronzes et statues érotiques du cabinet secret; avec leur explication* (Paris, 1857), pl. 1. Los Angeles, Getty Research Institute, 86-B5371.

of the Venus Room in the museum—pointing as it does to the unintended consequences of isolating the nudes, the potentially divergent reactions of the viewers, and the inconsistencies in the principles applied (why, for example, female nudes only and not male?).

The most notorious attempt to police the "obscenity" of Pompeii and Herculaneum was what is usually called the Secret Cabinet (the Italian title varied, from Gabinetto Segreto to Gabinetto degli Oggetti Osceni, Gabinetto Riservato, or Raccolta Pornografica).[4] The arrangement was based on broadly the same principles as the Venus Room: namely, to remove from public view the images deemed inappropriate for unrestricted access, while devising rules for who, if anyone, might be allowed to see them. The history of this cabinet is normally told as a story that correlates those changing rules of access with the growth (or rejection) of cultural liberalism and political openness more generally. In broad terms, so this narrative goes, the trajectory over the last two centuries has been toward greater openness, so that now the Secret Cabinet in the museum is open to all, with

only a mild warning outside about its contents. But admittedly there have been a few ups and downs: repressive regimes generally excluded all-comers; Fascism kept people out, whereas liberal democracy has let people in.

The standard account of the Secret Cabinet runs something like this:[5] it was established in 1819 in the Museo Borbonico, where the archaeological collections from the old Royal Museum at Portici had gradually been transferred. Behind the scheme was the museum director Michele Arditi—though a few years later (in the final footnote of a little tract in which he argued that the phallic symbolism of the ancient world was not a sign of erotic excess, but a weapon against the evil eye) he went out of his way to credit the future King Francis I with the idea. Francis had enjoyed a royal visit to the museum with his wife and daughter, and as he was leaving, he observed that it would be a good idea to "shut away all the obscene objects, of whatever material they were made, in a single room, and only to allow entry to adults of good reputation."[6] We cannot be certain who first thought of it, and it was anyway hardly an original idea, for there had already been various forms of restricted access to erotica in the old museum at Portici. (In his 1762 *Letter and Report on the Discoveries at Herculaneum*, J.J. Winckelmann discusses the infamous statue of Pan copulating with a goat and explains that when he visited Portici a special license was required to see it—which he did not apply for.[7]) But the upshot was that just over a hundred objects—paintings, sculptures,

MUSEO NAZIONALE.

PRIMO PIANO.

MUSEO NAZIONALE.

PIANTERRENO.

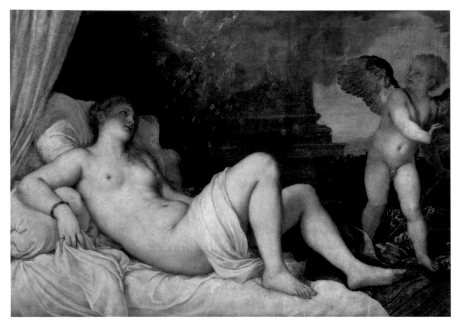

of gold (fig. 45), as well as Luca Cambiaso's *Venus and Adonis* (then thought to be a work of Veronese). Objects seem to have moved between these different collections and were controlled under different regimes of restriction. When Spinelli shut away the archaeological obscenities of the first floor in the 1850s, for example, he very soon put Titian's *Danae* and the *Venus and Adonis* under lock and key too.[12] It is probably not very helpful to think in terms of *the* Secret Cabinet as a single room, with clearly defined contents (as the modern display in Naples tries to imply), but rather as a series of different locations in the museum, under a series of different and changing restrictive regimes. In fact, the Secret Cabinet was almost as much a state of mind as any particular physical location.[13]

The chronology, too, is more complicated than it seems. That is partly because the formal rules governing access to the restricted collections were forever being adjusted in line with the changing views of the museum management and in response to external pressure of all kinds, whether from Bourbon kings or the national government. My summary highlights only the major changes, in what must have been a constantly shifting set of protocols and conflicting policies. At the very moment, for example, that Maiuri was attempting to restrict access more heavily, the relevant government minister in Rome was writing to ask him whether the very existence of a Secret Cabinet "was compatible with the dignity of a great scholarly institution" (should not the stuff either be on public display or in store?).[14] But more to the point, it is very hard to know how strictly the rules were applied or how easily they could be evaded (whether by influence, persuasive talk, or hard cash). It is even harder, in other words, to reconstruct the history of *visiting* these collections than to reconstruct the history of the rule book that claimed to regulate it.

Take, for example, what we know of the 1820s, when for the first time official permits were required in order to see the "reserved objects" in the Naples museum (fig. 46). There was, in the first few years, an enormous and rapid increase in the number of requests for access; in 1822 there were just twenty, by 1824 they had reached three hundred. So far as we know, no request was ever refused. This fact alone hints that the rules had merely a declarative force or that, thanks in part to the inconvenience of the application process, they were self-policing (only those who were confident of being admitted applied) and did not play any directly practical part in exclusion. The recommendation, in the internal memo of 1954, that "particularly insistent" foreign-

FIG. 45. Titian (Italian, ca. 1488–1576), *Danae*, 1545. Oil on canvas, 120 × 127 cm (47¼ × 50 in.). Naples, Museo Nazionale di Capodimonte, S 83971.

FIG. 46. Permit to visit the Secret Cabinet issued to the composer Gaetano Donizetti, October 21, 1824. Naples, Archivio di Stato (after De Caro, 2000, 15).

FIG. 47. A. Delvaux, *Venus on the Shell*. Illustration in César Famin, *Musée royal de Naples* (see fig. 40), pl. 34.

FIG. 48. A.C. after N.V. *Ancient Bronzes from Herculaneum in the Royal Collection at Portici*. Illustration in Jean Claude Richard de Saint Non, *Voyage pittoresque, ou, Description des royaumes de Naples et de Sicile* vol. 1, pt. 2 (Paris, 1781–86), opposite p. 52. Los Angeles, Getty Research Institute, 88-B19555.

ers should be allowed in, may perhaps also reflect the standard practice for much of the nineteenth century. We certainly do not hear of a flood of angry exchanges between the museum officials (or those of the government ministry who at some periods handled requests) and people whose applications were refused on the grounds that they were not sufficiently scholarly or respectable. But how do we explain the increase in numbers in those early years? Was this because of greater numbers of tourists? Was it because of a greater interest among visitors for seeing the pornography? Or was it rather that the bureaucratic system was starting to work more efficiently—and determined would-be visitors thought they had little option but to apply to the authorities for a permit? Though the changing rules do tell their own story, it would be dangerous to infer from them how many people actually saw any of this material. The fact that there was at one point a trade in fake permits sold to tourists by the museum guards shows that there were other means of access apart from the official channels.[15]

But there are other intersecting chronologies as well. It is true that the headline concern of the series of rules and restrictions was *who* exactly should be allowed to look at what lay behind locked doors. Often this rested simply on the age, gender, and religion of the individual. Children were universally excluded and, for much of the museum's history, women and clerics too. At some periods, the particular reason a visitor had

for viewing the material was also paraded as a key qualification: scholars and artists were admissible, those who merely wanted to glimpse the dirty pictures were not. But another issue was exactly *what* material was thought to be corrupting or dangerous or otherwise unsuitable—and this too changed over the nineteenth and twentieth centuries. Particular objects were sometimes "reserved," sometimes placed on public display. The fresco of the naked Venus lying, pinup style, on a shell (see fig. 42, also fig. 47) also seems to have been one of the objects released to a general audience after Garibaldi's visit to the museum in 1860 (at least it is not among the more than two hundred objects listed in Fiorelli's catalogue of the pornographic collection in 1866).[16] Sometimes whole categories of objects became candidates for reassessment. In 1848, for example, a question was raised about some of the "ithyphallic" material (fig. 48); for if (as Arditi had argued) they were a form of primitive protection against the evil eye, rather than erotic in intention, then these works hardly belonged in a Secret Cabinet. All the same, just a

few years later, they, too, seem to have been among the obscenities locked up even more firmly by Spinelli.[17]

Visitors to the museum discussed the various regimes of restriction with considerable verve. Most nineteenth-century guidebooks and travel memoirs treated the Venus Room as faintly ludicrous (as our "Traveller" did), and they came very close to recognizing some of the curious consequences of this kind of segregation: to group all such statues together, off limits to women, children, and priests, was to increase rather than decrease their erotic charge. For the most part, however, they approved of the restricted access to the erotic paintings and exuberant phallic images from Pompeii. As *Notes on Naples* put it in 1838, "There is, however, another reserved room, at the seal of secrecy put on which none can murmur." Not even the idea that some objects were great art could rescue them. "In the atrocious subjects in the *Camera Oscena* not all the labour of the most accomplished art, and such is lavished upon these, should redeem them from their darkness."[18] Likewise the 1853 edition of Murray's *Handbook to Southern Italy*, while warning readers of the need to get a recommendation from the ambassador in order to make a visit, heartily approved that the obscenity was locked away: "access is, very properly, extremely difficult.... Very few, therefore, have seen the collection; and those who have are said to have no desire to repeat their visit."[19] Only occasionally, until well into the twentieth century, was any voice raised to object to the policing of what was generally seen as pornography. The author of the 1858 guide, who referred to the "false delicacy" that had made admission at that point well-nigh impossible, was far from typical.[20] If anything, we have more records of visitors who wanted a stricter, rather than a looser, regime.

There are probably various reasons why there were few complaints. In part we are dealing with general nineteenth-century ideas of propriety. In part, as I have noted, it seems likely that—except for one or two brief interludes, notably in the 1850s—those men who particularly wanted to see the material were able to do so and were not therefore driven to complain. (What the women felt at their exclusion we can only guess.) But, perhaps even more importantly, you did not actually need to go to Naples to get a sight of many of the most famous "reserved objects"; from the 1830s on, images were widely available from your armchair almost anywhere in Europe or America, thanks to a number of illustrated catalogues of the Secret Cabinet (not to mention several copies of key pieces, such as a small terracotta version of Pan and the Goat from the Townley Collection in the British Museum, traditionally attributed to the sculptor Joseph Nollekens).[21] Two of the best known, Louis Barré's *Musée Secret* and Colonel Famin's *Cabinet Secret*, both published an almost identical set of some sixty images of erotica from Pompeii and Herculaneum (by the artist Henri Roux), though ordered rather differently in each case: Famin starts off with Pan and the Goat (see fig. 40), Barré with a slightly more decorous painting of a "Faun" kissing a naked "Bacchant."[22] In their learned introductions, each author provided readers with plenty of academic alibis for enjoying what was to follow (Barré, for example, suggested to his readers that this material raised philosophical issues about the nature of progress). And each image was accompanied by a self-consciously sober, critical commentary; Famin's short essay on Pan and the Goat started by finding fault with the artistic rendering of the goat and finished by quoting some relevant, but highly respectable ancient texts, including a passage from a little-known, late first/early second-century essay by Plutarch on "Reason in Animals."

Many more people discovered the material in this printed form than ever visited the Naples museum, and these books played an enormous part in standardizing the image of the Secret Cabinet. While the objects moved around the museum in Naples itself, put on or taken off public display, these selections in books stayed the same, from edition to edition, through the nineteenth century—creating yet more chronological paradoxes. Even when the painting of Venus on her shell was freely accessible in the museum, for the armchair reader she was still part of the (textual) Secret Cabinet. The truth is that, in many respects and for most of its history, the Secret Cabinet was as much a book as a shifting collection of obscene, or not-so-obscene, objects.

But there is an intriguing sting in the tail. Almost all recent work on the Secret Cabinet stresses how different that regime of viewing was from the way these works of art were seen in the ancient world. Indeed in the nineteenth century, too, many students of Pompeii puzzled how to make sense of the fact that phalluses were found everywhere from street corner to bread oven. But this did not stop them from projecting their own cultural viewpoint onto the Romans and "discovering" secret cabinets in the ruins of Pompeii itself. One of the most notable of these was the so-called *venereum* in the House of Sallust, apparently isolated from the rest of the house, and decorated with erotic wall paintings. This was vividly brought to life in 1819, in a fictional account, by the great Pompeian scholar François Mazois, of a visit to Rome of a young Gallic prince at the time of Julius Caesar. The background and context for this fictional visit are provided by the houses of Pompeii which Mazois knew so well—including the House of Sallust. Here, in the *venereum*, he replicates closely the idea of the Secret Cabinet, as it was then being established in the Naples museum. The young prince is suitably shocked by the erotic images which confront him, but he and the reader are assured that the ladies of the house are not allowed in to see them.[23]

If the Secret Cabinet in the nineteenth century was in part a state of mind, it was a state of mind that was retrojected onto

the ancient world. This, of course, should make us think about our own engagement with the sexual images of Pompeii. We are partly seeing the preoccupations of the ancient world, but maybe we are seeing our own too.

Notes

1 ["A Traveller"], *Notes on Naples and Its Environs* (London, 1838); quotation from p. v.

2 Ibid., chapter 10, pp. 141–60; quotations pp. 141–42.

3 Ibid., chapter 12, pp. 172–93; quotations, pp. 174, 189–90. Milanese 2009 offers an evocative collection of images of the nineteenth-century museum (including fig. 39 in this volume).

4 This was not just a Neapolitan phenomenon; for the history of the Secret Cabinet in the British Museum, see Catherine Johns, *Sex or Symbol: Erotic Images of Greece and Rome* (London, 1982), 15–31.

5 The best detailed histories of the Secret Cabinet are the "Introduzione," De Caro 2000, 9–23 (this volume usefully reprints original documents and museum memoranda); and Laurentino García y García, "La raccolta pornografica del Gabinetto Segreto nel Museo Borbonico di Napoli," in *Louis Barré, Museo Segreto*, by Laurentino García y García and Luciana Jacobelli (Pompeii, 2001), 17–26. There is a useful critique of the "myth of the secret cabinet" in Kate Fisher and Rebecca Langlands, "The Censorship Myth and the Secret Museum," in Hales and Paul 2011, 301–15. They rightly criticize most earlier scholars (myself included) for simplifying and over-sexualizing the issues of display of Pompeian antiquities—even at the risk of turning a blind eye to the erotic dimensions of the debates. By and large, however, their account is a breath of fresh air, and we have reached broadly similar conclusions by different routes.

6 Michele Arditi, *Il Fascino e l'Amuleto contro del Fascino presso gli antichi* (Naples, 1825), 45–46. Fisher and Langlands 2011 (note 5), 307, are right to point to the anecdotal nature of this story of royal intervention.

7 Mattusch 2005, 155–56; and J. J. Winckelmann, *Letter and Report on the Discoveries at Herculaneum*, introduction, translation, and commentary by Carol C. Mattusch (Los Angeles, 2011), 87.

8 [John Murray], *Handbook for Travellers in Southern Italy* (London, 1853), 189.

9 De Caro 2000, 16–18.

10 [John Murray], *Handbook for Travellers in Southern Italy* (London, 1862), 150; and [John Murray], *Handbook for Travellers in Southern Italy* (London, 1865), 163.

11 De Caro 2000, 22.

12 Ibid., 16; and García y García 2001 (note 5), 20–21.

13 A room known as the Secret Cabinet is often marked on visitors' plans of the museum (commonly as a tiny place at the top of the stairs on the upper floor, as in fig. 44), but this is sometimes incompatible with written documents and descriptions. The modern Secret Cabinet is not in this position. The Venus Room, too, is variously identified—see, for example, fig. 43.

14 De Caro 2000, 20.

15 Ibid., 14.

16 Giuseppe Fiorelli, *Catalogo del Museo Nazionale di Napoli: Raccolta pornografica* (Naples, 1866).

17 De Caro 2000, 16.

18 [A Traveller] 1838 (note 1), 191–92.

19 [Murray] 1853 (note 8), 189.

20 [John Murray], *Handbook for Travellers in Southern Italy* (London, 1858), 137.

21 British Museum, inv. M. 550; a piece of paper stuck to the base reads: "COPY FROM MEMORY OF YE MARBLE GROUPE IN PORTICI MUSEUM."

22 Louis Barré, *Herculanum e Pompéi*, vol. 8, *Musée Secret* (Paris, 1840) (much reprinted; see the facsimile and essays in García y García and Jacobelli [note 5]); and "Colonel Famin," *Musée royal de Naples: Peintures, bronzes et statues érotiques du cabinet secret* (Paris, 1836) (much reprinted).

23 [François Mazois], *Le palais de Scaurus* (Paris, 1819) (first published anonymously, then under the name Mazois in 1822); discussed by Eric M. Moormann, "Fictitious Manuscripts from Herculaneum, Pompeii, and Antiquity," *Cronache Ercolanesi* 40 (2010): 239–49, esp. 247.

VICTORIA C. GARDNER COATES

Pompeii on the Couch

THE MODERN FANTASY OF "GRADIVA"

From the time of the first excavations of Herculaneum and then Pompeii, fascination with the horrific demise of the inhabitants of the sites percolated just below the more academic enthusiasm for the recovered antiquities. Judging from Pliny the Younger's widely read accounts of the disaster, many people had perished, and their fates were the subject of much curiosity. This interest only increased in the early nineteenth century, when changes in archaeological practice revealed impressions in the volcanic mud where the bodies once lay, providing a jumping-off point for reviving their long-lost human prototypes (although it would take some decades to develop the casting process by which those impressions were recorded).

Imagining who these ancient Pompeians might have been and weaving elaborate fantasies around them became increasingly popular. While some of these creations were male, notably the so-called Sentinel of Pompeii,[1] most were female—imaginary women of the past conjured up to satisfy contemporary desires. As William St Clair and Annika Bautz have pointed out elsewhere in this volume, the most popular example is the slave girl Nydia from Edward Bulwer-Lytton's 1834 novel *The Last Days of Pompeii*. Nydia personified an idealized Victorian type of the virtuous slave. Her character's combination of unrequited love and heroic sacrifice made her a person of intense interest in the nineteenth century (pl. 69), but she was no more Pompeian than Queen Victoria herself. Bulwer-Lytton's protestations of archaeological accuracy notwithstanding, there is no evidence that such an individual ever walked the streets of Pompeii. Despite her popularity and enduring association with the site, Nydia is in the final analysis the creature of another time and place radically removed from the Bay of Naples in A.D. 79.

Nydia was not alone. In 1852, Théophile Gautier published his short novel *Arria Marcella: A Souvenir of Pompeii*, the protagonist of which was the beautiful specter of a lost Pompeian.[2] Attracted by the exquisite impression of a female breast that had survived in the hardened ash of Vesuvius, the hero, Octavian, recalls the original woman back to life. Arria Marcella and Octavian find themselves passionately in love, until the tolling of a church bell dispels the pagan spirit and brings Octavian back to

the present. Unlike the virtuous Nydia, Arria Marcella is a Victorian antiheroine, lustful and pagan as she rejects her father's conversion to Christianity. As such, she held her own fascination for a nineteenth-century audience. Given Gautier's familiarity with the artifacts of Pompeii and his detailed description of the ancient city, subsequent admirers of the novel have searched not for Arria Marcella herself, but for her impression, which Octavian viewed in the Naples museum. Amedeo Maiuri, who was superintendent of excavations at Pompeii from 1924 to 1961 and knew as much about the surviving relics from the sites as anyone at the time, records his sad, fruitless search through the museum's storage rooms for the elusive Arria Marcella. Finally, even Maiuri had to abandon his quest, provocatively reflecting on how the ancient Pompeians seem to pass in and out of contemporary fashion.[3]

Gautier's dark, tangled fantasy of desire and deathless love among the ruins strongly influenced the next fantasy female to appear on the Pompeian stage. In 1903 Wilhelm Jensen published his novella, *Gradiva: A Pompeian Fancy*, the tale of the young German archaeologist Dr. Norbert Hanold who develops a fixation on a plaster cast of an ancient relief of a walking woman, which he had purchased in Rome.[4] From the outset, clues to Gradiva's modernity are apparent—for starters, Norbert does not fixate on the classical original, but rather on his modern copy, which is a very different object. Jensen also described Gradiva as an immediate presence that is antithetical to the classical ideal familiar to Norbert's contemporaries:

> In no way did she remind one of the numerous extant
> bas reliefs of a Venus, a Diana or other Olympian
> goddess and equally little of a Psyche or nymph. In her
> was embodied something humanly commonplace—not
> in a bad sense—to a degree a sense of present time,
> as if the artist, instead of making a pencil sketch of her
> on a sheet of paper as is done in our day, had fixed
> her in a clay model quickly from life as she passed on
> the street…So the young woman was fascinating,
> not at all because of plastic beauty of form, but because
> she possessed something rare in antique sculpture,

a realistic, simple, maidenly grace which gave the impression of imparting life to the relief.[5]

Convinced that Gradiva is not the creature of a crowded, busy metropolis like Rome, Norbert imagines her in Pompeii, and eventually he feels compelled to pursue her there. Gradiva duly appears to him each day at noon, and he believes himself to be coexisting between the past and present before becoming aware that Gradiva does not belong to the classical past but rather to his own past. She turns out to be his childhood sweetheart Zoë Bertgang, onto whom he has imposed his fantasy (just as Gradiva signifies "she who advances" in Latin, Zoë translates as "she lives" in Greek, and Bertgang as "walking forward" in German). His discovery allows this flesh and blood heroine to be satisfactorily reunited with her hero in a happy ending. Zoë, then, represents the purity of first love that is duly consummated in marriage, once again embodying a contemporary ideal.

Like *The Last Days* and *Arria Marcella*, *Gradiva* might have come down to us as an entertaining togate period piece, but Jensen's work found a more famous admirer, who made the novella the subject of an intense study. On the recommendation of Carl Jung, Sigmund Freud took up the work and applied his developing practice of psychoanalysis to it, probing the text for the secrets of Norbert's mind. Freud published *Delusions and Dreams in Jensen's Gradiva* in 1907,[6] transforming Jensen's novella into a psychoanalytic case study and confirming Pompeii's modern status as a place where not only could the past be accessed, but the self could be explored in Freudian terms.

Gradiva must have seemed almost custom-made for Freud, and in a way it was. Jensen's novella emerged from the same antiquarian, Teutonic zeitgeist that produced Freud himself, and it incorporated some of Freud's favored themes, such as the role of archaeology as an allegory for the exploration of the self. Even better, the story was set in Pompeii, and Freud considered Pompeii, with its history of violent burial and subsequent excavation, the quintessential example of this allegory.[7] He made this point explicitly in *Delusions and Dreams*, writing of Norbert's positioning of Gradiva in that city:

> Finally, his phantasy transported her to Pompeii, not "because her quiet calm nature seemed to demand it," but because no other or better analogy could be found in his science for his remarkable state, in which he became aware of his memories of his childhood friendship through obscure channels of information. Once he had made his own childhood coincide with the classical past (which it was so easy for him to do), there was a perfect similarity between the burial of Pompeii—the disappearance of the past combined with its preservation—and the repression, of what he possessed a knowledge through what might be described as "endopsychic" perception.[8]

In Freud's text, the figure of Gradiva emerges as muse and mentor in the journey of self-discovery and healing through

FIG. 49. Sigmund Freud's study in Vienna with cast of Gradiva on the wall at right, 1938. London, The Freud Museum.

psychoanalysis as she embodies the explorative promise of her name, "she who advances." Freud felt so well acquainted with her that, after a surprise encounter with the original relief in the Vatican (pl. 14.1), he wrote in a letter home "Just imagine my joy when, after being alone so long, I saw today in the Vatican a dear familiar face!"[9] He, like Norbert, subsequently obtained a full-scale plaster-cast replica of one of the figures in the relief, a profile image of a woman walking gracefully, her fluttering robes suggesting that she is actually in motion. Isolated from her original companions and artfully framed, this Gradiva is a monumental heroine who is the sole object of the work. Freud then installed the relief in his study in Vienna, where it could be an inspiration to the patients on his famous couch, and took it with him to London when he moved there at the end of his life (pl. 14 and fig. 49). For Freud, again like Jensen and Norbert, it seemed not to matter that the relief had no discernible link to Pompeii. Indeed, he knew perfectly well that it had not been found anywhere near the Bay of Naples, as he noted in the second edition of *Delusions and Dreams*.[10] But for Freud's purposes, it was Gradiva herself rather than a Pompeian provenance that was important, because his Gradiva had nothing to do with ancient Pompeii—she was a modern fantasy that furthered the pursuit of psychoanalysis.

An accident of archaeology reinforced the new role of Pompeii as a locus for self-exploration when, in 1909, the Villa of the Mysteries was unearthed on the outskirts of the Roman town. The structure contained some of the most striking examples of ancient fresco painting found at the Bay of Naples sites, and unlike the iconic images from the Bourbon excavations, these were left whole and in their original context instead of being carved up and removed. The content was also different from the more straightforward mythological scenes of previous finds; these frescoes defied a precise identification in classical literature, which made them all the more suited to imaginative modern interpretations. The ritualistic content of room 5 appeared to be an ancient prototype for the imagery of the violent, dreamlike world of the subconscious defined by Freud, as subsequent psychoanalytical analysis attests (fig. 50).[11] The frescoes seemed startlingly modern in content—a sort of telepathic time tunnel between the psyches of the past and of the present day.[12] Amedeo Maiuri's definitive publication of the Villa of the Mysteries, which first appeared in 1931, was accompanied by dazzling Kodachrome color plates that over a series of editions broadly disseminated the discovery to an eager audience.[13]

Freud's essay on *Gradiva* also gained additional momentum in 1931, when it was published in French translation and became accessible to the Surrealist group of artists then active in Paris.[14] The figure of Gradiva was transformed once again, this time into the muse for an artistic movement. Surrealists such as André Breton, Salvador Dalí, André Masson, and Marcel

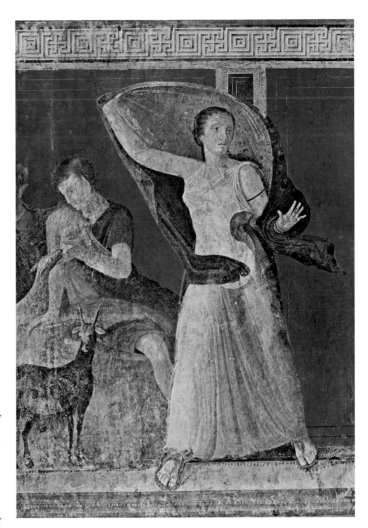

FIG. 50. The so-called Frightened Woman from the Villa of the Mysteries, east wall of room 5, plate 6 in Amadeo Maiuri, *La Villa dei Misteri* (Rome, 1931)

Duchamp were drawn to the figure of Gradiva, who became, in different ways, an inspiration to all of them. As the ideal woman who exists in a liminal state between fantasy and reality, and whose love brings the psychic healing they so desperately pursued, she seemed tailor-made for their purposes.[15] As Jensen's title indicated, she was a fantasy—a concept Freud's analysis reinforced—and so for the Surrealists, who championed the primacy of fantasy over reality, Gradiva was a cult figure.

The connection between this Gradiva and actual antiquity became ever more tenuous as she became identified with the living models that inspired the Surrealists. Unlike other figures from classical mythology adopted by modern artists in an effort to find a continuity of human experience from the ancient past to the present day, Gradiva has no actual ancient roots, which lends her a unique aura of modernity unburdened by antiquity. This disconnect was embraced by the Surrealists, who celebrated Gradiva's modernity. As the leader of the movement, André

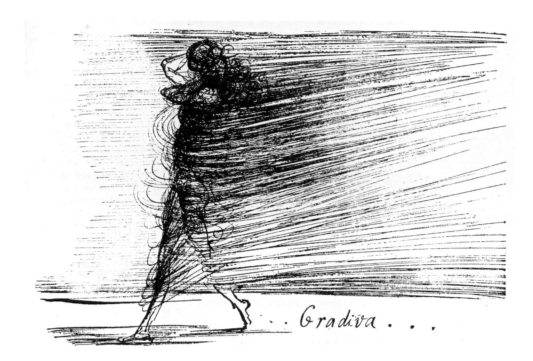

FIG. 51. Salvador Dalí, *Gradiva*. Illustration in Salvador Dalí, *The Secret Life of Salvador Dalí* (London, 1949), p. 239. Los Angeles, Getty Research Institute, 90-B1658.

Breton, wrote:

> Gradiva? This title, drawn from Jensen's wonderful book, means primarily, SHE WHO MOVES FORWARD. Who could "she" be, other than tomorrow's beauty, as yet hidden from the multitude, and only glimpsed here and there, as one draws near some object, goes past a painting, turns the pages of a book? She adorns herself with all the lights of the *never seen* that force most men to lower their eyes. Yet she haunts their dwellings, gliding at dusk through the corridor of poetic premonitions.[16]

"Tomorrow's beauty" was hardly a dead creature of the past but rather has become the vibrant, ideal woman of the future who, as Breton went on to explain, exists "[o]n the bridge between fantasy and reality, 'hitching up her dress with a small gesture of her left hand'…On the borders of utopia and truth, which is to say right at the heart of life."[17]

Over the course of the 1930s, two artists who had very different relationships with the Surrealist movement also took up the Gradiva theme. When Salvador Dalí moved to Paris in 1929, he was already interested in Freud's writings.[18] After reading *Delusions and Dreams* Dalí became fixated on the character of Gradiva, whom he fused with the fascinating (and formidable) Gala Éluard, whom he had recently met.[19] Gala took on many guises in Dalí's œuvre, but in the early 1930s Gradiva was one of the more powerful. Dalí's Gradiva was quickly assumed into the intense and personal fantasy life that was Dalí's chosen milieu. Until the advent of Gala-Gradiva, it was a painful world that threatened to consume the artist with madness, but Gala brought healing and inspiration as well as love—and so filled a role similar to the Gradiva of Jensen's novel.[20]

Dalí executed a number of works related to the Gradiva theme beginning in 1931, including a now-lost painting on copper and a number of drawings (fig. 51). In the drawings, Gradiva's nature as the kinetic woman who is defined by motion is conveyed by the artist's swirling, agitated line and the torsion of the figure. The variety of imagery indicates how deeply Gradiva had penetrated into Dalí's psyche: she is shown contemplating a skull (her own?) in a memento mori guise and as a companion to another of the artist's totem figures, William Tell.[21] Beyond the occasional raised foot and implied motion of the figure, little connects her to the literary Gradiva save for the hallucinatory, dreamlike state shared by Jensen's hero and the artist.

Dalí's most monumental depiction of Gradiva is the 1932 *Gradiva Discovers the Anthropological Ruins (A Retrospective Fantasy)* (pl. 15). Unlike the drawings, in this painting Gradiva is robed in drapery that could function as either classical garb or a shroud. She clings to a figure who is shaped like a man but is in a decrepit state—hence the "anthropological ruins" of the title. This figure is Dalí with the trademark ink pot on his shoulder, who is, as he is missing face, heart, and genitals, in sore need of Gradiva's healing embrace. Gradiva is, in fact, the animate figure in this image who can bring the ruined man back to life.[22] The results of their encounter, however, are left ambiguous and the background details do not provide conclu-

sive evidence of how this love affair will end—with the happy fulfillment that awaited Norbert and Zoë, or the sterile emptiness that Dalí feared?

André Masson's 1939 *Gradiva* radically reinterprets the Gradiva theme in the context of the French painter's personal experience (pl. 16). While Dalí enjoyed close ties with the Surrealists, especially with Marcel Duchamp, Masson had a more troubled relationship with the movement, which he eventually left altogether, declaring himself more of a "sympathizer" than an actual participant.[23] Masson had experienced a dramatic physical trauma in 1917 that shaped his postwar activities; he participated in World War I as a volunteer and was eventually shot through the chest. Left exposed to the elements overnight, the artist experienced his own mini-Passion including a celestial vision, only to be rescued and resurrected the next day. The experience was cathartic, but Masson sustained lifelong deep physical and psychological wounds that left him even more in need of Gradiva's grace than Dalí.

The artist explored the liminal space between life and death, and between art and reality, in a series of paintings (including the 1938 *Pygmalion* as well as *Gradiva*), in which the promise of beauty and sexual love carries within it the threat of violent death.[24] While intensely personal, Masson's interpretation of Gradiva hews closer both to the classical tradition and to Jensen's text than does Dalí's more idiosyncratic vision. Masson selected a seminal and identifiable moment early in the novel, when the fevered Norbert imagines Gradiva's death in the eruption of Vesuvius. Norbert visualizes his beloved walking through the quaking streets of the city oblivious to her impending doom; she ascends to the portico of the temple of Apollo, sits down on the top step, and calmly lays her head on the marble:

> Now the pebbles were falling in such masses that they condensed into a completely opaque curtain; hastening quickly after her, however, he found his way to the place where she had disappeared from view, and there she lay, protected by the projecting roof, stretched out on the broad step as for sleep but no longer breathing, stifled by the sulphur fumes. From Vesuvius the red glow flared over her countenance, which, with closed eyes, was exactly like that of a beautiful statue. No fear or distortion was apparent, but a strange equanimity, calmly submitting to the inevitable was manifest in her features. Yet they quickly became more indistinct as wind drove to the place the rain of ashes, spread over them first like a gray gauze veil, extinguished the last glimpse of her face, and soon, like a Northern winter, snowfall buried whole figure under a smooth cover.[25]

In addition to referencing the text, Masson selected a widely recognizable classical model for his figure, the so-called *Sleeping Ariadne* type (pl. 16.1 and fig. 26). He may have studied this work in Nicolas Poussin's wax copy, which entered the Louvre in 1855, if not in one of many other copies or engravings.[26] But whatever he consulted was at least one copy removed from the original, so Masson was basing his image of an imaginary ancient woman on an ersatz antique.

The *Sleeping Ariadne* was a loaded choice for a model. While she has been variously identified as Cleopatra, Ariadne abandoned by Theseus, or Ariadne being discovered by Bacchus, the fact remains that the figure is asleep, and presumably, dreaming. As such, she seems to anticipate the modern, Freudian obsession with the significance and interpretation of dreams. By quoting her, Masson invoked the dreamlike state of both Norbert and Gradiva. The artist also seems to have been inspired by the brilliant color and twisting figures of the Villa of the Mysteries frescoes, which he knew well from Maiuri's publication if not from the originals.[27] His colors are perhaps closer to the saturated, brilliant tones of the color plates than they are to the more muted, aged original frescoes.

Masson's painting does depart from Norbert's description of Gradiva's demeanor; rather than the submissive, docile maiden who like Nydia accepts her fate, this far more aggressive female seems to writhe, genitals exposed, as her mummification takes place. In perhaps an echo of Masson's wartime near-death experience, death brings Gradiva solitary sexual fulfillment. For Masson, then, Gradiva emerges as alter ego as well as muse.

Around the time Masson was working on his *Gradiva*, André Breton opened a gallery on the Left Bank with the same name. The enterprise was actually dedicated to a pantheon of women who in various ways inspired the Surrealists, but Breton gave Gradiva pride of place, apparently because he thought hers the most commercially viable name—a choice that speaks to the power of Gradiva during this period as she not only inspired art, she might also sell it (this hope proved elusive as the gallery only survived for a matter of months). Marcel Duchamp designed the entryway for the space, creating an iconic glass image of an embracing couple that the artist would revisit and reinvent for the rest of his life (fig. 52).[28] The pair are shown in silhouette, suggesting that they are ghosts or fantasies like the original Gradiva—products of the imagination onto which viewers could project their own imaginings. The couple may reflect Dalí's *Gradiva* composition, which Duchamp certainly would have known, and demonstrates that Duchamp was an active participant in the twentieth-century reinvention of Pompeii—an experience that may well have shaped the artist's approach to the model of a breast he crafted, which inspired the cover of the *Surrealisme en 1947* exhibition catalogue discussed elsewhere in this volume (pl. 17).

Gradiva's appeal did not die with the Surrealist movement. She resurfaced in the late twentieth century in Roland Barthes's *A Lover's Discourse: Fragments*, in which Gradiva received her

own chapter.[29] Jacques Derrida also revived the theme in *Archive Fever: A Freudian Impression*, which was partially written while the author was living near the Bay of Naples. Derrida returned to Freud's analysis of Jensen's *Gradiva* to turn the tables and analyze Freud himself. Derrida proposed that Gradiva's spirit haunted Freud as much as she did Norbert Hanold, and that in the end the quest for her is as elusive as the quest for Pompeii, which must remain in its ruinous state.[30] In 1999, the French artists Anne and Patrick Poirier created an installation piece at the Getty Center in Los Angeles that, following Derrida's lead, documented their quest for the elusive Gradiva through the labyrinth of the Getty Research Institute's collections.[31] Gradiva also inspired the 2005 film *Gradiva (C'est Gradiva qui vous appelle)* directed by Alain Robbe-Grillet. In this telling, the hero once again pursues his female object of obsession through an eroticized waking dream, but now the location is modern Morocco, the context is orientalist, not classicizing, and the sex is sadomasochism, not the healing love of Zoë Bertgang—yet another transformation that cements Gradiva's role as the product of the modern psyche, not of ancient Pompeii.[32]

FIG. 52. The Gradiva gallery in 1937, with the entrance door designed by Marcel Duchamp, 1937.

Notes

Many thanks to Sophie Leighton and the staff of the Freud Museum, as well as to Kenneth Lapatin and Jon Seydl.

1 For the fictional construct of the Sentinel of Pompeii, see Behlman 2007.
2 Gautier 1901.
3 Amedeo Maiuri, *Pompei ed Ercolano: Fra case e abitanti* (Giunti, 1998), 42.
4 Wilhelm Jensen, *Gradiva: Ein pompejanisches Phantasiestück* (A Pompeian Fancy) (Dresden and Leipzig, 1903). On the title page of the first edition is a plaster cast of "Gradiva," excerpted from a fragmentary three-figure relief in the Vatican Museums in Rome (see pl. 14.1).
5 Jensen 1913, 3–4.
6 Sigmund Freud, *Delusions and Dreams in Jensen's Gradiva*, in *Standard Edition of the Complete Psychological Works of Sigmund Freud* (1953–74), 9:3–95.
7 The trope had appeared, for example, in Freud, *Notes Upon a Case of Obsessional Neurosis*, in *Standard Edition*, 10:176: "I then made some short observations upon *the psychological differences between the conscious and the unconscious*, and upon the fact that everything conscious was subject to a process of wearing away, while what was unconscious was relatively unchangeable; and I illustrated my remarks by pointing to the antiques standing about it my room. They were, in fact, I said, only objects found in a tomb, and their burial had been

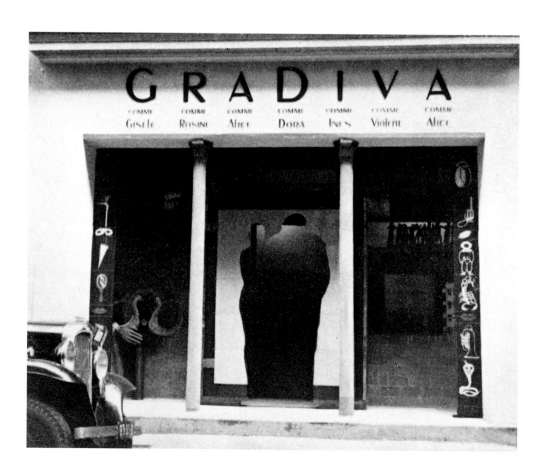

their preservation: the destruction of Pompeii was only beginning now that it had been dug up" [emphasis in original]. See also Richard H. Armstrong, *A Compulsion for Antiquity: Freud and the Ancient World* (Ithaca and London, 2005), 194–97; and Daniel Orrels, "Rocks, Ghosts and Footprints: Freudian Archaeology," in Hales and Paul 2011, 185–98.

8 Freud, *Delusions and Dreams,* in *Standard Edition* (note 6), 9:51.

9 *Letters of Sigmund Freud,* selected and edited by Ernst L. Freud (New York, 1975), 133.

10 "The relief of the girl who steps along in this way, which Jensen describes as being Roman, and to which he gives the name of 'Gradiva,' is in fact derived from the zenith of Greek art. It is in the Museo Chiaramonti in the Vatican (No. 644), and has been restored and interpreted by Hauser [1903]": Freud, *Delusions and Dreams, Postscript to the 2nd Edition* (1912), in *Standard Edition* (note 6), 9:95.

11 See, for example, Bice Benvenuto, *Concerning the Rites of Psychoanalysis, or The Villa of the Mysteries* (Cambridge, 1994).

12 For a thorough discussion of how the Villa of the Mysteries frescoes were interpreted as modern psychodramas, see Bergmann 2007, esp. 251–53.

13 Amedeo Maiuri, *La villa dei misteri* (Rome, 1931).

14 Sigmund Freud, *Délire et rêves dans un ouvrage littéraire: La "Gradiva" de Jensen,* trans. J. Bellemin-Noel (Paris, 1931).

15 See Brown 2001, 104–6; and Chadwick 1970, 415.

16 André Breton, *Free Rein,* trans. Michel Parmentier and Jacqueline d'Amboise (Lincoln, Neb., 1995), 19.

17 Ibid., 22.

18 Dalí eventually met Freud in London in 1938, an encounter dramatized in Terry Johnson's 1993 play, *Hysteria: Or Fragments of an Analysis of an Obsessional Neurosis.*

19 Gala (Elena Dimitrovnie Diakanova) was at the time married to Paul Éluard and was the mistress of Max Ernst. See Brown 2001, 40–53 and 164–78.

20 Dawn Ades, ed., *Dalí's Optical Illusions* (New Haven, Conn., and London, 2000), 80. Dalí's association of Gala with Gradiva is explicit; for example he dedicated his 1942 autobiography, *The Secret Life of Salvador Dalí,* "A Gala-Gradiva, celle qui avance" (To Gala-Gradiva, she who advances). He went on to write of her:

> Thus was realized once more that myth, the leit-motif of my thinking, of my esthetic, and of my life: death and resurrection! The wax manikin with the sugar nose, then, is an 'object-being' of delirium, invented by the passion of one of those women who, like the heroine of the tale, like Gradiva, or like Gala, are able, by virtue of the skilful simulacrum of their love, to illuminate moral darkness with the sharp lucidity of 'living madmen.'...And it is these very limits, which were peculiar to me, which are defined with a materialized symbolism in the form of a veritable 'surrealist object' in the tale I have just told—where the wax manikin ends, where the sugar nose begins, where Gradiva ends, and where Zoë Bertrand begins in Jensen's *Delirium and Dream*" (Dalí 1993, 239–40).

Consciously or not, Dalí conflates Jensen's text and Freud's analysis of it into a single work.

21 Ades and Taylor 2004, 178–80.

22 William Jeffrett has interpreted the pair as a dual image of Gala-Gradiva in her destroyed ancient and animated contemporary states, which may to some extent be true, but the scale of the ruined figure and the presence of the ink pot suggest it is to some extent masculine and associated with Dalí himself. See Jeffrett and Guigon 2002.

23 Martin Reis, "André Masson: Surrealism and His Discontents," *Art Journal* 61, no. 4 (2002): 76.

24 Ibid., 77–79. Both paintings deal with the creative act: *Pygmalion* as the statue is brought to life, and *Gradiva* as the living woman is transformed into a statue.

25 Jensen 1913, 12–13.

26 Chadwick 1970, 422. See also Francis Haskell and Nicolas Penny, *Taste and the Antique: The Lure of Classical Sculpture 1500–1900* (New Haven, Conn., and London, 1981), 184–87.

27 Bergmann 2007, 253.

28 Antje von Graevenitz, "Duchamp's Tür 'Gradiva': Eine literarische Figur und ihr Surrealistenkreis," *Avant Garde* 2 (1989): 63–96.

29 Roland Barthes, *A Lover's Discourse: Fragments,* trans. Richard Howard (New York, 1978), 124–26.

30 Derrida 1996, 85–88.

31 *The Shadow of Gradiva: A Last Excavation Campaign through the Collections of the Getty Center by Anne and Patrick Poirier,* installation, The Getty Center, Los Angeles, November 6, 1999–January 30, 2000.

32 For the film *Gradiva,* see www.imbd.com/title/tt0485798/ (last accessed March 5, 2012).

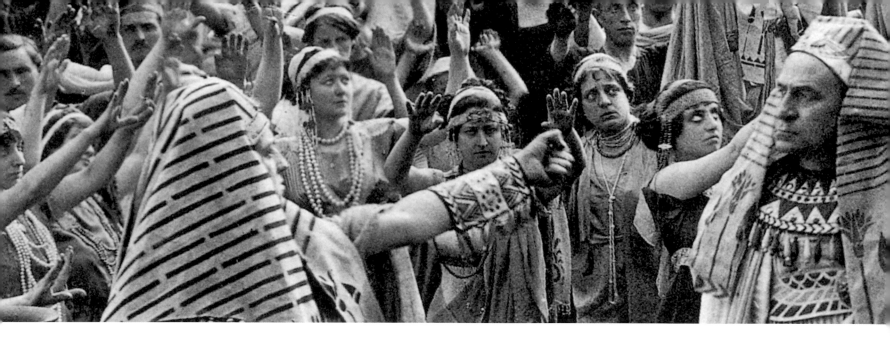

ADRIAN STÄHLI

Screening Pompeii

THE LAST DAYS OF POMPEII IN CINEMA

In the wake of the recent revival of Graeco-Roman Holly-wood epics—launched by Ridley Scott's Oscar-winning box-office success *Gladiator* in 2000—an interest in a blockbuster staging of the last days of Pompeii has also emerged. Roman Polanski initially planned to adapt Robert Harris's 2003 novel *Pompeii* for the screen; he intended to direct and produce the movie, which, with a projected budget of $130 million, would have been his biggest and most expensive film to date. Shooting should have started in August 2007 in Spain, but Polanski exited the project, allegedly due to location and script problems, and the project was downsized to a TV miniseries (to be directed by Paul W. S. Anderson and produced by Ridley Scott).[1] It is not surprising that Polanski should seek to bring the last days of Pompeii to the screen. The destiny of the doomed city, spectacularly buried under the ashes of Mount Vesuvius, has gained more attention recently due to the worldwide success of Harris's best-selling historical thriller, but it has long been a favorite subject of historical films set in Roman antiquity. In the early years of film, it was at the forefront of cinematic innovation, responsible for some of the first major box-office successes in the history of the movies.[2]

The last days of Pompeii first appeared on screen in Italy, which was the leading nation in the production and worldwide distribution of movies before World War I. Initially a fairground attraction or screened by traveling cinemas in temporarily installed show booths and tents, at *caffè-concerti*, and in vaudeville and variety theaters, movies in Italy became an increasingly successful economic commodity. Beginning around 1905, an emerging film industry of powerful production companies controlled the distribution of films and established the first permanent movie theaters.[3] The development of new techniques of cinematic narrative and representation, camera movement, set design, colored film images, and special effects and the introduction of full-length features enabled films to gain artistic prestige, to compete successfully with traditional forms of popular entertainment, and to attract a growing mass audience. Italian historical films about antiquity were at the forefront of this development.[4] They offered thrilling stories, exotic locations,

spectacular sets, monumental architecture, extravagant costumes, impressive crowd scenes involving hundreds of extras, gladiator combats and chariot races, battle scenes, lavish feasts and orgies, lascivious eroticism, and cruel martyrdom. All of this made them particularly suitable as vehicles for exhibiting the "imaginative power of the cinematic mechanism"[5] and for establishing film as a new form of artistic mass entertainment. Among the first full-length features ever produced were historical films set in Roman antiquity, including *Quo vadis?* (1913) and *Cabiria* (1914), which received worldwide critical acclaim and gained huge success at the box office.[6] Their richly developed narratives, acting style, special effects, and spectacular decorations, as well as the quality of their photography, had an enormous impact on both the domestic and the emerging American film industry.

Aside from their visual effects and the grandeur of their mise-en-scène, the success of early Italian movies with historical and, more specifically, ancient subjects was largely due to their narrative qualities. Earlier short features, most of them

with a playing time rarely exceeding eight minutes, condensed their stories to a sequence of a few stagelike scenes that were only loosely connected to each other.[7] It was a movie about the destruction of Pompeii, Luigi Maggi's *Gli ultimi giorni di Pompei* (Italy, 1908), which paved the way for full-length movies by developing for the first time a complex cinematic narrative, adapting the story line of Edward Bulwer-Lytton's novel *The Last Days of Pompeii* (fig. 53).[8] Although the story had to be reduced to a comparatively small number of scenes, all the main protagonists of the novel are present, propelling the plot through their different and precisely drawn characters, their interactions, and their conflicts: the young dandy Glaucus is in love with beautiful Ione but has a rival both jealous and dangerous in the Egyptian priest Arbaces, who kills Ione's brother Apaecides after failing to initiate him into the mysteries of Isis.[9] Arbaces then uses the love of the blind slave girl Nydia for Glaucus, her master, to put the blame on him for the murder of Apaecides. The eruption of Mount Vesuvius strikes the vile Arbaces dead, while blind Nydia shows Ione and Glaucus the way out of the

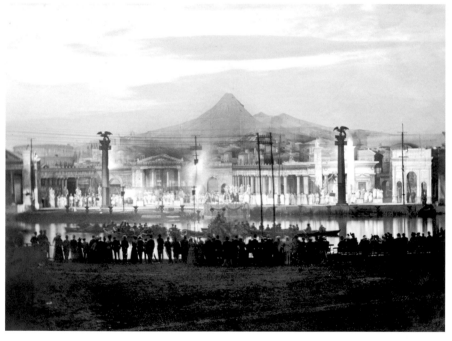

FIG. 53. Film still from *Gli ultimi giorni di Pompei* (directed by Luigi Maggi, Italy, 1908).

FIG. 54. James Pain's pyrodrama by day, *The Last Days of Pompeii*, at Alexandra Palace, London, 1898.

collapsing city and rescues both. The only main character of the novel omitted in the movie is Julia, the rival of Ione and the real instigator of Arbaces's plot against Glaucus.

Earlier short features with Pompeii in the title had not even referenced the city's destruction by Mount Vesuvius, let alone Bulwer-Lytton's novel. "Pompeii" simply indicated that the story, usually one of romantic love, took place in what were considered typical Roman residential interiors and urban settings. Only occasionally, as is the case in *La rivale (Scene di vita di Pompei)* (The Rival [Scenes from Life in Pompeii]) (Italy, 1908) and *Martire pompeiana* (Pompeian Martyr), directed by Giuseppe De Liguoro (Italy, 1909), did topics like the rivalry of two women for the same man seem to allude to to the central motif of Bulwer-Lytton's *Last Days*.[10]

Maggi's film gained overwhelming domestic and international success; French newspapers considered it the "most sensational movie" of its period.[11] Its realistic acting and filmic representation, as well as the splendor of its lavish and accurately drawn historical sets and costumes, were widely praised. With its unusually long playing time of around twenty minutes, *Gli ultimi giorni di Pompei* marks the beginning not only of an increase in the length of movies in general (and especially epic films) but also of an increase in both the number of movies about Roman antiquity and the number of films produced in Italy, which peaked between 1911 and 1914 with more than a thousand films per year.[12]

Full-length feature films require a complex narrative, which in this period was provided by historical novels, opera, and stage plays.[13] During the nineteenth century, historical novels set in Roman antiquity had gained enormous popularity and counted among the best sellers of the period.[14] Many cinema spectators were no doubt familiar with at least the main protagonists and plot outlines of these novels, and the effect of this recognition was to facilitate their understanding of movies based on these stories. In the case of Pompeii and its destruction, Bulwer-Lytton's *Last Days*—probably the most popular of all nineteenth-century historical novels—had become the canonic narrative of Pompeii's extinction. It had been adapted as early as 1835 for a circus show produced by Rufus Welch and as a play by Louisa Medina, staged in New York.[15] Aside from the early short movies that used the name of Pompeii merely as an indication of some tie to ancient Roman life, all Italian movies about Pompeii since Maggi's seminal *Gli ultimi giorni di Pompei* have based their screenplays on Bulwer-Lytton's novel.

But movies set in antiquity also originated in (and competed with) other forms of mass entertainment that were typical of the late nineteenth and early twentieth centuries: "toga plays" and stage spectacles. These were enormously successful and reached large audiences; some toga plays (*The Sign of the Cross*, first produced in 1895) were staged up to ten thousand

times within a few years and reached a weekly attendance of more than seventy thousand spectators.[16] Comparably large audiences were attracted by circus spectacles staging popular Roman themes, which regularly included gladiator and lion combats, chariot races, scenes of Christian martyrdom, and the destruction of cities with firework effects. Imre Kiralfy's circus spectacle *Nero, or the Destruction of Rome* was first staged at an outdoor theater on Staten Island in 1888 and then integrated into Barnum's *Greatest Show on Earth*.[17] Stage shows like these provided the emerging cinematic culture with established patterns of narration and a trove of visual motifs.

Of crucial importance for the early history of movie epics, and particularly the emergence of films depicting the last days of Pompeii, was the most spectacular of all toga melodramas, the outdoor play *The Last Days of Pompeii*, based on Bulwer-Lytton's novel, which was seen by multitudes in America and Europe (fig. 54). This pyrodrama with fireworks emulating the eruption of Mount Vesuvius was staged by James Pain, who constructed a vast outdoor theater in Coney Island near New York in which to perform *The Last Days* for an audience of ten thousand spectators. Each performance involved three hundred extras for the crowd scenes (chariot races, a procession of priests, gladiator combats, and the destruction of the city) and promised in announcements a complete burn-down of Pompeii every evening (pls. 85 and 86).[18]

In 1913, two new films based on Bulwer-Lytton's novel followed Maggi's success. The first one was directed by Eleuterio Rodolfi and produced—like Maggi's movie five years before—by the Ambrosio Company. The second one (of which no print seems to survive) was directed by Giovanni Enrico Vidali for Pasquali Film and released under the title *Jone* (Ione), after the female protagonist.[19] The Rodolfi version displayed within its long running time of more than one hundred minutes a rich variety of grand sets, enlivened by an impressive crowd involving hundreds of extras (figs. 55 and 56), while the editing made extensive use of cross-cutting to trace parallel stories rather than just developing a linear narration. Compared with Maggi's film, the arena and gladiator scenes were extended, paying considerably more attention than Bulwer-Lytton to the lavishly displayed exotic ceremonies and dances of Arbaces's Egyptian rituals. The Rodolfi and Vidali films were both shot on three-dimensional sets that carefully reconstructed Pompeian architecture, streets, house interiors, and furniture, rather than merely using painted backgrounds; some exterior scenes of the Vidali version were even shot in authentic locations at Pompeii. Both films stage the destruction of Pompei as a spectacular climax, the Vidali film by using actual footage from an eruption of Mount Vesuvius.

The Gilded Age of Italian silent movies (1911–14) falls in a period when Italian patriotic nationalism, militarism, and colo-

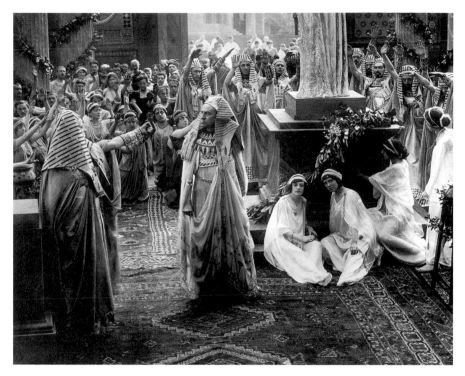

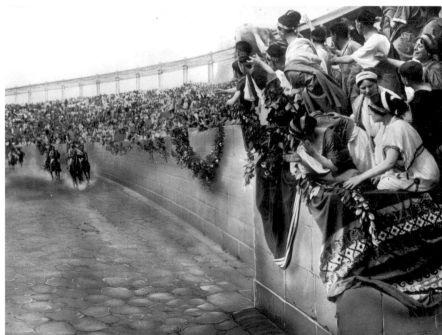

FIG. 55. Film still from *Gli ultimi giorni di Pompei* (directed by Eleuterio Rodolfi, Italy, 1913).

FIG. 56. Film still from *Gli ultimi giorni di Pompei* (directed by Eleuterio Rodolfi, Italy, 1913).

nialist expansion were intensifying, the latter reaching its peak with the invasion and occupation of formerly Ottoman Libya in 1911. Italian historical movies, particularly epics set in Roman antiquity, reflect these social and political developments, all of which coalesced into a drive to construct a new national identity based on the propagandistic concept of *romanità*—the idea that the ancient Roman empire could be renewed across the Mediterranean through the agency of the modern Italian state.[20] Thus, these movies regularly emphasized a thoroughly positive view of Romans and Roman civilization, taking the side of the official, secular politics of the government against the Vatican and its own ambitions of moral and political leadership in Italy. They glorify the Romans, the ancestors of modern Italians, as morally superior and avoid references to the competing moral authority of Christianity.

This is most obvious in the various movies about the last days of Pompeii. In both versions of *Gli ultimi giorni di Pompei* from 1913, but also in Maggi's seminal film from 1908, references to the Christian religion—although crucial in Bulwer-Lytton for understanding of the conflict between Arbaces and Apaecides—are rigorously downplayed, while at the same time Nydia and Glaucus's Greek origins and his final conversion to Christianity are omitted. In contrast to Bulwer-Lytton's novel, the antagonism is not between morally upright Greeks (Glaucus, Ione, and the blind slave Nydia) and corrupt and decadent Pompeians, seduced by the Egyptian Arbaces into religious aberration, but between the ethically superior Romans and the conspiring villains of an oriental priesthood threatening to infiltrate and undermine the Roman community and its values. The visual representation of Pompeii's architecture supports and enhances this contrast: the oriental priests meet in dimly lit, somber, and extravagantly decorated rooms to perform their exotic rites, while the interiors of the Pompeian houses open into gardens filled with light and surrounded by white marble columns. Finally, the eruption of Mount Vesuvius is presented not as a divine judgment from God extinguishing a Roman city fallen from grace through its own decadence and corruption but instead as an event that purges the city of its foreign infiltrators.

By the mid-1920s, the circumstances of Italian cinema had completely changed. Italy had gradually lost its leading position in the international film market and had also fallen behind German and American movies in terms of technical and aesthetic innovations.[21] Italian film companies tried to regain their former reputation by building on the past achievements of the Gilded Age of Italian cinema with the production of lavish, extremely expensive historical movies set in Roman antiquity. But the relaunches of former box-office successes such as *Quo vadis?* (Enrico Guazzoni, Italy, 1924) proved to be highly uninspired and anachronistic, symptoms of the industry's artistic and technical stagnation. These films could no longer compete with the vivid, expressive acting and dynamic film cutting of American productions like *Ben Hur* (Fred Niblo, U.S.A., 1925). Despite enormous investments in Italian post–World War I film production, the Unione Cinematografica Italiana, a large consortium of almost all the major Italian film companies, founded in 1919 to sustain the production and distribution of Italian movies, went bankrupt in 1926 due to the economic recession and the failure of major Italian banks. The worldwide distribution network for Italian films collapsed, and American productions overtook the domestic market.

One of the last major efforts to salvage Italian cinema was *Gli ultimi giorni di Pompei* (Italy, 1926), directed by Carmine Gallone and Amleto Palermi and produced by a company explicitly established for that purpose.[22] With its playing time of more than three hours and a total of 1,395 takes (many of them hand-colored), it was not only one of the longest and most lavish, but also one of the most expensive (production costs totaled seven million lira) Italian movies realized to date. The abundantly rich story line closely follows Bulwer-Lytton's narrative and reintroduces all the main characters earlier versions had dropped to keep the plot tight. Glaucus is explicitly named as being of Greek origin and the antagonism between Christians and pagans, so important to Bulwer-Lytton, is now at least partly reintroduced. Apaecides, first seduced by the frivolous pleasures of Arbaces's mysteries of Isis, later joins the Christian community; for his baptism, the Christians assemble in a catacomb, which has no counterpart in the novel but has since become a typical feature of epic films. A few months before, *La fanciulla di Pompei* (The Girl from Pompeii) (Italy, 1925), a film set in modern Pompeii (which is famous for one of Italy's major sanctuaries of devotion, the Santuario della Madonna del Rosario), had already featured prominently the motif of a hero's initial dedication to the lasciviousness and orgiasm of ancient pagan ceremonies—imagined in his dream fantasies—and his final conversion to Christianity. His conversion is provoked by his beloved regaining her eyesight, lost in an eruption of Mount Vesuvius, during a ceremony in the Santuario; the two eventually marry.[23]

The set decorations of Gallone and Palermi's *Gli ultimi giorni* display sumptuous architectural settings—among them the public baths and the arena—as well as the luxurious interiors of Pompeian houses. The latter are adorned with wall paintings and furniture and crowded with life-size sculptures, which in many cases were based on archaeological evidence and artifacts from Roman times and even on the excavations of Pompeii itself. The movie is further enriched by a good deal of female nudity in several bathing scenes (fig. 57), as well as in a dance performance during the initiation of Apaecides into the Isis mysteries, which ends with an orgy of female dancers and male participants, including Apaecides. Although clearly emphasizing *romanità* as the core ideology of the newly estab-

lished Fascist regime, the film appeals to its spectators with overwhelming visual and voyeuristic pleasures. Its voyeurism was, however, criticized in many Italian newspapers as pagan decadence. The film did not achieve the international box-office success the producers had hoped for and failed to reach its goal—it could not salvage the Italian film industry. It was the last epic on Roman antiquity produced during the Fascist era, with the sole exception of *Scipione l'Africano* (Scipio Africanus) (Italy, 1937), a propaganda movie glorifying Mussolini's colonial wars in Africa.[24]

For today's audiences, the most impressive feature of Gallone and Palermi's *Gli ultimi giorni* is still the extremely elaborate and detailed richness and variety of its imagery, which suggests, in many instances, authenticity in the representation of ancient Roman buildings, costumes, and lifestyle. Historical movies set in Roman antiquity regularly aim at such an authenticity in representing history, but by no means is this historical authenticity as a historian or archaeologist would reconstruct it. Instead movies create their own authentic past according to the expectations of the spectators and their familiarity with a visual and narrative tradition, thus reproducing, but also producing and enhancing, contemporary cultural stereotypes or myths about antiquity.[25]

In most cases, the visual models of representing antiquity used for epics are rooted in the visual culture of the nineteenth century.[26] Nineteenth-century paintings depicting Roman battle scenes, triumphal processions, gladiatorial games, chariot races, naval battles in the arena, banquets, orgies, bathing scenes with prominently displayed female nudity, or scenes of domestic life in Pompeian interiors were extremely popular and circulated through engravings, photographs, and advertisments in newspapers, journals, and books,[27] appearing as well on theater and circus posters.[28] These iconic images have shaped popular knowledge and perpetuated visual stereotypes about the ancient world. Toga plays reenacted famous paintings as tableaux vivants on stage: Pain's pyrodrama staged at least two tableaux that referenced famous pictures, Lawrence Alma-Tadema's *The Flower Market* (fig. 58) and Edward Poynter's *Faithful unto Death* (pl. 31), both of them depicting scenes taken from Bulwer-Lytton's novel.[29] Cinema benefitted from the audience's familiarity with this well-established practice of enlivening pictures, which stimulated the impression of an "authentic" antiquity—authentic insofar as it fulfilled the expectations of spectators familiar with these paintings of how Roman antiquity "looked." This recognition effect led many filmmakers of the silent movie era to make explicit and large use of such reenactments of nineteenth-century pictures.[30] Both above-mentioned images by Alma-Tadema and Poynter return in *Gli ultimi giorni di Pompei* from 1926 (fig. 59). But references to such pictures also provided film directors, and set and costume designers,

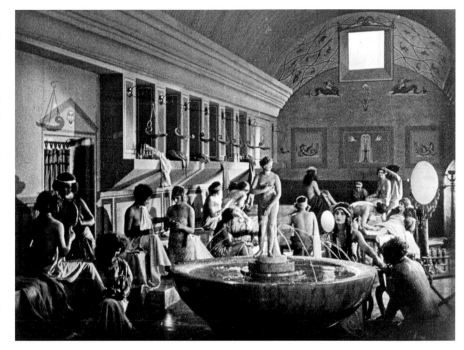

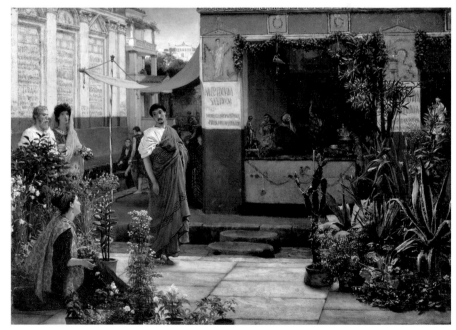

FIG. 57. Film still from *Gli ultimi giorni di Pompei* (directed by Carmine Gallone and Amleto Palermi, Italy, 1926).

FIG. 58. Lawrence Alma-Tadema (Dutch and British, 1836–1912), *The Flower Market*, 1868. Oil on wood, 42.2 × 58 cm (16⅝ × 22⅞ in.). Manchester, U.K., City Galleries, Manchester Art Gallery, 1934.417.

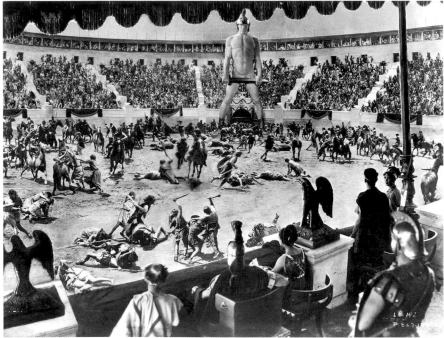

FIG. 59. Film still from *Gli ultimi giorni di Pompei* (directed by Carmine Gallone and Amleto Palermi, Italy, 1926).

FIG. 60. Film still from *The Last Days of Pompeii* (directed by Ernest Schoedsack, U.S.A., 1935).

with comprehensive and vivid visualizations of Roman architecture and the customs of daily life—visualizations that rather arid archaeological reconstructions could hardly provide. Thus these nineteenth-century pictures enriched films with seemingly antiquarian authenticity.

In 1935, the theme of Pompeii's destruction was taken up for the first time in a Hollywood production, *The Last Days of Pompeii*, directed for RKO by Ernest B. Schoedsack and Merian C. Cooper, the directors of the sensational box-office success *King Kong* in 1933, also produced by RKO (fig. 60).[31] Accurate reconstructions of Pompeian architecture, furniture, wall decorations, or statues were not a priority in this film. Instead, the movie largely focuses on spectacular scenes of Mount Vesuvius's eruption and collapsing buildings, including a huge over–life-size statue in the arena that breaks in pieces and falls on the fleeing Pompeians. The film keeps the title from Bulwer-Lytton's novel but abandons its plot. Bulwer-Lytton's melodrama of love and jealousy is replaced by a story of Christian salvation: Marcus, a former blacksmith, becomes a gladiator and earns a fortune as a slave trader, but during the destruction of Pompeii he discovers Christian values, helps slaves to escape from the burning city, defending them selflessly against Roman soldiers. Buried under the collapsing city, he dies, but not without being comforted at the last minute by a visitation from Christ himself. The story relies heavily, as Maria Wyke has demonstrated, on motifs typical of contemporary gangster movies: Marcus takes advantage of the available opportunities for his self-advancement, makes a successful career as an entrepreneur that enables him to get rich, but, at the same time, he is also corrupt and a criminal.[32] The film thus follows the rules of Hollywood's Production Code, established in 1930, which required that movies should either avoid showing violence and crime or compensate for their inclusion by emphasizing moral values. Nevertheless, *The Last Days* flopped at the box office, probably due to its exaggerated exhibition of Christian morality and the completely implausible span of time covered in the story. During a journey to Judaea, Marcus witnesses the crucifixion of Christ and dies in the eruption of Vesuvius some forty-six years later. To make it commercially more successful, the film was later screened in a twin-pack with *King Kong*. No other producer or director has since dared to take up the theme: *The Last Days* remains the only movie made in America on this subject up to the present day.

In Italy, on the other hand, one of the first epics produced after World War II was again a film staging the last days of Pompeii, *Les derniers jours de Pompéi* (France/Italy, 1948, released as *Gli ultimi giorni di Pompei* in Italy). This French-Italian coproduction was directed by Marcel L'Herbier and Paolo Moffa and starred several well-known French movie actors, including Georges Marchal in the role of Glaucus.[33] Part of an attempt to

relaunch the post–World War II film industry by looking to the box-office successes of the silent movie era, *Les derniers jours de Pompéi*—financed by the conservative Italian Democrazia Cristiana party—was obviously intended to mark a clear break with Fascist ideology and its emphatic filmic display of *romanità*, which was replaced by a solid Catholic point of view. In showing the persecution of Christians and suggesting a connection between the destruction of the city and the triumph of Christianity over decadent Roman paganism, *Les derniers jours* is indeed the first screen adaption of *The Last Days of Pompeii* to focus on the teleological perspective so precious to Bulwer-Lytton.

Although *Les derniers jours de Pompéi* has its narrative weaknesses, the film was a box-office success, at least in Italy, and contributed to the revival of epics in Italian post–World War II cinema[34]—a revival that also matched the interests of the American film industry. After World War II, American film companies profited from the low production costs and wages in Italy, the still-existing infrastructure and technology of Cinecittà, and an available workforce to realize major Hollywood epics in Italy (*Quo Vadis* [U.S.A., 1951], for example, was entirely shot in Cinecittà and in the neighborhoods of Rome).[35] As the economic gains from American film productions were frozen in Italy, American companies reinvested their profits in Italian dummy corporations that produced movies destined primarily for the American film and television market but which were successful in Italy as well. In order to reduce costs, many if not most actors—with the exception of the leads—were Italians credited under American nicknames, such as Mario Girotti and Carlo Pedersoli, who both made their first steps to fame under their nicknames Terence Hill and Bud Spencer in a major Italian epic, *Annibale/Hannibal* (Italy/U.S.A., 1959), produced by United Artists and starring Victor Mature.[36]

American epics of the post–World War II era were largely dominated by a Cold War perspective in which the belligerent imperialism and corrupt dictatorship of the Roman emperors is seen as a surrogate for Communism, as well as for the now-defeated Nazi and Fascist regimes. The oppressed and persecuted, but eventually triumphant, Christians are glorified as martyrs, the American and Western values of freedom and democracy portrayed as being as based on Christian belief.[37] A large Hollywood production of the last days of Pompeii was apparently not suited to serve these ideals: there is no bloodthirsty tyrant terrorizing Christians and sacrificing them in the arena and finally being punished for his vices and his nastiness, and it is the erupting volcano that exterminates the depraved city, not the bravery of Christians stubbornly standing up for their moral values.

It is no surprise, therefore, that the only movie about the destruction of Pompeii in the 1950s financed with American capital is a relatively cheap Italian-Spanish-German film, *Gli ultimi giorni di Pompei* (Italy/Spain/Germany, 1959), directed by Sergio Leone, who replaced Mario Bonnard during shooting. An overwhelming success at Italian box offices, this film launched Leone's international career.[38] Hardly anything is left from Bulwer-Lytton's narrative other than the names of the protagonists, the romantic love story between Glaucus and Ione (played by the young German actress Christine Kaufmann), and the antagonism between the Egyptian priest Arbaces (Fernando Rey) and the Pompeian Christian community. Bulwer-Lytton's narrative was largely replaced by a simple plot, a conspiracy of the sinister Arbaces and the intriguing Julia to seize power over the city. *Gli ultimi giorni* was produced by the Spanish organization of Opus Dei and is therefore packed with the persecution of Christians, who are blamed for the murder of Apaecides by Arbaces and Julia. Most of its success was based on the impressive muscles of its lead actor, Steve Reeves (as Glaucus), the most acclaimed body-building star among male leads in the 1950s. The producers of *Gli ultimi giorni* tried to repeat its success some years later with *Anno 79 D.C.: La distruzione di Ercolano* (A.D. 79: The Destruction of Herculaneum) (Italy/France, 1962) by reusing some of the footage of the earlier movie and changing the name of the city devastated by the volcano.[39] Brad Harris starred as the muscular hero Marcus Tiberius in a story that again focused on a conspiracy, this time a plot to assassinate the emperor Titus during an arena spectacle in Herculaneum.

These two Italian movies were the last films about the destruction of Pompeii produced for the big screen. In this and succeeding sword-and-sandal movies, the fate of the doomed city has been replaced by a focus on fist fights, duels, battle scenes, and arena spectacles, centered around a muscular hero besting conspirators, assassins, and any other villains opposing him. The narrative inspired by Bulwer-Lytton's novel and first used to emphasize Roman moral superiority over depraved orientals, then rewritten as a tale of Christian triumph over a doomed pagan civilization, came to its end as a muscleman's fight against evil—a theme that can be presented far more succesfully in other film genres.

Notes

1 For Polanski's film project, see www.variety.com (February 1, April 15, May 22, and September 11, 2007); for the TV miniseries *Pompeii*, see www.imdb.com (last accessed March 8, 2012). In the early 2000s, there were also rumors of plans for two other screen versions of the story of Pompeii, one by James Cameron, director and producer of *Titanic*, to be titled *Ghosts of Vesuvius*, based on a nonfiction book by Charles Pellegrino, and another project produced by Universal Pictures and directed by Fernando Meirelles, director of *Cidade de Deus*. Both films

were apparently never realized; see www.peplums.info/pep34a.htm (last accessed March 8, 2012).

2 For historical films set in Roman antiquity in general, see Wyke 1997; Wyke 1999; Jon Solomon, *The Ancient World in the Cinema* (New Haven and London, 2001); Laura Cotta Ramosino, Luisa Cotta Ramosino, and Cristiano Dognini, *Tutto quello che sappiamo su Roma l'abbiamo imparato a Hollywood* (Milan, 2004); Junkelmann 2004; Martin Lindner, *Rom und seine Kaiser im Historienfilm* (Frankfurt am Main, 2007); Lochman, Späth, and Stähli 2008; Arthur J. Pomeroy, *"Then it was Destroyed by the Volcano": The Ancient World in Film and on Television* (London, 2008); Jeffrey Richards, *Hollywood's Ancient Worlds* (London and New York, 2008); Dumont 2009; and Martin M. Winkler, *The Roman Salute: Cinema, History, Ideology* (Columbus, 2009). For epics about the last days in Pompeii in particular, see Martinelli 1994; Wyke 1997, 147–82; Solomon 2001 (as cited above), 80–83; Pesando 2003; and Dumont 2009, 517–25.

3 For early Italian cinema production in general, see Aldo Bernardini, *Cinema muto italiano I: Ambiente, spettacoli e spettatori, 1896–1904* (Rome, 1980); Aldo Bernardini, *Cinema muto italiano II: Industria e organizzazione dello spettacolo, 1905–1909* (Rome, 1981); Aldo Bernardini, *Cinema muto italiano III: Arte, divismo e mercato, 1910–1914* (Rome, 1982); Brunetta 1991; Brunetta 1993, vol. 1; Bernardini 1996a; Bernardini 1996b; Pierre Sorlin, *Italian National Cinema 1896–1996* (London and New York, 1996); Riccardo Redi, *Cinema muto italiano (1896–1930)* (Venice, 1999); Marcia Landy, *Italian Film* (Cambridge, 2000), 21–47. For traveling cinemas in particular, see Aldo Bernardini, *Cinema italiano delle origini: Gli ambulanti* (Gemona, 2001).

4 For early Italian epics, see Giorgio De Vincenti, "Il kolossal storico-romano nell'immaginario del primo Novecento," in *Bianco e Nero: Rivista del Centro sperimentale di cinematografia* 49, 1 (1988): 7–26; Brunetta 1991, 62–71; Brunetta 1993, 1:52–53, 130–230; Wyke 1997; Wyke 1999; Junkelmann 2004, 91–97; and Aubert 2009.

5 Wyke 1997, 25.

6 For *Quo vadis?* (Enrico Guazzoni, Italy, 1913), see Wyke 1997, 119–28; Wyke 1999, 193–95; Landy 2000 (note 3), 29–32; Aldo Bernardini, Vittorio Martinelli, and Matilde Tortora, *Enrico Guazzoni: Regista pittore* (Doria di Cassano Jonio, 2005), 32–40, 147–49; Aubert 2009, 274; and Dumont 2009, 498–500. For *Cabiria* (Giovanni Pastrone, Italy, 1914), see *Giovanni Pastrone: Cabiria; Visione storica del III secolo a.C. Didascalie di Gabriele D'Annunzio* (Museo Nazionale del Cinema, Turin, 1977); Angela Dalle Vacche, *The Body in the Mirror: Shapes of History in Italian Cinema* (Princeton, N.J., 1992), 27–45; Paolo Bertetto and Gianni Rondolino, eds., *Cabiria e il suo tempo* (Milan, 1998); Aubert 2009, 138–55, 277–78; Dumont 2009, 274–76; Winkler 2009 (note 2), 94–120; and Stähli 2008, 113, n. 18 (with further references).

7 For a list of Italian silent movies between 1905 and 1910, see Bernardini 1996a and Bernardini 1996b.

8 For *Gli ultimi giorni di Pompei*, see Martinelli 1994, 35–37; Bernardini 1996a, 205–9; Wyke 1997, 158–59; Aubert 2009, 122–27, 215–16; and Dumont 2009, 517–18. The earliest known movie about the destruction of Pompeii was a British short film from 1900, *The Last Days of Pompeii* by Robert William Paul, its title referring to Bulwer-Lytton's novel but depicting only the eruption of Mount Vesuvius with people fleeing: Martinelli 1994, 35; Aubert 2009, 216; and Dumont 2009, 517.

9 Maggi himself starred as Arbaces.

10 For *La rivale (Scene di vita di Pompei)*, see Martinelli 1994, 37; Bernardini 1996a, 190–91; Aubert 2009, 215; and Dumont 2009, 518. For *Martire*

pompeiana, see Martinelli 1994, 37; Bernardini 1996a, 327–28; Aubert 2009, 220; and Dumont 2009, 518.

11 Martinelli 1994, 37.

12 For the number of historical films, as well as the total number of films produced in Italy between 1905 and 1931, see Aubert 2009, 28, fig. 1. For the increasing length of movies since 1911 (with movies about antiquity being at the forefront of this trend), see Aubert 2009, 31, fig. 2.

13 For the narrative sources of Italian historical films, see Aubert 2009, 49–60. For nineteenth-century novels about Roman antiquity in general, see Malamud 2009, 122–49.

14 For nineteenth-century historical novels about ancient Pompeii and its destruction, see Moormann 2003 and Jacobelli 2008b.

15 For Bulwer-Lytton's *The Last Days of Pompeii*, see Moormann 2003 and Malamud 2009, 122–33. For Rufus Welch's *The Last Days of Pompeii*, see Richard D. Flint, "Rufus Welch: America's Pioneer Circus Showman," *Bandwagon* 14, no. 5 (1970): 6. For Medina's *The Last Days of Pompeii*, see Yablon 2007.

16 For toga plays and stage spectacles in general, see Mayer 1994 and Malamud 2009, 173–99. For Wilson Barrett's *The Sign of the Cross* (1895), see Mayer 1994, 104–88.

17 For Imre Kiralfy and Barnum's *Nero*, see Wyke 1997, 123; Malamud 2000, 79–82; Malamud 2001, 51–54; and Malamud 2009, 174–77.

18 For early stage adaptions of Bulwer-Lytton's novel, see Mayer 1994, 19–20; and Yablon 2007, 192–93. For James Pain's pyrodrama *The Last Days of Pompeii*, staged for the first time 1879 in London, later in Brooklyn, and beginning in 1882 on Manhattan Beach at Coney Island, see David Mayer, "Romans in Britain 1886–1910: Pain's 'The Last Days of Pompeii,'" *Theatrephile* 2, 5 (1984/85): 41–50; Mayer 1994, 90–103; Wyke 1997, 157; Malamud 2000, 77–84; Malamud 2001; Yablon 2007; and Malamud 2009, 178–79; see also pls. 85–6.

19 For Eleuterio Rodolfi's *Gli ultimi giorni di Pompei* (Italy, 1913), see Martinelli 1994, 37–46; Wyke 1997, 161–65; Wyke 1999, 195–97; Aubert 2009, 127–30, 276; and Dumont 2009, 518. For Giovanni Enrico Vidali's *Jone o gli ultimi giorni di Pompei* (Italy, 1913), see Martinelli 1994, 37–46; Wyke 1997, 161–65; Aubert 2009, 120, 272; and Dumont 2009, 518. A third movie based on Bulwer-Lytton's novel, planned at the same time by Gloria Productions, was abandoned after the early release of the two competing versions: Martinelli 1994, 37–40; Wyke 1997, 159–60; and Dumont 2009, 519.

20 For Italian film and the cult of *romanità*, see Brunetta 1993, 1:130–230; Wyke 1997, 17–22. For the Italian cult of *romanità* in general, see Marla Stone, "A flexible Rome: Fascism and the Cult of *Romanità*," in *Roman Presences: Receptions of Rome in European Culture, 1789–1945*, ed. Catharine Edwards (Cambridge 1999), 205–20.

21 For Italian film in the post–World War I period and during the Fascist era, see Marcia Landy, *Fascism in Film: The Italian Commercial Cinema, 1931–1943* (Princeton, N.J., 1986); Brunetta 1991, 127–36; Dalle Vacche 1992 (note 6), 18–56; Brunetta 1993, 1:231–94; Brunetta 1993, vol. 2; Riccardo Redi, "Da 'Quo Vadis' a Pompeii,'" in Redi 1994, 27–34; Sorlin 1996 (note 3); Landy 2000 (note 3), 48–71; and Steven Ricci, *Cinema and Fascism: Italian Film and Society, 1922–1943* (Berkeley, Los Angeles, and London, 2008).

22 For *Gli ultimi giorni di Pompei*, see Redi 1994; Wyke 1997, 165–71; Aubert 2009, 130–36, 299; and Dumont 2009, 519–20.

23 For *La fanciulla di Pompei* (Giulio Antamoro, Italy, 1925), see Aubert 2009, 298; and Dumont 2009, 519.

24 For *Scipione l'Africano* (Carmine Gallone, Italy, 1937), see Dumont 2009, 276–78; and Stähli 2008, 114, n. 21 (with further references).

25 For recent contributions to the question of the representation of history in historical films and particularly in epics, see Stähli 2008, 106, n. 2 (with further references).

26 For nineteenth-century visual sources of epics set in Roman antiquity in general, see De Vincenti 1988 (note 4); Stefania Parigi, "La rievocazione dell'antico," in Redi 1994, 67–84; Ivo Blom, "*Quo vadis?* From Painting to Cinema and Everything in Between," in *La decima musa: Il cinema e le altre arti; Atti del VII Convegno internazionale di studi sul cinema, Udine / Gemona del Friuli, 21–25 marzo 2000*, ed. Leonardo Quaresima and Laura Vichi (Udine, 2001), 281–96; Junkelmann 2004, 61–89; and Stähli 2008. For paintings representing the destruction of Pompeii, see Stähli 2011.

27 For a case study of the diffusion of paintings by Jean-Léon Gérôme, see *Gérôme & Goupil: Art et entreprise* (Paris and Bordeaux, 2000).

28 Advertising posters announcing the American productions of William Young's and Klaw and Erlanger's stage adaptions of Lewis Wallace's novel *Ben-Hur* (1880) both used the famous painting *The Chariot Race* by Alexander von Wagner (1876, Manchester Art Gallery, inv. 1898.12; reproduced in Mayer 1994, 201 [ill.]); see, respectively, Mayer 1994, 202 (ill.) and Malamud 2009, 135, fig. 5.5. This painting also influenced film sequences, among others the chariot races in Fred Niblo's *Ben-Hur* (U.S.A., 1925) and in its remake by William Wyler (U.S.A., 1959), while Jean-Léon Gérôme's famous *Thumbs Down* (1872, Phoenix Art Museum, inv. 1968.52; reproduced in *The Spectacular Art of Jean-Léon Gérôme*, exh. cat. [Los Angeles: The Getty Center; Paris, Musée d'Orsay, 2010], 126–29, cat. 71) was used as the poster motif announcing Imre Kiralfy's spectacle *Nero, or the Destruction of Rome* in 1890; see Malamud 2000, 105, fig. 14; and Malamud 2009, 176, fig. 6.12.

29 For Lawrence Alma-Tadema's *The Flower Market* (1868, Manchester Art Gallery, inv. 1934.417), see R. J. Barrow, *Lawrence Alma-Tadema* (London and New York, 2001), 40–41, pl. 35.

30 See Joanna Barck, *Hin zum Film – Zurück zu den Bildern: Tableaux Vivants; "Lebende Bilder" in Filmen von Antamoro, Korda, Visconti und Pasolini* (Bielefeld, 2008).

31 For *The Last Days of Pompeii* (U.S.A., 1935), see Martinelli 1994, 47–51; Wyke 1997, 171–80; and Dumont 2009, 520–21. For American epics of the 1920s and 1930s set in ancient Rome, see Margaret Malamud, "An American Immigrant in Imperial Caesar's Court: Romans in 1930s Films," *Arion*, 12, no. 2 (2004): 127–59; and eadem, "Swords-and-Scandals," *Arethusa* 41 (2008): 157–83.

32 See Wyke 1997, 174–75. Jon Seydl has further observed that there is a Depression-era narrative in Marcus's inability to pay for his wife's medical care in this film, which was made the same year the Social Security act was signed but several years before it went into effect.

33 For *Les derniers jours de Pompéi/Gli ultimi giorni di Pompei* (France/Italy, 1948), see Martinelli 1994, 51–52; Wyke 1997, 181–82; and Dumont 2009, 521–22.

34 For Italian film production in the post–World War II era in general, see Brunetta 1991 and Brunetta 1993, vols. 3 and 4. For Italian epics in particular, see Brunetta 1991, 280–98, 406–38, 608–10; Brunetta 1993, 3:574–82; Brunetta 1993, 4:394–97; and Wyke 1997.

35 For American film productions in Italy and Italo-American coproductions after World War II, see Brunetta 1991, 280–98; Brunetta 1993, 3:31–34, 46–59, 152–76; and Brunetta 1993, 4:3–27. For American epics in general, see Vivian Sobchack, "'Surge and Splendor': A Phenomenology of the Hollywood Historical Epic," *Representations* 29 (1990): 24–49; and Jon D. Solomon, "In the Wake of *Cleopatra*: The Ancient World in the Cinema since 1963," *Classical Journal* 91, no. 2 (1996): 113–

40. For American post–World War II epics set in Roman antiquity, see Wyke 1997; Winkler 2001; Cotta Ramosino, Cotta Ramosino, and Dognini 2004 (note 2); Monica Silveira Cyrino, *Big Screen Rome* (Malden, Mass., 2005); Lindner 2007 (note 2); and Richards 2008 (note 2). For *Quo Vadis* (Mervyn LeRoy, U.S.A., 1951), see Dumont 2009, 501–4; Winkler 2009 (note 2), 94–120; and Stähli 2008, 119, n. 27 (for further references).

36 For *Annibale/Hannibal* (Carlo Ludovico Bragaglia and Edgar G. Ulmer, Italy/U.S.A., 1959), see Dumont 2009, 279–81.

37 See Wyke 1997, 15–17; and Winkler 2001.

38 For *Gli ultimi giorni di Pompei* (Mario Bonnard, Sergio Leone, and Sergio Corbucci, Italy/Spain/Germany, 1959), see Martinelli 1994, 52; Wyke 1997, 182; Pomeroy 2008 (note 2), 32–46; and Dumont 2009, 522.

39 For *Anno 79 D.C.: La distruzione di Ercolano* (Gianfranco Parolini, Italy/France 1962), see Martinelli 1994, 52; and Dumont 2009, 522.

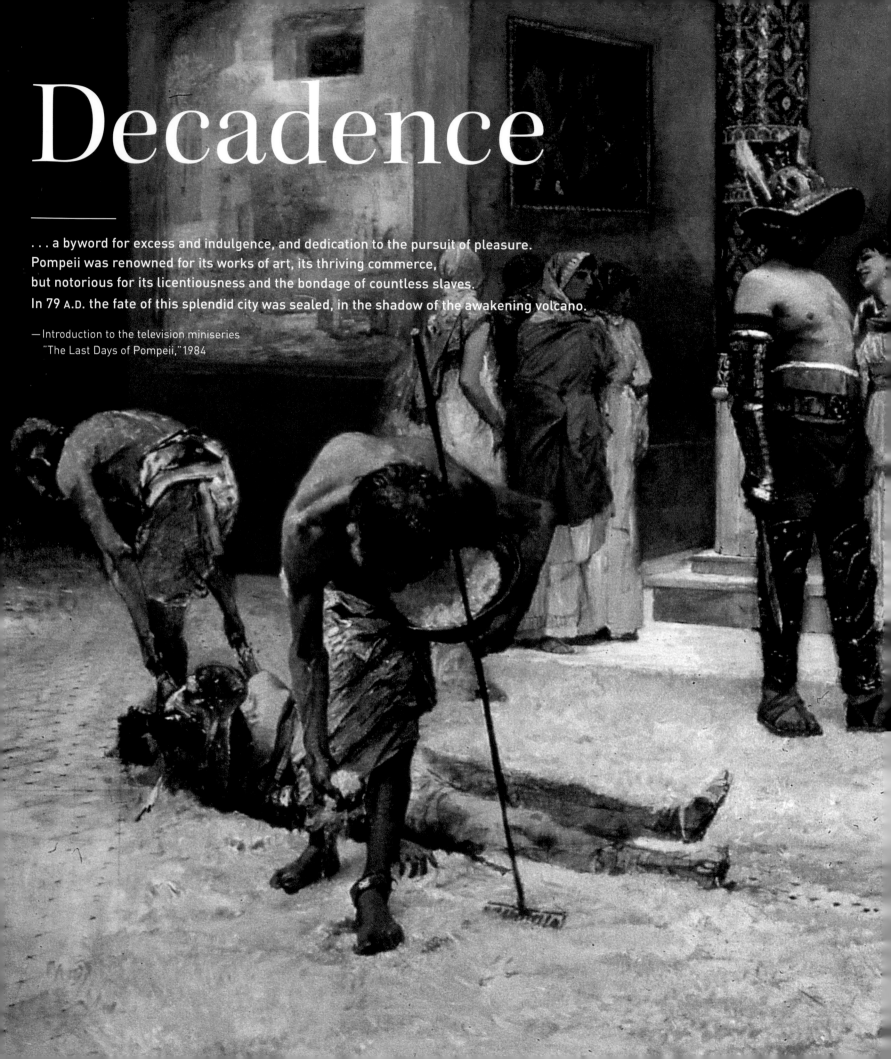

Decadence

. . . a byword for excess and indulgence, and dedication to the pursuit of pleasure.
Pompeii was renowned for its works of art, its thriving commerce,
but notorious for its licentiousness and the bondage of countless slaves.
In 79 A.D. the fate of this splendid city was sealed, in the shadow of the awakening volcano.

—Introduction to the television miniseries
 "The Last Days of Pompeii," 1984

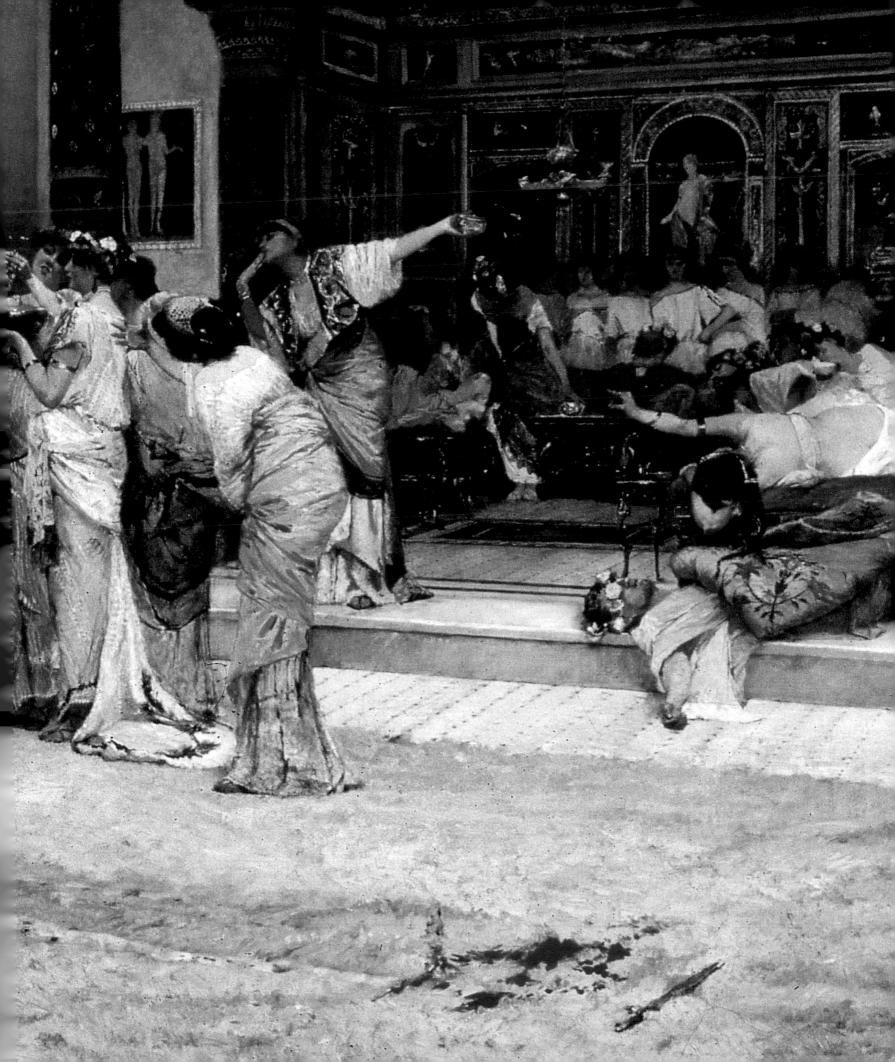

Cupid Seller

The image of the so-called *Cupid Seller* captured the imagination of the Neoclassical movement. This brightly painted ancient fresco was found in the mid-eighteenth century, during the excavations of a series of Roman villas at Castellammare di Stabia (ancient Stabiae), a coastal town just south of Pompeii. In antiquity, Stabiae was the setting for large and luxurious vacation villas owned by the Roman elite, who were attracted by its stunning views of the Bay of Naples. The *Cupid Seller* was found in a sprawling series of rooms and porticos now referred to as the Villa di Arianna, which contained many finely executed and well-preserved wall paintings that were promptly cut out of the walls and taken into the Bourbon royal collections.

At first glance the *Cupid Seller* scene appears comical and lighthearted. On further viewing the conspiratorial poses of the buyer and her companion, who rests a hand on her shoulder with their heads bent together, the pleading gestures and movements of the two uncaged Cupids, one with outstretched arms, the other with plaintively raised head, and the violent motion and challenging gaze of the seller, impart a darker tone and an element of pathos to the subject matter that may seem strange and surprising to a modern audience.

The vignette of the *Cupid Seller* originally formed part of a display of what is termed the Third Style of Pompeian wall painting, known for its inclusion of mythological scenes and fantastical imagined landscapes. The presence of another scene from ancient comedy near the original location of the *Cupid Seller* in the Villa di Arianna suggests that the Roman fresco may represent a known scene from poetry or theater, and the careful arrangement of the protagonists against the two interior walls has a stage-set-like quality. In general, ideas of capturing love and buying the affection of a loved one were popular in poetry from the earlier Greek and Alexandrine poets up to Roman authors contemporary with the *Cupid Seller's* date. Ovid's notorious *Ars Amatoria* (The Arts of Love), which appeared in the last years of the first century B.C., details how to ensnare a member of the opposite sex, giving tips to women on attracting men, and vice versa.

Once uncovered, the *Cupid Seller* found a highly receptive audience throughout eighteenth-century Europe. The fresco was engraved by Carlo Nolli and published in volume three of *Delle antichità di Ercolano* in 1762 (pl. 2). As the long-awaited official publications of the Bay of Naples excavations, the *Antichità* was the authoritative source for the finds and a powerful vehicle for their propagation—particularly for the images, as the court artists employed for this project had the exclusive official license to draw directly from the objects. This motif in particular became widely popular; the *Cupid Seller* continued to capture the attention and imaginations of nineteenth-century audiences who saw it or its many reproductions and reinterpretations. One of the earliest, and most influential, of these reimaginings of the ancient fresco is the 1763 *La marchande d'amours* (Cupid Seller) by Joseph-Marie Vien (pl. 3).

Vien was a pioneering French exponent of Neoclassicism. Trained under Charles-Joseph Natoire in Paris, he won the Prix de Rome in 1744 and studied in Italy until 1750. He was admitted to the Académie Royale in 1751 and became a significant teacher as well as a painter in his own right, counting among his students Jacques-Louis David.

After he returned to Paris, Vien became acquainted with the powerful antiquarian Anne-Claude-Philippe de Caylus, who encouraged the artist's classicizing inclinations. It was likely Caylus's copy of the *Antichità* that Vien studied for this painting, as he would not have seen the original fresco (it was discovered in 1759, after he returned to France). Caylus also encouraged the artist to revive ancient painting techniques, notably encaustic, during this period.

Even though Vien claimed to be a fanatical devotee of the antique, his image makes no pretense of being a copy of the classical fresco. The original title (*La marchande à la toilette*) is based on contemporary terminology, and the gestures are also of-the-moment to the point of being rude. Vien personally encouraged viewers to compare the two directly in the *livret* that accompanied the 1763 Paris Salon, an exercise that immediately reveals dramatic differences between the compositions, just as Vien must have intended. The bright colors of the ancient fresco have been replaced with refined pastels, and the figures slimmed and attenuated. The impression is that of an eighteenth-century Neoclassical salon, not a room in an ancient villa. Thus, this first attempt to re-create one of the precious surviving examples of Roman painting recovered from the Bay of Naples was not an homage to the original, but rather an attempt to update it—and improve it—for the refined taste of Paris in the 1760s.

Vien was successful in this effort. The painting was acquired by the duc de Brissac, who gave it to his paramour Jeanne Bécu, comtesse du Barry, the former mistress of Louis XV and a major patron of Vien. The painting remained in her Château de Louveciennes until both she and de Brissac came to a bad end during the Reign of Terror.

1

CUPID SELLER FROM THE VILLA DI ARIANNA, STABIAE

Roman, 1st century A.D.
Fresco, 29 × 35 cm (11⁷/₁₆ × 13¹³/₁₆ in.)
Naples, Museo Archeologico Nazionale,
Soprintendenza speciale ai beni archeologici di Napoli e Pompei, 9180

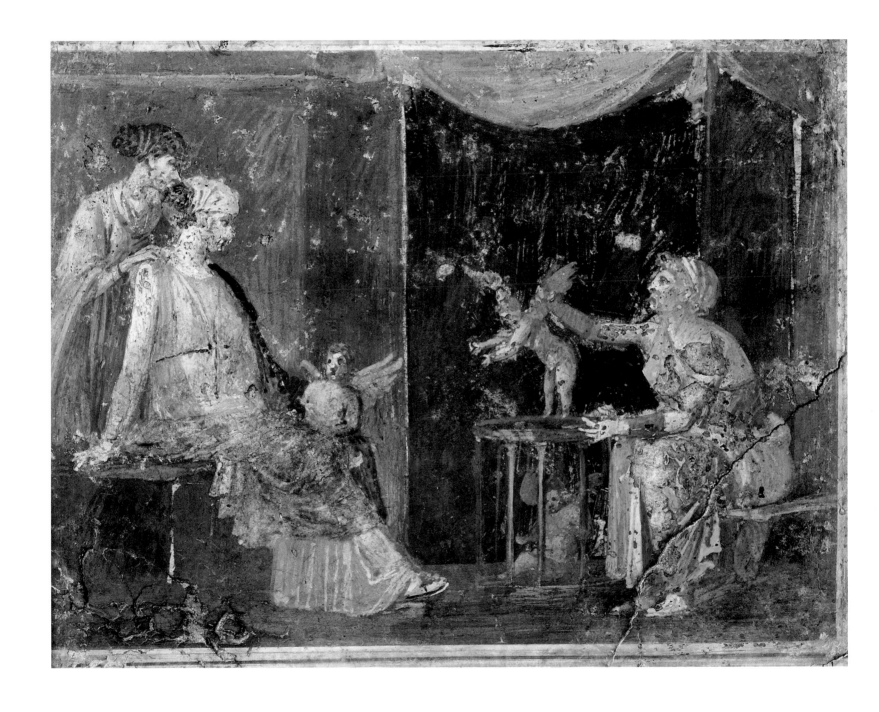

2

Carlo Nolli
Italian, 1710–1785

after a design by Giovanni Elia Morghen
Italian, 1721–ca. 1807

CUPID SELLER

1762
Etching and engraving.
Plate 7 in vol. 3 of *Delle antichità di Ercolano* (Naples, 1762)
Los Angeles, Getty Research Institute, 84-B21058

Gio. Morghen Reg. del. mezzo palmo Napolitano C. Nolli Reg. f.

mezzo palmo Romano

3

Joseph-Marie Vien the Elder
French, 1716–1809

CUPID SELLER

1763
Oil on canvas, 117 × 140 cm (46¹⁄₁₆ × 55⅛ in.)
Paris, Musée du Louvre, inv. no. 8424 (MR2663)

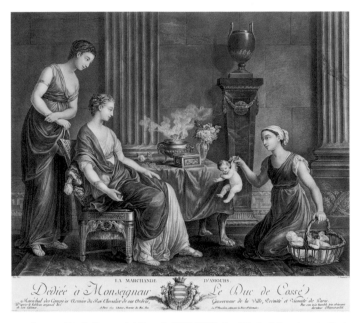

3.1. Jacques Firmin Beauvarlet (French, 1731–1797), *Cupid Seller* (after Joseph-Marie Vien the Elder), 1778. Etching and engraving, 41.5 × 48 cm (16⅚ × 18⅞ in.). Philadelphia Museum of Art, 1985-52-4945. The Muriel and Philip Berman Gift, acquired from the John S. Phillips bequest of 1876 to the Pennsylvania Academy of the Fine Arts, with funds contributed by Muriel and Philip Berman, gifts (by exchange) of Lisa Norris Elkins, Bryant W. Langston, Samuel S. White 3rd and Vera White, with additional funds contributed by John Howard McFadden, Jr., Thomas Skelton Harrison, and the Philip H. and A.S.W. Rosenbach Foundation, 1985.

Jacques Firmin Beauvarlet prepared a large-scale print of Vien's painting (pl. 3.1), which was displayed in the Salon of 1779, and propagated the image widely. Both the painting and the ancient fresco (and sometimes a combination of the two), as well as the related prints, inspired a cottage industry of imitations, running from textiles and other common household goods to luxury items, such as waxes, Wedgwood jasperware, and even engraved gems.

Vien was not the only eighteenth-century artist who was interested in the *Cupid Seller*. A decade after his *La marchande d'amours* was exhibited, the Swiss artist Henry Fuseli revisited the ancient fresco (pl. 4). While Fuseli's idiosyncratic approach to psychologically charged themes has defined him as a protomodernist, this characterization can distract from recognition of his academic, Neoclassical tendencies. Fuseli had a rigorous education, including study of art-historical writings by Anton Raphael Mengs and J. J. Winckelmann, and he was a theologian and philosopher as well as an artist. He traveled to Rome

in 1770 to study and visited Naples in 1775 before moving to England in 1779. When in Naples he may have seen the *Cupid Seller*, then installed at the museum at Portici. Fuseli was at that time involved in a series of unhappy affairs of the heart, which may have informed his interpretation of the subject.

Rejecting the refined charm and elegance of Vien, Fuseli instead portrays a disturbing, almost violent scene in which a crone thrusts a limp cupid toward a recoiling maiden, rather like a witch forcing a philter on an unwilling customer. Love is not a courtly pleasure but a dark, frightening affair with an uncertain outcome. The scene is made all the more unsettling by Fuseli's slashing lines and strong light-and-dark contrasts. Like Vien, Fuseli took ample liberties with the original, omitting the standing girl and framing curtain to focus on the central encounter. He also made his drawing appear more fragmentary than the original, simulating rough edges as if it is broken, while the fresco is a smooth rectangle. The drawing is thus a transformation of the original rather than a copy, as it presents a radically altered composition informed by the personal circumstances of the artist. | AS & VCGC

SELECTED BIBLIOGRAPHY

Ancient fresco/Nolli
Ajello, R., ed., *Le antichità di Ercolano* (Naples, 1988).

Allroggen-Bedel, A., "Die Wandmalereien aus der Villa in Campo Varano (Castellammare di Stabia)." *Mitteilungen des deutschen archäologischen Instituts, römische Abteilung* 84 (1977): 27–89.

Ascione, G. C., "Wer Kauft Liebesgötter? [Anyone for Gods of Love?]," in Howe et al. 2004, 87–89.

Bragatini and Sampaolo 2010, 1146–47, no. 31.

Elia, O., *Pitture di Stabia* (Naples, 1957), 68.

Mastroroberto, M., "7. The Cupid Vendor," in Howe et al. 2004, 113.

Mattusch 2005, 284–85.

Valladares, H., "Four Women from Stabiae: Eighteenth-Century Antiquarian Practice and the History of Ancient Roman Painting," in Coates and Seydl 2007, 73–93.

Vien/Beauvarlet
Faroult, Leribault, and Scherf 2011, 78, 89–92.

Gaehtgens, Thomas W., and Jacques Lugand, *Joseph-Marie Vien peintre du roi (1716–1809)* (Paris, 1998).

Fuseli
Pressley, Nancy L., *The Fuseli Circle in Rome: Early Romantic Art of the 1770s* (New Haven, Conn., 1986).

Schiff, Gert, *Johann Heinrich Füssli: Oeuvrekatalog* (Zurich, 1973).

Henry Fuseli
Swiss, active England, 1741–1825

CUPID SELLER

1775–76
Black and red chalk on paper, 30 × 48.5 cm (11¹³/₁₆ × 19⅛ in.)
New Haven, Conn., Yale Center for British Art, Paul Mellon Fund, B1982.8

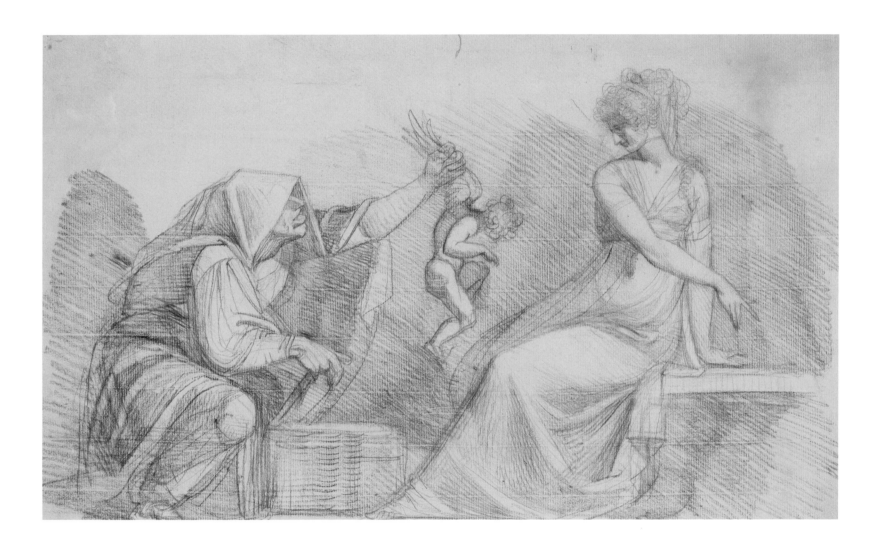

Élisabeth Louise Vigée-LeBrun
French, 1755–1842

LADY HAMILTON AS A BACCHANTE

1790
Oil on canvas, 133.4 × 105.4 cm (52½ × 41½ in.)
Liverpool, Lady Lever Art Gallery, LL3527

Vigée-LeBrun trained under her father, Louis Vigée, who provided his daughter with the contacts necessary to break into the overwhelmingly masculine profession of artist. She specialized in portraiture and became the favored painter of Marie Antoinette, producing more than two dozen images of the queen that clearly demonstrate the sitter's status and virtue while preserving an apparent naturalness and informality.

Vigée-LeBrun fled France during the Revolution and became a popular portrait painter internationally. Her continental travels included an extended visit to Naples in 1790. There she was befriended by the British ambassador William Hamilton and his young and lovely mistress-turned-wife, Emma Hart (1761?–1815), who had previously been the mistress of Hamilton's nephew, Charles Grenville, among others. When the aristocratic Charles tired of Emma, he sent her on what she thought was a short visit to Naples, but she was actually a gift to his uncle. Emma made the best of a bad situation and in 1791 married Sir William, who was a well-known collector and dealer of antiquities as well as a diplomat. She later became the mistress of Horatio Nelson.

While Vigée-LeBrun referred in her autobiography to the somewhat scandalous Emma as "sarcastic," "cunning," and "dressed badly as a rule" (Vigée-Lebrun, 152), she also records socializing with the couple and going on excursions with them around the countryside. She wrote a long description of Lady Hamilton's life, including an account of how she had been an artist's model as a young woman and came to be expert in what were known as "attitudes." These performances involved Emma striking different poses and assuming different expressions, frequently based on classical statues, as if she were a living work of art. The performances were exclusive affairs that took place in the Hamiltons' salon, where clad in a simple, antique-inspired tunic and with only a few shawls and a vase as props, she would delight her audience with a rapid-fire transformation from one character to the next. Vigée-LeBrun noted that as a bacchante, Lady Hamilton was "delightful," with "animated eyes and hair in disorder" (Vigée-Lebrun, 151). The artist captured her expression in this charming and vivacious portrait that records both the sitter's lovely face and graceful figure. She cuts a spiraling diagonal across the canvas, stretching from her raised hands, which hold a tambourine that suggests the sound as well as the motion that were part of the attitudes.

Rather than documenting an indoor performance, Vigée-LeBrun depicts Emma in front of Mount Vesuvius, its smoke echoing the sitter's flowing hair. The volcano places the scene in the Bay of Naples and invokes the ancient disaster, while also referring to Emma's husband. Sir William was a pioneering volcanologist who climbed the crater some sixty-five times and sponsored daily documentation of its activities. The artist was similarly drawn to Vesuvius, which obligingly provided her with some pyrotechnics during her visit. She described one particularly frightening trek to the crater, claiming she stood right at the edge of a huge molten lava flow that seemed like the entrance to hell. Vigée-LeBrun and her party were enveloped in smoke and ash and had to retreat: "I reached my house in pitiable condition; my dress was simply a drenched cinder; I was nearly dead with fatigue" (Vigée-LeBrun, 158). In other words, she shared the experience of Vesuvius's ancient victims—all except for dying. Vigée-LeBrun was not scared off, however, and returned to scale the crater another time, witnessing dramatic tongues of flame against the night sky.

The Liverpool picture is one of three portraits of Emma Hamilton that Vigée-LeBrun executed during this period, including others showing her in the guise of Ariadne and as a Sibyl. Rather nastily, the artist claimed that she painted Emma as a special favor to Sir William, who begged her to do it but then turned around and sold the portrait for profit—a pattern he repeated with a smaller sketched head of Emma the artist later gave him as a gift. Vigée-LeBrun subsequently records a visit with Lady Hamilton in London after her husband's death, during which Vigée-LeBrun prevailed on Emma to revive her famous attitudes on a specially constructed stage in the artist's studio. Emma Hamilton died in France shortly thereafter, penniless and alone. | vcgc

SELECTED BIBLIOGRAPHY

Bailey, John Thomas Herbert, *Emma, Lady Hamilton: A Biographical Essay, with a Catalogue of Her Published Portraits* (New York, 1900).

Jenkins, Ian, with K. Sloan, *Vases and Volcanoes: Sir William Hamilton and his Collection*, exh. cat. (London, 1996).

Lada-Richards, Ismene, "'Mobile Statuary': Refractions of Pantomime Dancing from Callistratus to Emma Hamilton and Andrew Ducrow," *International Journal of the Classical Tradition* 10, no. 1 (Summer 2003): 3–37.

Ramage, Nancy, "Sir William Hamilton as Collector, Exporter and Dealer: The Acquistion and Dispersal of his Collections," *American Journal of Archaeology* 94, no. 3 (July 1990): 469–80.

Sheriff, Mary, *The Exceptional Woman: Élisabeth Vigée-Lebrun and the Cultural Politics of Art* (Chicago, 1997).

Vigée-Lebrun, Élisabeth-Louise, *Memoires of Madame Vigée-Lebrun*, trans. Morris F. Tyler (New York, 1879).

6

Jean-Auguste-Dominique Ingres
French, 1780–1867

ANTIOCHUS AND STRATONICE

ca. 1838
Oil on fabric, 48.1 × 63.9 cm (18 15/16 × 25 1/8 in.)
The Cleveland Museum of Art, Mr. and Mrs. William Marlatt Fund, 1966.15

Struck by a mysterious illness, Antiochus hovers near death. His grieving father, King Seleucus, who had recently taken Stratonice as his wife, summons a doctor. Noticing that the sight of the young woman quickens Antiochus's pulse and that passion has caused his sickness, the physician describes the youth's predicament to his father, who selflessly offers Stratonice to his son. The subject, both a love story and an example of parental devotion, enjoyed considerable popularity well into the 1800s in literature, theater, and the visual arts. Ingres, a key exponent of the classical tradition in the nineteenth century, chose a moment midway through the story, when the doctor realizes the source of the young man's malady. The artist's interpretation thus focuses on the son's lovesickness rather than the father's magnanimity, and by placing the narrative in a Herculanean setting underscores the eroticism and emotional excess of the subject.

Ingres had long been interested in the story, a historical event of around 294 B.C. from the region that is present-day Syria, related by numerous ancient authors, including Lucian, Valerius Maximus, and Plutarch. He owned a score for Étienne Méhul's 1792 opera *Stratonice* and executed preliminary drawings as early as ca. 1807, but a commission from the duc d'Orléans in 1833 launched his work in earnest. Smarting from criticism of some of his recent paintings, Ingres moved to Rome as the director of the French Academy the following year, throwing himself into this composition. Careful study of archaeology was deeply important to Ingres, who established a course at the school in this subject immediately upon his arrival.

Although the architecture itself does not represent a particular building from the excavations, one of the wall paintings at right reproduces the well-known *Theseus and the Minotaur* fresco—one of the first paintings to be excavated from the Porticus (often called the Basilica) at Herculaneum (Naples, Museo Archeologico Nazionale, 9049). The other wall painting, with only one figure sketched in, reproduces a now-obscure work from Herculaneum, *Hercules Strangling the Snakes* (Naples,

Museo Archeologico Nazionale, 9012), whose findspot was not recorded. Ingres probably studied these works firsthand in the museum at Naples, but each had also been published several times in major publications ranging from *Delle antichità di Ercolano* to Tommaso Piroli's 1804 *Antiquités d'Herculaneum* and the journal *Histoire de l'art d'après les monuments*. The figure of Stratonice, resting her chin on her hand, may also stem in part from an ancient source, the *Ulysses and Penelope* fresco from the Maecellum at Pompeii.

Ingres meticulously prepared his painting with many drawings, and he struggled mightily with this composition, particularly the pose of Antiochus, which he obsessively reworked. Ingres ultimately abandoned the Cleveland painting, leaving many passages unresolved, and infrared reflectography reveals careful underdrawing in many passages, with others executed more improvisationally. In 1840 he completed the commission with a larger painting, received ecstatically (Chantilly, Musée Condé), which included different wall paintings from Herculaneum; he also painted two variations in the 1860s. For these later works he depended heavily on assistants and more advanced collaborators, especially for the architecture and the archaeological detail, while this painting appears to be more fully the work of the artist alone. | JLS

SELECTED BIBLIOGRAPHY

Lapauze, Henry, *Ingres, sa vie et son œuvre (1780–1867), d'après des documents inédits* (Paris, 1911), 350, 353–56.

Mattusch 2008, 240–1, cat. 109.

Picard-Cajan, Pascale, "Capturer l'antique: Ingres et le monde archéologique romain." In *Ingres et l'antique: L'illusion grecque*, ed. Pascale Picard-Cajan (Arles, 2006), 41–50.

Robinson, William H., entry in Cleveland 1999, 2:364–67.

Siegfried, Susan L., *Ingres: Painting Reimagined* (New Haven and London, 2009), 214–35.

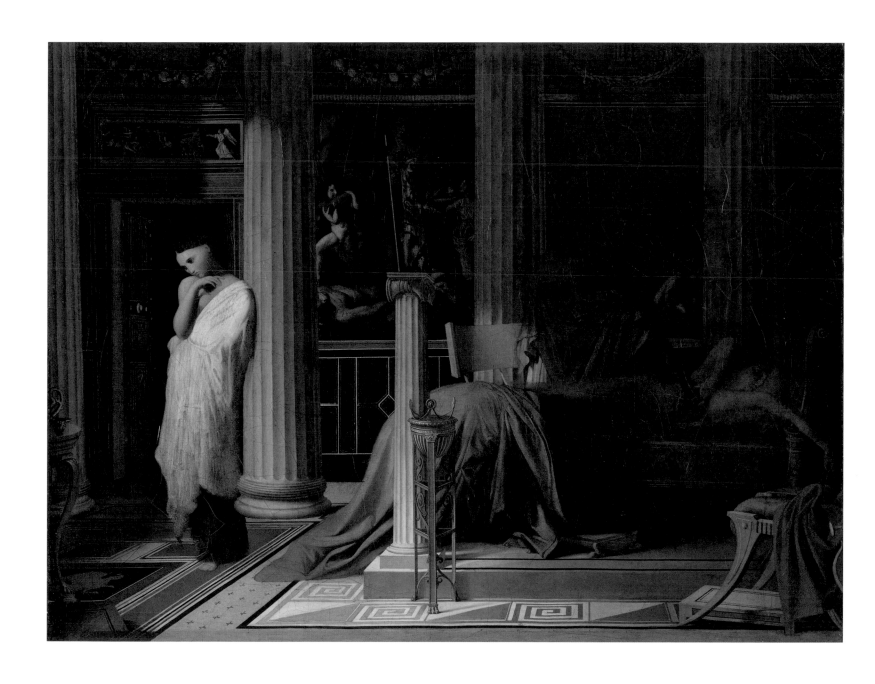

Théodore Chassériau
French, 1819–1856

TEPIDARIUM: THE ROOM WHERE THE WOMEN OF POMPEII CAME TO REST AND DRY THEMSELVES AFTER BATHING

1853
Oil on canvas, 1.71 × 2.58 m (5 ft. 7⅜ in. × 8 ft. 5⅝ in.)
Paris, Musée d'Orsay, RF 71

Chassériau was raised in Samaná in Saint Domingue (now the Dominican Republic), before moving to Paris in 1830. He trained in the studio of Jean-Auguste-Dominique Ingres, the leading proponent of the French classicizing, academic style (see pl. 6). Like his master, the young Chassériau was a precocious draftsman and first exhibited paintings at the Paris Salon of 1836 at the age of seventeen. After a series of successes there, Chassériau joined his former master in Rome (1840–41), where Ingres was serving as the director of the French Academy. While Ingres and Chassériau continued to share their love of the ancient past, the younger artist also began drawing extensively from nature and studying the grand compositions of monumental Renaissance fresco cycles. He became increasingly interested in luxurious, orientalist themes and, in what may have been a bid for personal independence more than a stylistic rupture, subsequently broke decisively with Ingres.

During his trip to Italy, Chassériau visited Pompeii and sketched extensively in the newly excavated Forum Baths (also known as the Baths of Fortuna). One of three main bath facilities at Pompeii, only the Forum Baths were in active use at the time of the eruption, having been rapidly repaired after the earthquake in A.D. 62. Their excavation in 1823 caused a sensation: given the small bathing facilities infrequently found in private houses, a larger public complex was assumed to have existed but remained hidden for the first century of the site's exploration. The Forum Baths provided a more complete picture of Roman bathing practices—long a subject of fascination—than had previously been available, enhancing the impression that Pompeii was the principal locus from which to access the ancient world.

Chassériau's image of the tepidarium is for the most part carefully correct in its archaeological detail. The artist not only relied upon his personal observations and drawings made in situ but also employed recent publications to refresh his memories. He would have consulted François Mazois's *Les ruines de Pompéi* (see pl. 61.1), which was completed after the author's death by Franz Christian Gau in 1838 and contained the earliest published images of the Forum Baths. Noted for their accuracy, Mazois's illustrations eschewed the creative license taken by Francesco Piranesi (see pls. 62–63) and did not include figures, ancient or modern. In addition, as Sarah Betzer has recently pointed out, Chassériau probably used William Gell's 1832 *Pompeiana* as a source (pl. 7.1). Gell's text on the Forum Baths is illustrated in a plate by Wilhelm Zahn, who, as Gell noted, used a camera lucida to capture their interior as precisely as possible. Chassériau's perspective is closely analogous to Zahn's, lending his image an aura of archaeological correctness that is enhanced by the detailed reproduction of the furniture—notably the benches on which the women sit—which was also found at the site.

Chassériau's painting is, however, far from a disinterested mechanical reproduction of the baths. By focusing on the interior as exclusively female, rather like a Roman harem, he imbues the *Tepidarium* with the luxurious sensuality that permeates his later works. Small changes to the decoration enhance this theme, notably the support figures flanking the wall niches that are in reality male (see also pl. 13.1) but in this canvas are female caryatids, apparently inspired by the Porch of the Maidens of the Erechtheum on the Acropolis of Athens. The artist thus marks this space as exclusively female, transforming it from ancient reality to suit his vision of the past.

7.1. Benjamin Winkles (British, fl. ca. 1829), after William Gell (British, 1777–1836), *The Tepidarium*. Plate XXIX (opposite p. 136) in vol. 1 of William Gell and John P. Gandy, *Pompeiana: The Topography, Edifices and Ornaments of Pompeii, the Result of the Excavations since 1819* (London, 1832).

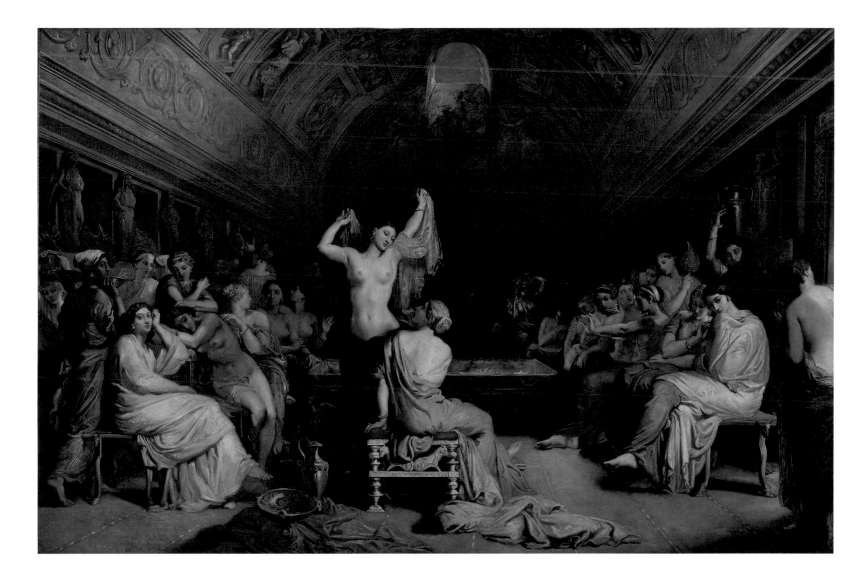

Chassériau may well have been influenced by his close friend the art critic and author Théophile Gautier (1811–1872), who had written favorably of his works from the time of his first public exhibition. Gautier saw Chassériau as uniting the theoretically contradictory ideals of Ingres's linear classicism with Eugène Delacroix's more sensual romanticism. During the years Chassériau was meditating on the *Tepidarium*, Gautier was working on a Pompeian project of his own: the 1852 novel *Arria Marcella*. As is discussed in the essay "Pompeii on the Couch" in this volume, Arria Marcella was an ancient Pompeian woman who is brought back to life by the desire of a modern young man, who admires the surviving impression of her breasts in the hardened mud of Vesuvius. This fusion of the antiquarian and the sensual proved irresistible, and naked or semiveiled breasts became a frequent motif in Pompeian imagery (see pl. 17).

By the time of this painting, Chassériau's enthusiasm for the female nude was already well established in paintings such as the *Venus Anadyomene* (Paris, Musée du Louvre, 1838) and the *Toilet of Esther* (Paris, Musée du Louvre, 1841). But the *Tepidarium* turns this theme into a catalogue of the female body in various stages of undress, focusing on the seminude central figure, who not only reveals but also aggressively flaunts her breasts to the admiring figure seated below her. The implied touch of this figure's up-reaching hand suggests more direct contact to come, highlighting the Forum Baths as a place for the uninhibited sexual behavior increasingly associated with the ancient Pompeians. But the painting retains a moral overtone, for the beautiful breasts so proudly offered by the central figure are, of course, doomed, like those of Gautier's Arria Marcella, to the Sodom and Gomorrah–style punishment soon to be inflicted by Vesuvius.

This monumental, multifigured painting was a declaration of Chassérieau's maturity as a painter. He artfully combined the classicism he had learned from Ingres with his own orientalism in a composition inspired by the great Renaissance frescoes of Raphael's Stanza della Segnatura in the Vatican. The *Tepidarium* owes a particular debt to Raphael's *School of Athens,* with its multitude of harmoniously interlocking figures focused on a central pair and set in a grand vaulted classical interior, an association that signals the scale of the artist's ambition for this painting. Rather than an erotic cabinet piece designed for the private delectation of a patron, this work was intended— and understood—as a large, public expression of Chassérieau's mature style and was immediately purchased by the state and reexhibited at the 1855 Exposition Universelle in Paris. Chassérieau's successful fusion of his various models was widely celebrated as a masterpiece; his champion Gautier declared that the picture was so convincing that it appeared to be an actual ancient fresco torn from the walls of Pompeii. Of course, the *Tepidarium* is no such thing—while the background may be classicizing, the central theme of decadent sexuality owes far more to the contemporary understanding of orientalism than to antiquity. | VCGC

SELECTED BIBLIOGRAPHY

Betzer, Sarah, "Afterimage of the Eruption: An Archaeology of Chassérieau's *Tepidarium* (1853)," *Art History* 33, no. 3 (June 2010): 466–89.

Betzer, Sarah, "Archaeology Meets Fantasy: Chassérieau's Pompeii in Nineteenth-Century Paris," in Hales and Paul 2011, 118–35.

Gautier, Théophile, "Salon de 1853. Premier article," *La Presse*, June 24, 1853.

Guégan, Stéphane, Vincent Pomarède, and Louis-Antoine Prat, eds., *Théodore Chassériau (1819–1856): The Unknown Romantic* (New Haven and London, 2002).

Nead, Lynda, *The Female Nude: Art, Obscenity, and Sexuality* (London, 1992).

8

Lawrence Alma-Tadema
Dutch and British, 1836–1912

AN EXEDRA

1869
Oil on wood, 38 × 60.3 cm (15 × 23¾ in.)
Poughkeepsie, N.Y., Vassar College, Frances Lehman Loeb Art Center,
Gift of Mrs. Avery Coonley (Queene Ferry, class of 1896), 1939.4.1

Alma-Tadema began his career in Antwerp painting medieval subjects. His 1863 honeymoon to Pompeii (coinciding with the escalation of excavations and the making of the first body casts under Giuseppe Fiorelli) proved pivotal, inspiring an intense interest in classical antiquity and especially in the excavated cities and their artifacts of daily life. As a result, Alma-Tadema asked his London-based dealer, Ernest Gambart, to support his shift to genre painting set in antiquity. His work in this arena proved successful from his first efforts in 1865.

Five luxuriously dressed patricians on an excursion outside the walls of Pompeii have stopped at the Tomb of Mamia. Two animatedly point out toward the Bay of Naples in the distance, while another pair converse; the fifth, an elderly man, dozes contentedly. Meanwhile, a barefoot slave sits unhappily on the curb, waiting to be summoned.

Located outside the Herculaneum Gate on the Street of the Tombs, this monument was excavated relatively early—between 1758 and 1764—under the guidance of Karl Weber. Artists long favored the picturesque spot, which was just before the main entrance to Pompeii (until the entrance was moved to the site's southwest corner in the 1860s). In the later nineteenth century the tomb was increasingly associated with more languid activities, often charged with eroticism, as seen in the works of Turpin de Crissé (see fig. 9) and Guglielmo Plüschow (see pl. 13).

Alma-Tadema's more straight-laced reconstruction characteristically combines a precise representation of known structures with an imagined narrative and architectural elements of his own invention. With little archaeological grounding, he inserted a temple into the background and added palmettes to each end of the tomb, taking these motifs from François Mazois's

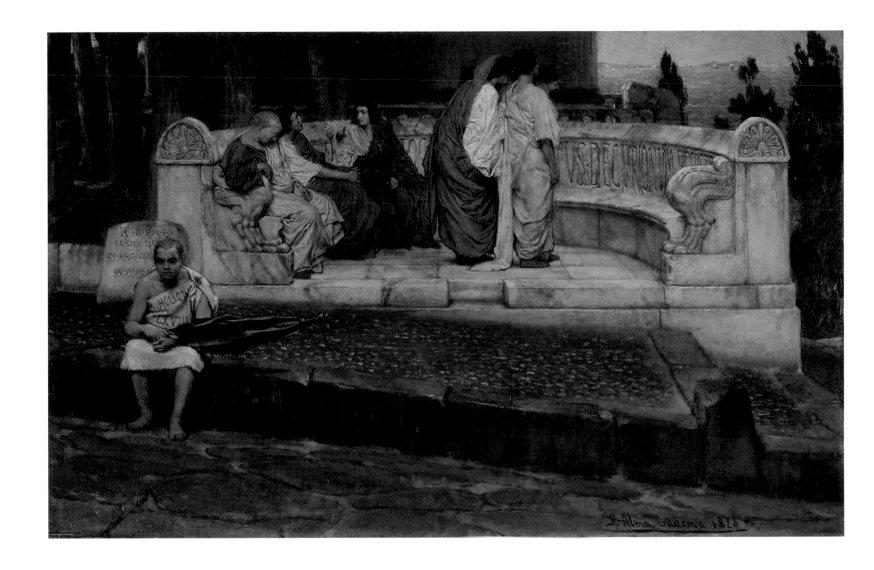

well-known compendium, *Les ruines de Pompéi* of 1824–38.

In contrast to *Glaucus and Nydia* (see pl. 70), where the enslaved Nydia is presented as chaste and beautiful, the stout, exhausted slave in *An Exedra* wears a garment crudely marked with a number and his owner's name. The slave slumps over while holding his master's parasol, and his shaven head, vacant eyes, and blocky shape interrupt the graceful hemicycle of figures. Although Alma-Tadema often addressed the enervation and indulgence of the Roman empire in his work, this startling indictment of slavery is without peer in his œuvre.

Teio Meedendorp and Luuk Pijl cite and incorrectly date a photograph (as ca. 1863) by Guglielmo Plüschow as Alma-Tadema's source, but the work, purchased by the artist several decades later, could not have been used for this painting. However, its presence in his collection demonstrates Alma-Tadema's continued interest in the site over many years. The exedra appears in well over twenty of his pictures, but none are set so explicitly in Pompeii nor are so pointed in their critique. | JLS

SELECTED BIBLIOGRAPHY

Barrow, R. J., *Lawrence Alma-Tadema* (London, 2001), 34–35.

Cuypers, Constant, "De Droom van Alma Tadema," *Kunstschrift* 35, no. 4 (July-August 1991): 38–49.

Meedendorp, Teio, and Luuk Pijl, entry in *Sir Lawrence Alma-Tadema*, ed. Edwin Becker (New York, 1997), 154–56.

Alfred Elmore
British, 1815–1881

POMPEII, A.D. 79

1878
Oil on canvas; 91.4 × 71.1 cm (36 × 28 in.)
New Haven, Conn., Yale Center for British Art, Paul Mellon Fund, B1987.17

The Irish-born artist Alfred Elmore was a celebrated practitioner of the quintessentially Victorian genre of domestic history painting. Having completed his training in London at the Royal Academy, in 1840 Elmore embarked on a tour of Europe that culminated with two years in Rome, where he conceived a number of genre pictures with subjects from Italian history. He returned to London in 1844 and was elected an academician in 1857. By the 1870s Elmore was less invested in the Shakespearean, Hogarthian, and monarchic history narratives that had made him famous, and he increasingly painted classical subjects informed by sketches made at Rome and Pompeii in the 1840s and in Algiers around 1866. The exhibition of this work at the Royal Academy in 1878 anticipated by one year the octodecentenary of the destruction of Pompeii.

Elmore's mysterious picture of Pompeii employs the soft palette, languorous attitude, sensuous textures, and vague archaeological references typical of Victorian classical painting but hints at an unresolved story. Ancient Greek and Roman subjects did not define Elmore's œuvre as they did for Alma-Tadema, and his characteristic reliance on narrative devices is evident in this work. Without the explicit title and smoking volcano, the woman's distracted expression would not itself signal mortal danger. For modern viewers the relationship between the two figures is not as clear as it was to Victorians, who tended to see a young mother and daughter. Sufficient ambiguity, however, allows the possibility that they are mother and son; sisters; nanny and child; or servant and mistress. The deadly ash has yet to eclipse the sunlight flooding the tender scene, and the viewer cannot determine if the figures are ignorant of the approaching danger or willfully embracing their fate and seeking simple comforts in their final hours. Contemporary reviewers were struck by the inappropriate ease of the couple before the volcano: "Elmore's 'Pompeii' is a symbolical picture of the state of security which was so terribly disturbed in the year A.D. 79. A lovely woman and child are sleeping at mid-day, in luxurious forgetfulness, unheeding the smoke and flame which is issuing from the top of Mount Vesuvius, seen in the distance, soon about to rain terror and destruction on the fair but

doomed city" ("Pictures at the Royal Academy"). The painting is neither a cautionary tale of the down-fall that follows excess, nor a carpe diem admonishment, but Elmore's Pompeian references provide a familiar historical framework for appreciating the painting's classical charms. Indeed, many Victorian reviews ignored the historical context as secondary and instead highlighted the stylistic attractions of the work; the *Birmingham Daily Post* remarked blandly that, "the food and hand resting on the bench should be noted," and the *Illustrated London News* stated that the "delicate study" was "chiefly remarkable for its symmetrical drawing and careful arrangement of drapery."

Like many Victorian history painters of his generation, Elmore strove for a sense of the authenticity conveyed by careful attention to historical detail, achieved through study of furnishings, costumes, and telling domestic minutiae. However, *Pompeii* is not a rigorous exercise in creating a historically accurate interior. The easily moveable wooden *lecti* (couches), that populated Pompeian households have been replaced by an improbable marble couch, covered with a particularly incongruous Victorian pillow and a furry animal skin that surely would have magnified the oppressive heat of an August day on the Bay of Naples. The shapes of the vessels are anachronistic, and their earthy brown, matte color is inconsistent with the glossy slips on pots found in wealthy Pompeian homes. The enormous double colonnade lends grandeur but is incompatible with Pompeian, low-roofed, domestic architecture, though such a fictitious arrangement may have been found in Roman wall paintings. The pieces of the *opus sectile* (cut work) floor are both too large and uncharacteristically polychromatic (incorporating rare Egyptian porphyry) for a Pompeian home; they may have been adopted from a late-Roman or medieval church floor. In sum, in sharp contrast to the works of Alma-Tadema (see pls. 8 and 70), Elmore's paintings convey the atmosphere of a classical interior without the artist scrutinizing excavation records or making quotations of well-known finds but rather through imparting a tactile sumptuousness consistent with Victorian aesthetic sensibility. | CK

SELECTED BIBLIOGRAPHY

"Art Notes," *Magazine of Art* 4 (1881): xvii, xxxi.

Birmingham Daily Post, May 7, 1878.

Illustrated London News, June 15, 1878, 551.

"The Pictures at the Royal Academy.–II," *Building News and Engineering Journal* 34 (May 17, 1878): 488.

Personal correspondence with Kevin Cole.

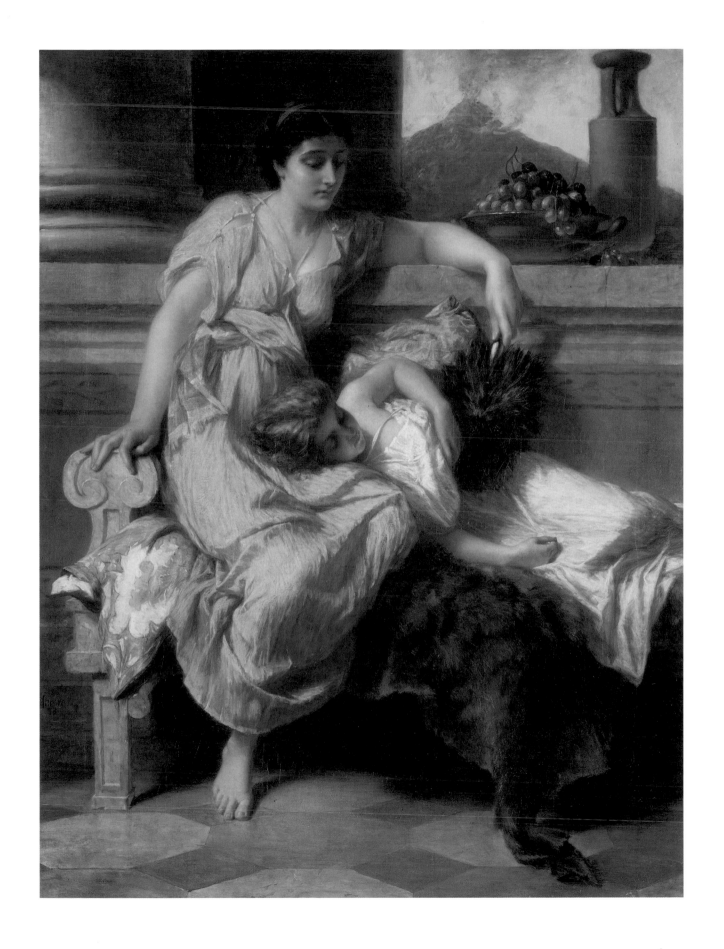

Francesco Netti
Italian, 1832–1894

GLADIATOR FIGHT DURING A MEAL AT POMPEII

1880
Oil on canvas, 115 × 208 cm (45¼ × 81⅞ in.)
Naples, Museo di Capodimonte, 3860/3861 (358 PS)

Born to a well-to-do South Italian family, Netti attended elite schools in Naples and, at the insistence of his parents, earned a law degree. But painting was his passion, and he studied with various masters, first in Naples, then for several years in Rome and eventually in Paris, where he was influenced greatly by Gustave Courbet and especially Jean-Léon Gérôme. In his early years he was fascinated by classical antiquity, but after returning to Naples in 1871 he seems to have focused initially more on criticism than on art. By the end of the decade he was again painting, immersing himself in Greek and Roman subjects.

Netti knew well the collections of the Archaeological Museum in Naples. He returned repeatedly to the ancient frescoes of female dancers painted on the walls of a chamber tomb at Ruvo from the fourth century B.C., which had been excavated in 1833 and subsequently detached and moved there (Museo Archeologico Nazionale, 9353-7). He depicted these gracious figures both as the products of an ancient painter admiring his own work (*Ancient Painter before His Work*; private collection) and as living women at ancient festivals (*Dancer;* Bari, Archivio Biblioteca Museo Civico Altamura, and *Ancient Chorus*; Naples, Galleria Accademia Belle Arti). Reflecting on the realistic representation of the ancient world in these paintings, Netti wrote:

> Local character, which is frequently admirable in these works [representing ancient subjects], is rather the local character that we imagine that antiquity should have had, instead of that which it actually had. We think them ancient, want to believe that they are, but I don't know that a Roman, if he returned to live amongst us, would recognize himself there. Everything that is represented there is authentic, is true: the site has been copied at the place—the building still exists—the restoration cannot be otherwise; what is missing? What is missing always is the spirit and the ancient life that gave these places a significance, now lost, and which we cannot but guess at without knowing whether we have found it.... the guide to examining and appreciating an ancient subject will be the aspiration to a past time that shrouds in mystery both historical figures and events and it will be, above all, the portrayal of that which never changes: human passions and the appearance of nature (Sperken 1980, 17–18).

Gladiator Fight during a Meal at Pompeii, Netti's most famous work, was displayed at the 1880 National Exposition in Turin and purchased immediately by Queen Margarita of Italy. Considered his most important painting by his contemporaries, it was widely praised, although the critic Camillo Boito lamented the subject matter: drunken banqueters, half-nude women, and a corpse.

Netti's grim moralizing scene of mortal combat staged for the entertainment of dissolute, drunken Romans borrowed its protagonist from Gérome's famous gladiatorial canvas *Thumbs Down* (1872; Phoenix Art Museum). The painting is underpinned by the precise depiction of specific archaeological artifacts (such as the helmet of the victorious gladiator depicting scenes from the sack of Troy; pl. 10.1), architectural details (for example, the mosaic columns from the Villa of the Mosaic Columns; Naples, Museo Archeologico Nazionale, 10000). The polychrome marble statue of Venus in the background is clearly the Venus

10.1. Thracian gladiator's helmet found in the Gladiators' Barracks at Pompeii in 1767. Naples, Museo Archeologico Nazionale, 5673.

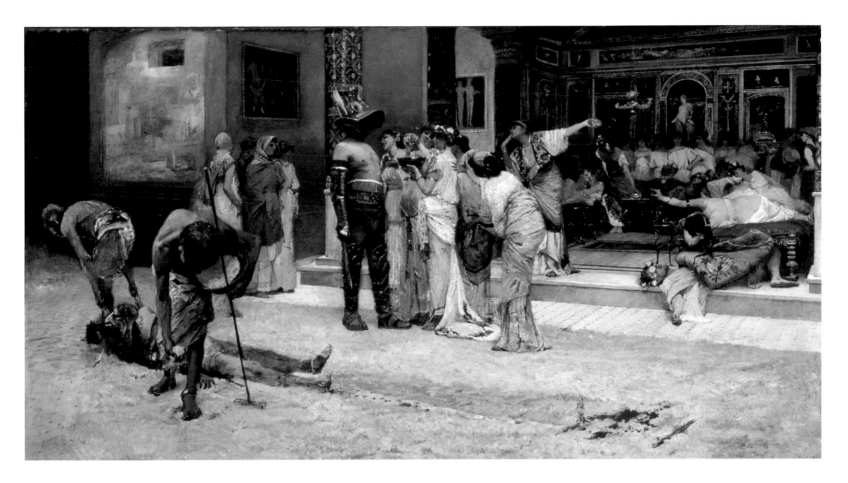

Lovatelli excavated at Pompeii in 1873 (House I.2.17; Naples, Museo Archeologico Nazionale, 109608). It has also been suggested that In the four women standing to the left, with heads draped, Netti brought to life some of the dancers from Ruvo, with which he was so taken. The artist not only carefully replicated archaeological realia but also evidently took great delight in inventing the lost fabrics and embroideries of the ancient world, creating, for example, the sumptuous vestlike garment worn by the woman blowing the victor a kiss, a distinctly modern gesture.

Although scholars have declared the architectural environment depicted in *Gladiator Fight during a Meal at Pompeii* to be as fanciful as the event shown, there is actually good ancient evidence for both. To be sure, the scenes decorating the walls are common types: sacro-idyllic scenes appear frequently in Roman wall painting; Achilles on Skyros (where Odysseus exposed the young Greek warrior disguised in women's clothing) is represented at least nine times at Pompeii alone; and the Three Graces were among the most popular ancient iconographies, repeated in multiple media. More importantly, these three images were excavated in a configuration identical to that of the painting on the walls of a small garden *cubiculum* in the

10.2. House of Apollo (VI.7.23) at Pompeii.

so-called House of Apollo (VI.7.23; pl. 10.2), although two are in mosaic rather than fresco. Moreover, in this building complex, behind a single-stepped platform, are two rectilinear niches flanking a central arched one, as in Netti's painting. Thus, although today it is much deteriorated, there can be no doubt that this space provided the model for Netti's architectural setting.

Scholars have likewise asserted that Netti's moralizing painting has little basis in ancient practice, and this, for the most part, is true, as Roman gladiators generally performed in the amphitheater and, being valuable, did not often fight to the death. Some ancient authors, however, did descry, for ideological purposes, the dissolute habits of the pre-Roman inhabitants of Campania (the region surrounding Pompeii), which they claimed included staging such violent games during meals. In the first century A.D., the politician and poet Silius Italicus (*Punica* 11.43–55), wrote of the Cumaeans: "their way of life was defiled by every stain…it was their ancient custom to enliven their banquets with bloodshed, and to combine with their feasting the horrid sight of armed men fighting; often the combatants fell dead above the very cups of the revelers, and the tables were stained with streams of blood."

If Roman authors disparaged the earlier inhabitants of Campania, Greeks ascribed the same base practices to the Romans themselves. The Peripatetic philosopher Nikolaos of Damascus (who served as tutor to the children of Marc Antony and Cleopatra) wrote that

> The Romans staged spectacles of fighting gladiators not merely at their festivals and in their theatres, borrowing the custom from the Etruscans, but also at their banquets. At any rate, it often happened that some would invite their friends to dinner, not merely for other entertainment, but that they might witness two or three pairs of contestants in gladiatorial combat; on these occasions, when sated with dining and drink, they called in the gladiators. No sooner did one have his throat cut than the masters applauded with delight at this feat (*Histories*, quoted by Athenaios, *Deipnosophistai* 4.153f–154a).

Whether Netti himself actually knew these texts is unclear, but he read widely and had studied ancient art carefully during his years in Rome. His painting, however, combines the drunkenness and gluttony noted by Greek and Latin authors with violence and sex (absent from those ancient accounts), as presumably well-born ladies swoon around the victor, offering him wine as emaciated slaves drag off the body of his fallen opponent. Indeed, in a study for this painting one of the drunken women is naked, and in another early painting (*The Gladiator*, 1872) Netti depicts a well-dressed woman embracing a resting gladiator, reflecting, in all probability, the popular interpretation of the skeleton of a richly jeweled lady found in the Gladiators' Barracks of Pompeii in the 1760s, wrongly thought to have been an upper-class Roman woman engaged in a tryst with her gladiator lover, rather than someone fleeing from the volcano who, along with several others, took refuge while trying to escape the city. It has also been suggested that the painting constitutes a contemporary critique of the Italian ruling class: "The drunkards in the background of Netti's picture present an overindulgent and bloodthirsty ruling class which oppresses and even slaughters 'at home' its own population, namely the southerners" (Figurelli, 151).

Despite the success of *Gladiator Fight during a Meal at Pompeii*, Netti soon abandoned antiquity as a theme for his work, believing, with other critics, that it had reached a saturation point. Henceforth he devoted himself to depictions of contemporary life. | KL

SELECTED BIBLIOGRAPHY

Figurelli, Luna, "Italian Painters and the 'Southern Question,'" in Hales and Paul 2011, 136–52.

Galante, Lucio, "Francesco Netti, il critico e il pittore," *Annali dell'Università di Lecce, Facoltà di Lettere e Filosofia* 8–10, no. 2 (1977–80 [1981]): 103–36.

Sperken, Christine Farese, *Francesco Netti (1832–1894): Un intellettuale del Sud* (Bari, 1980), 17–18, 52–53, nos. 54 and 55 (with prior bibliography).

Sperken, Christine Farese, *Francesco Netti* (Naples, 1996), esp. 15–20, pls. 23–31.

Sperken, Christine Farese, in *Civiltà dell'Ottocento: Le arti figurative* (Naples, 1997), 589, 625.

Tangorra, Vito, *Francesco Netti: Pittore e Critico d'Arte* (Bari, 2008), 29, 32, pl. 9.

Photography by Von Gloeden and Plüschow

Hailing from a minor German noble family, Wilhelm von Gloeden trained in art and art history. He initially moved to southern Europe on account of poor health, eventually settling in Taormina, Sicily, where he took up photography as an amateur. The loss of family money in the late 1880s forced him to turn his pastime into a profession, and he initially sold postcards and other tourist views while developing a more artistic studio practice. Von Gloeden played a key role in his adoptive community—beyond his emotional and sexual rapport with some models, he also provided employment and financial support for a far larger circle. The recuperation of his reputation in the 1960s and 1970s as a protomodern gay artist fostered a view of von Gloeden as operating within an obscure and hidden subculture, but in fact he enjoyed considerable financial and artistic success in his lifetime, and his work was widely exhibited and published. He played a critical role in opening up Taormina to tourism, and visitors to his studio ranged from Oscar Wilde and King Edward VII to Alexander Graham Bell.

Although von Gloeden photographed landscapes, genre subjects, portraits, and female nudes, today he is known nearly exclusively for his images of young, naked males. While these works comprised a significant part of his practice, the more openly erotic images seem to have been sold in a private market and were not available to every studio visitor. These works, appearing during his lifetime in key publications such as *Die Schönheit* and *Der Eigene,* played an important role in forging a specifically gay visual language. Nonetheless, his work had fallen out of favor well before his death in 1931, and Fascist operatives destroyed about a third of his negatives later in the decade.

Von Gloeden wrote about rewarding a group of models for their work with a trip to Naples. This visit has led to the assumption that *Youths on a Terrace* (pl. 11) was executed in the Vesuvian region, but it was, in fact, staged in Sicily, as indicated by a caption on several prints. The loose and painterly background, moreover, lacks von Gloeden's customary crispness, which he achieved through long exposures, careful direction to his sitters, and his mastery of the albumen silver process, with meticulously prepared large glass plates. The view of the volcano across the bay is either a painted backdrop or was retouched on the negative.

In plate 11, the Neapolitan setting, the elegantly posed figures, the luxurious props, and the distant vista all demonstrate von Gloeden's rapport with the paintings of Lawrence Alma-Tadema (see pls. 8 and 70), whom he at times directly emu-

lated. Alma-Tadema in turn had an extensive collection of von Gloeden's photographs, which he used as models for his paintings—just one example of the interweaving of photography and painting in this period. Von Gloeden's tableau plays down the eroticism found in much of his other work, presenting his five young models at a considerable distance from the camera. None of the young men touch one another; two are discreetly draped, one appears from behind, and the others pose so their genitals are not visible.

The reception of this photograph is not known, since no original owners of the prints have been identified, and the work seems not to have been published until the late twentieth century. The discretion and formality of the image suggest a wider target audience beyond an exclusively gay clientele, with the photograph's subject tied to fin-de-siècle attitudes about the Mediterranean, the academic nude, and a German interest in nudist culture. Nonetheless, the notion of re-creating ancient life by placing reanimated figures among the ruins has a long history in Pompeian image-making, dating back to the early nineteenth century with Francesco Piranesi (see pl. 63 and fig. 4) and continuing through history painting later in the century (see pl. 73).

Gugliemo Plüschow remains more elusive and less well documented, and his œuvre is still being untangled from that of his cousin von Gloeden, a situation complicated by the fact that he neither dated nor annotated his prints. By the early 1870s, Plüschow had moved to Rome, where he Italianized his first name. He enjoyed success by the 1880s, and by the early 1890s he was in Naples. Although he survived primarily as a portrait photographer, no example of this work has yet been identified. The clientele for his extant œuvre—mostly frank nudes of both sexes—is not known in depth, but he was patronized by expatriate gay men, who favored his images of young men. Unlike von Gloeden, Plüschow worked in urban environments, and his career ended in Rome with an accusation of corrupting a minor, which resulted in house arrest. He eventually returned to Germany in 1910, after which point his career is untraced.

How Plüschow created his tableaux (pls. 12–13.1) in a major tourist site—particularly given the large cameras and glass plates required for his method, the reliance on daylight, and the elaborate poses assumed by young models—is not known. Some photographs could have been executed out of the public eye, but the three sites presented here were among the most visited at Pompeii. However, the murkier resolution of these images

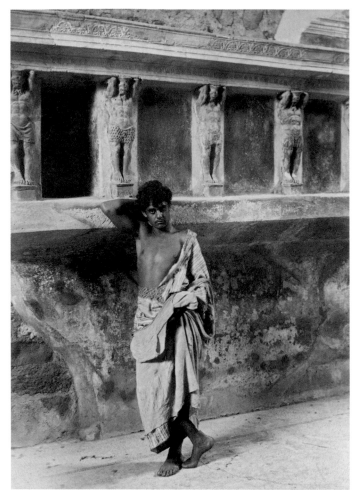

13.1. Guglielmo Plüschow (German, active Italy, 1852–1930), *Youth in the Forum Baths at Pompeii*, ca. 1900. Silver gelatin or albumen print, 11.5 × 16 cm (4⁹⁄₁₆ × 6⁵⁄₁₆ in.). Munich, Museum für Abgüsse Klassischer Bildwerke, Photo 5494.

lation of protective gates, indicates that the photographs were executed in or just after 1896, when the excavations there concluded.

These photographs characterize Plüschow's blunter and more explicit style. He was less likely than von Gloeden to retouch negatives and paid less attention to facial expressions, chiaroscuro, and graceful poses. Likewise, he connects the Pompeian sites more directly to sexual desire. Two sites here—the Tomb of Mamia, outside the Herculaneum Gate, and the Forum Baths—had a history of being eroticized and linked to same-sex desire (see fig. 9 and pl. 8).

While same-sex desire is today the primary frame for interpreting Plüschow, some audiences understood his works in other ways. Plüschow's photographs follow von Gloeden's figural mode, also connecting to the language of history painting. The Birmingham prints were once owned by Alma-Tadema, who bought these pictures—along with many other prints by the artist—for his enormous photographic archive, using them as figure studies and guides to archaeological settings. Plüschow also created prints similar to that of the House of the Faun (pl. 12) for E. Neville Rolfe's article "A Pompeiian Gentleman's Home Life," published in the general interest American periodical *Scribner's Magazine* in 1898. The article describes the recently excavated House of the Vettii (without mentioning the Priapus fresco). Lavishly illustrating the article, Plüschow's prints repopulate the site with contemporary youths standing in for the previous inhabitants, thus tying his work, like that of von Gloeden, to a long-standing tradition of resurrecting an antiquity tinged with decadence. | JLS

points to the use of smaller plates, quicker sessions, and a less painstaking preparation of silver salts.

Plüschow's models, in contrast to those of von Gloeden, are not consistently identifiable across his œuvre and appear to have been hired for individual sessions. His chronology also remains fuzzy, with the dates suggested for Plüschow's Pompeian photographs varying wildly. However, his work at the House of the Vettii, which shows the site before the instal-

SELECTED BIBLIOGRAPHY

Aldrich, Robert, *The Seduction of the Mediterranean: Writing, Art, and Homosexual Fantasy* (London and New York, 1993), 136–61.

Miraglia, Marina, "I nostri antenati: Guglielmo Plüschow alla ricerca del bello ideale," *AFT* (*Archivio Fotografico Toscano*) 4, no. 7 (July 1988): 62–67.

Pohlmann, Ulrich, *Wilhelm Von Gloeden: Sehnsucht nach Arkadien* (Berlin, 1987).

Pohlmann, Ulrich, "Alma-Tadema and Photography," in Edwin Becker, *Sir Lawrence Alma-Tadema* (New York, 1997), 111–27.

Weiermair, Peter, *Guglielmo Plüschow* (Cologne, 1994).

Wilhelm von Gloeden
German, active Italy, 1856–1931

YOUTHS ON A TERRACE

1890–1900
Albumen print, 27.9 × 35.6 cm (11 × 14 in.)
New York, Keith de Lellis Gallery

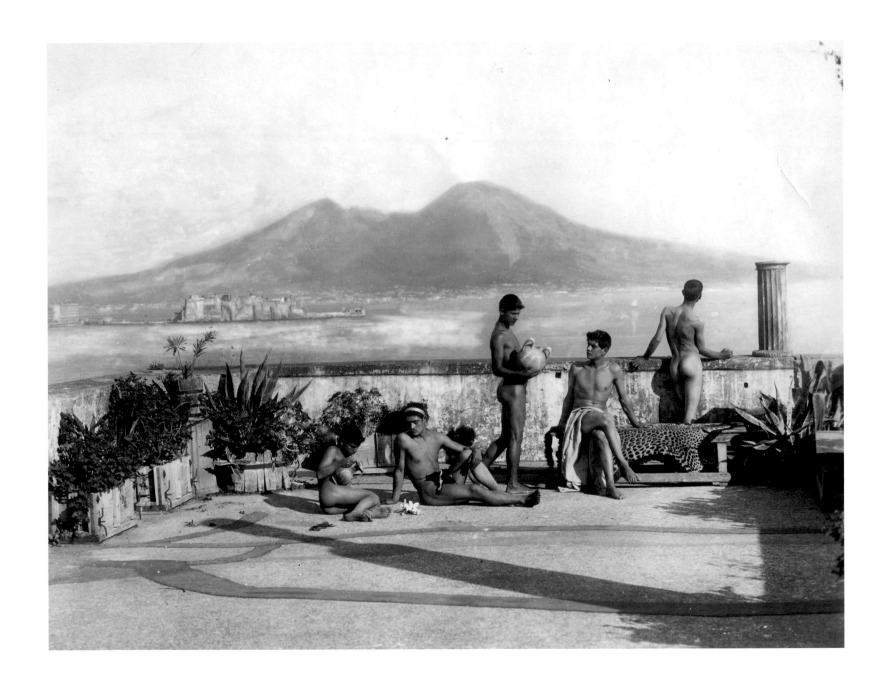

Guglielmo Plüschow
German, active Italy, 1852–1930

YOUTHS IN THE HOUSE OF THE FAUN AT POMPEII

c. 1900
Silver gelatin print, mounted on cream board,
print: 11.7 × 16.4 cm (4⁹/₁₆ × 6⁷/₁₆ in.); mount: 30.4 × 45.5 cm (11¹⁵/₁₆ × 17¹⁵/₁₆ in.)
University of Birmingham, Cadbury Research Library:
Special Collections (Alma-Tadema Collection 11160)

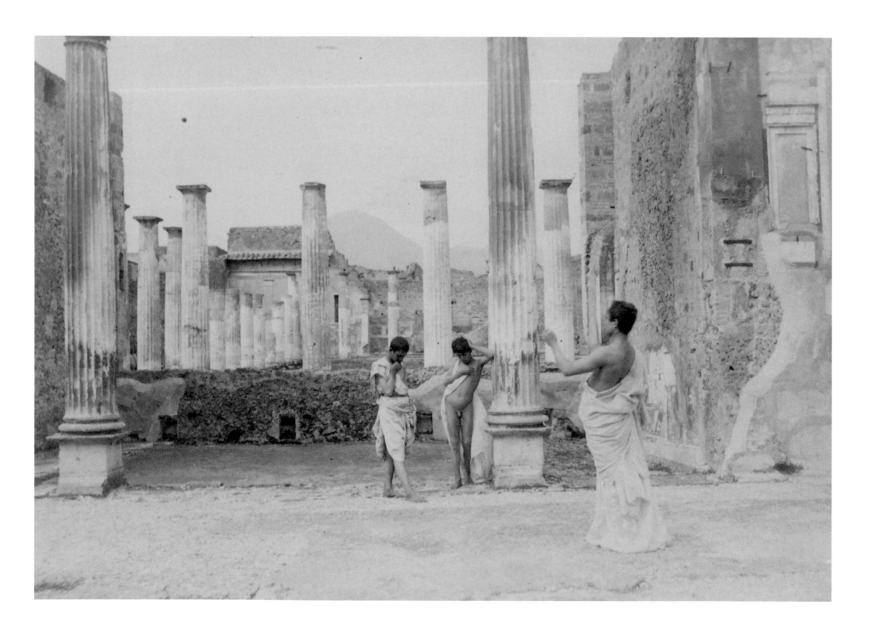

13

Guglielmo Plüschow
German, active Italy, 1852–1930

FLUTEPLAYER AND BOYS AT THE TOMB OF MAMIA AT POMPEII

c. 1900
Silver gelatin or albumen print, mounted on cream board,
print: 11.3 × 15.8 cm (4⁷/₁₆ × 6³/₁₆ in.); mount: 30.4 × 45.5 cm (11¹⁵/₁₆ × 17¹⁵/₁₆ in.)
University of Birmingham, Cadbury Research Library:
Special Collections (Alma-Tadema Collection 12478)

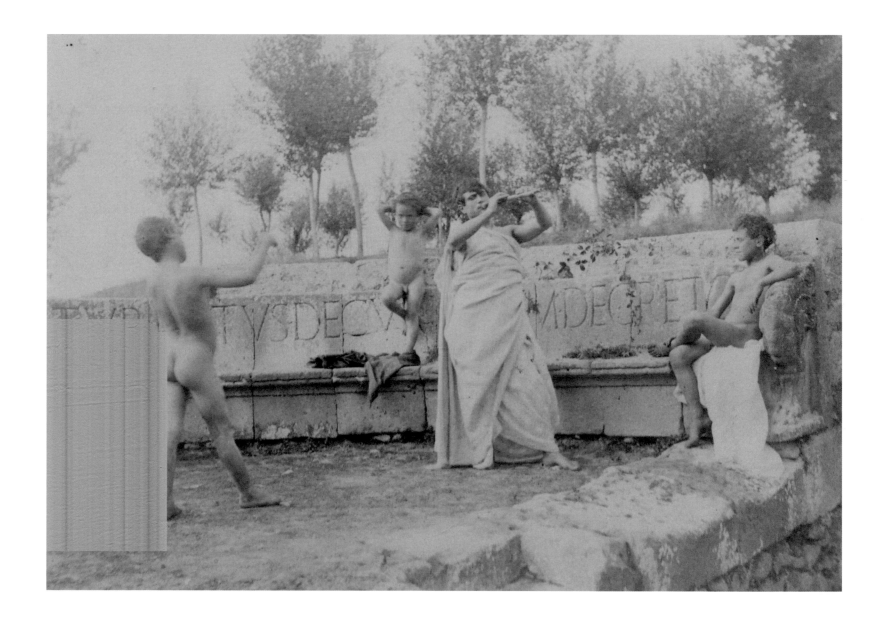

14

SIGMUND FREUD'S CAST OF "GRADIVA"

ca. 1910
Plaster cast, 79.5 × 44.8 × 7.8 cm (31¼ × 17⅝ × 3⅛ in.)
London, Freud Museum, 3713

Freud became fascinated with Wilhelm Jensen's 1903 novella *Gradiva: A Pompeian Fancy* after Carl Jung brought it to his attention. Freud wrote an extensive analysis of the story, *Delusions and Dreams in Jensen's* Gradiva, that went into several multilingual editions; indeed, it can be argued that Freud's essay has been more influential than the original text.

Jensen's *Gradiva* is the story of a neurotic archaeologist, Harold Norbert. Norbert develops an obsession with a young woman named Gradiva, who he believes lived in ancient Pompeii. He associates her with an ancient relief, buys a modern copy of it, and then pursues her spirit to Pompeii itself. Norbert has an extended dream of her death in the eruption of Vesuvius, and then experiences daily visions of Gradiva walking gracefully through the streets of the city. Ultimately, the specter of Gradiva is revealed to be Norbert's childhood love Zoë Bertgang, who has been impersonating her ancient rival in an attempt to bring the archaeologist back to the present.

Freud found in *Gradiva* a model for his new practice of psychoanalysis, in which Norbert's practice of archaeology became analogous to the exploration of the levels of the human psyche, both conscious and unconscious. The character of Gradiva ("she who advances") emerged as a feminine ideal promising both love and healing. Gradiva proved personally compelling to Freud, who in imitation of Norbert purchased a plaster cast of the ancient original that he displayed in his Vienna and London studies (see fig. 49).

In this context, Gradiva was presented along with Freud's extensive collection of antiquities, as well as his reproductions of Renaissance works of art and opulent oriental carpets that were piled on the floor and furniture of his offices. The complex, layered display was designed to engage and inspire the patients who reposed on his famous couch. In the original installation, "Gradiva" would have been one of the first objects to meet a patient's eye and she would have seemed to be walking directly toward their space.

The object that has come to be known as Gradiva, however, has nothing to do with ancient Pompeii. The original is part of a multifigure relief in the Vatican (Museo Chiaramonti, 1283), created after Pompeii was buried and found in Rome, and which is considered to be a Roman copy of an ancient Greek original (pl. 14.1). In *Gradiva* Jensen claims that Norbert encountered the original relief in a "great Roman collection," then acquired a cast on which he fixated, conjuring up the Pompeian connection out of his own fantasy rather than through any archaeological

evidence. This account may well reflect Jensen's own experience of coming across a neglected antique that seemed to him strangely modern and whose pose then inspired his description of Gradiva's unusual style of walking, which in turn inspired her name: "one could perceive clearly that in advancing, the right foot, lingering, if only for a moment, rose on the tips of the toes almost perpendicularly...with her unusual gait, she must have left behind in the ashes a foot-print different from all the others" (Jensen, 46).

Isolated from her original companions and produced in plaster cast, this "Gradiva" is a replica of a replica that has been manipulated and renamed to suit a thoroughly modern purpose.
| vcgc

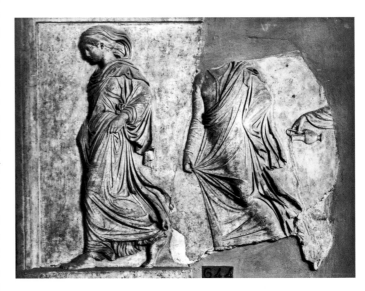

14.1. "Gradiva" relief, Roman copy of Greek original. Marble, 72.5 × 84 cm (28½ × 33⅛ in.). Vatican City, Museo Chiaramonti, VII/2, inv. 1283.

SELECTED BIBLIOGRAPHY

Armstrong, Richard H., *A Compulsion for Antiquity: Freud and the Ancient World* (Ithaca and London, 2005).

Freud, Sigmund, *Delusions and Dreams in Jensen's Gradiva,* in *Standard Edition of the Complete Psychological Works of Sigmund Freud* (1953–74), 9:3–95.

Hughes, Judith M., *From Freud's Consulting Room: The Unconscious in a Scientific Age* (Cambridge, 2004).

Jensen 1913.

Orrels, Daniel, "Rocks, Ghosts and Footprints: Freudian Archaeology," in Hales and Paul 2011, 185–98.

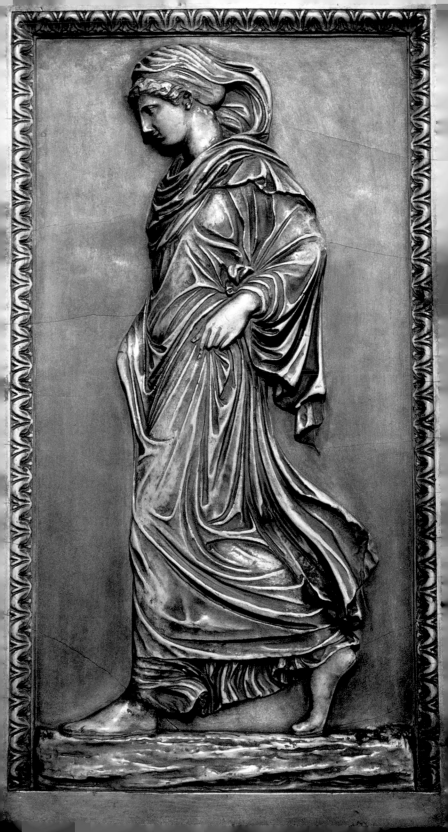

15

Salvador Dalí
Spanish, 1904–1989

GRADIVA REDISCOVERING THE ANTHROPOMORPHIC RUINS

1931–32
Oil on canvas, 65 × 54 cm (25¹¹⁄₁₆ × 21¼ in.)
Madrid, Thyssen-Bornemisza Collection, 1975.39

Salvador Dalí was born into an upper middle-class Catalan family in northeastern Spain. On his fifth birthday he was solemnly informed by his parents that he was the reincarnation of an older brother (also named Salvador), who had died shortly before he was born. This experience shaped Dalí's approach to identity and memory, as he believed he was both a stand-in for and a successor to his brother, that he was both present and absent, and that their memories were fused.

Dalí was a precocious draftsman and he was encouraged to study art by his parents, who hosted his first exhibition in their home in 1917. At the age of eighteen, Dalí moved to Madrid and enrolled in the Real Accademia de Bellas Artes de San Fernando. Already a flamboyant personality who favored opulent, oriental clothing and extreme behavior, Dalí managed to get himself expelled from the academy in 1926 and traveled briefly to Paris, where he met Pablo Picasso. He then settled in Spain and began to develop the hyperrealist technique fused with bizarre subconscious imagery that was to define his mature style.

The young artist quickly came to the attention of the Surrealists, who were impressed with the dream-state film *Un chien andalou* Dalí created in collaboration with Luis Buñuel. Dalí returned to Paris in 1929, where a catalogue by the artist André Breton accompanied his first solo exhibition. Dalí soon established a close relationship with Gala Éluard, the beautiful wife of the Surrealist poet Paul Éluard. She was also the mistress of the artist Max Ernst and ten years Dalí's senior. They married in 1934.

Gala emerged for Dalí as a fusion of model, muse, mother, and wife who relieved his myriad sexual inhibitions and inspired an outpouring of creativity. Dalí identified her with a number of alter egos, one of the first of which was the imaginary ancient Pompeian "Gradiva," heroine of Wilhelm Jensen's 1903 novella of the same name (see pls. 14 and 16). By 1931, when Gala and Dalí were established as a couple, the artist would have known both Jensen's text and Sigmund Freud's influential analysis, *Delusions and Dreams in Jensen's Gradiva*, in French translation (see the essay "Pompeii on the Couch" in this volume). Just as Gradiva fused the ancient and the living and brought the promise of healing to the psychologically troubled (as diagnosed by Freud) archaeologist Harold Norbert, so Gala seemed to Dalí to provide a chance for stability and prosperity.

Dalí was forthright in his praise for Gala as Gradiva in his 1942 autobiography, *The Secret Life of Salvador Dalí*, dedicating the book to "Gala-Gradiva" and including a drawing of her (see fig. 51). In numerous drawings by Dalí (examples are also in Munich, London, and private collections), Gradiva appears as a swirling dynamo, the Surrealist embodiment of forward motion toward self-knowledge. The artist's most complex statement on this theme, *Gradiva Discovering the Anthropomorphic Ruins* is more ambiguous. Rather than a figure in motion, the white, robed Gradiva in this painting quietly embraces the artist's self-representation—identified by the ink pot on his shoulder—a figure without a brain, heart, or genitals. It is not clear if Gradiva is consoling him, healing him, or both.

The ruins in the background are not remnants of antiquity but rather some sort of record of humanity—possibly the human psyche—that Gradiva is exploring. As Pablo Picasso later recalled, Dalí had become obsessed with the human body casts from Pompeii and proposed casting entire sections of Paris to create a similar record of a simulated modern mass destruction, a project that might illuminate Dalí's imagery in this painting. | VCGC

SELECTED BIBLIOGRAPHY

Ades and Taylor 2004.

Brassaï (Gyula Halász), *Conversations with Picasso*, trans. Jane Marie Todd (Chicago, 1999), 97.

Brown 2001.

Dalí 1993.

Jeffrett and Guigon 2002.

André Masson
French, 1896–1987

GRADIVA

1939
Oil on canvas, 97 × 103 cm (38³/₁₆ × 40½ in.)
Paris, Centre Pompidou, achat avec la participation du Fonds du Patrimoine et de la
Sociéte des Amis du Musée national d'art moderne, 2011, Inv. AM 2011–6.

André Masson received his early training in Brussels, then in 1913 moved to Paris, where he enrolled in the École des Beaux-Arts. A somewhat eccentric young man, whose enthusiasms included Richard Wagner and vegetarianism, Masson's early artistic interest was in the emerging Cubist movement.

In 1915 Masson joined the French infantry to fight in World War I, hoping that he would experience the sort of heroic events depicted in Wagner's operas. Fighting in the Somme offensive, he was severely wounded in the chest and left exposed on the battlefield overnight. The artist experienced hallucinogenic visions of the supernatural inspired by the fighting raging around him and emerged severely scarred, both physically and psychologically.

After his recovery and return to Paris, Masson came to the attention of André Breton, the leader of the Surrealist movement, who encouraged him to join the Surrealists and abandon Cubism for a more symbolic, biomorphic style. During the 1920s and 30s, the independent and still deeply disturbed Masson engaged in an uneasy relationship with the group (Breton expelled Masson from the Surrealists in 1929, although they were reconciled in 1937).

In this period, Masson became increasingly fascinated with powerful mythological female figures, such as Ariadne, Ophelia, and Gradiva. The latter became the subject for this painting in 1939 (for background on Gradiva, see "Pompeii on the Couch" in this volume and pl. 14). Unlike Salvador Dalí, who subsumed Gradiva into his personal mythology (see pl. 15), Masson depicts a scene from Wilhelm Jensen's 1903 novella in which the hero Harold Norbert imagines Gradiva's death during the eruption of Vesuvius, which appears in the background of the painting. While for Masson, as for the other Surrealists, Gradiva was a figure who promised healing love, the artist concentrates here on the moment of death, perhaps recalling his own wartime experience, which holds within it the promise of resurrection.

Masson's composition is dominated by the monumental reclining figure of Gradiva, who according to Jensen passively accepted her fate as she was transformed from a living woman into a lifeless form ("her face became paler as if it were changing to white marble": Jensen, 12). The artist selected the ancient Roman *Sleeping Ariadne* (pl. 16.1) as his model, explicitly linking Gradiva to the classical past. But the *Ariadne* provided more than just a figural model; she linked Gradiva to an ancient prototype—the legendary beauty who sinks into a deathlike sleep and is subsequently abandoned by one lover and found by another.

The dominating red panels behind the main figure were inspired by the Villa of the Mysteries frescoes, which were discovered in 1909 (see fig. 50). The apparently violent, even occult, imagery of these frescoes is not clearly legible to the modern viewer, making them an appropriate model for the Surrealists, who sought in their works to capture the subconscious.

Masson's manipulation of these models, however, is modern. He breaks down the figure into fractured, shifting planes and aggressively enlarges her genitalia, which appear in the form of a conch shell. Her gracefully raised foot, which echoes Norbert's fetish and is based on a classical relief (see pl. 14.1), appears to support her torso, while the symbolic natural elements Masson favored, such as poppies and bees, swirl around her. The poppies here represent the descent into death and sleep but also rebirth, as Jensen notes, "red, flowering, wild poppies, whose seeds the winds had carried thither...had sprouted in

16.1. *Sleeping Ariadne*, Roman copy of Hellenistic original, A.D. 130–140. Marble. Rome, The Vatican, Museo Pio Clementino, Galleria delle Statue, 3589.

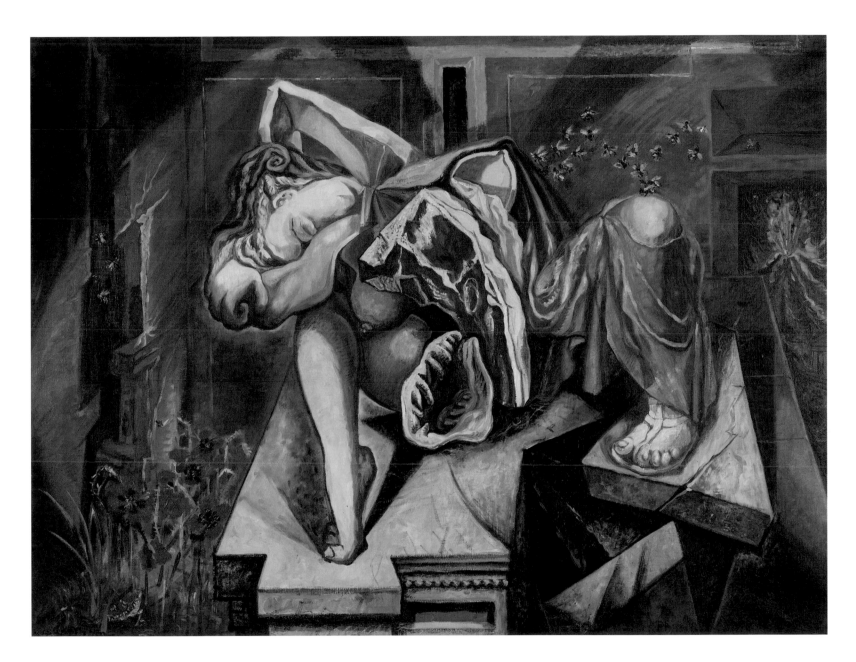

the ashes" (Jensen, 52). The bees, themselves a common classical element, may here refer to the insects that trouble Norbert by alighting on Gradiva and spoiling her beauty (although when he attempts to catch them in his mouth they enable him to kiss her). Masson's Gradiva, like her literary prototype, fuses the ancient with the contemporary in a Surrealist vision of the erotic female ideal. | VCGC

SELECTED BIBLIOGRAPHY

Chadwick 1970.

Clébert, Jean-Paul, *Mythologies d'André Masson* (Geneva, 1971).

Jensen 1913.

Ries 2002.

Rubin, William, and Carolyn Lanchner, *André Masson*, exh. cat. (New York, 1976).

Marcel Duchamp
French, 1887–1968

STUDY FOR "PRIÈRE DE TOUCHER" (*PLEASE TOUCH*)

1947
Plaster, 40.6 × 40.6 × 10.2 cm (in frame) (16 × 16 × 2 in.)
Philadelphia Museum of Art, Gift of Enrico Donati, 1997-33-1

The chameleonlike artist Marcel Duchamp redefined the fundamental concept of art in the twentieth century. By proposing that "ready-made" objects could become works of art simply through the conceptual intervention of the creator, Duchamp turned millennia of artistic production on its head by declaring the manual act of creation irrelevant.

The radical nature of Duchamp's act has to some extent distracted from his reliance on the very tradition he is seen to have undermined. Born into a family of artists in Normandy, by 1904 Duchamp was in Paris, where he enrolled in the Académie Julian—the art school that had been established in 1868 by Rodolphe Julian as an alternative to the traditional École des Beaux-Arts. Duchamp described himself as an indifferent student, and while this may have been an attempt to downplay his technical training, his experience at the academy, where rigorous drawing after life models was emphasized, would have provided him with important grounding in human anatomy.

In his early period, Duchamp experimented with a wide range of styles, including Impressionism and Cubism, but in 1913 he largely abandoned traditional painting in favor of the ready-made, with works such as *Bicycle Wheel* (1913 original lost; 1951 replica; New York, Museum of Modern Art) and *Fountain* (1917 original lost; 1964 replica; Philadelphia Museum of Art). Duchamp introduced some of his enduring alter egos during this period, notably "R. Mutt," the name with which he signed and dated the mass-produced urinal, as well as "Rrose Sélavy," Duchamp's female persona, who first appeared in 1921.

In the 1920s and 30s, Duchamp became associated with the Dada and Surrealist movements in Paris through his close friendships with André Breton, Paul Éluard, and Man Ray. Duchamp seemed almost obsessively devoted to chess during this period, leading many to conclude he had abandoned his artistic activities, but he was at work on a miniature, portable version of his creations titled *Boîte-en-valise* (1935–41; New York, Museum of Modern Art). He also collaborated in several Surrealist projects, such as designing the doorway for Breton's gallery "Gradiva" in 1937 (see fig. 52). Duchamp's participation in this effort provides a direct linkage between the artist and the Surrealists who, under Breton's influence, were executing Pompeii-related projects during this period (see pls. 15 and 16).

During the Nazi occupation of Paris in 1942, Duchamp moved to New York and began a period of secret—but intense—artistic production that would result in his masterwork, the *Etant donnés: 1° la chute d'eau, 2° le gaz d'éclairage* (Given: 1. The Waterfall; 2. The Illuminating Gas; 1946–66), installed posthumously according to the artist's instructions in the Philadelphia Museum of Art. The *Etant donnés* positions viewers as voyeurs peering through peepholes in a rustic wooden door, through which they gaze at the reclining body of a nude woman, who holds a gas lamp in one hand, while a waterfall flows in the background. The work appears to address the intersection of art, nature, and sexual love, which were all themes that had consumed the artist throughout his long career.

The precise meaning of the *Etant donnés* remains enigmatic, in no small part because Duchamp executed it in such secrecy. Even the training he undertook to complete the work was kept under close wraps. Few knew that he was taking lessons in plaster casting so he would be able to take precise impressions of the body of his mistress, Maria Martins (a sculptor in her own right who was married to the Brazilian ambassador to the United States), who was to serve as one of the models for the woman in the *Etant donnés*.

Duchamp also used plaster to create sculptures of Maria and made drawings of her as well. Two of the more detailed studies are this model of her breast and a drawing of her raised foot—the two body parts most closely associated with the imaginary Pompeian objects of desire, Arria Marcella and Gradiva. In both cases Duchamp's sensitive, detailed, and naturalistic technique belies his repeated renunciation of the manual production of art and suggests a complex relationship between the living breast of his beloved mistress, the vanished breasts of the beauties of Pompeii, and the famous impressions in ash that made them present in perpetuity.

Duchamp initially planned to make the plaster breast the cover of the catalogue *Le surréalisme en 1947*, an exhibition dominated by the artists' response to World War II. He brought the plaster model to the studio of his collaborator Enrico Donati, but when they contemplated how difficult it would be to produce hundreds of individual plaster casts of the breast, not to mention the casts' fragility, they decided to take the path of least resistance and instead purchased plastic breasts ("falsies") from

a nearby medical supply shop. Donati and Duchamp then hand-colored the false breasts and added stickers reading "Prière de toucher" (Please touch). The process was still labor-intensive, leading Donati to reflect that he had not thought before that he could tire of breasts—to which Duchamp replied, "That is the point." | VCGC

SELECTED BIBLIOGRAPHY

d'Harnoncourt, Anne, and Walter Hopps, "*Etant donnés: 1° la chute d'eau 2° le gaz d'éclairage*: Reflections on a New Work by Marcel Duchamp," *Philadelphia Museum of Art Bulletin 64, no. 299–300* (1969): 6–58.

Girst, Thomas, "Duchamp's Window Display for André Breton's *Le Surréalisme et la Peinture* (1945)," *Tout-Fait: The Marcel Duchamp Online Studies Journal* (January 2002): http://www.toutfait.com/issues/volume2/issue_4/articles/girst/girst4.html (last accessed April 21, 2012).

Kuenzli, Rudolf, and Francis Naumann, eds., *Marcel Duchamp: Artist of the Century* (Cambridge, Mass., 1989).

Taylor, Michael, *Marcel Duchamp: Étant donnés*, exh. cat. (Philadelphia, 2009).

18

Hernan Bas
American, b. 1978

VESUVIUS

2005
Acrylic, gouache, and water-based oil on wood, 122 × 91.5 × 5 cm (48 × 36 × 2 in.)
Miami, Rubell Family Collection

Behind a lush, overgrown shoreline and a fragment of classicizing architecture—perhaps an aqueduct—Vesuvius erupts, while two slender youths in T-shirts maneuver a rowboat into shallow waters. Unruffled, they both look back at the exploding volcano. One crouches, still holding onto the vessel, while the other stands up, an arm akimbo. The figures are at the cusp of maturity—not yet men, no longer boys. Their emotional state is likewise ambiguous: are they trying to escape (but how could they without oars)? Has their private retreat been interrupted? Or are they simply curious about the eruption?

A Miami painter and installation artist, Bas has had little formal training. His unusual mixed technique—at once watery and densely layered—intensifies the complexity of the narrative. He creates an isolated and private world, but rather than appearing evasive or cool, the youths seem self-conscious of their hovering state, maintaining an erotic tension and an awareness of their sexuality, though disinclined to articulate their thoughts directly.

Bas draws on diverse sources, from Boy Scout manuals to Old Master paintings, and he also makes reference to the fin-de-siècle aesthetic movement. In this way, his ambiguity nests within a larger history of dandyism and queer aesthetics. The painting recalls the work of artists such as Wilhelm von Gloeden (see pl. 11), where adolescent male beauty is suffused with eroticism, but sexual identity is left open to the imagination. In both cases, the works of art are instruments of projection and imagination rather than of clarity and definition. Bas probes this language of coding—a preoccupation of the artist during the mid-2000s—here investigating, in his words, "the roots of the modern Homo clichés as they developed in the period leading to the origin of the tell-tale signs" (Coetzee, 36).

Von Gloeden set his photograph at Pompeii to code same-sex desire into his work—the perceived decadence of the ancient city permitting space for an alternative, imagined sexuality. Bas, aware of this late-nineteenth-century understanding of the buried cities, uses the geological and emotional violence of the volcano, in tandem with the ambiguity and androgyny of his young men. But Bas not only presents a knowing play of concealing and revealing but also gives a romantic, and wholly contemporary, dimension to his young protagonists. | JLS

SELECTED BIBLIOGRAPHY

Coetzee 2007.

Eichler, Dominic, entry in *Ideal Worlds: New Romanticism in Contemporary Art*, exh. cat., David Altmeid et al. (Frankfurt, Schirn Kunsthalle, 2005), 107–8.

Ratteneyer, Christian, entry on Bas in *2004 Whitney Biennial*, exh. cat. (New York, Whitney Museum of American Art, 2004).

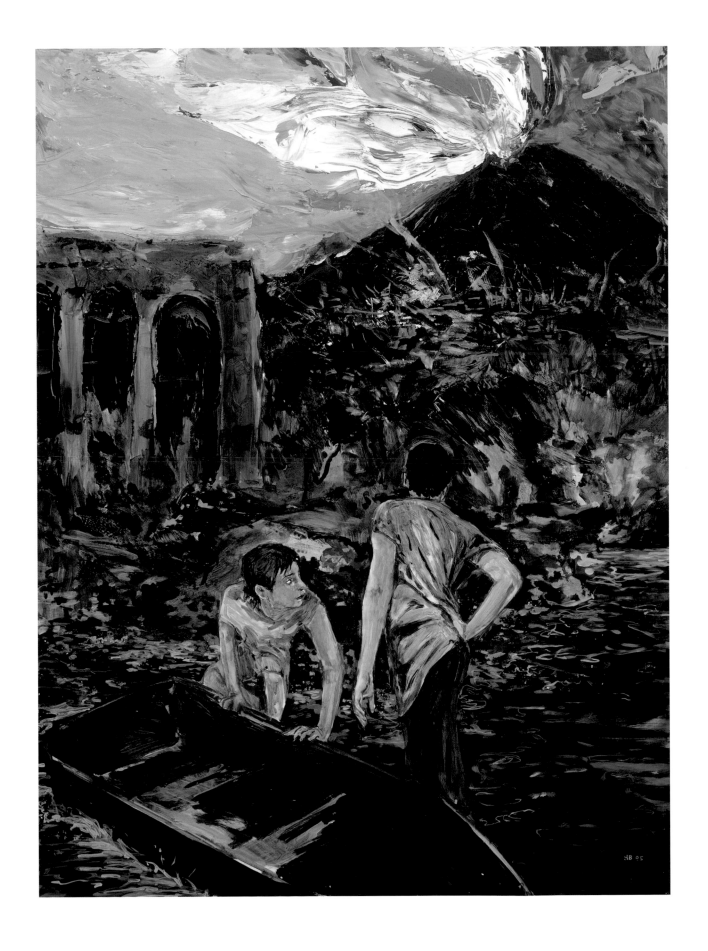

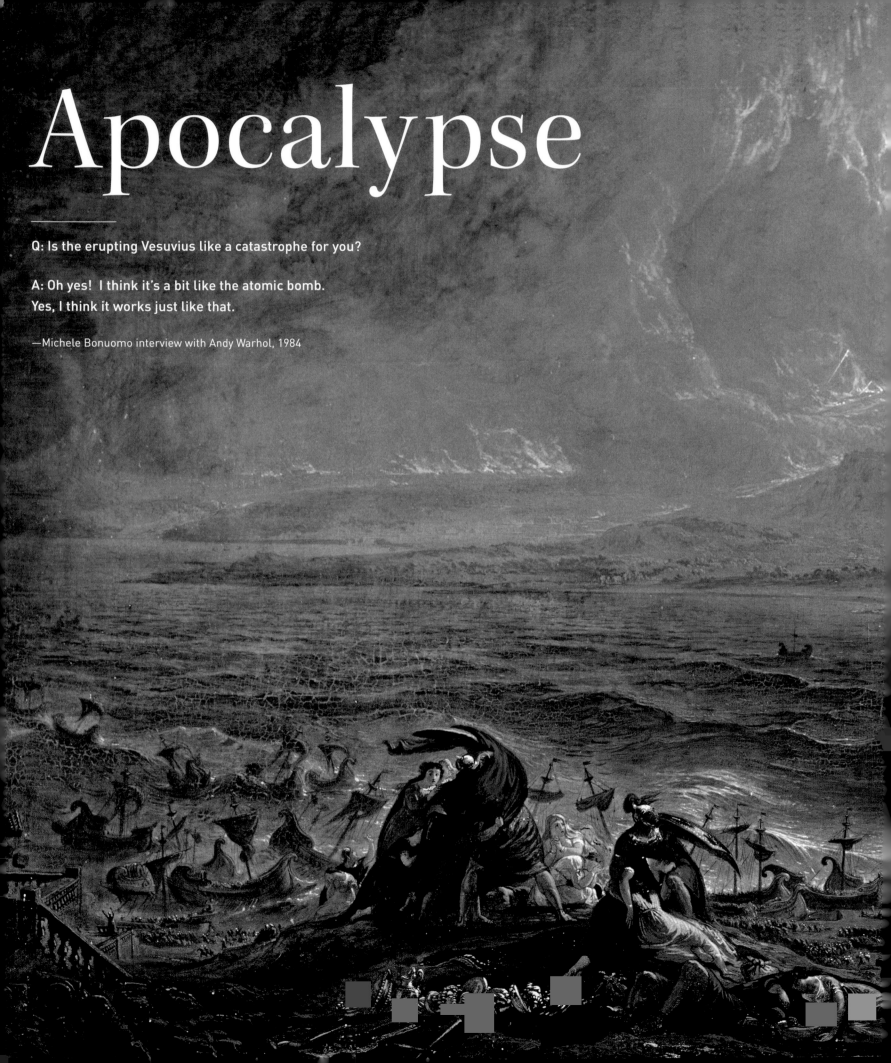

Apocalypse

Q: Is the erupting Vesuvius like a catastrophe for you?

A: Oh yes! I think it's a bit like the atomic bomb.
Yes, I think it works just like that.

—Michele Bonuomo interview with Andy Warhol, 1984

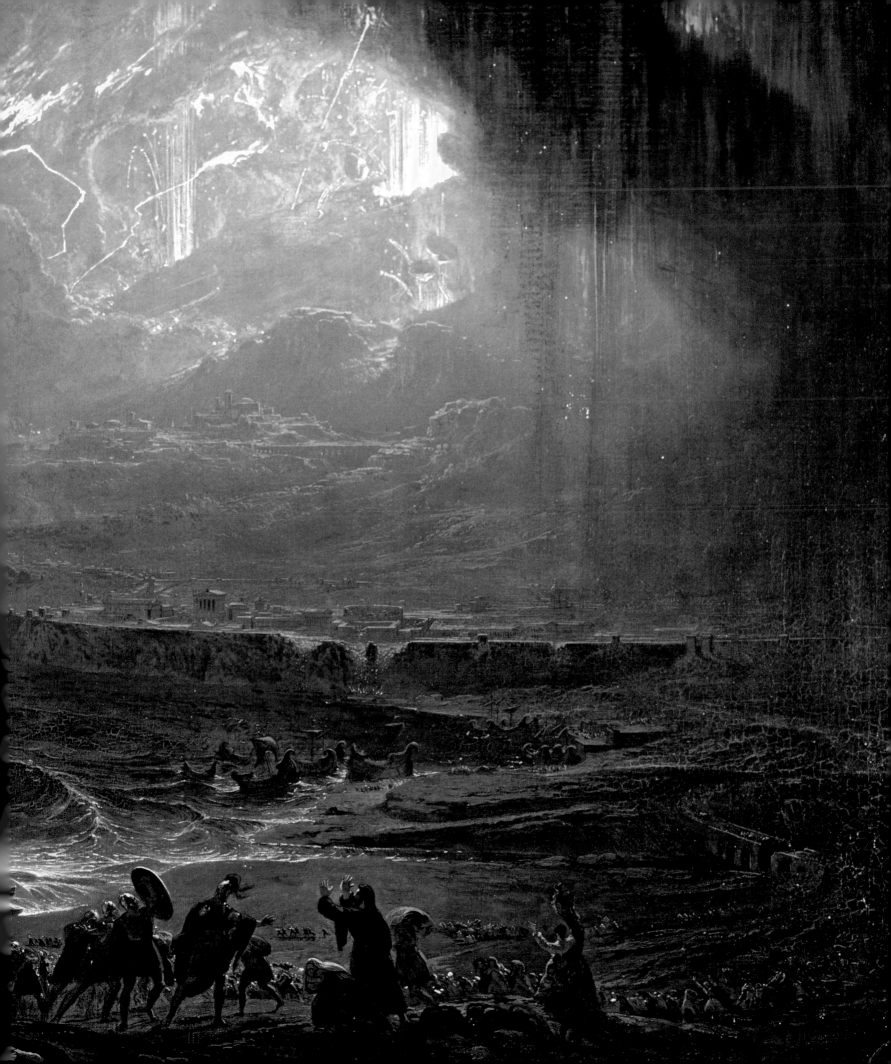

Jacob More
British, active in Rome, 1740–1793

MOUNT VESUVIUS IN ERUPTION

1780
Oil on canvas, 151.1 × 200 cm (59½ × 78¾ in.)
Edinburgh, National Gallery of Scotland, NG 290

The Scottish landscape painter Jacob More was among the first to craft a monumental image of the destruction of ancient Pompeii. Trained in Edinburgh, More designed stage sets before moving to London in 1771, where he studied under the British landscape painter Richard Wilson. More moved to Rome in 1773 and remained there for the rest of his career as a landscape painter, portraitist, and dealer for Grand Tourists visiting Italy as well as an active clientele in Britain.

During this period, More witnessed several eruptions of Vesuvius that fascinated contemporary artists such as his friend Joseph Wright of Derby. Rather than pursuing a scientific approach to documenting the eruptions of his own time as Wright did, More placed his direct observations into an antique context by including in the foreground the vignette of Pliny the Elder expiring. Attracted by the visual drama of nocturnal pyrotechnics, he also painted Mount Etna in eruption in 1788 as well as an earlier depiction of Vesuvius as a representation of fire in a series of the four elements for the earl-bishop of Bristol and Derry.

More's model was the classicizing grandeur of Claude Lorrain's landscapes, a seventeenth-century ideal that he combined with a thoroughly Romantic appreciation for dramatic natural events. This sensibility was famously documented in Edmund Burke's 1756 *Philosophical Enquiry into Origins of Our Ideas of the Sublime and Beautiful*. According to Burke, the intense sympathy aroused by the suffering of others—particularly heroic historic figures—provoked a particular form of emotional delight. He argued that the catastrophic had a beauty and appeal of its own, as well as the power to transport human beings out of their comfortable, everyday lives into a heightened plane of being:

> there is no spectacle we so eagerly pursue, as that of some uncommon and grievous calamity; so that whether the misfortune is before our eyes, or whether they are turned back to it in history, it always touches with delight. This is not an unmixed delight, but blended with no small uneasiness. The delight we have in such things, hinders us from shunning scenes of misery; and the pain we feel, prompts us to relieve ourselves in relieving those who suffer; and all this antecedent to any reason, by an instinct that works us to its own purposes, without our concurrence (Burke, 43).

More's painting reflects Burke's influential ideas, as the sweeping, bird's-eye view of the disaster dwarfs the pitiful human figures, even the great scholar Pliny and his companions. Their efforts to shield themselves from nature's wrath are fruitless, as the great umbrella cloud of ash gathers over the scene, ready to engulf both man and his creations, which is made all the more dramatic by More's theatrical staging. The painting, while purporting to document the events of A.D. 79, is thus a combination of More's training as a stage-set designer and landscape painter, as well as the contemporary philosophy of Burke. For More's viewers, the painting would have been an opportunity to bear witness to both the awesome spectacle of disaster and the wrenching human drama, reordered to suit their eighteenth-century aesthetic and philosophical principles. | VCGC

SELECTED BIBLIOGRAPHY

Burke, Edmund, *A Philosophical Enquiry into the Origin of our Ideas of the Sublime and Beautiful*, ed. Adam Phillips (Oxford, 1990).

Irwin, David, "Jacob More, Neo-Classical Landscape Painter," *Burlington Magazine* 113, no. 836 (Nov. 1972): 774–79.

Murphy 1978.

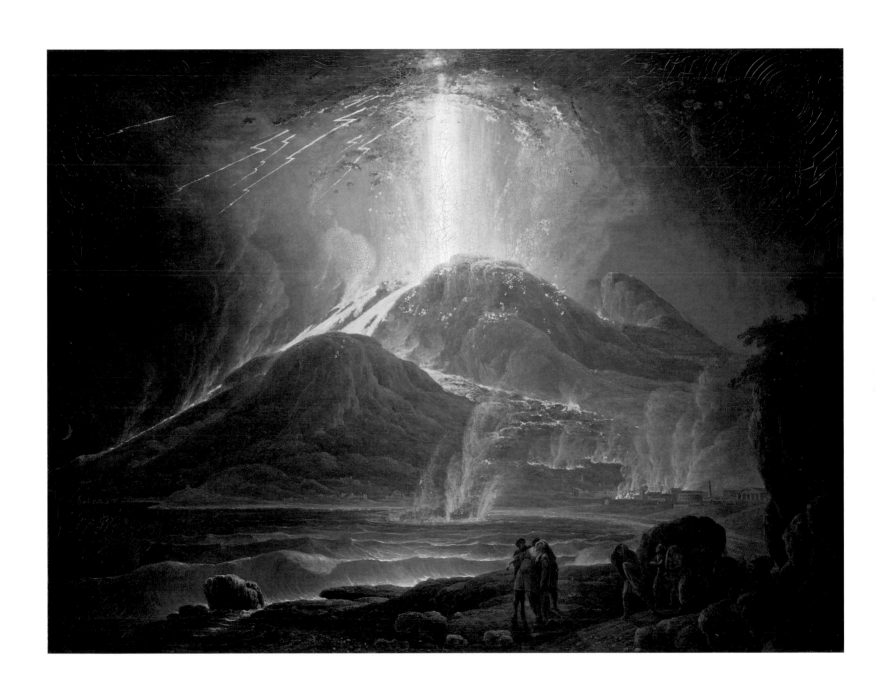

Angelica Kauffmann
Swiss, 1741–1807

PLINY THE YOUNGER AND HIS MOTHER AT MISENUM, 79 A.D.

1782
Oil on canvas, 103 × 127.5 cm (40⁹/₁₆ × 50¼ in.)
Princeton, N.J., Princeton University Art Museum, Museum purchase, Gift of Franklin H. Kissner, y1969-89

The Swiss-born painter Angelica Kauffmann was the most successful female history painter of the late eighteenth century. She had the good fortune to be born the daughter of the minor painter Joseph Johann Kauffmann, providing her with access to the artistic training so difficult for females to come by during this period. Early travel with her father, particularly through Italy, proved formative for Kauffmann, who encountered not only classical and Renaissance models but also contemporary history painters such as Benjamin West. In 1766, Kaufmann traveled alone to England, where she found a lively market for her pictures and refined her neoclassicizing style. She was befriended by Sir Joshua Reynolds and became a founding member of the Royal Academy in 1768.

Following her return to the continent in 1781, Kauffmann continued to send paintings back to her British patrons, including George Bowles, who amassed a substantial collection of the artist's work. After a visit to Naples in 1782, Kauffmann embarked on a trio of major paintings for Bowles, including *Cornelia, Mother of the Gracchi* (Richmond, Virginia Museum of Fine Arts), *Virgil Composing His Epigram* (private collection), and *Pliny the Younger and His Mother at Misenum*. All three show scenes from Roman history that took place on the Bay of Naples, but the relationship among these three highly unusual subjects is more complex than simple geography. They are further connected by their exploration of the means by which individuals become the stuff of history: Cornelia through the exploits of her sons; Virgil through the writings commemorated in his epigram; and Pliny through his record of the great events he witnessed. The trio was exhibited at the Royal Academy in 1784, possibly as an in absentia declaration by Kauffmann of her status as a major painter of history.

Pliny and His Mother at Misenum, like More's *Eruption of Vesuvius* (pl. 19) and Valenciennes's *Death of Pliny the Elder* (pl. 21), is based on Pliny the Younger's late-first-century A.D. account of the eruption of Vesuvius, which was written on the request of the historian Tacitus. But instead of focusing on the description of the death of Pliny's uncle and adoptive father, Pliny the Elder, Kauffmann elected to illustrate a passage describing the younger Pliny's activities:

We [Pliny and his mother] sat down in the forecourt of the house, between the buildings and the sea close by. I don't know whether I should call this courage or folly on my part (I was only seventeen at the time) but I called for a volume of Livy and went on reading as if I had nothing else to do. I even went on with the extracts I had been making. Up came a friend of my uncle's who had just come from Spain to join him. When he saw us sitting there and me actually reading, he scolded us both—me for my foolhardiness and my mother for allowing it. Nevertheless, I remained absorbed in my book (Pliny, letter 6. 20).

Kauffmann's eschewal of the more sensational elements in this story to focus on Pliny's study of the history that informed his later letters to Tacitus enhances her claims to being a legitimate painter of history—and so among the first tier of artists in eighteenth-century academic circles. Throughout her life, as a woman and as a popular painter of portraits, Kauffmann had to battle the stigma of being considered a lesser artist. By placing her signature on the bench that supports Pliny, as he supports the tablet bearing the words of Livy, Kauffmann creates a visual chain of history that transmits the events of the classical past to the present day, while in turn linking her to her avowed ancient prototype. | VCGC

SELECTED BIBLIOGRAPHY

Coates 2011.

Pliny the Younger (Gaius Plinius Caecilius Secundus), *Letters and Panegyrics*, vol. 1, trans. Betty Radice (Cambridge, Mass., 1969).

Roworth, Wendy Wassyng, "Kauffmann and the Art of Painting." In *Angelica Kauffmann, A Continental Artist in Georgian England*, ed. W. W. Roworth (London, 1993), 11–94.

Roworth, Wendy Wassyng, "Ancient Matrons and Modern Patrons: Angelica Kauffmann as a Classical History Painter," in *Women, Art and the Politics of Identity in 18th-Century Europe*, ed. Melissa Hyde and Jennifer Milam (Ashgate, U.K., 2003), 188–210.

Traub, H. W., "Pliny's Treatment of History in Epistolary Form," *Transactions and Proceedings of the American Philological Association* 86 (1955): 213–32.

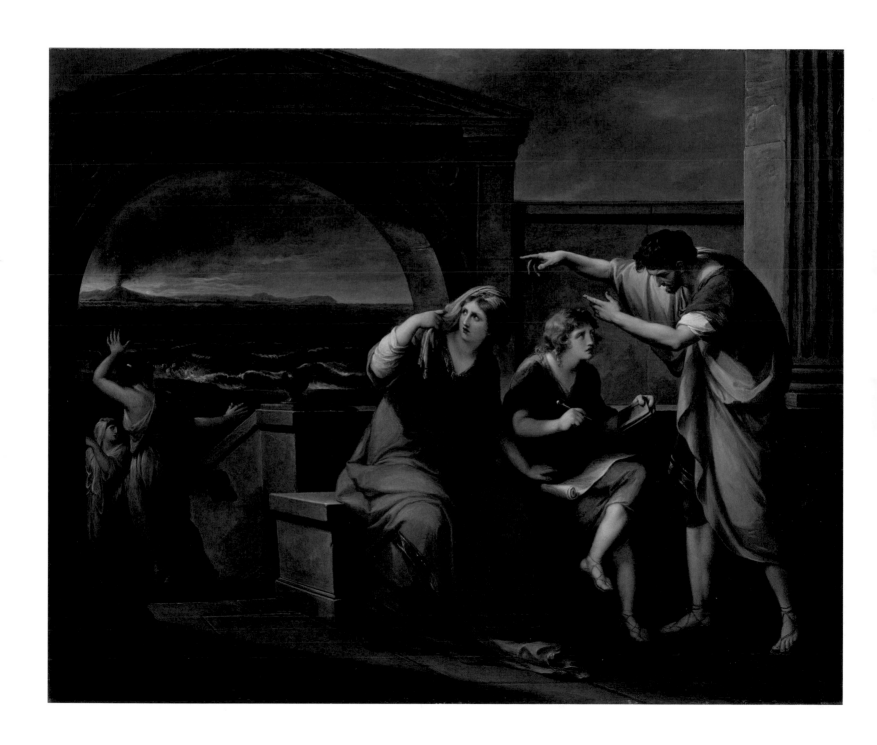

Pierre Henri de Valenciennes
French, 1750–1819

THE ERUPTION OF VESUVIUS, AUGUST 24, 79 A.D.

1813
Oil on canvas, 147.5 × 195.5 cm, (58⅛ × 76⅞ in.)
Toulouse, Musée des Augustins, 7811

Valenciennes was born in Toulouse. After studying under Jean-Baptiste Despax, he made his first trip to Italy in 1769, then he returned to Paris to train as a landscape painter with Gabriel-François Doyen. Valenciennes traveled again to Italy in 1777, where he remained for eight years. Upon his return, he became a powerful figure in the French Academy, which at that time was seeking, in imitation of Nicolas Poussin, to institutionalize the genre of *paysage historique* (historical landscapes) and thus elevate landscape paintings (formally known as *vedute* [views]) to the high status of traditional history painting. As part of this effort, Valenciennes wrote an extended and influential treatise, the *Elémens de perspective pratique à l'usage des artistes* (Elements of Practical Perspective, for Use by Artists), which transformed the way landscape painting was taught and evaluated.

During his second sojourn in Italy, Valenciennes spent substantial time with the great French landscape painter Claude-Joseph Vernet, then resident in Rome. Vernet encouraged the younger artist to sketch in oil directly from nature and then incorporate those sketches into finished compositions of historical subjects (in the twentieth century these plein-air sketches would serve to revive Valenciennes's reputation). Valenciennes also traveled extensively during this period, an experience he would later encourage other young artists to imitate. He made a long journey to southern Italy and Sicily in 1779, during which he witnessed the eruption of Mount Vesuvius.

It was not lost on Valenciennes, or on his contemporaries, that this eruption took place almost exactly 1,700 years after the destruction of Pompeii and the other Bay of Naples sites. Throughout his time in southern Italy, Valenciennes showed a lively interest in the ancient history of the region, painting, for example, a detailed view of the Greek ruins at Agrigento.

Being present at the eruption naturally turned his thoughts to his classical predecessors, notably Pliny the Younger, who had described for the historian Tacitus the death in the disaster of his uncle, Pliny the Elder. In this account, Pliny the Elder led the Roman fleet then under his command to rescue victims of the eruption, and then attempted to set an example for others by resting calmly and not trying to flee. It became clear too late that escape was in order, but as he made his way down to the beach he collapsed from asphyxiation and succumbed.

As in Jacob More's *Mount Vesuvius in Eruption* (see pl. 19), the landscape and the erupting volcano dominate Valenciennes's composition. But here the human drama rivals the natural catastrophe. Viewers can easily discern the collapsing Pliny in the middle foreground. He is further amplified by the two flanking slaves, who are mentioned by Pliny the Younger. Valenciennes focused on the juxtaposition of the demise of the greatest classical natural historian with one of the greatest natural disasters of the ancient world. This theme elevated the carefully constructed landscape with its detailed classical architecture and naturalistic volcano, both based on the artist's direct observations, to the highest ranks of contemporary academic painting. | VCGC

SELECTED BIBLIOGRAPHY

Carus, Carl Gustav, *Nine Letters on Landscape Painting: Written in the Years 1815–1824*, trans. David Britt (Los Angeles, 2002): 19–22.

Conisbee, Philip, "Pre-Romantic *Plein-air* Painting," *Art History* 2 (1969): 413–28.

Marlais, Michael, John Varriano, and Wendy M. Watson. *Valenciennes, Daubigny, and the Origins of French Landscape Painting*, exh. cat. (South Hadley, Mass., 2004).

Mattusch 2008.

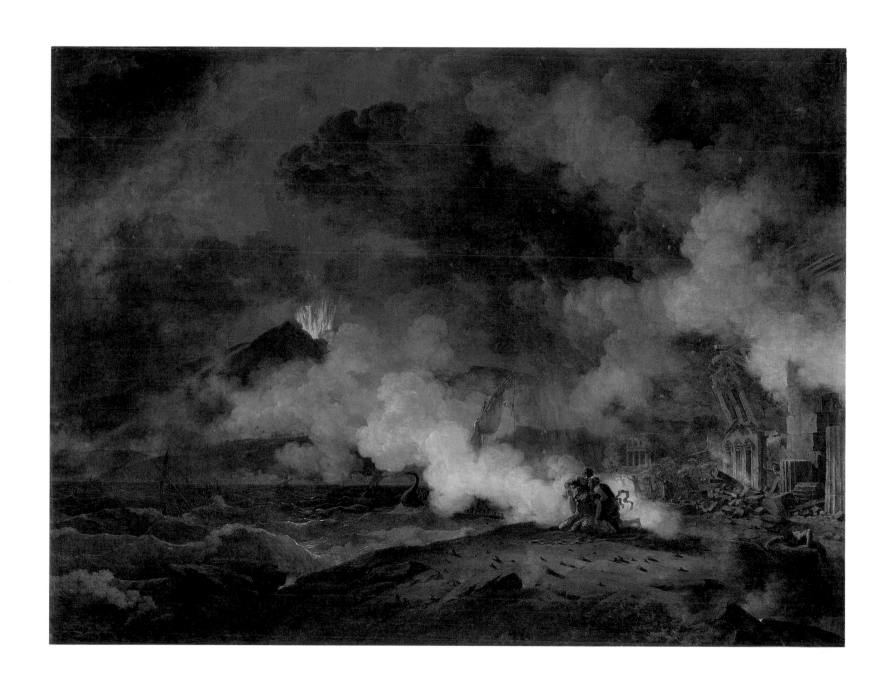

22

John Martin
British, 1789–1854

THE DESTRUCTION OF POMPEII AND HERCULANEUM

ca. 1822–26
Oil on canvas, 83.8 × 121.9 cm (32¹³⁄₁₆ × 48 in.)
University of Manchester (U.K.), Tabley House Collection

John Martin, also known as "Mad Martin," was among the most popular painters of early-nineteenth-century Britain. Born into an eccentric Northumberland family, he trained with the Piedmontese china painter Boniface Musso before moving to London in 1807. Martin continued to paint china and glass, but he studied diligently to make the transition from the decorative arts to history painting. His first attempt to exhibit at the Royal Academy was rejected in 1810, but Martin persevered and was successful in 1812 with *Sadak in Search of the Waters of Oblivion* (St. Louis Art Museum). In *Sadak* Martin established his formula of small figures engulfed by a swirling, dramatic landscape that highlights the weakness of man compared to the force of nature.

Martin's later canvases grew exponentially in size and drama. In 1820 he unveiled the sensational *Belshazzar's Feast* (private collection), an Old Testament subject from the Book of Daniel. The canvas measures 160 × 249 cm (63 × 98 in.) and is dominated by an enormous, nocturnal architectonic landscape showing the royal palace in Babylon, which was legendarily eight miles in circumference, as well as the Tower of Babel and a ziggurat. The tiny foreground figures react to the legendary "writing on the wall" that foretells the destruction of all these riches in a mighty act of God. The painting was included in the British Institute's 1821 exhibition of contemporary painting and was so popular that special barriers had to be erected to keep the crowds back. Highbrow critics were less enthusiastic (John Constable called it a "pantomime") and accused Martin of employing sensationalist effects that appealed to the common man. Indeed, Martin's style does reflect the increasingly popular spectacles and panoramas that purported to recreate historical disasters for contemporary audiences, and the artist did have a keen nose for the commercial, but his compositions rely on his laboriously self-taught mastery of perspective—a sophisticated and highly technical skill.

Martin followed the success of the *Belshazzar* with a vast canvas, *The Destruction of Pompeii and Herculaneum*, in 1822. The painter generally preferred to paint according to his own inclinations and then sell his works to collectors, but this project was executed for Richard Grenville, the first duke of Buckingham and Chandos (1776–1839). The duke was an admirer of Martin's work and apparently particularly interested in this project as both the extensive correspondence between the artist and patron and the high price of eight hundred guineas attest.

While Martin did not travel to Pompeii, he had opportunities to study the most recent finds in William Gell and Joseph Gandy's *Pompeiana* (1819; see fig. 5). He was also familiar with Herculaneum through the activities of his close friend, the poet Edwin Atherstone (1788–1882), whose long poem "The Last Day of Herculaneum" was prefaced by reprints of Pliny the Younger's letters to Tacitus about the disaster. These two sources would have provided background for both the painting's archaeological correctness and the victims' dramatic suffering. Showing Pompeii and Herculaeum from a viewpoint in Stabiae, Martin depicts specific buildings from the excavations, including the Temple of Jupiter and the Amphitheater of Pompeii. Martin documented this careful work in an attendant publication, the *Descriptive Catalogue of the Destruction of Pompeii & Herculaneum with other Pictures now Exhibiting at the Egyptian Hall, Piccadilly* (the Egyptian Hall was a popular venue for the display of sensational pictures, notably Théodore Géricault's *Raft of the Medusa* the previous year; see pl. 27.1).

Atherstone's 1821 poem was an important source. The verses are not so much a continuous narrative as a series of vignettes of violent suffering as the victims bemoan their fate,

> Some struck their dearest friends,
> But grasp'd their enemy close:—some wail'd aloud;
> Beat on their breasts—and tore their hair away,—
> And wrung their hands; then wept and wail'd again.
> Convulsed with ceaseless laughter, others fell
> Backward upon the ground;—and some there were,
> By terror as by lightning kill'd, stretch'd out
> Upon the earth: while by the tottering walls
> Supported, others sat, stiffen'd and dead,
> With jaw depress'd, and ghastly open eye,
> Upon the startled gazer glaring grim.

Martin's pitiably small foreground figures capture these varied, desperate responses to the disaster as they flee toward the viewer, suggesting that we may be the next to be consumed.

Martin's painting for Grenville, with its fusion of the archaeological and melodramatic, was so successful that a second, smaller version was purchased by Sir John Leicester in 1826. This

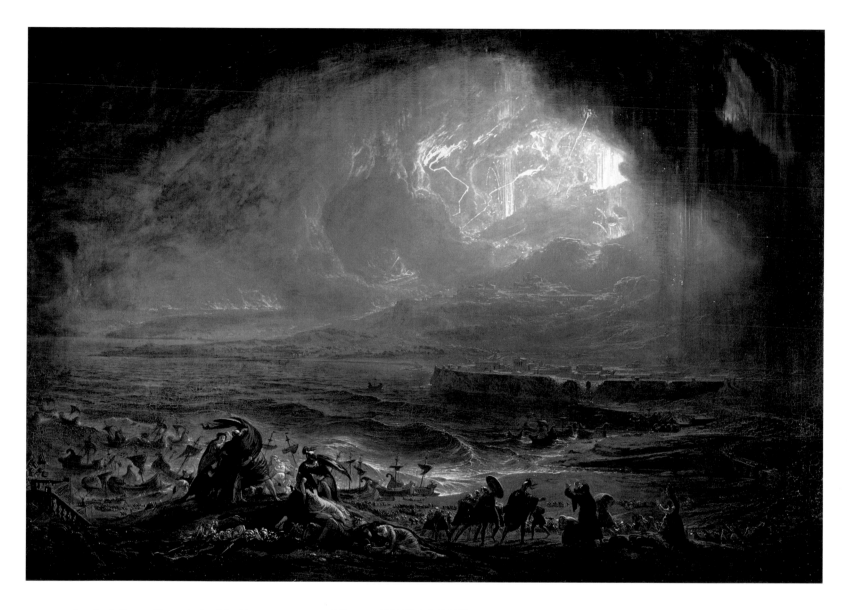

canvas closely follows the original in its enormous, sublime landscape that engulfs the figures in the tradition of Jacob More (see pl. 19), although this version does not include the figures of Pliny the Elder and his companions. The Tabley House painting has, however, been the main representative of this subject in studies of Martin's œuvre. As the artist's reputation went into a decline in the late nineteenth century, the larger picture was sent to the Manchester City Art Gallery, and thence to the Tate Gallery, where it was stored in the basement. In 1928 a disastrous flood seriously damaged the canvas, to the extent that it was more or less abandoned as lost for most of the twentieth century. However, a thorough modern restoration of the surviving canvas by Sarah Maisey has returned it to much of its former glory and encouraged a broader modern reassessment of Martin's work. | VCGC

SELECTED BIBLIOGRAPHY

Atherstone 1821.

Feaver, William, *The Art of John Martin* (Oxford, 1975).

Martin, John, *A Descriptive Catalogue of the Destruction of Pompeii & Herculaneum with other Pictures now Exhibiting at the Egyptian Hall, Piccadilly* (London, 1822).

Murphy 1978.

Myrone 2011.

23

Sebastian Pether
British, 1790–1844

ERUPTION OF VESUVIUS WITH DESTRUCTION OF A ROMAN CITY

1824
Oil on canvas, 71.4 × 92 cm (28⅛ × 36¼ in.)
Boston, Museum of Fine Arts, Grant Walker Fund, 1978.157

Sebastian Pether specialized in paintings of landscapes, sunsets, and particularly moonlit scenes, as well as fires and other destructive effects of nature. In 1826, at the Royal Academy in London, he exhibited *A Caravan Passing the Desert Overtaken by a Sandstorm* and *Destruction of a City by a Volcano*, a large canvas that he later presented to the Royal Manchester Institution. The latter is now unfortunately lost, and whether it bore any relationship to this smaller canvas, painted two years earlier, is not known. Another small surviving picture that Pether painted in 1825 (Kansas City, Nelson-Atkins Museum, F96-17) depicts a contemporary, rather than historical eruption of Vesuvius, also shown by night underneath a full moon.

The city in this painting is generally thought to be Herculaneum. The volcano is certainly Vesuvius, which can be recognized by its bifurcated cone. Although the sea is still (as it is in many depictions of eighteenth- and nineteenth-century eruptions of Vesuvius), which contradicts Pliny the Younger's description of the events of A.D. 79, the city directly in the path of the lava flowing down from the mountain is clearly an ancient one with an aqueduct and other classical buildings. That its large colonnaded temple is topped with an oddly post-antique cupola is perhaps a result of Pether's inadequate understanding of ancient architecture or his superimposition of later Italianate buildings on the scene.

The mingling of ancient and modern is also present elsewhere in the painting. In the left foreground, beneath a large tree, a standing man and seated woman—in early-nineteenth-century dress!—observe the destruction of the city. Likewise on the right, a group of diminutive figures approach the disaster, rather like the tourists who climbed the volcano in Pether's day. Pether, however, never actually saw the volcano erupt, for he never traveled to Italy.

Perhaps to add veracity to this imaginary scene, dozens of chunks of what appears to be lava were embedded in the picture's gilt frame. Close inspection, however, reveals that this putative volcanic debris is in fact trimmed wood burl. Thus, what was intended as a physical reinforcement of the image's historical veracity is itself false.

Interestingly enough, the obituary of the impoverished Pether, which appeared in *Gentleman's Magazine*, mentions frames. Referring to the painter's difficult circumstances, the anonymous author recalls an event some years after the creation of this painting: "In the spring of 1842, by the assistance of a picture-frame maker, he was enabled to paint three pictures, which he intended for exhibition, and they were sent to the Royal Academy for the purpose: the whole were rejected. It occasioned him deep despondency and great mortification. The reason he imagined to have been the enormous size and depth of the frames furnished by the person in whose hands he was placed by his necessities." The obituary also notes that the "bent" of Pether's mind was toward "the mechanical arts" and that "he first suggested the idea and the construction of the stomach pump to a surgeon … who introduced it to the medical profession." Art, however, was the family profession. His father, uncle, and one of his nine children, Henry, were also painters.

| KL

SELECTED BIBLIOGRAPHY

Murphy 1978, 17.

O'Donoghue, F. M., "Pether, Sebastian William Thomas (1790–1844)" (revised by J. Desmarais), *Oxford Dictionary of National Biography* (Oxford, 2004): http://www.oxforddnb.com/view/article/22032 (last accessed March 19, 2012).

"Sebastian Pether," *Gentleman's Magazine* 177 (July 1844): 99.

Auguste Desperret
French, 1804–1865

THIRD ERUPTION OF THE VOLCANO OF 1789

1833
Lithograph, hand-colored with watercolor, image: 19.2 × 28.3 cm (7⁹/₁₆ × 11⅛ in.);
page: 34 × 24.5 cm (13⅜ × 9⅝ in.)
Plate 279 in *La Caricature* 135 (June 6, 1833)
Inscription: *Troisième éruption du Volcan de 1789, qui doit avoir lieu avant la fin du monde,
qui fera trembler tous le trônes et renversera une foule de monarchies*
(Third eruption of the volcano of 1789; which will take place before the end of the world,
and will shake every throne and overturn a host of monarchies)
Los Angeles, Getty Research Institute, 85-S422

The Parisian weekly *La Caricature,* founded by Charles Philipon and active from 1830 to 1835, published some of the period's most noteworthy satirical prints, including work by Honoré Daumier and J. J. Grandville. The journal adopted a strong antimonarchical stance and was a key instrument of republican, populist opposition during the July Monarchy. In 1830 the counterrevolutionary Bourbon king Charles X was deposed in favor of Louis Philippe, a constitutional monarch supported aggressively by the wealthy bourgeoisie, primarily merchants and bankers. At this moment, caricatures emerged as a major forum for expressing political ideals, a phenomenon that stemmed from increased freedom of the press. Desperret's visually arresting and densely allusive work characterizes the language of these prints.

The word *Liberté* (Liberty) violently explodes from the mouth of Vesuvius. Encampments dot the mountain, marked with European flags, audaciously waving to celebrate the eruption. Meanwhile, streams of lava and a storm of rocks—some inscribed *juillet* (July)—scatter troops in the middle ground. Marked with a coat of arms, a ruined building bears the date 1789 and a pair of crossed swords, while stones strewn across the foreground—cracked to suggest that they tumbled to the ground long before the current eruption—bear the inscriptions *Droit Divin* (divine right), *Droit d'aînesse* (birthright), *féodalité* (the feudal system), and *DÎMES* (tithing).

According to the anonymous text on the facing page of the magazine, the volcano represents revolution and has already erupted twice, once in 1789 for the French Revolution, when it destroyed the monarchy and its system of feudal rights; and a second time in 1830, overthrowing King Charles X. The author—citing widespread hatred among the lower classes inspired by the tyranny, injustice, and violence of the current regime—anticipates a third revolution, but this one—rather than being limited to France—would spread across the world, creating an entirely new Europe. The wrecked building should thus be understood as signifying the ancien régime; the falling stones refer to the 1789

and 1830 July revolutions; and the troops represent the French army fleeing in the face of popular uprising.

In the summer of 1833, Desperret executed several prints for *La Caricature*. Like most satirical prints in this era, his work depended both on a sophisticated understanding of current events and a broader awareness of other political cartoons. *La Caricature* articulated the preoccupations of the liberal, republican opposition to the monarchy during the early years of the July Monarchy, which saw—despite much talk about expanding the franchise and opening up opportunities to a wider citizenry—intensified political and economic pressure on the working classes by the wealthy bankers and merchants who supported the king. In mid-1833, opposition on the left hardened against Louis Philippe's recent military and political aggression, which consolidated his power against opponents abroad and deepened an authoritarian internal order, including the repression of a major strike in the coal mines at Anzin, on the Belgian border, the previous month.

Yearning for a new revolution was a major theme of *La Caricature*, and for Desperret, the eruption is at once a destructive and a generative force, destroying monarchical rule for the good of the French people. From the French Revolution forward, Vesuvius was deployed as a powerful metaphor for populist rage, although its interpretation was by no means fixed and it could be used to express disapproval for irrational destruction as well as being the natural result of pent-up forces. Desperret uses Vesuvius to compare the French monarchies of 1789 and 1830 to the excesses and injustices of imperial Rome. | JLS

SELECTED BIBLIOGRAPHY

Bosch-Abele, Susanne, *La Caricature (1830–1835): Katalog und Kommentar* (Weimar, 1997) (with prior bibliography).

Kerr, David S., *Caricature and French Political Culture, 1830–1848: Charles Philipon and the Illustrated Press* (Oxford and New York, 2000).

Troisième éruption du Volcan de 1789,

Qui doit avoir lieu avant la fin du monde, qui fera trembler tous les trônes et renversera une foule de monarchies.

Joseph Franque
French, 1774–1833

SCENE DURING THE ERUPTION OF VESUVIUS

1827
Oil on canvas, 2.96 × 2.28 m (9¾ × 7½ ft.)
Philadelphia Museum of Art, Purchased with the George W. Elkins Fund, 1972, E1972-3-1

Franque was born in the small village of Le Buis, Drôme, in the south of France. He and his twin brother Jean-Pierre, the sons of a farmer, were so naturally gifted that they were both sent to the École Gratuite in Grenoble to study art and both became history painters and frequent collaborators.

In Napoleonic Paris, Joseph Franque studied with the master painter Jacques-Louis David, from whom he learned the principles of grand, historical compositions and to emphasize classicizing detail. He first exhibited a historical subject, *Hercules Rescuing Alcestis from the Underworld,* at the Paris Salon in 1806, while at the same time gaining a reputation as an excellent portraitist who was particularly adept at large-scale, multifigured works. In this capacity, he received considerable patronage from the imperial family.

In 1814, toward the end of Napoleon's reign, Franque traveled to Italy, eventually settling in Naples, where he would remain as a respected professor at the Accademia di Belle Arti for the rest of his life. As in Paris, he was sought after as a fashionable portraitist; he also continued to have an active clientele in France.

The *Scene during the Eruption of Vesuvius* was the last painting Franque sent back to a Paris Salon. It marks a significant departure from earlier disaster pictures such as those in this exhibition by Jacob More, Angelica Kauffmann, and John Martin (see pls. 19, 20, and 22) in that the main actor, Vesuvius, as well as significant persons, such as the Elder and Younger Pliny, are absent. Instead, Franque focuses on the human tragedy of the volcano's anonymous victims, whose remains were being uncovered in the ongoing excavations. Franque made this clear in his description of the painting for the Salon brochure: "A mother, terrified by the eruption of Vesuvius, flees in a chariot with her two daughters, bearing a young child in her arms. This unfortunate family is surprised and enveloped by a rain of fire, the fury of which increases moment by moment. The older of the two girls has already fallen, the other tries to rush to her mother who, no longer able to support herself, falls dragging the girl with her" (as quoted in Rosenthal).

Franque's subject is based on the 1812 excavation report of A. L. Millin, the French archaeologist who recorded the discovery of a group of female bodies who were understood to be a family. The most interesting detail was their surviving jewelry:

Three golden rings and a pair of pear-decorated earrings proclaimed their affluence and elegance. One of the rings is in the form of a coiled serpent whose head extends along the finger. Another ring, which because of its size could only have been worn by a girl, or an extremely small and dainty woman, bears a small garnet on which a lightning bolt is engraved. The earrings resemble small balances, whose pans are pearls suspended on thick gold wire… These earrings were attached by a hook, and were easy to put on. There is no doubt that they might once have graced the ears of a pretty woman (as quoted in Rosenthal).

As Donald Rosenthal has noted, Franque did deviate from Millin's full report by, for example, putting the women in a chariot rather than huddling in a portico, thus creating the context of a dramatic escape attempt rather than passive victimhood. But Franque was closely attentive to the details of the surviving jewelry; indeed, we can assume he studied the original artifacts in Naples. Viewers of his picture in Paris would have gotten the sense that they were not only witnessing the human tragedy of these three women but also gaining knowledge of the most up-to-date details from recent excavations.

The demise of wealthy, sophisticated, and beautiful women in the eruption of A.D. 79 was an ongoing subject of fascination. In this case, the tragedy of a mother trying to save her daughters imbued the theme with pathos, which Franque makes inescapable by filling his composition with twisting, seminude forms that threaten to spill out of the picture plane into real space. It would not have escaped the artist or his viewers that the women depicted in this image were the ancient prototypes of Franque's modern upper-class sitters. In addition, his attention to the jewelry highlights the contrast between the ephemeral bodies and their surviving ornaments, which would inspire classical revival jewelry to adorn women many centuries after the originals were entombed by Vesuvius. | VCGC

SELECTED BIBLIOGRAPHY

Bollen, Elizabeth, *Beauty and Betrayal: Ancient and Neoclassical Jewelry* (Sydney, 2010).

Rosenthal, Donald, "Joseph Franque's *Scene during the Eruption of Vesuvius.*" *Philadelphia Museum of Art Bulletin* 75, no. 324 (March 1979): 3–15.

Karl Bryullov
Russian, 1799–1852

THE LAST DAY OF POMPEII

1833
Oil on canvas, 4.56 × 6.5 m (15 × 21 ft.)
St. Petersburg, State Russian Museum, ZH 5084

This massive canvas, conceived and painted over several years, made the career of its painter and catapulted him to fame as the greatest Russian painter of the day. Bryullov had graduated with distinction from the Imperial Academy of Fine Arts in 1821. In 1823, supported by the newly formed Russian Society for the Promotion of Artists, he traveled to Rome with his brother Alexander. Karl Bryullov remained in Italy until 1835 and spent many of his early days there visiting museums and galleries, studying and sketching ancient and early modern works of art, and painting portraits of visiting Russian nobles.

The Society for the Promotion of Artists required each of its pensioners to produce a large historical painting, and Bryullov may have been inspired to take up his subject by seeing a performance of Giovanni Pacini's opera *L'ultimo giorno di Pompei* (see pls. 65–68), which opened in Naples in November 1825 and continued to be performed there for several years. Bryullov may have visited and sketched Pompeii in May 1824. He returned to the site while traveling in southern Italy in the summer of 1827 with this painting's initial patron, the Russian countess Maria Razumovskaya. The commission, however, was subsequently taken up by Anatoly Nikolaevich Demidov, the prince of San Donato (a Russian industrialist and patron of the arts residing in Italy), whom Bryullov had apparently met in Naples. The painting was to be completed by 1830 for 40,000 francs. Preliminary sketches show that the project was well underway by 1828, and contemporary letters indicate that Bryullov was studying Pliny the Younger's letters to Tacitus. His decision to set the scene along the Street of the Tombs, the principal entrance for visitors to the site in the early nineteenth century, was also made by 1828.

Bryullov took so long to realize the painting that Demidov despaired of its completion and threatened to cancel the commission. However, when the painting was finally finished in 1833, Bryullov opened his studio on Via San Claudio in Rome to a rapturous response. The aging Scottish novelist Walter Scott is said to have spent more than an hour before the canvas entranced: he praised it as "an epic in colors," while Vincenzo Camuccini, head of the Academy of St. Luke, declared it a "flaming colossus." The Italian archaeologist Pietro Ercole Visconti devoted a long article to it extolling the painter as well as the painting (Goldovsky 2003).

En route from Rome to St. Petersburg, the canvas was displayed before enthusiastic crowds at the Pinacoteca Brera in Milan, where Bryullov was elected to the local academy of art—and where the painting was seen by and inspired Edward Bulwer-Lytton—and in Paris, where, at the Salon of 1834 it won a gold medal. In Russia it was praised by aristocrats and shopkeepers alike. Newspapers reported its positive popular reception, while Nikolay Gogol penned a long essay, calling it a "feast for the eyes," "one of the brightest phenomena of the 19th century," and "the radical resurrection of painting" (Goldovsky 2003). The painting also inspired Alexander Pushkin to write a poem about the destruction of Pompeii, while the dissident Alexander Herzen, among others, saw in it a deep political allegory about the fall of European monarchies.

Demidov presented the painting to Czar Nicholas I, who passed it on to the Imperial Academy of Fine Arts so that young painters might benefit from studying it. Bryullov himself was granted an audience with the czar, who gave him a diamond ring and made him a cavalier of the Order of St. Anna. The painter was also appointed associate professor at the Imperial Academy.

Modeled, in part, on earlier masterpieces, such as Raphael's fresco *Fire in the Borgo* (1514–17), which Bryullov had studied in the Vatican, and Nicolas Poussin's *The Plague at Ashdod* (1630), Bryullov's tumultuous canvas is populated by twenty-seven figures struggling to survive the fiery eruption of Mount Vesuvius—some having already given up the ghost. Amidst collapsing buildings and toppling statues, diverse groups suggest distinct narratives that are different from those of Pacini's opera or Bulwer-Lytton's novel. In the right foreground, for example, a young man standing over a collapsed older woman apparently represents Pliny the Younger refusing his mother's pleas to abandon her to save his own life (a scene transferred from Misenum to Pompeii). The soldier and boy carrying an older man in the center may depict an attempt to rescue Pliny the Elder from Stabiae, but the group can also be read as a variant derived from Raphael's fresco and ultimately from the ancient story of Aeneas rescuing his father from the destruction of Troy. The fallen woman in a bright yellow garment, whose infant child sits helplessly beside her, is paralleled by a figure in Poussin's canvas, but may also be drawn from descriptions of some of

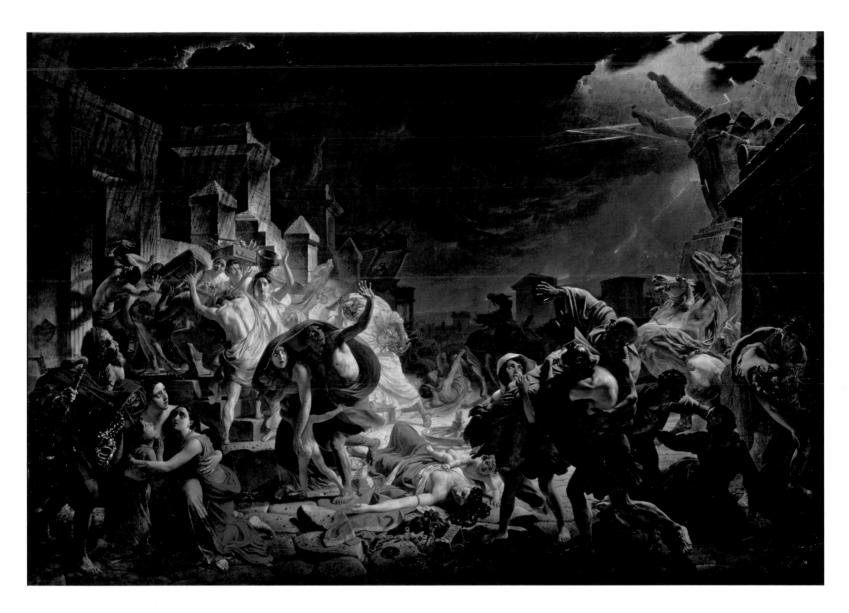

26.1. Self-portrait of the artist. Detail of *The Last Day of Pompeii*.

the skeletons found at Pompeii in early excavations (see also pl. 25). The young family group fleeing, further to the left, may be drawn from figures in Pacini's opera (see pl. 68) and seems to have inspired other artists, such as Giovanni Benzoni (see pl. 28).

The diverse psychological reactions of the figures are variously expressed in their faces: surprise, fear, greed, agony, loss, hope, heroism, self-sacrifice. The woman crouching with two girls in the left foreground is said to be a portrait of Bryullov's (intimate?) friend, the Countess Julia Samoilova with her two adopted daughters Giovannina and Amazilia. The artist included himself in a self-portrait among the crowd, brightly lit, as a Pompeian painter carrying on his head a box of paint pots and brushes (pl. 26.1). The young woman before him with a bronze vessel on her head seems to be a variant of a figure in Raphael's fresco, while in the lower left corner of Bryullov's scene the old

man wearing a wooden cross around his neck hints anachronisictally at the salvation of early Christians.

Archaeological details throughout the painting—from the polygonal stone roadway and sepulchral architecture to the jewels, mirrors, lamps, stools, and other implements carried by the victims—are evidence of Bryullov's long study of artifacts in the Naples museum. Yet the dramatic lighting, seething bodies, broken chariots, and collapsing buildings give the painting a feeling that is far from academic. Indeed, Bryullov was widely praised for bringing a new romantic sensibility to classicizing history painting, and *The Last Day of Pompeii* was extolled as "the first day of Russian painting!" (Goldovsky 2003).

In 1968 the painting was featured on Soviet 2-kopek postage stamps and in 1998 on Russian 1.5-ruble stamps. | KL

SELECTED BIBLIOGRAPHY

Allenova, Olga, et al., *Karl Bryullov in the Tretyakov Gallery* (in Russian) (Moscow, 2000).

Bowlt, John E., "Russian Painting in the Nineteenth Century," in *Art and Culture in Nineteenth-Century Russia*, ed. Theofanis George Stavrou (Bloomington, Ind., 1983), 113–39.

Goldovsky, Grigory, et al., *Karl Brullov 1799–1852: Painting, Drawing, and Watercolours from the Collection of the Russian Museum* (St. Petersburg, 1999).

Goldovsky, Grigory, in *Maestà di Roma da Napoleone all'unità d'Italia*, exh. cat. ed. S. Susinno et al. (Rome, Scuderie del Quirinale, Galleria nazionale d'arte moderna, and the French Academy at the Villa Medici, 2003), 368–69.

Jacobelli 2009, 58.

Volkov, Solomon, *St. Petersburg: A Cultural History*, trans. Antonina W. Bouis (New York, 1995), 61–63.

27

Frédéric Schopin
French, 1804–1880

THE LAST DAYS OF POMPEII

ca. 1850
Oil on canvas, 59 × 91 cm (23 9/16 × 35 7/8 in.)
Paris, Petit Palais, Musée des Beaux-Arts, PDUT01413

Born to a French family in northern Germany, Schopin trained in Antoine-Jean Gros's Paris studio. Runner-up for the Prix de Rome in 1830, he won the competition the following year. Despite exhibiting many times at the Paris Salon between 1835 and 1879, Schopin remains a shadowy figure and still lacks a monograph. Most of his works were historical subjects in medieval, biblical, or classical settings, as well as harem scenes, although he also executed decorative schemes at Fontainebleau, the Hôtel de Ville in Paris, and the Gallery of Battles at Versailles.

In this painting, chaos reigns and everyone's escape is blocked. At center, a family seeks to move forward through flood waters: a uniformed soldier carries an elderly man on his back, while a woman carrying a baby vainly attempts to encourage a naked boy to press on, despite his fear of the drowning figures before them. Other groups have even less success. Frightened oxen upset a wagon at left, about to spill another family into the water. They in turn block an overstuffed vehicle, pulled by two horses, one rearing back, while a charioteer vainly tries to push ahead. One occupant furiously strikes a man—already being strangled by another person in the chariot—either an attempt to lighten the load or to stave off brigands. At lower right, in shadow, one soldier has dismounted his horse, while another lifts a woman out of the water.

27.1. Théodore Géricault (French, 1791–1824), *The Raft of the Medusa*, 1819. Oil on canvas, 4.91 × 7.16 m (16 × 23½ ft.) Paris, Musée du Louvre.

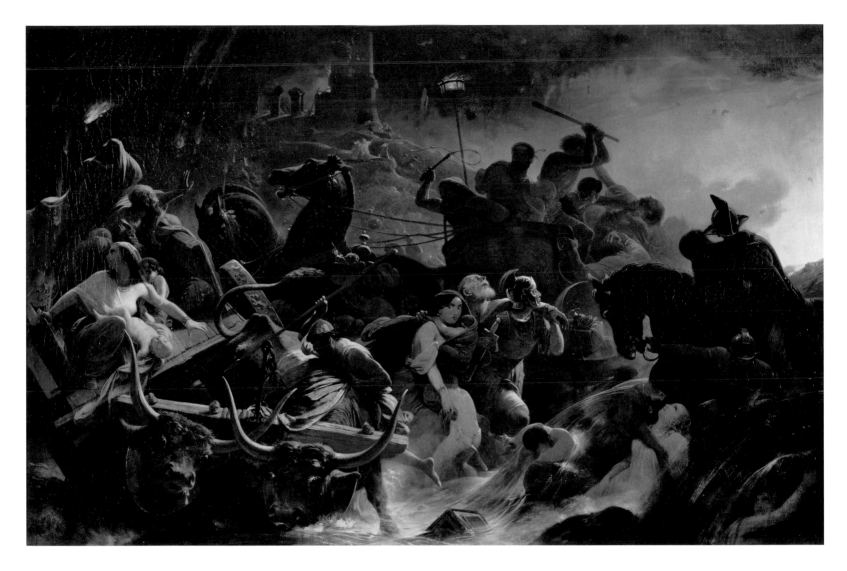

Schopin's vision of Pompeii's end includes a tremendous flood, as well as the eruption of Vesuvius, source of the rain of cinders that has already left the city in flaming ruins. This dual disaster reflects the ongoing geologic debates about the formative roles of volcanic action versus massive flooding, with Schopin combining the two (see the essay by Jon Seydl in this volume).

Whether Schopin traveled to Pompeii while studying in Rome is unknown. In 1848 the academy in St. Petersburg named him a member. His travel to Russia undoubtedly included the opportunity to study *The Last Day of Pompeii* by Karl Bryullov (see pl. 26). The impact of this massive, highly regarded canvas in terms of subject, palette, and composition resonates deeply in Schopin's painting and allowed the painter to reintroduce the genre of the Pompeian disaster picture to France. However, unlike Bryullov, or Théodore Chassérieau in his *Tepidarium* (see pl. 7), on view in Paris a few years later, Schopin does not stuff his painting with archaeologically accurate detail or iden-

tifiable ruins, choosing instead a more generalized tableau of pandemonium.

In the breadth of reactions, as well as in the organization of the picture, with figures rising in shadow in the right middle ground, the painting recalls the best-known French disaster picture of this period, Théodore Géricault's *Raft of the Medusa* (pl. 27.1), another work where human actions intensify an already horrific calamity. Schopin populates his work with a similar range of figures, from the most venal to the heroic, although in this case, no one will be rescued. | JLS

SELECTED BIBLIOGRAPHY

Bénézit, E, *Dictionnaire…* (Paris, 1999), 12:515.

Kaiser, F.-W. *De natuur als atelier: Het Franse landschap van Corot tot Cézanne*, exh. cat. (Paris, 2004).

Stähli 2011, 125, fig. 83.

Giovanni Maria Benzoni
Italian, 1809–1873

THE POMPEIANS (FLIGHT FROM POMPEII)

1873
Marble, H: 108.5 cm (42¹¹/₁₆ in.); Diam (plinth): 68.6 cm (27 in.)
Inscribed: G M BENZONI F ROMA A1873 (G. M. Benzoni made this in Rome in the year 1873)
The Art Institute of Chicago, Gift of Mr. and Mrs. S. M. Nickerson, 1900.83

Had I had the plaster in my hands I would have modeled this group which formed in my mind at the sight of that immense calamity on the spot. As soon as I returned to Rome I worked manically with a fever induced by the image of that horrendous event. I seemed to hear the terrible rumbling issuing from the summit of the mountain in whose bowels lay the fiery betrayal. I read the descriptions of those terrible days, but nobody's account left its mark as had my few hours spent among the ruins (Rota [trans. Christie's]).

Thus Benzoni described how a visit to Pompeii in the 1860s inspired him to fashion this statue of a young couple and their infant fleeing the eruption of Vesuvius. Benzoni's dramatic composition, however, has a long history outside of the sculptor's fevered imagination, not only in Pompeian imagery but also in the broader history of art. The muscular male figure raising a billowing garment and the pathos-filled motif of a woman protecting her child derive from the so-called Florentine Niobids, an ancient Roman marble group modeled on Greek prototypes that was found on the Esquiline Hill in Rome in 1583 and has since 1781 been displayed in the Uffizi in Florence. The fantasy of escape from Pompeii originated with the letters of the younger Pliny, and the representation of family groups that refer to Aeneas escaping Troy with his family can be traced back at least to a 1787 watercolor sketch by J. W. von Goethe (Weimar, Kunstsammlungen). Such groups also appear prominently in several other works representing figures attempting to escape the eruption of Vesuvius, including those by Martin, Franque, Bryullov, and Sanquirico (see pls. 22, 25, 26, and 65–68). They evidently reflect reports of the discovery of skeletons of parents with children by early excavators at Pompeii. Benzoni's vision, therefore, seems to have been influenced by modern texts and images—and perhaps even by performances—as well as by his experiences on site.

The man raises his cloak to protect his wife and child from the falling ash, clumps of which rest on their garments and at their feet. Objects dropped in flight surround them. These meticulously copied archaeological artifacts include a bro-

ken amphora, Roman coins with a profile head on one side, inscribed S. C. (*Senatus Consultum*) on the other, snake bracelets, fibulae (brooches), a woven gold necklace with amphora-shaped pendants, a mirror decorated with a bearded head, and a lamp with a head of Jupiter above an eagle. Two loaves of bread, partially buried in the ash, reflect recent archaeological finds. In 1866 eighty-one loaves, each scored into eight sections, were recovered from the sealed oven of a bakery at Pompeii. One of Benzoni's carved loaves bears an inscription in Latin, copied after a loaf found in the so-called Casa di Cervi in Herculaneum in 1748, which reads: CELERIS.Q.GRANI | VERI.SER (made by Celer, slave of Quintus Granius Verus) (Naples, Museo Archeologico Nazionale, 84596).

Benzoni was born in Songavazzo in northern Italy. When he was eleven he went to live with his uncle, a cabinetmaker. His talent as a carver was recognized and he was brought to the attention of Luigi Tadini, count of Crema, who admitted him to the academy in Lovere. The artist eventually set out for Rome, where he apprenticed with Giuseppe Fabris, a follower of Canova, and attended the Academy of St. Luke. Benzoni subsequently opened his own atelier, where, as demanded by the market, he produced sacred, profane, and funerary statuary. He

28.1. Detail of artifacts covered in ash.

eventually employed as many as fifty workmen and fashioned portrait busts, and mythological and allegorical figures. The biblical matriarch *Rebecca* was his most successful work: at least thirty-seven copies are known. Benzoni's studio, like that of his contemporary Randolph Rogers (see pl. 69), was a popular stop on the itinerary of travelers, including such notables as the popes Gregory XIV and Pius IX, the emperor of Russia, the sultan of Turkey, and the sovereigns of Holland and Italy.

The original terracotta model for this statue is said to have remained in possession of Benzoni's heirs near Bergamo, while the earliest known marble example, carved in 1868, was sold to the New York hoteliers Mr. and Mrs. Paran Stevens. Following their 1895 estate sale, this life-size version went on view in the foyer of the old Waldorf-Astoria Hotel on Fifth Avenue. Another life-size copy, unsigned and undated, is currently in the lobby of Grand Hotel et des Palmes in Palermo, Sicily, which was built in 1856 as the home of the Ingham-Withaker family and converted into a hotel in 1874. The Chicago version, on display here, is smaller in scale and was carved in the final year of Benzoni's life. It was installed by 1883 in the lavish mansion of Chicago liquor and banking magnate Samuel M. Nickerson. Dubbed the "Marble Palace," the house was the largest private residence in Chicago at the time of its completion. Mounted on a columnar pedestal, this statue was the centerpiece of Nickerson's art gallery, which included canvases by Albert Bierstadt, William-Adolphe Bouguereau, Frederic Edwin Church, Thomas Cole, Gustave Doré, George Inness, Sr., and many others.

A fifth version of Benzoni's marble composition, today in the Ballarat Botanical Gardens outside Melbourne, Australia, was purchased in 1887 by gold mine executives who sought to beautify their city. Unveiled in 1888, this copy, of heroic proportions, was carved by Benzoni's sometime pupil, the Australian sculptor Charles Francis Summers (1858–1945). Whether this work or a sixth surviving example is the unfinished marble reported in Benzoni's studio at his death is uncertain. On the English market in the early 1980s (Frank Collins Antiques), that sixth statue seems identical to one on display in the Todmorden Town Hall in Yorkshire, which was acquired by textile manufacturer John Fielden to adorn his newly constructed Dobroyd Castle in 1869. It is inscribed "C. B. BENZONI F. ROMA A. 1878," indicating that Benzoni's son (?) Giovanni Battista completed it. The pedestals of this statue and the Australian example have low reliefs with further images of Pompeii's destruction. Summers carved those in Ballarat with scenes from Bulwer's novel: the Roman sentinel remaining at his post (see pl. 31); Nydia leading Glaucus and Ione to safety; Arbaces seeking to escape the eruption with his treasure overwhelmed by falling buildings; and the widespread destruction of the eruption. The carver of the reliefs on the Yorkshire statue is unknown. They depict a

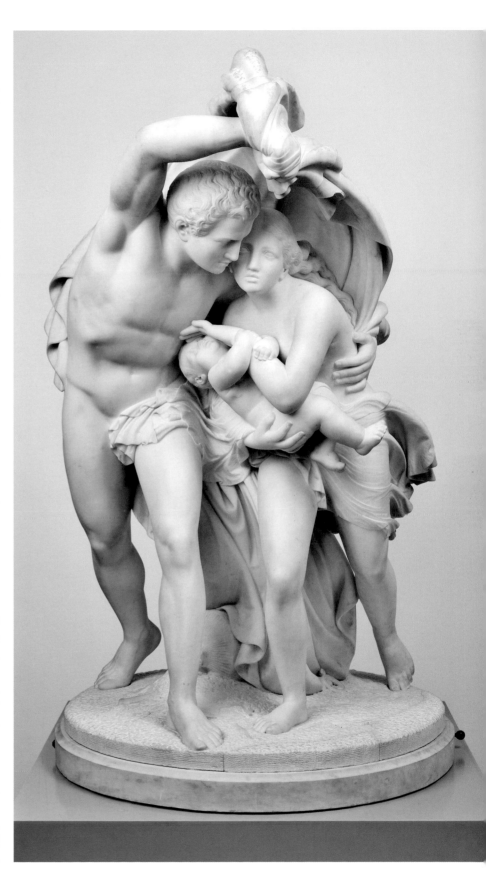

mother cradling her fallen child, a bearded man leading an old woman through a city gate guarded by a sentry, a woman kneeling over a dying man, and figures fleeing with urns as buildings collapse around them. | KL

SELECTED BIBLIOGRAPHY

Bertazzoni, Roberta, *Giovanni Maria Benzoni 1809–1873* (Songavazzo, 2009).

Boström, Antonia, "Giovanni Maria Benzoni, Randolph Rogers, and the Collecting of Sculpture in Nineteenth-century Detroit," *Sculpture Journal* 4 (2000): 151–59.

Chicago Daily Tribune, July 8, 1883, page 17.

Christie's, London, May 30, 1996 (sale 5598), lot 271.

Corpus Inscriptionum Latinarum (Berlin, 1883), vol. 10, pt. 2, p. 916, no. 8058.18.

"Frank Collins Antiques," *Apollo* 113–14 (October 1981): 110.

Haskell, Francis, and Nicholas Penny, *Taste and the Antique: The Lure of Classical Sculpture 1500-1900* (New Haven, Conn., and London, 1981), 274–49, no. 66.

Rota, D. Giuseppe, *Un artista bergamesca dell'Ottocento: Giov. Maria Benzoni nella storia della scoltura e nell'epistolario famigliare* (Bergamo, 1938), 418, no. 21.

Sotheby's, New York, May 23, 1990, lot 63.

Personal communications from Claire L. Lyons, Lucia Ferruzza, Andrea Modesti and Ivano Ferazzoli, Peter Marquand, Catherine Emberson, and Damion Priestley.

29

James Hamilton
American, 1819–1878

THE LAST DAYS OF POMPEII

1864
Oil on linen, 152.2 × 122 cm (59 15/16 × 48 1/16 in.)
Brooklyn Museum, Dick S. Ramsay Fund, 55.138

The Irish-born James Hamilton trained in Philadelphia, but his loose and thick application of paint and atmospheric compositions differ from the tight, controlled handling preferred by most American artists in the mid-1800s. His interest in Joseph Mallord William Turner deepened during an 1854 visit to England, and this painting abundantly demonstrates the British artist's impact on Hamilton in its dramatic light effects and dense layers of paint.

Hamilton never visited Italy and wholly invented the setting for *The Last Days of Pompeii* (a conscious literary conceit, given that numerous accurate maps and views were readily available to him in Philadelphia). Pompeii appears in mid-destruction, seen from the Bay of Naples. Flaming buildings and lightning illuminate a dark swirl of ash. A bolt strikes a column at center, undoing a chunk of masonry. This last detail refers directly to the death of Arbaces, the villain of Edward Bulwer-Lytton's novel *The Last Days of Pompeii* (the painting's eponymous title), who is killed at the novel's climax while attempting to seize the heroine, Ione.

The work was likely paired with *Foundering* (also Brooklyn Museum), which represents a ship desperately tossed in a vicious storm. The boat's inverted Confederate flag must be understood in the context of the Civil War in America. *The Last Days of Pompeii*, also painted in 1864, may have a political dimension, its urban conflagration alluding likewise to the cataclysmic war.

Mrs. Bloomfield Moore, a Philadelphia novelist and patron of art and engineering, purchased both paintings directly from the artist and eventually donated them to the Philadelphia Museum of Art, which deaccessioned them in 1944, when the taste for Hamilton's work was at low ebb. Pompeii particularly interested Mrs. Moore, who also prominently displayed a version of Randolph Rogers's *Nydia* (see pl. 69) at the entrance to her home and wrote *On Dangerous Ground*, an 1876 novel whose young American heroine visits the Bay of Naples and takes part in a staging of Bulwer-Lytton's narrative in the House of the Faun. | JLS

SELECTED BIBLIOGRAPHY

Carbone, Teresa, entry in *American Paintings in the Brooklyn Museum: Artists Born by 1876* (New York: Brooklyn Museum, in association with D. Giles, 2006), 586–89 (with previous bibliography).

Seydl 2011, 222–24.

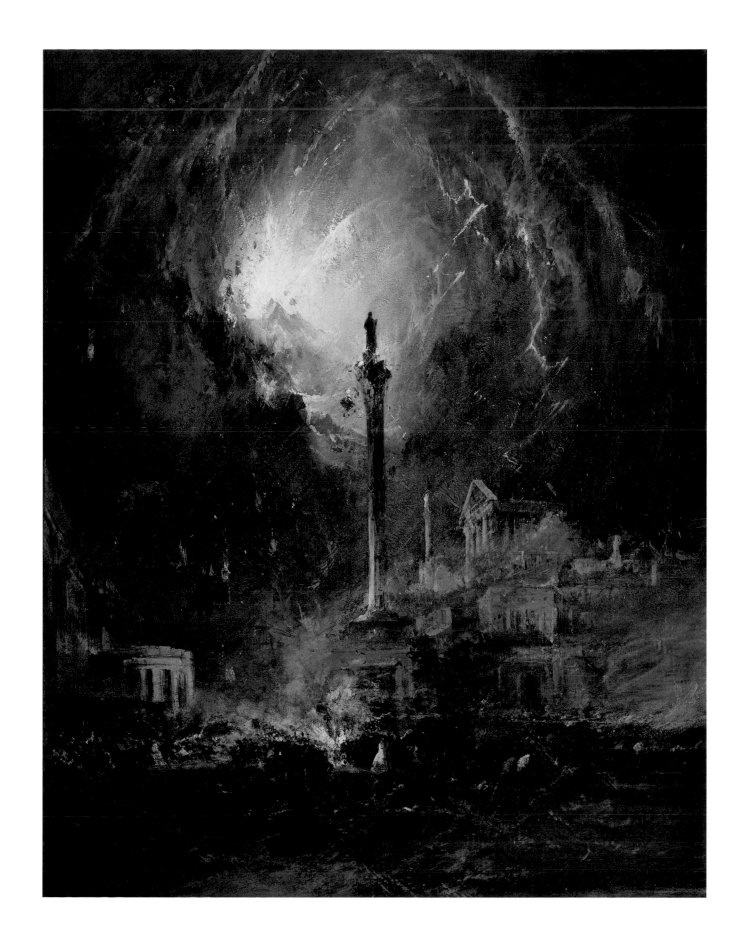

Albert Bierstadt
American, 1830–1902

MOUNT VESUVIUS AT MIDNIGHT

1868
Oil on canvas, 42.6 × 60.7 cm (16¾ × 23⅞ in.)
The Cleveland Museum of Art, Gift of S. Livingstone Mather, Philip Richard Mather, Katherine Hoyt (Mather) Cross,
Katherine Mather McLean, and Constance Mather Bishop, 1949.541

The nineteenth-century landscape painter Albert Bierstadt remains best known for his theatrical, immense, and exceedingly popular canvases that captured the sublime majesty of the American West. His artistic talent was matched by his aptitude for self-promotion and marketing. During the heyday of his career, from the 1860s through the 1870s, he ranked among the most financially comfortable artists of his era, having secured many lucrative purchases and commissions from wealthy American and British patrons. At this time, a significant number of Bierstadt's major works were exhibited internationally as "Great Pictures" in either single-object or intimate solo-artist shows requiring paid admission. In addition, he arranged to have several important compositions reproduced as engravings or chromolithographs, thus extending their commercial potential. Nevertheless, despite such efforts, the artist's considerable renown would not remain constant: Bierstadt's meticulous style of painting—a product of his training within the orbit of the Kunstakademie in Düsseldorf during the early 1850s—increasingly came to be viewed as old-fashioned, victim to the more fluid and immediate style promulgated by the Barbizon painters and later the Impressionists. At the time of his death, he essentially was an art-historical footnote. It took more than a half-century to restore Bierstadt's reputation; today he is once again viewed as a central figure in the annals of American art.

Bierstadt was in London during January 1868, when he learned that Mount Vesuvius had begun erupting. Although he had come to Europe to market his work and not to exploit its iconographic potential, he nevertheless found Vesuvius irresistible and potentially as compelling as his signature Western subjects. Bierstadt departed for Rome and remained for four months, and it is presumed—but not verified by documentary evidence—that he traveled on to the site of the volcano. At a London gallery in June, he debuted a large canvas entitled *Mount Vesuvius at Midnight*, which was later exhibited in New York, Boston, and Chicago, as well as in New Bedford, Connecticut, where he had spent much of his childhood. Even though this painting is now unlocated, contemporary descriptions confirm that the small canvas in Cleveland is a close variant. Bierstadt's conception is unusual in its point of view: rather than portray Vesuvius from across the Bay of Naples, the artist depicts the western side of the mountain. Here, amid the backdrop of the erupting cone, further illuminated by clouded moonlight, cooled lava has intermingled with melted and frozen snow amid brush and trees, which have to varying degrees succumbed to extreme temperatures and poisonous gases. A ruined structure in the right foreground attests to the destructive power of the volcano. Such a motif evokes the ruins—often Gothic—that were a staple in German Romantic art, undoubtedly a type of work to which the artist was exposed during his overseas study. Despite mixed critical reviews, Bierstadt's large painting was sufficiently admired by the general public to warrant him turning down the substantial offer of $10,000 for its purchase. Furthermore, the artist had the image copyrighted for chromolithographic reproduction in September 1869, and it was published later that year.

The inception of the Cleveland painting has puzzled Bierstadt scholars, who have debated whether it could be a study for the large unlocated canvas or a later autograph copy. The paucity of finished preliminary studies elsewhere in the artist's œuvre tends to discount, though not firmly rule out, the former proposition. The mystery now appears solved: the recent discoveries of two chromolithographic impressions of the subject—one found in the Cabinet des Estampes of the Bibliothèque nationale in Paris, and the second acquired by the Birmingham Museum of Art in Alabama—strongly suggest that Bierstadt executed the Cleveland painting in preparation for the print, for both compositions are identical in size. | MC

SELECTED BIBLIOGRAPHY

Anderson, Nancy K., and Linda S. Ferber, *Albert Bierstadt: Art and Enterprise*, exh. cat. (New York, The Brooklyn Museum, 1990).

Carr, Gerald L., "Albert Bierstadt, Big Trees, and the British: A Log of Many Anglo-American Ties," *The Arts* 60 (June/Summer 1986): 60–71.

Hendricks, Gordon, *Albert Bierstadt: Painter of the American West* (New York, 1974).

Strazdes, Diana, entry in *The Lure of Italy: American Artists and the Italian Experience*, exh. cat. by Theodore Stebbins, Jr., et al. (Boston, Museum of Fine Arts, 1992), 276.

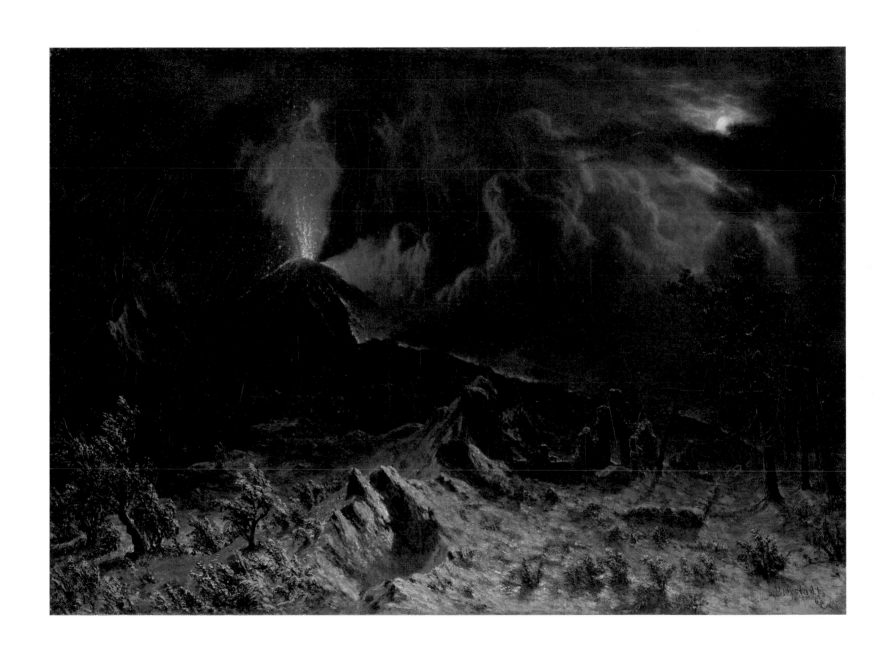

Edward John Poynter
British, 1836–1919

FAITHFUL UNTO DEATH

1865
Oil on canvas, 115 × 75.5 cm (45¼ × 29¾ in.)
Liverpool, Walker Art Gallery, WAG2118

Poynter's *Faithful unto Death* depicts a Roman soldier standing guard while the eruption of Mount Vesuvius destroys Pompeii around him. Wearing a gleaming breastplate and helmet, he is partially sheltered by the arched gateway leading into the city. Behind him, dramatic balls of fire plummet toward cowering victims. The dead lie sprawling with their prized possessions scattered about them. With a glance of trepidation, the soldier raises his eyes upward, his hands gripping his spear tightly.

Faithful unto Death was the first of Poynter's paintings to gain widespread public success. Exhibited at the Royal Academy, London, in 1865, the work established him as part of the fledgling Victorian classical movement, of which Lawrence Alma-Tadema (see pls. 8 and 70) was another key member. Born into well-to-do English society, Poynter had spent time in Rome and trained in Paris, before returning to London in 1859 and beginning his career painting scenes based on Roman history and Greek mythology. The fact that the Victorian-period English education system was rooted in the study of ancient Greece and Rome, combined with a relatively high level of exposure among the upper classes to archaeological ruins from tourism, works of art, and publications, meant that such subjects found an appreciative following.

The subject of *Faithful unto Death* may already have been familiar to many viewers through site guides and popular fiction. In Edward Bulwer-Lytton's novel *The Last Days of Pompeii* the Roman soldier makes a cameo appearance near the end of the book:

> the fugitives hurried on—they gained the gate—they
> passed by the Roman sentry; the lightning flashed
> over his livid face and polished helmet, but his stern
> features were composed even in their awe. He remained
> erect and motionless at his post. That hour itself had
> not animated the machine of the ruthless majesty
> of Rome into the reasoning and self-acting man.
> There he stood amidst the crashing elements; he had
> not received the permission to desert and escape
> (Bulwer-Lytton, *Last Days of Pompeii*, book 5, chapter 6).

Thus Bulwer-Lytton embellishes his description with an indictment of the inhumanity of the imperial Roman state: without new orders, the soldier is forced to stay at his post. A similar critique appears in the first published report that the remains of a sentinel had been found at Pompeii—Sir William Gell suggested that the soldier would have faced death at the hands of his superiors "in conformity with the severe discipline of his country," if he had abandoned his duty and escaped (Gell 1832, 94).

Both Bulwer-Lytton's account and Poynter's painting stemmed from the story that the skeleton and weapons of a soldier had been found in a stone niche during excavations conducted just outside the Herculaneum Gate. However, the road winding down from the gate was lined with the tombs of wealthy and influential citizens, as was common Roman practice, and the uncovered niche was, in fact, part of such a tomb, rather than a guard post. Moreover, no skeletal remains or weapons from the niche were recorded by the excavators. Instead, early guides may have embellished their tours of Pompeii with the story of the soldier on guard. By the time of Poynter's work, the story was being questioned, but the moral and dramatic appeal of the tale held firm.

The lesson of *Faithful unto Death* is easily apparent: the strong, youthful guard performs his duty, while the weak and greedy fall behind him. The scene speaks directly to Victorian ideas of masculine virtue: the women are disheveled and fearful, while the other man clearly visible in the background deviously grasps a vessel. The idea of complete faithfulness to one's duty, central to Roman society and played up by late-Republican Roman authors emphasizing how Rome's glory had been based on strength of character and unyielding loyalty to the state, resonated with Victorian audiences. The parallels between Roman expansion and British imperial ambitions were readily made by the Victorians. British civil servants, steeped in Roman history and sent out to distant continents, strove to emulate Roman generals and politicians in performing their colonial duties above all else. Poynter's painting became emblematic of this ideal, and *Faithful unto Death* was reproduced in children's textbooks as a model of obedient behavior.

Poynter's image, however, is by no means straightforward. The soldier stands firm, but his raised glance and wide eyes betray uncertainty and fear. His slightly parted lips and clenched grip on his spear add to the sense that he is held to his place unwillingly. His taut musculature reveals the tension between

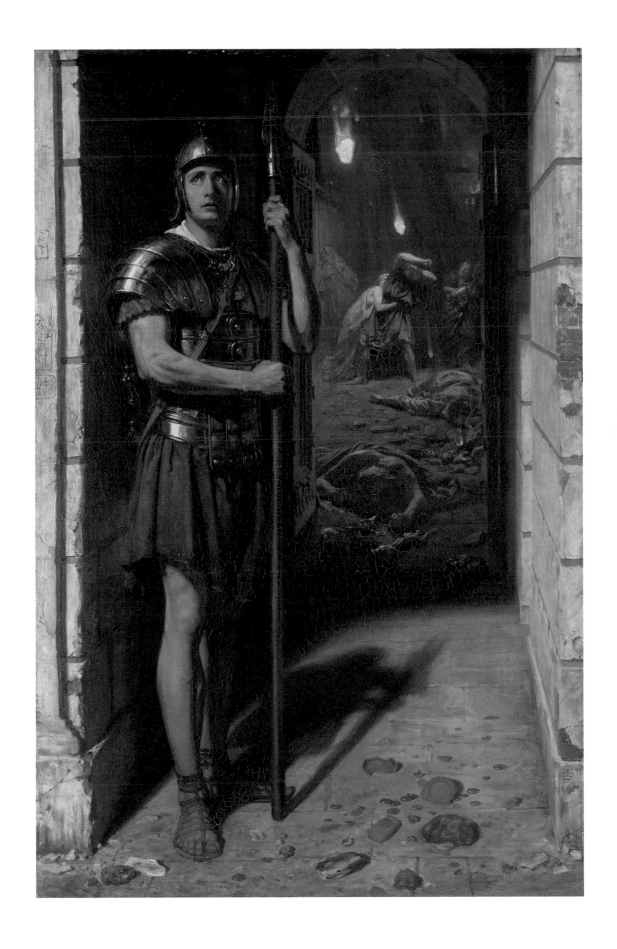

his emotional response and his (lack of) action. His eyes draw in the viewer and elicit sympathy, as Lee Behlman argues, and do the most to undermine the conviction of the moral exemplum, expressing a disquiet with the concept of doing one's duty regardless of all else. Thus, *Faithful Unto Death* implicitly offers a critique of the state, which was made explicit by Gell and Bulwer-Lytton, and a commentary on the futility of self-sacrifice. | AS

SELECTED BIBLIOGRAPHY

Behlman 2007, 157–70.

Prettejohn, Elizabeth, "Catalogue II. Recreating Rome. Edward John Poynter, 43. Faithful unto Death," in *Imagining Rome: British Artists and Rome in the Nineteenth Century*, ed. M. Liversidge and C. Edwards (London, 1996), 126–28.

Vance, Norman, *The Victorians and Ancient Rome* (Oxford, 1997).

Wood, Christopher, *Olympian Dreamers: Victorian Classical Painters* (London, 1983).

32

Hector Leroux
French, 1829–1900

HERCULANEUM 23 AUGUST AD 79

1881
Oil on canvas, 190 × 303 cm (74¾ × 119¼ in.)
Paris, Musée d'Orsay, RF 345 (formerly on deposit at the Musée des Beaux-Arts, Dijon, from the Musée du Louvre)

Leroux was groomed to succeed his father as a hairdresser in Verdun, but his skill at drawing won him a scholarship to the École des Beaux-Arts, which he entered in 1849. Eight years later he won second prize in the Prix de Rome, and he remained in Italy, where for the next twenty-five years he was greatly inspired by classical antiquity. The vast majority of his paintings feature figures from ancient history and literature by such authors as Caesar, Horace, and Tibullus. He seems to have been especially taken with the Vestal Virgins, whom he painted repeatedly throughout his career, depicting them in various locales. He was also deeply interested in ancient dress and wrote a learned, unpublished study of the costumes of the Greeks, Romans, Gauls, Germans, and Etruscans.

In this monumental canvas, Leroux combines human pathos in the foreground with detailed geophysical observation: rough seas batter sailboats beneath breaking storm clouds, while the volcano spews ash and fireballs. Herculaneum, rather than Pompeii, is referred to in the title of the work, but the city is hardly visible. The center of the painting is empty and only a bridge and some stairs can be discerned at left.

Here the Vestals are featured ahistorically, for they were actually present only in Rome, not in other ancient cities. In the foreground Leroux depicts three exhausted figures, having dropped their treasure, while three others, followed by two barely visible servants, climb to safety from the left. One raises both arms dramatically, looking back toward the exploding mountain. Pascale Linnant de Bellefonds has recently sug-

gested that Leroux derived the main three-figure group from the decoration on an ancient silver mirror found at Pompeii in 1758 (Naples, Museo Archeologico Nazionale, 25490) that was widely promulgated in prints (pl. 32.1). Formerly identi-

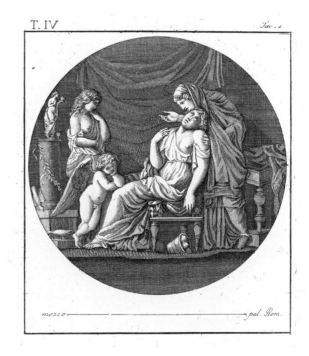

32.1. Tommaso Piroli (Italian, ca. 1752–1824), *Design on Mirror from Pompeii*. Plate 1 in vol. 4 of Francesco and Pietro Piranesi, *Antiquités d'Herculaneum* (Paris, 1804).

fied as depicting Aphrodite or Dido, the mirror actually represents Phaedra. In Leroux's adaptation, the cupid before the seated woman in the mirror has been replaced by another female figure, but the general composition is the same. In fact, the sharply bent right arm of the added woman seems to substitute for that of the principal seated figure in the print. Phaedra's sewing basket, toppled underneath her chair, moreover, has been replaced by the Vestals' sacred implements: spiral staff and toppled brazier.

This canvas was originally commissioned by an industrialist to form part of a panorama, but following a general attack on such paintings published in *Le Figaro* by the critic Albert Wolff before the contract had been signed, the project was cancelled, even though Leroux had completed several preliminary studies. One of these, of the elegant woman standing behind the seated Vestal, is inscribed with the name of the painter's daughter, Laura. The completed painting was shown to acclaim in the Paris Salon of 1881 and was purchased by the French state. The image was subsequently promulgated in prints, and a smaller canvas (three by four feet) was recorded in the early twentieth century to have been in the collection of John G. Johnson in Philadelphia—perhaps the same painting that was auctioned at Christie's, Monaco, on June 19, 1994 (lot 96; 75 × 110.6 cm [29.5 × 43.5 in.]). | KL

SELECTED BIBLIOGRAPHY

Champlin, John Denison, and Charles Callahan Perkins, eds., *Cyclopedia of Painters and Paintings*, 2:239. New York, 1913.

Foucart, Bruno. In *Furansu kaiga no seika: Ru saron no kyoshōtachi / La tradition et l'innovation dans l'art français par les peintres des Salons,* exh. cat. (Tokyo, 1989), 278.

Gohel, Louis-Michel, Christine Peltre, and Philippe Bruneau, *Louis-Hector Leroux: Verdun, 1829–Angers 1900; Peintures et Equisses,* exh. cat. (Bar-le-Duc and Verdun, France, 1988).

Leroux-Revault, Laura, *Hector Le Roux: Le poète pinceau des Vestales* (Bar-le-Duc, France, 1979).

Linnant de Bellefonds, Pascale, "Le 'motif de Phèdre' sur les sarcophages romains: Comment l'image crée la vertu," in *Iconographie funéraire et société: Corpus antique, approaches nouvelles?* Ed. F. Baratte and M. Galiner (Perpignan, 2012).

Arturo Martini
Italian, 1889–1947

THE DRINKER/THIRST/DRINKING MAN

1934–35
Pietra di Finale, 74 × 94 × 217 cm (29 × 37 × 85½ in.)
Rome, Galleria nazionale d'arte moderna e contemporanea

Martini's early sculpture demonstrated keen awareness of the international avant-garde. However, following World War I, like many other Italian artists, Martini reacted against the fragmentation and flux of Futurism and Cubism, and he participated in the return to order associated with the journal *Valori plastici* and the Novecento movement. Martini sought to revive figurative sculpture, developing a distinctive interest in vernacular, Italian sculpture from earlier centuries (especially the Renaissance) as well as Etruscan art. This taste manifested itself both in his choice of materials—majolica, terracotta, and local stones, as opposed to bronze and marble—as well as his resistance to the heroic, classical forms associated with mainstream art in Fascist Italy. As Emily Braun has recently observed, "Martini's use of popular, indigenous sources implicated his work in the *Italianità* at the same time as his often-irreverent *volgare* subtly evaded totalitarian ideologies and classicizing ideals" (Braun, 146).

In November 1931 Martini visited Pompeii, where he explored the excavations that had expanded rapidly under the direction of Amedeo Maiuri, superintendent at the site since 1924. He also studied the plaster casts of Vesuvius's victims, both those made in the nineteenth century and those produced more recently under the leadership of Vittorio Spinazzola, director of excavations from 1910 to 1924.

Soon thereafter the sculptor began a group of life-size, prone figures including *The Girl* (1931; location unknown), *Thirst* (1932–34; Milan, Museo del Novecento), and the present work, variously entitled *The Drinker*, *Thirst*, or *Drinking Man*. Martini began with a bozzetto in 1933 and started work the following year on the final version, which was eventually exhibited in several state-sponsored exhibitions. In contrast to the classicizing, athletic body that dominated Italian Fascist sculpture, *The Drinker* is prone, with cloth twisted beside him and his mouth attached to a source of water. Martini carved in pietra di Finale, a soft limestone found near his studio in Vado Ligure. This traditional, vernacular building material, used in ancient and Renaissance architecture, doubly invoked Pompeii through its rough, porous quality, which resembles volcanic tufa and—especially when chiseled roughly—recalls the surfaces of the plaster body casts. The consciously awkward proportions of the man likewise disassociate the work from heroic classicism, positioning Pompeii as a model for ordinary Romans undergoing suffering, enduring a thirst that should be understood as metaphysical instead of literal. | JLS

SELECTED BIBLIOGRAPHY

Braun 2010.

Campiglio 2008.

Ferrari, Claudia Gian, Elena Pontiggia, and Livia Velani, eds., *Arturo Martini*, exh. cat. (Milan, 2006) (with prior bibliography).

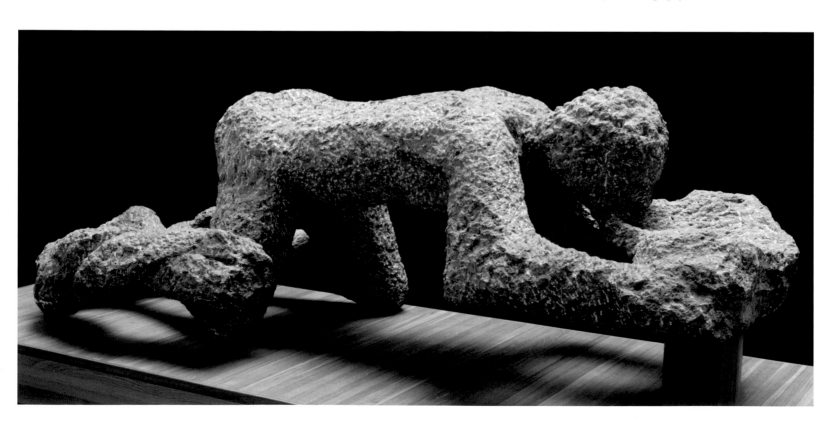

34

Unknown photographer

AMERICAN B-25 MITCHELL BOMBERS FROM THE 447TH SQUADRON OF THE
321ST BOMBARDMENT GROUP OF THE TWELFTH AIR FORCE, BASED AT PORETTA, CORSICA,
FLY PAST VESUVIUS IN ERUPTION, MARCH 17–21, 1944

Gelatin silver print, 11.4 × 14.5 cm (4½ × 5¹⁄₁₆ in.)
Archive of Raymond D. Yusi, Army Corps of Engineers,
Pacific Palisades, California

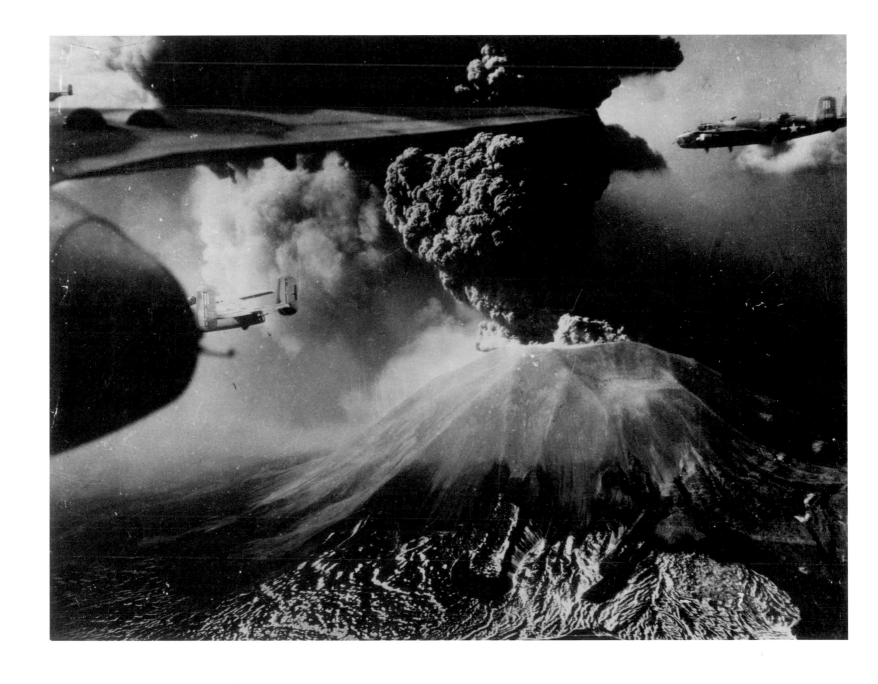

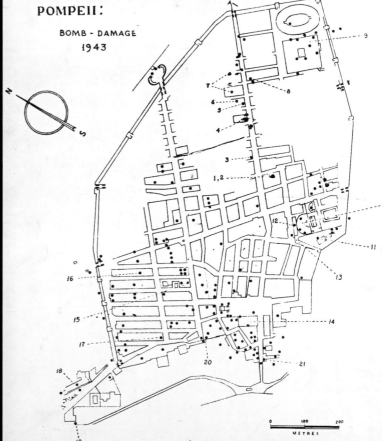

POMPEII:

BOMB - DAMAGE
1943

TOP LEFT
34.1. House of Epidius Rufus (IX.1.20) after bombing

TOP RIGHT
34.2. House of Triptolemus (VII.7.5) after bombing

BOTTOM LEFT
34.3. Region VII, section 6 after bombing

BOTTOM RIGHT
34.4. Plan showing bomb strikes at Pompeii

As part of Operation Avalanche to liberate southern Italy in the autumn of 1943, Allied forces fought to dislodge German soldiers and disrupt their resupply routes. Unfortunately, significant intersections of both roads and railways, as well as bridges and overpasses, were located very near to the archaeological site of Pompeii—as they still are today. Indeed, the major thoroughfare from Naples to Salerno ran through the modern town of Pompeii, which borders the archaeological site. Thus the site was badly damaged by Allied bombing.

It has been suggested that the Allies deliberately bombed Pompeii, erroneously believing German troops to have been encamped and/or storing ammunition there, but it is equally likely that facing German counterattacks that nearly forced the evacuation of the Salerno beachhead, the Allies launched an intensive air campaign to prevent German supplies and reinforcements from reaching the front. Precision bombing, so familiar to us today from recent campaigns in the Near East, was then unknown, and although Allied pilots may not have intended to target Pompeii, significant "collateral damage" did take place.

The first bombing raid struck on August 24, 1943 (ironically the anniversary of the eruption of Vesuvius), and further, heavier raids occurred between September 13 and 24. These were carried out by units of the American Twelfth Air Force and the British Royal Air Force (RAF). Damage was incurred at various points throughout the archaeological site (over 160 hits were recorded), and some of its most famous monuments were struck, including the Porta Marina (the modern entrance to the site) and the Houses of Epidius Rufus (pl. 34.1), Triptolemus (pl. 34.2), the Faun, and the Vettii. The site museum was totally destroyed, as were dozens of other houses (pls. 34.3 and 34.4), as contemporary photographs and limited contemporary accounts attest. Although there is no evidence of a concerted cover-up by either the Allies or, subsequently, by Italian authorities, these incidents were not widely reported, though a few descriptions did appear in Italian and foreign newspapers.

After the war, many of the damaged buildings were rebuilt, including a large stretch of the famous Via dell'Abbondanza, but others were left in ruins, and their present state is not much changed. Ironically, the recent, highly publicized collapse of some Pompeian buildings (such as the House of the Gladiators after heavy rains in November 2010) did not harm ancient structures, for those no longer exist; rather, it was post–World War II reconstructions that were damaged.

A different irony occurred half a year after the Allies bombed Pompeii. Following the expulsion of the Germans, an American airfield was established on the edge of the site, near Terzigno. When Vesuvius erupted in late March 1944—the largest eruption since 1906—the wind blew north for the first three days, and the planes of the Twelfth Air Force's 340th Bombardment Group were safe. But on March 22 the wind shifted, and nearly all of the squadron's bombers were covered with hot ash that burned their fabric control surfaces; glazed, melted, or cracked their Plexiglas windows; and even tipped some of them over. The destruction of these eighty planes was the greatest single loss of Allied aircraft in the entire Second World War. | KL

SELECTED BIBLIOGRAPHY

Aurigemma, Salvatore, Introduction in *Pompeii alla luce degli scavi novi di Via dell'Abbondanza (anni 1910–1923)* by Vittorio Spinazzola (Rome, 1953), 1: xix–xxxi.

Berry, Joanne, *The Complete Pompeii* (London, 2007), 60–61.

"British Officer's Account of Allied Bomb at Pompeii," *The Times* (London), November 9, 1943.

García y García 2006.

Haulman, Daniel L., "The Mountain and the Mitchells: The Destruction of the 340th Bombardment Group in WWII," *Journal of the American Aviation Historical Society* (Fall 1989): 230–33.

Maiuri, A., "Restauri di Guerra a Pompei," *Le Vie d'Italia* (1947): 215–21.

Paul, Joanna, "Pompeii, the Holocaust, and the Second World War," in Hales and Paul 2011, 340–55.

VanderPoel 1986, vol. IIIA, pp. xvi–xvii.

Personal communications from Don Kaiser and Nigel Pollard.

César
French, 1921–1998

SEATED NUDE, POMPEII

1954
Iron, H: 167 cm (65¾ in.)
Private Collection, courtesy Malingue S. A.

César Baldaccini, born into an Italian immigrant family in Marseilles, sought alternative paths to the carving and casting traditions that had long dominated French sculpture. His disconnect with elite Parisian culture, as well as a lack of money, led him initially to weld scrap metal, accentuating the industrial, working-class aspect of his practice. He surged to fame in 1960 with ready-mades constructed out of crushed cars. These works, known as "Compressions," brought him to the forefront of *nouveau réalisme*, a movement that focused on everyday urban materials and emphasized found objects and assemblages (but with a formalist bent) that would dominate the remainder of his career.

This early work demonstrates César's connections to an innovative group of European sculptors in the aftermath of World War II, such as Germaine Richier (see pl. 36) and Alberto Giacometti, who rejected abstraction, instead adopting an expressionist mode based on the body. For these artists, the traumatized body addressed the impossibility of depicting formal beauty in the wake of Nazi atrocities, atomic warfare, and wartime privations. For César, however, Pablo Picasso's approach of reworking found material to metaphoric ends also proved critical and moved him in different directions than other contemporary figural sculptors.

The title explicitly connects this sculpture to Pompeii. A 1949 visit to the site left the artist struck by the expressive potential of the body casts. Despite the outward differences between those objects and his work—dark metal composed additively, in contrast to white plaster filling a space left by decayed matter—César's skeletal, hollow form, with rods spun like a web in the body's interior, similarly articulates the void of a dematerialized body. The cataclysm that took the lives of the Pompeians finds a modern equivalent in César's blasted carcasses. The woman's flesh in both *Seated Nude, Pompeii* and *Torso* (pl. 35.1) has been seared away, seemingly by an atomic bomb or industrial catastrophe, in a reflection of the welding process enacted on a passive female body. By drawing a connection between this unstable, ample shape and the actual bodies from antiquity, César rejects classical forms, while the Pompeian subject also allows him to distance his work from myth in favor of something that simultaneously addresses a

longer cultural history and the particular concerns of postwar Europe. | JLS

SELECTED BIBLIOGRAPHY

Baldaccini, César, *César*, exh. cat. (Paris, Galerie nationale du Jeu de Paume, 1997).

Cabanne 1971.

Cone, Michèle C., "The Mature Richier, the Young César: Expressionist Confluences in French Postwar Sculpture," *Art Journal* 53, no. 4 (Winter 1994): 73–78.

Durand-Ruel, Denyse, *César catalogue raisonné*, vol. 1 (Paris, 1994) (with prior bibliography).

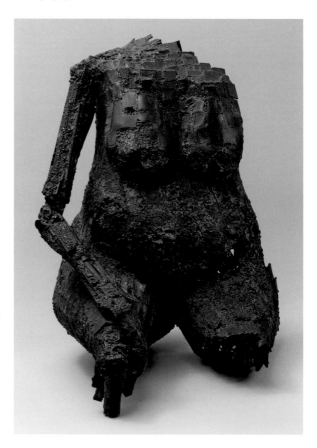

35.1. César (French, 1921–1998), *Torso*, 1954. Iron, 77.1 × 59.4 × 68.8 cm (30⅜ × 23⅜ × 27⅛ in.). New York, Museum of Modern Art, 25.1960.

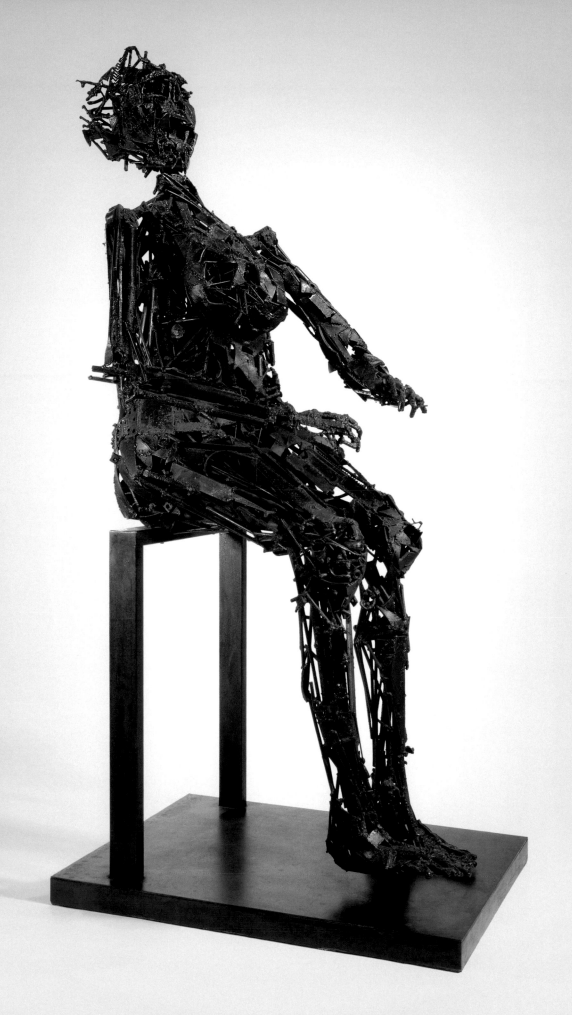

36

Germaine Richier
French, 1904–1959

THE SEED

1955
Bronze, 144.8 × 35 × 34.3 cm (57 × 13¾ × 13½ in.)
Washington, D.C., Hirshhorn Museum and Sculpture Garden, Gift of Joseph H. Hirshhorn, 1966, 66.4240

Richier was among a group of European sculptors, including César and Marino Marini (see pls. 35 and 37), who, in the wake of the horrors of World War II, used Pompeian body casts as a critical point of departure for figurative sculpture. She trained with Antoine Bourdelle as a traditional sculptor in the long shadow of Rodin, initially making portraits and female nudes. As a student in 1935 she traveled to the Bay of Naples, where the casts made an enormous impression on her. Yet the aftereffects of this encounter would not develop fully until after the war. Exiled in Switzerland, she worked alongside Alberto Giacometti and Marini, who all eschewed the sleek machine aesthetic that arose between the wars as well as the Fascist, classicizing body. In the mid-1940s, deeply aware of existentialist philosophy and seeking a new approach to sculpture, she began to draw on childhood memories, especially of wildlife and folklore. Like many postwar European artists, she sought liberation from tradition, rejecting technology and elite culture in favor of primitive ideas and forms.

Richier remained committed to roughly cast figural sculpture, hybrid bodies that merge animal and human forms. She left surfaces disturbed, strafed with voids and interruptions, and impressed with objects. As David Sylvester noted in 1955, "Richier brings matter to the point of dissolution only to hold it all the more firmly together," an approach demonstrated by the trauma she inflicted on the objects, scraping the surface and opening voids in the sculpture.

She returned many times to the subject of the standing female, experimenting with poses, actions, and levels of finish. *The Seed*, with its truncated hands and rubbed face, is among the most startling of these works. The isolated, slender woman connects to the work of Giacometti. Yet, while his figures are clearly people in existential isolation, in this work Richier merges human and insect. The bent, expressive arms interact with the surrounding space, engaging the viewer in a distressing dialogue of suffering and survival—the emaciated figure giving the impression of being melted or seared by radiation.

While Richier's interest in the primitive and the surreal has been much discussed, the impact of the casts of Pompeii on her work has received less attention, but they are a critical source for the artist's œuvre. *The Seed,* like the casts, appears to have experienced a cataclysm, which has disfigured and mangled the body, though it has not suppressed a desire to communicate with the viewer. As distorted, hybrid creatures with lost features, their surfaces bearing the trace of burial, Richier's works—like those of Arturo Martini (see pl. 33)—draw on the ordinary victims of the disaster at Pompeii. The French title *Le Grain* in this connection seems to mean less "grain" than "seed"—a husk with traces of life. | JLS

SELECTED BIBLIOGRAPHY

Barbaro, Luca Massimo, "L'opera di Germaine Richier e l'Italia," in Germaine Richier, ed. Luca Massimo Barbero (Venice, 2006).

Guiter, Françoise, "Biographie. Catalogue des œuvres," in *Germaine Richier Rétrospective*, exh. cat. (Paris, Fondation Maeght, 1996).

Lammert, Angela, and Jörn Merkert, eds., *Germaine Richier*, exh. cat. (Berlin, Akademie der Künste, 1997).

Morris 1993, nos. 161 and 162.

Sylvester 1955.

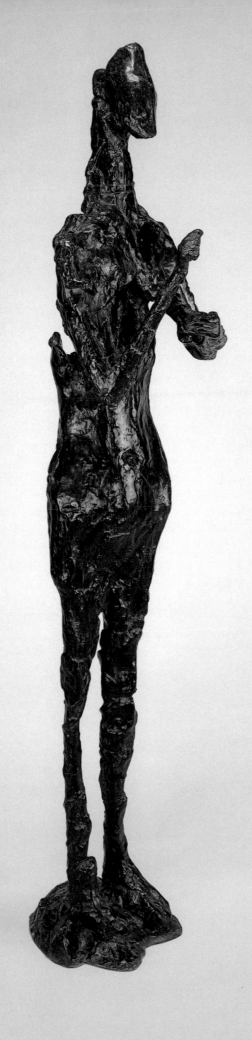

Marino Marini
Italian, 1901–1980

THE MIRACLE

1954
Bronze, 116.9 × 172.8 × 88.9 cm (46 × 68 × 35 in.)
Baltimore Museum of Art, Alan and Janet Wurtzburger Collection, 1966.55.17

Marini emerged as a mature artist during the return to order in the 1920s, drawing on historically Tuscan sources, which included both Etruscan and Renaissance art. He maintained contact with modern artists in Paris throughout the 1930s, and while exiled in Switzerland during the Second World War, worked closely with Germaine Richier and Alberto Giacometti, who encouraged his expressive, rigorous approach to the figure.

Best known for his continual reinterpretation of the horse and rider, Marini began painting, printing, and sculpting this subject in the mid-1930s. These works, of considerable formal balance, invoked heroic equestrian sculpture. The horsemen faded from his work during the war in favor of the female nude but returned afterward, at first with impassioned optimism. However, Marini's anxieties mounted over the potential destruction of civilization under the specter of nuclear war, and his mood blackened in the face of his perceived helplessness. The horse-and-riders, which had previously depended on the

victorious hero enduring as a sign of humanity, now began to be assaulted by mysterious forces (pl. 37.1).

In this sculpture, the animal has fallen to its knees; its expressionless head, pressed to the ground, appears lifeless. The traumatized rider—his back arched and stiff, head thrown back, and arms pressed behind him—has regressed to an infantile reflex, unable to act on his own. Without hair and ears, his anguished face reveals the man's other senses fully engaged, with his wide-eyed stare, flared nostrils, and bared teeth. Many of Marini's earlier horsemen sport erections, but this rider has no trace of genitals, and his truncated, skinny arms turn back at impossible angles, appearing from many viewpoints to be amputated, utterly incapable of seizing control of the steed. The sculptor's technique, with rough, barely chased surfaces and visible seams—further emphasizes this troubled state.

Visiting Pompeii and seeing the body casts profoundly affected Marini, as it had Arturo Martini, César, and Richier (see pls. 33, 35, and 36). This experience supplanted his earlier interest in ancient and Renaissance precedents for his equestrian sculptures. As he later stated, "The fossilized corpses that have been unearthed in Pompeii have fascinated me more than the Laocoön group in the Vatican. If the whole earth is destroyed in our atomic age, I feel that the human forms which may survive will have become sculptures similar to mine" (Roditi).

Unlike Richier, Marini saw his distressed men and horses not only as figures in existential crisis but as caught up in moral questions about war, technology, and the capacity for annihilation. Notions of decadence and apocalypse played a critical role in how Marini's practice changed after the war. For Marini, "The catastrophe that overcomes man and animal resembles that which destroyed Sodom and Pompeii" (Roditi). | JLS

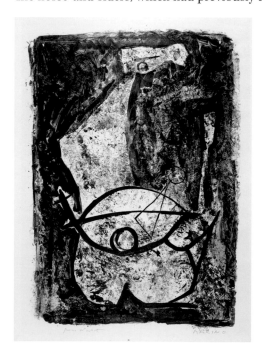

37.1 Marino Marini (Italian, 1901–1980). *Miracle*, 1965. Lithograph, 77 × 55.5 cm (30 5/16 × 20 7/8 in.). The Cleveland Museum of Art, Seventy-fifth anniversary gift of Brenda and Evan H. Turner, 1992.144.

SELECTED BIBLIOGRAPHY

Marino Marini, exh. cat. (Milan, Palazzo Reale and Museo Marino Marini, 1989–90).

Marino Marini: Catalogue Raisonné of the Sculptures, with an introduction by Giovanni Carandente (Milan, 1998).

Roditi, Edouard, "Interview with Marino Marini," in *Dialogues on Art* (New York, 1960), 45–46.

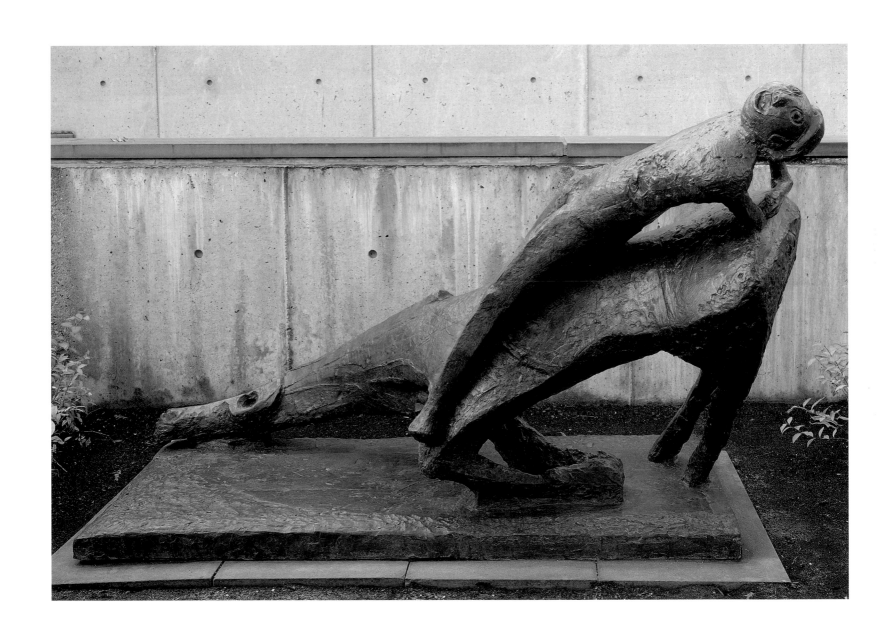

William Baziotes
American, 1912–1963

POMPEII

1955
Oil on canvas, 152.4 × 121.9 cm (60 × 48 in.)
New York, Museum of Modern Art, 189.1955

Although Baziotes was associated with the Abstract Expressionist movement, his work does not possess the same gestural force as that of his peers. The influence of Symbolist poetry and his sustained engagement with automatism—a Surrealist technique of dissociation from one's conscious state in order to make art through involuntary actions—led the artist to create paintings featuring occult, biomorphic forms that silently loom in the painted field. These phantasmagoric manifestations of Baziotes's subconscious often include mythic themes related to his Greek heritage. But for *Pompeii,* Baziotes revealed in a letter to the Museum of Modern Art's director Alfred Barr that he had drawn inspiration from ancient Rome (Cavaliere, 130). Rome's "decadence, satiety, subtlety, and languor" appealed to him, and he was entranced by ancient wall paintings that revealed a "veiled melancholy" and "elegant plasticity" (ibid.). Baziotes further explained that the background of *Pompeii* was inspired by what he considered to be the ancient Romans' skilled depiction of geology. The hazy black cloud was intended to symbolize "fire, lava, and destruction," and the three spikes in the foreground to represent death and ruination (ibid.).

Two years before this painting, Baziotes created a pastel, also entitled *Pompeii,* now in the collection of the Wadsworth Atheneum (pl. 38.1). Although it has a cooler palette of lavender, blue, and grays, the figures that appear to emerge from the depths of the picture plane lend the pastel a similarly enigmatic mood. It was this mysterious character that Baziotes loved most in a painting. As he once stated, he embraced "the stillness and the silence. I want my pictures to take effect very slowly, to obsess and to haunt" (Baziotes, 11). | LZ

SELECTED BIBLIOGRAPHY

Alloway, Lawrence, ed., *William Baziotes: A Memorial Exhibition,* exh. cat. (New York, The Solomon R. Guggenheim Foundation, 1965).

Baziotes, William, "Notes on Painting," *It Is* 4 (Autumn 1959): 11.

Cavaliere, Barbara, "An Introduction to the Method of William Baziotes," *Arts Magazine* 51 (April 1977): 124–31.

Nordness, Lee, and Allen S. Weller, *Art: USA: Now* (New York, 1963), 2:260–62.

38.1 William Baziotes (American, 1912–1963), *Pompeii,* 1953. Pastel over charcoal on grey wove paper, 48.3 × 63.2 cm (19 × 24⅞ in.). Hartford, Conn., Wadsworth Atheneum, Gift of Philip Goodwin, 1957.603.

39

Robert Rauschenberg
American, 1925–2008

SMALL REBUS

1956
Combine: oil, graphite, paint swatches, paper, newspaper, magazine clippings, black and white photographs,
U.S. map fragment, fabric, and 3-cent stamps on canvas, 88.9 × 116.8 × 4.4 cm (35 × 46 × 1¾ in.)
Los Angeles, The Museum of Contemporary Art, The Panza Collection, 87.18
Art © Estate of Robert Rauschenberg / Licensed by VAGA, New York, NY

Small Rebus belongs to a body of mixed-media works Robert Rauschenberg created beginning in the mid-1950s that are known as "Combines." The Combines blur the boundaries between traditional categories of painting and sculpture, between avant-garde and kitsch, through a bricolage of elements such as newspaper and magazine clippings, items from everyday life, even rubbish. In this composition, a strip of paint swatches laid out across the canvas contrasts with the haphazard drips and patches of color, perhaps a nod to the Abstract Expressionist movement Rauschenberg repudiated. A drawing of a clock without hands, a blank piece of sheet music, and a diagram of the brain (illustrating sensory perception) together demonstrate the artist's "concern with dismantling the riddle of the creative process" (De Salvo, 34). Finally, a selection of newspaper and magazine clippings are strewn about the canvas—including the young track star looking as though he might plummet from the photograph if not for the black circle drawn around him, reminding the viewer that this is in fact an image. At bottom of the composition is the well-known photograph of the cast of the dog from Pompeii (see fig. 14), whose contorted body is frozen in a state of agony.

How can one begin to make sense of this muddle of seemingly unrelated imagery? Rosalind Krauss asserts that in a work like *Small Rebus* "what Rauschenberg was insisting upon was a model of art that was not involved with what might be called the cognitive moment (as in single-image painting) but instead was tied to the *durée*—to the kind of extended temporality that is involved in experiences like memory, reflection, narration, proposition" (Krauss, 41). Memory, typically something private and internalized, spills onto the canvas. Rauschenberg includes personal elements, like the photograph of his parents and sister

on the right, alongside images culled from magazines and newspapers, stamps, and maps. Memory is thus transformed, "from something that is private to something that is collective insofar as it arises from the shared communality of culture. This is not culture with a capital C but rather a profusion of facts, some exalted but most banal, each of which leaves its imprint as it burrows into and forms experience"(Krauss, 52).

What remains problematic about this piece is the title, *Small Rebus,* which challenges the viewer to find a cohesive narrative in these disparate fragments. Art historian Thomas Crow proposes that *Small Rebus* can be read in terms of the dialectics of rise and fall. Indeed, the sharp angle in the photograph of the runner, giving the impression that he is free-falling, is counteracted by the gymnast climbing the rope in the photograph below, almost as if the two bodies are weights attached to a pulley. On the left-hand side of the composition is a reproduction of Titian's *Rape of Europa.* Zeus's eventual ascent into heaven in the guise of a bull is contrasted with a yellowed newspaper photograph of a *torero* fighting a bull. Both the descent of the athlete and the eventual defeat of the bull seem to imply an allegorical link to the ill-fated dog of Pompeii. | LZ

SELECTED BIBLIOGRAPHY

De Salvo, Donna M., Paul Schimmel, Russell Ferguson, and David Ditcher, *Hand-Painted Pop: American Art in Transition, 1955–62,* exh. cat. (Los Angeles, Museum of Contemporary Art, 1992).

Joseph, Brandon W., ed., *Robert Rauschenberg* (Cambridge, Mass., 2002).

Krauss 1974.

Rauschenberg, Robert, Paul Schimmel, and Thomas Crow, *Robert Rauschenberg: Combines,* exh. cat. (Los Angeles, Museum of Contemporary Art, 2005).

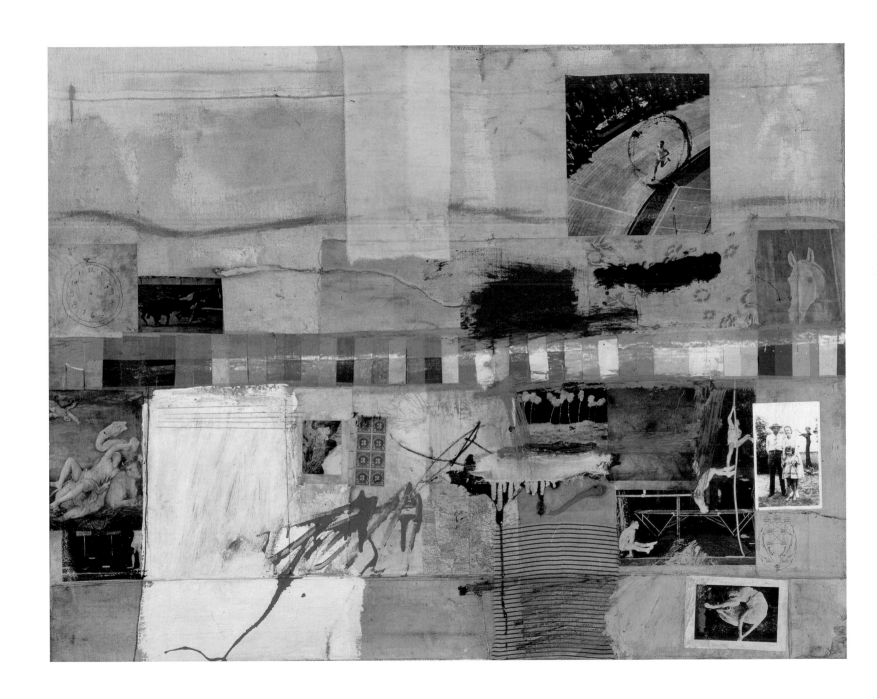

Rothko's Seagram Murals

In 1958 Mark Rothko was commissioned to paint a series of murals for the Four Seasons restaurant, housed in the newly completed Seagram Building in New York City designed by Mies van der Rohe. According to Rothko's assistant Dan Rice, he agreed to take the project because it offered a unique opportunity to control the entire environment. The artist had always disapproved of the way his paintings were displayed in museum settings and thought his work was better suited for permanent installation.

The Seagram murals marked a turning point in the artist's career. Rice said: "I believe he actually felt that he had gone as far as he could in painting until the proposal for the Seagram Building murals was presented to him. It absolutely supplied him with a whole new dimension" (Glimcher, 5). This shift is most immediately apparent in the palette Rothko chose for the series, which is much darker than the vibrant hues he had previously used in his "classical" period of the mid-fifties. Another distinguishing factor is that Rothko turned a number of the works on their side; having to work with the architecture proposed a new set of problems for Rothko to address. In fact, the murals themselves have often been described as columns, doors, or windows.

In the spring of 1959, with the commission underway, the Rothko family boarded the USS *Constitution* for a European vacation. On this trip Rothko met John Fischer, the editor-in-chief at *Harper's Magazine*. The artist harbored a deep resentment toward "the whole machine for the popularization of art—universities, advertising, museums, and the Fifty-seventh Street salesmen" and confided to Fischer his concerns about his work for the Four Seasons commission along with his more general dismay with the art world (Fischer, 20). Fischer published his recollections in *Harper's Magazine* shortly after Rothko's death in 1970, emphasizing Rothko's fascination with ancient art, as well as his sense of alienation and anger toward institutions, critics, and patrons. Rothko told Fischer that he had accepted the Seagram project "with strictly malicious intentions. I hope to paint something that will ruin the appetite of every son of a bitch who ever eats in that room" (Fischer, 16).

In Europe, Rothko visited Naples, Paestum, and Pompeii. He had always admired the art of antiquity: "the modern artist has a spiritual kinship with the emotions which these archaic forms imprison and the myths which they represent" (Bruno, 236), and figurative works from his early career often reflect motifs from Graeco-Roman art. In Pompeii, Rothko felt a "deep affinity" between the Seagram murals and those in the Villa of the Mysteries insofar as both possessed, "the same feeling, the same broad expanses of somber color" (Fischer, 22). The rich palette for the series—deep reds, maroons, and oranges—also recalls fire, lava, smoke, and dried blood. Even more than a similarity of color to the ancient murals, Rothko's aim of creating a stifling environment that would make the patrons of the Four Seasons feel trapped, or buried, recalls the moralizing allegory imposed upon Pompeii: the eruption of Vesuvius was retribution for the excesses of the ancient Romans.

Art historian Vincent Bruno has explored the relationship between Rothko's art and the Second Style of Pompeian painting, observing that both sought not just to decorate but to transform their environment integrally. "In the Roman murals, as in Rothko's art, the color-field becomes the border that separates the physical world we occupy from an imaginary world beyond the picture plane, while the colonnades in front appear to project, thus involving the viewer in a spatial continuum that leads from an everyday world within the confines of a room to a realm beyond the ordinary, a realm of fantasy" (Bruno, 238).

Despite the significance of this series (the largest public Abstract Expressionist commission) many surrounding details remain murky because the murals were never installed. Rothko claimed to have been misled about the space in which they were to be placed, and Rice confirmed that the artist was led to believe that one of the rooms would be an employee canteen and the other a boardroom. Furthermore, Rothko's friend Katharine Kuh proposed: "When he was working on the project, his imagination plus a dash of wishful thinking projected an idyllic setting where captivated diners, lost in reverie, communed with the murals. I'm afraid it never entered his head that the works would be forced to compete with a noisy crowd of conspicuous consumers" (Breslin, 405). When he took his wife to the restaurant, Rothko was disgusted by the environment. "Anybody who will eat that kind of food for those kind of prices will never look at a picture of mine," he ranted (Glimcher, 9).

Before withdrawing from the project in 1960, Rothko created around forty paintings for the commission, including three separate sets of large-scale works, as well as individual studies. After completing the first group of murals for the restaurant and selling them individually, Rothko kept the remaining two unfinished groups for years. He eventually agreed to give a

40

Mark Rothko
American, b. Russia, 1903–1970

UNTITLED (SEAGRAM MURAL SKETCH)

1959
Oil and acrylic on canvas, 183.5 × 152.7 cm (72¼ × 60⅛ in.)
Washington, D.C., National Gallery of Art,
Gift of the Mark Rothko Foundation, Inc. 1985.38.2

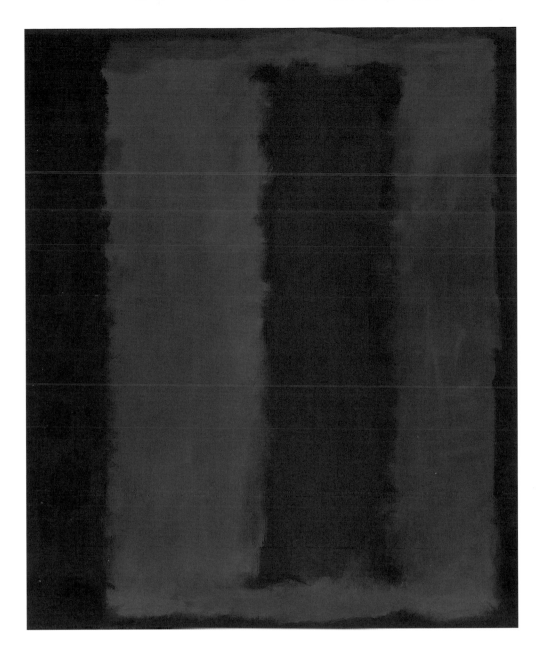

group of nine murals to the Tate Modern in London provided that they would be permanently installed in a room together. The Seagram murals arrived at the Tate on the same day that Rothko committed suicide in 1970.

Besides those in the Tate and several murals owned by Rothko's children, the rest of the Seagram murals are in the collections of the National Gallery of Art in Washington, D.C., and the Kawamura Museum in Tokyo. The murals included in this exhibition were part of a large gift—295 paintings and works on paper and 650 sketches—presented to the National Gallery by the Mark Rothko Foundation in 1985 and 1986. The works are in various states of completion—for example, cat. 44 demonstrates the dark underpainting Rothko began with in order to intensify and give depth to the colors of his painting. | LZ

SELECTED BIBLIOGRAPHY

Anfam, David, *Mark Rothko: The Works on Canvas: Catalogue Raisonné* (New Haven, Conn., 1998).

Breslin, James E. B., *Mark Rothko: A Biography* (Chicago, 1993).

Bruno, Vincent J., "Mark Rothko and the Second Style: The Art of the Color-Field in Roman Murals," in *Eius Virtutis Studiosi: Classical and Post-Classical Studies in Memory of Frank Edward Brown (1908–1988)*, ed. Russell T. Scott and Ann Reynolds Scott (Washington, D.C., 1993), 235–55.

Fischer, John, "The Easy Chair: Mark Rothko, Portrait of the Artist as an Angry Man," *Harper's Magazine* 241, 1442 (July 1970): 16–23.

Glimcher, Arnold, *The 1958–1959 Murals: Second Series*, exh. cat. (New York, Pace Gallery, 1978).

Mark Rothko, the Seagram Mural Project, exh. cat. (Liverpool, Tate Gallery Liverpool, 1988).

Polcari, Stephen, "Mark Rothko: Heritage, Environment, and Tradition," *Smithsonian Studies in American Art* 2, no. 2 (Spring 1988): 33–63.

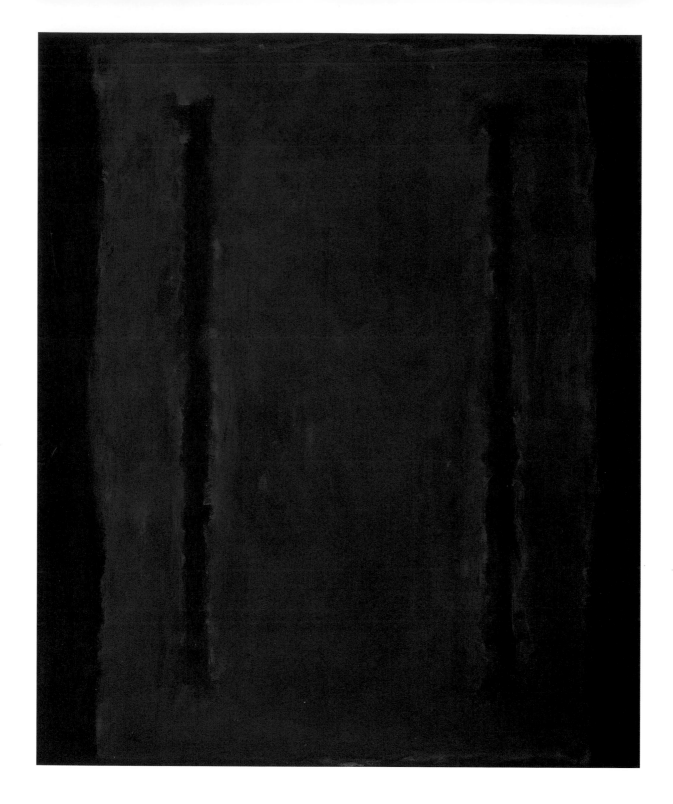

41

Mark Rothko
American, b. Russia, 1903–1970

UNTITLED (SEAGRAM MURAL SKETCH)

1958
Oil and acrylic on canvas, 183.1 × 152.6 cm (72^1/$_{16}$ × 60^1/$_{16}$ in.)
Washington, D.C., National Gallery of Art, Gift of the Mark Rothko Foundation, Inc. 1985.38.1

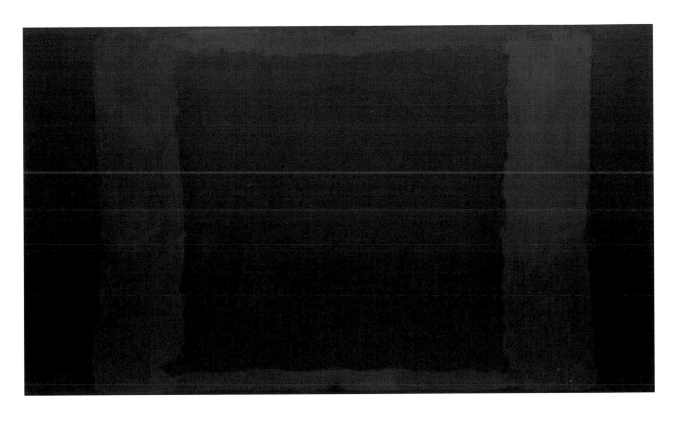

42

Mark Rothko
American, b. Russia, 1903–1970

UNTITLED (SEAGRAM MURAL)

1959
Oil on canvas, 269 × 457.8 cm (105⁷/₈ × 180¼ in.)
Washington, D.C., National Gallery of Art,
Gift of the Mark Rothko Foundation, Inc. 1986.43.167

43

Mark Rothko
American, b. Russia, 1903–1970

UNTITLED (SEAGRAM MURAL SKETCH)

1958
Oil on canvas, 266.1 × 252.4 cm (104¾ × 99³/₈ in.)
Washington, D.C., National Gallery of Art,
Gift of the Mark Rothko Foundation, Inc. 1986.43.170

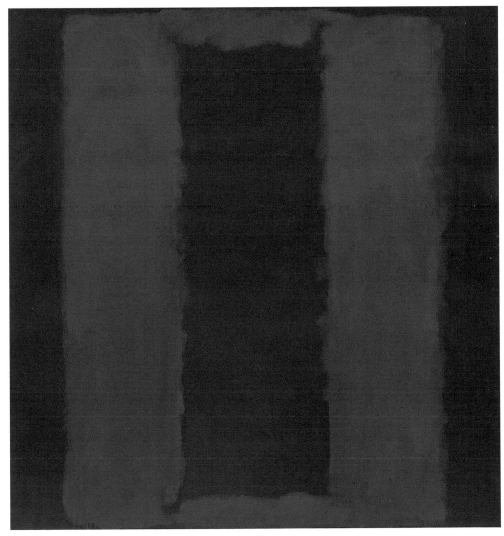

44

Mark Rothko
American, b. Russia, 1903–1970

UNTITLED (SEAGRAM MURAL SKETCH)

1959
Oil and acrylic on canvas, 267.2 × 289.2 cm (105³/₁₆ × 113⁷/₈ in.)
Washington, D.C., National Gallery of Art,
Gift of the Mark Rothko Foundation, Inc. 1985.38.4

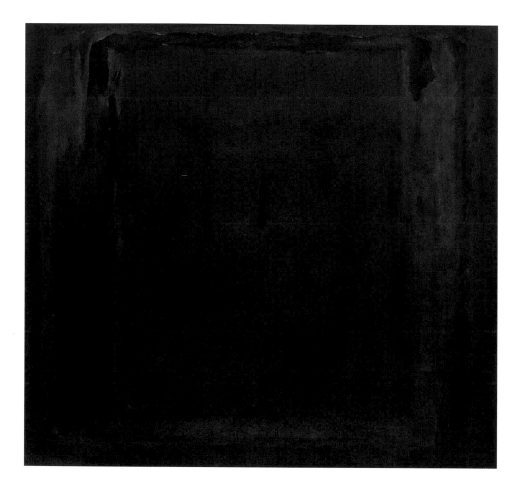

45

Mark Rothko
American, b. Russia, 1903–1970

UNTITLED

1958, reworked 1964/65
Oil, acrylic, and mixed media on canvas,
2.67 × 1.14 m (8 ft. 9¹/₈ in. × 3 ft. 9 in.)
Washington, D.C., National Gallery of Art,
Gift of the Mark Rothko Foundation, Inc. 1986.43.146

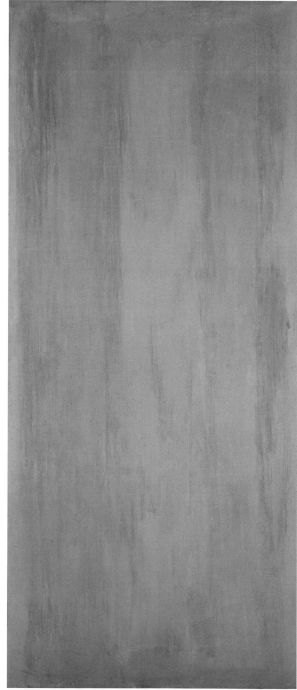

46

Mark Rothko
American, b. Russia, 1903–1970

UNTITLED (SEAGRAM MURAL SKETCH)

1959
Oil and mixed media on canvas, 182.6 × 450.2 cm (71⅞ × 177¼ in.)
Washington, D.C., National Gallery of Art, Gift of the Mark Rothko Foundation, Inc. 1986.43.156

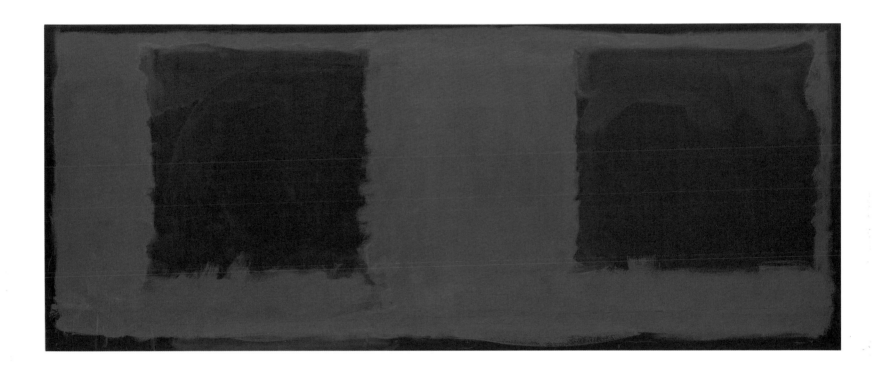

Mark Rothko
American, b. Russia, 1903–1970

UNTITLED (SEAGRAM MURAL)

1959
Oil and mixed media on canvas, 265.4 × 288.3 cm (104½ × 113½ in.)
Washington, D.C., National Gallery of Art, Gift of the Mark Rothko Foundation, Inc. 1985.38.5

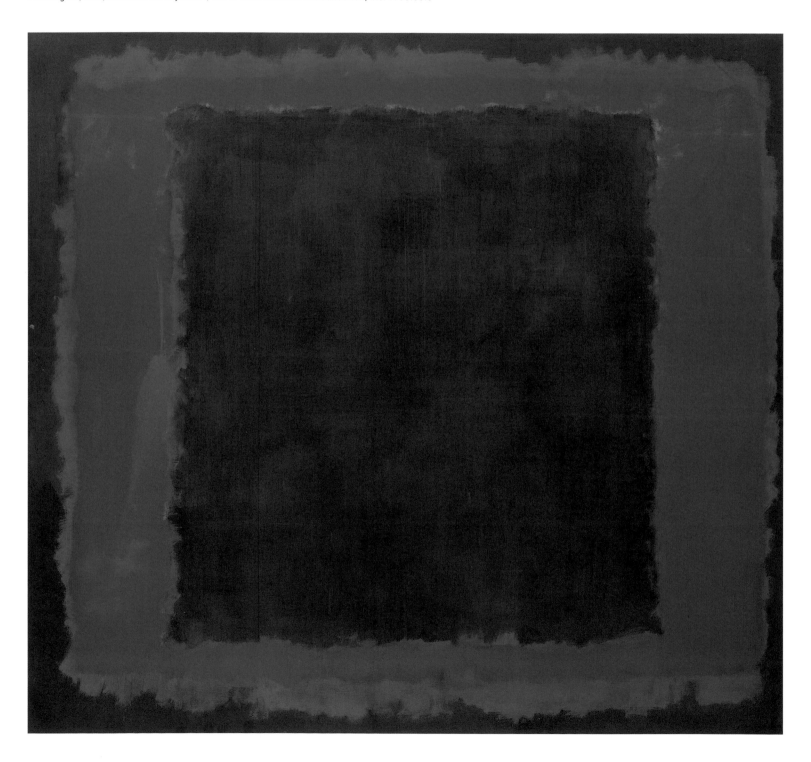

48

Mark Rothko
American, b. Russia, 1903–1970

UNTITLED (SEAGRAM MURAL SKETCH)

1959
Oil and acrylic on canvas, 182.8 × 152.6 cm (71¹⁵⁄₁₆ × 60¹⁄₁₆ in.)
Washington, D.C., National Gallery of Art,
Gift of the Mark Rothko Foundation, Inc. 1985.38.3

49

Mark Rothko
American, b. Russia, 1903–1970

UNTITLED (SEAGRAM MURAL SKETCH)

1959
Oil on canvas, 265.4 × 457.2 cm (104½ × 180 in.)
Washington, D.C., National Gallery of Art,
Gift of the Mark Rothko Foundation, Inc. 1985.38.6

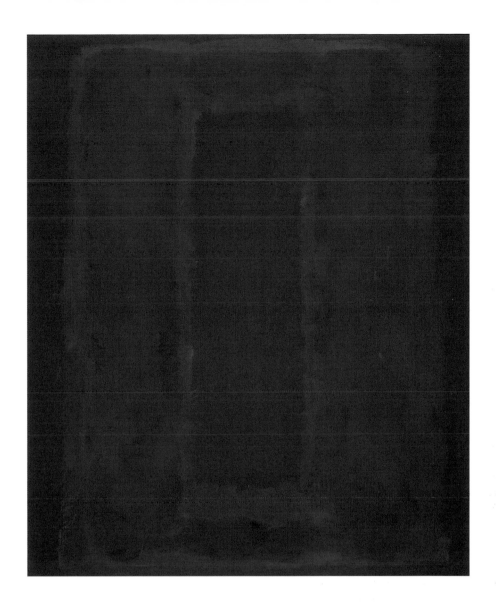

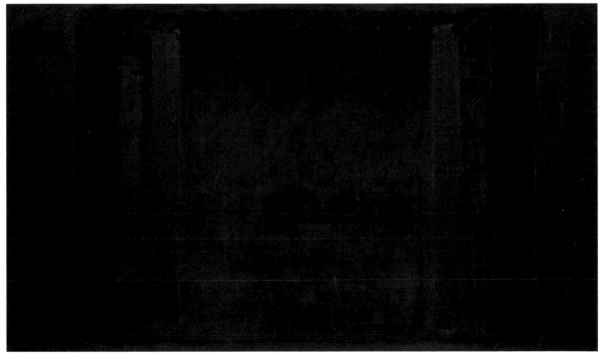

Warhol's *Vesuvius*

Lucio Amelio, a contemporary art dealer from Naples, commissioned Warhol to create a series of images of Vesuvius, including sketches, prints, and paintings, in 1985. After he opened his first gallery in 1965, Amelio worked tirelessly to develop an international contemporary art scene in Naples. From the Neapolitan gallerist's perspective, Vesuvius was not just a symbol of catastrophe, but it was also an icon of his native landscape, constantly reimagined in art over the centuries, and he thought it merited re-examination by the famous Pop artist.

Warhol had previously created works for Amelio's project responding to the 1980 Irpinia earthquake that devastated southern Italy. In this exhibition, held at the Reggia di Caserta in Naples, Amelio included some of the most prominent figures in contemporary art, including Joseph Beuys, Anselm Kiefer, Robert Rauschenberg, Cy Twombly, and Mario Merz, all of whom created works to raise awareness of the earthquake and money for the survivors. While some artists focused on the theme of natural catastrophe and referred to Vesuvius, Warhol made a triptych of massive silk-screened paintings of the front page of the Neapolitan newspaper *Il Mattino* entitled *Fate Presto* ("Hurry Up") after the headline urging readers to make haste to help the victims of the disaster. The earthquake only seemed to strengthen Amelio's resolve to build up the arts scene in Naples and his commission of the Vesuvius series in 1985 seems almost like an ode to Naples.

Fate Presto recalls Warhol's well-known "death and disaster" works of the 1960s (images of accidents, electric chairs, the recently widowed First Lady Jackie Kennedy, and Marilyn Monroe after her suicide), but his depiction of Vesuvius lacks the grim yet indifferent character of these earlier works. This distinction is, in par-t, due to Warhol's use of a hand-painted technique in this series, which moved away from the purely mechanical silkscreen process he used to underscore the mass-produced images that were his source material. Warhol explained that he hand-painted the Vesuvius series in order "to give the impression of [the works] having been painted just one minute after the eruption" (Naples 1985, 36). According to the artist, this technique made Vesuvius more abstract (ibid. 35). Indeed, the image of the eruption has a frenzied, erotic quality, particularly in the smaller canvas of the two included in the exhibition (pl. 50), where the flesh tone of the volcano enhances its phallic nature.

So far, little information has been made available on the Vesuvius series besides the 1985 exhibition catalogue. Research is challenging because Warhol's later work has not received the same critical attention as his early work, and the Time Capsules in the Warhol Archives from the late 1980s are still being catalogued and are thus unavailable to researchers. However, materials found in a number of "Idea Boxes" in the Warhol Archives with source material for his work demonstrate that Warhol consulted a variety of sources for the Vesuvius series.

Scholars have speculated that Warhol used a painting by a well-known practitioner for his source (Joseph Wright of Derby, Pierre Jacques Volaire, or the lesser-known Camillo de Vito), but it was in fact a postcard of a painting by an unknown artist. The actual postcard is lost, but a black-and-white photocopy of the original image exists, *Eruzione al 1913* (Eruption of 1913; Andy Warhol Archives, Idea Box 21). Based on materials in the Idea Box, Warhol's process emerges. He manipulated the original, cropping various elements out of the photocopied image, including a small boat and a figure fishing, in order to focus fully on the form of Vesuvius. He enlarged a facsimile of the postcard and drew atop the image with a thick marker, delimiting the basic form of the volcano and adding painterly flourishes, which he then transferred to acetate for the silkscreens. Knowing that he drew on a postcard situated the series with his larger œuvre, since this process relates to the mass production of images.

In addition to the *Eruzione al 1913* postcard, Warhol used Giorgio Sommer's 1872 photograph of the eruption, now in the Andy Warhol Archives (2001.2.2242), for several drawings. By transforming a mundane postcard with his vibrant palette and cartoonish effects, Warhol shows that seriality and kitsch were not just hallmarks of Pop Art, but also relate to the proliferation of volcanic images collected as Grand Tour souvenirs. Angela Tecce noted that, "the 19th-century saw the emergence of the concept of kitsch considered as a category of the self, an inauthentic subjectivity" (Naples 1985, 22). Underscoring this idea, Warhol wrote with an ambivalent air of sarcastic resignation in his diary: "For Lucio Amelio I'm doing the Volcanoes. So I guess I'm a commercial artist. I guess that's the score" (Hackett, 645).

| LZ

SELECTED BIBLIOGRAPHY

Hackett, Pat, ed., *The Andy Warhol Diaries* (New York, 1989).

Naples 1985.

Pratt, Alan R., ed., *The Critical Response to Andy Warhol* (Westport, Conn., 1997).

Terrae motus, exh. cat. (Herculaneum, Villa Campolieto, 1984).

Terrae motus: La collezione Amelio alla Reggia di Caserta, exh. cat. (Milan, Reggia de Caserta, 2001).

50

Andy Warhol
American, 1928–1987

MOUNT VESUVIUS

1985
Screenprint on linen, hand-colored with acrylic, 72.4 × 81.3 cm (28½ × 32 in.)
Pittsburgh, The Andy Warhol Museum, Founding Collection,
Contribution The Andy Warhol Foundation for the Visual Arts, Inc., 1998.1.3178

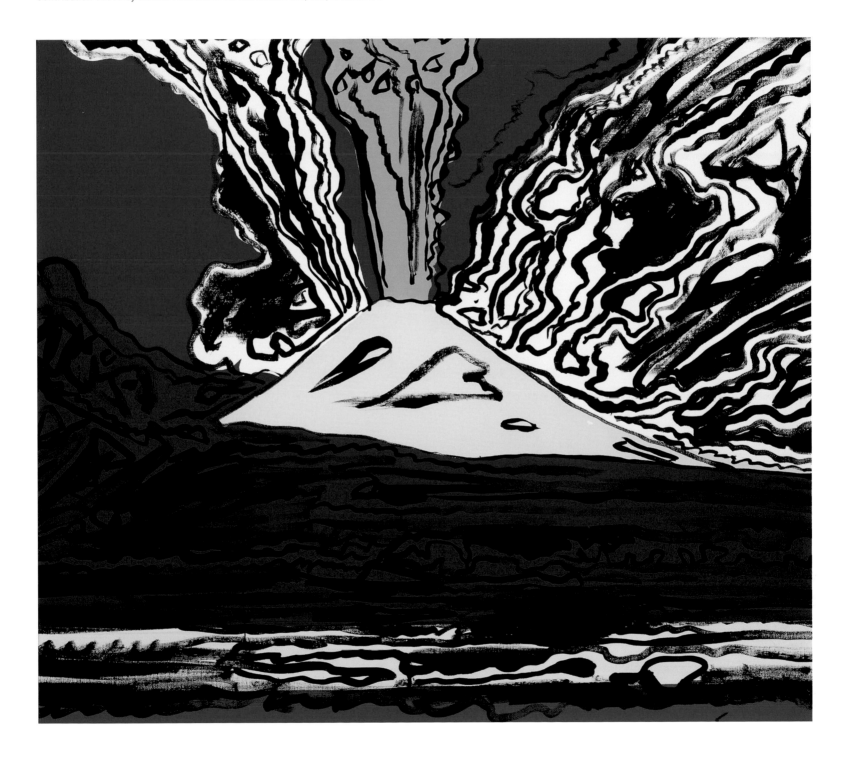

51

Andy Warhol
American, 1928–1987

VESUVIUS (ARTIST'S PROOF 48/50)

1985
Screenprint
79.9 × 99.7 cm (31$\frac{7}{16}$ × 39$\frac{1}{4}$ in.)
Pittsburgh, The Andy Warhol Museum,
Founding Collection,
Contribution The Andy Warhol Foundation
for the Visual Arts, Inc., 1998.1.2489

52

Andy Warhol
American, 1928–1987

VESUVIUS (#365)

1985
Screenprint on Arches 88 paper
80 × 100 cm (31$\frac{1}{2}$ × 39$\frac{3}{8}$ in.)
Pittsburgh, The Andy Warhol Museum,
Founding Collection,
Contribution The Andy Warhol Foundation
for the Visual Arts, Inc., 1998.1.3867

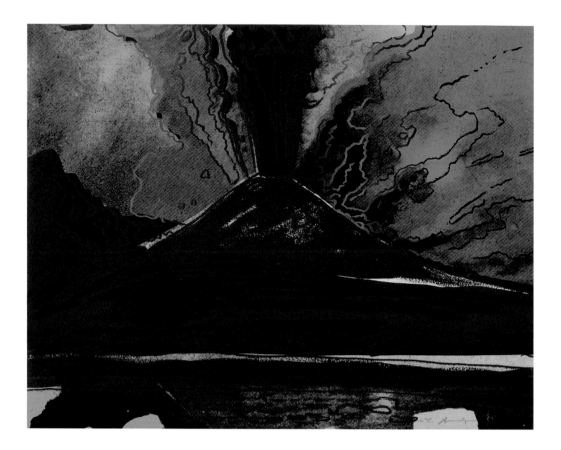

53

Andy Warhol
American, 1928–1987

MOUNT VESUVIUS

1985
Screenprint on linen, hand-colored with acrylic, 198.1 × 208.3 cm (78 × 82 in.)
Pittsburgh, The Andy Warhol Museum, Founding Collection,
Contribution The Andy Warhol Foundation for the Visual Arts, Inc., 1998.1.3177

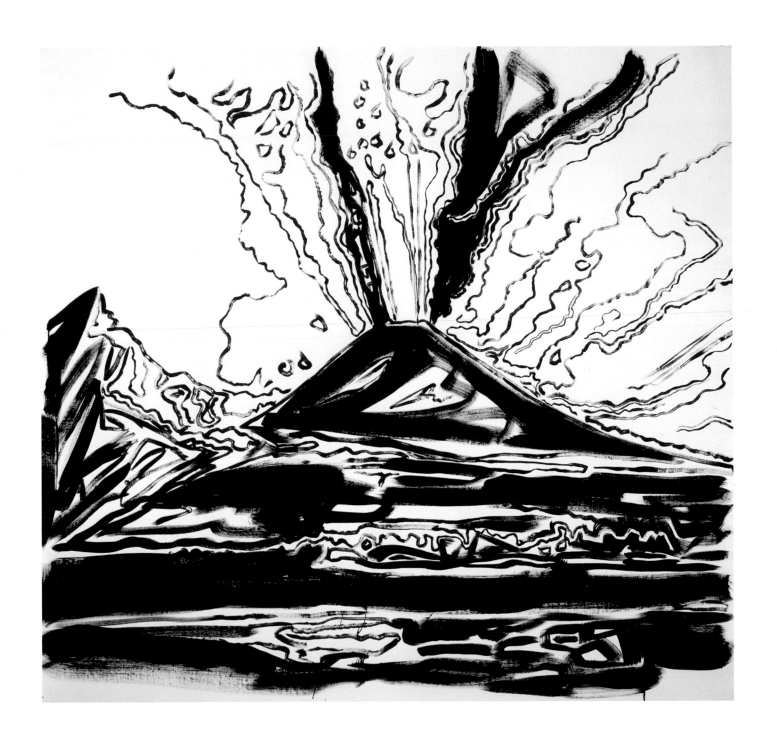

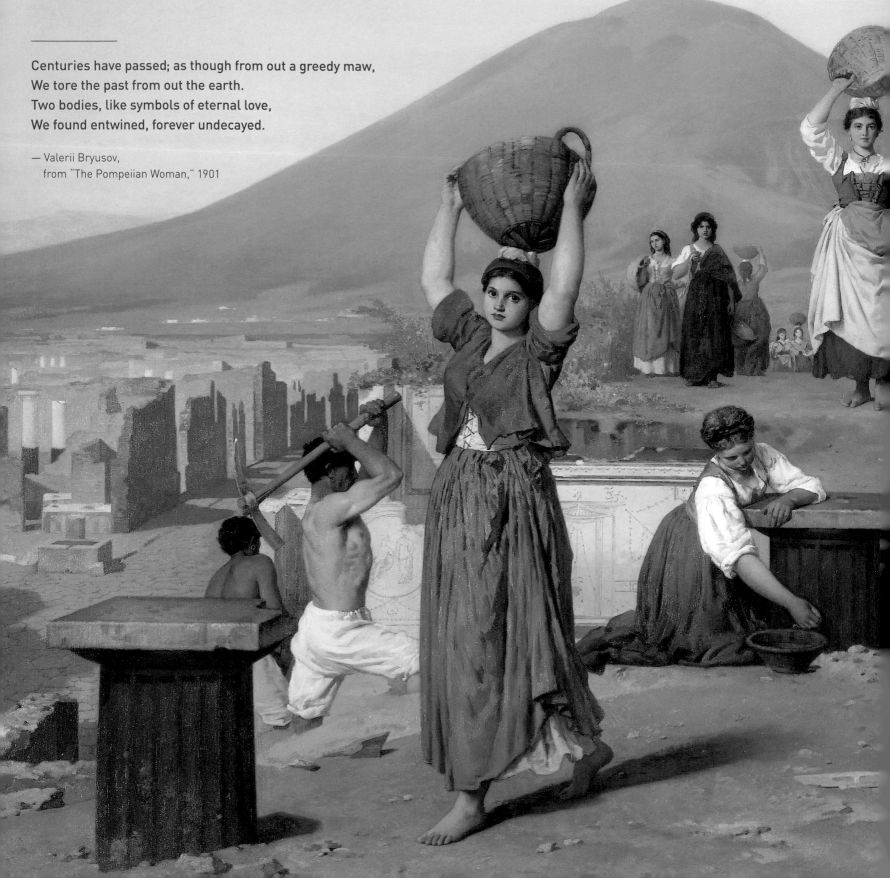

Resurrection

Centuries have passed; as though from out a greedy maw,
We tore the past from out the earth.
Two bodies, like symbols of eternal love,
We found entwined, forever undecayed.

— Valerii Bryusov,
 from "The Pompeiian Woman," 1901

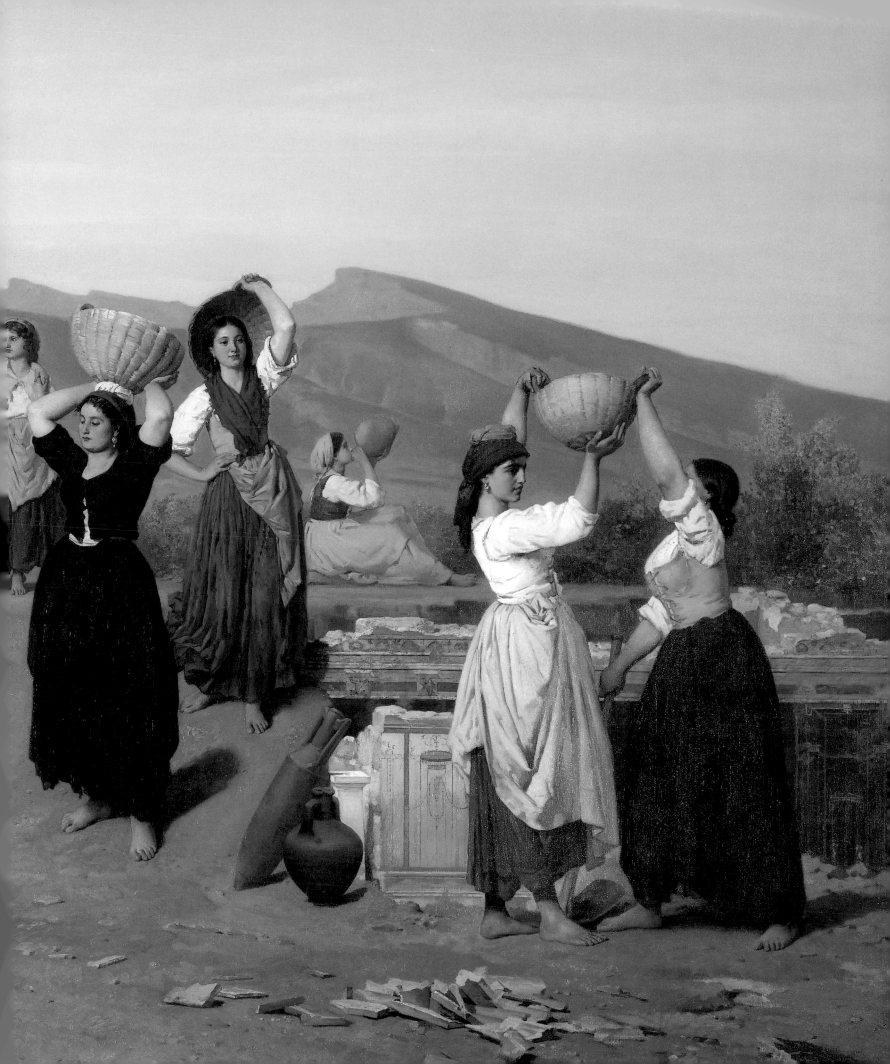

Jakob Philipp Hackert
German, active Italy, 1737–1807

THE EXCAVATIONS AT POMPEII

1799
Oil on canvas, 118 × 164 cm (46½ × 64½ in.)
Attingham Park, The Berwick Collection (The National Trust), U.K.

Hackert was the most significant German landscape painter of the 1700s. He came to Italy in 1768, arriving in Naples two years later. King Ferdinand IV of Naples appointed Hackert court painter in 1786, although he also enjoyed widespread popularity with German and other foreign patrons. His fame spread considerably through prints of his work by his brother Georg.

Hackert made six gouaches of the buried cities in the early 1790s, which were reproduced as engravings. While those works focused on close views in and around Pompeii, this painting presents a panorama of all the excavations in the south-central part of the city, near the Stabian Gate. These structures were among the earliest to be excavated; in 1799 they were farthest from the main entrance to Pompeii, the Herculaneum Gate, and represented the digs' southeastern-most edge (see fig. 3). From a position roughly atop the House of Menander (excavated in the 1920s), Hackert presents the site looking west-southwest. Yet in contrast to the precision implied by his meticulous technique, Hackert altered the landscape to emphasize the most recognizable and widely reproduced monuments. In particular, Hackert raised the Temple of Isis higher in relation to nearby buildings and increased its size (Piranesi and Desprez presented the monument much more accurately, see fig. 2). He also adjusted the relationship of the visible structures, including, to the left of the Temple of Isis, the Theater, the Gladiator Barracks, the Quadriporticus, the Triangular Forum, and the Small Theater.

Hackert's painting represents a way of understanding the site that precedes the nineteenth-century notion of the Last Days. Hackert focuses on the ruins as an archaeological site firmly planted in the present (a relatively new subject in European art), rather than a place to project ideas about why the city was destroyed or to re-create imagined ideas about the classical past. Mount Vesuvius is notably absent, and the combination of tourists, workers, and peasants fashion the site as bucolic and utopian. The painting thus adopts an intellectual approach to the city that is firmly planted in the Enlightenment and eighteenth-century landscape traditions.

An 1827 sale catalogue indicates that Thomas Noel Hill, the second baron Berwick, commissioned the picture, but Alastair Laing argues that this source appears to be incorrect given that Berwick's Grand Tour took place long before the date of this picture. The work more likely began as a royal commission, along with a pendant of Lake Avernus. During the Napoleonic invasion, Hackert fled Naples, finishing this painting in Pisa, and Berwick probably purchased the pair during the peace of Amiens in 1802, which temporarily reopened travel between England and the Continent. A ravenous collector of Old Master paintings, Berwick also had a specific interest in the buried cities, having acquired numerous antiquities during his travels as well as a large model of Mount Vesuvius. The last item (now lost) was built by Edward Daniel Clarke, a geologist at Cambridge who led Berwick's Grand Tour. The sale catalogue described it as an "ingenious piece of workmanship.... constructed of the materials of the mountain, with such accuracy of outline, and justness of proportion, that Sir William Hamilton pronounced it to be the best ever produced of the kind, either by foreigner or native. The model is mounted on a stout oak frame, and the size, exclusive of the frame, 6 feet 10¼ inches, and 2 feet high, in the centre of the mountain." | JLS

SELECTED BIBLIOGRAPHY

Laing, Alastair, *In Trust for the Nation: Paintings from National Trust Houses* (London, 1995), 88–89 (with prior bibliography).

Stolzenberg, Andreas, "Die archäologische Landschaft: Jakob Philipp Hackerts Reise nach Paestum und Sizilien im Jahre 1777 und die Ausgrabungen in Pompeji," in *Jakob Philipp Hackert: Europas Landschaftsmaler der Goethezeit* (Weimar and Hamburg: 2008), 38–40.

Personal correspondence from Sarah Kay (e-mail of November 4, 2009).

Jakob Philipp Hackert
German, active Italy, 1737–1807

THE EXCAVATIONS AT POMPEII

1799
Oil on canvas, 118 × 164 cm (46½ × 64½ in.)
Attingham Park, The Berwick Collection (The National Trust), U.K.

Hackert was the most significant German landscape painter of the 1700s. He came to Italy in 1768, arriving in Naples two years later. King Ferdinand IV of Naples appointed Hackert court painter in 1786, although he also enjoyed widespread popularity with German and other foreign patrons. His fame spread considerably through prints of his work by his brother Georg.

Hackert made six gouaches of the buried cities in the early 1790s, which were reproduced as engravings. While those works focused on close views in and around Pompeii, this painting presents a panorama of all the excavations in the south-central part of the city, near the Stabian Gate. These structures were among the earliest to be excavated; in 1799 they were farthest from the main entrance to Pompeii, the Herculaneum Gate, and represented the digs' southeastern-most edge (see fig. 3). From a position roughly atop the House of Menander (excavated in the 1920s), Hackert presents the site looking west-southwest. Yet in contrast to the precision implied by his meticulous technique, Hackert altered the landscape to emphasize the most recognizable and widely reproduced monuments. In particular, Hackert raised the Temple of Isis higher in relation to nearby buildings and increased its size (Piranesi and Desprez presented the monument much more accurately, see fig. 2). He also adjusted the relationship of the visible structures, including, to the left of the Temple of Isis, the Theater, the Gladiator Barracks, the Quadriporticus, the Triangular Forum, and the Small Theater.

Hackert's painting represents a way of understanding the site that precedes the nineteenth-century notion of the Last Days. Hackert focuses on the ruins as an archaeological site firmly planted in the present (a relatively new subject in European art), rather than a place to project ideas about why the city was destroyed or to re-create imagined ideas about the classical past. Mount Vesuvius is notably absent, and the combination of tourists, workers, and peasants fashion the site as bucolic and utopian. The painting thus adopts an intellectual approach to the city that is firmly planted in the Enlightenment and eighteenth-century landscape traditions.

An 1827 sale catalogue indicates that Thomas Noel Hill, the second baron Berwick, commissioned the picture, but Alastair Laing argues that this source appears to be incorrect given that Berwick's Grand Tour took place long before the date of this picture. The work more likely began as a royal commission, along with a pendant of Lake Avernus. During the Napoleonic invasion, Hackert fled Naples, finishing this painting in Pisa, and Berwick probably purchased the pair during the peace of Amiens in 1802, which temporarily reopened travel between England and the Continent. A ravenous collector of Old Master paintings, Berwick also had a specific interest in the buried cities, having acquired numerous antiquities during his travels as well as a large model of Mount Vesuvius. The last item (now lost) was built by Edward Daniel Clarke, a geologist at Cambridge who led Berwick's Grand Tour. The sale catalogue described it as an "ingenious piece of workmanship.... constructed of the materials of the mountain, with such accuracy of outline, and justness of proportion, that Sir William Hamilton pronounced it to be the best ever produced of the kind, either by foreigner or native. The model is mounted on a stout oak frame, and the size, exclusive of the frame, 6 feet 10¼ inches, and 2 feet high, in the centre of the mountain." | JLS

SELECTED BIBLIOGRAPHY

Laing, Alastair, *In Trust for the Nation: Paintings from National Trust Houses* (London, 1995), 88–89 (with prior bibliography).

Stolzenberg, Andreas, "Die archäologische Landschaft: Jakob Philipp Hackerts Reise nach Paestum und Sizilien im Jahre 1777 und die Ausgrabungen in Pompeji," in *Jakob Philipp Hackert: Europas Landschaftsmaler der Goethezeit* (Weimar and Hamburg: 2008), 38–40.

Personal correspondence from Sarah Kay (e-mail of November 4, 2009).

55 56 57

Chinea Prints

From the very beginning of formal excavations at Herculaneum in 1738, officials of the Bourbon monarchy closely guarded access to both the site and the finds, which were removed to the royal palace at nearby Portici. They were motivated by the need to preclude illicit exports and the desire to ensure absolute domestic control over the crown's antiquarian patrimony. In 1749 and again in 1755, however, the princely Colonna family, representatives of the Neapolitan monarchy in Rome, publically highlighted Herculanean discoveries during the *Chinea*. This annual festival honored Saints Peter and Paul and ostensibly commemorated the Bourbon kings' fealty to the pope but in actuality ostentatiously celebrated their wealth and power. The two-day festival took place on June 29 and 30 and included the ritual presentation of a white horse (*chinea*) and seven thousand gold ducats as tribute, as well as the gift of copious red and white wine for the people of Rome. Its culmination was a pair of pyrotechnic displays launched from elaborate temporary structures, the so-called *macchine*.

Souvenir prints and descriptions written up in the local press record that in July 1749 the second *macchina* erected in front of the Palazzo Farnese was a fanciful reconstruction of the Theater of Herculaneum (pl. 55), then, as now, buried deeply underground. According to the caption below the image of the newly discovered building, it was through great expenditure and the sublime merit of the Neapolitan king that "an innumerable treasure of equestrian consular statues, busts, columns of precious marble, inscriptions…and marvelous paintings of the best taste" were recovered and preserved intact.

The second *macchina* in the Jubilee year 1750 was an artificial Vesuvius, commemorated in a print that depicts groups of eager naturalists ascending to its crater (pl. 56). According to the caption, although the volcano had proven deadly to the "philosopher and celebrated writer" Pliny the Elder in A.D. 79, now, under the "benevolent rule" of the Bourbon king, the volcano had been tamed and could be climbed without danger. Thus, not only were archaeological discoveries conveyed to Rome through these *macchine* but also the possibility of safely re-experiencing the disaster itself.

Five years later the first *macchina* at the festival took the form of a triumphal bridge surmounted by the figure of Hercules (pl. 57), immediately below which a Latin inscription honored "Charles, King of the Two Sicilies, Advancer of the Fine Arts, for uncovering Herculaneum" (CAROLO VTRIVSQVE SICILIAE REGI BONARVM ARTIVM AMPLIFICATORI OB HERCVLANVM DETECTAM).

According to the longer caption at the bottom, the bridge supported "the most precious remains from antiquity…recovered under the ruins of the city of Herculaneum," and a contemporary witness reported that the items displayed in Rome included "statues, relics, symbols, and rarities from the ruins of the ancient city of Herculaneum, excavated through the munificence of royal initiative" (*statue, memorie, simboli, e rarità delle ruina dell' antica Città di Ercolano, fatte scavare di sotterra della munificenza del genio Reale*). None of the items depicted, however, are recognizably Herculanean artifacts.

The *Chinea* prints were engraved in advance so they could be distributed during the festival and thus they are not eyewitness records of the events. In fact, comparison between a surviving preliminary sketch of the 1755 *macchina* by its architect Paolo Posi and the print engraved by Giuseppe Vasi reveals significant differences in the figure of Heracles surmounting the bridge and in the statues, trophies, and other artifacts with which it is decorated. None of these can, in either case, be securely identified with finds from the excavations, however, and there is little evidence that either Posi or Vasi, resident in Rome, actually saw or strove to represent accurately the original antiquities from Herculaneum—or that actual ancient statues, reliefs, trophies, etc. were shipped from the museum at Portici to Rome and for a single day placed on this temporary architecture designed, above all, for the launching of fireworks. In fact, despite the language of the prints' captions and contemporary reports, which were intended to accentuate the high culture and munificence of the king, it seems most unlikely that the original objects were actually put on display in Rome. Nonetheless, although they offered viewers reconstructions and, at best, copies, if not outright inventions, rather than ancient works themselves, the *Chinea* of 1749 and 1755 can be counted as the first temporary exhibitions of Herculanean finds outside Naples. | KL

SELECTED BIBLIOGRAPHY

Ferrari, Giulio, *Bellezze architettoniche per le feste della Chinea in Roma nei secoli XVII e XVIII: Composizioni di palazzi, padiglioni, chioschi, ponti, ecc. per macchine pirotecniche* (Turin, 1919), pls. 12, 20.

Moore, John E., *The Chinea: A Festival in Eighteenth-century Rome* (Ph.D. diss., Harvard University, 1992).

Moore, John E., "Prints, Salami, and Cheese: Savoring the Roman Festival of the Chinea." *Art Bulletin* 77 (1995): 584–608.

Sassoli, Mario Gori, *Della* Chinea *e di altre "Macchine di Gioia": Apparati architettonici per fuochi d'artificio a Roma nel Settecento*, exh. cat. (Rome, Villa Farnesina, 1994), 120, 122, 129–30, nos. 48, 50, 60.

Tice, James T., and James G. Harper, eds., *Giuseppe Vasi's Rome: Lasting Impressions from the Age of the Grand Tour*, exh. cat. (Eugene, University of Oregon, Jordan Schnitzer Museum of Art; Princeton, N.J., Princeton University Museum of Art, 2010–11), 61–62, 169, no. 90.

Trinity Fine Art, *Architectural and Decorative Drawings*, sales cat. (London, 1990), 40, no. 19.

55

Ennemond Alexandre Petitot
(draughtsman and engraver)
French, active Italy 1727–1801

after Michelangelo Specchi (architect)
Italian, ca. 1684–ca. 1750

SECOND *MACCHINA* OF THE CHINEA OF 1749:
THE THEATER AT HERCULANEUM

Engraving, 41 × 48 cm (16⅛ × 18¹⁵⁄₁₆ in.)
Los Angeles, Getty Research Institute, Special Collections
95-F0, 1749/II

56

Michele Sorrelò (engraver)
Italian

after Francesco Perziado (draughtsman)
Spanish, active ca. 1748–1750

after Michelangelo Specchi (architect)
Italian, ca. 1684–ca. 1750

SECOND *MACCHINA* OF THE CHINEA OF 1750:
MOUNT VESUVIUS

Engraving, hand-colored with watercolor,
40 × 44 cm (15¾ × 17⅜ in.)
Los Angeles, Getty Research Institute, Special Collections
95-F0, 1750/II

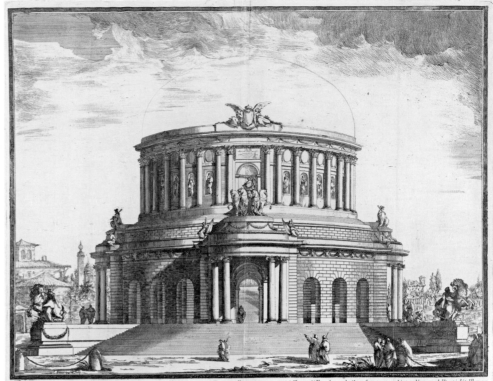

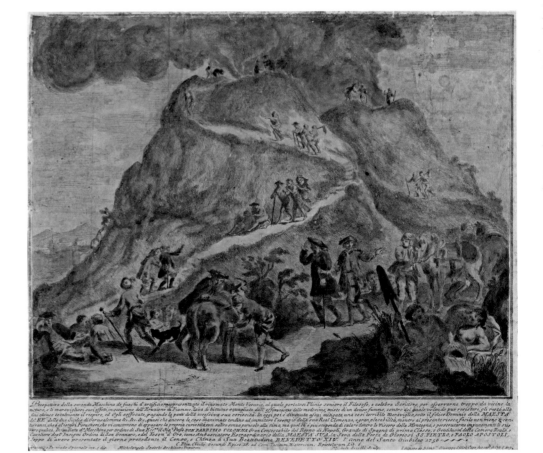

Giuseppe Vasi (engraver)
Italian, 1710–1782

after a design by Paolo Posi (architect and draughtsman)
Italian, 1708–1776

FIRST *MACCHINA* OF THE CHINEA OF 1755: TRIUMPHAL BRIDGE ADORNED
WITH RELICS OF THE CITY OF HERCULANEUM

Engraving, 39 × 56 cm (15³⁄₈ × 22¹⁄₁₆ in.)
Los Angeles, Getty Research Institute, Special Collections 95-F0, 1755/I

Forgeries of Pompeian Frescoes

The Bourbon court's strict control of finds recovered from the sites buried by Vesuvius only increased the desire of antiquarians and collectors for such artifacts. As the cupidity of eager—and wealthy—collectors could not be satisfied by genuine excavated material, which was reserved for the royal collections, some actual antiquities were provided with false provenances so that their owners might gain prestige. A striking example is a bust of the emperor Septimius Severus, who reigned A.D. 193–211, more than a century after the eruption of Vesuvius, that was, as late as 1863, said to have been excavated at Herculaneum, a false provenance that was repeated in the scholarly literature as recently as the 1990s. In other cases, forgers stepped in to fill the gap between supply and demand, creating works they claimed had been discovered in clandestine excavations near Pompeii and Herculaneum and smuggled out of the territories controlled by the Neapolitan kings.

Among the earliest producers of these pseudo-antiquities was Giuseppe Guerra, who, like all successful forgers, adapted his products to suit the tastes, desires, and expectations of his clientele. Guerra was patronized by such prominent foreign connoisseurs and collectors of ancient art as Cardinal Albani; King George II of England; Baron Christian Heinrich Gleichen, the Danish ambassador to Naples; Princess Friederike Sophie Wilhelmine, sister of the king of Prussia; and the comte de Caylus. The comte reveled in the possession of a fresco depicting a Greek warrior that had been modeled on an ancient fresco found a century earlier in Rome, and praised two relief mosaics—a genre unknown in antiquity—that were said to be from Herculaneum but had actually been fashioned by Pompeo Savini after the much-admired paintings of Flora and other figures from the Villa di Arianna at Stabiae, excavated in 1759 (for example, Naples, Museo Archeologico Nazionale, 8834).

Born in Venice, Guerra worked in Naples, decorating porcelains in the Reale Fabbrica de Capodimonte. After unsuccessfully offering the court his services as a restorer of the genuine ancient paintings in the royal collections, he moved to Rome, where he produced "ancient" frescoes, which he claimed a friend had found underground near Pompeii. In Rome he had the advantage not only of operating outside the jurisdiction of the Neapolitan kings but also of supplying clients who were far away from the ancient originals and thus unable to compare them to his creations.

According to the Roman priest Antonio Piaggio, who was instrumental in early attempts to unroll and decipher papyri from the Villa dei Papiri at Herculaneum, Guerra took from the Roman catacombs undecorated "fragments from buried ancient walls and separated the surface, or the *intonacatura* of the fresco, and transferred that onto a slab of stone. Then he painted on top of it different and whimsical characters.... These paintings he then artificially darkened, and smoked; others he scratched and flaked to make them seem more readily like remains from the known ruins and the flow of dark [volcanic] material."

Guerra either copied his imagery from already known antiquities, like the Greek warrior, or he invented it to illustrate scenes from classical texts—in the eighteenth century even genre scenes were usually interpreted through the lens of ancient history and literature. Indeed, collectors and scholars sought to demonstrate their erudition by identifying obscure imagery.

Guerra's fresco of two warriors carrying the body of a third (pl. 58), sold to the Jesuit scholar Arcangelo Contucci, dean of the Collegio Romano in Rome, which acquired many of his paintings, was probably intended to illustrate a scene from the tenth book of Virgil's *Aeneid*, where the poet describes the death and return of the body of the Arcadian prince Pallas. Contucci, however, told antiquarian J. J. Winckelmann that it depicted the famous fourth-century-B.C. Theban general Epaminondas "being carried from the field during the Battle of Mantinea, in full iron armor," which the Saxon scholar lampooned as "the norm for knights in medieval tournaments." Winckelmann, who would subsequently be duped by other forgers, considered Guerra to be "a very mediocre painter" and criticized his "spindle-thin elongated figures" (Winkelmann, 83–86).

Neapolitan court officials, believing that the paintings appearing on the Roman market were genuine, tracked Guerra down and pressed charges. Like so many later forgers, he was forced to prove his innocence on charges of smuggling by proving that he had created the paintings himself, while locked in a cell.

The activities of other forgers are not so well documented, but their works likewise illuminate the desires and preconceptions of modern collectors more than those of ancient artists and patrons. Two previously unpublished panels on red ground, thought to represent festivals in honor of Venus and Bacchus, entered the collections of the Musée de Cluny in 1859, a gift from M. Cattoire de Bioncourt. Both were said to have been discovered at Pompeii and were highly praised by the curator of the Cluny, Edmond du Sommerard, for their fineness

of execution and state of preservation. One (pl. 59) depicts a naked woman propped up on pillows reclining on a wheeled bed surrounded by cupids, one of whom holds an arrow, while the others drop incense onto a brazier. Behind the woman, who wears a crescent moon on her forehead and may therefore have been meant to depict Selene rather than Venus, there is an opening, as well as a yellow panel, with a red and blue zone below it and an anchor above.

In the other fresco (pl. 60), a woman, cut off by the left border of the panel, crouches with a basket of fruit, while two men sacrifice rams: one crouching before an altar, while the other drags in the second victim, the hind quarters of which are cut off by the right border. Behind them, a flute player (whose right leg is also truncated) and a man, a woman, and a child dance wildly, with arms raised, while a second child climbs a tree. The scene is set in a rural shrine, with palm, oak, and cypress trees, a stone vase on a pillar, two half-draped statues on a plinth, and another statue within an arched pavilion.

Both frescoes are painted on fragments of ancient walls, as was Guerra's practice, but there is no ancient parallel for the style of the figures. The female figure on the wheeled bed surrounded by cupids, however, does recall one of the Bacchic friezes in the of the House of the Vettii in Pompeii, but that was only excavated in 1894–95. Various scenes of cavorting putti had been excavated earlier at the Villa di Arianna at Stabiae and at Herculaneum (Naples, Museo Archeologico Nazionale, 9279, 9176–79, 9218). The other, more complex composition draws on various sources. So-called sacro-idyllic scenes of rural sanctuaries are common in Roman painting, although ancient painters never depicted trees in this manner, nor did they include truncated figures within the painted borders. The crouching man may be drawn from the Skythian executioner in scenes of the Flaying of Marsyas, which appears on ancient sarcophagi as well as in other media. The man on the right in an animal skin, however, relies more on contemporary notions of prehistoric savages than ancient iconography. | KL

SELECTED BIBLIOGRAPHY

Aghion, Irène, ed., *Caylus, mécène du roi: Collectionner les antiquités au XVIIIe siècle* (Paris, 2002), 148, no. 72.

Burlot, Delphine, et al., "La supercherie du faussaire Giuseppe Guerra mis en evidence par l'étude du Guerrier grec du Cabinet des médailles," *Technè* 27–28 (2008): 29–35.

Consoli Fiego, G., "False pitture di Ercolano," *Napoli Nobilissima* 2 (1921): 84–88.

D'Alconzo, Paola, *Picturae excisae: Conservazione e restauro dei dipinti ercolanesi e pompeiani tra XVIII e XIX secolo* (Rome, 2002), 53–54.

D'Alconzo, Paola, "Naples and the Birth of a Tradition of Conservation: The Restoration of Wall Paintings from the Vesuvian Sites in the Eighteenth Century," *Journal of the History of Collections* 19 (2007): 203–14.

Delle Antichità di Ercolano (Naples, 1760), vol. 2, preface.

De Vos, M., "Giuseppe Guerra e il Museo Kircheriano," In *Enciclopedismo in Roma barocca: Athanasius Kircher e il Museo del Collegio Romano tra Wunderkammer e museo scientifico*, ed. M. Casciato et al. (Venice, 1986), 327–30.

Eristov, H., "Les antiquités d'Herculanum dans la correspondence de Caylus," in *Il Vesuvio e la città vesuviane 1730–1860: In ricordo di George Vallet* (Naples, 1998), 145–61, esp. 153–55.

Kersauson, Kate de, *Catalogue des portraits romains: Musèe du Louvre* (Paris, 1996), 2:356–57, no. 163.

Nicastro, B., "La riscoperta settecentesca della tecnica pittorica ad encausto e il caso dei falsi di Giuseppe Guerra," *Annali dell'Università di Ferrara Sezione Lettere*, n.s. 4 (2003): 293–316.

Pelzel, Thomas, "Winckelmann, Mengs and Casanova: A Reappraisal of a Famous Eighteenth-Century Forgery," *Art Bulletin* 54 (1972): 300–315.

Prisco, Gabrielle, ed., *Filologia dei materiali e trasmissione al futuro: Indagini e schedatura sui dipinti murale del MANN* (Rome, 2009), 99–101, 163, 166, fig. 177.

Sommerard, Edmond du, *Musée des Thermes et de l'Hôtel de Cluny: Catalogue et description des objets d'art de l'Antiquité, du Moyen-Âge et de la Renaissance, exposés au Musée* (Paris, 1866), nos. 1661, 1662.

Winckelmann, J. J., *Letter and Report on the Discoveries at Herculaneum*, introduction, translation, and commentary by Carol C. Mattusch (Los Angeles, 2011), 83–85.

Personal communications from Delphine Burlot and Daniel Roger.

58

Giuseppe Guerra
Italian, 1709–1761

THE DEATH OF EPAMINONDAS (also known as THE DEATH OF PALLAS)

ca. 1750–60
Early modern paint on ancient fresco, 36.5 × 40.2 cm (14⅜ × 15⅞ in.)
Naples, Museo Archeologico Nazionale,
Soprintendenza speciale ai beni archeologici di Napoli e Pompei, sn-13

59

Unknown artist

VENUS (?) AND A PROCESSION OF CUPIDS

ca. 1800–50
Early modern paint on ancient fresco, 12.2 × 13.5 cm (4¹³⁄₁₆ × 5⁵⁄₁₆ in.)
Paris, Musée du Louvre, MNC 879 (formerly Musée de Cluny, 1662
[mislabeled 2662])

60

Unknown artist

A SACRIFICE

ca. 1800–50
Early modern paint on ancient fresco, 22 × 22 cm (8⁵⁄₈ × 8⁵⁄₈ in.)
Paris, Musée du Louvre, MNC 880 (formerly Musée de Cluny, 1661)

Pierre Gabriel Berthault
French, ca. 1748–ca. 1819

after a design by Louis Jean Desprez
French, 1743–1804

TOMB OF KING ANDRÉ, HUSBAND OF THE FAMOUS QUEEN JEANNE OF NAPLES

and

Claude Mathieu Fessard
French, 1740–1803

after a design by Jean-Honoré Fragonard
French, 1732–1806

VIEW OF A SKELETON DISCOVERED AT POMPEII, NEAR VESUVIUS

Etchings on page 89 of Jean Claude Richard de Saint-Non,
Voyage pittoresque, ou, Description des royaumes de Naples et de Sicilie,
vol. 1, part 1 (Paris, 1781).
Los Angeles, Getty Research Institute, 88-B19555

Saint-Non's *Voyage pittoresque*, published between 1781 and 1786, has been praised as the most beautiful and sumptuous privately printed travelogue ever produced. Among the many artists who helped to illustrate its five folio volumes was Jean-Honoré Fragonard. Having previously won the Prix de Rome, Fragonard spent the summer of 1760 as Saint-Non's guest at the Villa d'Este and the following year accompanied him on a tour of Italy, making drawings that served as the models for some of the numerous illustrations in the volume.

Fragonard's drawing of the discovery of the skeleton of a woman in the cellar of a house in Pompeii (now Lyons, Musée des Arts Décoratifs, 429), however, was made a decade later and only then employed by Fessard for the *Voyage pittoresque*. Fragonard had returned to Italy in 1773 on a lengthy trip with his brother-in-law, the financier Pierre-Jacque Onézyme Bergeret de Grancourt, who recorded their visit to Pompeii on May 6, 1774, along with Bergeret's son, Fragonard's daughter, and Jean Vignier, the future third Mrs. Bergeret, and a guide, who appears in the background of the engraving holding a key:

> In one house, among others, in the room downstairs where they must have done the washing, we could see all the implements, the stove, the washtub, etc.... and a heap of volcano ash upon which rested the skeleton of a woman, as if, having tried to escape from the choking ashes coming in from all sides, she had finally fallen backwards and died. Everything about the placement and position of her bones indicated that this was clearly what had happened, and one remains stunned at the contemplation of the events of 1,700 years ago (Dwyer, 8).

The accompanying text does not explain the juxtaposition of this image with that of the tomb of King André in the cathedral of Naples. The visual parallels are nonetheless clear to the thoughtful reader, pondering the connections between the ancient and medieval unfortunates. The king, as the caption relates, was assassinated in 1360 by his wife, who had ordered him to be thrown from a window at Aversa, near Naples, and left unburied. In Desprez's moody reimagining of the entombment, the king's tearful nurse and a canon of Saint Gennaro bury him by lamplight. The female victim of Vesuvius, in contrast, was buried, unmourned, almost instantly by the volcano and had only recently been revealed to the light of the sun.

In a subsequent part (vol. 1, pt. 2, pp. 142–43), however, Fragonard's image is explained, ascribing its position in the book to a "chance displacement." We learn further that the skeleton had, on the recommendation of the British ambassador (and amateur archaeologist) Sir William Hamilton, been left in the same position and location where it had been found: "Preserved in that place it makes a profoundly stirring impression; conveyed elsewhere it is no longer of any interest. It is truly unfortunate that the same consideration was not made before transplanting such a wealth of inscriptions, paintings, statues, and columns, which, now in the Museum at Portici, still hold a more or less noble distinction, but, left in their original place, would become a treasure and a considerable envy."

Fragonard's drawing appears transformed in Henry Wilkins's *Suite of Picturesque Views of the Ruins of Pompeii*, published in French in 1819. There a man and woman in early-nineteenth-century dress are surprised by the skeleton, while another man emerges from the arched opening at the back of the room, as in Fragonard's image.

Fifty years after Fragonard visited Pompeii and made the sketch that formed the basis for Fessard's engraving, a similar composition was published by François Mazois (in a print by Angelo Testa) in the second volume of his opulent publication

Dessiné par Desprès.　　　　　　　　　　　　　　　　　　　Gravé par Berthault.

Tombeau du Roi André mari de la fameuse Reine Jeanne de Naples

Ayant été assassiné par les ordres de la Reine et jetté par une fenestre à Aversa, il restoit sans Sépulture, si sa Nourrice et un Chanoine
de St. Janvier ne lui eussent fait élever à leurs frais ce modeste Tombeau dans l'Eglise Cathédrale de Naples en 1360.

Dessiné par Fragonard Peintre du Roi.　　　　　　　　　　　　　　　　　Gravé par Foüard.

Vue d'un Caveau découvert à Pompeia près du Vésuve

Saisant partie d'une Maison située sur les Murs de cette ancienne Ville.

N° 89.　　　　　　　　　　　　　　　　　　　　　　　　　　　　　　　　A.P.D.R.

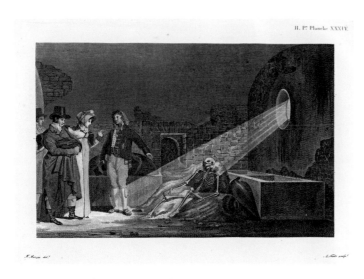

H. P.ᵉ Planche XXXIV.

61.1. Angelo Testa (Italian, b. ca. 1775), *Visit of the Holy Roman Emperor Joseph II to Pompeii.* Lithograph. Plate 34 in vol. 2 of François Mazois, *Les ruines de Pompéi* (Paris, 1824).

Les ruines de Pompéi (Paris, 1824) in a slightly different architectural setting. This engraving commemorates the visit of the Holy Roman emperor Joseph II to Pompeii on April 7, 1769, when he toured the house (VIII.2.39) that still bears his name (pl. 61.1). As in Fragonard's image, a strong raking light enters the vaulted room through a circular window at the right, but the round basin is gone and the skeleton is brought to the foreground, along with a large, pointed storage vessel. The cast of characters here includes a local guide, who gestures toward the skeleton while the bonneted female companion of the emperor raises her hand in surprise. The top-hatted emperor and a third man, also in early-nineteenth-century dress, look on in dismay. This scene was further adapted in other publications, such as Johannes Overbeck's *Pompeji* (1856) and August Mau's *Pompeii: Its Life and Art* (1907), with minor changes (in one instance, for example, the woman turns away from the skeleton, now identified as that of a male). A contemporary account of the emperor's visit, written by Francesco de la Vega, director of the excavations at the time, makes it clear that on his visit to Pompeii in 1769 (five years before Fragonard returned to the site and saw a different skeleton in another building), the sovereign was accompanied by his sister, Queen Maria Carolina of Naples, and her husband, King Ferdinand, as well the Hapsburg ambassador,

Ernst Graf von Kaunitz-Rittberg, Sir William Hamilton, his secretary D'Hancarville, and de la Vega himself. Whether any contemporary drawing of the emperor's visit was made—providing a model on which Fragonard could playfully recast himself and his companions as the imperial party—or Mazois drew on Fragonard's earlier image of a different event to illustrate the stately visit remains uncertain.

The Italian artist Pietro Fabris, however, did draw the same vaulted room as Fragonard, also in 1774, with basin and skeleton, but no visitors. His ink-and-watercolor version shows the space from a different angle, more clearly indicating the stairway leading down to it, and was the model for an engraving that illustrates a communication from William Hamilton to the London Society of Antiquaries, and was subsequently published in the journal of the Society, *Archaeologia*. In the accompanying text, Sir William, who later married Emma Hart (see pl. 5), does not mention the imperial visit, but boasts, "It was at my instigation that the bones were left untouched on the spot where they were found." He also reports that "the skeleton of the washer-woman (for anatomists say it is that of a female)...seems to have been shut up in this vault, the stair case having been filled with rubbish, and to have waited for death with calm resignation, and true Roman fortitude, as the attitude of the skeleton really seems to indicate." | KL

SELECTED BIBLIOGRAPHY

Dwyer 2010.

Hamilton, William, "Account of the Discoveries at Pompeii," *Archaeologia: or Miscellaneous Tracts Relating to Antiquity Published by the Society of Antiquaries of London* 4 (1777): 160–75, esp. 163–64, pl. IX.

Jenkins, Ian, and Kim Sloan, *Vases and Volcanoes: Sir William Hamilton and His Collection*, exh. cat. (London, 1996), 43, fig. 16.

Lamers, Petra, *Il viaggio nel sud dell'Abbé de Saint-Non* (Naples, 1995), 194–95, 287–88, nos. 162, 296, 296a.

Mau, August, *Pompeii: Its Life and Art*, 2nd edn., trans. F. W. Kelsey (New York, 1907), 346, fig. 177.

Overbeck, Johannes, *Pompeji* (Leipzig, 1856), 28, fig. 3.

Rosenberg, Pierre, *Fragonard*, exh. cat. (New York, 1988), 393–94, no. 189.

Wilkins, H., *Suite de vues pittoresques des ruines de Pompéi et un précis historique de la ville avec un plan des fouilles qui ont été faites jusqu'en Février 1819 et une description des objects les plus intéressants* (Rome, 1819), 7.

Piranesi's *Antiquités*

Giovanni Battista (also known as Giambattista) Piranesi, a student of Giuseppe Vasi (see pl. 57), is without doubt the most famous and influential printmaker of the eighteenth century. His legacy overshadows that of his contemporaries and certainly that of his son, Francesco, who inherited his drawings and plates, republished and distributed his work, and continued to produce large-scale prints of ancient sites and artifacts long after Giovanni Battista's death.

The first two volumes of Francesco's large-format *Antiquités de la Grande Grèce, aujourd'hui Royaume de Naples* focus on the architecture of Pompeii and rely on drawings made by his father, beginning in 1770, while the third volume presents various finds from Vesuvian sites that were housed in the royal museum at Portici. The text by Antoine-Joseph Guattani intended to accompany these plates was never published.

Francesco's personal interest in the Vesuvian cities had manifested itself two decades earlier than these volumes, when he produced a suite of engravings of the Theater of Herculaneum in 1783. Two years later he produced the first widely distributed plan of the site of Pompeii, which he twice revised (see fig. 3). He also made prints of contemporary eruptions of Vesuvius and, with his brother Pietro, published the six-volume *Antiquités d'Herculanum*, with dry, documentary engravings by Tommaso Piroli of ancient wall paintings, statues, lamps, and candelabra in the museum at Portici (see pl. 32.1).

As a printmaker, Francesco, like his father, employed a variety of techniques, though modern critics consider his work "less dynamic and more stilted than his father's" in that "the son's work resembles the father's *en ambre*" (VanderPoel, 187). Some of his Pompeian prints are dark, brooding, and heavily atmospheric; others are measured plans and sections of buildings; others are precise line drawings, drier still. Among the most striking are Francesco's representations of the Pompeian streets, shops, and houses brought to light by the early excavators. These ruins, lacking roofs and with plants growing from crumbling walls, are populated by ancient Romans—soldiers driving chariots along roads paved with polygonal slabs, citizens in togas or centurions in armor conversing with one another, and servants preparing meals. The addition of these figures, who wear contemporary dress in his father's sketches, collapses time, adding a fourth dimension to the engravings. This striking combination of past and present (see also pl. 73) is eerily underscored by the dramatic skies, their darkness implying the eruption of nearby Vesuvius, and the distorted, unnaturally large scale of the architecture, which diminishes the human players. The engravings feature significant archaeological details, such as ancient graffiti, the counter of a *thermopolium* (snack bar) strangely converted in to a sarcophagus with two portraits (see fig. 4), or a phallus relief (far larger than in reality) built into a brick wall.

In the third volume, which Francesco engraved after his own drawings, rather than his father's, he mingles documentary images with abstractions, such as a selection of monumentalized ancient tools explored more for their formal shapes than their historical character. There is a further story behind these prints celebrating daily life and labor: Francesco produced them while living in exile in Paris, having been active in Roman revolutionary politics in the last years of the eighteenth century as an advocate of economic and agricultural reform. | KL

SELECTED BIBLIOGRAPHY

Kockel, Valentin, "Archäologie und Politik: Francesco Piranesi und seine drei Pompeji-Pläne," *Rivista di Studi Pompeiani* 11 (2000): 33–46.

Lizzani 1952.

Pucci 1979.

Thomas, Hylton A., "Piranesi and Pompeii," *Kunstmuseets Årskrift* 39–42 (1952–55): 13–28.

VanderPoel 1986, 5: 181–88.

Wilton-Ely, John, *The Mind and Art of G. B. Piranesi* (London, 1978), 117–20.

Francesco Piranesi
Italian, ca. 1756–1810

THE HORRIBLE MOMENT OF THE SECOND DESTRUCTION OF THE CITY OF POMPEII BY THE LAVA AND ASHES OF VESUVIUS

Etching and engraving, 65 × 99 cm (25⅝ × 39 in.)
Plate 1 in *Antiquités de Pompeïa*, vol. 1 of *Antiquités de la Grande Grèce, aujourd'hui Royaume de Naples* (Paris, 1804).
Oxford, Ohio, Miami University Library, The W. W. Wertz Art and Architecture Library

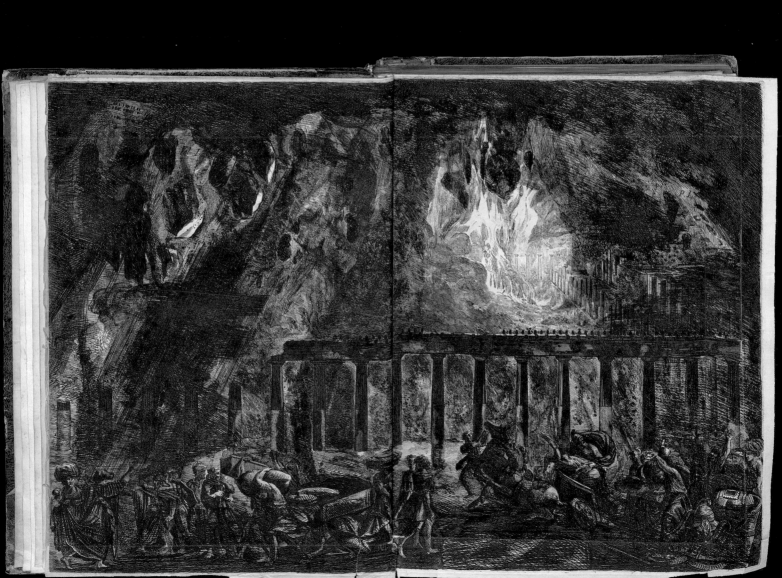

Francesco Piranesi
Italian, ca. 1756–1810

after a design by Giovanni Battista Piranesi
Italian, 1720–1778

VIEW OF THE TAVERN AT POMPEII
WITH AN EMBLEM OF PRIAPUS

Etching and engraving, 65 × 99 cm (25⅝ × 39 in.)
Plate 24 in *Antiquités de Pompeïa*,
vol. 1 of *Antiquités de la Grande Grèce,
aujourd'hui Royaume de Naples* (Paris, 1804).
Oxford, Ohio, Miami University Library,
The W.W. Wertz Art and Architecture Library

64

Francesco Piranesi
Italian, ca. 1756–1810

TOOLS OF MASONS AND AGRICULTURAL
WORKERS FOUND AT POMPEII

Etching and engraving, 65 × 99 cm (25⅝ × 39 in.)
Plate 6 in *Contenant les usages civils, militaires et religieux…*,
vol. 3, pt. 1 of *Antiquités de la Grande Grèce,
aujourd'hui Royaume de Naples* (Paris, 1807).
Oxford, Ohio, Miami University Library,
The W.W. Wertz Art and Architecture Library

Vue de la Taverne de Pompeïa, qui a pour enseigne Priape. L'on apperçoit l'interieur par les deux entrées.

Outils de Maçons et d'Agriculteurs trouvés à Pompeïa.

Opera Sets

To celebrate the name day of the reigning queen of Naples, Maria Isabella, on November 19, 1825, Giovanni Pacini's operatic extravaganza, *L'ultimo giorno di Pompeii* premiered at the Royal Theater of San Carlo. Although its title resembles that of Edward Bulwer-Lytton's epic melodrama (*Last Day*, rather than *Days*), which was published a decade later, the opera's plot was entirely different. It opens with Sallustio reaching the pinnacle of his political career, having been elected chief magistrate of Pompeii. During his investiture he is caught in a trap set by the tribune Appio Diomede, whose love for Sallustio's wife, Octavia, had been rejected. Seeking revenge, Appio bribes Fausto, Sallustio's freedman, and arranges for Clodio, son of Pubblio, guardian of the baths, to be disguised as a girl and hidden among Octavia's handmaidens. The youth is then exposed and confesses, accusing Octavia of having seduced him. Octavia pleads her innocence, but the evidence of her immorality and corruption appears overwhelming, and Sallustio, as judge, has no choice but to condemn his beloved wife to be buried alive. The timely eruption of Vesuvius, however, terrifies Pubblio, who, fearing the wrath of the gods, confesses his perfidy. He and Appio are quickly immured in place of Octavia, who, reunited with her husband and son, escapes the doomed city.

The libretto was written by Andrea Leone Tottola, but both the idea of setting an opera at Pompeii and the outlines of the plot were the brainchild of Antonio Niccolini, scenographer at San Carlo, who knew the ancient site well (he also published a sixteen-volume catalogue of the royal Bourbon museum [1824–57]). No illustrations of the initial production in Naples survive, but contemporary reviews and revivals attest to its success. The spectacle entered the Neapolitan repertory and was repeated over the next four seasons, subsequently traveling to Milan, Rome, Vienna, Paris, Venice, and London.

At La Scala in Milan in 1827, the sets, probably closely following Niccolini's, were designed by Alessandro Sanquirico. Analysis of these and other surviving drawings indicate that he relied considerably on archaeological publications, such as *Delle Antichità di Ercolano* (for Sallustio's House), Gell's *Pompeiana* (for the Forum and the Street of Tombs), and Saint-Non's *Voyage pittoresque* (for the House of Diomede). Other ahistorical scenes were invented, such as the underground sepulcher in which Octavia was interred (a punishment actually reserved for Vestal Virgins at Rome who broke their vow of chastity).

Accounts of the opera's climax in Naples reveal that no expense was spared for the *deus ex machina*: as the music thundered, the underground burial chamber shook violently and its huge columns collapsed, breaking apart and causing huge pieces of the vaulting to crash down from above.

At the same time as the ceiling fell in…there fell from the flies at the back of the stage innumerable pieces of rock made out of cardboard colored with red lead and heightened by red powder mixed with huge quantities of sawdust, so that they appeared to be stones and ashes from Vesuvius. Simultaneously, nine curtains of ash-colored gauze on which were painted billowing clouds of fire and smoke rose one after the other to display the great eruption, which was pictured on a large, transparent oil cloth drop-curtain 400 *palmi* long, wound round a drum eight *palmi* in diameter. This drop-curtain was painted with tongues of flame and balls of fire shooting out the smoke, reflecting red and giving the illusion that you were looking at red flames rather than at a transparent curtain. They had assembled at the back of the stage two large hollow boxes made of tin, with a number of zig-zag openings which when turned—now slowly, now quickly—gave a true effect of lightning as Bengal fire [a mixture of niter, sulfur, charcoal, and antimony] was discharged inside. Besides this, two large bellows, also at the back of the stage, blew out Lycopodium powder [made from highly flammable moss spores], a box of which [San Carlo impresario Domenico] Barbaja had sent for from Milan. It was said that he burned about ten ducats worth of Lycopodium powder at each performance. Shortly afterwards, fiery lava was seen to be moving towards the ruins on the stage with such verisimilitude that the people in the stalls were terrified (Black, 99).

The following day Pacini received a letter of congratulation conveying the "special pleasure" of King Francesco and was appointed to the Royal Academy of Fine Arts. And at a subsequent meeting of the Council of State, the sovereign ordered that Tottola be awarded a bonus of thirty ducats. | KL

SELECTED BIBLIOGRAPHY

Black, John, "The Eruption of Vesuvius in Pacini's *L'ultimo giorno di Pompei*," *Donizetti Society Journal* 6 (1988): 95–104.

Jacobelli 2009.

Loubinoux, Gérard, "*L'ultimo giorno di Pompei (Le dernier jour de Pompei*), opéra de Giovanni Pacini et Andrea Leone Tottola," in *Il Vesuvio e le città vesuviane 1739–1860* (Naples, 1988), 497–508.

Pesando 2003, esp. 36–37.

Tottola, Andrea Leone, and Giovanni Pacini, *L'ultimo giorno di Pompei: Dramma per musica* (Naples, 1825).

Unknown engraver
after a design by Alessandro Sanquirico
Italian, 1777–1849

ATRIUM OF THE HOUSE OF SALLUSTIO

66 (BOTTOM)

Carlo Sanquirico
Italian, active ca. 1830

after a design by Alessandro Sanquirico
Italian, 1777–1849

ENTRANCE TO POMPEII
FROM THE NOLAN GATE

67 (OPPOSITE TOP)

Angelo Biasioli
Italian, active ca. 1830

after a design by Alessandro Sanquirico
Italian, 1777–1849

THE FORUM OF POMPEII
DECORATED FOR A FESTIVAL

68 (OPPOSITE BOTTOM)

Carlo Sanquirico
Italian, active ca. 1830

after a design by Alessandro Sanquirico
Italian, 1777–1849

SUBTERRANEAN CHAMBER INTENDED
FOR SUPPLICATION TO THE KING

Aquatints, hand-colored with watercolor,
each 39 × 49 cm (15⅜ × 19⁵⁄₁₆ in.)
Unnumbered plates from *L'ultimo giorno di Pompei* in
*Raccolta di varie decorazioni sceniche inventate ed eseguite
per il R. Teatro alla Scala di Milano* (Milan, ca. 1827–32)
Los Angeles, Getty Research Institute, Special Collections
93-B15110

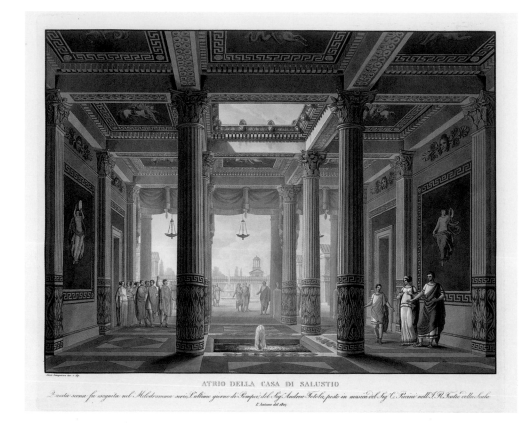

ATRIO DELLA CASA DI SALUSTIO

Questa scena fu eseguita nel Melodramma serio L'ultimo giorno di Pompei del Sig.ʳ Andrea Totola posto in musica del Sig.ʳ C. Pacini nell'I.R. Teatro della Scala
L'Autunno del 1827

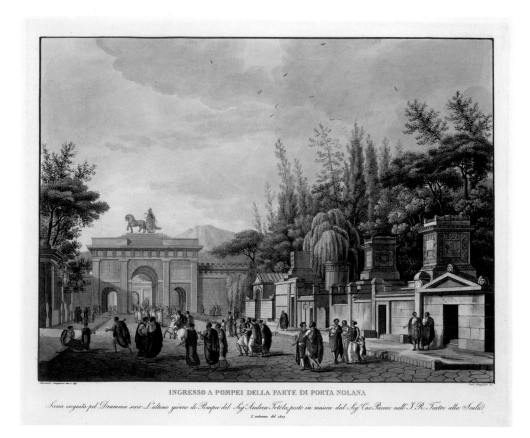

INGRESSO A POMPEI DELLA PARTE DI PORTA NOLANA

Scena eseguita pel Dramma serio L'ultimo giorno di Pompei del Sig.ʳ Andrea Totola posto in musica dal Sig.ʳ Cav.ᵉ Pacini nell'I.R. Teatro alla Scala
L'autunno del 1827

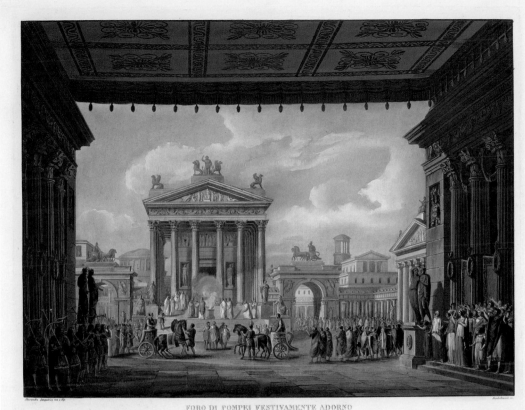

FORO DI POMPEI FESTIVAMENTE ADORNO

Scena eseguita pel Dramma serio L'ultimo giorno di Pompei del Sig.r Tottola posto in musica dal Sig.r Cav. Pacini nell'I. R. Teatro alla Scala.

L'Autunno dell'anno 1827.

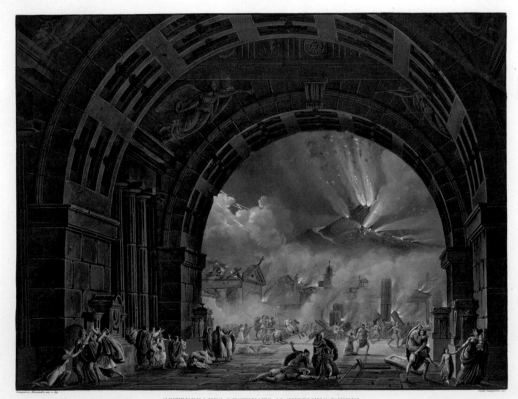

SOTTERRANEO DESTINATO AL SUPPLIZIO DE'REI

Scena eseguita pel Dramma serio L'ultimo giorno di Pompei del Sig.r Tottola posto in musica dal Sig.r Cav. Pacini nell'I. R. Teatro alla Scala.

L'Autunno dell'anno 1827.

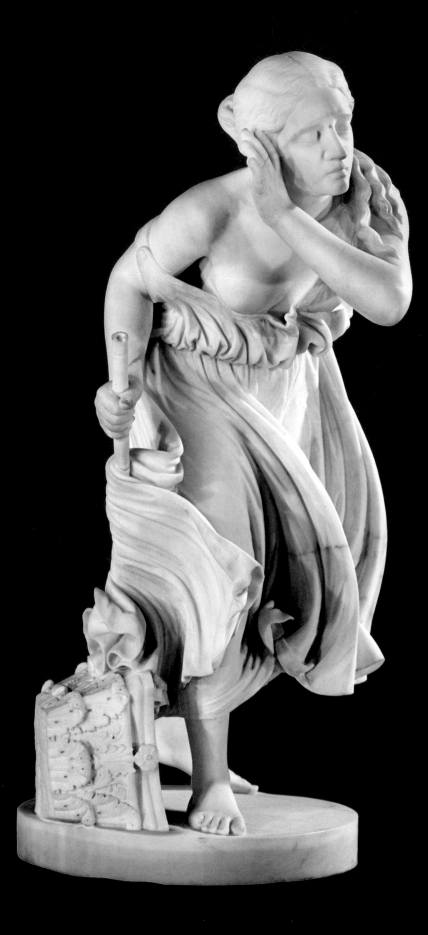

Randolph Rogers
American, 1825–1892

NYDIA, THE BLIND FLOWER GIRL OF POMPEII

Modeled ca. 1854
Marble, 91.9 × 43.9 × 64.1 cm (36⅛ × 17¼ × 25¼ in.)
Washington, D.C., Smithsonian American Art Museum, Transfer from
the National Museum of American History,
Division of Cultural History, Smithsonian Institution, 1973.127

Rogers was raised in Ann Arbor, Michigan, and studied with the sculptor Lorenzo Bartolini in Rome, where, aside from brief visits to the United States, he spent the rest of his career. His studio was extremely popular with visiting Americans, and he received steady commissions for historical and literary subjects, portraits, tombs, and civic monuments. His significant patronage from Italians is much less well known and included an enormous commission late in his career for the rebuilding of the basilica of San Paolo fuori le Mura outside Rome.

Nydia, however, is Rogers's best-known subject and one of the artist's early successes. It depicts a heroine in Bulwer-Lytton's novel *The Last Days of Pompeii*, the enslaved, blind, flower girl who falls in love with the Athenian patrician Glaucus. At novel's end, Nydia, who can pass through the city by gauging the sound of her footsteps on Pompeii's pavement, leads Glaucus and his beloved Ione through the blinding ash to their escape by sea, where Nydia ultimately commits suicide. Rogers first modeled the prototype for *Nydia* around 1854, and carvers in his studio began sculpting life-size and half-scale versions in the same year. Rogers claimed to have produced 167 examples of the work, and over 50 documented versions survive.

Rogers's complex and original conception moved beyond illustrating the novel. Nydia insistently leans forward, hand to ear, straining to hear, while the toppled Corinthian capital at her feet signifies the city's destruction. The dramatic form and intricate carving, with the figure's garments fluttering from running through the streets, underscore the implied chaos around her. Rogers depicts Nydia alone, leaving the precise moment ambiguous, adding suspense and energy: is Nydia making her way to Glaucus and Ione, or should we imagine the couple following behind her?

Rogers's conception relied on Hellenistic sculpture in Italian collections, such as the Medici *Niobe* (Florence, Galleria degli Uffizi), but *Nydia*'s pose and the active narrative ultimately owe far more to Roman Baroque sculpture, particularly the work of Gianlorenzo Bernini (for example, his *David* [1623] and *Apollo and Daphne* [1624] at the Villa Borghese). *Nydia*'s agitated, asymmetrical form thus rejects the containment of sculpture typical of his American expatriate contemporaries,

including Harriet Hosmer and William Wetmore Story. Moreover, the intensity of *Nydia* departs from Rogers's own earlier work, such as *Ruth Gleaning* (a carving he often showed in tandem with *Nydia*), which, while sharing elements such as the exposed breast, clinging garments, and wavy hair cascading over one shoulder, also demonstrates more emotional and physical restraint than the Pompeian subject.

Rogers's play on the sensations of experiencing sculpture also contributed to *Nydia*'s immense popularity, which included an enthusiastic reception at the 1876 American Centennial celebrations in Philadelphia. Just as Bulwer-Lytton's text described Nydia as a beautiful adolescent, we behold a beautiful sculpture. Yet, in a point of pathos in both text and object, Nydia's blindness prevents her from experiencing the visual beauty that we experience on seeing her. Rogers furthermore heightens Nydia's sexuality in a reversal of the character's chasteness: the beautiful skin and the labial folds of the clinging drapery encourage a sexualized response, while Nydia, both blind and literally of stone, twice cannot return our gaze. Moreover, the young woman's stooped pose places her body unusually low to the ground and therefore accessible to the viewers' touch, moving the work away from the conventional heroic, standing figure. Reversing our visual experience, Nydia listens to her own footsteps, footsteps we cannot hear, and which, according to the novel, demonstrate the heightened approach to hearing only available to the blind ("Her blindness rendered the scene familiar to her alone": Bulwer-Lytton v, 7). Nydia's silent hearing inverts our visual pleasure at beholding the sculpture.

Nydia's composure in the face of annihilation also emerges from a popular nineteenth-century conception of the stoic sentinel of Pompeii, later explored by Mark Twain in *Innocents Abroad* and by Edward John Poynter (see pl. 31). The concept of the sentinel derives from an early-nineteenth-century misreading of archaeological evidence, according to which the figure was thought to have stood firm at his post at the Herculaneum Gate throughout the eruption. Rather than the disorderly panic that characterized earlier nineteenth-century depictions of the last days of Pompeii, Nydia remains in control of her imbalanced body. Likewise, her torqued form would have gained resonance

in comparison to Vesuvius's tormented victims, commonly interpreted at this moment as selfish, materialistic pagans who refused to leave the city. The body casts of the victims, first displayed in the 1860s, fueled renewed interest in the ancient Pompeians and inflected, if not Rogers's initial conception of Nydia, then certainly subsequent appreciation of the sculpture.

The metaphoric value of white marble's purity had a strong valence in nineteenth-century America. Especially in contrast to the dark destruction of Pompeii so carefully described by Bulwer-Lytton and depicted by contemporary artists such as James Hamilton (see pl. 29), the white stone signifies Nydia's moral goodness, as well as her claimed classical pedigree. Nydia is possibly the most widely represented slave in the nineteenth century. As Leanne Hunnings has observed, Bulwer-Lytton's *Nydia*—psychologically complex, assertive, and poetic—complicated the typical depiction of slaves in nineteenth-century literature, presenting her as a delicate Greek girl with considerable interiority, born free and only later enslaved. Rogers's white sculpture bears traces of this mildly subversive way of depicting enslavement, and many of his American patrons may well have embraced this view even more than the sculptor himself. Indeed, from the artist's perspective, *Nydia* certainly cannot be interpreted as a straightforward critique of slavery, for his own position is ambiguous. His writings are mute on the subject, and his many depictions of Lincoln and commissions for Civil War monuments in the northern states must be balanced with his work on a major monument for the state of Virginia throughout the Civil War and his marriage into a slave-holding family. | JLS

SELECTED BIBLIOGRAPHY

Bulwer-Lytton 1834.

Hunnings 2011.

Rogers, Millard F., Jr., *Randolph Rogers: American Sculptor in Rome* ([Amherst, Mass.], 1971).

Seydl 2011 (with prior bibliography).

Lawrence Alma-Tadema
Dutch and British, 1836–1912

GLAUCUS AND NYDIA

1867, reworked 1870
Oil on wood, 39 × 64.3 cm (15⁵/₁₆ × 25⁵/₁₆ in.)
The Cleveland Museum of Art, Gift of Mr. and Mrs. Noah Butkin, 1977.128

This painting interprets chapter 4 in book 2 of Edward Bulwer-Lytton's 1834 novel *The Last Days of Pompeii* and represents a tender, quiet moment relatively unusual for *Last Days* subjects. Nydia, a blind slave, has fallen in love with Glaucus, a young patrician, who in turn loves the noble Ione. When Glaucus asks Nydia to model jewelry he is considering as a gift for Ione, Nydia's jealousy flares, culminating in a tantrum. Later that evening, as a peace offering, Nydia offers a bouquet to Glaucus to give to Ione. Recognizing the slave's feelings, Glaucus declines the offer, encouraging her to weave the flowers into a garland for him instead.

This early Pompeian work did not sell immediately on its completion in 1867, and Alma-Tadema appears to have reworked the panel in 1870. X-radiographs indicate that Nydia underwent considerable change: her garment is less revealing, covering her arms; her legs are drawn up in a pose that conveys more tension than her originally outstretched leg; and her headdress is more exotic, while her hair is longer. With these alterations, Alma-Tadema downplayed Nydia's physical availability and emphasized the pair's chaste relationship. The revisions speak to the artist's interest in dealing with the Christian subplot of Bulwer-Lytton's novel and his broader concerns about enslavement, which come to fruition in *An Exedra* (see pl. 8) two years later.

Alma-Tadema depended heavily on photographs to develop his compositions. In 1863, while visiting Pompeii, he began his collection, eventually compiling one of the most extensive archives of any painter in the period (see pls. 12 and 13). His revisions also included the addition of the *trapezophoroi* (tabble

supports) in the form of griffins in the upper right, a well-known object from the House of Meleager at Pompeii (VI.9.13), which was inspired by a photograph by Giorgio Sommer in his collection (pl. 70.1). | JLS

SELECTED BIBLIOGRAPHY

Diederen, Roger, entry in Cleveland 1999, 4–7 (with prior bibliography).

Pohlmann, Ulrich, "Alma-Tadema and Photography," in Edwin Becker, ed., *Sir Lawrence Alma-Tadema* (New York, 1997), 111–27.

70.1 Giorgio Sommer (Italian, b. Germany, 1834–1914), *The House of Meleager*, ca. 1875. Albumen silver print, 18.7 × 23.5 cm (7³/₈ × 9¼ in.). Washington, D.C., National Gallery of Art Library, Department of Image Collections.

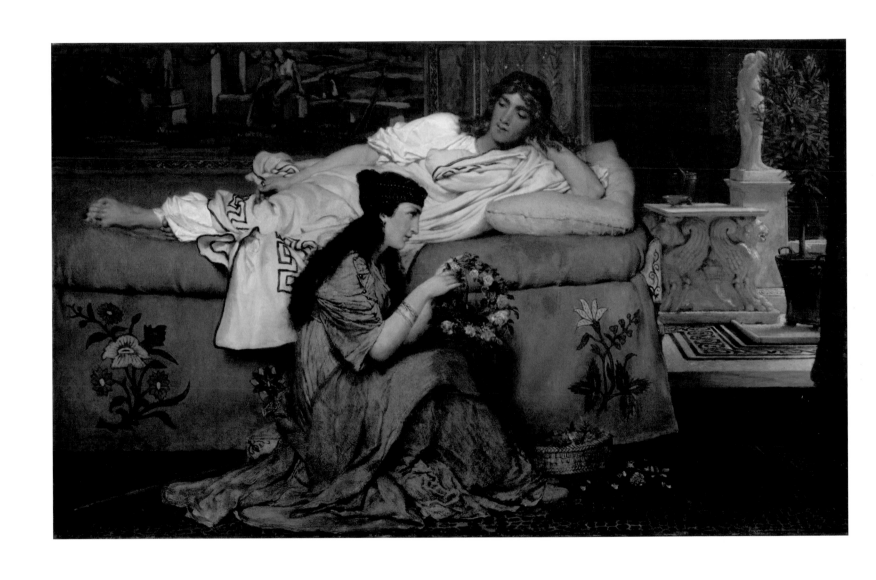

Christen Købke
Danish, 1810–1848

THE FORUM, POMPEII, WITH VESUVIUS
IN THE DISTANCE

1841
Oil on canvas, 70.8 × 87.9 cm (27⅞ × 34⅝ in.)
Los Angeles, J. Paul Getty Museum, 85.PA.43

The son of a baker, Købke entered the Royal Danish Academy of Art in Copenhagen when he was twelve, and, by his early twenties had won several prizes for his landscape paintings. In 1838, with a stipend from the academy, he journeyed to Italy, where, in the company of other Danes, he visited Rome, Naples (where he copied ancient frescoes in the museum), Portici, Sorrento, Capri, and Pompeii, the last at least three times.

Although Købke's paintings of Pompeii commissioned by the Danish Fine Arts Society appear to be highly realistic, they are not entirely accurate. He did not produce them on-site but rather back in his studio in Denmark, where he drew on various sketches and incorporated extraneous architectural elements, plants, and animals to construct precise, detailed views of romanticized, crumbling ruins. A drawing (pl. 71.1) and an oil study for *The Forum*, both made on-site on July 10, 1840, lack the fallen Ionic columns and vegetation that appear in the foreground of the painting to the left of the fountain. Købke made a separate pencil drawing of these (pl. 71.2), and clearly combined the images. In the final painting he inserted the two lizards scrambling in the dirt in the foreground and a third on the truncated column to the right, adding pathos to the scene. In the distance he introduced a herd of goats grazing through the desolate site, even though in his day Pompeii was an increasingly popular tourist destination. Købke also added a weed-topped capital to the Doric column at center left and increased the overgrowth of the vegetation throughout. He sharpened the detail of the ravines on the slopes of the volcano and changed the position of the low clouds in what is, for the most part, a clear blue sky. While Vesuvius is not depicted as a threat, by intensifying the contrast between light and dark and by painting the architectural fragments in the foreground almost completely in shadow, Købke added drama to the composition, heightening the sense of desolation—the feeling that, despite the bright blue sky, the site is a ruin of a ruin and that human endeavor is for naught. | KL

71.1. Christen Købke, *Forum at Pompeii*, 1840. Pencil, 24.9 × 37 cm (9¾ × 14⅝ in.). Copenhagen, Statens Museum for Kunst, Kobberstiksamling, KKSgb2910.

71.2. Christen Købke, *Fallen Columns, Pompeii*, 1840. Pencil, 24.6 × 37.2 cm (9⅝ × 14⅝ in). Copenhagen, Statens Museum for Kunst, Kobberstiksamling, KKSgb2911.

SELECTED BIBLIOGRAPHY

Berman, Patricia G., *In Another Light: Danish Painting in the Nineteenth Century* (London, 2007), 88–89, fig. 60.

Fischer, Erik, entry in *Zeichnungen aus Dänemark von Abildgaard, Juel, Eckersberg, Købke, Lundbye und Marstrand: Kopenhagener Schule des 18. und. 19. Jahrhunderts aus dem Besitz der Königlichen Kupferstichsammlung in Kopenhagen*, exh. cat. (Berlin, Nationalgalerie, 1989), 72, no. 75.

Jakobsen, Kristian, "Christen Købke i Pompeji," in *Fynske Minder 1965* (Odense, 1966), 215–32, fig. 4.

Mattusch 2008, 301–3, no. 150.

Monrad, Kasper, entry in *Paysages d'Italie: Les peintres du plein air (1780–1830)*, exh. cat., ed. Anna Ottani Cavina (Paris, Réunion des musées nationaux, 2001), 330, no. 205.

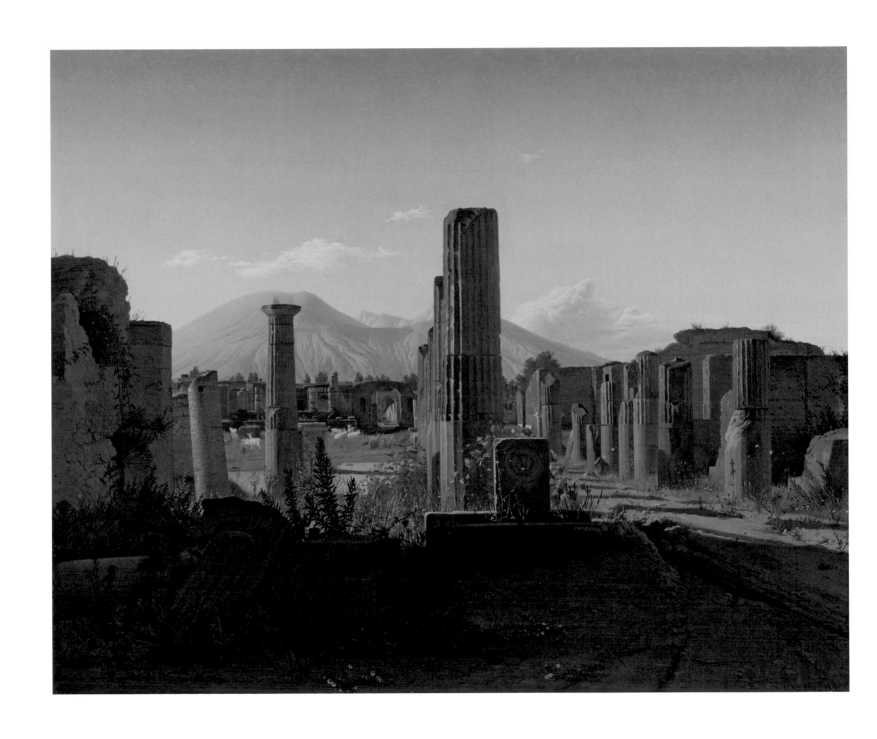

Robert S. Duncanson
American, 1821–1872

POMPEII

1855
Oil on canvas, 53.3 × 43.2 cm (21 × 17 in.)
Washington, D.C., Smithsonian American Art Museum,
Gift of Dr. Richard Frates 1983.95.158

A self-taught artist, Duncanson matured as a landscape painter in Cincinnati. Sponsored by his patron, the abolitionist and winemaker Nicholas Longsworth, Duncanson traveled to Europe in April 1853. In England, Joseph Mallord William Turner's paintings stunned the artist, and when his group moved on to Italy after a brief stop in France, he fell in with the Americans who clustered around Hiram Powers's Florentine studio. While not documented in the Bay of Naples, Duncanson likely visited there, as did many artists from the United States who went abroad in the mid-1800s. Duncanson's Italian sojourn profoundly affected him. He wrote that "Every day…sheds a new light over my path—what is becoming dark and misty is gradually becoming brighter."

Duncanson returned to Ohio in 1854 and for the next two years concentrated on Italianate landscapes, probably based on sketches he had made overseas. He was underwhelmed by the American expatriate painters in Italy, whom he called "mean Coppyest producing pictures." By contrast, *Pompeii* is characteristic of Duncanson's work in this period—an original composition based on nature studies but thoughtfully composed from his imagination. The vertical canvas departs from his typical horizontal format, giving the picture an unusual grandeur, which is further emphasized by the arched top, associated more with altarpieces than landscape. Letters from November 1854 to a former apprentice indicate that Duncanson had exhibited at least one other picture with the same title (now unlocated), and in 1871, toward the end of his career, he painted two smaller, horizontal Pompeian pictures (also Smithsonian American Art Museum).

Despite the title, nothing specifically Pompeian appears in this work aside from a languidly smoking Vesuvius. Duncanson invented the architecture; the large fragment of the wall painting is deliberately vague; and the topography resembles no particulars of the Bay of Naples. The airy composition and low point of view opening onto flat ground reveals the impact of fantasy landscapes by eighteenth-century painters in Italy, especially Jan Frans van Bloemen, Andrea Locatelli, and Giovanni Paolo Panini. Duncanson certainly would have seen their work while abroad; Panini's work similarly incorporated invented ruins, populated with conversing figures.

Seeing ancient ruins in person had a powerful impact on Duncanson and tied his practice into a larger American nineteenth-century tradition in the long shadow of Thomas Cole. Classical ruins in American painting in this era often refer to the collapse of civilizations and the failure of empire, as well as offer a critique of antiquity: its paganism, its decadence, and—for some—the practice of slavery. While some scholars have interpreted related pictures by Duncanson as critical of slavery based on Duncanson's African American identity, *Pompeii* resists such an overt interpretation. But the artist does include a tiny but meaningful detail at the center—a bent-over figure digs with a hoe, overseen by a top-hatted man and what seems to be a well-to-do family. Duncanson would likely have seen the arduous excavating at Pompeii—extremely difficult labor, often done by prisoners or underage workers with occasionally violent overseers (see pl. 76)—and this vignette, rarely depicted by artists, subtly addresses this practice. | JLS

SELECTED BIBLIOGRAPHY

Ketner, Joseph D., *The Emergence of the African-American Artist: Robert S. Duncanson, 1821–1872* (Columbia, Mo., and New York, 1993) (with prior bibliography).

Personal communication with Mark Cole and Joseph D. Ketner.

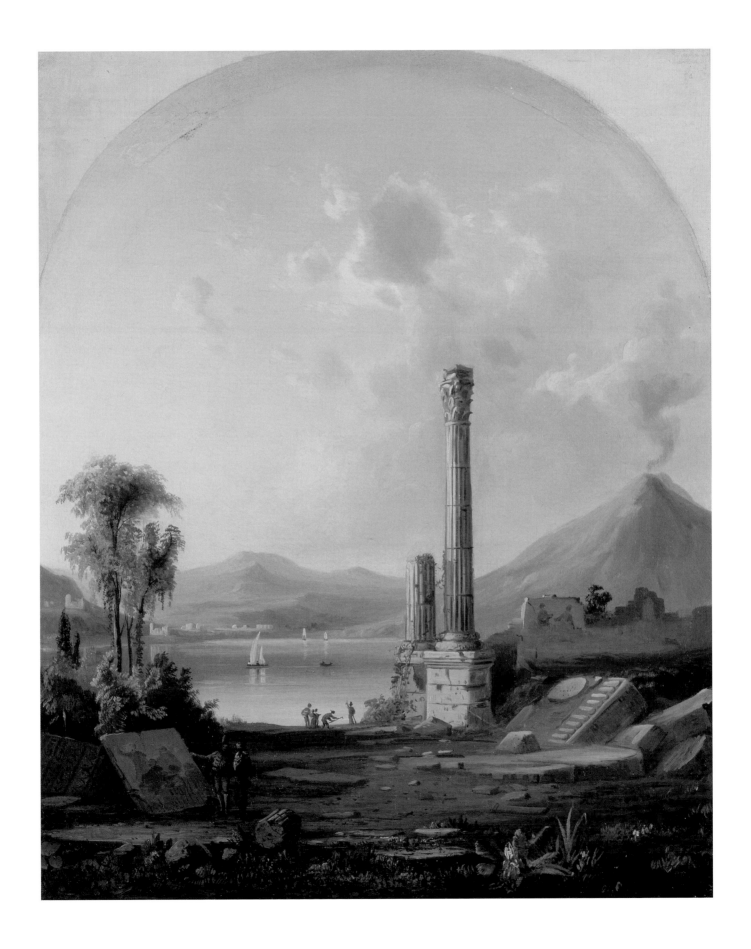

Paul Alfred de Curzon
French, 1820–1895

A DREAM IN THE RUINS OF POMPEII
(THE SPIRITS OF ITS ANCIENT INHABITANTS RETURN TO VISIT THEIR HOMES)

1866
Oil on canvas, 71 × 104 cm (28 × 41 in.)
Bagnères-de-Bigorre, Musée des Beaux-Arts Salies, 146

A minor noble from the south of France, Curzon trained under the landscape painter Nicolas-Louis Cabat, a member of the Barbizon school who traveled extensively in France (and later Italy), studying from nature. Curzon's early works, too, are French landscapes.

In 1846, the year after his first showing at the Paris Salon, Curzon traveled to Rome, Florence, and Venice. He returned to Italy as a resident at the Académie de Rome from 1850 to 1853. During this period, he combined his close study of nature with increasing attention to ancient and Renaissance models. Curzon journeyed to southern Italy in 1851 in the company of fellow painter and academician William-Adolphe Bouguereau, visiting Pompeii, where he sketched the House of the Faun (VI.12.2).

The House of the Faun was among the largest and most opulent urban dwellings discovered at Pompeii. It was built in the second century B.C. and covered a full city block. The house was excavated from 1829 to 1833, revealing a series of luxurious indoor and outdoor spaces that contained spectacular works of art. Notable among the finds were the extraordinary Alexander mosaic and the ebullient bronze statue that gave the house its name (see pl. 77.1). The dwelling was extensively studied as the best-preserved example of Roman upper-class domestic architecture.

After he returned to Paris, Curzon used his drawings of the House of the Faun as the basis for a major painting. He crafted a dramatic vista through the ruined house to the great peristyle in the back, all constructed according to a perspectival system that recalls Renaissance models. In the background, a smoking Vesuvius hovers over the city. As in the closely contemporary photographs by Michele Amodio of Pompeian body casts (see fig. 30), the juxtaposition of the ancient Pompeians with the modern, smoking Vesuvius creates a perpetual reminder of the disaster that killed them. But Curzon did not reconstruct the ruins and populate them with ancient Romans, as his friend Théodore Chassériau did with the *Tepidarium* (see pl. 7). Nor did he create a modern image of the excavated ruins with contemporary figures in the style of Giorgio Sommer (see fig. 28). Instead, Curzon took a hybrid approach, as did Francesco Piranesi (see pl. 63 and fig. 4). He treated a relatively recent find with a careful archaeological correctness that would have

been appreciated by viewers interested in the ongoing discoveries, but his figures are the ancients themselves—who have been brought back to life by the excavation. Men, women, and children converse and meditate in the orderly but ruined interior, accompanied by peacocks that might be ancient birds or their modern descendants. The peacock is a venerable emblem of immortality, mentioned in authors ranging from Origen to Saint Augustine, and as such is an appropriate companion to the ancient spirits. In this conception, archaeology is a means not only to study antiquity but also to resurrect it.

Curzon casts this dramatic tension between the victims and the volcano in an elegiac, pastoral idiom that recalls models from Renaissance Venice, notably Giovanni Bellini's *Sacred Allegory,* which he would have seen in Florence (pl. 73.1). Bellini's painting has long been interpreted as a meditation on the Christian soul as it moves through purgatory to redemption. It fuses classical and Christian imagery, an approach Curzon echoed in his use of the peacocks. The two paintings are thus not only strikingly similar in their compositions, but also in their themes—human spirits continuing their journey in the afterlife. In the case of Curzon, this posthumous journey takes place in an archaeological rather than a Christian context, thus putting a contemporary twist on the concept. In addition,

73.1. Giovanni Bellini (Italian, 1431/36–1516), *Sacred Allegory*, ca. 1490–1500. Oil on panel, 73 × 119 cm (28¾ × 46⅞ in.). Florence, Galleria degli Uffizi, 184409.

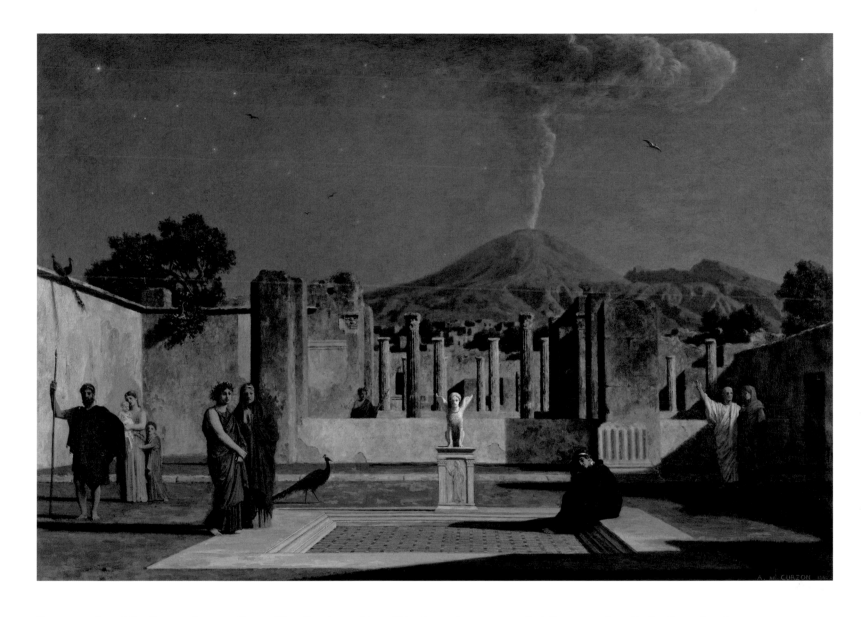

Curzon replaced the famous bronze *Faun* with a Greek marble sphinx on an archaizing figured plinth. By placing this figure at the center of his image Curzon signals it is a riddle, possibly explained by the constellation of the Sphinx (incorporated into Orion to the left of Vesuvius)—which is itself an Egyptian symbol of resurrection.

Curzon's imaginative contribution to the popular genre of Pompeian painting in nineteenth-century France was well-received by his contemporaries. Théophile Gautier, for example, singled out this painting in his analysis of the 1866 Salon, where it was first exhibited. Gautier connected it to his 1852 novel *Arria Marcella,* which likewise fused contemporary archaeology with revivified ancients, noting that his text and Curzon's painting shared the same "retrospective phantasmagoria"—or fantasy of projection onto the remains of the past. Gautier continues,

"his dream has an aspect at the same time fantastic and real; fantastic, because the figures are only shadows; real, because its architecture has the solidity of the real thing." | VCGC

SELECTED BIBLIOGRAPHY

Cassanelli, Roberto, "Pompeii in Nineteenth-Century Painting," in Cassanelli et al. 2002, 40–47.

Curzon, Henri de, *Alfred de Curzon, peintre (1820–1895): Sa vie et son œuvre après ses souvenirs, ses lettres, ses contemporains* (Paris, 1916).

Gautier, Théophile, "Salon de 1866," *Le Moniteur,* June 12, 1866.

The Second Empire 1852–1870, exh. cat. (Philadelphia Museum of Art; Detroit Institute of Arts; Paris, Grand Palais, 1978–79), 283–84.

CABINET WITH OBJECTS PRESENTED TO POPE PIUS IX

Hexagonal walnut and glass case with applied gilt brass letters reading (in Latin): ANTIQVITATIS·MONVMENTA|E·RVDERIBVS· POMPEIORVM·EFFOSSA|IX KAL·NOVEMBR·ANN·MDCCCXLIX | ADSTANTE·D·N·PIO·IX·PONT·MAX | EIDEMQ·LIBERALITATE· FERDINANDI·II|VTRIVSQVE·SICILIAE·REGIS·D·D (Monuments of antiquity unearthed from the ruins of Pompeii on the ninth day before the Kalends of November in the presence of Our Lord Pius IX Supreme Pontiff and given as a gift to him by the generosity of Ferdinand II, King of the Two Sicilies)
H (including cauldron above): 236 cm (92⅞ in.); W (max. diagonal): 137 cm (53¹⁵/₁₆ in.)

Cauldron, bronze, 56 × 70 cm (22¹/₁₆ × 20⁹/₁₆ in.)
Herm of Bacchus, marble, 17.8 × 11 cm (7 × 4⁵/₁₆ in.)
Statuette of *Lar Familiaris*, bronze, 11.9 (with base 15.8) × 9.9 cm (4¹¹/₁₆ [6³/₁₆] × 3¹⁵/₁₆ in.)
Bottle, glass, 15.2 × 10.5 cm (6 × 4⅛ in.)
Jug, glass, 19.2 × 12.4 cm (7⁹/₁₆ × 4⅞ in.)
Lava millstone, 18 × 27 cm (7⅛ × 10⅝ in.)
Equestrian relief, marble, 55.5 × 62.5 × 3 cm (21¹³/₁₆ × 24⁹/₁₆ in.)
Stone pilaster, 80 × 23 cm (31½ × 9¹/₁₆ in.)
Cylindrical vessel, bronze, 37 × 25 cm (14⁹/₁₆ × 9⅞ in.)
Pail, bronze, 18 × 32 cm (7⅛ × 12⅝ in.)
Ewer, terracotta, 21 × 8 cm (8¼ × 3³/₁₆ in.)

Vatican City, Museo Profano, 66711, 66492, 66488, 66482, 66483, 66713, 66714, 64092, 66712, 66468, 66479, 66496

Pope Pius IX visited the excavations at Pompeii with much fanfare on October 22, 1849. After taking the Vesuvian railway from Naples, the pontiff and his entourage entered the site through the Herculaneum Gate. They were led around the main streets of the excavated area, passing a selection of houses, including the richly decorated House of the Faun, and taking in the city walls. During this tour, the pope was asked if he wished to see an excavation in action, to which he readily acquiesced. He observed digging in several places, including a house and some shops. Although there is debate over the exact locations of these sites, they were near the intersection of the Via Fortuna and the Via Stabiana, and one is likely to have been the House of Marcus Lucretius.

A detailed account of the tour was made by Stanislao D'Aloe, who published a description of the papal sojourn in Naples; the visit is also described in the excavation diaries of Giuseppe Fiorelli, long-time inspector, and later director, at the site. The descriptions of the objects uncovered on October 22 largely coincide between the two accounts, enabling the certain identification of the artifacts shown here as a selection of those found during the pope's tour and given to him by the Bourbon king Ferdinand II.

Doubts have arisen, however, about the extent to which the excavations for the pope were staged, and whether or not the

finds had been preselected. Fiorelli mentions the preparations for the pope's visit, and acknowledges that potential dig sites were carefully chosen. Excavations that had been begun in a certain house were moved to another location because of the "modesty of the finds" (*Pio IX a Pompei*, 22).

The objects themselves exhibit a striking diversity in type and material, with items of marble, bronze, glass, terracotta, and local stone (as well as of ivory, bone, and iron; not displayed here). If the selection of objects was managed, then it was arranged not to impress the pope with the most precious or most aesthetically appealing treasures found at Pompeii, but to display the breadth and beauty of typical finds from the site, and emphasize the high quality and variety of objects used by the ancient inhabitants of Pompeii on a daily basis. The containers range from a basic terracotta pitcher to a more "high-end" bronze cauldron and an ornate bronze vessel complete with lid. Similarly, the glass bottle and jug demonstrate the good preservation of Pompeian finds and the regular use of glass in Roman households. The lava millstone, used for grinding flour and grains, may have come from one of the shops. The stone pilaster could have been used to support statuary or objects for sale in a shop. The small bronze statuette pertains to domestic cult: it is a figure of the *Lar Familiaris*, or god of the household, which would have been kept in a shrine probably in the atrium of the home. The marble herm head of Bacchus also had a cultic significance. Herms such as this one were used within the home to ward off evil, as well as for decoration.

The highest-quality, most unusual and controversial object in the assemblage is the marble relief of a horse and rider (pl. 74.1). On discovery, it was described as depicting Alexander the Great on his horse Bucephalus. The likelihood of such a magnificent, and historical, piece being uncovered by chance during the pope's visit has aroused suspicion, and it has been much debated whether the marble was indeed found at Pompeii or was planted there. The relief appears to be a Greek votive offering showing an anonymous hero from Greece, South Italy, or Sicily rather than a famous historical figure. If it is indeed a Greek original, was it planted—suggesting that even objects "excavated" at Pompeii are not actually from Pompeii? Or is there some other reason that it was found in a Pompeian context dated centuries later than its creation? Annamaria Comella and Grete Stefani have argued the marble should be seen as a genuine discovery made during the pope's visit, pointing out that similar reliefs have been recovered from other parts of Pompeii. Although such reliefs originally had a strong religious significance for the Greeks, they were more like antiques for the Pompeian elites and were displayed decoratively in wealthy homes. Another possibility is that it may be a later classicizing relief produced around the first century B.C. or A.D.

74.1. Equestrian relief from the cabinet.

This group of artifacts, installed in and on top of a hexagonal walnut "reliquary" complete with a Latin inscription declaring their provenance, preserves an archaeological snapshot from October 22, 1849. A comprehensive array of relatively everyday objects, they gained value through their discovery under the very eyes of the pope and their reflection of the basics as well as the luxuries of Pompeian life. | AS

SELECTED BIBLIOGRAPHY

Comella, Annamaria, *Da anathemata a ornamenta: rilievi votivi greci riutilizzati in Italia in epoca romana* (Rome, 2011).

Comella, Annamaria, and Grete Stefani, "Un vecchio e discusso ritrovamento di Pompei: Il rilievo votivo greco col cavaliere." *Rivista di studi pompeiani* 18 (2007): 27–39.

D'Aloe, Stanislao, *Diario della venuta e del soggiorno in Napoli di S. Beatitudine Pio IX P.M. Naples, sett., 1849–marzo, 1850* (Naples, 1849–50).

Fiorelli, Giuseppe, *Pompeianarum Antiquitatum Historia* (Naples, 1860–64).

Pio IX a Pompei: Memorie e testimonianze di un viaggio, exh. cat. (Naples, 1987).

Performing Archaeology

Edouard Sain's painting portrays a delightful and highly idealized scene of local peasant women participating in the excavations of Pompeii. The site is immediately identifiable by the looming presence of Mount Vesuvius in the background, for the volcano had come to signify the site almost more than the excavations themselves. The excavated city appears on a lower level at left, represented by the remains of a public fountain at the intersection of two streets, an ancient storefront, the so-called Bar of Fortunata (VI.3.20) excavated in 1806; with its distinctive counter of sunken storage jars. The two columns with red bases are the artist's insertions (compare Giorgio Sommer's photograph of the same buildings, pl. 83).

On a higher level in the nearby region VII, which was excavated well before Sain's time, young women engage in various activities. Several walk toward the viewer, threading their way through architectural fragments emerging from the ash and dirt. Arms aloft, they sway easily under light, empty baskets, and seem almost to be dancing. The foremost girl gazes out engagingly at the viewer. A woman at right, incongruously holding a mattock, helps her companion to steady the newly filled basket she is lifting to her head. Another woman kneels, seeming to clean the dirt off a partially exposed column, while leaning her arm fully across it. Further behind, a woman rests, drinking from a large clay vessel similar to those being uncovered.

Other finds lie casually in the foreground, undamaged and pristine: a round water jug and a narrow amphora used for transporting oil or wine lean against a small pillar. Brightly colored and intricately painted walls protrude from the dirt. A scattering of terracotta fragments may indicate roof tiles. This house is being excavated from the top down—but such objects would in actuality be found at floor level, not at the height of the columns. Finally, off to the left and on a slightly lower level than the women, two men are engaged more vigorously in the excavation process. Anonymous laborers, their faces are hidden. Both are shirtless—one toils with a pickax, while the other turns toward the wall being uncovered.

Born in Cluny, Saône-et-Loire, France, Sain made a successful career of painting romanticized landscapes and portraits. Enamored of the Italian countryside, he spent time living on Capri and married an Italian. *Excavations at Pompeii* won a medal on its debut at the Paris Salon in 1866, and Sain continued to receive honors in France, including becoming a Chevalier of the Legion of Honor and a member of the Society of French Artists, until his death in Paris in 1910.

The photograph promulgated by Edizione Esposito (pl. 76) not long after captures perhaps more accurately the realities of Pompeian excavation, although it, too, emphasizes a certain point of view. Created soon after Sain's painting, which was also photographed by Giorgio Sommer and included in many widely distributed albums of Pompeii in lieu of views of actual digging, this photograph shows a large group of sullen, shabbily dressed boys, their heads bowed under the weight of the baskets hoisted onto their shoulders. In the foreground, an overseer holds a long cane. In the background, we can see the tops of columns and walls of the House of the Silver Wedding (V.2.i) excavated in the early 1890s, while the columns and architectural elements are similar to those in Sain's painting. The downtrodden and dusty boys, however, are a world away from the painter's young, attractive women, who move gracefully among the ruins in long skirts and bare feet. Instead, the photograph reminds the viewer of the use of forced laborers and prisoners to undertake the hot, dirty, and often dangerous work of uncovering the remains of Pompeii and Herculaneum. In the distant background of the photograph appear the figures of two men gazing out over the site, accompanied by a third standing a few paces behind, perhaps a servant. These two men, presumably archaeologists, or even tourists, make vivid the divide between those managing the site and enjoying the discoveries, and those clearing out the ruins. | AS

SELECTED BIBLIOGRAPHY

Compin, I., and A. Roquebert, *Catalogue sommaire illustré des peintures du Musée du Louvre et du Musée d'Orsay* (Paris, 1986), 203.

Voir l'Italie et mourir: Photographie et peinture dans l'Italie du XIXe siècle; sur une idée d'Ulrich Pohlmann et de Guy Cogeval, exh. cat. (Paris, Musée d'Orsay, 2009), 242.

75

Edouard Alexandre Sain
French, 1830–1910

EXCAVATIONS AT POMPEII

1865
Oil on canvas, 120 × 172 cm (47¼ × 67¹¹⁄₁₆ in.)
Paris, Musée d'Orsay, MI757

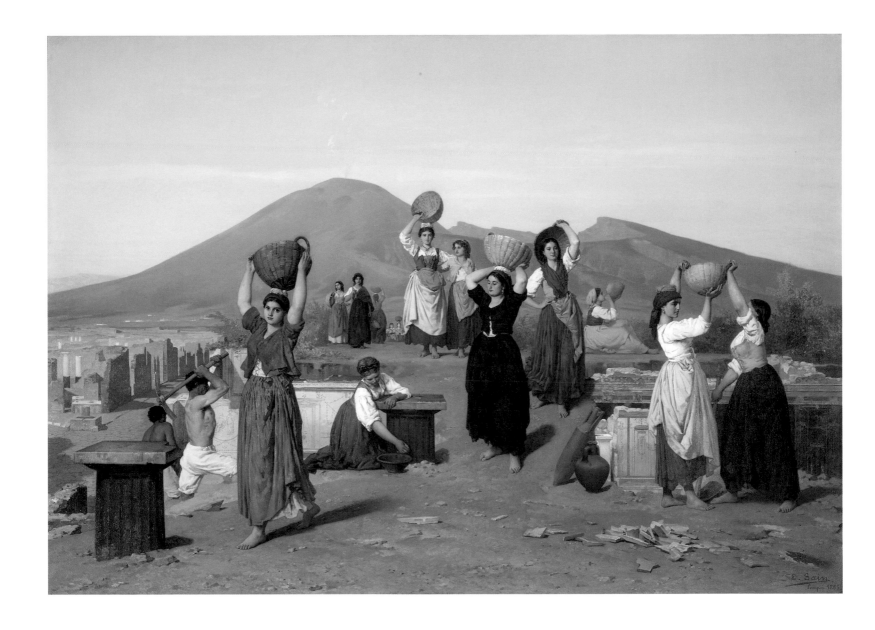

76

Edizioni Esposito
Italian, active 1870s–1890s

POMPEII—RECENT EXCAVATIONS

1892–94
Albumen silver print, 19.2 × 24.3 cm (7 9/16 × 9 1/16 in.)
Los Angeles, J. Paul Getty Museum, 2004.51.1

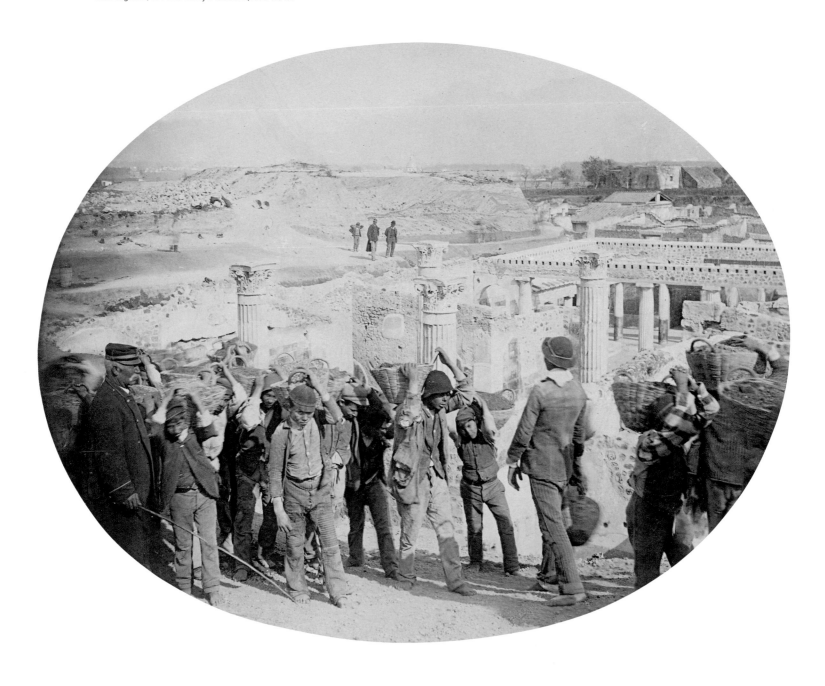

Hippolyte Alexandre Julien Moulin
French, 1832–1884

A LUCKY FIND AT POMPEII

1863
Bronze, 187 × 64 × 103.5 cm (73⅝ × 25¼ × 40¾ in.)
Paris, Musée d'Orsay, RF 190 (LUX 79)

Moulin, a shopkeeper's son, was forced to abandon a formal education in sculpture at the École des Beaux-Arts, where he had enrolled in 1855, due to financial pressures. To support himself he became a language tutor, although he continued to pursue sculpture, studying intermittently with Auguste Louis Marie Ottin and Antoine-Louis Barye. Moulin exhibited his works at the Paris Salon over the course of two decades beginning in 1857 winning medals for his entries on three occasions. In his later years Moulin succumbed to mental illness before dying in Charenton in 1884.

A Lucky Find at Pompeii is Moulin's most famous work. Signed by the artist and dated on its base to 1863, the sculpture was first presented at the Paris Salon of 1864, where it was well received critically and awarded a medal. That same year the French government bought the sculpture for 7,000 francs, and it was subsequently presented at the Exposition Universelle in Paris in 1867 and the Exposition Universelle in Vienna in 1873. Thereafter it entered the collection of the Musée du Luxembourg and then that of the Louvre, before it was relocated to the Musée d'Orsay. The original was forged by the Jacquier foundry, and due to its popularity smaller copies of various sizes were later produced and offered for sale by Thiébaut et fils and then Thiébaut frères, Fumière et Gavignot.

Moulin's life-size statue playfully blends his contemporary world with that of antiquity. A nude Neapolitan youth with a shovel slung over his left shoulder rejoices in the discovery of an artifact from Pompeii, which he admires as he holds it up in his right hand. The boy's pose was inspired by the statue of a dancing faun discovered on October 28, 1830, in the eponymous House of the Faun (pl. 77.1). Moulin's figure closely references its ancient predecessor, although the faun carries nothing in his hands and balances his weight on both feet, whereas Moulin's youth stands only on his right toes and raises his left foot entirely. The connection between these sculptures would have been evident to many nineteenth-century Salon viewers, for the ancient bronze faun statue was a much celebrated Pompeian find widely circulated in prints and photographs that had also influenced several other artists, such as the sculptor Eugène-Louis Lequesne.

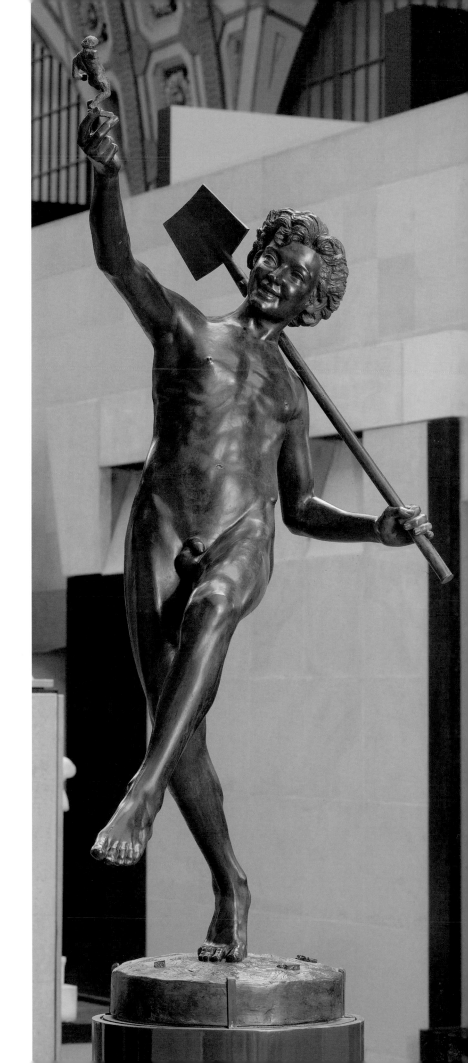

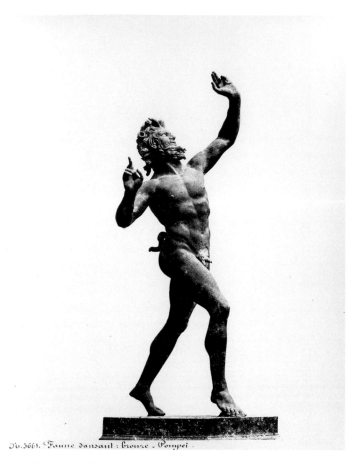

77.1. Michele Amodio (Italian, active ca. 1850–ca. 1880). *No. 3661, Dancing Faun, bronze, Pompeii*, 1874, Albumen silver print. Los Angeles, Getty Research Institute, Special Collections, 91.R.2.

Moulin's statue reflects the contemporary fascination with the ongoing excavation of Pompeii, not only through its composition but also in the "lucky find" itself, which is a variant of a bronze statuette of drunken Herakles found in Pompeii (Naples, Museo Archeologico Nazionale, 5266). The boy's pleasure with his archaeological discovery embodies the nineteenth-century European enthusiasm for both the objects newly unearthed at Vesuvian sites and the process of their recovery, however idealized. Indeed, the irreverent pose and nudity of Moulin's Neapolitan youth constitute a fantastical vision of contemporary archaeological practices, almost as if an ancient statue has come to life while excavating the ruins of its past home. | NSII

SELECTED BIBLIOGRAPHY

Butler, Ruth, *Nineteenth-Century French Sculpture: Monuments for the Middle Class*, exh. cat. (Louisville, J. B. Speed Art Museum, 1971), 202, no. 75.

Fusco, Peter, and H. W. Janson, eds., *The Romantics to Rodin: French Nineteenth-Century Sculpture from North American Collections*, exh. cat. (Los Angeles County Museum of Art, 1980), 308, no. 170.

Lami, Stanislas, *Dictionnaire des sculpteurs de l'école française aux dix-neuvième siècle*, vol. 3 (Paris, 1919), 491.

Les artistes français en Italie de Poussin à Renoir, exh. cat. (Paris, Musée des Arts Décoratifs, 1934), 116, no. 776.

Pingeot, Anne, Antoinette Le Normand-Romain, and Laure de Margerie. *Musée d'Orsay: Catalogue sommaire illustré des sculptures* (Paris, 1986), 202.

Body Casts

Since the discovery of the Bay of Naples sites, no objects have captured the imagination of the modern public so much as the casts taken from the hollows in the volcanic ash left by the decayed bodies of Vesuvius's victims. Beginning in the early eighteenth century, the excavations revealed a treasure trove of antiquities, including unparalleled examples of ancient frescoes and well-preserved architecture that allowed for a new understanding of the Roman past. But the ancients themselves remained elusive, save Pliny the Elder, whose plight was immortalized in the letters of his nephew, Pliny the Younger, to the historian Tacitus (see pls. 19–21).

Shortly after Herculaneum and then Pompeii were rediscovered, excavators encountered human skeletons (see pl. 61) and were aware that decayed organic material—including foodstuffs, plants, and animals as well as human bodies—had left voids in the hardened ash and pyroclastic flow that buried the sites. An impression of a draped female breast was cut out of the volcanic material in 1772, brought back to the royal museum in Portici, and eventually moved to the museum in Naples, where it inspired Théophile Gautier's 1852 novel *Arria Marcella*. Despite the interest in the suffering of the ancient Pompeians that began in the late eighteenth century, and the fact that plaster had been used for centuries to cast both bodies and statues, knowledge of the human remains at Pompeii was limited to the skeletons until 1863. While efforts were made to identify individuals through the surviving objects found near them, notably jewelry, the bones remained largely anonymous.

The archaeologist and antiquarian Giuseppe Fiorelli became inspector of the Pompeii excavations in 1847, when he was only twenty-four years old. After the unification of Italy in 1860, Fiorelli's power increased as he became director of the excavations and a professor of archaeology at the University of Naples. He developed an interest in casting the voids in the volcanic ash, beginning with decayed wooden architectural elements, and later attempting a full cast of a body.

In early February 1863, Fiorelli successfully cast a series of impressions found along a street near the Stabian Baths. He knew immediately that he had produced not only something with a visceral connection with antiquity but also a new class of object: "the most exacting labors...have opened the way to obtaining an unknown class of monuments, through which archaeology will be pursued not in marbles and bronzes but over the very bodies of the ancients, stolen from death, after eighteen centuries of oblivion" (Dwyer, 45–46).

Fiorelli continued to produce casts in the 1860s and 70s, which were first displayed in the so-called House of the Plaster Bodies. This space proved insufficient, and in 1875 he opened a new on-site museum in the excavated ancient storage vaults near the Porta Marina, which he had converted to the main entry site for the site (allowing him to, among other things, ensure that all visitors paid the requisite fee). This space absorbed many items deemed inappropriate for the archaeological museum in Naples, notably domestic objects and human remains which, while they were not understood by scholars to be works of art, were extremely popular with the general public.

The centerpiece of the new exhibit of the casts, now displayed in glass cases so they could be seen from all angles, was the figure of a young woman lying on her stomach (pl. 79) in a pose that seemed to recall the ancient Roman *Sleeping Hermaphrodite* (Rome, Villa Borghese). The graceful pose and well-cast face of the Pompeian woman, not to mention her seminudity, made her an object of both archaeological curiosity and erotic fascination.

After Fiorelli's death in 1896, casts continued to be made. Another major discovery took place in the so-called House of the Cryptoporticus (1.6.2) excavated in 1916 and named for the dramatic subterranean space that probably served as a wine cellar. Numerous bodies were found here. Groups were always exciting as they allowed not only for the imagined recovery of individual victims but also of their relationship to each other. A pitiful pair of women (a mother and daughter? sisters? strangers?), for example, huddled together to find comfort at the end—an embrace that comes down to us as an apparent manifestation of eternal devotion, although the details of their relationship, like their actual bodies, have long vanished (pl. 80).

In 1937 one of the most evocative male impressions was found: the so-called Crouching Man, also known as the "Muleteer" on account of the mule found near him (see pl. 78). The man was in fact found face down, but at some point the cast was rotated so he appears to crouch, head in hands. In this presentation, the Muleteer appears more active—not quite dead—and recalls icons of modern art, such as Edward Munch's *The Scream* (1893; National Gallery, Oslo) and August Rodin's *The Thinker* (1902; Musée Rodin, Paris) This cast has proven so popular that the cowering man has become a de rigueur participant in any display of the Pompeian figures, and many duplicates now exist.

CROUCHING MAN
(also known as THE "MULETEER")
FROM THE LARGE PALAESTRA

Late 20th–/early 21st-century aftercast of a plaster cast
made in 1937
Resin, 87 × 47 × 57 cm (34¼ × 18½ × 23⁷⁄₁₆ in.)
Soprintendenza speciale ai beni archeologici di Napoli
e Pompei, copy of SAP 20626

Despite Fiorelli's insistence that these objects not be considered works of art, they are objects of the highest artifice that have elicited passionate responses from the public from the time of their first unveiling. As Eugene Dwyer has noted, they have been irresistible aids to imagined suffering. The nineteenth-century American consul William Dean Howells, for example, recorded that "the man in the last struggle has thrown himself upon his back, and taken his doom sturdily— there is sublime calm in his rigid face. The women lie upon their faces, their limbs tossed and distorted, their draperies tangled and heaped about them, and in every fibre you know how hard they died" (Dwyer, 55). Howells, like so many viewers,

was clearly fascinated by the recorded moment of death from so many centuries ago, which he reinterpreted in light of contemporary gender mores, notably the victims' masculine stoicism and feminine hysteria.

The casts have also proven remarkably adaptive to changing audiences. Unlike other archaeological wonders that have eventually proven archaic and uninteresting, their appeal has endured. Interpretation of them, not to mention their very fabric, has changed dramatically over time. Figures fall in and out of fashion based on their contemporary appeal, and copies are made that are ever more removed from the original body. Victims continue to be found; in 2000, molds were made of forty-

YOUNG WOMAN WITH GARMENT ROLLED
AROUND HER HIPS FROM REGION VI

Late 20th–/early 21st-century aftercast of a plaster cast made in 1875
Resin, 28.4 × 55 × 157.5 cm (11⅛ × 21⅝ × 62 in.)
Soprintendenza speciale ai beni archeologici di Napoli e Pompei,
copy of SAP 25899

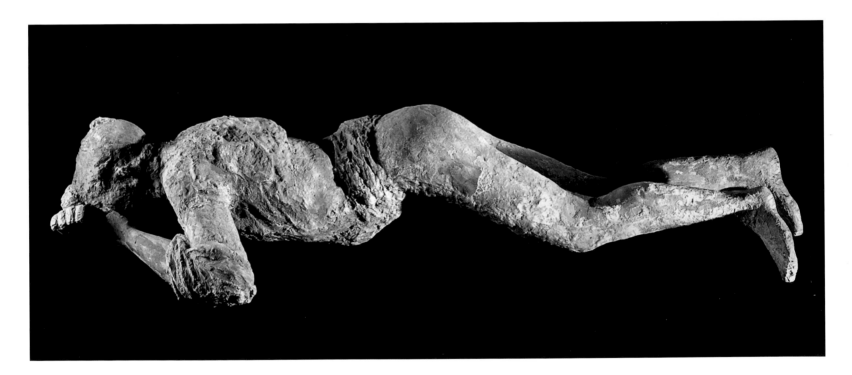

eight voids at Herculaneum. These twenty-first-century casts
were created by the injection of silicone rubber, and advances
in technology promise more incarnations to come. | vcgc

SELECTED BIBLIOGRAPHY

De Carolis, Ernesto, and Giovanni Patricelli, "Le vittime dell'eruzione," in
Guzzo et al. 2003, 56–72.

Dwyer 2010.

Fiorelli, Giuseppe, "Scoverta Pompejana," *Giornale di Napoli*, February 12, 1863.

Lazer 2009.

Stefani 2010.

80

TWO HUDDLED BODIES FROM THE GARDEN
OF THE HOUSE OF THE CRYPTOPORTICUS

2003 aftercast of a plaster cast made in 1916
Resin, 38 × 150 × 123 cm (14^{15}/$_{16}$ × 59^{1}/$_{16}$ × 48^{7}/$_{16}$)
Soprintendenza speciale ai beni archeologici di Napoli e Pompei,
copy of SAP (no accession number)

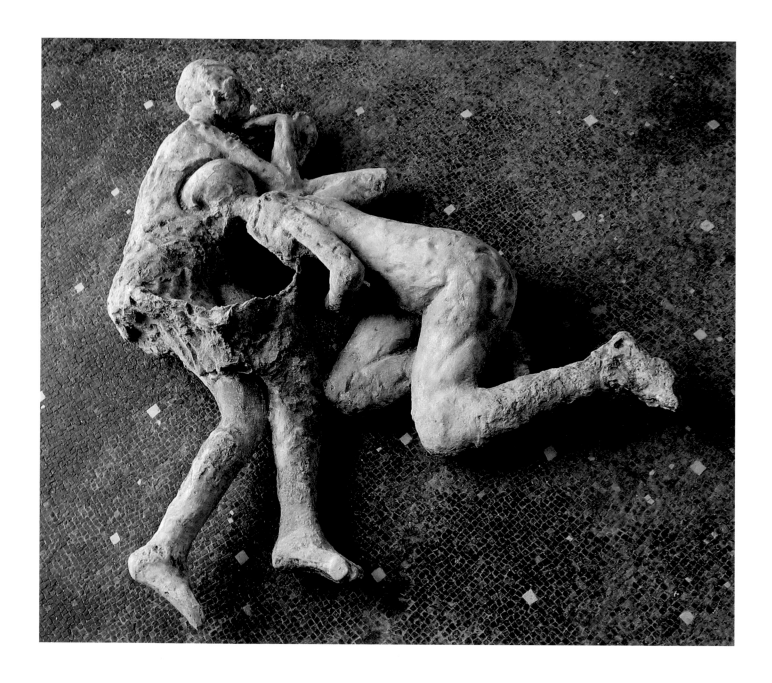

The Photographs of Giorgio Sommer

Sommer was the preeminent photographer working around the Bay of Naples in the nineteenth century. Born in Frankfurt-am-Main, he was given a camera by his father as a young man; when the family fell on hard times, he decided to become a professional photographer. He apprenticed at the firm of Andreas and Sons before starting on his own in 1853, when he was active in Germany and Switzerland.

Sommer emigrated to Italy in 1857, just in time for the political reunification of the peninsula for the first time since the Roman empire. He was in Pompeii on September 25, 1860, when Giuseppe Garibaldi, the leader of the Italian Risorgimento, visited the site, and he was permitted to capture this illustrious visitor and his entourage. In 1865, Victor Emmanuel II named Sommer photographer to the King of Italy.

Sommer was voraciously interested in all aspects of Italian culture, from the spectacular antiquities in the Naples museum and the ongoing excavations at Pompeii to the daily life of peasants in the south. Sommer emphasized the region's history, and his images allow viewers to reflect on both the passage of time and on the events of the present day. While his photographs are often understood as documentary, his corpus has a strong, coherent artistic vision and a remarkably consistent technique (all the more impressive given the large number of photographers in his atelier, notably Edmondo Behles).

Sommer's studio became something of a tourist attraction in its own right. It moved several times during his early years but was eventually established on the central and fashionable Piazza della Vittoria in Naples. His photographs quickly became standard souvenirs of the region. Working in many scales and at many price points, from luxury albums to postcards and stereographs, Sommer had something for every collector, and his photographs were widely distributed to an international clientele.

The artist also enjoyed a close working relationship with Giuseppe Fiorelli, who for many decades was director of excavations at Pompeii and oversaw archaeology in the region. Sommer thus enjoyed privileged access to the site—particularly during off hours, when he could capture any angle without the distracting presence of tourists. He also used the connection to establish a unique sales technique. The services of the on-site guides were ostensibly free with the price of an admission ticket, so they could not be paid by visitors. But they could sell photographs and receive a commission, supplementary income they were happy to receive.

The three images here show the variety and complexity of Sommer's work (along with other examples in this volume; see figs. 13–14, 27–29 and pl. 84.1). The photographs likewise demonstrate Sommer's technical mastery of the silver albumen process; his long exposures on large plates captured an exceptional level of detail. The Temple of Fortune (pl. 81)—seen looking to the east, with the Via della Fortuna in deep perspective—may seem at first the most conventional image, as the composition was often repeated by other photographers in subsequent decades. But Sommer may well have established this view, for while the building had been discovered in 1823, it was only fully excavated in 1859. Figures are comparatively rare in Sommer's Pompeian work and here appear to be "extras," artfully scattered through the composition to give a sense of scale.

The House of the Hanging Balcony (pl. 82) was an even more recent discovery. One of Fiorelli's first major excavations, work began in 1863, the same year he developed the technique to plaster-cast the vanished bodies of Vesuvius's victims. Sommer composed his image, devoid of figures, with a patchwork of light and dark shapes that flattens the space, reducing the legibility of the architecture and the wall painting. A claustrophobic enclosure emphasizes the mystery of this private pleasure garden, underscoring the effects of light over documentation of architectural form. Especially with the application of color, Sommer aligned his work with other recent artistic developments in Italy, particularly the Macchiaioli, the Risorgimento movement associated with the exploration of light and shadow and the presentation of native subject matter.

Sommer made the panorama (pl. 83) near some of the earliest excavations, in the northwest corner of the city. Rather than looking up one of Pompeii's well-known streets toward Vesuvius, the view follows the Vico di Modesto with the small Bar of Fortunata placed at center (compare the painting by Sain, pl. 75). Sommer exploited a vantage that no longer exists, for the photographer stood on the upper story of a house (VII.6.7), excavated first in 1760 and again in 1841, but never restored after it was bombed in 1943 (see pl. 34.3). At first glance the photograph is a straightforward topographical image exploiting the new technique of panoramic photography; this process, emerging in the 1860s, involved multiple, wet-plate glass negatives that would be developed on-site, then printed in the studio for a more broad and comprehensive perspective than had previously been possible.

Giorgio Sommer
Italian, b. Germany, 1834–1914

POMPEII, TEMPLE OF FORTUNE (NO. 1207)

1870s
Albumen silver print, with applied color, 20.2 × 26 cm (7⅞ × 10¼ in.)
Los Angeles, Getty Research Institute, Special Collections, 2003.R.14.2

Giorgio Sommer
Italian, b. Germany, 1834–1914

POMPEII, HOUSE OF THE HANGING BALCONY
(NO. 1256)

1870s
Albumen silver print, with applied color,
25.3 × 20.3 cm (9¹⁵⁄₁₆ × 8 in.)
Los Angeles, Getty Research Institute, Special Collections,
2003.R.14.6

Sommer's photograph is, however, far from a disinterested record of nineteenth-century Pompeii. The photographer instead created an eerily depopulated image of what Scottish novelist Walter Scott called the "City of the Dead," an approach to Pompeii's landscape that also appeared in other media (see pl. 71). The crowds of tourists and workers that thronged to the site are noticeably absent, and the photograph offers an exclusive view that normal visitors to Pompeii would not experience. Sommer blocks off cross streets almost entirely and avoids major monuments (the peristyle of the House of Pansa is in the center right, but it is nearly impossible to identify), thus encour- aging the viewer to focus on the barren, uninhabited nature of this vista. | VCGC KL JLS

SELECTED BIBLIOGRAPHY

Desrochers 2003.

Lyons et al. 2005.

Maffioli, Monica, Silvio Balloni, and Nadia Marchioni, *I Macchiaioli e la foto- grafia*, exh. cat. (Florence, 2008).

Miraglia and Pohlmann 1992.

Weinberg 1981.

Giorgio Sommer
Italian, b. Germany, 1834–1914

POMPEII PANORAMA (NO. 1259)

1870s
Albumen silver print, with applied color, 20.5 × 25.5 cm (8¹/₁₆ × 10¹/₁₆ in.)
Los Angeles, Getty Research Institute, Special Collections, 2003.R.14.7

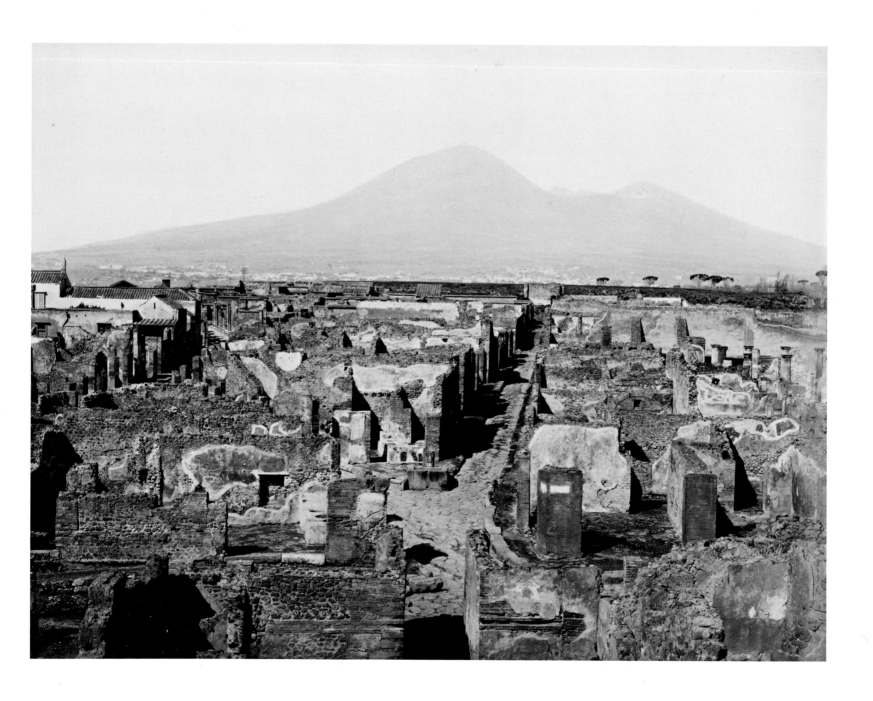

Auguste Louis Lepère
French, 1849–1918

**with Tony Beltrand (French, 1847–1904), Eugène Dété (French, b. 1848),
and Frédéric Florian (Swiss, 1858–1926), after a design by M. G. Giusti**

ITALY. THE FESTIVAL OF POMPEII, THE CIRCUS OF GLADIATORS

1884
Wood engraving, 32.2 × 46.7 cm (12⅝ × 18⅜ in.)
The Cleveland Museum of Art, Gift of John Bonebrake, 2007.258.

On a late afternoon, with Vesuvius smoking in the background, a band of gladiators battle before a cheering audience in the Amphitheater at Pompeii. In the nearly full venue, ancient Roman soldiers and men in togas mingle with men and women in late-nineteenth-century dress, many protecting themselves from the blazing sun with parasols. Most prominently, two women in bustles applaud boisterously, egging on the fighters. To maximize the battle's energy, Lepère distorts the perspective, presenting the athletes at a larger scale and in greater detail than many of the spectators.

Lepère created this print for reproduction, after a sketch by M. G. Giusti, in the Parisian periodical *Le monde illustré* for May 24, 1884. Accompanied on the following page by a more straightforward re-creation of an ancient chariot race, this print records an actual event at Pompeii. In May 1884, as a fund-raiser for relief efforts after a recent earthquake, three days of re-creations

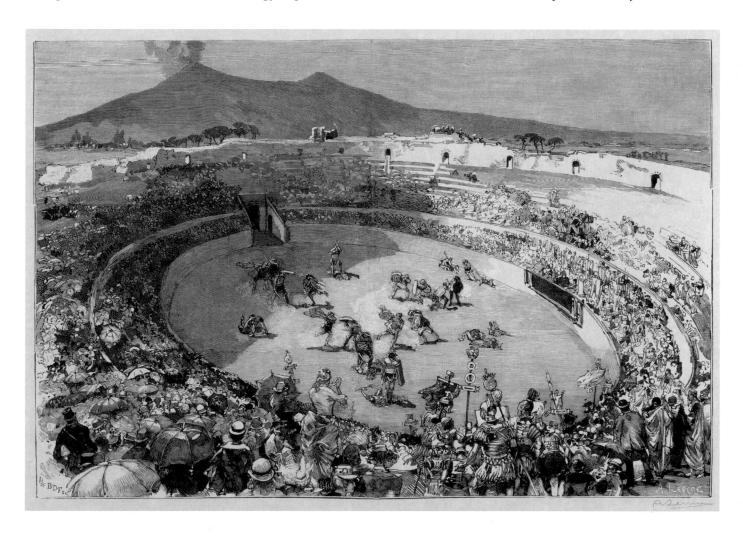

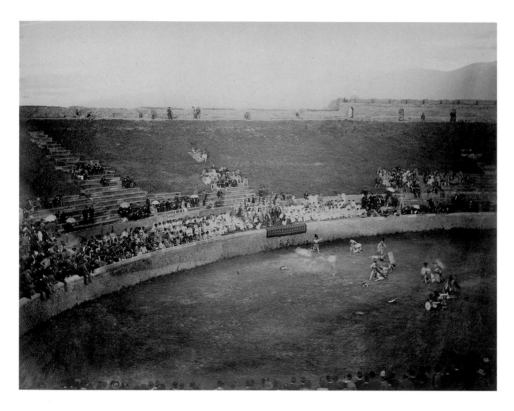

84.1. Giorgio Sommer (Italian, b. Germany, 1834–1914), *Gladiator Battle in the Amphitheater at Pompeii*, 1884. Albumen silver print. Florence, Alinari.

of ancient life in Pompeii took place and were enthusiastically reported in the British, American, and French press.

The mix of ancient and contemporary figures in an intact site (certainly more intact than the Amphitheater actually was in 1884) speaks to the blending of imagined and archaeological realities that was common in nineteenth-century depictions of Pompeii. However, a photograph, presumably from this same event (pl. 84.1), demonstrates how few people actually attended. Organized by Giulio de Petra, the head of excavations, and acted out by local performers, the events incurred serious debt and were never again re-created at that scale. As Mary Beard has noted, Pompeii had long oscillated between being understood as the city of the dead and a living, open-air museum. The games connect to de Petra's overall vision for Pompeii: he heavily reconstructed buildings, left finds in place, and presented the site in a less ruinous state. Yet, reinserting living figures seems to have pushed the city of the dead too much into the background for late-nineteenth-century visitors. In a place well known for the plaster casts of the volcano's victims that littered the site, revivifying dead Pompeiians on-site evidently had little appeal, in contrast to representations such as Lepère's print, which would have been enjoyed far away from the buried cities. | JLS

SELECTED BIBLIOGRAPHY

Beard in Mattusch 2012.

Lotz-Brissonneau, Alphonse, *Catalogue raisonné de l'œuvre gravé d'Auguste Lepère, 1849–1918,* with text by A. Lotz-Brissonneau, G. M. Texier-Bernier, and J. Lethève (Dijon and Paris, 2002), 281.

Pain's Pyrodramas

The history of mass entertainment based on Pompeii begins in earnest with the fireworks shows at Vauxhall Gardens and the panoramas at Covent Garden in London during the 1820s. Theatrical productions and operas on both sides of the Atlantic inspired by Edward Bulwer-Lytton's 1834 novel *The Last Days of Pompeii* followed, as did many exhibitions about Pompeii (for which see Kenneth Lapatin's essay in this volume). However, prior to the advent of film, the spectacular pyrotechnic shows staged by the British fireworks entrepreneur James Pain beginning in the 1870s probably brought the largest number of people—across a wide range of social classes—in contact with the phenomenon of Pompeii.

Pain's pyrodramas—large-scale dramatic events that culminated in staged conflagrations—began in London, where the show entitled *The Last Days of Pompeii* proved especially popular. Although Pain's firm worked in the United States from 1879 (and Australia from 1886), his initial Pompeian production in America took place on Coney Island in 1885. It was aimed at working-class and immigrant audiences as well as more traditional theatergoers.

Pain's basic plotline came from Bulwer-Lytton, although the *New York Times* review of June 11, 1885, makes only passing reference to characters, focusing instead on the spectacle, describing barges, processions, games, races, acrobatics, dancing, and combat, and—most significantly—the earthquake and eruption that dominated the production. As Nick Yablon has noted, Pain's disaster extravaganza thus differed completely from the character-driven plays—which maintained (or even intensified) the novel's political, religions, and class-conscious elements. Viewed across a body of water, understood as the Bay of Naples, the actors pantomimed, a technique well suited to audiences not conversant with theater conventions (or even the English language). Each staging could vary depending on available talent, but all performances strung together athletic, musical, and dance elements over a simple Pompeian narrative, assumed to be familiar in broad strokes to all audiences.

The program was staged regularly on Coney Island for over three decades, shutting for good in 1914. In the 1880s Pain began marketing the program across America, and it was held in at least thirty-seven locations, including New Orleans (1885), Louisville (1886), Boston (1888), Pittsburgh (1889, 1891, and 1904), Washington, D.C. (1890 and 1904), Minneapolis (1890, 1901, and 1906), Fort Worth (1891), Nashville, (1891), Buffalo (1891), Cincinnati (1891), Chicago (1892), Cleveland (1892), Denver (1892), Milwaukee (1892), Lincoln, Nebraska (1892), Peoria (1892), Omaha (1894 and 1896), Indianapolis (1895), Detroit (1896), Paducah, Kentucky (1902), St. Louis (1902 and 1911), Wichita (1902), Canton, Ohio (1903), Oklahoma City (1903), Portland, Oregon (1903), Richmond, Virginia (1904 and 1911), San Antonio (1904), Los Angeles (1905), Salt Lake City (1905), Seattle (1905), Spokane (1905), Lewiston, Maine (1907), St. Joseph, Missouri (1911), Cape Girardeau, Missouri (1911), Little Rock (1912), Hastings, Nebraska (1912), and Syracuse, New York (1913). A reduced version of the show eventually settled into the state fair circuit.

Newspapers accounts in Cleveland and Fort Worth reveal Pain's business model. The firm required large down payments to bring the spectacle to a city, usually for a one- to two-week run. Investors were required to create a multiacre, custom-built venue, with a large body of water, a long stage, and seating for around ten thousand. Efficient public transportation was critical. Since the actors were secondary, local performers trained by Pain's staff played most roles, and they were rarely named.

B. J. Falk's large photograph (pl. 85) depicts an early part of the performance connected to the arrival of the villain Arbaces and was probably made in connection with the refreshment and expansion of the Coney Island program in 1903. Falk's panorama reveals the scale and the collapsible sets (touring productions depended more heavily on painted backdrops). In its deep perspective, the photograph reveals the diminished importance of individuals. The highly didactic booklet from the Cincinnati spectacle (pl. 86) accentuates the emphasis on music, dancing, and gladiator battles with its miniscule representation of the performers.

By the late nineteenth century, the eruption of Vesuvius had become a metaphor for a larger social disorder that was connected to the urban dislocations of modern industrial capitalism. By placing its audiences in an "amphitheater," beholding a large-scale spectacle, Pain deliberately invoked the excess of Pompeii and, given the consistent concerns in the press about maintaining order and moving large crowds, articulated the emphasis on taming its potentially explosive working-class audiences through spectacular entertainment. | JLS

SELECTED BIBLIOGRAPHY

"Another Use for a Baseball Park: Fireworks at Athletic Park": http://oldmilwaukee.net/forum/viewtopic.php?f=5&t=240 (last accessed March 11, 2012).

Cleveland Plain Dealer, July 6, 1889, and July 6, 16, and 29, 1892.

Jones, Jan L., *Renegades and Showmen: A Theatrical History of Fort Worth from 1873–2001* (Fort Worth, 2006).

Yablon 2007.

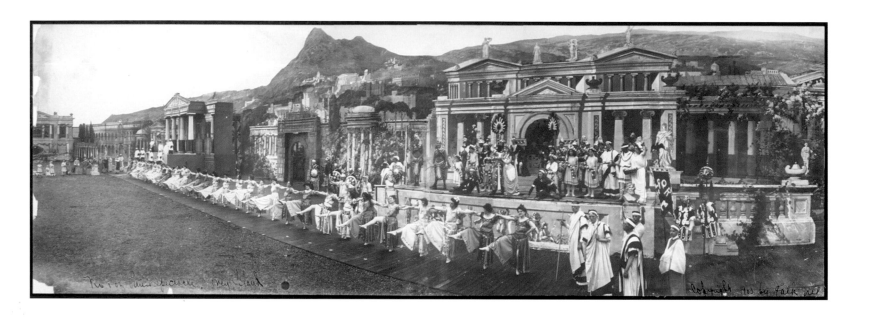

85

B. J. Falk
American, 1853–1925

NO. 1 OF PAIN'S SPECTACLE, CONEY ISLAND

1903
Silver printing-out paper, 24.1 × 71.1 cm (9½ × 28 in.)
Washington, D.C., Library of Congress, Prints and Photographs Division, LC-USZ62-114523

86

H. B. Thearle & Company

BOOKLET FOR PAIN'S *LAST DAYS OF POMPEII*

1891
Chromotypography, 24 × 18 cm (9½ × 7⅛ in.)
Los Angeles, Getty Research Institute, 2850-629

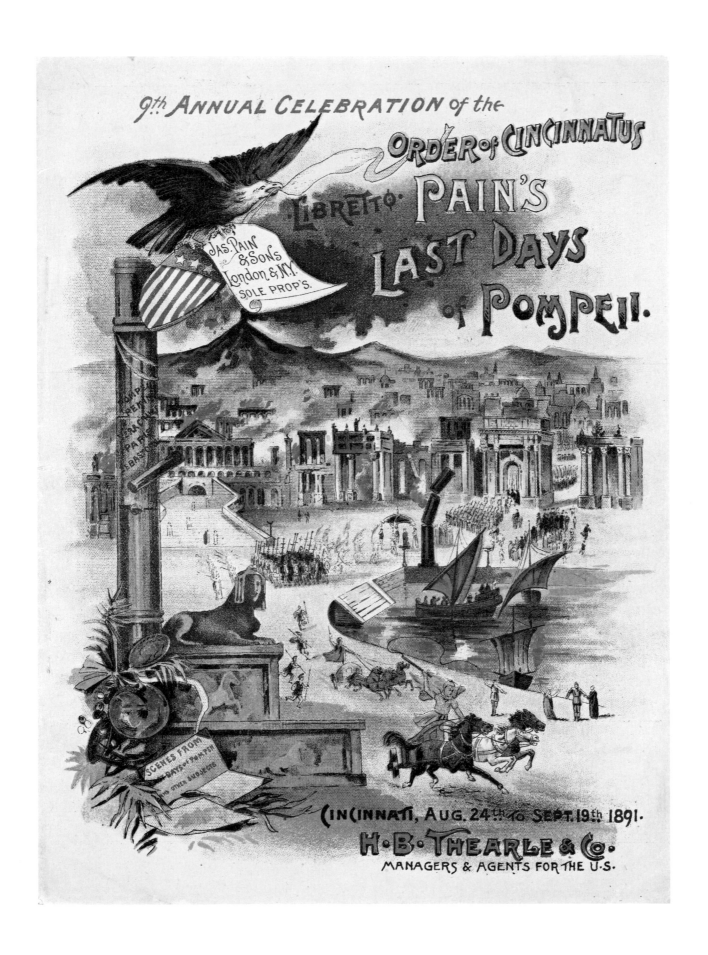

Enzo Cucchi
Italian, b. 1949

VESUVIUS SEEN, VESUVIUS LOVED

1996
Fresco, 45 × 60.3 cm (17¾ × 23¾ in.)
New York, Tony Shafrazi Gallery

Enzo Cucchi, born in the province of Ancona in central Italy, painted a bizarre, dreamlike landscape where a ship with skulls cascading in its wake sails underneath the blank stare of an enormous red eye hovering in the smoke of Vesuvius. Such a cryptic amalgamation of signs, drawing on primordial themes of journey, mortality, and myth, is typical of the neo-expressionist Transavanguardia movement with which Cucchi was associated from the late 1970s through the mid-1980s. Critic Achille Bonito Oliva describes the Transavanguardia as "taking a nomad position which respects no definitive engagement, which has no privileged ethic beyond that of obeying the dictates of a mental and material temperature synchronous to the instantaneity of the work" (Oliva, 19). This "cultural nomadism" is linked to the rise of postmodernism and the belief advanced by theorists that there is no interpretive rubric from which meaning can be derived.

Vesuvio visto, Vesuvio amato is part of a series of enigmatic frescoes and drawings entitled *Simm'nervusi* ("we are nervous" in Neapolitan dialect). By returning to the Pompeian medium of fresco, Cucchi pays tribute to ancient artistic precedents. Scrawled across Naples in the early 1980s, the slogan *simm' nervusi* was considered, with other political graffiti, to be an expression of the angst and anger citizens felt, particularly after the 1980 Irpinia earthquake that killed nearly 3,000 people and left 250,000 in the region homeless (Andy Warhol also turned to Vesuvius in response to this event, see pls. 50–53). The drawn-out rebuilding process was riddled with corruption, causing many Italians to lose faith in their government. Given the magnitude of this natural disaster and its proximity to Naples and Pompeii, parallels were drawn between this event and the eruption of Vesuvius in A.D. 79.

Yet the volcano, as depicted here and throughout Cucchi's work, is not simply a symbol of disaster and destruction. Vesuvius, both seen and seeing, is an integral aspect of the artist's native landscape and here a kind of guardian of the people. Skulls resurface throughout Cucchi's work, not as morbid symbols of death, but as talismans of good luck as they are understood in southern Italy. Because this series was realized in the mid-1990s, the title *Simm'nervusi* seems to express an apprehension regarding the future as well as a longing for a distant past. | LZ

SELECTED BIBLIOGRAPHY

Giannelli, Ida, *Transavanguardia* (Milan, 2002).

Marenzi, Luca, Dieter Meier, and Carter Ratlin, *Enzo Cucchi: Simm'nervusi*, exh. cat. (New York: Tony Shafrazi Gallery, 1997).

Oliva, Achille Bonito, "The Italian Trans-avantgarde," *Flash Art* 92–93 (Oct.–Nov. 1979): 17–20.

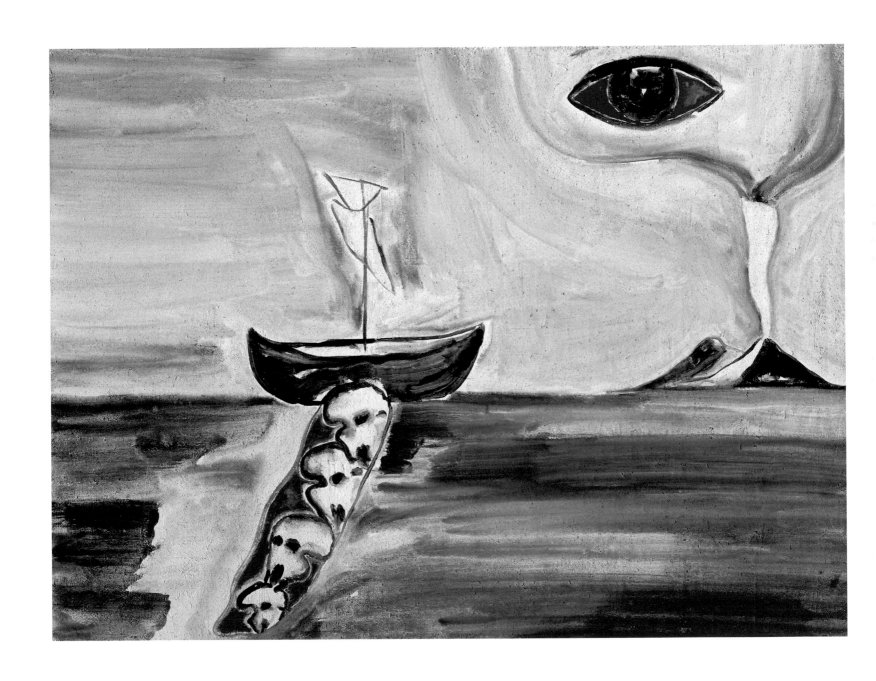

88

Allan McCollum
American, b. 1944

THE DOG FROM POMPEI

1991
Cast-fiber-reinforced Hydrocal, each 53.3 × 53.3 × 53.3 cm (21 × 21 × 21 in.)
as presented in one possible combination, September 9–October 23, 2010
New York, Friedrich Petzel Gallery

Allan McCollum is known for his work in series that addresses notions of originality and the ideological implications of mass production that affect the way we engage with art. Central to his practice is the idea that the "aura" of the original work of art is lost or diminished in copies or reproductions. The artist explained:

> I think that part of the challenge we face in living with the copies we make ourselves is that we experience them as alienating because they always seem to represent something else, they're never the thing itself. So to the degree to which we're enmeshed in relationships with our own copies in the world, we are constantly in a state of banishment from the imaginary 'source' of things—from the original things that these copies seem to replicate (Bartman and Lawson, 3).

Beginning in the early 1990s, McCollum was inspired by archaeology and the idea of a copy not created by a machine but preserved in some way by nature. McCollum realized three series—*The Dog from Pompei, Lost Objects* (casts of dinosaur bones), and *Natural Copies* (casts of dinosaur tracks)—that diverge from his prior work in being less immediately concerned with the status of the art object.

Although the dog of Pompeii (see fig. 14) was a guard dog, like the ferocious canine depicted in the mosaic in the vestibule of the House of the Tragic Poet that is labeled *cave canem* (beware of the dog), McCollum's dog is in a vulnerable position on its back, writhing in pain. The dramatic cast of the dog was not the artist's first, nor even his second, choice when he looked to the ancient site for inspiration. McCollum initially sought to cast a loaf of bread from Pompeii because it was a quotidian object that lacked any emotional charge: "I wanted to use an object that had utterly no significance, that was mundane, that was domestic and ephemeral, that was only accidentally preserved, and that was unsettling exactly because it was so common. Because to look at the ghost of a common, everyday object that's nineteen hundred years old is unsettling" (Bartman and Lawson, 14). However, to the artist's dismay the loaf was deemed too fragile, so he had to find another object for the series. His second choice was a chest of drawers preserved by the ash, but he was denied permission to make a mold of this as well. According to McCollum, "It looked very much more like an art object of a more abstract type…It would have had a whole different slew of references" (ibid., 13).

McCollum ended up using a second-generation cast of the famous dog from the House of Vesonius Primus (VI.14.20), first cast in 1874, despite his concerns that the emotional charge of the canine's contorted form would overwhelm the viewer and distract from his fundamental goal for this series: to create an environment that would make the viewer reflect on how people utilize artifacts to engage with history. McCollum was interested in the way artifacts could, "represent this enormous, monumentally sad absence of a whole world we'll never retrieve again" (ibid., 12). The repetitive process used to create each dog only served to amplify this sadness. "Making copies from a mold feels like constantly trying to *bring something back* that used to be there but isn't anymore. You take a cavity that's made of rubber and you fill it with plaster and you pop it out and it looks just like the original, but it isn't quite. So you do it again and again and again" (ibid.). In this work McCollum draws on the Freudian notion of the death drive, this innate impulse to reenact a traumatic experience over and over again to no avail. The sense of mourning and melancholy is thus articulated not just through the image of the dog itself. Reflection on the process of its creation, the hollow absent presence of the cast, repeated ad infinitum, creates an uncanny environment and a powerful narrative of loss and disappearance. | LZ

SELECTED BIBLIOGRAPHY

Allan McCollum: Natural Copies, exh. cat. (Hannover, Sprengel Museum, 1996).

Bartmann, William S., and Thomas Lawson, *Allan McCollum* (Los Angeles, 1996).

Benjamin, Walter, *The Work of Art in the Age of its Technological Reproducibility and Other Writings on Media* (Cambridge, Mass., 2008).

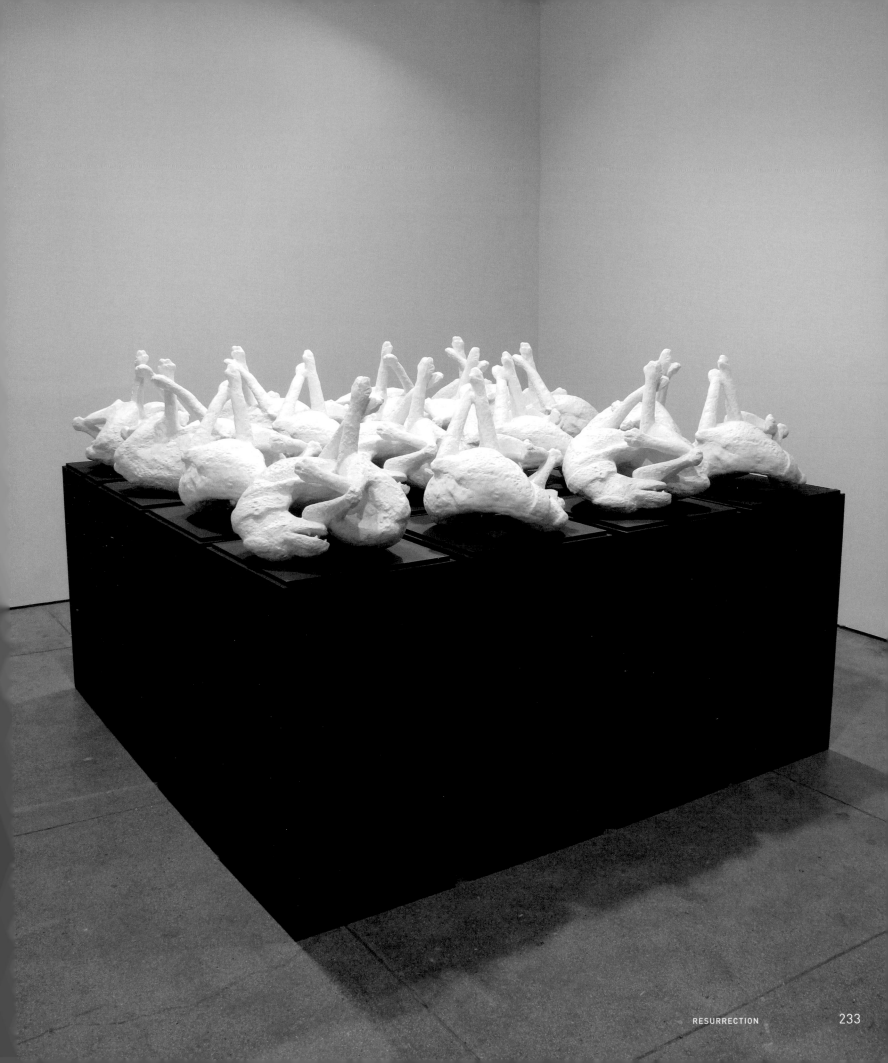

89

Antony Gormley
British, b. 1950

UNTITLED

2002
Mild steel blocks, each: 25 × 25 × 50 mm (1 × 1 × 1¹⁵/₁₆ in.); overall: 45 × 189 × 53 cm (17¹¹/₁₆ × 74⁷/₁₆ × 20⁷/₈ in.)
Collection of Asher Waldfogel and Helyn MacLean (courtesy White Cube)

Gormley uses the human form, based on the proportions of his own body, and examines the relationships of those forms to their surrounding space. Many works are site specific, such as the monumental Corten steel *Angel of the North* (Gateshead, U.K.), completed in 1998, and *One & Other* of 2009, where 2,400 people, chosen by lot, each spent one hour on the empty plinth in Trafalgar Square, London. The sculpture presented here, by contrast, can be displayed in different locations. By welding together blocks of an easily worked, sturdy, industrial steel, the sculpture is at once dematerialized and enormously weighty. *Untitled* lies directly on the floor, demanding that the viewer look down on the figure.

In February 2010, Gormley offered the following statement about this work and two others, *GUT IV* (private collection) and *SPLEEN I* (private collection), executed at the same time in 2002:

> The pyroclastic cloud that covered Pompeii in ash burned all the oxygen in the atmosphere and vaporised the bodies of the inhabitants in poses of fall-out is relevant for my work. The "lost body"—as the most extreme form of translation from life to something close to art—is a radical replacement for the lost wax process and is more direct, more shocking, more about human fragility and our desire for survival. They are shadows that have been made solid, holes that have been filled. I started my work making moulds which were left empty or filled with a darkness which I associated with our experience of body's

darkness. The plaster forms cast from these Pompeian holes are very much masses that materialise a human space in space—a spatial displacement rather than a figural representation. The bodies each lie or crouch in their unique position of facing death but they do not have the morbidity of the mummy, more a direct existential appeal reminding us that life can end at any time whether during a trip to the shops or while sleeping. They are a form of future shock; a premonition of some cataclysmic end whether through lack of air or a nuclear winter. The abstracted bodies of Pompeii A.D. 79 models the end of the human project and gives us a foretaste of our own demise, in the manner of the dinosaur skeleton, but much more immediate. I made three pieces, inspired by a visit in 2002, all of which try to think about a lack of air, fall-out, and the end of time.

| JLS

SELECTED BIBLIOGRAPHY

Mack, Michael, ed., essay by Richard Noble, introduction and chapter texts by Antony Gormley, *Antony Gormley* (Göttingen, 2007).

www.antonygormley.com (last accessed May 6, 2012)

Personal communication (e-mail from Shela Sheikh, February 26, 2010).

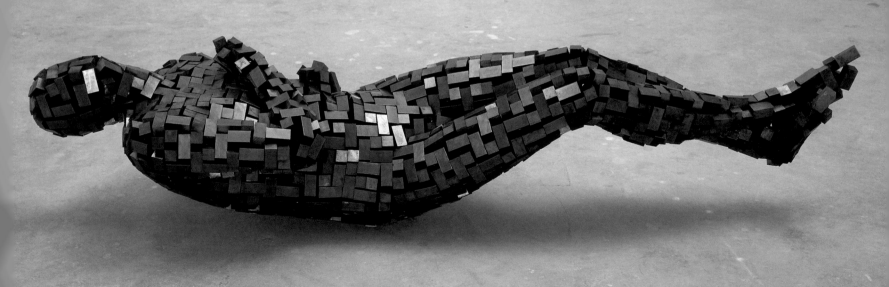

Tacita Dean
British, b. 1965

THE RUSSIAN ENDING

2001
20 photogravures on paper, 54 × 79.4 cm (21¼ × 31¼ in.)
New York, Marian Goodman Gallery

Tacita Dean gained recognition in the 1990s mainly for her elegiac films shot in 16mm. Her work often explores lost or forgotten histories and blurs the boundary between fact and fiction. For *The Russian Ending,* Dean utilized postcards found at flea markets across Europe as source material. The postcards, featuring tragic images of funerals, accidents, wars, and natural disasters, date to around the time of World War I when "disaster tourism" was a growing phenomenon.

The title derives from a practice in the early days of the Danish film industry in which two endings were created for the same film: a pleasant ending for the American market and a sad ending for the Russian audience. Dean overlays each mournful image with handwritten film directions. Thus each print is transformed into an excerpt from a storyboard for an imagined film's Russian ending. The notations describe both sources of inspiration and cinematographic effects such as the sounds, lighting, and camera movements and angles that Dean envisioned for the final tragic moments of these twenty films. The notes only vaguely sketch out the elements of the scene, allow-

ing the viewer to fill in the details. The photogravures are displayed in a gridded format, so the viewer is inclined to read the works as a continuum of one inevitable tragedy after the next.

Among these images is a scene of Vesuvius in eruption, which Dean has subtitled *The (Italian) Russian Ending* (pl. 90.1). She envisions this fictive film to be "based on a contemporary transcription of the story of Pompeii…set in 1906," which was the date of a major modern eruption of the volcano. Other commentary on the image describing the volcano, "she erupts, of course" and "she continues to rumble into the future," emphasizes the role Vesuvius has in the modern imagination as an icon of death and destruction. | LZ

SELECTED BIBLIOGRAPHY

Dietrich, Dorothea, "The Space In Between: Tacita Dean's *Russian Ending,*" *Art on Paper* 6, no. 5 (May–June 2002): 48–53.

Wallis, Claire, et al., *Tacita Dean,* exh. cat. (London, Tate Britain, 2001).

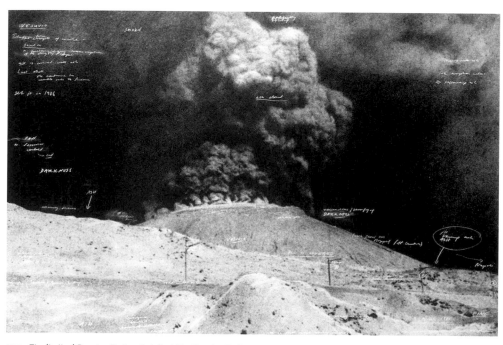

90.1. *The (Italian) Russian Ending.* Detail of *The Russian Ending.*

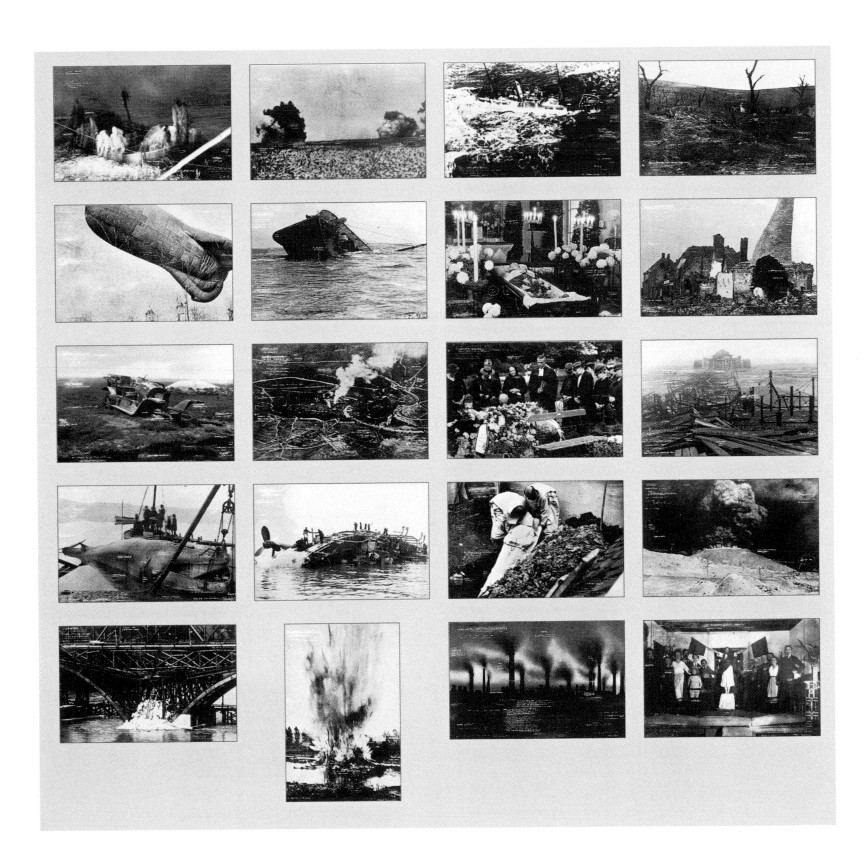

Michael Huey
American, active Austria, b. 1964

POMPEII

2008
C-print, Diasec-mounted on aluminum, edition of 5 (+2), 205 × 180 cm (80¾ × 70⅞ in.)
Courtesy Newman Popiashvili Gallery and the artist

Michael Huey has focused on the layering of meaning in photography. He often works with preexisting images, carefully selecting and examining his source material. In a process he describes as "archival," Huey seeks out images and objects—often insignificant—and, following a period of intense observation, re-presents them, in the process revealing something in the original work that is not normally visible.

In 2009, Huey published *Pompeii* with a timeline outlining the stages involved in its creation, from the initial wall painting in Pompeii to the present work of art.

1. "Original" Fourth Style mural painted in a Pompeian villa, ca. A.D. 64
2. Villa buried under ash and debris about fifteen years later
3. Pompeii rediscovered in mid-eighteenth-century: excavated through mid-nineteenth
4. Mural re-drawn from surviving fragments and completed, likely as a pattern
5. Mural reconstruction photographed by Giorgio Sommer around 1870
6. Photograph colorized by Sommer or a contemporary studio assistant
7. Colorized photograph included in a souvenir album on Pompeii
8. Chemical and physical deterioration of image over the following 135 years
9. Album image re-photographed with Sinar p2 negative format mechanical camera
10. Analog production of *Pompeii* in wall-sized format, with Diasec surface

The enormous scale and saturated palette both suggest the use of digital photography, but Huey created the work with analog processes. His confounding technique, as well as his multivalent use and reuse of source materials obscures questions of authorship, even implying a collaboration with the makers, known and unknown, of the source works. In this way, Huey questions the ability of photography to convey meaning, while opening up "glimpses toward something ambiguous and not entirely knowable" (Huey, 35).

Pompeii stems in part from an album by Giorgio Sommer, the most prominent nineteenth-century topographical and documentary photographer of the buried cities, an artist who himself reflected deeply on disaster and remembrance (see pls. 81–82, fig. 13). The Sommer photo adapted by Huey depicts a painting of Hercules with a woman and child from the House of Queen Caroline (VIII.3.14). While this fresco was excavated in the early nineteenth century, it was lost in only a few decades, owing both to its exposure to the elements and a destructive practice used by nineteenth-century guides in which wall paintings were dampened to saturate their colors, inevitably leading to abrasion. The original image, as well as Huey's layered processes, draws attention to the idea of loss through the vulnerability and precariousness of photography. As Huey himself stated: "The idea of 'Pompeii' bound the seemingly disparate items together as a metaphor for things cataclysmically lost, long buried, later rediscovered, excavated, and put to new uses. As it happens, this also describes the individual trajectories of most of my works." | JLS

SELECTED BIBLIOGRAPHY

Huey 2009.

Ward 2010.

www.michaelhuey.com (last accessed March 21, 2012).

Lucy McKenzie
Scottish, b. 1977

CHEYNEY AND EILEEN DISTURB A HISTORIAN AT POMPEII

2005
Acrylic and ink on paper, 254 × 368.3 × 12.7 cm (100 × 145 × 5 in.)
Los Angeles, The Museum of Contemporary Art,
Purchased with funds provided by the Drawing Committee, 2006.7

McKenzie's multivalent work layers historical influence, personal experience, and visual modes of communication. The scene depicts an anecdote involving her friends—artists Cheyney Thompson and Eileen Quinlan—who sneaked into a closed section of the Villa of the Mysteries at Pompeii and startled a historian who was studying the wall paintings. Unlike other artists who have been inspired by the decadence, melancholy, and disaster of Pompeii, McKenzie presents a humorous, lighthearted occurrence framed by the ancient frescoes. Although *Cheyney and Eileen Disturb a Historian at Pompeii* may first appear to be nothing more than the comical portrayal of an unexpected encounter, the young artist's affinity for appropriation and bricolage suggests there are more complex issues at stake that are concerned with the study of public art.

Painted in the style of Hergé's beloved cartoon character Tintin (including the punctuation above the figures' heads), the spirit of McKenzie's narrative recalls Tintin's adventurous exploits in foreign lands. While studying decorative painting at the École de Peinture Van Der Kelen in Brussels, McKenzie encountered many murals of Tintin throughout the city. The graphic novel—which she found to be revered in Belgium as "a serious art form"—relates to historical attitudes, ways of seeing, and a language specific to a region despite its international recognition (Graw, 130). McKenzie describes Tintin as "symbolic of a graphic style specific to Benelux and therefore a simplified 'mini-Europe'" (ibid.). In addition to Hergé's agreeable protagonist, "the gold mine" of erotic comic books and the erotic content of the Villa of the Mysteries murals also seem to have intrigued the young artist (ibid.).

While her œuvre spans a variety of media, including painting, drawing, fashion design, and installations, murals are a recurrent interest, especially the ideological motivations embedded in public art. McKenzie has remarked on how murals attempt to "encapsulate the problems of the world in a waving child or a dove" (Darling, 57–58). In addition to images that are culturally coded or universally shared, she examines how such signs gain meaning and recognizes "the importance of rumor and anecdote in the creation of cultural history" (Graw, 130). *Cheyney and Eileen Disturb a Historian at Pompeii,* which resembles in size a public mural, poses a tension between a personal, trivial episode and the massive scale at which it is depicted.

McKenzie's broader interest in murals stems from her native Scotland, where a muralist art campaign occurred in the late sixties after the destruction of Victorian tenement architecture in Glasgow. Murals were used to "brighten up the scars left by the new concrete megastructures" that replaced the historic architecture (Mulholland, 109). The project was controversial because many felt that the murals signified the undesirability of their neighborhood and constituted an artificial way to cover up a deeper wound. | LZ

SELECTED BIBLIOGRAPHY

Darling, Michael, and Friedrich W. Heubach, *Painting in Tongues*, exh. cat. (Los Angeles, Museum of Contemporary Art, 2006).

Graw, Isabella, "On the Road to Retreat: An Interview with Lucy McKenzie," *Parkett* 76 (2006): 130–37.

Mulholland, Neil, "Dreams of a Provincial Girl," *Parkett* 76 (2006): 106–11.

Ruf, Beatrix, "Lucy McKenzie," *Cream* 3. London, 2003.

Appendix: Pompeii Exhibitions

Exhibitions focusing on or prominently featuring material from Pompeii and other Vesuvian sites or their modern reception.
Compiled by Kenneth Lapatin, Niki Stellings-Hertzberg, and Antero Tammisto.

Pompei no Iseki exhibition at the Osaka Fine Arts Museum, 1950.

Year	Title	City	Venue	Catalogue
1749	Il Teatro di Ercolano	Rome	Chinea Festival, Piazza Farnese	
1755	Ponte trionfale	Rome	Chinea Festival, Piazza Farnese	
1843–	Pompejanum	Aschaffenburg	Pompejanum	
1845–	Destruction of Pompeii and Herculaneum by Hermann Schievelbein	Berlin	Neues Museum, Greek Court	
1846–1926	Pompeian Pavilion	London	Buckingham Palace	Gouner, L. *Decorations of the Garden-Pavilion in the Grounds of Buckingham Palace*. London, 1846.
1856–1936	Pompeian Court	London	Crystal Palace	Scharf, G., et al. *The Pompeian Court in the Crystal Palace*. London, 1854.
1856–91	Maison Pompéienne	Paris	18 Avenue Montaigne	
1900	Padiglione pompeiano	Naples	Esposizione nazionale d'Igiene	*Guida di Napoli e della Esposizione d'Igiene*. Naples, 1900.
1926	Villa dei Misteri di Maria Barosso	Rome	Borghese Gallery at the Villa of Umberto I	
1937	Mostra d'arte Pompeiana	Pompeii	unknown	Ascione, N. *Mostra d'arte Pompeiana*. Pompeii, 1937.
1937	Mostra augustea della Romanità	Rome	Palazzo delle Esposizioni	Giglioli, G. Q., et al. *Mostra augustea della Romanità: Catalogo*. Rome, 1937.
1948	Pompeiana	Northhampton, MA	Smith College Museum of Art	Schenck, E. C., et al. *Pompeiana*. Northhampton, Mass., 1948.
1950–1	Pompei no Iseki	Osaka	Osaka Fine Arts Museum	Tsunoda, B. *Pompei no Iseki*. Osaka, 1951.
1958	Pompei ed Ercolano: Attraverso le stampe e gli acquerelli del '700 e '800	Naples	Museo Archeologico Nazionale di Napoli	Maiuri, A., et al. *Pompei ed Ercolano: Attraverso le stampe e gli acquerelli del '700 e '800*. Naples, 1958.
1967	Ponpei Kodai Bijutsuten	Tokyo	Museum of Western Art	Bijutsukan, K. S., O. S. Bijutsukan and F. B. Kaikan. *Ponpei Kodai Bijutsuten*. Tokyo, 1967. Italian title: *Pompei: Mostra d'arte pompeiana*
→ 1967	Ponpei Kodai Bijutsuten	Osaka	City Museum	same as in Tokyo
→ 1967	Ponpei Kodai Bijutsuten	Fukuoka	Prefectural Culture Center	same as in Tokyo
1973	Pompéi	Paris	Petit Palais	Vallet, G., et al. *Pompéi*. Paris, 1973.
→ 1973	Pompeji: Leben und Kunst in den Vesuvstädten	Essen	Villa Hügel	Andreae, B., et al. *Pompeji: Leben und Kunst in den Vesuvstädten*. Recklinghausen, 1973.
→ 1973–4	Pompeji: Leben und Kunst in den Vesuvstädten	The Hague	Haags Gemeentemuseum	Wijsensbeek, L. J. F., et al. *Pompeii*. The Hague, 1973.
→ 1974	Pompeji: Leben und Kunst in den Vesuvstädten	Zurich	Kunsthaus	Wehrli, R., et al. Pompeji: *Leben und Kunst in den Vesuvstädten*. Zurich, 1974.
→ 1974	Pompeia: Vita arte nas cidades do Vesuvio	Lisbon	Fundacao Calouste Gulbenkian	*Pompeia: Vita arte nas cidades do Vesuvio*. Lisbon, 1974.

Year	Title	City	Venue	Catalogue
1974–	The Villa dei Papiri	Los Angeles	The J. Paul Getty Museum	Neuerburg, N. *Herculaneum to Malibu: A Companion to the J. Paul Getty Museum Building: A Descriptive and Explanatory Guide to the Re-created Ancient Roman Villa of the Papyri*, 1974
1976	Dai Ponpei ten: eiko no kiseki	Tokyo	Nihonbashi Mitsukoshi Gallery	*Dai Ponpei ten: eiko no kiseki*. Tokyo, 1976. Italian title: *Pompeii: La vita quotidiana nell'antichità Romana*
→ 1976	Dai Ponpei ten: eiko no kiseki	Osaka	Kitahama	same as in Tokyo
→ 1976	Dai Ponpei ten: eiko no kiseki	Sapporo	unknown	same as in Tokyo
1976-7	Pompeii A.D. 79	London	Royal Academy	Ward-Perkins, J., and A. Claridge. *Pompeii A.D. 79*. London, 1976.
→ 1977-8	Pompeji aar 79	Humlebæk (Denmark)	Louisiana Museum of Modern Art	Oestergaard, J. S., ed. *Pompeji aar 79. Louisiana 10. September 1977–1 Januar 1978*. Humlebæk, 1977.
→ 1978-9	Pompeii A.D. 79	Boston	Museum of Fine Arts	Ward-Perkins, J., and A. Claridge. *Pompeii A.D. 79*. Boston, 1978.
→ 1978-9	Pompeii A.D. 79	Chicago	Art Institute of Chicago	same as in Boston
→ 1978-9	Pompeii A.D. 79	Dallas	Museum of Fine Arts	same as in Boston
→ 1978-9	Pompeii A.D. 79	New York	American Museum of Natural History	same as in Boston
→ 1980-81	Pompeii A.D. 79	Melbourne	National Gallery of Victoria	Ward-Perkins, J., and A. Claridge. *Pompeii A.D. 79: Treasures from the National Archaeological Museum, Naples and the Pompeii Antiquarium, Italy*. Sydney, 1981.
→ 1981	Pompeii A.D. 79	Adelaide	Art Gallery of South Australia	same as in Melbourne
→ 1981	Pompeii A.D. 79	Sydney	Art Gallery of New South Wales	same as in Melbourne
→ 1981-2	El Arte de Pompeya	Mexico City	Museo de San Carlos	*El Arte de Pompeya*. Mexico City, 1981.
1977	Pompeii as Source and Inspiration: Reflections in Eighteenth- and Nineteenth-Century Art	Ann Arbor	University of Michigan Museum of Art	*Pompeii as Source and Inspiration: Reflections in Eighteenth- and Nineteenth-Century Art*. Ann Arbor, 1977.
1978	Visions of Vesuvius	Boston	Museum of Fine Arts	Murphy, A. R. *Visions of Vesuvius*. Boston, 1978.
1979	Pompeii: Pompeiana supellex; Objects of Everyday Life in the City Destroyed by Vesuvius	Toronto	Ontario Science Centre	*Pompeii: Pompeiana supellex; Objects of Everyday Life in the City Destroyed by Vesuvius*. Toronto, 1979.
1980	Pompei e il recupero del Classico	Ancona	Galleria d'Arte moderna	Pasquali, M. *Pompei e il recupero del Classico*. Ancona, 1980.
1981	Pompéi: Travaux et envois des architectes français au XIXe siècle	Paris	École nationale supérieure des beaux-arts	De Caro, S., et al. *Pompéi: Travaux et envois des architectes français au XIXe siècle*. Paris, 1981.
→ 1981	Pompei e gli architetti Francesi dell'ottocento	Naples	École française de Naples	De Caro, S., et al. *Pompei e gli architetti francesi dell'Ottocento*. Rome. 1981.
1981	Echoes from Roman Villas: Pompeian Mural Paintings from the collection of Dr. Elie Borowki / Vestiges de villas romaines: Peintures murales pompéiennes de la collection du Dr. Elie Borowki	Ottawa	National Gallery of Canada	Pantazzi, M. *Echoes from Roman Villas: Pompeian Mural Paintings from the Collection of Dr. Elie Borowski / Vestiges de villas romaines: Peintures murales pompéiennes de la collection du Dr. Elie Borowski*. Ottawa, 1981.
1981	Pompei 1748–1980: I tempi della documentazione	Rome	Curia Senatus (Forum Romanum)	*Pompei 1748–1980: I tempi della documentazione*. Rome, 1981.
→ 1981	Pompei 1748–1980: I tempi della documentazione	Pompeii	Antiquarium	same as in Rome
1983	Casina dell'Aquila: Recupero di un'immagine	Pompeii	Casina dell'Aquila	*Casina dell'Aquila: Recupero di un'immagine*. Pompeii, 1985.
1984	Terrae motus	Herculaneum	Villa Campolieto	*Terrae motus*. Naples, 1984.
1985	Blei-Pompeji: Konzeptionelle Recherche und Fiktion	Berlin	Alte Nazarethkirche am Leopoldplatz	Gilow, F., and W. Aue. *Blei-Pompeji: Konzeptionelle Recherche und Fiktion/Performance*. Berlin, 1985.
1986	Terrae motus 2	Herculaneum	Villa Campolieto	Oliva, A. B., and M. Bonuomo. *Terrae motus 2*. Naples, 1986.
→ 1987	Terrae motus: Naples, tremblement de terre	Paris	Grand Palais	*Terrae motus: Naples, tremblement de terre*. Naples, 1987.
1986	Gli ori di oplontis: Gioielli Romani dal suburbio Pompeiano	Rome	Castel Sant'Angelo	D'Ambrosio, A. *Gli ori di oplontis: Gioielli Romani dal suburbio Pompeiano*. Naples, 1987.
→ 1986	Gli ori di oplontis: Gioielli Romani dal suburbio Pompeiano	Agrigento	Villa Genuardi	same as in Rome
→ 1988	The Gold of Oplontis: Roman Jewellery from the Pompeian Suburb	Brisbane	World Expo '88	*The Gold of Oplontis: Roman Jewellery from the Pompeian Suburb*. Naples, 1988.
→ 1988	The Gold of Oplontis: Roman Jewellery from the Pompeian Suburb	Adelaide	Museum of Classical Archaeology	same as in Brisbane
→ 1989	Gli ori di oplontis: Gioielli Romani dal suburbio Pompeiano	Torre Annunziata	Spolettificio	same as in Rome
→ 1989-90	Gli ori di oplontis: Gioielli Romani dal suburbio Pompeiano	Teramo	Museo Civico	same as in Rome
→ 1992	Gold aus Pompeji: Archäologische Funde aus den Villen von Oplontis	Mönchengladbach	Museum Schloss Rheydt	Sternberg, C. *Gold aus Pompeji: Archäologische Funde aus den Villen von Oplontis*. Mönchengladbach, 1992.
→ 1993	Gli ori di oplontis: Gioielli Romani dal suburbio Pompeiano	Venice	Centro Culturale Zitelle	same as in Rome
→ 1996	El oro de Oplontis: Joyería romana del suburbio de Pompeya	Seville	Banca Ferdinando	
→ 1996	L'or d'Oplontis: Bijoux romains de la banlieue de Pompéi	Brussels	Musée Royaux	
1987	Pio IX a Pompei: Memorie e testimonianze di un viaggio	Pompeii	Casina dell'Aquila	Conticello, B., L. Boyle et al. *Pio IX a Pompei: Memorie e testimonianze di un viaggio*. Naples, 1987.
1988	Progetto Pompei: Primo stralcio; Un bilancio	Pompeii	Casina dell'Aquila	*Progetto Pompei: Primo stralcio: Un bilancio*. Naples, 1988.
1988	Legni e bronzi di Ercolano	Rome	Castel Sant'Angelo	Budetta, T., and M. Pagano. *Ercolano: Legni e piccoli bronzi; Testimonianze dell'arredo e delle suppellettili della casa romana*. Rome, 1988.

Year	Title	City	Venue	Catalogue
1988	Il tesoro di Boscoreale: Una collezione di argenti da mensa tra cultura ellenistica e mondo romano; Pitture, suppellettili, oggetti vari della "Pisanella"	Pompeii	Casina dell'Aquila	*Il tesoro di Boscoreale: Una collezione di argenti da mensa tra cultura ellenistica e mondo romano; Pitture, suppellettili, oggetti vari della "Pisanella."* Milan, 1988.
1989	Italienische Reise: Immagini pompeiane nelle raccolte archeologiche germaniche	Pompeii	Casina dell'Aquila	Conticello, B., et al. *Italienische Reise: Pompejanische Bilder in den deutschen archäologischen Sammlungen/Italienische Reise: Immagini pompeiane nelle raccolte archeologiche germaniche.* Naples, 1989.
→ 1989	Italienische Reise: Pompejanische Bilder in den deutschen archäologischen Sammlungen	Berlin	Staatliche Museen	same as in Pompeii
1989	Stabiae: Pitture e stucchi delle ville romane	Rome	Castel Sant'Angelo	Forte, P. M. *Stabiae: Pitture e stucchi delle ville romane.* Naples, 1989.
1989	Testimonianze dall'area archeologica vesuviana	Pompeii	Casina dell'Aquila	*Testimonianze dall'area archeologica vesuviana.* Naples, 1989.
1989–90	Le ville romane di Terzigno	Terzigno	Casa Comunale	Cicirelli, C. *Le ville romane di Terzigno.* Terzigno, 1989.
1990	Rediscovering Pompeii	New York	IBM Gallery of Science and Art	Conticello, B., A. Varone, and L. F. dell'Orto. *Rediscovering Pompeii.* Rome, 1990.
→ 1990–91	Rediscovering Pompeii	Houston	Museum of Fine Arts, Houston	same as in New York
→ 1991–92	Att återupptäcka Pompeji	Malmö	Rooseum	same as in New York with summary in Swedish
→ 1992	Rediscovering Pompeii	London	Accademia Italiana delle Arti e delle Arti Applicate	*Rediscovering Pompeii: A guide to the Exhibition.* London, 1992.
→ 1992–3	Pompeii: Terug naar de bedolven stad	Amsterdam	Nieuwe Kirk	Moormann, E. M., et al. *Pompeii: Terug naar de bedolven stad.* Amsterdam, 1992.
→ 1993	Pompeji wiederentdeckt	Stuttgart	Galerie der Stadt	Dell'Orto, L. F., and B. Conticello. *Pompeji wiederentdeckt.* Rome, 1993.
→ 1993	Pompeji wiederentdeckt	Hamburg	Museum für Kunst und Gewerbe	same as in Stuttgart
→ 1993–4	Riscoprire Pompei	Rome	Musei Capitolini, Palazzo dei Conservatori	*Riscoprire Pompei.* Rome, 1993.
→ 1994	Pompeji wiederentdeckt	Basel	Antikenmuseum Basel und Sammlung Ludwig	Dell'Orto, L. F., and B. Conticello. *Pompeji wiederentdeckt.* Rome, 1994.
→ 1994–5	Rediscovering Pompeii	Sydney	Australian Museum	
1990	Tra Stabia e Pompei	Gaeta	Palazzo de Vio	
→ 1990	Tra Stabia e Pompei	Benevento	Centro d'Arte	
1990	Fotografi a Pompei nell'800 dalle collezioni del Museo Alinari	Pompeii	Casina dell'Aquila	Maffioli, M. *Fotografi a Pompei nel'800 dalle collezioni del Museo Alinari.* Florence, 1990.
1991	Il Giardino della Casa dei Casti Amanti	Rome	Palazzo delle Esposizioni	
1991	Il Giardino dipinto nella Casa del Bracciale d'Oro a Pompei e il suo restauro	Florence	Sala d'Arme di Palazzo Vecchio	Cresti, C. *Il Giardino dipinto nella Casa del Bracciale d'Oro a Pompei e il suo restauro.* Florence, 1991.
1991	Cronache del 79 d.C.: Frammenti di vita quotidiana alle pendici del Vesuvio	Rome	Complesso Monumentale di S. Michele a Ripa	Conticello, B., et al. *Cronache del 79 d.C.: Frammenti di vita quotidiana alle pendici del Vesuvio.* Rome, 1991.
1991	Terme del Sarno	Pompeii	Casina dell'Aquila	Ioppolo, G. *Terme del Sarno: Iter di una analisi per la conoscenza.* Rome, 1991.
1992	Bellezza e lusso: Immagini e documenti di piaceri della vita	Rome	Castel Sant'Angelo	Cappelli, R. *Bellezza e lusso: Immagini e documenti di piaceri della vita.* Rome, 1992.
1992	Il territorio vesuviano nel 79 d.C.: Dallo scavo archeologico alla ricostruzione ambientale	Pompeii	Casina dell'Aquila	*Il territorio vesuviano nel 79 d.C.: Dallo scavo archeologico alla ricostruzione ambientale.* Pompeii, 1992.
1992	Domus, viridaria, horti picti	Pompeii	Casina dell'Aquila	Conticello, B., and F. Romano, eds. *Domus, viridaria, horti picti.* Naples, 1992.
→ 1992	Domus, viridaria, horti picti	Naples	Biblioteca Nazionale	same as in Pompeii
1992	Allan McCollum: "The Dog from Pompei"	Madrid	Galeria Weber, Alexander y Cobo	
→ 1992	Allan McCollum: "The Dog from Pompei"	New York	John Weber Gallery	
→ 1993	Allan McCollum: "The Dog from Pompei"	Naples	Studio Trisorio	
1993	Le immagini della memoria: Il tesoro ritrovato	Rome	Castel Sant'Angelo	Cappelli, R. *Le immagini della memoria: Il tesoro ritrovato.* Rome, 1993.
1993	Enchanted Landscapes: Wall Paintings from the Roman Era	Jerusalem	Bible Lands Museum	Rosenberg, S. *Enchanted Landscapes: Wall Paintings from the Roman Era.* London, 1993.
1993	David Cannon Dashiell: "Queer Mysteries"	San Francisco	Walter and McBean Galleries San Francisco Art Institute	N. Blake, D. C. Dashiell, R. Solnit, *David Cannon Dashiell: "Queer Mysteries."* San Francisco, 1993.
→ 1995	Visual Aid at Sixteen with David Cannon Dashiell's Queer Mysteries	San Francisco	Yerba Buena Arts Center	
→ 1996	David Cannon Dashiell: "Queer Mysteries"	San Francisco	San Francisco Museum of Modern Art	
1993–4	Mulierum ornamenta: Ori e gemme dalle ceneri del Vesuvio	Torre del Greco	Palazzo Vallelonga	Cicirelli, C. *Mulierum ornamenta: Ori e gemme dalle ceneri del Vesuvio.* Torre del Greco, 1993.
1994	Il grano e le macine	Bolzano	Castel Tirolo	
1994	Terrecotte figurate a Pompei	Pompeii	Casina dell'Aquila	D'Ambrosio, A. *Terrecotte figurate a Pompei.* Pompeii, 1994.
1994	Pompeii: The Eternal Soul	New York	CFM Gallery	Godfrey, Y. *Pompeii: The Eternal Soul.* New York, 1994.
1994	Ercolano e Pompei: Sistemi di illuminazione nel primo secolo dopo Cristo	Pompeii	Casina dell'Aquila	De Carolis, E., and F. Tessuto. *Ercolano e Pompei: Sistemi di illuminazione nel primo secolo dopo primo Cristo.* Pompeii, 1994.

Year	Title	City	Venue	Catalogue
1995	Unter dem Vulkan: Meisterwerke der Antike aus dem Archäologischen Nationalmuseum Neapel	Bonn	Kunst- und Ausstellungshalle der Bundesrepublik Deutschland	Altringer, L. *Unter dem Vulkan: Meisterwerke der Antike aus dem Archäologischen Nationalmuseum Neapel.* Bonn, 1995.
→ 1995–6	À l'ombre du Vesuve	Paris	Petit Palais	Velay, P., et al. *À l'ombre du Vesuve: Collections du Musée national d'Archéologie de Naples.* Paris, 1995.
1995	Vita religiosa nell'Antica Pompei	Boscoreale	Antiquarium	Cicirelli, C. *Vita religiosa nell'Antica Pompei.* Pompeii, 1995.
1996	Campania 2000	Montreal	Italian Cultural Institute	
→ 1996	Campania 2000	Toronto	Italian Cultural Institute	
1996	Abitare sotto il Vesuvio	Ferrara	Palazzo dei Diamanti	Borriello, M.R., et al. *Pompei: Abitare sotto il Vesuvio.* Ferrara, 1996.
→ 1997	Pompeii: chwe ho we nar	Seoul	Seoul Arts Center, Hangaram Art Museum	*Pompeii: chwe ho we nar.* Seoul, 1997. English title: *Pompeii: Living Beneath Vesuvius.*
→ 1997	Pompeii: chwe ho we nar	Busan	Tongmyŏng University Art Museum	same as in Seoul
→ 1997–8	Pompeii: chwe ho we nar	Incheon	Incheon Culture and Arts Center	same as in Seoul
1997	Iside: Il mito, il mistero, la magia	Milan	Palazzo Reale	Arslan, E. A., et al. *Iside: Il mito, il mistero, la magia.* Milan, 1997.
1997	Lucerne romane	Bologna	Museo Civico	Meconcelli, G., and E. De Carolis. *Lucerne romane: Breve storia dell'illuminazione nell'antica Roma.* Bologna, 1997.
1997	Ponpei no hekigaten: 2000-nen no nemuri kara yomigaeru kodai Rōma no bi	Yokohama	Yokohama Museum of Art	Bijutsukan, Y., and F. Bijutsukan. *Ponpei no hekigaten: 2000-nen no nemuri kara yomigaeru kodai Rōma no bi.* Yokohama, 1997.
→ 1997	Ponpei no hekigaten: 2000-nen no nemuri kara yomigaeru kodai Rōma no bi	Fukuoka	Fukuoka Art Museum	same as in Yokohama
→ 1997–8	Pompeii, picta fragmenta: Decorazioni parietali dalle città sepolte	Turin-Ligotto	Salone dei beni artistici e culturali	Guzzo, P. G., and G. C. Ascione. *Pompeii, picta fragmenta: Decorazioni parietali dalle città sepolte.* Turin, 1997.
→ 1998	Pompeii, picta fragmenta: Decorazioni parietali dalle città sepolte	Portici	Palazzo Reale	same as in Turin-Ligotto
1997	Tunica lintea aurata	Naples	Museo Archeologico Nazionale di Napoli	
1998	LUXUS - Pompejin Kultaa ja Koruja	Helsinki	Ulkomaisen taiteen museo Sinebrychoff	Castrén, P., R. Berg, et al. *Pompeji : Venuksen kaupunki.* Helsinki, 1998.
→ 1998–9	Guld og smykker fra Pompeji	Kolding	Museet på Koldinghus, Denmark	Jenvold, B. *Guld og smykker fra Pompeji.* Kolding, 1998.
1998	Romana pictura: La pittura romana dalle origini all'età bizantina	Rimini	Palazzi del Podesta e dell'Arengo	Donati, A. *Romana pictura: La pittura romana dalle origini all'età bizantina.* Milan, 1998.
→ 1998–9	Romana pictura: La pittura romana dalle origini all'età bizantina	Genova	Palazzo Ducale	same as in Rimini
1998	Pompei Oltre la vita: Nuove testimonianze dalle necropoli	Boscoreale	Antiquarium	Guzzo, P. G. *Oltre la vita: Nuove testimonianze dalle necropoli.* Naples, 1998.
1998	Sotto I lapilli: Studi nella Regio I di Pompei/ Unpeeling Pompeii: Studies in Region I	Pompeii	Auditorium	Berry, J., ed. *Sotto I lapilli: Studi nella Regio I di Pompei.* Milan, 1998. English edition: *Unpeeling Pompeii. Studies in Region I of Pompeii.* Milan, 1998.
1998	Album di Pompei di Bernardino Montañés, 1849	Naples	Museo Archeologico Nazionale di Napoli	Hernández Latas, J. A., et al. *Álbum de Pompeya de Bernardino Montañés, 1849.* Zaragoza, 1999.
→ 1998–9	Álbum de Pompeya de Bernardino Montañés, 1849	Zaragoza	Palacio de Sástago	same as in Naples
1999	Pitture nella Reggia dalle città sepolte: Affreschi antichi da Pompei, Stabiae, Ercolano	Portici	Palazzo Reale	*Pitture nella Reggia dalle città sepolte: Affreschi antichi da Pompei, Stabiae, Ercolano.* Naples, 1999.
1999	Homo Faber: Natura, scienza e tecnica nell'antica Pompei	Naples	Museo Archeologico Nazionale di Napoli	Ciarallo, A., and E. De Carolis, *Homo Faber: Natura, scienza e tecnica nell'antica Pompei.* Milan, 1999.
→ 1999–2000	Pompeii: Life in a Roman Town	Los Angeles	Los Angeles County Museum of Art	Ciarallo, A., and E. De Carolis, eds. *Pompeii: Life in a Roman Town.* Milan, 1999.
→ 2000	Pompeji: Natur, Wissenschaft und Technik in einer römischen Stadt	Munich	Deutsches Museum	Munzinger, M., W. Rathjen, and M. Rosaria Borriello. *Pompeji: Natur, Wissenschaft und Technik in einer römischen Stadt.* Munich, 2000.
→ 2001	Pompéi: Nature, science et techniques	Paris	Palais de la Découverte	Ciarallo, A., A. Barbet, et al. *Pompéi: Nature, science et techniques.* Milan, 2001.
→ 2001	Sekai isan Ponpei ten: Ponpei to Ponpei ni kurasu hitobito	Tokyo	Edo-Tokyo Museum	Aoyagi, M., A. Ciarallo, and E. De Carolis. *Sekai isan Ponpei ten : Ponpei to Ponpei ni kurasu hitobito.* Tokyo, 2001. Italian title: *Pompei e i suoi abitanti*
→ 2001–2	Sekai isan Ponpei ten: Ponpei to Ponpei ni kurasu hitobito	Kobe	Kobe City Museum	same as in Tokyo
→ 2002	Sekai isan Ponpei ten: Ponpei to Ponpei ni kurasu hitobito	Nagoya	Aichi Prefectural Museum of Arts	same as in Tokyo
→ 2002	Sekai isan Ponpei ten: Ponpei to Ponpei ni kurasu hitobito	Kagoshima	Kagoshima City Museum of Art	same as in Tokyo
→ 2002	Sekai isan Ponpei ten: Ponpei to Ponpei ni kurasu hitobito	Matsue	Shimane Art Museum	same as in Tokyo
1999	Casali di ieri casali di oggi: Architetture rurali e tecniche agricole nel territorio di Pompei e Stabiae	Boscoreale	Antiquarium	*Casali di ieri casali di oggi: Architetture rurali e tecniche agricole nel territorio di Pompei e Stabiae.* Naples, 2000.

Year	Title	City	Venue	Catalogue
→ 2000	Casali di ieri casali di oggi: Architetture rurali e tecniche agricole nel territorio di Pompei e Stabiae	Naples	Palazzo Reale	same as in Boscoreale
1999	Still Lifes from Pompeii	Paris	Maison de l'Unesco	De Caro, S. *Still Lifes from Pompeii*. Naples, 1999.
→ 1999–2000	Xenia Pompeiana: Natures mortes de Pompéi	Strasbourg	Palais du Rhin	De Caro, S. *Natures mortes de Pompéi*. Naples, 2000.
→ 2000	Arte y naturaleza en Pompeya: Obras maestras del Museo arqueológico nacional de Nápoles	Barcelona	Museu d'arqueologia de Catalunya	De Caro, S. *Arte y naturaleza en Pompeya : obras maestras del Museo arqueológico nacional de Nápoles*. Naples, 2000.
→ 2001	La natura morta nelle pitture e nei mosaici delle città vesuviane	Naples	Museo Archeologico Nazionale di Napoli	De Caro, S. *La natura morta nelle pitture e nei mosaici delle città vesuviane*. Naples, 2000.
1999–2000	The Shadow of Gradiva: A Last Excavation Campaign through the Collections of the Getty Center by Anne and Patrick Poirier	Los Angeles	Getty Research Institute	
1999–2000	Ponpei ten	Tokyo	Shinagawa Intercity Gallery	Aoyagi, M., and S. De Caro. *L'archeologia del vulcano: Quante Pompei sotto il Vesuvio?* Tokyo, 1999.
2000	La Pittura Romana: Dal pictor al restauratore	Trento	Palazzo Thun	Barbet, A. *La Pittura Romana: Dal pictor al restauratore.* Imola, 2000.
→ 2000	La Pittura Romana: Dal pictor al restauratore	Bologna	Complesso di San Giovanni in Monte	same as in Trento
2000	Gli antichi ercolanesi: Antropologia, società, economia	Herculaneum	Villa Campolieto	Pagano, M. *Gli antichi ercolanesi: Antropologia, società, economia.* Naples, 2000.
2000	The Villa of the Mysteries in Pompeii: Ancient Ritual Modern Muse	Ann Arbor	Kelsey Museum of Art	Gazda, E. K., ed. *The Villa of the Mysteries in Pompeii: Ancient Ritual Modern Muse.* Ann Arbor, 2000.
2000	L'Alma mater a Pompei: Le pitture dell'insula del centenario	Bologna	S. Giovanni in Monte	Scagliarini Corlàita, D., and A. Coralin. *L'Alma mater a Pompei: Le pitture dell'insula del centenario.* Imola, 2001.
→ 2001	L'Alma mater a Pompei: Le pitture dell'insula del centenario	Rome	German Archaeological Institute	same as in Rome
→ 2001	L'Alma mater a Pompei: Le pitture dell'insula del centenario	Boscoreale	Antiquarium	same as in Rome
→ 2002	L'Alma mater a Pompei: Le pitture dell'insula del centenario	Terni	Centro Carsulae	same as in Rome
2000–1	In Stabiano: Cultura e archeologia da Stabiae; l'età arcaica e l'età romana	Castellammare di Stabia	Palazzetto del Mare	Ascione, G. C. *In Stabiano: Cultura e La città e il territorio tra archeologia da Stabiae; La città e il territorio tra l'età arcaica e l'età romana.* Castellammare di Stabia, 2001.
2001	Messaggi dell'antichità	Siena	S. Maria della Scala	
2001	Pompeii: Images from the buried cities	Aberdeen	Aberdeen Art Gallery	Guzzo, P. G. *Pompeii: Images from the Buried Cities.* Naples, 2001.
2001	Wokot Quo Vadis	Warsaw	Muzeum Narodowe w Warszawie	Dombrowolskiego, W. *Wokot Quo Vadis: Sztuka; Kultura Rzymu Czasow Nerona.* Warsaw, 2001.
2001–2	Sangue e arena	Rome	Colosseum	La Regina, A., ed. *Sangue e arena.* Milan, 2001.
2001–2	Oro, argento e mirra: Lusso e bellezza nell'antica Roma	Pordenone	Villa Galvani	D'Ambrosio, A. *Oro, argento e mirra: Lusso e bellezza Roma nell'antica Roma.* Rome, 2002.
2002	Vesuvio 79 A.D.: Vita e morte ad Ercolano, mostra fotografica e di reperti archeologici	Naples	Museo di Antropologia	Petrone, P. P., and F. G. Fedele. *Vesuvio 79 A.D.: Vita e morte ad Ercolano, mostra fotografica e di reperti archeologici.* Naples, 2002.
2002	Volcans meurtriers	Fort de France	Pavillon Bougenot	Bari, H., G. Boudon, and G. C. Parodi. *Volcans meurtriers.* Paris, 2002.
→ 2002–3	Volcans meurtriers	Paris	Jardin des Plantes	same as in Fort de France
2002	Antiquity Recovered	Philadelphia	Arthur Ross Gallery, University of Pennsylvania	Coates, V. C. Gardner, and J. L. Seydl. *Antiquity Recovered: Pompeii and Herculaneum in Philadelphia Collections.*
2002	Eleanor Antin: The Last Days of Pompeii	New York	Ronald Feldman Fine Arts	
→ 2002	Eleanor Antin: The Last Days of Pompeii	Vienna	Galerie Hilger	
→ 2002	Eleanor Antin: The Last Days of Pompeii	Santa Monica, CA	Craig Krull Gallery	
→ 2003	Eleanor Antin: The Last Days of Pompeii	Milan	Marella Arte Contemporanea	
→ 2004	Eleanor Antin: The Last Days of Pompeii	San Diego	Mandeville Art Gallery	
→ 2009	Eleanor Antin: Classical Frieze	Los Angeles	Los Angeles County Museum of Art	
→ 2009	Eleanor Antin: Classical Frieze	Brussels	Galerie Erna Hecey	
2002–3	Lo sport nell'italia antica, a Pompei ed Ercolano	Boscoreale	Antiquarium	
2002–3	Riflessi pompeiani a Ferrara: Dimore patrizie a confronto	Ferrara	Museo Archeologico Nazionale	*Riflessi pompeiani a Ferrara: Dimore patrizie a confronto.* Milan, 2002.
2002–3	Pompei: Le stanze dipinte	Rome	Auditorium parco della musica	Guzzo, P. G., and M. Mastroroberto. *Pompei: Le stanze dipinte.* Milan, 2002.
2003	Menander: La Casa del Menandro di Pompei	Boscoreale	Antiquarium	Stefani, G., et al. *Menander: La Casa del Menandro di Pompei.* Milan, 2003.
2003	Vesuvio: Dentro il vulcano	Naples	Osservatorio Vesuviano	
2003	Storie da un'eruzione	Naples	Museo Archeologico Nazionale di Napoli	Guzzo, P. G. *Storie da un'eruzione.* Milan, 2003. Abridged English edition: *Tales from an Eruption: Pompeii, Herculaneum, Oplontis.* Milan, 2003.
→ 2003–4	Da Pompei a Roma: Histoires d'une éruption; Pompéi, Herculanum, Oplontis/Da Pompei a Roma: Kroniek van een uitbarsting; Pompeji, Herculaneum, Oplontis.	Brussels	Musées royaux d'art et d'histoire	Guzzo, P. G. *Da Pompei a Roma: Histoires d'une éruption; Pompéi, Herculanum, Oplontis.* Ghent, 2003. Flemish edition: *Da Pompei a Roma: Kroniek van een uitbarsting; Pompeji, Herculaneum, Oplontis.* Ghent 2003.

Year	Title	City	Venue	Catalogue
→ 2004	Storie da un'eruzione	Trieste	Museo Storico del Castello di Miramare	same as in Naples
→ 2004–5	Pompeji: Die Stunden des Untergangs: 24. August 79 n. Chr	Mannheim	Reiss-Engelhorn Museen	Guzzo, P. G., and A. Wieczorek. *Pompeji: Die Stunden des Untergangs; 24. August 79 n. Chr.* Stuttgart, 2004.
→ 2005	Tales from an Eruption	Gatineau	Canadian Museum of Civilization	same as in Naples and Brussels
→ 2005–6	Stories from an Eruption	Chicago	Field Museum	Guzzo, P. G. *Pompeii: Stories from an Eruption; Guide to the Exhibition.* Milan, 2005.
→ 2006	Ponpei no kagayaki: kodai rōma toshi saigo no hi	Tokyo	Bunkamura Museum Tokyo	Aoyagi, M. *Ponpei no kagayaki: kodai rōma toshi saigo no hi.* Tokyo, 2006.
→ 2006	Ponpei no kagayaki: kodai rōma toshi saigo no hi	Sendai	Sendai City Museum	same as in Tokyo
→ 2006	Ponpei no kagayaki: kodai rōma toshi saigo no hi	Fukuoka	Fukuoka Art Museum	same as in Tokyo
→ 2006–7	Ponpei no kagayaki: kodai rōma toshi saigo no hi	Osaka	Suntory Museum	same as in Tokyo
→ 2007	Pangbei mo ri: yuan zi huo shan pen fa de gu shi	Beijing	World Art Museum	D'Ambrosio, A., P. G. Guzzo, and M. Mastroroberto. *Pangbei mo ri : yuan zi huo shan pen fa de gu shi.* Beijing, 2007.
→ 2007	Pangbei mo ri: yuan zi huo shan pen fa de gu shi	Zhejiang	West Lake Art Museum	same as in Beijing
→ 2007–8	Pompeii: Tales from an Eruption	Birmingham, AL	Birmingham Museum of Art	Guzzo, P. G., et al. *Pompeii: Tales from an Eruption; Guide for the Exhibition.* Milan, 2007.
→ 2008	Pompeii: Tales from an Eruption	Houston	Museum of Fine Arts, Houston	same as in Birmingham
2003–4	Neo	Utrecht	Centraal Museum	Brand, J., et al. *Neo.* Utrecht, 2003.
2003–4	Lo splendore di glycera: Moda, costume, bellezza nell'Italia antica	Naples	Museo Archeologico Nazionale di Napoli	Borriello, M. R., et al. *Lo splendore di glycera: Moda, costume, bellezza nell'Italia antica.* Naples, 2004.
2004	Moda costume e bellezza a Pompei e dintorni	Boscoreale	Antiquarium	Bonifacio, G. *Moda costume e bellezza a Pompei e dintorni.* Pompeii, 2004.
2004 →	Vitrum: Il vetro fra arte e scienza nel mondo Romano	Florence	Museo degli Argenti, Palazzo Pitti	Beretta, M., and G. Di Pasquale. *Vitrum: Il vetro fra arte e scienza nel mondo Romano.* Florence, 2004.
2006	Le verre dans l'empire romain: Arts et sciences	Paris	Cité des Sciences et de l'Industrie	Beretta, M., and G. Di Pasquale. *Le verre dans l'empire romain: Arts et sciences.* Paris, 2006.
2004	Cose mai viste	Naples	Museo Archeologico Nazionale di Napoli	
2004	In Stabiano: Exploring the Ancient Seaside Villas of the Roman Elite	Washington, DC	National Museum of Natural History	Howe, T. N., et al. *In Stabiano: Exploring the Ancient Seaside Villas of the Roman Elite.* Castellammare di Stabia, 2004.
→ 2005	In Stabiano: Exploring the Ancient Seaside Villas of the Roman Elite	Little Rock	Arkansas Art Center	Howe, T. N., et al. *In Stabiano: Exploring the Ancient Seaside Villas of the Roman Elite.* U.S. Tour 2005–2008. Castellammare di Stabia, 2005.
→ 2005–6	In Stabiano: Exploring the Ancient Seaside Villas of the Roman Elite	Reno	Nevada Museum of Art	same as in Little Rock
→ 2006	In Stabiano: Exploring the Ancient Seaside Villas of the Roman Elite	San Diego	San Diego Museum of Art	same as in Little Rock
→ 2006	In Stabiano: Exploring the Ancient Seaside Villas of the Roman Elite	Atlanta	Michael C. Carlos Museum	same as in Little Rock
→ 2006–7	In Stabiano: Exploring the Ancient Seaside Villas of the Roman Elite	Toledo, OH	Toledo Museum of Art	same as in Little Rock
→ 2007	In Stabiano: Exploring the Ancient Seaside Villas of the Roman Elite	Madison, WI	Chazen Museum of Art	same as in Little Rock
→ 2007	In Stabiano: Exploring the Ancient Seaside Villas of the Roman Elite	Dallas	Dallas Museum of Art	same as in Little Rock
→ 2007–8	In Stabiano: Exploring the Ancient Seaside Villas of the Roman Elite	Jacksonville	Cummer Museum of Art and Gardens	same as in Little Rock
2004	Oplontis: 40 anni di ricerca	Boscoreale	Antiquarium	Fergola, L. *Oplontis: 40 anni di ricerca.* Pompeii, 2004.
2005	Il ritorno di Dioniso. Esposizione delle statue della Villa Augustea.	Somma Vesuviana	Palazzo Municipale	
2005	Cibi e sapori a Pompei e dintorni	Boscoreale	Antiquarium	Stefani, G., G. Bonifacio, et al. *Cibi e sapori a Pompei e dintorni.* Pompeii, 2005.
2005	Cibi e sapori dell'area vesuviana	Naples	Museo Archeologico Nazionale di Napoli	Borriello, M., et al. *Cibi e sapori dell'area vesuviana.* Naples, 2005.
2005	Convivium: L'aristocrazia romana a tavola	Ravenna	Domus del Triclinio (Chiesa di S. Nicolò)	*Convivium: L'aristocrazia romana a tavola; Mosaici e arredi dai più importanti Musei archeologici italiani.* Ravenna, 2005.
2005	Un dia en pompeya	Barcelona	Maritime Museum	
→ 2006	A Day in Pompeii	Taipei	National Taiwan Science Education Center	
→ 2007	A Day in Pompeii	Mobile	Gulf Coast Exploreum Science Center	*A Day in Pompeii.* Seattle, 2007.
→ 2007–8	A Day in Pompeii	St. Paul	Science Museum of Minnesota	reissue of Mobile publication
→ 2008	A Day in Pompeii	San Diego	San Diego Natural History Museum	reissue of Mobile publication
→ 2008–9	A Day in Pompeii	Charlotte, NC	Discovery Place	reissue of Mobile publication
→ 2009	A Day in Pompeii	Melbourne	Melbourne Museum	*A Day in Pompeii.* Melbourne, 2009.
→ 2009–10	A Day in Pompeii	Wellington	Te Papa Museum	same as in Melbourne
→ 2010	A Day in Pompeii	Perth	Western Australian Museum	*A Day in Pompeii.* Welshpool, Western Australia, 2010.
→ 2010–11	Life in A Roman Town 79 CE	Singapore	National Museum	
→ 2011	Pompeii the Exhibit: Life and Death in the Shadow of Vesuvius	New York	Discovery Center Times Square	*Pompeii the Exhibit: Life and Death in the Shadow of Vesuvius.* Seattle, 2011 [reissue of Mobile publication]
→ 2011–12	A Day in Pompeii	Cambridge, MA	Museum of Science	reissue of Mobile publication

Year	Title	City	Venue	Catalogue
→ 2012	A Day in Pompeii	Cincinnati	Museum Center	reissue of Mobile publication
→ 2012–13	A Day in Pompeii	Denver	Museum of Nature and Science	reissue of Mobile publication
2005	Bajo la cólera del Vesuvio: Testimonios de Pompeya y Herculano en la época de Carlos III	Valencia (Spain)	Real Academia de Bellas Artes de San Carlos	Zarzosa, C. R., and J. L. J. Salvador, eds. *Bajo la cólera del Vesuvio: Testimonios de Pompeya y Herculano en la época de Carlos III*. Valencia, 2004.
2005	Verschüttet vom Vesuv: Die letzten Stunden von Herculaneum	Haltern	LWL-Römermuseum	Mühlenbrock, J., and D. Richter. *Verschüttet vom Vesuv: Die letzten Stunden von Herculaneum*. Mainz, 2005.
→ 2005–6	Verschüttet vom Vesuv: Die letzten Stunden von Herculaneum	Berlin	Pergamonmuseum	same as in Haltern
→ 2006	Verschüttet vom Vesuv: Die letzten Stunden von Herculaneum	Bremen	Focke-Museum Bremer Landesmuseum für Kunst und Kulturgeschichte	same as in Haltern
→ 2006	Verschüttet vom Vesuv: Die letzten Stunden von Herculaneum	Munich	Archäologische Staatssammlung	same as in Haltern
→ 2006–7	De Laatste Uren van Herculaneum	Nijmegen	Museum Het Valkhof	Wiechers, R., et al. *Herculaneum: Verwoest door de Vesuvius*. Nijmegen, 2006.
2005	L'ultimo giorno di Ercolano di Francesco Podesti, 1800–1895	Rome	Galleria Carlo Virgilio	Podesti, F., F. Mazzocca, and C. Virgilio. *L'ultimo giorno di Ercolano di Francesco Podesti, 1800–1895*. Rome, 2005.
2005	Il giardino: Realtà e immaginario nell'arte antica	Sorrento	Villa Fondo, Museo archeologico della Penisola Sorrentina "Georges Vallet"	Budetta, T., ed. *Il giardino: Realtà e immaginario nell'arte antica*. Castellammare di Stabia, 2005.
2005	Pompei antica: Immagini per la storia	Boscoreale	Antiquarium	Stefani, G. *Pompei antica: Immagini per la storia*. Pompeii, 2005.
2005–6	Stagioni nell'antica Pompei	Pompeii	Area Archeologica	Ciarallo, A. *Stagioni nell'antica Pompei*. Naples, 2005.
2005–6	Eureka: Scienza e prodigi da Archimede a Plinio	Naples	Museo Archeologico Nazionale di Napoli	Lo Sardo, E., ed. *Eureka: Scienza e prodigi da Archimede a Plinio*. Naples, 2005.
2006	Argenti a Pompei	Naples	Museo Archeologico Nazionale di Napoli	Guzzo, P. G. *Argenti: Pompei, Napoli, Torino*. Milan, 2006.
→ 2006–7	Argenti-Pompei, Napoli, Torino	Turin	Museo di Antichità	same as in Naples
2006	Antonio Petracca: Identity Theft	New York	Italian American Museum	Cocchiarelli, M., and M. Berardi. *Antonio Petracca: Identity Theft*. New York, 2006.
2006	Otium Ludens	Ravello	Museo Villa Rufolo	
→ 2007–8	Otium Ludens: Antichnye freski Stabii. Iz muzeev Italii.	St. Petersburg	State Hermitage Museum	Guzzo, P. G., G. Bonifacio, and A. M. Sodo. *Otium Ludens: Stabiae, at the Heart of the Roman Empire*. Castellammare di Stabia, 2007.
→ 2008	Tian huo yi zhen: Luoma di guo de you le yu wen wu	Hong Kong	Hong Kong Museum of Art	Longobardi, N., ed. *Tian huo yi zhen: Luoma di guo de you le yu wen wu*. Hong Kong, 2008.
→ 2008	Otium: L'arte di vivere nelle domus romane di età romana	Ravenna	Chiesa di San Nicolò	Guzzo, P. G., G. Bonifacio, and A. M. Sodo. *Otium Ludens: Stabiae, cuore dell'impero romano*. Castellammare di Stabia, 2009.
2006	Cibi dell'Anima: Una sera a casa di Giulio Polibio	Naples	Città della Scienza	
2006	Pompejanisch Rot: Die Faszination für Pompeji in Europa	Basel	Universitätsbibliothek	Stähli, A. *Pompejanisch Rot: Die Faszination für Pompeji in Europa*. Basel, 2006.
2006–7	Egittomania: Iside e il mistero	Naples	Museo Archeologico Nazionale di Napoli	De Caro, S. *Egittomania: Iside e il mistero*. Milan, 2006.
2006–7	Vesuvius 1906	Boscoreale	Antiquarium	
2006–7	Gradiva Project William Cobbing	Rome	Via Gramsci	
→ 2006–7	Gradiva Project William Cobbing	Pompeii	Regione VI Insula XIV	
→ 2006–7	Gradiva Project William Cobbing	London	Freud Museum	
→ 2007–8	Gradiva Project William Cobbing	London	Camden Arts Centre	Bird, J. et al. *Gradiva Project William Cobbing*. London, 2007.
2007	Ocio y Placer en Pompeya	Murcia	Museo Arqueológico de Murcia	Poveda Navarro, A. M., F. J. Navarro Suárez. *Ocio y Placer en Pompeya*. Murcia, 2007.
2007	Vivre en Europe Romaine	Bliesbruck-Reinheim	Parc archéologique de Bliesbruck-Reinheim	Petit, J. P., and S. Santoro. *Vivre en Europe romaine: De Pompéi à Bliesbruck-Reinheim*. Paris, 2007.
2007	Il plastico del giardino della casa dei Casti Amanti	Turin	Castello di Masino	
2007	Pompeii Tagged	New York	Kim Foster Gallery	*Antonio Petracca: Pompeii Tagged*. New York, 2007.
→ 2007	Il giardino antico da Babilonia a Roma: Scienza, arte e natura	Florence	Limonaia del Giardino di Boboli	Di Pasquale, G., and F. P. Sillabe, eds. *Il giardino antico da Babilonia a Roma: Scienza, arte e natura*. Livorno, 2007.
2007	The Herculaneum Women and the Origins of Archaeology	Los Angeles	The J. Paul Getty Museum at the Getty Villa	Daehner, Jens, ed. *The Herculaneum Women: History, Context, Identities*. Los Angeles, 2007. German edition: *Die Herkulanerinnen: Geschichte, Kontext und Wirkung der antiken Statuen in Dresden*. Munich, 2008.
2007	Luxus und Dekadenz	Haltern	LWL-Römermuseum in Haltern am See	Aßkamp, R., et al. *Luxus und Dekadenz: Römisches Leben am Golf von Neapel*. Mainz, 2007.
→ 2007–8	Luxus und Dekadenz	Bremen	Focke-Museum Bremer Landesmuseum für Kunst und Kulturgeschichte	same as in Haltern
→ 2008–9	Luxe en decadentie: Leven aan de Romeinse goudkust	Nijmegen	Museum Het Valkhof	Hunink, V., S. Piras, et al. *Luxe en decadentie: Leven aan de Romeinse goudkust*. Nijmegen, 2008.
→ 2009	Luxus und Dekadenz	Munich	Archäologische Staatssammlung München	same as in Haltern
2007–8	The Eye of Josephine	Atlanta	The High Museum	Denoyelle, M. and S. Decamps. *The Eye of Josephine: The Antiquities Collection of the Empress in the Musée du Louvre*. Atlanta, 2007.

Year	Title	City	Venue	Catalogue
→ 2008–9	De Pompei à Malmaison, les antiques de Joséphine	Rueil Malmaison	Château de Malmaison	Denoyelle, M. and S. Decamps. *De Pompai à Malmaison, les antiques de Joséphine*, Paris 2008.
2007–8	Alma Tadema e la nostalgia dell'antico	Naples	Museo Archeologico Nazionale di Napoli	Querci, E., and S. De Caro. *Alma Tadema e la nostalgia dell'antico*. Milan, 2007.
→ 2008	Alma Tadema and Antiquity	Hanover, NH	Hood Museum of Art	
2007–8	Pompeya bajo Pompeya	Alicante	Museo Arqueológico Provincial Alicante	Ribera, A., M. Olcina, and C. Ballester, eds. *Pompeya bajo de Pompeya: Las excavaciones en la casa di Ariadna*. Alicante, 2007.
→ 2008	Pompeya bajo Pompeya	Valencia (Spain)	Museo de Prehistoria de Valencia	same as in Valencia
2007–8	Rosso Pompeiano	Rome	Palazzo Massimo alle Terme	Nava, M. L., et al. *Rosso Pompeiano*. Milan, 2007.
2008	Domus Pompeiana: talo Pompejissa	Helsinki	Amos Anderson Art Museum	Castrén, P., et al. *Domus Pompeiana: Talo Pompejissa*. Helsinki, 2008. Swedish edition: *Domus Pompeiana: Ett hus i Pompeji*. Helsingfors, 2008. Italian edition: *Domus Pompeiana: Una casa a Pompei*. Helsinki, 2008.
2008	Uno alla volta: La tavoletta cerata	Boscoreale	Antiquarium	*Uno alla volta: La tavoletta cerata*. Pompeii, 2008.
2008	Pompeya y Herculano: A la Sombra del Vesubio	Salamanca	Sala de exposiciones, Caja Duero de Salamanca	Borriello, M., et al. *Pompeya y Herculano: A la Sombra del Vesubio*. Salamanca, 2008.
2008	Classical Fantasies: The Art of South Italy	Sydney	Nicholson Museum	
2008	I tesori nascosti di Santa Maria la Carità	Santa Maria la Carità	Casa Comunale	
2008	Il gladiatore	Naples	Museo Archeologico Nazionale di Napoli	Borriello, M., and P. G. Guzzo. *Il gladiatore*. Naples, 2008.
2008–9	Pompeis Panem Gustas: Pompeji till bords	Hässleholm	Hässleholm Kulturhus	Varone, A. *Pompeis panem gustas: Pompeji till bords*. Rome, 2008.
2008–9	Ercolano: Tre secoli di scoperte	Naples	Museo Archeologico Nazionale di Napoli	Borriello, M., et al. *Ercolano: Tre secoli di scoperte*. Milan, 2008.
2008–9	Documenting Discovery: The Excavation of Pompeii and Herculaneum	Washington, DC	National Gallery of Art Study Center	
2008–9	Pompeii and the Roman Villa: Art and Culture around the Bay of Naples	Washington, DC	National Gallery of Art	Mattusch, C. C., ed. *Pompeii and the Roman Villa: Art and Culture around the Bay of Naples*. Washington, D.C., 2008.
→ 2009	Pompeii and the Roman Villa: Art and Culture around the Bay of Naples	Los Angeles	Los Angeles County Museum of Art	same as in Washington, D.C.
→ 2009–10	Pompeya y una Villa Romana	Mexico City	Instituto Nacional de Antropología Historia (INAH)	Mattusch, C. C., ed. *Pompeya y una villa romana: Arte y cultura alrededor de la bahía de Nápoles*. Mexico City, 2009.
2009	Uno alla volta: La groma	Boscoreale	Antiquarium	*Uno alla volta: La groma*. Pompei, 2009.
2009	Belle comme la Romaine: Cosmétiques et soins du corps de l'Antiquité au Moyen Age	Cluny	Musée national du moyen age	Sani, J. M., et al. *Le bain et le miroir: Soins du corps et cosmétiques de l'Antiquité à la Renaissance*. Paris, 2009.
2009	Il Teatro Antico e le Maschere	Naples	Museo Archeologico Nazionale di Napoli	
2009	Wen Ming Zhan: Qin Han, Luo Ma	Beijing	World Art Museum	
→ 2009–10	Wen Ming Zhan: Qin Han, Luo Ma	Luoyang	Luoyang Museum of Henan Province	
→ 2010	Qin Han and Roman Civilizations/I due imperi: L'aquila e il dragone	Milan	Palazzo Reale	De Caro, S., and M. Scarpari. *I due imperi: L'aquila e il dragone*. Milan, 2010.
→ 2010–11	Qin Han and Roman Civilizations/I due imperi: L'aquila e il dragone	Rome	Palazzo Venezia	same as in Milan
2009	Kodai Rōma teikoku no isan	Tokyo	National Museum of Western Art	Aoyagi, M., et al. *Kodai Rōma teikoku no isan*. Tokyo, 2009. Italian title: *L'eredità dell'Impero romano*
→ 2010	Kodai Rōma teikoku no isan	Nagoya	Aichi Prefectural Museum of Art	same as in Tokyo
→ 2010	Kodai Rōma teikoku no isan	Aomori	Aomori Museum of Art	same as in Tokyo
→ 2010	Kodai Rōma teikoku no isan	Sapporo	Hokkaido Museum of Modern Art	same as in Tokyo
2009	Sex? in the City: Images of Sexuality in Roman Domestic Space	Saskatoon	University of Saskatchewan Museum of Antiquities	*Sex? in the City: Images of Sexuality in Roman Domestic Space*. Saskatoon, 2009.
2009–10	Luxus: Il piacere della vita nella Roma imperiale	Turin	Museo Archeologico	Fontanella, E. *Luxus: Il piacere della vita nella Roma imperiale*. Rome, 2009.
2009–10	Roma: La pittura di un impero	Rome	Scuderie del Quirinale	La Rocca, E., et al. *Roma: La pittura di un impero*. Milan, 2009.
2009–10	Conservare il cibo da Columella ad Artusi: I luoghi della conservazione	Civitella di Romagna	Castello di Cusercoli	Ciarallo, A., and B. Vernia. *Conservare il cibo da Columella ad Artusi: I luoghi della conservazione*. Ghezzano, 2009.
2009–10	Classical Fantasies: The Age of Beauty	Sydney	Nicholson Museum	
2009–13	Roman Ephebe from Naples	Los Angeles	The J. Paul Getty Museum at the Getty Villa	
2010	Pompei ten: Sekai isan kodai Rōma bunmei no kiseki	Fukuoka	Fukuoka City Museum	Terebi, N., F. Hakubutsukan, and Y. Bijutsukan. *Ponpei ten: sekai isan kodai Rōma bunmei no kiseki*. Tokyo, 2010. English title: Pompeii: *Miracle of Ancient Rome and World Heritage Site*.
→ 2010	Pompei ten: Sekai isan kodai Rōma bunmei no kiseki	Yokohama	Yokohama Museum of Art	same as in Fukuoka
→ 2010	Pompei ten: Sekai isan kodai Rōma bunmei no kiseki	Nagoya	Nagoya City Museum	same as in Fukuoka
→ 2010	Pompei ten: Sekai isan kodai Rōma bunmei no kiseki	Niigata	Niigata Prefectural Museum of Art / Niigata Modern Art Museum	same as in Fukuoka
→ 2011	Pompei ten: Sekai isan kodai Rōma bunmei no kiseki	Sendai	Sendai City Museum	same as in Fukuoka

Year	Title	City	Venue	Catalogue
2010	Histrionica: Teatri, maschere e spettacoli nel mondo antico	Ravenna	Complesso di San Nicolò	Borriello, M. R. *Histrionica: Teatri, maschere e spettacoli nel mondo antico*. Milan, 2010.
2010	Pompei e il Vesuvio: Scienza, conoscenza ed esperienza	Pompeii	Piazza Anfiteatro	*Pompei e il Vesuvio: Scienza, conoscenza ed esperienza*. Rome, 2010.
2010	Pompeii. Tainy pogrebennogo goroda	Moscow	State Historical Museum	
2010	Volcano: Turner to Warhol	Compton Verney	Compton Verney	Hamilton, J. *Volcano: Turner to Warhol*. Compton Verney, 2010.
2010–11	Uno alla volta: I calchi	Boscoreale	Antiquarium	Stefani, G. *Uno alla volta: I calchi*. Pompeii, 2010.
2010–11	Vinum nostrum: Arte, scienza e miti del vino nelle civiltà del Mediterraneo	Florence	Museo degli Argenti, Pitti Palace	Di Pasquale, G. *Vinum nostrum: Arte, scienza e miti del vino nelle civiltà del Mediterraneo*. Florence, 2010.
2010–	Pompei seinamaalingud	Tartu	University of Tartu Art Museum	
2011	Apollo from Pompeii: Investigating an Ancient Bronze	Los Angeles	The J. Paul Getty Museum at the Getty Villa	
→ 2012	Apollo di Pompei	Naples	Museo Archeologico Nationale di Napoli	
2011	Pompeji–život u sjeni Vezuva	Zagreb	Klovićevi Dvori Gallery	
2011	Mostra dei dipinti murali di Pompei	Pompeii	Comune di Pompei Salone di Rappresentanza	
2011	Roma—A Vida e os Imperadores	Belo Horizonte, Brazil	Casa Fiat de Cultura	
→ 2012	Roma—A Vida e os Imperadores	São Paulo	Museu de Arte de São Paulo	
2011–12	Pompéi, un art de vivre	Paris	Musée Maillol	Nitti, P. *Pompéi, un art de vivre*. Paris, 2011.
2011–12	Drevnosti Gerkulanuma	St. Petersburg	State Hermitage Museum	De Caro, S., and A. Trofimova, eds. *Drevnosti Gerkulanuma/Antichità da Ercolano*. St. Petersburg, 2011.
→ 2012	Drevnosti Gerkulanuma	Moscow	Pushkin Museum	same as in St. Petersburg
2011–12	Classical Fantasies: Pompeii and the Art of South Italy	Sydney	Nicholson Museum	
2011–12	Pompeji, Nola, Herculaneum: Katastrophen am Vesuv	Halle	State Museum for Prehistory	Meller, H., and J. A. Dickmann. *Pompeji, Nola, Herculaneum: Katastrophen am Vesuv*. Munich, 2011.
2012	Fremde Welt ganz nah—Pompeji im Gartenreich	Wörlitz	Schloss and Villa Hamilton	
2012–13	The Last Days of Pompeii: Decadence, Apocalypse, Resurrection	Los Angeles	The J. Paul Getty Museum at the Getty Villa	Gardner Coates, V. C., K. Lapatin, and J. L. Seydl, eds. *The Last Days of Pompeii: Decadence, Apocalypse, and Resurrection*. Los Angeles, 2012.
→ 2013	The Last Days of Pompeii: Decadence, Apocalypse, Resurrection	Cleveland	Cleveland Museum of Art	same as in Los Angeles
→ 2013	Derniers Jours de Pompéi: Décadence, Apocalypse, Résurrection	Quebec City	Musée national des beaux-arts du Québec	same as in Los Angeles
2012–13	Inside Out: Pompeian Interiors Exposed	Los Angeles	Italian Cultural Institute	
2013	Pompeii and Herculaneum: Living and Dying in the Roman Empire	London	British Museum	Roberts, P. *Pompeii and Herculaneum: Living and Dying in the Roman Empire*. London, 2013.

The authors welcome additions and corrections to this Appendix.

Year	Title	City	Venue	Catalogue
→ 2004	Storie da un'eruzione	Trieste	Museo Storico del Castello di Miramare	same as in Naples
→ 2004-5	Pompeji: Die Stunden des Untergangs: 24. August 79 n. Chr	Mannheim	Reiss-Engelhorn Museen	Guzzo, P. G., and A. Wieczorek. *Pompeji: Die Stunden des Untergangs; 24. August 79 n. Chr.* Stuttgart, 2004.
→ 2005	Tales from an Eruption	Gatineau	Canadian Museum of Civilization	same as in Naples and Brussels
→ 2005-6	Stories from an Eruption	Chicago	Field Museum	Guzzo, P. G. *Pompeii: Stories from an Eruption; Guide to the Exhibition.* Milan, 2005.
→ 2006	Ponpei no kagayaki: kodai rōma toshi saigo no hi	Tokyo	Bunkamura Museum Tokyo	Aoyagi, M. *Ponpei no kagayaki: kodai rōma toshi saigo no hi.* Tokyo, 2006.
→ 2006	Ponpei no kagayaki: kodai rōma toshi saigo no hi	Sendai	Sendai City Museum	same as in Tokyo
→ 2006	Ponpei no kagayaki: kodai rōma toshi saigo no hi	Fukuoka	Fukuoka Art Museum	same as in Tokyo
→ 2006-7	Ponpei no kagayaki: kodai rōma toshi saigo no hi	Osaka	Suntory Museum	same as in Tokyo
→ 2007	Pangbei mo ri: yuan zi huo shan pen fa de gu shi	Beijing	World Art Museum	D'Ambrosio, A., P. G. Guzzo, and M. Mastroroberto. *Pangbei mo ri : yuan zi huo shan pen fa de gu shi.* Beijing, 2007.
→ 2007	Pangbei mo ri: yuan zi huo shan pen fa de gu shi	Zhejiang	West Lake Art Museum	same as in Beijing
→ 2007-8	Pompeii: Tales from an Eruption	Birmingham, AL	Birmingham Museum of Art	Guzzo, P. G., et al. *Pompeii: Tales from an Eruption; Guide for the Exhibition.* Milan, 2007.
→ 2008	Pompeii: Tales from an Eruption	Houston	Museum of Fine Arts, Houston	same as in Birmingham
2003-4	Neo	Utrecht	Centraal Museum	Brand, J., et al. *Neo.* Utrecht, 2003.
2003-4	Lo splendore di glycera: Moda, costume, bellezza nell'Italia antica	Naples	Museo Archeologico Nazionale di Napoli	Borriello, M. R., et al. *Lo splendore di glycera: Moda, costume, bellezza nell'Italia antica.* Naples, 2004.
2004	Moda costume e bellezza a Pompei e dintorni	Boscoreale	Antiquarium	Bonifacio, G. *Moda costume e bellezza a Pompei e dintorni.* Pompeii, 2004.
2004 →	Vitrum: Il vetro fra arte e scienza nel mondo Romano	Florence	Museo degli Argenti, Palazzo Pitti	Beretta, M., and G. Di Pasquale. *Vitrum: Il vetro fra arte e scienza nel mondo Romano.* Florence, 2004.
2006	Le verre dans l'empire romain: Arts et sciences	Paris	Cité des Sciences et de l'Industrie	Beretta, M., and G. Di Pasquale. *Le verre dans l'empire romain: Arts et sciences.* Paris, 2006.
2004	Cose mai viste	Naples	Museo Archeologico Nazionale di Napoli	
2004	In Stabiano: Exploring the Ancient Seaside Villas of the Roman Elite	Washington, DC	National Museum of Natural History	Howe, T. N., et al. *In Stabiano: Exploring the Ancient Seaside Villas of the Roman Elite.* Castellammare di Stabia, 2004.
→ 2005	In Stabiano: Exploring the Ancient Seaside Villas of the Roman Elite	Little Rock	Arkansas Art Center	Howe, T. N., et al. *In Stabiano: Exploring the Ancient Seaside Villas of the Roman Elite.* U.S. Tour 2005-2008. Castellammare di Stabia, 2005.
→ 2005-6	In Stabiano: Exploring the Ancient Seaside Villas of the Roman Elite	Reno	Nevada Museum of Art	same as in Little Rock
→ 2006	In Stabiano: Exploring the Ancient Seaside Villas of the Roman Elite	San Diego	San Diego Museum of Art	same as in Little Rock
→ 2006	In Stabiano: Exploring the Ancient Seaside Villas of the Roman Elite	Atlanta	Michael C. Carlos Museum	same as in Little Rock
→ 2006-7	In Stabiano: Exploring the Ancient Seaside Villas of the Roman Elite	Toledo, OH	Toledo Museum of Art	same as in Little Rock
→ 2007	In Stabiano: Exploring the Ancient Seaside Villas of the Roman Elite	Madison, WI	Chazen Museum of Art	same as in Little Rock
→ 2007	In Stabiano: Exploring the Ancient Seaside Villas of the Roman Elite	Dallas	Dallas Museum of Art	same as in Little Rock
→ 2007-8	In Stabiano: Exploring the Ancient Seaside Villas of the Roman Elite	Jacksonville	Cummer Museum of Art and Gardens	same as in Little Rock
2004	Oplontis: 40 anni di ricerca	Boscoreale	Antiquarium	Fergola, L. *Oplontis: 40 anni di ricerca.* Pompeii, 2004.
2005	Il ritorno di Dioniso. Esposizione delle statue della Villa Augustea.	Somma Vesuviana	Palazzo Municipale	
2005	Cibi e sapori a Pompei e dintorni	Boscoreale	Antiquarium	Stefani, G., G. Bonifacio, et al. *Cibi e sapori a Pompei e dintorni.* Pompeii, 2005.
2005	Cibi e sapori dell'area vesuviana	Naples	Museo Archeologico Nazionale di Napoli	Borriello, M., et al. *Cibi e sapori dell'area vesuviana.* Naples, 2005.
2005	Convivium: L'aristocrazia romana a tavola	Ravenna	Domus del Triclinio (Chiesa di S. Nicolò)	*Convivium: L'aristocrazia romana a tavola; Mosaici e arredi dai più importanti Musei archeologici italiani.* Ravenna, 2005.
2005	Un dia en pompeya	Barcelona	Maritime Museum	
→ 2006	A Day in Pompeii	Taipei	National Taiwan Science Education Center	
→ 2007	A Day in Pompeii	Mobile	Gulf Coast Exploreum Science Center	*A Day in Pompeii.* Seattle, 2007.
→ 2007-8	A Day in Pompeii	St. Paul	Science Museum of Minnesota	reissue of Mobile publication
→ 2008	A Day in Pompeii	San Diego	San Diego Natural History Museum	reissue of Mobile publication
→ 2008-9	A Day in Pompeii	Charlotte, NC	Discovery Place	reissue of Mobile publication
→ 2009	A Day in Pompeii	Melbourne	Melbourne Museum	*A Day in Pompeii.* Melbourne, 2009.
→ 2009-10	A Day in Pompeii	Wellington	Te Papa Museum	same as in Melbourne
→ 2010	A Day in Pompeii	Perth	Western Australian Museum	*A Day in Pompeii.* Welshpool, Western Australia, 2010.
→ 2010-11	Life in A Roman Town 79 CE	Singapore	National Museum	
→ 2011	Pompeii the Exhibit: Life and Death in the Shadow of Vesuvius	New York	Discovery Center Times Square	*Pompeii the Exhibit: Life and Death in the Shadow of Vesuvius.* Seattle, 2011 [reissue of Mobile publication]
→ 2011-12	A Day in Pompeii	Cambridge, MA	Museum of Science	reissue of Mobile publication

Year	Title	City	Venue	Catalogue
→ 2012	A Day in Pompeii	Cincinnati	Museum Center	reissue of Mobile publication
→ 2012–13	A Day in Pompeii	Denver	Museum of Nature and Science	reissue of Mobile publication
2005	Bajo la cólera del Vesuvio: Testimonios de Pompeya y Herculano en la época de Carlos III	Valencia (Spain)	Real Academia de Bellas Artes de San Carlos	Zarzosa, C. R., and J. L. J. Salvador, eds. *Bajo la cólera del Vesuvio: Testimonios de Pompeya y Herculano en la época de Carlos III*. Valencia, 2004.
2005	Verschüttet vom Vesuv: Die letzten Stunden von Herculaneum	Haltern	LWL-Römermuseum	Mühlenbrock. J., and D. Richter. *Verschüttet vom Vesuv: Die letzten Stunden von Herculaneum*. Mainz, 2005.
→ 2005–6	Verschüttet vom Vesuv: Die letzten Stunden von Herculaneum	Berlin	Pergamonmuseum	same as in Haltern
→ 2006	Verschüttet vom Vesuv: Die letzten Stunden von Herculaneum	Bremen	Focke-Museum Bremer Landesmuseum für Kunst und Kulturgeschichte	same as in Haltern
→ 2006	Verschüttet vom Vesuv: Die letzten Stunden von Herculaneum	Munich	Archäologische Staatssammlung	same as in Haltern
→ 2006–7	De Laatste Uren van Herculaneum	Nijmegen	Museum Het Valkhof	Wiechers, R., et al. *Herculaneum: Verwoest door de Vesuvius*. Nijmegen, 2006.
2005	L'ultimo giorno di Ercolano di Francesco Podesti, 1800–1895	Rome	Galleria Carlo Virgilio	Podesti, F., F. Mazzocca, and C. Virgilio. *L'ultimo giorno di Ercolano di Francesco Podesti, 1800–1895*. Rome, 2005.
2005	Il giardino: Realtà e immaginario nell'arte antica	Sorrento	Villa Fondo, Museo archeologico della Penisola Sorrentina "Georges Vallet"	Budetta, T., ed. *Il giardino: Realtà e immaginario nell'arte antica*. Castellammare di Stabia, 2005.
2005	Pompei antica: Immagini per la storia	Boscoreale	Antiquarium	Stefani, G. *Pompei antica: Immagini per la storia*. Pompeii, 2005.
2005–6	Stagioni nell'antica Pompei	Pompeii	Area Archeologica	Ciarallo, A. *Stagioni nell'antica Pompei*. Naples, 2005.
2005–6	Eureka: Scienza e prodigi da Archimede a Plinio	Naples	Museo Archeologico Nazionale di Napoli	Lo Sardo, E., ed. *Eureka: Scienza e prodigi da Archimede a Plinio*. Naples, 2005.
2006	Argenti a Pompei	Naples	Museo Archeologico Nazionale di Napoli	Guzzo, P. G. *Argenti: Pompei, Napoli, Torino*. Milan, 2006.
→ 2006–7	Argenti-Pompei, Napoli, Torino	Turin	Museo di Antichità	same as in Naples
2006	Antonio Petracca: Identity Theft	New York	Italian American Museum	Cocchiarelli, M., and M. Berardi. *Antonio Petracca: Identity Theft*. New York, 2006.
2006	Otium Ludens	Ravello	Museo Villa Rufolo	
→ 2007–8	Otium Ludens: Antichnye freski Stabii. Iz muzeev Italii.	St. Petersburg	State Hermitage Museum	Guzzo, P. G., G. Bonifacio, and A. M. Sodo. *Otium Ludens: Stabiae, at the Heart of the Roman Empire*. Castellammare di Stabia, 2007.
→ 2008	Tian huo yi zhen: Luoma di guo de you le yu wen wu	Hong Kong	Hong Kong Museum of Art	Longobardi, N., ed. *Tian huo yi zhen: Luoma di guo de you le yu wen wu*. Hong Kong, 2008.
→ 2008	Otium: L'arte di vivere nelle domus romane di età romana	Ravenna	Chiesa di San Nicolò	Guzzo, P. G., G. Bonifacio, and A. M. Sodo. *Otium Ludens: Stabiae, cuore dell'impero romano*. Castellammare di Stabia, 2009.
2006	Cibi dell'Anima: Una sera a casa di Giulio Polibio	Naples	Città della Scienza	
2006	Pompejanisch Rot: Die Faszination für Pompeji in Europa	Basel	Universitätsbibliothek	Stähli, A. *Pompejanisch Rot: Die Faszination für Pompeji in Europa*. Basel, 2006.
2006–7	Egittomania: Iside e il mistero	Naples	Museo Archeologico Nazionale di Napoli	De Caro, S. *Egittomania: Iside e il mistero*. Milan, 2006.
2006–7	Vesuvius 1906	Boscoreale	Antiquarium	
2006–7	Gradiva Project William Cobbing	Rome	Via Gramsci	
→ 2006–7	Gradiva Project William Cobbing	Pompeii	Regione VI Insula XIV	
→ 2006–7	Gradiva Project William Cobbing	London	Freud Museum	
→ 2007–8	Gradiva Project William Cobbing	London	Camden Arts Centre	Bird, J. et al. *Gradiva Project William Cobbing*. London, 2007.
2007	Ocio y Placer en Pompeya	Murcia	Museo Arqueológico de Murcia	Poveda Navarro, A. M., F. J. Navarro Suárez. *Ocio y Placer en Pompeya*. Murcia, 2007.
2007	Vivre en Europe Romaine	Bliesbruck-Reinheim	Parc archéologique de Bliesbruck-Reinheim	Petit, J. P., and S. Santoro. *Vivre en Europe romaine: De Pompéi à Bliesbruck-Reinheim*. Paris, 2007.
2007	Il plastico del giardino della casa dei Casti Amanti	Turin	Castello di Masino	
2007	Pompeii Tagged	New York	Kim Foster Gallery	*Antonio Petracca: Pompeii Tagged*. New York, 2007.
→ 2007	Il giardino antico da Babilonia a Roma: Scienza, arte e natura	Florence	Limonaia del Giardino di Boboli	Di Pasquale, G., and F. P. Sillabe, eds. *Il giardino antico da Babilonia a Roma: Scienza, arte e natura*. Livorno, 2007.
2007	The Herculaneum Women and the Origins of Archaeology	Los Angeles	The J. Paul Getty Museum at the Getty Villa	Daehner, Jens, ed. *The Herculaneum Women: History, Context, Identities*. Los Angeles, 2007. German edition: *Die Herkulanerinnen: Geschichte, Kontext und Wirkung der antiken Statuen in Dresden*. Munich, 2008.
2007	Luxus und Dekadenz	Haltern	LWL-Römermuseum in Haltern am See	Aßkamp, R., et al. *Luxus und Dekadenz: Römisches Leben am Golf von Neapel*. Mainz, 2007.
→ 2007–8	Luxus und Dekadenz	Bremen	Focke-Museum Bremer Landesmuseum für Kunst und Kulturgeschichte	same as in Haltern
→ 2008–9	Luxe en decadentie: Leven aan de Romeinse goudkust	Nijmegen	Museum Het Valkhof	Hunink, V., S. Piras, et al. *Luxe en decadentie: Leven aan de Romeinse goudkust*. Nijmegen, 2008.
→ 2009	Luxus und Dekadenz	Munich	Archäologische Staatssammlung München	same as in Haltern
2007–8	The Eye of Josephine	Atlanta	The High Museum	Denoyelle, M. and S. Decamps. *The Eye of Josephine: The Antiquities Collection of the Empress in the Musée du Louvre*. Atlanta, 2007.

Year	Title	City	Venue	Catalogue
→ 2008–9	De Pompei à Malmaison, les antiques de Joséphine	Rueil Malmaison	Château de Malmaison	Denoyelle, M. and S. Decamps. *De Pompai à Malmaison, les antiques de Joséphine*, Paris 2008.
2007–8	Alma Tadema e la nostalgia dell'antico	Naples	Museo Archeologico Nazionale di Napoli	Querci, E., and S. De Caro. *Alma Tadema e la nostalgia dell'antico*. Milan, 2007.
→ 2008	Alma Tadema and Antiquity	Hanover, NH	Hood Museum of Art	
2007–8	Pompeya bajo Pompeya	Alicante	Museo Arqueológico Provincial Alicante	Ribera, A., M. Olcina, and C. Ballester, eds. *Pompeya bajo de Pompeya: Las excavaciones en la casa di Ariadna*. Alicante, 2007.
→ 2008	Pompeya bajo Pompeya	Valencia (Spain)	Museo de Prehistoria de Valencia	same as in Valencia
2007–8	Rosso Pompeiano	Rome	Palazzo Massimo alle Terme	Nava, M. L., et al. *Rosso Pompeiano*. Milan, 2007.
2008	Domus Pompeiana: talo Pompejissa	Helsinki	Amos Anderson Art Museum	Castrén, P., et al. *Domus Pompeiana: Talo Pompejissa*. Helsinki, 2008. Swedish edition: *Domus Pompeiana: Ett hus i Pompeji*. Helsingfors, 2008. Italian edition: *Domus Pompeiana: Una casa a Pompei*. Helsinki, 2008.
2008	Uno alla volta: La tavoletta cerata	Boscoreale	Antiquarium	*Uno alla volta: La tavoletta cerata*. Pompeii, 2008.
2008	Pompeya y Herculano: A la Sombra del Vesubio	Salamanca	Sala de exposiciones, Caja Duero de Salamanca	Borriello, M., et al. *Pompeya y Herculano: A la Sombra del Vesubio*. Salamanca, 2008.
2008	Classical Fantasies: The Art of South Italy	Sydney	Nicholson Museum	
2008	I tesori nascosti di Santa Maria la Carità	Santa Maria la Carità	Casa Comunale	
2008	Il gladiatore	Naples	Museo Archeologico Nazionale di Napoli	Borriello, M., and P. G. Guzzo. *Il gladiatore*. Naples, 2008.
2008–9	Pompeis Panem Gustas: Pompeji till bords	Hässleholm	Hässleholm Kulturhus	Varone, A. *Pompeis panem gustas: Pompeji till bords*. Rome, 2008.
2008–9	Ercolano: Tre secoli di scoperte	Naples	Museo Archeologico Nazionale di Napoli	Borriello, M., et al. *Ercolano: Tre secoli di scoperte*. Milan, 2008.
2008–9	Documenting Discovery: The Excavation of Pompeii and Herculaneum	Washington, DC	National Gallery of Art Study Center	
2008–9	Pompeii and the Roman Villa: Art and Culture around the Bay of Naples	Washington, DC	National Gallery of Art	Mattusch, C. C., ed. *Pompeii and the Roman Villa: Art and Culture around the Bay of Naples*. Washington, D.C., 2008.
→ 2009	Pompeii and the Roman Villa: Art and Culture around the Bay of Naples	Los Angeles	Los Angeles County Museum of Art	same as in Washington, D.C.
→ 2009–10	Pompeya y una Villa Romana	Mexico City	Instituto Nacional de Antropología Historia (INAH)	Mattusch, C. C., ed. *Pompeya y una villa romana: Arte y cultura alrededor de la bahía de Nápoles*. Mexico City, 2009.
2009	Uno alla volta: La groma	Boscoreale	Antiquarium	*Uno alla volta: La groma*. Pompei, 2009.
2009	Belle comme la Romaine: Cosmétiques et soins du corps de l'Antiquité au Moyen Age	Cluny	Musée national du moyen age	Sani, J. M., et al. *Le bain et le miroir: Soins du corps et cosmétiques de l'Antiquité à la Renaissance*. Paris, 2009.
2009	Il Teatro Antico e le Maschere	Naples	Museo Archeologico Nazionale di Napoli	
2009	Wen Ming Zhan: Qin Han, Luo Ma	Beijing	World Art Museum	
→ 2009–10	Wen Ming Zhan: Qin Han, Luo Ma	Luoyang	Luoyang Museum of Henan Province	
→ 2010	Qin Han and Roman Civilizations/I due imperi: L'aquila e il dragone	Milan	Palazzo Reale	De Caro, S., and M. Scarpari. *I due imperi: L'aquila e il dragone*. Milan, 2010.
→ 2010–11	Qin Han and Roman Civilizations/I due imperi: L'aquila e il dragone	Rome	Palazzo Venezia	same as in Milan
2009	Kodai Rōma teikoku no isan	Tokyo	National Museum of Western Art	Aoyagi, M., et al. *Kodai Rōma teikoku no isan*. Tokyo, 2009. Italian title: *L'eredità dell'Impero romano*
→ 2010	Kodai Rōma teikoku no isan	Nagoya	Aichi Prefectural Museum of Art	same as in Tokyo
→ 2010	Kodai Rōma teikoku no isan	Aomori	Aomori Museum of Art	same as in Tokyo
→ 2010	Kodai Rōma teikoku no isan	Sapporo	Hokkaido Museum of Modern Art	same as in Tokyo
2009	Sex? in the City: Images of Sexuality in Roman Domestic Space	Saskatoon	University of Saskatchewan Museum of Antiquities	*Sex? in the City: Images of Sexuality in Roman Domestic Space*. Saskatoon, 2009.
2009–10	Luxus: Il piacere della vita nella Roma imperiale	Turin	Museo Archeologico	Fontanella, E. *Luxus: Il piacere della vita nella Roma imperiale*. Rome, 2009.
2009–10	Roma: La pittura di un impero	Rome	Scuderie del Quirinale	La Rocca, E., et al. *Roma: La pittura di un impero*. Milan, 2009.
2009–10	Conservare il cibo da Columella ad Artusi: I luoghi della conservazione	Civitella di Romagna	Castello di Cusercoli	Ciarallo, A., and B. Vernia. *Conservare il cibo da Columella ad Artusi: I luoghi della conservazione*. Ghezzano, 2009.
2009–10	Classical Fantasies: The Age of Beauty	Sydney	Nicholson Museum	
2009–13	Roman Ephebe from Naples	Los Angeles	The J. Paul Getty Museum at the Getty Villa	
2010	Pompei ten: Sekai isan kodai Rōma bunmei no kiseki	Fukuoka	Fukuoka City Museum	Terebi, N., F. Hakubutsukan, and Y. Bijutsukan. *Ponpei ten: sekai isan kodai Rōma bunmei no kiseki*. Tokyo, 2010. English title: Pompeii: *Miracle of Ancient Rome and World Heritage Site*.
→ 2010	Pompei ten: Sekai isan kodai Rōma bunmei no kiseki	Yokohama	Yokohama Museum of Art	same as in Fukuoka
→ 2010	Pompei ten: Sekai isan kodai Rōma bunmei no kiseki	Nagoya	Nagoya City Museum	same as in Fukuoka
→ 2010	Pompei ten: Sekai isan kodai Rōma bunmei no kiseki	Niigata	Niigata Prefectural Museum of Art / Niigata Modern Art Museum	same as in Fukuoka
→ 2011	Pompei ten: Sekai isan kodai Rōma bunmei no kiseki	Sendai	Sendai City Museum	same as in Fukuoka

Year	Title	City	Venue	Catalogue
2010	Histrionica: Teatri, maschere e spettacoli nel mondo antico	Ravenna	Complesso di San Nicolò	Borriello, M. R. *Histrionica: Teatri, maschere e spettacoli nel mondo antico.* Milan, 2010.
2010	Pompei e il Vesuvio: Scienza, conoscenza ed esperienza	Pompeii	Piazza Anfiteatro	*Pompei e il Vesuvio: Scienza, conoscenza ed esperienza.* Rome, 2010.
2010	Pompeii. Tainy pogrebennogo goroda	Moscow	State Historical Museum	
2010	Volcano: Turner to Warhol	Compton Verney	Compton Verney	Hamilton, J. *Volcano: Turner to Warhol.* Compton Verney, 2010.
2010–11	Uno alla volta: I calchi	Boscoreale	Antiquarium	Stefani, G. *Uno alla volta: I calchi.* Pompeii, 2010.
2010–11	Vinum nostrum: Arte, scienza e miti del vino nelle civiltà del Mediterraneo	Florence	Museo degli Argenti, Pitti Palace	Di Pasquale, G. *Vinum nostrum: Arte, scienza e miti del vino nelle civiltà del Mediterraneo.* Florence, 2010.
2010–	Pompei seinamaalingud	Tartu	University of Tartu Art Museum	
2011	Apollo from Pompeii: Investigating an Ancient Bronze	Los Angeles	The J. Paul Getty Museum at the Getty Villa	
→ 2012	Apollo di Pompei	Naples	Museo Archeologico Nazionale di Napoli	
2011	Pompeji-život u sjeni Vezuva	Zagreb	Klovićevi Dvori Gallery	
2011	Mostra dei dipinti murali di Pompei	Pompeii	Comune di Pompei Salone di Rappresentanza	
2011	Roma—A Vida e os Imperadores	Belo Horizonte, Brazil	Casa Fiat de Cultura	
→ 2012	Roma—A Vida e os Imperadores	São Paulo	Museu de Arte de São Paulo	
2011–12	Pompéi, un art de vivre	Paris	Musée Maillol	Nitti, P. *Pompéi, un art de vivre.* Paris, 2011.
2011–12	Drevnosti Gerkulanuma	St. Petersburg	State Hermitage Museum	De Caro, S., and A. Trofimova, eds. *Drevnosti Gerkulanuma / Antichità da Ercolano.* St. Petersburg, 2011.
→ 2012	Drevnosti Gerkulanuma	Moscow	Pushkin Museum	same as in St. Petersburg
2011–12	Classical Fantasies: Pompeii and the Art of South Italy	Sydney	Nicholson Museum	
2011–12	Pompeji, Nola, Herculaneum: Katastrophen am Vesuv	Halle	State Museum for Prehistory	Meller, H., and J. A. Dickmann. *Pompeji, Nola, Herculaneum: Katastrophen am Vesuv.* Munich, 2011.
2012	Fremde Welt ganz nah—Pompeji im Gartenreich	Wörlitz	Schloss and Villa Hamilton	
2012–13	The Last Days of Pompeii: Decadence, Apocalypse, Resurrection	Los Angeles	The J. Paul Getty Museum at the Getty Villa	Gardner Coates, V. C., K. Lapatin, and J. L. Seydl, eds. *The Last Days of Pompeii: Decadence, Apocalypse, and Resurrection.* Los Angeles, 2012.
→ 2013	The Last Days of Pompeii: Decadence, Apocalypse, Resurrection	Cleveland	Cleveland Museum of Art	same as in Los Angeles
→ 2013	Derniers Jours de Pompéi: Décadence, Apocalypse, Résurrection	Quebec City	Musée national des beaux-arts du Québec	same as in Los Angeles
2012–13	Inside Out: Pompeian Interiors Exposed	Los Angeles	Italian Cultural Institute	
2013	Pompeii and Herculaneum: Living and Dying in the Roman Empire	London	British Museum	Roberts, P. *Pompeii and Herculaneum: Living and Dying in the Roman Empire.* London, 2013.

The authors welcome additions and corrections to this Appendix.

Selected Bibliography

Exhibition catalogues devoted to Pompeii, Herculaneum, and related subjects, many of which traveled to multiple venues, are listed in the Appendix to this volume.

ADES AND TAYLOR 2004
Ades, Dawn, and Michael R. Taylor, with Montse Aguer. *Dalí.* New York, 2004.

ATHERSTONE 1821
Atherstone, Edwin. "The Last Days of Herculaneum." In *The Last Days of Herculaneum, and Abradates and Panthea: Poems.* London, 1821.

AUBERT 2009
Aubert, Natacha. *Un cinéma d'après l'antique: Du culte de l'Antiquité au nationalisme dans la production muette italienne.* Paris, 2009.

BEARD 2012
Beard, Mary. "Taste and the Antique: Visiting Pompeii in the Nineteenth Century." In Mattusch 2012 (see below).

BEHLMAN 2007
Behlman, Lee. "The Sentinel of Pompeii: An Exemplum for the Nineteenth Century." In Coates and Seydl 2007 (see below), 157–70.

BERGMANN 2007
Bergmann, Bettina. "Seeing Women in the Villa of the Mysteries: A Modern Excavation of the Dionysiac Murals." In Coates and Seydl 2007 (see below), 230–69.

BERNARDINI 1996A
Bernardini, Aldo. *Il cinema muto italiano: I film dei primi anni, 1905–1909.* Rome, 1996.

BERNARDINI 1996B
Bernardini, Aldo. *Il cinema muto italiano: I film dei primi anni, 1910.* Rome, 1996.

BLIX 2008
Blix, Göran. *From Paris to Pompeii: French Romanticism and the Cultural Politics of Archaeology.* Philadelphia, 2008.

BRAGATINI AND SAMPAOLO 2010
Bragatini, I., and V. Sampaolo. *La pittura Pompeiana.* Naples, 2010.

BRAUN 2010
Braun, Emily. "Bodies from the Crypt and Other Tales of Italian Sculpture between the World Wars." In *Chaos and Classicism: Art in France, Italy, and Germany, 1918–1936,* edited by Kenneth E. Silver. New York, 2010, 144–57.

BROWN 2001
Brown, Betty Ann. *Gradiva's Mirror: Reflections on Women, Surrealism and Art History.* New York, 2001.

BRUNETTA 1991
Brunetta, Gian Piero. *Cent'anni di cinema italiano.* Rome and Bari, 1991.

BRUNETTA 1993
Brunetta, Gian Piero. *Storia del cinema italiano.* 4 vols. Rome, 1993.

BULWER-LYTTON 1834
Bulwer-Lytton, Edward. *The Last Days of Pompeii.* Cutchogue, N.Y., 1976 (originally published London, 1834).

CABANNE 1971
Cabanne, Pierre. *César par César.* Paris, 1971.

CAMPIGLIO 2008
Campiglio, Paolo. "Arturo Martini e Pompei: Tra mito del quotidiano e indagine sul corpo." In *I misteri di Pompei: Antichità pompeiane nell'immaginario della modernità,* edited by Renzo Cremante et al. Pompeii, 2008, 135–46.

CASSANELLI ET AL. 2002
Cassanelli, Roberto, Pier Luigi Ciapparelli, Enrico Colle, and Massimiliano David. *Houses and Monuments of Pompeii: The Works of Fausto and Felice Niccolini.* Los Angeles, 2002.

CHADWICK 1970
Chadwick, Whitney. "Masson's *Gradiva*: The Metamorphosis of a Surrealist Myth." *Art Bulletin* 52, no. 4 (1970): 415–422.

CLEVELAND 1999
The Cleveland Museum of Art Catalogue of Paintings: Part 4; European Paintings of the 19th Century. Cleveland, 1999.

COATES 2011
Coates, Victoria C. Gardner. "Making History: Pliny's Letters to Tacitus and Angelica Kaufmann's *Pliny the Elder and His Mother at Misenum.*" In Hales and Paul 2011 (see below), 48–61.

COATES AND SEYDL 2007
Coates, Victoria C. Gardner, and J. L. Seydl, eds. *Antiquity Recovered: The Legacy of Pompeii and Herculaneum.* Los Angeles, 2007.

COETZEE 2007
Coetzee, Mark, ed. *Hernan Bas: Works from the Rubell Family Collection.* Exh. cat. New York, Brooklyn Museum, 2007.

CONTICELLO ET AL. 1990
Conticello, Baldassare, et al. *Rediscovering Pompeii.* Exh. cat. Rome, 1990.

COOLEY AND COOLEY 2004
Cooley, Alison E., and M. G. L. Cooley. *Pompeii: A Sourcebook.* London and New York, 2004.

CREMANTE ET AL. 2008
Cremante, Renzo et al., eds. *I misteri di Pompei: Antichità pompeiane nell'imaginario della modernità; Atti della giornata di studio. Pavia, Collegio Ghisler, 1. Marzo 2007.* Pompeii, 2008.

CROW 2005
Crow, Thomas. "Rise and Fall: Theme and Idea in the Combines of Robert Rauschenberg." In *Robert Rauschenberg: Combines,* exh. cat., edited by Paul Schimmel. Los Angeles, Museum of Contemporary Art, 2005, 252–54.

DAEHNER 2007
Daehner, Jens, ed. *The Herculaneum Women: History, Context, Identities.* Exh. cat. Los Angeles, 2007.

DALÍ 1993
Dalí, Salvador. *The Secret Life of Salvador Dalí*. Translated by Haakon M. Chevalier. Mineola, N.Y., 1993.

DALY 2011
Daly, Nicholas. "The Volcanic Disaster Narrative: From Pleasure Garden to Canvas, Page, and Stage." *Victorian Studies* 53, no. 2 (Winter 2011): 255–85.

DARLEY 2012
Darley, G. *Vesuvius*. Cambridge, Mass., 2012.

DE CARO 2000
De Caro, Stefano. *Il Gabinetto Segreto del Museo Archeologico Nazionale di Napoli*. Naples, 2000.

DESROCHERS 2003
Desrochers, Brigitte. "Giorgio Sommer's Photographs of Pompeii." *History of Photography* 27, no. 2 (Summer 2003): 111–29.

DUMONT 2009
Dumont, Hervé. *L'antiquité au cinema: Vérités, légendes et manipulations*. Paris and Lausanne, 2009.

DWYER 2007
Dwyer, E. "Science or Morbid Curiosity? The Casts of Giuseppe Fiorelli and the Last Days of Romantic Pompeii." In Coates and Seydl 2007 (see above), 171–88.

DWYER 2010
Dwyer, Eugene. *Pompeii's Living Statues: Ancient Roman Lives Stolen from Death*. Ann Arbor, Mich., 2010.

FAROULT, LERIBAULT, AND SCHERF 2011
Faroult, Guillaume, Christophe Leribault, and Guilhem Scherf, eds. *L'antiquité rêvée: Innovations et resistances au XVIIIᵉ siècle / Antiquity Revived: Neoclassical Art in the Eighteenth Century*. Exh. cat. Paris, Musée du Louvre; rev. Houston, Museum of Fine Arts, 2011.

FISCHER 1970
Fischer, John. "The Easy Chair: Mark Rothko, Portrait of the Artist as an Angry Man." *Harper's*, July 1970, 16–23. Reprinted in Mark Rothko, *Writings on Art*, edited by Miguel López-Remiro. New Haven, Conn., 2006, 130–38.

GARCÍA Y GARCÍA 2006
García y García, Laurentino. *Danni di guerra a Pompei: Una dolorosa vicenda quasi dimenticata; Con numerose notizie sul "Museo Pompeiano" distrutto nel 1943*. Rome, 2006.

GAUTIER 1901
Gautier, Théophile. *Arria Marcella*. In *The Works of Théophile Gautier*, translated by F. C. de Sumichrast. New York, 1901, 11: 315–367.

GAZDA 2000
Gazda, Elaine K., ed. *Villa of the Mysteries in Pompeii: Ancient Ritual, Modern Muse*. Exh. cat. Ann Arbor, Mich., Kelsey Museum, 2000.

GAZDA 2007
Gazda, Elaine K. "Replicating Roman Murals in Pompeii: Archaeology, Art, and Politics in Italy of the 1920s." In Coates and Seydl 2007 (see above), 207–29.

GELL 1832
Gell, William. *Pompeiana: The Topography, Edifices, and Ornaments of Pompeii: The Results of Excavations since 1819*. London, 1832.

GELL AND GANDY 1817–19
Gell, William, and John P. Gandy. *Pompeiana: The Topography, Edifices, and Ornaments of Pompeii*. London, 1817–19.

GORDON 2007
Gordon, Alden R. "Subverting the Secret of Herculaneum: Archaeological Espionage in the Kingdom of Naples." In Coates and Seydl 2007 (see above), 37–57.

GUZZO ET AL. 2003
Guzzo, Pier Giovanni, et al. *Tales from an Eruption: Pompeii, Herculaneum, Oplontis: Guide to the Exhibition*. Exh. cat. Milan, 2003.

HALES 2006
Hales, Shelly J., "Re-Casting Antiquity: Pompeii and the Crystal Palace," *Arion*, third series, 14, no. 1 (2006): 99–134.

HALES AND PAUL 2011
Hales, Shelly, and Joanna Paul, eds. *Pompeii in the Public Imagination from Its Rediscovery to Today*. Oxford, 2011.

HOSOE 2007
Hosoe, Eikoh. *Deadly Ashes: Pompeii, Auschwitz, Trinity Site, Hiroshima*. Tokyo, 2007.

HOWE ET AL. 2004
Howe, Thomas Noble, et. al. *In Stabiano: Exploring the Ancient Seaside Villas of the Roman Elite*. Exh. cat. Castellammare di Stabia, 2004.

HUEY 2009
Huey, Michael, with essays by Abraham Orden and Jasper Sharp. *Ash, Inc.* Exh. cat. Vienna, Song Song, 2009.

HUNNINGS 2011
Hunnings, Leanne. "Between Victimhood and Agency: Nydia the Slave in Bulwer's 'The Last Days of Pompeii.'" In *Ancient Slavery and Abolition: From Hobbes to Hollywood*. Oxford, 2011, 181–207.

JACOBELLI 2008A
Jacobelli, Luciana ed. *Pompei. La costruzione di un mito. Arte, letteratura, aneddotica di un'icona touristica*. Rome 2008.

JACOBELLI 2008B
Jacobelli, Luciana. "Arria Marcella e il *Gothic Novel* pompeiano." In Cremante et al. 2008 (see above, 53–65).

JACOBELLI 2009
Jacobelli, Luciana. "Pompei ricostruita nelle scenografie del melodrama." In "L'ultimo giorno di Pompei." Special issue, *Rivista di Studi Pompeiani* 20 (2009): 49–60.

JENSEN 1913
Jensen, Wilhelm. *Gradiva: A Pompeiian Fancy*. Translated by Helen M. Downey. New York, 1913.

JEFFRETT AND GUIGON 2002
Jeffrett, William, and Emmanuel Guigon. *Dalí: Gradiva*. Madrid, 2002.

JOSEPH 2002
Joseph, Branden W., ed. *Robert Rauschenberg*. Cambridge, 2002.

JUNKELMANN 2004
Junkelmann, Marcus. *Hollywoods Traum von Rom: "Gladiator" und die Tradition des Monumentalfilms*. Mainz, 2004.

KOCKEL 1985
Kockel, Valentin. "Archäologische Funde und Forschungen in den Vesuvstädten I." *Archäologischer Anzeiger* (1985): 495–571.

KRAUSS 1974
Krauss, Rosalind. "Rauschenberg and the Materialized Image." Reprinted in Joseph 2002 (see above), 36–43.

LAZER 2009
Lazer, Estelle. *Resurrecting Pompeii*. New York and London, 2009.

LOCHMAN, SPÄTH, AND STÄHLI 2008
Lochman, Tomas, Thomas Späth, and Adrian Stähli, eds. *Antike im Kino: Auf dem Weg zu einer Kulturgeschichte des Antikenfilms*. Basel, 2008.

LOCKHART 1838
Lockhart, John Gibson. *Memoirs of the Life of Sir Walter Scott, Bart*. Edinburgh and London, 1838.

LYONS ET AL. 2005
Lyons, Claire L., John K. Papadopoulos, Lindsey S. Stewart, and Andrew Szegedy-Maszak. *Antiquity and Photography: Early Views of Ancient Mediterranean Sites*. Los Angeles, 2005.

MALAMUD 2000
Malamud, Margaret. "The Imperial Metropolis: Ancient Rome in Turn-of-the-Century New York." *Arion* 7, no. 3 (2000): 64–108.

MALAMUD 2001
Malamud, Margaret. "Roman Entertainments for the Masses in Turn-of-the-Century New York." *The Classical World* 95, 1 (2001): 49–57 (also published in *Journal of Popular Culture* 35, no. 3 [2001]: 43–58).

MALAMUD 2009
Malamud, Margaret. *Ancient Rome and Modern America*. Malden, Mass., and Oxford, U.K., 2009.

MARTINELLI 1994
Martinelli, Vittorio. "Sotto il vulcano." In Redi 1994 (see below), 35–62.

MATTUSCH 2005
Mattusch, Carol C. *The Villa dei Papiri at Herculaneum: Life and Afterlife of a Sculpture Collection*. Los Angeles, 2005.

MATTUSCH 2008
Mattusch, Carol C. *Pompeii and the Roman Villa: Art and Culture around the Bay of Naples*. Exh. cat. Washington, D.C., 2008.

MATTUSCH 2012
Mattusch, Carol C., ed. *Rediscovering the Ancient World on the Bay of Naples*. Studies in the History of Art, vol. 79 (Washington, D.C.), 2012.

MAYER 1994
Mayer, David, ed. *Playing Out the Empire:* Ben-Hur *and Other Toga Plays and Films, 1883–1908; A Critical Anthology*. Oxford, 1994.

MILANESE 2009
Milanese, A. *Album Museo: Immagini fotografiche ottocentesche del Museo Nazionale di Napoli*. Naples, 2009.

MIRAGLIA AND POHLMANN 1992
Miraglia, Marina, and Ulrich Pohlmann, eds. *Un viaggio fra mito e realtà: Giorgio Sommer Fotografo in Italia, 1857–1891*. Rome, 1992.

MOORMANN 2003
Moormann, Eric M. "Literary Evocations of Ancient Pompeii." In Guzzo et al. 2003 (see above), 15–33.

MORRIS 1993
Morris, Frances, ed. *Paris Post War: Art and Existentialism, 1945–55*. London, 1993.

MURPHY 1978
Murphy, Alexandra R. *Visions of Vesuvius*. Boston, 1978.

MYRONE 2011
Myrone, Martin, ed. *John Martin: Apocalypse*. London, 2011.

NAPLES 1985
Vesuvius by Warhol. Exh. cat. Naples, Museo nazionale di Capodimonte, 1985.

NICHOLS FORTHCOMING
Nichols, Marden F. "The Pompeian Style in America." In *Collectors' Choice: Art and Display in American Private Collections*. The Frick Collection Studies in the History of Collecting 3. University Park, PA, 2013.

PARSLOW 1995
Parslow, Christopher Charles. *Rediscovering Antiquity: Karl Weber and the Excavation of Herculaneum, Pompeii, and Stabiae*. New York and Cambridge, Mass., 1995.

PESANDO 2003
Pesando, Fabrizio. "Shadows of Light: Cinema, *Peplum* and Pompeii." In Guzzo et al. 2003 (see above), 34–45.

REDI 1994
Redi, Riccardo, ed. *Gli ultimo giorni di Pompei*. Naples, 1994.

ROSENTHAL 1979
Rosenthal, Donald. "Joseph Franque's *Scene during the Eruption of Vesuvius*." *Bulletin of the Philadelphia Museum of Art* 75, no. 324 (March 1979): 2–15.

SEYDL 2011
Seydl, Jon L. "Experiencing Pompeii in Late Nineteenth-Century Philadelphia." In Hales and Paul 2011 (see above), 224–25.

STÄHLI 2008
Stähli, Adrian. "Die faschistische Antike im Film." In Lochman, Späth, and Stähli 2008 (see above), 106–19.

STÄHLI 2011
Stähli, Adrian. "Katastrophenszenarien: Der Untergang von Pompeji in Bildern." In *Jenseits von Pompeji: Faszination und Rezeption,* edited by Felicia S. Meynersen and Carola Reinsberg. Mainz, 2011, 116–33.

STEFANI 2010
Stefani, Grete. *I Calchi*. Exh. cat. Naples, 2010.

VANDERPOEL 1986
VanderPoel, Halsted B. *Corpus Topographicum Pompeianum*. Rome, 1986.

WALLACE-HADRILL 2011
Wallace-Hadrill, Andrew. *Herculaneum: Past and Future*. London, 2011.

WARD 2010
Ward, Ossian. "Michael Huey: Out of the Past." *Art in America* (June/July 2010): 135.

WARD-PERKINS AND CLARIDGE 1976
Ward-Perkins, John, and Amanda Claridge. *Pompeii A.D. 79*. Exh. cat. London, 1976.

WARD-PERKINS AND CLARIDGE 1978
Ward-Perkins, John, and Amanda Claridge. *Pompeii A.D. 79*. Exh. cat. Boston, 1978.

WEINBERG 1981
Weinberg, Adam D. *The Photographs of Giorgio Sommer*. Rochester, N.Y., 1981.

WINKLER 2001
Winkler, Martin M. "The Roman Empire in American Cinema after 1945." In *Imperial Projections: Ancient Rome in Modern Popular Culture*, edited by Sandra R. Joshel, Margaret Malamud, and Donald T. McGuire. Baltimore and London, 2001, 50–76.

WYKE 1997
Wyke, Maria. *Projecting the Past: Ancient Rome, Cinema, and History*. New York and London, 1997.

WYKE 1999
Wyke, Maria. "Screening Ancient Rome in the New Italy." In *Roman Presences: Receptions of Rome in European Culture, 1789–1945*, edited by Catherine Edwards. Cambridge, 1999, 188–204.

YABLON 2007
Yablon, Nick. "'A Picture Painted in Fire': Pain's Reenactments of *The Last Days of Pompeii*, 1879–1914." In Coates and Seydl 2007 (see above), 189–206.

Illustration Credits

About the Authors

ANNIKA BAUTZ's work focuses on historical topics related to the book and reception studies. Her *The Reception of Jane Austen and Walter Scott* (2007) discusses the fates of Austen and Scott over time, taking in publication history, materiality, and access. She has also written on changing attitudes to moral questions in texts as evidenced by materials from outside the text, such as illustrations, and on the development of historical romance. Holder of a Ph.D. in English literature, she is lecturer in English at Plymouth University, U.K.

MARY BEARD holds a Chair of Classics at Cambridge University and is a fellow of Newnham College. She is classics editor of the *Times Literary Supplement* and author of the blog "A Don's Life." Her books include *The Parthenon*, *The Invention of Jane Harrison*, *The Roman Triumph*, and *The Fires of Vesuvius: Pompeii Lost and Found*, and she is coauthor of *The Colosseum* (all Harvard University Press).

VICTORIA C. GARDNER COATES received her Ph.D. from the University of Pennsylvania and is a consulting curator at the Cleveland Museum of Art. She was, with Jon L. Seydl, cocurator of *Antiquity Recovered: Pompeii and Herculaneum in Philadelphia Collections* in 2002 and coeditor of *Antiquity Recovered: The Legacy of Pompeii and Herculaneum* in 2007. Her work focuses on issues of reception and the history of the classical tradition, and she has published on Benvenuto Cellini, Angelica Kauffmann, Claude Lorrain, and Nicolas Poussin.

KENNETH LAPATIN, a classical archaeologist, is associate curator in the Department of Antiquities at the J. Paul Getty Museum and served as guest curator in 2009 of *Pompeii and the Roman Villa: Art and Culture around the Bay of Naples* at the Los Angeles County Museum of Art. Among his books and articles are several studies of the evolution of the Getty Villa in Malibu, a modern replica of the Villa dei Papiri at Herculaneum. His other research interests include ancient Greek and Roman luxury arts, archaeological forgery, and historiography.

JON L. SEYDL is the Paul J. and Edith Ingalls Vignos, Jr., curator of European painting and sculpture, 1500–1800, at the Cleveland Museum of Art. A specialist in seventeenth- and eighteenth-century Italian art, he wrote his dissertation on the Sacred Heart in the eighteenth century, while working at the Philadelphia Museum of Art on the exhibition *The Splendor of Eighteenth-Century Rome*. With Victoria Coates, he co-edited the 2007 volume *Antiquity Recovered: The Legacy of Pompeii and Herculaneum*.

WILLIAM ST CLAIR, senior research fellow, School of Advanced Study, University of London, is the author of *The Reading Nation in the Romantic Period* (Cambridge, 2004), and a chapter on the nineteenth century in *The Cambridge History of the Book in Britain*, volume 6. St Clair explores how price, access, and timing of access to texts are related to political, economic, and technological structures and restraints, including intellectual property. He has written on ancient and modern Greece, notably in *Lord Elgin and the Marbles* (Oxford, rev. ed., 1998) and *That Greece Might Still Be Free* (Cambridge, rev. ed., 2008).

ADRIAN STÄHLI is professor of classical archaeology in the Department of The Classics at Harvard University. His scholarship encompasses Greek sculpture and vase painting, visual studies, the history of sexuality, the body and gender, the history of collecting, reception of antiquity, and the history of archaeological scholarship. He curated a 2006 exhibition on the impact of the excavations of Pompeii and Herculaneum on European culture in Basel. His works include a coedited catalogue on antiquity in cinema and articles on the function and reception of images in ancient Greece, "talking objects," and the reception of the last day of Pompeii in modern painting.

Index

Note: page numbers in *italics* indicate figures;
those followed by n refer to notes, with note
number.

A

Abakanowicz, Magdalena, 31n74
Abbate, Giuseppe, 34, 35, 43n17
Allegory of Spring (Mura), *16*, 17
Alma-Tadema, Lawrence: *An Exedra*, 22, 102–3, *103*;
 The Flower Market, 83, *83*; *Glaucus and Nydia*,
 52–53, 103, 202, *203*; photography collection of,
 202; Plüschow and, 110; and Victorian classical
 movement, 150; von Gloeden and, 23, 109
Aloe, Stanislao D', 210
Ambrosio Company, 81
Amelio, Lucio, 25–26, 176
American films on Pompeii, 82, 84, *84*, 85
Amodio, Michele, 46, 48, 49, *49*, 51n9, 208, 216
Anderson, Paul W. S., 78
An Exedra (Alma-Tadema), 22, 102–3, *103*
Annibale (1959 film), 85
Anno 79 D.C.: La distruzione di Ercolano (1962 film),
 85
Delle antichità di Ercolano, 45, *46*, 50, 90, 92,
 98, 197
Antiochus and Stratonice (Ingres), 98, *99*
Antiquités de la Grande Grèce (Piranesi), 17–18, *19*,
 20, 26, 45, 194, *195*, *196*
Antiquités d'Herculaneum (Piranesi, Piranesi, and
 Piroli), 98, *152*, 194
Apaecides (Bulwer-Lytton character): in film, 79,
 82, 85; images of, 55
apocalypse: images focused on, 125–79; modern
 notions of, and meaning of Pompeii, 7
apocalypse, Pompeii as prototype of, 16, 23–26, *24*;
 and absence of figures within images, 24, 223;
 in Levi, 15
Arbaces (Bulwer-Lytton character): in Bulwer-
 Lytton's novel, 52, 53, *54*; in dramatic
 productions, 227; in film, 79–80, 82, 85; images
 of, *54*, *145*, *146*
archaeology, see Pompeii, archaeology of
Arditi, Michele, 62, 67
Arria Marcella (Gautier), 26, 70–71, 101, 120, 209,
 217
Ars Amatoria (Ovid), 90
Aschaffenburg, Pompeijanum, 42n6
Atherstone, Edwin, "The Last Day of Herculaneum,"
 19, 20, 132
Atrium of the House of Sallustio (Sanquirico), *198*
Auldjo, John, 57

B

Bacelli, Guido, 37
Baiardi, Ottavio, 45
Baldaccini, César. *See* César
Bałka, Mirosław, *Salt Seller*, 28, *28*
The Banquet of Arbaces (Speed), 54
Barosso, Maria, 37
Barr, Alfred, 164
Barré, Louis, *Musée Secret*, 68
Barthes, Roland, *A Lover's Discourse: Fragments*,
 75–76
Bartolini, Lorenzo, 200
Barye, Antoine-Louis, 215
Bas, Hernan and coding of same-sex desire, 23;
 Vesuvius, 23, 122, *123*
Bassolino, Antonio, 43n34
Baziotes, William: *Pompeii* (1953 pastel), 164, *164*;
 Pompeii (1955 oil), 164, *165*
Bazzani, Luigi, *Visit to Pompeii*, 21, *21*
The Beast Evinced No Sign (Greatbatch), 58
Beauvarlet, Jacques Firmin, *Cupid Sellers*, 94, *94*
Bécu, Jeanne (comtesse du Barry), 90
Behles, Edmondo, *48*, 221
Behlman, Lee, 152
"Behold!" He Shouted with a Voice of Thunder
 (Gleeson), 55
Bell, Alexander Graham, 109
Bellini, Giovanni, *Sacred Allegory*, 208, *208*
Belshazzar's Feast (Martin), 132
Beltrand, Tony, 225
Ben Hur, 82, 87n28
Benzoni, Giovanni Maria: *The Pompeians [Flight
 from Pompeii]*, 24, 141, 144–46, *145*, *146*; *Rebecca*,
 145
Bergeret de Grancourt, Pierre-Jacques Onézyme,
 191
Bergmann, Bettina, 22
Berlusconi, Silvio, 39, *39*
Bernini, Gianlorenzo, 200
Berthault, Pierre Gabriel, *Tomb of King André,
 Husband of the Famous Queen Jeanne of Naples*,
 191–93, *192*
Berwick, Thomas Noel Hill, baron of, 182
Betzer, Sarah, 100
Beuys, Joseph, 176
Bicycle Wheel (Duchamp), 120
Bierstadt, Albert, *Mount Vesuvius at Midnight*,
 148, *149*
Blessington, Lady Marguerite Gardiner, 56
The Blind Girl of Pompeii (Sartain, *after* Leutze),
 20, *20*
Bloemen, Jan Frans van, 206

Boîte-en-valise (Duchamp), 120
Boito, Camillo, 106
Bonaparte, Napoléon-Joseph-Charles Paul (prince
 of France), 34
Bonnard, Mario, 85
Bonucci, Carlo, *Pompei descritta....*, 19
Bonuomo, Michele, 124
Boscoreale, Antiquarium, 39
Bouguereau, William-Adolphe, 208
Bourdelle, Antoine, 160
Bowles, George, 128
Braun, Emily, 154
Breton, André: Dalí and, 116, *117*; Duchamp and, 120,
 121; on Gradiva character, 73–74; and *Gradiva*
 gallery, 75, *76*, 120; Masson and, 118, *119*
Brissac, duc de, 90
Brogi, Giacomo, 62
Browne, Hablot Knight, *The Last Days of Pompeii*, 56
Browne, Malcolm, 38
Bruno, Vincent, 168
Bryullov, Karl, *The Last Day of Pompeii*, 19, 20,
 140–42, *140–1*, 143
Bryusov, Valerii, "A Pompeian Woman," 26, 180
Buckingham Palace, Garden Pavilion, 42n6
Bulwer-Lytton, Edward: Bryullov's *Last Day of
 Pompeii* and, 140; career of, 55; *Pelham*, 55. *See
 also The Last Days of Pompeii* (Bulwer-Lytton)
Buñuel, Louis, 116
Burford, Robert, *The Ruins of Pompeii and the
 Surrounding Country*, 19
Burke, Edmund, 126
Bush, Laura, 39, *39*
Byron, Lord, 53

C

Cabat, Nicolas-Louis, 208
Cabiria (1914 film), 79
Cambiaso, Luca, *Venus and Adonis*, 66
Cameron, James, 85–86n1
Campana, P., 46
Camuccini, Vincenzo, 140
Canedi, V. Francesco, *I musici*, 58
capitalism, images of Pompeii as critique of, 21,
 22, 24
*A Caravan Passing the Desert Overtaken by a
 Sandstorm* (Pether), 134
La Caricature (periodical), 136
Casson, Hugh, 38
Castelli, Giovanni, 43n17
Cast, Pompeii (Sommer), *27*, 28–29
casts of victims of Vesuvius, *27*, 27–28, 217–19, *218*,
 219, *220*; aesthetic mediation in, 47–48, *49*, 51n8;

artwork inspired by, 25, 154, *154*, 158, *158*, *159*, 160, 162, 232, 233, 234, *235*; as both artwork and artifact, 48; and contemporary art, 28–29; Dalí's fascination with, 116; Eastern European artists and, 28–29, 31n74; in exhibitions, 38, 39–40, 217; impact on sculptural interpretation, 201; new/recent casts, 218–19; and perceptions of Pompeii, 27; photographs of, 27, 27–28, *48*, 48–49, *49*, 51n9; and popularity of plaster copies of artworks, 47; public fascination with, 47, 217, 218; as subject of drawings and engravings, 51n9; technology for, development of, 47, 48; World War II bombing and, 25; *see also* dog from House of Vesonius Primus

Caylus, Anne-Claude-Philippe de, 90

César: and casts of Pompeii victims, 25, 160; *Seated Nude, Pompeii, 1*, 25, 158, *159*; *Torso*, 158, *158*

The Chariot Race (von Wagner), 87n28

Charles III (king of Spain), 17

Charles X (king of France), 136

Chassériau, Théodore: *Tepidarium: The Room Where the Women of Pompeii Came to Rest and Dry Themselves after Bathing*, 60–61, 100–102, *101*, 143; *Toilet of Esther*, 101; *Venus Anadyomene*, 101

Cheyney and Eileen Disturb a Historian at Pompeii (McKenzie), 240, *241*

Un chien andalou (Buñuel film), 116

Chinea, macchine of, 34, 184; prints of, 184, *185*, *186*

Christianity, 18–21, 51n10, 52, 54–56, 58, 70–71, 81–82, 84–85, 142, 146, 200, 202, 208; in films about Pompeii, 82, 84, 85; and 19th-century U.S. responses to Pompeii, 20, 23

Cicero, 37

circulating libraries, in 19th-century publishing industry, 55–56

circus shows, Roman-themed, 80, 81

Clarke, Edward Daniel, 182

classical movement, Victorian, 104, 150

Coburn, Alvin Langdon, *Vesuvius*, 23, *23*

Coffey, Frederick, *Conversion and Blessing of Apaecides*, 55

Cole, Thomas, 206

Collins, Joan, 21

Colonna family, 184

Constable, John, 132

Contucci, Arcangelo, 187

Conversion and Blessing of Apaecides (Coffey), 55

Cooper, Merian C., 84, *84*

Cornelia, Mother of the Gracchi (Kauffmann), 128

Courbet, Gustave, 106

The Courtyard of the Stabian Baths (Sommer), 46, *47*

Crouching Man (The Muleteer) (body cast), 217, *218*

Crow, Thomas, 28, 166

Crystal Palace, Sydenham, Pompeian Court at, *34*, 34–35

Cubism, Masson and, 118

Cucchi, Enzo: *Simm'nervusi* series, 230; *Vesuvius Seen, Vesuvius Loved*, 230, *231*

Cupid Seller from Villa di Arianna, Stabiae, 21, 90, *91*; images modeled on, 90–94, *92–95*

Curzon, Paul Alfred de, *A Dream in the Ruins of Pompeii*, 26, 208–9, *209*

D

Dalí, Salvador: *Gradiva*, 74, *74*; and Gradiva, 73, 74–75, 77n20; *Gradiva Rediscovering the Anthropomorphic Ruins*, 26, 74–75, 116, *117*; *The Secret Life of Salvador Dalí*, 116

Danae (Titian), 64–66, *66*

Dancing Faun statue (House of the Faun), 60, 215, *216*

Dashiell, Peter Cannon, *Queer Mysteries*, 23, 31n42

Daumier, Honoré, 136

David, Jacques Louis, 90, 138

Dean, Tacita, *The Russian Ending*, 26, 236, *236*, *237*

The Death of Epaminondas [Death of Pallas] (Guerra), 187, *189*

Death of Sardanapalus (Delacroix), 21, 53

decadence of Pompeii: as cause of disaster, 7, 21, 55, 58; Victorian reaction to, 35. See also sexual images at Pompeii

decadence of Pompeii, depictions of, 89–123; in Bulwer-Lytton's *The Last Days of Pompeii*, 52, 55; as celebration of homoerotic possibilities, 22–23; as commentary on contemporary social issues, 21–22; as common theme, 16; eroticization of images, 21, 22–23

Delacroix, Eugène: *Death of Sardanapalus*, 21, 53; romanticism of, 101

Delusions and Dreams in Jensen's Gradiva (Freud), 26, 72–73, 74, 114, 116

Delvaux, A.: *Pan and Goat*, 62; *Venus on the Shell*, 67, *67*

Demidov, Anatoly Nikolaevich, 19, 140

"Le dernier jour de Pompéi" (de Girardin), 19

Les derniers jours de Pompéi (1948 L'Herbier and Moffa film), 84–85

Derrida, Jacques: *Archive Fever: A Freudian Impression*, 76; on Freud's conception of repressed memory, 26

Design on a Mirror from Pompeii (Piroli), *152*, 152–53

Despax, Jean-Baptiste, 130

Desperret, Auguste, *Third Eruption of the Volcano of 1789*, 136, *137*

Desprez, Louis Jean, 191; *The Temple of Isis at Pompeii* (with Piranesi), 17, *17*

destruction and memory, interplay of, and Pompeii's grip on imagination, 15, 27

Destruction of a City by a Volcano (Pether), 134

The Destruction of Pompeii and Herculaneum (Martin), 19, 20, 24, 53, *124–25*, 132–33, *133*

Dété, Eugène, 225

Disraeli, Isaac, 57

dog from House of Vesonius Primus, body cast of, 27, 28–29, 166, 232

The Dog from Pompei (McCollum), 20–21, 232, *233*

Donati, Enrico, 120–21

Donizetti, Gaetano, i66, 66

Doyen, Gabriel-François, 130

Curzon, Paul Alfred de, *A Dream in the Ruins of Pompeii*, 26, 208–9, *209*

A Dream in the Ruins of Pompeii (Curzon), 26, 208–9, *209*

Dresser, Christopher, 35

Dressing Room of a Pompeian Beauty (Kirchbach), *54*

The Drinker/Thirst/Drinking Man (Martini), 24–25, 154, *154*

Duchamp, Marcel: *Bicycle Wheel*, 120; *Boîte-en-valise*, 120; *Etant donnés*, 120; *Fountain*, 120; and Gradiva, 73; and *Gradiva* gallery, 75, *76*, 120; and ready-made, 28, 120; *Study for "Prière de toucher,"* 120–21, *121*

Duncanson, Robert S., *Pompeii*, 206, *207*

Dwyer, Eugene, 217–8

E

Edward VII (king of England), 109

Der Eigene (journal), 109

Elémens de perspective pratique à l'usage des artistes (Valenciennes), 130

Elizabeth II (queen of England), 37–38

Elmore, Alfred, *Pompeii, A.D. 79*, 104, *105*

Éluard, Gala, 74, 77n20, 77n22, 116

Éluard, Paul, 116, 120

Emmanuel-Maurice de Lorraine (prince d'Elboeuf), 33

Enlightenment, and natural disasters, interest in, 23

entertainment, Pompeii-themed, 31n54; circus shows, 80, 81; pyrodramas of James Pain, 24, 32–33, *80*, 81, 83, 227, *228*, 229

Entrance to Pompeii from the Nolan Gate (Sanquirico), *8–9*, 198

Ernst, Max, 116

erotic images at Pompeii. See sexual images at Pompeii

eroticization: of Pompeii images, 21, 22–23; of touring of ruins, 21, *21*

The Eruption of Vesuvius (Valenciennes), 17, 128, 130, *131*

Eruption of Vesuvius with Destruction of a Roman City (Pether), 24, 134, *135*

Esposito, Edizioni, *Pompeii–Recent Excavations*, 212, *214*

Esposizione nazionale d'igiene (Naples, 1900), 36, *36*, 37

Esposizione Universale di Roma (EUR), Museum of Roman Civilization, 37

Etant donnés (Duchamp), 120

Eugene, Prince of Savoy, 33

Excavations at Pompeii (Sain), *180–81*, 212, *213*

The Excavations at Pompeii (Hackert), *6–7*, 182, *183*

exhibitions on Pompeii, 242–50; casts of Pompeii victims in, 38, 39–40; corporate sponsorships of, 39, 42; history of, 32–42; popularity of, 38, 39, 42n3; replicas and models used in, 35, 36, 37, 43n17; technology and, 38, 40–41, *41*, 50; as understudied, 32. See also Secret Cabinet of National Archaeological Museum, Naples

Exhumed (Szaposznikow), 28

Exposition Universelle (Paris, 1955), 101

F

Fabris, Giuseppe, 144
Fabris, Pietro, 193
Facchiano, Ferdinando, 38
Fairfield, Sumner Lincoln, "The Last Night of
 Pompeii," 19
Faithful Unto Death (Poynter), 83, 150–52, *151*
Falk, B. J., *No. 1 of Pain's Spectacle, Coney Island*,
 32–33, 227, *228*
Fallen Columns, Pompeii (Købke), 204, *204*
Famin, César, *Musée royal de Naples: Peintures,
 bronzes et statues érotiques du cabinet secret*,
 62, 68
La fanciulla di Pompei (1925 film), 82
Fate Presto (Warhol), 176
Félix, Rachel, 42n6
Ferdinand II (king of Two Sicilies), 210
Ferdinand IV (king of Naples), 36–37, 182, 193
Fessard, Claude Mathieu, *View of a Skeleton
 Discovered at Pompeii, Near Vesuvius*, 191–93, *192*
Fielden, John, 145
films on Pompeii, 78–85; American films, 84, *84*,
 85; dramatic productions laying foundation
 for, 80–81; and Hollywood production code, 84;
 influence of Bulwer-Lytton's *The Last Days of
 Pompeii* on, 58–59; Italian films, before World
 War I, 78–80, 81–82; Italian films, interwar,
 82–83; Italian films after World War II, 84–85;
 recreation of past through visual culture of 19th
 century, 83–84
Fiorelli, Giuseppe: and casting of Pompeii victims,
 27, 47, 48, 217, 218; catalog of pornographic
 materials by, 67; as head of excavations, 35,
 210–11, 217; and numbering system for Pompeii
 site, 30n37
Fire in the Borgo (Raphael), 140
First *Macchina of the Chinea of 1755: Triumphal
 Bridge Adorned with Relics of the City of
 Herculaneum* (Vasi), 184, *186*
Fischer, John, 168
Flight from Pompeii (Vanderlyn), 20, *20*
Flight from Pompeii [The Pompeians] (Benzoni),
 24, 140, 144–46, *145*, *146*
Florian, Frédéric, 225
The Flower Market (Alma-Tadema), 83, *83*
*Fluteplayer and Boys at the Tomb of Mamia at
 Pompeii* (Plüschow), 22, 102, *113*
forgeries of Pompeian frescoes, 187–88, *189–90*
The Forum, Pompeii, with Vesuvius in the Distance
 (Købke), 24, 204, *205*
Forum at Pompeii (pencil; Købke), 204, *204*
The Forum of Pompeii Decorated for a Festival
 (Sanquirico), *199*
Foundering (Hamilton), 146
Fountain (Duchamp), 120
Fragonard, Jean-Honoré, 191
Francesco (king of Naples), 197

Francis I (king of Two Sicilies), 62
Frank, Anne, 15
Franque, Joseph: *Hercules Rescuing Alcestis from
 the Underworld*, 138; *Scene During the Eruption of
 Vesuvius*, *14–15*, 19, 21, 138, *139*
Frederick Augustus II (elector of Saxony and king
 of Poland), 33
French Revolution, and 19th-century interest in
 catastrophe, 19, 136
frescoes, Pompeian, forgeries of, 187–88, *189–90*
Freud, Sigmund: archaeology of Pompeii as
 metaphor for exploration of self in, 72, 73,
 76–77n7, 114; *Delusions and Dreams in Jensen's
 Gradiva*, 26, 72–73, 74, 114, 116; Derrida on, 76;
 Gradiva image and, 72, 73, 114, *115*; on Pompeii,
 24
Fuseli, Henry, *Cupid Seller*, 94, 95

G

Gallone, Carmine, 82–83, *83*
Gambart, Ernest, 102
Gandy, John Peter, *Pompeiana* (with Gell), 18, 19, *19*,
 54, 100, *100*, 132, 197
Garibaldi, Giuseppe, 63, 67, 221
Gärtner, Friedrich von, 42n6
Gau, Franz Christian, 100
Gautier, Théophile: *Arria Marcella*, 26, 70–71, 101,
 120, 209, 217; Chassériau and, 101; Curzon and,
 209
Gell, William: Bulwer-Lytton's *The Last Days of
 Pompeii* and, 53–54, 57; influence of Bulwer-
 Lytton's fiction on, 26; *Pompeiana* (with Gandy),
 18, 19, *19*, 54, 100, *100*, 132, 197; on Roman military
 discipline, 150; tour of Pompeii with Scott, 19
Géricault, Théodore, *Raft of the Medusa*, 132, *142*, 143
Gérôme, Jean-Léon: influence on Netti, 106; *Thumbs
 Down*, 87n28, 106
Getty, J. Paul, and Villa dei Papiri, 6
Ghosts of Vesuvius (Cameron film project), 85–86n1
Giacometti, Alberto, 158, 160, 162
Girardin, Delphine Gay de, "Le dernier jour de
 Pompéi," 19
"The Girl-Child of Pompeii" (Levi), 14, 15
Girotti, Mario, 85
Giusti, M. G., 225
Gladiator (2000 film), 78
The Gladiator (Netti), 108
Gladiator Battle in the Amphitheater at Pompeii
 (Sommer), 226, *226*
Gladiator Fight During a Meal at Pompeii (Netti),
 88–89, 106–8, *107*
gladiators: images of, 88–89, 106–8, *107*; recreations
 of, *225*, 225–26, *226*; Roman practices, 108
Gladiators' Barracks, Pompeii, *106*, 108
gladiator's helmet (from Gladiators' Barracks,
 Pompeii), 106, *106*
Glaucus (Bulwer-Lytton character): in Bulwer-
 Lytton novel, 52, 53, 54–55; in film, 79–80, 82, 84,
 85; Gell on, 57; images of, 145, 200, 202, 203

Glaucus and Nydia (Alma-Tadema), *52–53*, 103, 202,
 203
Gleeson, Joseph Michael, *"Behold!" He Shouted with
 a Voice of Thunder*, 55
Gli ultimi giorni di Pompei (1908 Maggi film), 79–80,
 80, 82
Gli ultimi giorni di Pompei (1913 Rodolfi film), 78–79,
 81, *81*, 82
Gli ultimi giorni di Pompei (1926 Gallone and
 Palermi film), 82–83, *83*, 84
Gli ultimi giorni di Pompei (1948 L'Herbier and
 Moffa film), 84–85
Gli ultimi giorni di Pompei (1959 Leone film), 85
Goethe, Johann Wolfgang von, 40, 144
Gogol, Nicolai, 19, 140
Google Maps, and Pompeii, 50
Gormley, Antony: *Angel of the North*, 234; *GUT IV*,
 234; *One & Other*, 234; *SPLEEN*, 234; *Untitled*,
 234, *235*
Goss, William H., 43n15
Gradiva (C'est Gradiva qui vous appelle) (2005 film),
 76
Gradiva (Dalí), 26, 74, 116, *117*
Gradiva (Jensen), 26, 71–72, 116, 118; Freud on, 26,
 72–73, 74, 114; Dalí's *Gradiva* and, 74, 116, 118;
 Masson's *Gradiva* and, 75
Gradiva (Jensen character), 71–72; Freud's image of,
 72, 73, 114, *115*; original Greek relief portraying,
 70–71, 73, 77n10, 114, *114*; Surrealist fascination
 with, 73–75, *74*, 116, 117, 118, *119*, 120; in 20th-
 century art and criticism, 75–76
Gradiva (Masson), 26, 75, 118, *119*
Gradiva gallery, 75, 76, 120
Gradiva Rediscovering the Anthropomorphic Ruins
 (Dalí), 26, 74–75, 116, *117*
Grandville, J. J., 136
Gray, Thomas, *The Vestal; or, A Tale of Pompeii*, 19
Greatbatch, William, *The Beast Evinced No Sign*, 58
Gregory XIV (pope), 145
Grenville, Charles, 97
Grenville, Richard (first duke of Buckingham and
 Chandos), 132
Gros, Antoine-Jean, 142
Grüner, Wilhelm Heinrich Ludwig, 42n6
Guattani, Antoine-Joseph, 194
Guazzoni, Enrico, 82
Guerra, Giuseppe, 187, 188; *The Death of Epaminon-
 das [Death of Pallas]*, 187, *189*

H

Hackert, Jakob Philipp, *The Excavations at Pompeii*,
 6–7, 182, *183*
Hajas, Tibor, 31n74
Hales, Shelley, 35
Hamilton, Lady, Emma Hart, 97, *97*
Hamilton, James, 201; *Foundering*, 146; *The Last
 Days of Pompeii*, 22, 146, *147*
Hamilton, Sir William, 42n6, 97, 182, 191
Handbook to Southern Italy (Murray), 68

Hannibal (1959 film), 85
Harper Brothers Publishers, 58
Harper's Magazine, 168
Harris, Brad, 85
Harris, Robert, *Pompeii*, 78
Harry Potter: The Exhibition, 40, *40*
Hemans, Felicia, "The Image in Lava," 19, 26
Herculaneum 23 August AD 79 (Leroux), 152–53, *153*
Herculaneum, Hercules Strangling the Snakes fresco, 98
Herculaneum, Porticus, Theseus and Minotaur fresco, 98
Herculaneum, Villa dei Papiri, 187; busts in, 60; Getty replica of, 6
Herculaneum Women (sculpture), early display of, 33, *33*–34
Hercules Rescuing Alcestis from the Underworld (Franque), 138
Hercules Strangling the Snakes fresco, Herculaneum, 98
Herzen, Alexander, 140
Hill, Terence, 85
Histoire de l'art d'après les monuments (journal), 98
Holocaust: monument to, Golden Gate Park, San Francisco, 28; Pompeii as prototype of, 15
The Horrible Moment of the Second Destruction of the City of Pompeii by the Lava and Ashes of Vesuvius (Piranesi), *195*
The House of Meleager (Sommer), 202, *202*
Hosmer, Harriet, 200–201
Howells, William Dean, 218
Huey, Michael, *Pompeii*, 26, 238, *239*
Hundred Best Books (Lubbock), 57
Hunnings, Leanne, 201

I

IBM Gallery of Science and Art (New York), 38
"The Image in Lava" (Hemans), 19, 26
I musici (Canedi), *58*
Ingres, Jean-Auguste-Dominique: *Antiochus and Stratonice*, 98, *99*; Chassériau and, 100; classicism of, 101
Innocents Abroad (Twain), 201
International Convention Against Tuberculosis (1900), 36–37
Ione (Bulwer-Lytton character): in Bulwer-Lytton novel, 52, 53; in film, 79–80, 82, 85; images of, 145, 200; popularity of, 57
Irpinia earthquake (1980): anxiety created by, 230; relief fundraising after, 176; Warhol and, 25–26, 176
Italian film industry: films on Pompeii, before World War I, 78–80, 81–82; films on Pompeii, interwar, 82–83; films on Pompeii, post–World War II, 84–85; Gilded Age of, 81–82
Italy: nationalism of early 20th century, and *romanità*, 81–82, 82–83; Risorgimento, 46
Italy, Fascist: destruction of Von Gloeden's negatives, 109; and excavations at Pompeii, 24,

37; responses to Pompeii, 24–25
Italy. The Festival of Pompeii, The Circus of Gladiators (Lepère), *225*, 225–26

J

Japan: atomic bombing of, Pompeii as prototype of, 15, 30n46, 37; Pompeii exhibitions in, 37, 38
Jeffrett, William, 77n22
Jenkins, J. F., 36
Jensen, Wilhelm. See *Gradiva* (Jensen)
Jone (1913 Vidali film), 81
Joseph II (Holy Roman emperor), 193
Julia (Bulwer-Lytton character), 57, 80, 85
Julian, Rodolphe, 120
Jung, Carl, 72, 114

K

Kauffmann, Joseph Johann, 128
Kauffmann, Angelica: *Cornelia, Mother of the Gracchi*, 128; *Pliny the Younger and His Mother at Misenum*, 17, 128, *129*; *Virgil Composing His Epigram*, 128
Kaufmann, Christine, 85
Kernott, James Harfield, 19
Kiefer, Anselm, 176
Kiralfy, Imre, 81, 87n28
Kirchbach, Franck, *Dressing Room of a Pompeian Beauty*, *54*
Kleiner, Salomon, *The Small Herculaneum Woman in the lower Belvedere Garden in Vienna*, 33, *33*
Købke, Christen: *Fallen Columns, Pompeii*, 204, *204*; *The Forum, Pompeii, with Vesuvius in the Distance*, 24, 204, *205*; *Forum at Pompeii* (pencil), 204, *204*
Krauss, Rosalind, 28, 166
Kuh, Katharine, 168

L

Lady Hamilton as a Bacchante (Vigée-LeBrun), 97, *97*
Laing, Alastair, 182
Lar Familiaris, 211
"The Last Day of Herculaneum" (Atherstone), 19, 20, 132
The Last Day of Pompeii (1900 Paul film), 86n8
The Last Day of Pompeii (Bryullov), 19, 20, 140–42, *141*, *143*
The Last Days of Pompeii (1935 Schoedsack and Cooper film), 84, *84*
The Last Days of Pompeii (Browne), *56*
The Last Days of Pompeii (Bulwer-Lytton), 16–17; as canonic narrative of Pompeii's extinction, 80; as catalyst for Pompeii preoccupation, 18; Christian element in, 54–55, *55*; circus shows based on, 80, 81; coloring of Pompeii experience by, 57–59;

dedication to Gell, 53–54; emphasis on Roman decadence, 21, 52, 55; film adaptations of, 78, 79–80, 81, 82–83, 84–85; historical accuracy of, 56–57; and historical romance as genre, 54, 56–57; illustrations for, *54*, *55*, *56*, *58*; and naming of Pompeii sites, 26, 57; paintings and sculpture based on, 83, 145–46, *147*, 200, 200–203, *203*; plot of, 52; popularity and impact of, 6, 56, 57; production and marketing of, 55–56, 57; publication of, 19; publication outside Britain, 57, 58; public familiarity with, 35; as resurrection of dead city, 54; review of, 56–57; Roman soldier in, 150; sources and influences, 53–54; stage adaptations of, 19, 20, 21, 80–81, 227, *228*, *229*; U.S. responses to, 20; as warning about British social ills, 52–53. See also *specific characters* (Apaecides; Arbaces; Glaucus; Ione; Julia; Nydia)
The Last Days of Pompeii (Hamilton), 22, 146, *147*
The Last Days of Pompeii (Schopin), 142–43, *143*
Last Days of Pompeii pyrodrama (Pain), 24, *32–33*, *80*, 81, 83, 227, *228*, *229*
"The Last Night of Pompeii" (Fairfield), 19
La Vega, Francesco de , 43n17, 193
Lazer, Estelle, 51n9
Le Dien, *Firmin-Eugène, Street of the Tombs, Pompeii* (with Le Gray), *24*
Le Grey, Gustave, *Street of the Tombs, Pompeii* (with Le Dien), *24*
Leicester, Sir John, 132
Leone, Giovanni, 38
Leone, Sergio, 85
Leopold III Frederick Franz (duke of Anhalt-Dessau), 42n6
Lepère, Auguste Louis, *Italy. The Festival of Pompeii, The Circus of Gladiators*, *225*, 225–26
Lequesne, Eugène-Louis, 215, *216*
Leroux, Hector, *Herculaneum 23 August AD 79*, 152–53, *153*
Letter and Report on the Discoveries at Herculaneum (Winckelmann), 62
Leutze, Emanuel Gottlieb, *The Blind Girl of Pompeii*, 20, *20*
Levi, Primo, "The Girl-Child of Pompeii," 14, 15
L'Herbier, Marcel, 84–85
Linnant de Bellefonds, Pascale, 152
Lisbon earthquake of 1800, and Enlightenment interest in natural disasters, 23, 31n48
literature about Pompeii, fictional female characters in, 70–72. See also Arria Marcella; Gradiva; Nydia
Locatelli, Andrea, 206
Longsworth, Nicholas, 206
Lorrain, Claude, 126
Louis Philippe (king of France), 136
A Lover's Discourse: Fragments (Barthes), 75–76
Lubbock, Sir John, 57
Lucian, 98
A Lucky Find at Pompeii (Moulin), *215*, 215–16
Ludwig I of Bavaria, 34, 42n6
L'ultimo giorno di Pompei (Pacini), 19, 140, 197, *198*, *199*

M

Macchiaioli, 221
Maggi, Luigi, 79–80, *80, 82*
Maisey, Sarah, 133
Maison Pompéienne (Paris), 42n6
Maiuri, Amedeo, 24, 63, 66, 71, 73, 154
Man Ray, 120
Marchal, Georges, 84
Margherita of Savoy (queen of Italy), 36, 106
Maria Isabella (queen of Naples), 197
Marie Antoinette (queen of France), 97
Marini, Marino: and casts of Pompeii victims, 25, 160; *Miracle* [lithograph], *162; The Miracle* [sculpture], 25, *162, 163*
Martin, John: *Belshazzar's Feast,* 132; *The Destruction of Pompeii and Herculaneum,* 19, 20, 24, 53, *124–25,* 132–33, *133; Sadak in Search of the Waters of Oblivion,* 132
Martini, Arturo: *The Drinker/Thirst/Drinking Man,* 24–25, 154, *154; The Girl,* 154
Martins, Maria, 120
Martire pompeiana (1909 De Liguoro film), 80
Masson, André: *Gradiva,* 26, 75, 118, *119;* and Gradiva character, 73; *Pygmalion,* 75
Mattusch, Carol, *39*
Mature, Victor, 85
Mau, August, *Pompeii: Its Life and Art,* 193
MAV. *See* Museo Archeologico Virtuale
Mazois, François, 68; *Les ruines de Pompéi,* 19, 100, 102–3, 191–93, *193*
McCollum, Allan: *The Dog from Pompei,* 20–21, 232, *233; Lost Objects,* 232; *Natural Copies,* 232
McKenzie, Lucy, *Cheyney and Eileen Disturb a Historian at Pompeii,* 240, *241*
meaning of Pompeii: Bulwer-Lytton and, 18; change of with contemporary context, 7, 16; in Italian *romanità* films, 82; Piranesi and, 18
Medici *Niobe,* 200
Medina, Louisa, 20, 21, 80
Meedendorp, Teio, 103
Méhul, Étienne, *Stratonice,* 98
Meirelles, Fernando, 85–86n1
Mengs, Anton Raphael, 94
Merz, Mario, 176
Mies van der Rohe, Ludwig, 22, 168
Millin, A. L., 138
Miracle (lithograph; Marini), *162*
The Miracle (sculpture; Marini), 25, 162, *163*
Moffa, Paolo, 84–85
Moore, Mrs. Bloomfield, 146
More, Jacob, *Mount Vesuvius in Eruption,* 17, 23, 126, *127,* 128, 130
Morghen, Giovanni Elia, 92
Moulin, Hippolyte Alexandre Julien, *A Lucky Find at Pompeii,* 215, 215–16
Mount Vesuvius at Midnight (Bierstadt), 148, *149*
Mount Vesuvius in Eruption (More), 17, 23, 126, *127,* 128, 130
Mura, Francesco de, *Allegory of Spring,* 16, 17

Murray, John, *Handbook to Southern Italy,* 68
Musée royal de Naples: Peintures, bronzes et statues érotiques du cabinet secret (Famin), *62, 68*
Musée Secret (Barré), 68
Museo Archeologico Virtuale (MAV), 40, *41,* 51n17
Il Museo Borbonico: Secret Cabinet of, 62; segregation of sexual images in, 60–61. *See also* National Archaeological Museum, Naples
Museum of Virtual Archaeology, 40, *41,* 51n17
Musso, Boniface, 132
Mussolini, Benito, 24, 37

N

Naples, *risanamento* campaign in, 36–37
National Archaeological Museum, Naples, 35, 36, 37, 42n3; Venus Room of, 60–61, 62, 68. *See also* Secret Cabinet of National Archaeological Museum, Naples
National Gallery of Art, Washington, D.C., 39, *39*
National Hygiene Exposition (Naples, 1900), 36, *36,* 37
Natoire, Charles-Joseph, 90
natural disasters, Enlightenment interest in, 23
Nelson, Horatio, 97
Nero, or the Destruction of Rome (circus spectacle), 81, 87n28
Netti, Francesco: *Ancient Chorus,* 106; *Ancient Painter before His Work,* 106; *Dancer,* 106; *The Gladiator,* 108; *Gladiator Fight During a Meal at Pompeii,* 88–89, 106–8, *107*
Niblo, Fred, 82
Niccolini, Antonio, 19, 197
Nicholas I (czar of Russia), 140
Nickerson, Samuel M., 145
Nikolaos of Damascus, 108
nineteenth-century responses to Pompeii, 18–19; Christianity and, 20, 24; events of 1920s, 19–20; invented narratives characteristic of, 20; in United States, 20
No. 1 of Pain's Spectacle, Coney Island (Falk), 227, *228*
Nollekens, Joseph, 68
Nolli, Carlo, *Cupid Seller,* 90, *92*
Normand, Alfred Nicolas, 42n6
Notes on Naples (A Traveller), 60–62, 64, 68
nouveau réalisme, 158
Novecento movement, 154
nuclear war, anxiety about, and body casts from Pompeii, 20
Nydia (Bulwer-Lytton character): in film, 79–80, 82; as idealized Victorian type, 70; images of, 21–22, 103, 145, 146, *200,* 200–201, 202, *203;* in *The Last Days of Pompeii,* 52
Nydia, The Blind Flower Girl of Pompeii (Rogers), 146, 200, 200–201

O

Oliva, Achille Bonito, 230
Orléans, duc d', 98
Ottin, Auguste Louis Marie, 215
Overbeck, Johannes, *Pompeji,* 193
Ovid, Ars *Amatoria,* 90

P

Pacini, Giovanni, *L'ultimo giorno di Pompei,* 19, 141, 197, *198, 199*
Padiglione, Felice, 43n17
Pain, James, pyrodramas of, 24, *32–33,* 80, 81, 83, 227, *228, 229*
Palermi, Amleto, 82–83, *83*
Pan and Goat (Roman sculpture), *62;* copies of, 68; display of, as issue, 61; in illustrated catalogs of Secret Cabinet, 68
Paolo, Giovanni, 206
Paul, Robert William, 86n8
Pedersoli, Carlo, 85
peephole cabinets, Pompeii-themed, 31n54
Pelham (Bulwer-Lytton), 55
Pellegrino, Charles, 85–86n1
Perziado, Francesco, 184
Pether, Sebastian: *A Caravan Passing the Desert Overtaken by a Sandstorm,* 134; *Destruction of a City by a Volcano,* 134; *Eruption of Vesuvius with Destruction of a Roman City,* 24, 134, *135*
Petitot, Ennemond Alexandre, Second Macchina of the Chinea of 1749: The Theater at Herculaneum, 184, *185*
Philipon, Charles, 136
Philodemus, 17
Philosophical Enquiry into Origins of Our Ideas of the Sublime and Beautiful (Burke), 126
photography: aesthetic barrier in, 49; color, introduction of, 49; as creative process, 46–47; development of, and development of modern archaeology, 45–46; hand-tinting of, 49; and meaning, Huey on, 238; mingling of with painting, 109; photographers of Pompeii, 46; as souvenirs, 46, 221; stereoscopic images, *48,* 48–49, 51n12; as window into ancient world, 51n10. *See also* Colburn, Esposito, Falk, Le Dien, Le Gray, Huey, Plüschow, Sommer, Von Gloeden
Piaggio, Antonio, 187
Picasso, Pablo, 116, 158
Pijl, Luuk, 103
Piranesi, Francesco: *Antiquités de la Grande Grèce,* 17–18, *19,* 20, 26, 45, 194, *195, 196; Antiquités d'Herculaneum,* 98, 152, 194; blend of ancient and modern in images of, 22; creative license of, 100; *The Horrible Moment of the Second Destruction of the City of Pompeii by the Lava and Ashes of Vesuvius, 195;* and resurrection of Pompeii, 109; *The Temple of Isis at Pompeii* (with Desprez), 17, *17; Tools of Masons and Agricultural Workers*

Found at Pompeii, 194, 196; Topographical Map of the Discoveries at Pompeii, 17, *18*, 45, *194*; *View of the Street Passing under the Gate to the City of Pompeii, 19; View of the Tavern at Pompeii with an Emblem of Priapus*, *196*

Piranesi, Giovanni Battista (Giambattista), 17, 18, 194, *196*

Piranesi, Pietro, *152*, 194

Piroli, Tommaso: *Antiquités d'Herculaneum*, 98, *152*, 194; *Design on a Mirror from Pompeii, 152*, 152–53

Pius IX (pope), 145; Pompeian objects presented to, 210, 210–11, *211*; visit to Pompeii, 210–11

The Plague at Ashdod (Poussin), 140

Pliny the Elder: death of, 130, 217; depictions of death of, 17, 19, 126, *127*, 130–*131*, 133, 140

Pliny the Younger: account of Vesuvius eruption, 17, 39, 70, 128, 130, 132, 140, 144, 217; images of, *128*, *129*, 140

Pliny the Younger and His Mother at Misenum (Kauffmann), 17, 128, *129*

Plüschow, Guglielmo: career of, 109–10; eroticization of Pompeii in, 22–23; *Fluteplayer and Boys at the Tomb of Mamia at Pompeii*, 22, 102, *113*; influence of, 103; *Youth in the Forum Baths at Pompeii*, 109, *110*; *Youths in the House of the Faun at Pompeii*, 109, 110, *112*

Plutarch, 98

Poirier, Anne and Patrick, 76

Polanski, Roman, 78

Polybius, Julius, 41, *41*, 43n39

Pompeiana (Gell and Gandy), 18, 19, *19*, 54, 100, *100*, 132, 197

Pompeian Court at Crystal Palace, Sydenham, *34*, 34–35; critics' reaction to, 35

Pompeian Pavilion at *Esposizione nazionale d'igiene* (Naples, 1900), 36, *36*, 37

The Pompeians [Flight from Pompeii] (Benzoni), 24, 140, 144–46, *145*, *146*

Pompeian wall painting: Second Style of, 168; Third Style of, 90

"A Pompeian Woman" (Briusov), 26, 180

Pompei descritta (Bonucci), 19

Pompeii, archaeological site: Amphitheater, images of, *225*, 225–26, 226; bombing of in World War II: 25, 37, *156*, 157, 221; as prototype of destruction, 25, 37, 160; Forum Baths (Baths of Fortuna), 100, 110; House of the Ancient Hunt, 21; House of Apollo, *107*, 107–8; House of the Cryptoporticus, 217; House of Epidius Rufus, 157; House of the Faun: Alexander Mosaic, *39*, 208; Dancing Faun statue, 60, 215, *216*; images of, *112*, 208, *209*; World War II bombing and, 157; House of the Gladiators (aka Gladiators' Barracks, *106*, 108, 157; House of the Plaster Bodies, 48, 217; House of Sallust, *venereum* of, 68; House of the Silver Wedding, 212; House of the Tragic Poet, 34, 35, 57, 232; House of Triptolemus, 157; House of Vesonius Primus, body cast of a dog, 27, 28–29, 166, 232; House of the Vettii, 110, 157, 188; image of Priapus in, 22, 63, *63*; Tomb of Mamia, 22, *22*, 102, 110, *113*; Via dell'Abbondanza, 157; Villa of

the Mosaic Columns, 106; Villa of the Mysteries: feminist theories about, 22; frescoes, 73, *73*, 118; frescoes, copies of, 37; frescoes, influence on modern painters, 75; frescoes, photographs of, 49; images of, 240; and psychoanalytic approach to, 24, 73; Rothko on, 168

Pompeii, archaeology of: Bourbon excavations, as closely guarded, 34, 184; damage from early excavations, 44; history of, 29n17; images of, 212, *213*, *214*, *215*, 215–16; as metaphor for exploration of self, in Freud, 72, 73, 76–77n7, 114; and overturning of 18th-century conceptions of Rome, 17; and photography, development of, 45–46; Piranesi site maps, 17, *18*, 45, 194; sponsor-ship of, 17; technology in, 44–45; thoroughness of, 15, 29n4

Pompeii: contemporary written accounts, limited number of, 16, 17, 26, 29n5; high-tech exhibitions at, 41, *41*; historical reenactments at, 26, *225*, 225–26, *226*; numbering system for site, 30n37; as shorthand for all Bay of Naples sites, 16; works about, vast range of, 6; World War II bombing of, 25, 37, *156*, 157, 221

Pompeii (1953 pastel; Baziotes), 164, *164*

Pompeii (1955 oil; Baziotes), 164, *165*

Pompeii (Duncanson), 206, *207*

Pompeii (Harris), 78

Pompeii (Huey), 26, 238, *239*

Pompeii, A.D. 79 (Elmore), 104, *105*

Pompeii, House of the Hanging Balcony (No. 1256) (Sommer), 221, *223*

Pompeii: Its Life and Art (Mau), 193

Pompeii, Painted by Alberto Pisa, Described by W. M. Pisa (1910), 58

Pompeii: Street of the Mercuries (Scanden), 19

Pompeii, Temple of Fortune (No. 1207) (Sommer), 221, 222

"A Pompeiian Gentleman's Home Life" (Rolfe), 110

Pompeii Panorama (No. 1259) (Sommer), 44–45, 212, 221–22, *224*

Pompeii Quadriporticus Project, 50, *50*

Pompeii–Recent Excavations (Esposito), 212, *214*

Pompeijanum at Aschaffenburg, 42n6

PompeiViva, 41

Pompeji (Overbeck), 193

Posi, Paolo, 184, *186*

Poussin, Nicolas, 75, 130; *The Plague at Ashdod*, 140

Powell, Earl A. III, *39*

Powers, Hiram, 206

Poynter, Edward John, 201; *Faithful Unto Death*, 83, 150–52, *151*

Priapus, House of Vettii, Pompeii, image of, 22, 63, *63*

psychoanalytic approach to Pompeii, 24

publishing industry: in 19th century, 55–56; stereotype plates, impact of, 58

Pushkin, Alexander, 19, 140

Pygmalion (Masson), 75

pyrodramas of James Pain, 24, *32–33*, 80, 81, 83, 227, *228*, 229

Q

queer aesthetics: Bas and, 122; gay visual language, forging of, 109. *See also* Dashiell, David Cannon; Plüschow, Guglielmo; Von Gloeden, Wilhelm

Quo vadis? (1913 film), 79

Quo vadis? (1924 film), 82

Quo Vadis (1951 film), 85

R

Raft of the Medusa (Géricault), 132, *142*

Rape of Europa (Titian), 166

Raphael: *Fire in the Borgo*, 140; *School of Athens*, 101; *Stanza della Segnatura frescoes* (Vatican), 101

Rauschenberg, Robert: Combines of, 166; and Irpinia earthquake relief, 176; *Small Rebus, 12, 28*, 166, *167*

Razumovskaya, Maria, 140

Rebecca (Benzoni), 145

Rediscovering Pompeii exhibition (1990s), 38

Reeves, Steve, 85

replicas of Pompeian architecture and art: Pompeian Court at Crystal Palace, Sydenham, *34*, 34–35; popularity of, 34, 42n6

resurrection of Pompeii: Bulwer-Lytton's *The Last Days of Pompeii* as, 54; casts of victims and, 28; as common theme, 16; in Curzon's *A Dream in the Ruins of Pompeii*, 208–9, *209*; 18th-century images of, 17; history of, 26; images focused on, 181–241; lack of historical information and, 26; 19th-century images of, 18; problematics of, 26; tradition of, 109, 110; in von Gloeden, 109. *See also Arria Marcella* (Gautier); *Gradiva* (Jensen); *The Last Days of Pompeii* (Bulwer-Lytton)

Rey, Fernando, 85

Reynolds, Sir Joshua, 128

Rice, Dan, 168

Richier, Germaine: casts of Pompeii victims and, 25, 162; expressionism of, 158; *The Seed*, 25, 160, *161*

La rivale (Scene di vita di Pompei) (1908 De Liguoro film), 80

Robbe-Grillet, Alain, 76

Rodolfi, Eleuterio, 81, *81*, 82

Rogers, Randolph, 145; *Nydia, The Blind Flower Girl of Pompeii*, 146, *200*, 200–201; *Ruth Gleaning*, 201

Rolfe, E. Neville, "A Pompeiian Gentleman's Home Life," 110

Roman culture: depictions of, in Italian films of early 20th century, 81–82, 83–84; military discipline, critiques of, 150–51; Pompeii's overturning of conceptions about, 17

romanità, Italian nationalism of early 20th century, 81–82, 82–83

Rosenthal, Donald, 138

Rothko, Mark, Seagram murals, 22, 168–69, *169–75*

Routledge's Guide to Pompeian Court at Crystal Palace, Sydenham, 35

Roux, Henri, 68

Royal Academy, British, 37–38, 128
Les ruines de Pompéi (Mazois), 19, 100, 102–3, 191–93, *193*
The Ruins (Volney), 54
The Ruins of Pompeii and the Surrounding Country (Burford), 19
The Russian Ending (Dean), 26, 236, *236*, 237

S

Sacred Allegory (Bellini), 208, *208*
A Sacrifice (anon. forgery), 188, *190*
Sadak in Search of the Waters of Oblivion (Martin), 132
Sain, Edouard Alexandre, *Excavations at Pompeii*, *180–81*, 212, *213*
Saint Non, Jean Claude Richarde de, *Voyage pittoresque, ou, Description des royaumes de Naples et de Sicile*, 67, 191–93, *192*, 197
Salt Seller (Balka), 28, *28*
Samoilova, Julia, 141
San Paolo fuori le Mura basilica, 200
Sanquirico, Alessandro, 197; *Atrium of the House of Sallustio*, *198*; *Entrance to Pompeii from the Nolan Gate*, *8–9*, *198*; *The Forum of Pompeii Decorated for a Festival*, *199*; *Subterranean Chamber Intended for Supplication to the King*, *199*
Sardanapalus (Byron), 53
Sartain, John, *The Blind Girl of Pompeii*, 20, *20*
Savini, Pompeo, 187
Scanden, T., 19
Scene During the Eruption of Vesuvius (Franque), *14–15*, 19, 21, 24, 138, *139*
Scharf, George, 35, 40
Schimmel, Paul, 31n77
Schoedsack, Ernest B., 84, *84*
Die Schönheit (journal), 109
School of Athens (Raphael), 101
Scipione l'Africano (1937 film), 83
Scott, Ridley, 78
Scott, Walter, 19, 54, 140, 223
Scribner's Magazine, 110
Seagram Building murals (Rothko), 22, 168–69, *169–75*
Seated Nude, Pompeii (César), 25, 158, *159*
Second London International Exhibition of Industry and Art (1862), 35
Second Macchina of the Chinea of 1749: The Theater at Herculaneum (Petitot), 184, *185*
Second Macchina of the Chinea of 1750: Mount Vesuvius (Sorrelò), 184, *185*
Secret Cabinet of National Archaeological Museum, Naples, 62, 69n5; copies of images in, 68; history of entrance policies and contents, 62–64, *66*, 66–67; illustrated catalogs of, 68; modern images in, 64–66; modern version of, *64*; multiple locations of, 64–66, *65*, 69n13; policy on women's admission to, 63, 67, 68; unofficial access to, 63, 66–67, 68; visitors' opinions on, 68
The Secret Life of Salvador Dalí (Dalí), *74*, 116

The Seed (Richier), 25, 160, *161*
Segal, George, 28
Sentinel of Pompeii, 70, 83, 150–52, *151*
sexual images at Pompeii, 21, 60–69; differing sexual norms of Greeks and Romans, as ongoing issue, 61–62, 64, 67, 68–69; isolation of, in National Archaeological Museum, Naples, 60–61; policy on women's viewing of, 61, 63, 67, 68; ubiquity of in Pompeii, 61. *See also* Secret Cabinet of National Archaeological Museum, Naples
Schopin, Frédéric, *The Last Days of Pompeii*, 142–43, *143*
The Sign of the Cross (toga play), 80–81
Silius Italicus, 108
Simm'nervusi series (Cucchi), 230
slavery: Alma-Tadema critique of, 103; Bulwer-Lytton on, 202; Duncanson and, 206; images of Pompeii as critique of, 21–22; Rogers on, 201
Sleeping Ariadne, Vatican Museums (2nd century B.C.), 75, 118, *118*
Sleeping Hermaphrodite (Roman sculpture), 217
The Small Herculaneum Woman in the lower Belvedere Garden in Vienna (Kleiner), 33, *33*
Small Rebus (Rauschenberg), 12, 28, 166, *167*
Smith, Franklin Webster, 42n6
Sommer, Giorgio, 212, 221–23; Alma-Tadema and, 202; *Cast, Pompeii*, 27, *28*; *The Courtyard of the Stabian Baths*, 46, *47*; and dominant mode of Pompeii photographs, 23; *Gladiator Battle in the Amphitheater at Pompeii*, 226, *226*; *The House of Meleager*, 202, *202*; photographs of body casts, 27, *27*, 28, 48, 48–49, 51n9; *Pompeii, House of the Hanging Balcony (No. 1256)*, 221, *223*; *Pompeii, Temple of Fortune (No. 1207)*, 221, *222*; *Pompeii Panorama (No. 1259)*, 44–45, 212, 221–22, *224*; as preeminent photographer of Pompeii, 46, 221; reuse of images from, 26, 238; style of, 46, 48–49; *Two Body Casts, Pompeii*, 27, *27*; Warhol and, 176
Sommerard, Edmond de, 187
Sorrelò, Michele, *Second Macchina of the Chinea of 1750: Mount Vesuvius*, 184, *185*
Spagnuolo, Ferdinando, 43n34
Specchi, Michelangelo, 184
Speed, Lancelot, *The Banquet of Arbaces*, 54
Spencer, Bud, 85
Spinazzola, Vittorio, 154
Spinelli, Domenico, 63, 66
SPLEEN (Gormley), 234
Stabiae, villas at, 90; *see also Cupid Seller*
Stanza della Segnatura frescoes, Vatican (Raphael), 101
Stefani, Grete, 211
stereotype plates, impact on publishing industry, 58
Steward, Samuel, 22
Story, William Wetmore, 200–201
Stratonice (Méhul), 98
Pompeii, Street of the Tombs, 24, 140
Street of the Tombs, Pompeii (Le Dien and Le Gray), *24*

Study for "Prière de toucher" (Duchamp), 120–21, *121*
sublime, 19th-century interest in, 19, 23, 126
Subterranean Chamber Intended for Supplication to the King (Sanquirico), *199*
Suite of Picturesque Views of the Ruins of Pompeii (Wilkins, *ed.*), 191
Summers, Charles Francis, 145
Le surréalisme en 1947 exhibition, 120–21
Surrealists: automatism and, 164; Duchamp's *Study for "Prière de toucher,"* 120; images of Gradiva, 73–75, *74*, 116, *117*, 118, *119*, 120; *see also* Breton, Dalí, Masson
Sylvester, David, 160
Szaposznikow, Alina, *Exhumed*, 28

T

Tacitus, 17, 128, 130
Tadini, Luigi (count of Crema), 144
Tecce, Angela, 176
technology: for casts of Pompeii victims, development of, 47, 48; digital reconstructions of Pompeii, 49–50, *50*, 51n17; and excavation of sites, 44–45; in museum exhibits, 38, 40–41, *41*, 50; publications on Pompeii and, 45; stereotype plates, impact on publishing industry, 58; transformation of site into audience-friendly form, 44, 51; transformation of site perception, 49; as window into ancient world, 44, 51n10
television programs on Pompeii: influence of Bulwer-Lytton's *The Last Days of Pompeii* on, 58–59; TV miniseries, 78, 88
The Temple of Isis at Pompeii (Piranesi and Desprez), 17, *17*
Tepidarium: The Room Where the Women of Pompeii Came to Rest and Dry Themselves after Bathing (Chassériau), 100–102, *101*, 143
The Tepidarium (Winkles), 100
Tertullian, 30n35
Testa, Angelo, *Visit of the Holy Roman Emperor Joseph II to Pompeii*, 191–93, *193*
Theater of Herculaneum, *Chinea* reconstruction of, 184, *185*
Theseus and the Minotaur fresco, Porticus, Herculaneum, 98
Third Eruption of the Volcano of 1789 (Desperret), 136, *137*
Thumbs Down (Gérôme), 87n28, 106
Titian: *Danae*, 64–66, *66*; *Rape of Europa*, 166
toga plays, 80–81, 83
Toilet of Esther (Chassériau), 101
Tomb of King André, Husband of the Famous Queen Jeanne of Naples (Berthault), 191–93, *192*
Tools of Masons and Agricultural Workers Found at Pompeii (Piranesi), 194, *196*
Topographical Map of the Discoveries at Pompeii (Piranesi), 17, *18*, 45, 194
Torso (César), 158, *158*
Tottola, Andrea Leone, 19, 197
touring of ruins: 18th-century emphasis on, 17;

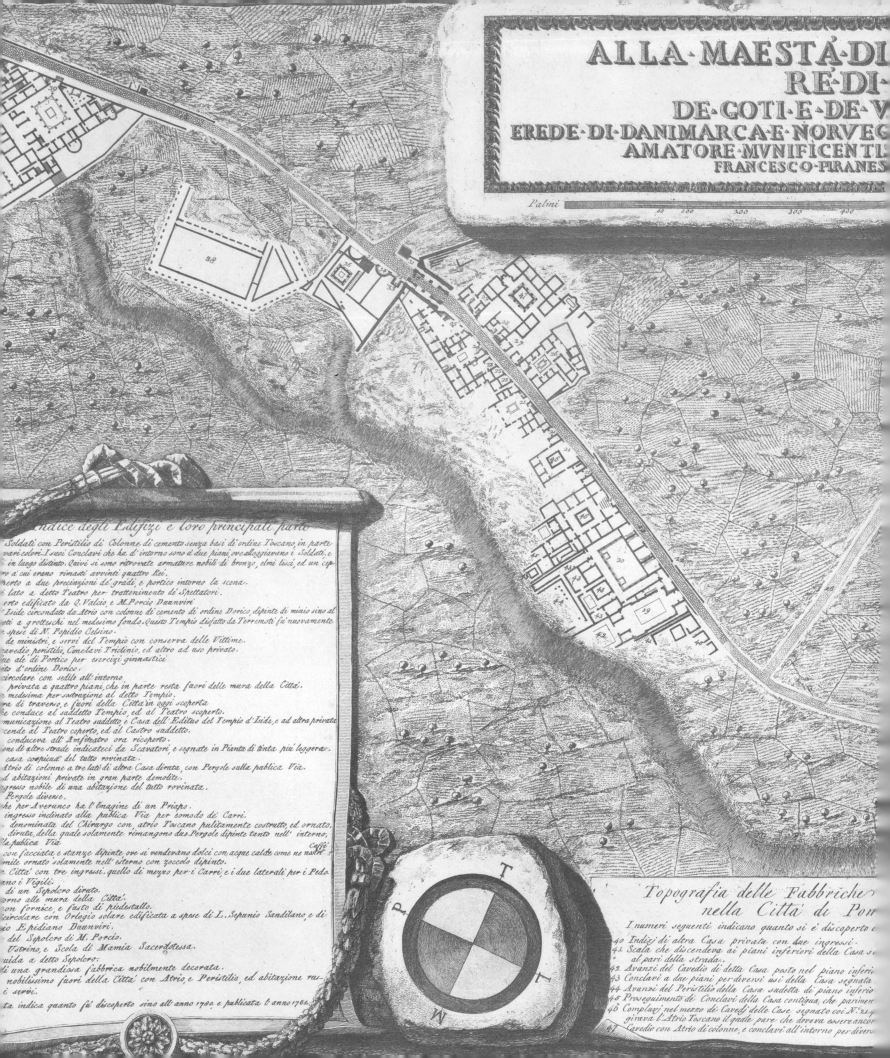

ALLA·MAESTÀ·DI
RE·DI·
DE·GOTI·E·DE·V
EREDE·DI·DANIMARCA·E·NORVE
AMATORE·MVNIFICENTI
FRANCESCO·PIRANES

Palmi

Topografia delle Fabbriche
nella Città di Pom